The Dodge Collection

THE DODGE
COLLECTION

*of Eighteenth-Century French and English Art
in The Detroit Institute of Arts*

CATALOGUE ENTRIES BY
ALAN PHIPPS DARR, THEODORE DELL,
HILARIE FABERMAN, HENRY H. HAWLEY,
CLARE LE CORBEILLER,
AND J. PATRICE MARANDEL

INTRODUCTION BY THEODORE DELL

HUDSON HILLS PRESS, NEW YORK
IN ASSOCIATION WITH
THE DETROIT INSTITUTE OF ARTS

FIRST EDITION

© 1996 by the Founders Society Detroit Institute of Arts
All rights reserved under International and Pan-American Copyright Conventions.

Published in the United States by Hudson Hills Press, Inc.,
Suite 1308, 230 Fifth Avenue, New York, NY 10001-7704.

Distributed in the United States, its territories and possessions,
Canada, Mexico, and Central and South America by National Book Network.
Distributed in the United Kingdom, Eire, and Europe by Art Books International Ltd.
Exclusive representation in Asia, Australia, and New Zealand by EM International.

FOR HUDSON HILLS PRESS

Editor and Publisher: Paul Anbinder

Editorial Assistant: Faye Chiu

Proofreader: Lydia Edwards

Indexer: Karla J. Knight

Designer: Howard I. Gralla

Composition: Angela Taormina

Manufactured in Japan by Dai Nippon Printing Company.

FOR THE DETROIT INSTITUTE OF ARTS

Director of Publications: Julia P. Henshaw

LIBRARY OF CONGRESS CATALOGUING-IN-PUBLICATION DATA

Detroit Institute of Arts.
The Dodge collection of eighteenth-century French and English art in the
Detroit Institute of Arts / catalogue entries by Alan Phipps Darr . . . [et al.] ;
introduction by Theodore Dell. — 1st ed.
p. cm.
Includes bibliographical references and index.
ISBN 1-55595-135-x (alk. paper)
1. Art, French—Catalogues. 2. Art, Modern—17th–18th centuries—France—Catalogues.
3. Art, English—Catalogues. 4. Art, Modern—17th–18th centuries—England—Catalogues.
5. Art—Michigan—Detroit—Catalogues.
6. Dodge, Anna Thomson, 1871–1970—Art collections—Catalogues.
7. Art—Private collections—Michigan—Detroit—Catalogues. 8. Detroit Institute of Arts—Catalogues.
I. Darr, Alan Phipps. II. Title.
N6846.D4 1996
709'.44'07477434—dc20 96-17761
CIP

CONTENTS

FOREWORD

If not for the great patrons of the past, American art museums would be vastly impoverished institutions. By leaving the contents of the central Music Room of Rose Terrace, her Grosse Pointe home, to the Detroit Institute of Arts, Anna Thomson Dodge preserved for us a glimpse into the life of two cultural periods: the lavish decorative arts of the French eighteenth century as reinterpreted by the wife of one of the wealthy automobile barons of twentieth-century America. The Mr. and Mrs. Horace E. Dodge Memorial Collection comprises more than 130 pieces of furniture, paintings, sculpture, Sèvres porcelain, and outstanding examples of the various other highly refined decorative arts that flourished in eighteenth-century France. Eschewing the many other grand ages of European culture, Mrs. Dodge had a single-minded passion for that spectacular age of elegant French culture, when highly skilled designers and artisans worked together with architects to create some of the most sophisticated interiors known in European history. For the early twentieth century, eighteenth-century France represented a high point in culture. It was a society built on conversation, wit, and the exchange of ideas about philosophy, literature, science, and the arts. Individuals cared passionately about all the details of their lives and realized that the decor of one's home speaks for one's social self.

The many photographs of Rose Terrace, published here for the first time accompanying the illuminating essay by Theodore Dell, are all that are left to give us a sense of the setting that Mrs. Dodge created for her treasures, for the house was demolished in 1976.

While it was a twentieth-century house designed for a modern American life-style, Mrs. Dodge filled her home with authentic French antiques, not reproductions. We can all now share in her delight in the delicate lines and delightful pink rosebuds of her *Jewel Coffer* (cat. 8), the exquisite craftsmanship of a finely decorated astronomical *Mantel Clock* (cat. 31), or the brilliant colors and exuberant forms of her many pieces of the finest Sèvres porcelain (cat. 39–63).

A woman of humble origins, Mrs. Dodge had the benefit of excellent advisors in the architect Horace Trumbell and the dealer Joseph Duveen. It is unlikely that collecting of the decorative arts of eighteenth-century France with such focus and on this scale by a private individual will occur again, and the Detroit Institute of Arts is honored and singularly grateful to be the recipient of such generosity. She also had the foresight to provide an endowment fund to support her bequest to the museum, including the expense of this publication. The National Endowment for the Arts generously provided a grant giving additional support to the catalogue, which received funding also from the Andrew Mellon Publications Endowment.

Work on this book was begun shortly after Mrs. Dodge's death in 1970 by the late Fred Cummings, curator and later director of the Detroit Institute of Arts. He was responsible for the original choice of scholars to write on the Dodge Collection, most notably furniture specialist Theodore Dell; Henry Hawley of The Cleveland Museum of Art; and the late Carl Dauterman of The Metropolitan Museum of Art. Hilarie Faberman of the Stanford University Art Museum, and J. Patrice Marandel, now of the Los Angeles County Museum of Art, joined them. The Sèvres portion, originally written by Dauterman, has been brought up to date by Clare Le Corbeiller of The Metropolitan Museum of Art. Many other scholars from Europe and America have generously lent their help; they are named in the acknowledgments. At the Detroit Institute of Arts, Curator of European Sculpture and Decorative Arts Alan Phipps Darr both contributed to the manuscript and coordinated the work of the specialists and his staff on the many details of the project. Dirk Bakker, Robert Hensleigh, and the photography department are responsible for the photography and Julia Henshaw and her staff for coordinating the publication. Howard Gralla, working with Paul Anbinder of Hudson Hills Press, has created the handsome design of this book. It is a great pleasure to see this work come to fruition and my heartiest thanks go to them all.

Samuel Sachs II
Director

ACKNOWLEDGMENTS

ALAN PHIPPS DARR:

The catalogue of a collection of this scope could not have been written without the generous and patient collaboration from scholars and specialists throughout America and Europe. For nearly two decades Theodore Dell, Henry Hawley, and I have pursued together the realization of this catalogue with enthusiasm, confidence, and a belief in the value of the work. My first thanks must go to them and to each of the other authors, past and present, for their knowledge, wit, perseverance, and years of good friendship: the late Carl Dauterman, the late Fred Cummings, Hilarie Faberman, J. Patrice Marandel, and Clare Le Corbeiller. Theodore Dell especially, and the other authors, who acknowledge those individuals who assisted them in the preparation of their respective entries, have steadfastly supported and inspired this publication since their initial involvement.

Since the present catalogue has been extensively researched and written over many years, to obtain a sense of its historical development requires some appropriate explanation. Fred Cummings, first as curator of European art and then as director of the museum (1973–84), and Susan Rossen, former publications director, conceived the initial organization of the catalogue in 1971 and selected leading specialists to write the catalogue entries: Theodore Dell for French furniture; Carl Dauterman of The Metropolitan Museum of Art for Sèvres porcelain; Henry Hawley of The Cleveland Museum of Art for gilt bronzes, small marble sculptures, silver, and tapestries; and later that decade, myself for the French terracotta sculptures. Research and writing began in earnest, but the catalogue proceeded slowly.

In 1978, shortly after I assumed a curatorial position in the European Art Department, the mantle of responsibility for the catalogue organization and completion of this manuscript was placed upon my shoulders. Since then, additional authors were selected. J. Patrice Marandel, former curator of European paintings at The Detroit Institute of Arts and now curator of European art at the Los Angeles County Museum of Art, agreed to write the entries on the set of four paintings by Fragonard and the murals by Sert; Hilarie Faberman, former curator of Western art at the University of Michigan Museum of Art, Ann Arbor, and now curator of modern and contemporary art at the Stanford University Art Museum, wrote the entries on the English paintings. Edith Standen, curator emeritus at The Metropolitan Museum of Art, advised on the tapestries. In addition, Tracey Albainy, assistant curator in the Department of European Sculpture and Decorative Arts since 1994, wrote the biographies of Roentgen

and Tassaert, contributed to other entries, and compiled the appendices, and Elena Calvillo, former research assistant, drafted the biography of Boucher. During the past three years, each of the authors kindly agreed to write artists' biographies and to revise and update each entry.

Carl Dauterman, author of the Sèvres entries, passed away in 1989. Because the state of research on Sèvres porcelain had advanced considerably since he submitted his manuscript, his daughter Eunice Dauterman asked that we update the entries. At my recommendation, we enlisted the services of other leading scholars of Sèvres porcelain. Rosalind Savill, now director of The Wallace Collection, London, first kindly agreed to read and comment on these entries. Later, Tamara Préaud, archivist of the Manufacture Nationale de Sèvres, carefully researched the archives at Sèvres and amended Dauterman's entries with new information on the dates of the original models, the firing, painting, and gilding of the Sèvres porcelains. David Peters of London, Adrian Sassoon, formerly of The J. Paul Getty Museum, Bernard Dragesco of Paris, and Ghenete Zelleke of The Art Institute of Chicago each contributed new and valuable information from their own research on Sèvres porcelain. Finally, to ensure that the Sèvres entries represented the most current state of research in this rapidly advancing field, Clare Le Corbeiller, curator of European Sculpture and Decorative Arts at The Metropolitan Museum of Art, graciously agreed to write biographies for the Sèvres painters and to incorporate all the recent information into the rewritten entries. Consequently, Le Corbeiller updated and rewrote Dauterman's earlier manuscript in its entirety.

Museum curators, institutions, specialists, and collectors in the United States and throughout Europe have contributed their support and cooperation to this publication. I would like to express my great appreciation to the following for their generous assistance and many valued kindnesses benefiting this publication: IN ENGLAND, Brian Allan, Sir Geoffrey de Bellaigue, Frank Berendt, David Hawkins, Sir Terence Hodgkinson, Jennifer Montagu, David Peters, Anthony Radcliffe, Adrian Sassoon, Rosalind Savill, the late Sir Francis Watson, and John Whitehead; IN FRANCE, Antoine d'Albis, Daniel Alcouffe, Jean-Dominique Augarde, Michèle Beaulieu, Patrice Bellanger, Jean Cailleux, Didier Cramoisan, Bernard Dragesco, Jean-René Gaborit, Ulrich Leben, Marianne Roland Michel, Philippe Palasi, Alexandre Pradère, Tamara Préaud, Jean Nérée Ronfort, Pierre Rosenberg, Guilhem Scherf, and François Souchal; IN THE UNITED STATES, David Agresta, Katharine Baetjer, Roger Berkowitz, the late

David Cohen, James David Draper, Joseph Focarino, Svetoslao Hlopoff, Wolfram Koeppe, Jeffrey Munger, James Parker, Anne Poulet, Olga Raggio, William Rieder, James Robinson, Edith Standen, Gerard Stora, Dean Walker, Joan Walker, Ian Wardropper, Gillian Wilson, and Ghenete Zelleke.

The steadfast support of many members of our museum staff and several other dedicated individuals in Detroit has been essential. The names of all contributors to this project are too numerous to list completely. However, several individuals were particularly important and should be singled out. In the department of European Sculpture and Decorative Arts, Tracey Albainy, and previously Bonita Fike and Elena Calvillo, were enthusiastically and tirelessly involved with the curator in coordinating the final revisions over the past ten years. The mass of new information and its entry on a new computer system was carefully coordinated under my direction at first by Bonita Fike, former assistant curator in this department and now associate curator of Twentieth-Century Art/Decorative Arts, and later by Tracey Albainy. In 1992, with assistance from Elena Calvillo, Fike carefully reentered and proofread each manuscript page, and organized the extensive bibliography with our former librarian, Carla Reczek. After Sheila Schwartz edited the manuscript in 1995, Tracey Albainy meticulously coordinated the insertions of editorial and authorial final revisions with exemplary care and an ever-cheerful awareness of the value of this long-anticipated publication. Lois Makee and Joan Kitka, departmental senior stenographers, provided additional administrative and secretarial support on numerous occasions. Without the dedication of these individuals and the understanding and support of my wife, Mollie Fletcher, and our sons, Owen and Alexander, this project would never have been realized.

Dirk Bakker and Robert Hensleigh, the director and associate director of photography, and the museum's Photography Department undertook a comprehensive campaign of new photography for this publication. They provided the exceptionally precise color, black-and-white, and computer-enhanced digital images used in this catalogue. For this publication, Hensleigh developed an innovative means of photographing the faint incised marks on the Sèvres porcelains under raking and reflected light, scanning them onto a state-of-the-art computer, and then enhancing the computer images so that the marks, barely discernible to the naked eye, appear clear in photographs.

The museum's Conservation Services Laboratory, especially Head Conservator Barbara Heller, Alfred Ackerman and Serena Urry (paintings conservation), Carol Forsythe and John Steele (objects conservation), Leon Stodulski (senior research scientist), James Robinson (visiting furniture conservator), and Jane Hutchins (visiting textile conservator) provided keen eyes, technical analyses, and valuable observations, which have been incorporated into the catalogue.

In the Publications Department, Julia P. Henshaw, director of publications, and her current and former colleagues, Cynthia Helms Bohn and others, offered helpful guidance gained from years of producing museum catalogues and provided many thoughtful suggestions about the book's final organization and design. Sheila Schwartz, editor in New York, and previously Joseph A. Focarino, editor of The Frick Collection publications, skillfully brought the authors' words into a uniform state for publication. The graphic designer Howard I. Gralla and co-publisher Paul Anbinder of Hudson Hills Press, New York, allowed flexibility and an active dialogue to make the publication as attractive and useful a resource as possible.

In Detroit we are also grateful to Samuel Sachs II, director of The Detroit Institute of Arts, Jan van der Marck, former chief curator, Joseph Bianco, executive vice-president, and the Development Department, especially John McDonagh, former director, Jim Huntley, associate director, and Jennifer Czajkowski, grants manager, for their encouragement and assistance in obtaining essential grant funding and their continued support of this publication. The National Endowment for the Arts awarded generous grants for conservation and publication of the Dodge Collection. Other funding was provided by the Mr. and Mrs. Horace E. Dodge Memorial Fund, an endowment established to support the care, presentation, and publication of this exceptional bequest, the Andrew W. Mellon Foundation, and the Founders Society of The Detroit Institute of Arts.

We are deeply grateful to each of the authors, staff, colleagues, and friends who have worked together to create this handsome publication—the second of several planned scholarly catalogues featuring the museum's distinguished European collections. Many profound thanks to all who have been involved during the past quarter century.

THEODORE DELL:

The author was asked by the late Fred Cummings twenty-five years ago to write the furniture section of the Dodge catalogue, and has worked on it, off and on, ever since. Completion and publication always seemed just around the corner.

The author feels most fortunate to have had the help of a number of highly intelligent people who have worked at The Detroit Institute of Arts. Susan F. Rossen, formerly Director of Publications, was the first of them, and subsequently became a good friend. The author worked closely with her on the early stages of the introduction concerning Mrs. Dodge, the building of Rose Terrace, and the formation of the collection. Many passages of her writing still exist in the essay.

Joseph A. Focarino, editor of The Frick Collection publications in New York, edited the Dodge catalogue manuscript

in the early 1980s, in his impressive way making everything more clear. All the authors who were involved with the project at that time greatly benefited. The final version of the manuscript has been skillfully edited by Sheila Schwartz.

Particular thanks should go to Alan Phipps Darr, assistant curator of European Art from 1978 and curator of European Sculpture and Decorative Arts since 1981, who has overseen the project and has always been most supportive. The friendship that has developed over the years is highly valued. In the same department, the author would like to express his gratitude to both Bonita Fike and Tracey Albainy, who as successive assistant curators undertook the myriad detailed projects involved in producing such a work. It was Tracey Albainy who finally brought the many ends of the project together. The author is most impressed.

Outside the museum, the author would like to thank Gillian Wilson at The J. Paul Getty Museum for allowing him access to the information she has gathered on the museum's version of the *Clock of the Four Continents;* Patrick Leperlier for helping to fill out the history of the Riesener commode; and Olivier LeFuel for arranging a viewing of the companion piece. Gratitude also goes to James Parker and William Rieder of The Metropolitan Museum of Art, the former for allowing access to the museum's Pavlovsk secretaire, and the latter to archival material pertaining to Mrs. Dodge's purchases.

For help regarding the physical aspects of the furniture, the author expresses thanks to the conservators Svetoslao N. Hlopoff, who restored much of the furniture soon after it entered the museum; and James Robinson, who continued with conservation of the Dodge furniture and facilitated the identification of the woods by removing tiny samples for microscopic analysis by J. Thomas Quirk. The author has enjoyed many hours of conversation with both of these men. Long-term friendships here are also involved.

Finally, in regard to the author's research on Mrs. Dodge, he would like to thank George H. Zinn, Jr., of the firm Butzel, Long, attorneys for Mrs. Dodge's estate, for allowing access to Mrs. Dodge's papers. A large portion of this archive has since been destroyed. It was of great value that the author was allowed to make photocopies of the pertinent material. Valuable insight into the personality of Mrs. Dodge was gained through conversations with the late W. Hawkins Ferry and with Ronald Fox, both of whom knew Mrs. Dodge in the later years of her life. And Dreck Wilson kindly shared information on Julien Abele, about whom he is writing a biography. The author is most grateful to each of these men.

Somehow, a project that was to be completed in one year ended up taking twenty-four. In this regard, the author would like to thank Julia Henshaw, Director of Publications at the museum, for showing both persistence and patience. Hopefully the wait will have proven worthwhile.

HILARIE FABERMAN:

For their kind assistance in the preparation of the entries on British painting, I would like to thank Brian Allen, director of the Paul Mellon Centre for Studies in British Art, London; John Hayes, former director of the National Portrait Gallery, London; and Aileen Ribeiro, professor at the Courtauld Institute of Art, University of London. My research was greatly facilitated by the work of the late Sir Ellis Waterhouse, who answered numerous questions about Detroit's pictures, and whose library and archive, now housed in the Mellon Centre in London, continue to serve as a valuable resource for students in the field.

HENRY H. HAWLEY:

During the quarter century I have sometimes been involved with the catalogue of the Dodge Collection, many people have most generously supplied me with information and photography of works of art in their care. Others have shared the previously unpublished fruits of their research, and for that help I would like to thank Jean-Dominique Augarde, Colin Bailey, Charles Cator, the late Anthony M. Clark, Theodore Dell, Bernard Dragesco, Svend Eriksen, Michel Gallet, Clare Le Corbeiller, Thomas J. McCormick, James Parker, the late Anthony Roth, Gerard J. Stora, Jacques Thirion, and Peter K. Thornton.

CLARE LE CORBEILLER:

I am particularly indebted to Tamara Préaud, Manufacture Nationale de Sèvres, and to Bernard Dragesco. Tracy Albainy, the Detroit Institute of Arts, kindly checked and corrected many details. For numerous points of information and advice I should like to thank Michael Hall, Didier Aaron Ltd.; Dr. Magret Klinge, Düsseldorf; Rosalind Savill, The Wallace Collection; Kimerly Rorschach, The David and Alfred Smart Museum of Art, Chicago; Jeffrey H. Munger, Museum of Fine Arts, Boston; Ghenete Zelleke, The Art Institute of Chicago; Mrs. Daniel P. Davison; G.V. Vdovin, Ostankino Museum; Elena Kalnitskaja, St. Petersburg; Adrian Sassoon; Katharine Baetjer, Laurence Libin, Walter Liedtke, and Marine Nudel, The Metropolitan Museum of Art; and Donna Corbin, Philadelphia Museum of Art.

The Dodge Collection

THE CREATION OF THE DODGE COLLECTION
Alan Phipps Darr

For over five decades until her death in 1970, Mrs. Horace E. Dodge was a leading patron of the cultural life of Detroit. She was intensely involved in the musical arts and gave the Detroit Symphony Orchestra continuous support. The Detroit Institute of Arts was also an ongoing beneficiary of Mrs. Dodge's generosity, beginning with a 1925 gift, Matteo di Giovanni di Bartolo's *Madonna and Child with Saint Catherine and Saint Anthony of Padua* (fig. 1). In 1957 she gave the museum nine murals depicting *The Story of Sinbad the Sailor* by the early twentieth-century Spanish painter José Maria Sert y Badia (fig. 2); this gift initiated her role as a major benefactor of the institution.

Mrs. Dodge's most magnificent gifts to the people of Detroit, however, were posthumous. Among the provisions in a codicil to her will was a bequest to The Detroit Institute of Arts of the contents of the Music Room of Rose Terrace, her Grosse Pointe Farms estate, along with an endowment of

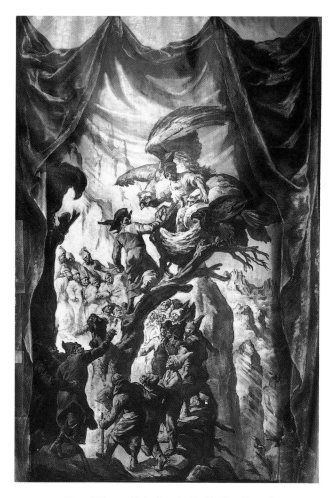

FIGURE 2 *Second Voyage: Sinbad in the Eagle's Nest* (from the series, *The Story of Sinbad the Sailor*). José Maria Sert y Badia (Spanish), 1923. Oil and gold leaf on canvas. Gift of Anna Thomson Dodge (57.75.3).

$1,000,000 for installation, conservation, and maintenance of the Music Room in the museum (fig. 3). The Dodge Bequest, with the initial support of the museum's Arts Commission, then-director Willis Woods, and curator of European Art Fred Cummings, offered opportunities to enrich the cultural life and imagination of this community for generations. Also in her will Mrs. Dodge donated $2,000,000 for a Dodge Fountain to be erected on a newly created community park plaza on the riverside in downtown Detroit in memory of her husband and son. Between 1973 and 1978, Isamu Noguchi erected the monumental stainless steel fountain near his obelisk on the Philip A. Hart Civic Center Plaza.

As Theodore Dell describes in the introduction to this book, Mrs. Dodge's early interest in eighteenth-century French art and the creation of Rose Terrace, her home mod-

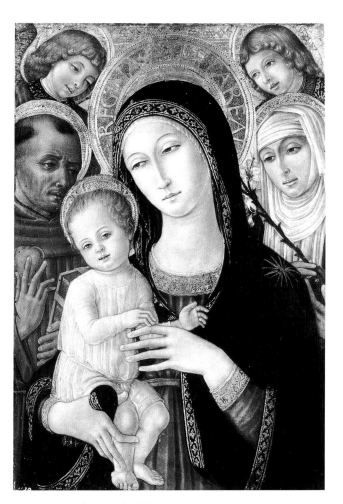

FIGURE 1 *Madonna and Child with Saint Catherine and Saint Anthony of Padua.* Matteo di Giovanni di Bartolo (Italian), c. 1480. Tempera on panel. Gift of Mrs. Horace E. Dodge (25.24).

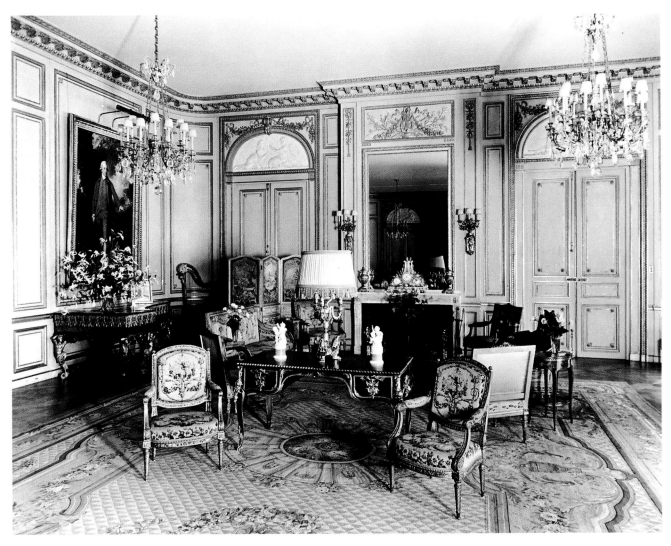

FIGURE 3 Music Room, Rose Terrace, photographed in the late 1930s, showing Mrs. Dodge's piano and harp under Gainsborough's portrait; nearby are other portions of her collection bequeathed to the Detroit Institute of Arts in 1970.

eled after the Petit Trianon at Versailles, were probably inspired by Eva Stotesbury, the distinguished Philadelphia and Palm Beach hostess and collector of French decorative arts, whose son had married Mrs. Dodge's daughter, Delphine, in 1920. Moreover, as Detroit was founded by the French in 1701, Mrs. Dodge's keen interest in French culture was also historical and must have had further personal and civic significance for her.

Among the last great homes built in America, Rose Terrace was one of the most magnificent (figs. 3, 4, and 5). Most impressive was the grand central salon, or Music Room, on the main floor, where Mrs. Dodge would receive her guests.

Much of Mrs. Dodge's finest European decorative arts forms one of the most distinguished and extensive groups of French decorative arts in any American private collection or museum. From their documented provenance it is clear that some of the pieces of furniture were made for various royal palaces in France—at Fontainebleau, Versailles, and Bellevue—and for other royal palaces in Russia and Poland. For example, the gilt-bronze candelabra (cat. 29) were

designed about 1766 by Victor Louis and made by Jean-Louis Prieur for the bedroom of King Stanislaus II Poniatowski at the Royal Palace in Warsaw. The pair of dark green porcelain vases from the royal Sèvres manufactory (cat. 52) was owned by Maria Feodorovna, Empress of Russia, Czar Nicholas I, Grand Duke Constantine Nikolaievich, and Grand Duke Constantine Constantinovich. Of considerable significance is the *Jewel Coffer* (cat. 8) by the German-born master *ébéniste* Martin Carlin, who worked in Paris for members of the royal family and others from 1766 to 1785. In 1932 the jewel coffer, elegantly decorated with ormolu mounts and Sèvres porcelain plaques painted with sprays of roses, must have appealed immediately to Anna Thomson Dodge as a masterwork for her newly built home "Rose Terrace" because of its refined decoration and its distinguished provenance. It is said to have been acquired originally by Friederike Sophie Dorothea, Duchess of Württemberg, and was known as the "Mütterchen" cabinet because she gave it to her daughter, Maria Feodorovna, as a wedding present upon Maria's marriage in October 1776 to Paul I, then Grand Duke and later

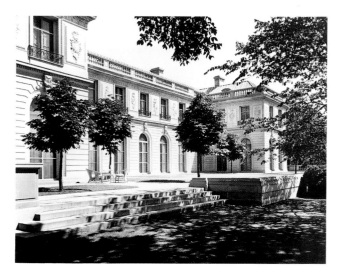

FIGURE 4 Garden Facade with terrace facing Lake St. Clair, Rose Terrace.

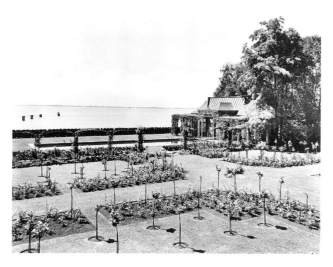

FIGURE 5 Rose Terrace Garden with view onto Lake St. Clair, swimming pool, pool house, and Mrs. Dodge's rose garden shortly after planting in the late 1930s.

Czar of Russia. This cabinet stood for decades in the bedroom of Maria Feodorovna in the Palace of Pavlovsk near St. Petersburg (fig. 6). Also from Russia (formerly in the collection of the Stieglitz Museum in St. Petersburg) is the superb writing table (cat. 14) by Jean-Henri Riesener, made for an aristocrat or member of a royal family. Riesener, like Carlin, was a German by birth and is often considered one of the greatest *ébénistes* working in the second half of the eighteenth century, receiving patronage from the leading courts throughout Europe.

Royal and aristocratic patronage of the arts in eighteenth-century France is exemplified also by many of Mrs. Dodge's *objets d'art* and enhanced by recent research that has led to the discovery of their original owners. During the eighteenth century, the display of wealth and luxury objects of artistic production signified the economic health of a country. The highest quality of artistic production in the eighteenth century was to be found in France under Louis XIV, Louis XV, and Louis XVI. Mrs. Dodge's chest of drawers by Riesener (cat. 15) was made for Louis XVI and bears the mark indicating that it was at his château at Fontainebleau. Recent research has demonstrated that Mrs. Dodge's *Bacchante and Satyr with Young Satyr* by Clodion (cat. 22) was most probably owned by Haranc de Presle, the great Parisian collector of small terracotta sculptural groups so highly prized in the late eighteenth century. The set of four paintings by Fragonard (cat. 64) has been shown to be among the artist's earlier works and likely made for the Hôtel de Mortemart-Rochechouart, when the artist was still in the studio of François Boucher.

The entries in this catalogue further illuminate the English aristocratic provenance of Mrs. Dodge's paintings by Gainsborough (cats. 65, 66), Hoppner (cat. 67), and Reynolds (cat. 68). Mrs. Dodge's tapestry of *Psyche Displaying Her*

Treasures to Her Sisters (cat. 37), woven from a cartoon by François Boucher, exemplifies the sumptuous production of the royal manufactory at Beauvais for foreign as well as French patrons. Recently, through heraldic research Philippe Palasi identified this tapestry as part of a set of five ordered in 1744 by Luigi Reggio e Branciforte-Colonna, the Neapolitan ambassador of the King of Spain to the French court.

To select the works of art and furnishings appropriate for the magnificent French eighteenth-century environment she envisioned, in the early 1930s Mrs. Dodge had obtained the

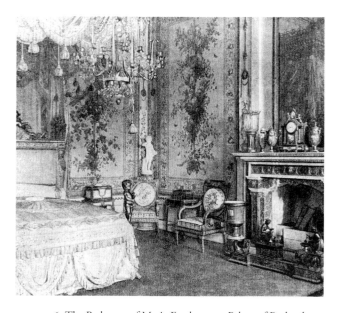

FIGURE 6 The Bedroom of Maria Feodorovna, Palace of Pavlovsk, near St. Petersburg. Photographed in the early twentieth century, the room appears as it was described in a letter of 1795 from Maria Feodorovna to her mother. The porcelains on the mantelpiece and the jewel cabinet to the right of the bed were acquired by Mrs. Dodge in 1932 through the dealer Joseph Duveen.

help of Joseph Duveen, the renowned English art dealer. Advisor to the most prominent American collectors, Duveen was instrumental in building great collections of European art, such as those of Benjamin Altman now in The Metropolitan Museum of Art, New York, and of Andrew Mellon and Samuel Kress, whose donations formed the nucleus of the collections of the National Gallery of Art, Washington, D.C. In those years Duveen arranged for Mrs. Dodge to benefit from his purchase of important eighteenth-century art works, often with noble and royal pedigrees, from the former Russian imperial collections.

The objects that were part of Mrs. Dodge's Music Room were transferred in 1971 to The Detroit Institute of Arts and are installed in the Ford wing of the museum, where they form the core of the Mr. and Mrs. Horace E. Dodge Memorial Collection. A few important works, which were collected by Mrs. Dodge but located elsewhere inside Rose Terrace, were acquired by the museum at the Christie's auction of Mrs. Dodge's collection in London in June 1971. These include the Marin terracotta *Maternity* (cat. 23), the four Fragonard pictures, and the monumental Duplessis gilt-bronze candelabra (cat. 34). Several key works located elsewhere at Rose Terrace were acquired at the same auction by The J. Paul Getty Museum and helped form the initial nucleus of that institution's French decorative arts collection.

According to a recent biography (Latham and Agresta 1989: 336), during the 1960s Mrs. Dodge offered The Detroit Institute of Arts the entire collection and contents of Rose Terrace, but without any operating endowment for the maintenance of the house; unfortunately, the museum could not accept this enormous collection and magnificent estate without funds for its maintenance. It is sad that Rose Terrace was demolished in 1976. The only part of the extensive collection Anna Thomson Dodge created that remains intact is that bequeathed to The Detroit Institute of Arts in memory of her husband. The sixty-eight objects discussed in the catalogue entries that follow and the works of art given by or acquired from the Dodge estate between 1925 and 1973 listed in Appendix I comprise the 130 pieces in the Mr. and Mrs. Horace E. Dodge Memorial Collection.

Over the years a portion of the interest from the Dodge endowment has been used to acquire notable works of art, especially French eighteenth-century works, such as the Roslin equestrian portrait of the duc d'Orléans and a monumental tortoiseshell, brass, and gilt-bronze pedestal clock, the *Clock of the Four Continents,* attributed to André-Charles Boulle and his workshop (fig. 7). A complete list of works of art acquired with the Mr. and Mrs. Horace E. Dodge Memorial Fund is provided in Appendix II.

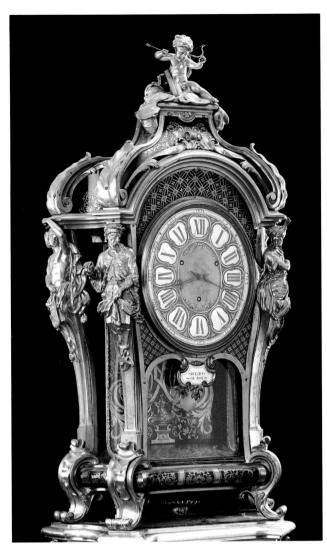

FIGURE 7 Pedestal Clock (detail). Attributed to the workshop of André-Charles Boulle and his sons (French), c. 1720. Oak with tortoiseshell, brass, and gilt-bronze mounts. Founders Society Purchase, Mr. and Mrs. Horace E. Dodge Memorial Fund, Josephine and Ernest Kanzler Founders Fund, and J. Lawrence Buell, Jr., Fund (1984.87).

We hope that this long-anticipated catalogue and the forthcoming reinstallation of the museum's Dodge, Firestone, Kanzler, and other collections in our renovated eighteenth-century French galleries, scheduled for completion in conjunction with this publication, will succeed in evoking at The Detroit Institute of Arts a new sense and appreciation of the beauty and refinement that Mrs. Horace E. Dodge created for her sublime environment at Rose Terrace.

ANNA THOMSON DODGE
AND THE BUILDING OF ROSE TERRACE
Theodore Dell

A vast fortune provides a host of advantages. If not love, it can buy companionship, devotion, and service. It can allow one to travel and be inspired by the achievements of mankind; it permits one to possess works of art that can provide a lifetime of enjoyment; and perhaps most satisfying of all, it enables one to create a world of one's choice, filled with beauty and buffered from the anxieties of the world outside.

In 1920, after the death of her husband, automobile magnate Horace E. Dodge, Anna Thomson Dodge (1871–1970) found herself in control of such a fortune. Over the following fifty years she was to use her money to gain all these advantages, but it was the creation of special worlds that gave her the greatest satisfaction.

Rose Terrace, the large Louis XVI–style house built in Grosse Pointe Farms outside Detroit during the early 1930s, was the most ambitious of all such projects for Anna Thomson Dodge. In choosing the style of eighteenth-century France for Rose Terrace, Mrs. Dodge was following the lead of other wealthy Americans who had built such houses during the closing years of the nineteenth and the first two decades of the twentieth centuries. The style's appeal to the rich of the day can be explained by its sense of order, its relaxed elegance, its aristocratic connotations, and its appropriateness to the gracious way of life they were attempting to lead.

But the house that Mrs. Dodge built was finer. Except perhaps for Miramar in Newport (see below), its detailing was better, and it was furnished throughout with fine eighteenth-century French furniture rather than, as with most such houses, overly elaborate reproductions or, as with a very few, elegant period furniture in one or two of the principal rooms. Rose Terrace was also significant in that it was the last house of its type to be built, having been started after the onset of the Depression and more than two decades after the building of such houses had ended.

It is clear from Mrs. Dodge's correspondence[1] that she had definite ideas about the world she wished to create at Rose Terrace, ideas she must have formulated through years of critical observation of the great houses she had visited. To realize her dream, she engaged the finest talents of the day, sparing no expense. For all those involved, the project became one of the most satisfying experiences of their careers since all aspects—building, decor, and setting—were so perfectly integrated. For Anna Thomson Dodge, it was the major achievement of her life. Rose Terrace was to become, in fact, such a personal creation that it had little meaning without her. And within a few years after her death in 1970 at the age of ninety-eight,[2] the collections and contents of

Rose Terrace had been dispersed among a number of public and private collections in Europe and America, and the house destroyed. All that remains intact of this extraordinary creation is the group of important furnishings from the principal salon of the house, referred to by Mrs. Dodge as the Music Room, which she bequeathed to The Detroit Institute of Arts in 1970 and which is the subject of the present publication. This seems a fitting time and place to chronicle how Rose Terrace came into being and to suggest the ambitious and determined character of the woman who conceived it.

Anna Thomson Dodge's life began modestly in Dundee, Scotland, on August 6, 1871. Very little is known about her early years. As a child she immigrated with her family to Detroit, where she was later to support herself as a piano teacher. It was in Detroit that she met the young garage mechanic, Horace E. Dodge (1868–1920), whom she married in 1896. The couple had two children, Delphine (1899–1943) and Horace, Jr. (1900–1963). Horace and his brother, John F. Dodge (1864–1920), quickly became two of the key figures in the dawning American technological age. Their enormous success can be attributed to their skill as mechanics, their great determination, enthusiasm, and business acumen— and the fact that they found themselves in Detroit precisely at the birth of the automobile industry.[3]

Horace Dodge was born in Niles, in southwestern Michigan. He and his brother trained in their father's shop, which specialized in machine motor work. Realizing that their opportunities were limited in Niles, the two young men left for Port Huron, Michigan, in 1886, then moved to Detroit. With Fred S. Evans, they later formed the Evans and Dodge Bicycle Company in adjacent Windsor, Ontario. In 1902, the year Henry Ford began to produce motor cars, the Dodge brothers began quantity production in Detroit of internal-conbustion engines, transmissions, and steering equipment. For many years they made parts at great profit for the Ford Motor Company. But in 1914 they decided to produce their own cars, and by 1917 the Dodge Brothers Motor Car Company was fourth in automobile production in America. Finally, during World War I, they set up a munitions plant reputed to be unsurpassed anywhere.[4]

Much of the original Dodge wealth came from the early purchase of Ford Motor Company stock: the Dodge brothers owned one-tenth of the company, which they sold in 1919 for $27,000,000. Horace and Anna Dodge were living quite comfortably then in the original Rose Terrace, a Jacobean-style sandstone mansion they had built in 1910 on a choice piece of lakeshore property in Grosse Pointe Farms.[5] It was

with the sale of the Ford stock that Horace, a surprisingly unpretentious man, made his first really extravagant purchases—the construction of a 257-foot oceangoing yacht, the *Delphine II,* and, more significantly for Anna Dodge, a house in Palm Beach.

But Horace Dodge was never to enjoy fully the fruits of his acumen and wealth, for he died suddenly in 1920, less than a year after the death of his brother, John. Anna Thomson Dodge was unexpectedly, at the age of forty-nine, the beneficiary of an enormous trust.[6] Five years later came the sale of the Dodge company itself to the New York investment firm of Dillon Read and Company for $146,000,000, the nation's largest cash transaction to that date.

Palm Beach was to have a profound influence on the rest of Anna Dodge's life, as well as those of her children. The marriage in 1920 of her daughter, Delphine, to James H. R. Cromwell, son of the much-admired Philadelphia and Palm Beach hostess Eva Stotesbury (1865–1956), began to draw Anna Dodge into the social life of America's wealthiest families and their world of beautiful houses and works of art. It was in Palm Beach in 1925, at the age of fifty-four, that she met Hugh Dillman (1885–1956), a former actor fourteen years her junior who was then dabbling in real estate. She married him the following year.[7]

Hugh Dillman was to give Anna Dodge a new lease on life, and she is said to have repeatedly credited him with teaching her how to have fun with her money.[8] In 1926 she acquired the Palm Beach estate Playa Riente, a huge Spanish-style stucco house designed by Addison Mizner in 1923 for the Oklahoma oil magnate Joshua S. Cosden.[9] During these years in Palm Beach, she solidified her friendship with the Stotesburys. Edward Stotesbury (1849–1938) was chief executive of the Philadelphia banking firm of Drexel and Company and co-partner of J.P. Morgan and Company, New York, while Eva, Stotesbury's second wife, was an elegant and charming woman who became known as the queen of Palm Beach society.[10] The friendship between Mrs. Dodge and Mrs. Stotesbury was long lasting, with Mrs. Dodge showing her friend many kind considerations years after their children had been divorced.[11]

Evidence is fragmentary, but it seems apparent that the seeds of the new Rose Terrace were sown at least as early as 1924 and that Joseph Duveen (1869–1939), one of the world's premier art dealers, was involved in the evolution of the idea.[12] As one of the richest Americans of her day, Anna Dodge had the potential to become one of Duveen's greatest clients, and she was cultivated accordingly.[13] A surviving letter from him, dated January 31, 1925, inquired, "are you making new plans for an entirely new residence as a result of our long, and to me most interesting talk, during my last visit to Detroit?"

Over the next five years, Duveen patiently attempted to kindle Anna Dodge's interest in collecting, first by sending

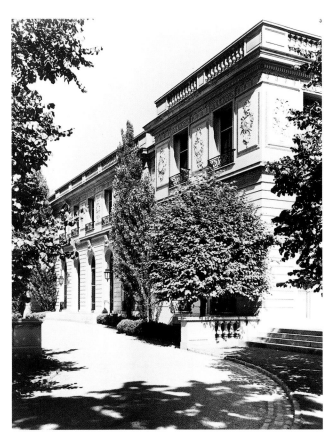

ENTRANCE FACADE OF ROSE TERRACE. Designed in the French neoclassical style by the Philadelphia architect Horace Trumbauer (1868–1938) and his assistant Julian Abele (1881–1950), the exterior of Rose Terrace was faced with limestone. Construction began in early 1931 and was completed a year later, although the interior was not finished until 1934, and the house was not in a truly functioning state until the spring of 1935. A gala housewarming reception for Detroit's elite was given the following November. Rose Terrace was intended to be used by Mrs. Dodge for the months of September through December of each year only, although in later years she lived there exclusively. This and the other photographs of Rose Terrace illustrated here are from a group made by Mattie Edwards Hewitt in 1938, which were bound into three volumes for Mrs. Dodge.

her a copy of the catalogue of the Henry E. Huntington collection in San Marino, which he had been instrumental in forming, by inviting her to his gallery in New York to see a suite of rose-ground, tapestry-covered chairs, which he described as "the most divinely beautiful things in the world," and eventually by arranging what he must have hoped would be an inspirational tour of the Huntington collection in the presence of Mr. Huntington himself. Although Duveen was unable to conduct any immediate business with Anna Dodge, he did give her much to think about, and his attentions ultimately paid off handsomely for them both.

In 1930, after years of rumination, Mrs. Dodge's plans solidified, and she commissioned from Horace Trumbauer (1868–1938) the designs for the second Rose Terrace, concurrently employing the Franco-American firm of L. Alavoine and Company to design and oversee the finishing of the inte-

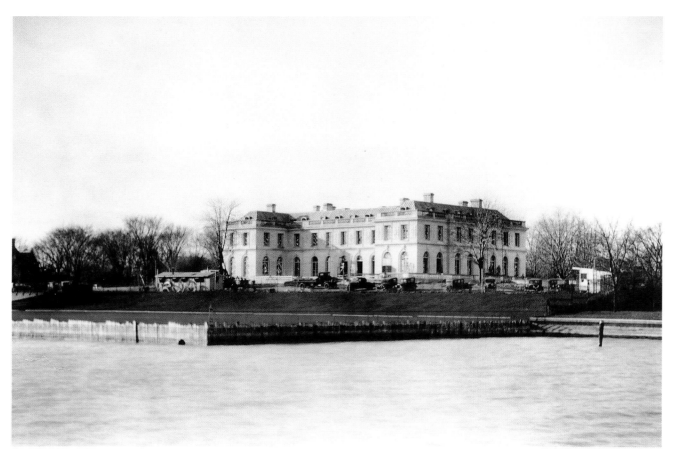

ROSE TERRACE UNDER CONSTRUCTION. Rose Terrace was constructed by the George A. Fuller Company of New York and Chicago. This photograph, taken from Lake St. Clair probably in early 1932, shows the structure of the house in its virtually completed state. After the landscaping was finished, it was no longer possible to get an unobstructed view of the house. As the house was built in the Depression, there was considerable criticism that not enough use was being made of local labor, though in fact much of the work, and especially that of the interior, was beyond the skills of local craftsmen.

riors. The building was to be an enlarged version of Miramar, the Louis XVI–style house that the Trumbauer firm had designed for Mrs. George Widener in Newport in 1913.[14]

It was almost certainly through the Stotesburys that Mrs. Dodge had been introduced both to the architecture of Horace Trumbauer, who in 1916 had designed Whitemarsh Hall, the Stotesburys' spectacular house outside Philadelphia, and to the decoration of Alavoine, the firm that, along with White Allom and Company, had been responsible for that house's interiors.[15] For many years, Trumbauer and Alavoine had collaborated on a number of important houses for wealthy Americans, perfecting a uniquely American interpretation of eighteenth-century French style, one that was both imposing and elegant.

As one of America's greatest classical architects, Horace Trumbauer excelled in his understanding of proportion and detail, having great respect for the architectural vocabulary that had been perfected before him.[16] Although he worked in a number of styles, according to the tastes of his clients, he was a Francophile at heart, and it was in an eighteenth-century French style that his most beautiful works were conceived.

As the architectural historian Wayne Andrews has aptly noted, "Trumbauer understood, as did few other architects of his generation, that only a magnificent setting could hope to satisfy an American with a magnificent income."[17] In addition to the Stotesburys' Whitemarsh Hall, Trumbauer designed houses for a number of other distinguished Americans, including: in Newport, The Elms for Edward Julius Berwind (1899) and Clarendon Court for Edward C. Knight, Jr. (1903); in Washington, a townhouse for Perry Belmont (1907); and in New York, residences for James B. Duke (1909, now the home of the Institute of Fine Arts of New York University) and James Speyer (1914). He also worked on several much-admired commercial buildings, including the New York quarters for Duveen Brothers (1910) and for Wildenstein and Company (1931), as well as the handsome New York Evening Post Building (1925). In addition, Trumbauer collaborated on the design of the Philadelphia Museum of Art (1919–29), and he produced designs for the entire campus of Duke University in Durham, North Carolina.

Trumbauer's office always remained in Philadelphia. As with any practice as extensive as his, a considerable share of

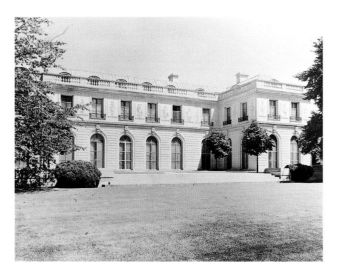

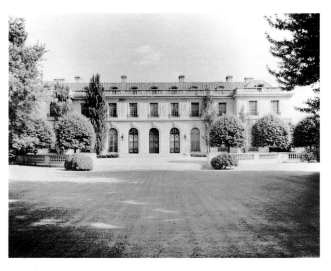

ENTRANCE FACADE. Rose Terrace was set back approximately five hundred feet from Lake Shore Drive in Grosse Pointe Farms, and entrance to the grounds was through an elaborate pair of wrought-iron gates. One approached the house down a long circular drive, coming to a halt on the balustraded forecourt shown here. Entrance into the house was through the tall glazed doors at center, decorated like the windows at either side with ironwork. Immediately inside was the vestibule, which spanned these three openings. The relatively low height of the facade and the even cadence of the window openings gave the building a serene dignity, while the tall arched windows on the ground floor and the carved trophies on the piers above helped add a sense of lightness. Mrs. Dodge's private suite occupied the entire right wing of the second story, with her bedroom being marked by the two windows on the right. Below was a small reception room, where guests could be ushered to wait for Mrs. Dodge. Behind the balustrade at top was the copper-clad attic floor occupied by the servants. The housekeeper was given pride of place with her living room and bedroom being situated behind the center three dormers. The space behind the two dormers to the right was used as resonating chamber for the echo organ, situated just above the ceiling of the two-story stair hall; the sounds of its pipes passed down into the main part of the house through a grille. The landscaping of the grounds was executed by the New York landscape architect Ellen Shipman (c. 1870–1950).

GARDEN FACADE WITH TERRACE. The windows at the back of the house looked out over a large lawn to Lake St. Clair. The Music Room on the ground floor stretched the width of the five central windows. In the wing at the right was the breakfast room, while in the corresponding wing at the left (not seen here) was the loggia, where Mrs. Dodge enjoyed entertaining friends at cards. Behind the second floor windows shown here were the guest bedrooms, although in the left wing was the sitting room of Mrs. Dodge's private suite, with her office just to the right.

the actual production was done by men working under him, since a large part of his own time necessarily was spent dealing with clients. In the case of Rose Terrace, much of the design was in fact conceived and worked out by one of Trumbauer's chief assistants, Julian Abele (1881–1950). A graduate of the Institute of Colored Youth and the University of Pennsylvania, the cultivated Abele was America's first distinguished black architect. Described by James Maher as Trumbauer's "aesthetic alter-ego," he was an immensely talented designer "who could refine and compose into excellent renderings and elevations [Trumbauer's] rough sketches," "who could swiftly grasp the sense of a proposed plan . . . and make those subtle adjustments in scale and treatment . . . that give to a style its inner coherence," and "who could, in sum, dramatize for a client precisely what Trumbauer had

been talking about."[18] Abele, too, was a Francophile, having completed his architectural studies at the École des Beaux-Arts in Paris. Like Trumbauer, Abele admired especially the sober and elegant architecture of Ange-Jacques Gabriel (1698–1782),[19] whose work inspired Trumbauer's brilliant designs for the Duke residence and the Duveen and Wildenstein buildings in New York, the Widener residence, Miramar, in Newport (see below), and Rose Terrace. Nevertheless, despite the degree of his responsibility in all these ventures, Abele remained more or less behind the scenes.[20]

The design of Rose Terrace was more an opportunity for refinement than it was a major innovative statement, since it was based on Miramar, the Newport home that Trumbauer and Abele had designed in 1913 for Mrs. George Widener — later Mrs. Alexander Hamilton Rice. While the nature of the relationship between Mrs. Dodge and Mrs. Rice is not known (it is likely that they met through the Stotesburys in Palm Beach or Philadelphia), Mrs. Dodge did visit Miramar with Trumbauer;[21] and she was so impressed by it that she decided to duplicate it for herself — but on a grander scale. Thus, the floor plans of Miramar and Rose Terrace are nearly identical, the most significant difference being Rose Terrace's greater size.

The principal rooms of Miramar, decorated by the Paris firm Carhlian, were furnished with important pieces of eighteenth-century French furniture acquired from Duveen, in contrast to the over-elaborate and heavy reproductions

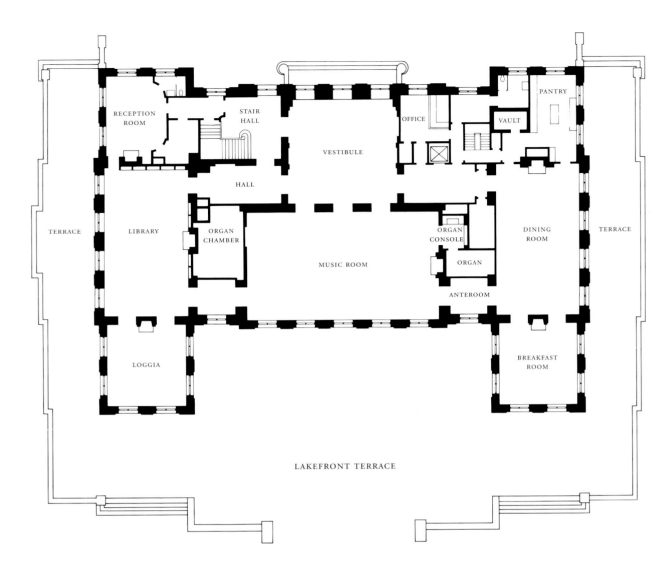

Within the floor plan:

RECEPTION ROOM STAIR HALL VESTIBULE OFFICE VAULT PANTRY

HALL

TERRACE LIBRARY ORGAN CHAMBER ORGAN CONSOLE DINING ROOM TERRACE

MUSIC ROOM ORGAN

ANTEROOM

LOGGIA BREAKFAST ROOM

LAKEFRONT TERRACE

PLAN OF THE GROUND FLOOR OF ROSE TERRACE. Measuring 162 by 104 feet, the three-story house consisted of a central core with two projecting wings at the rear. At the heart of the house was the Salon, or Music Room as Mrs. Dodge preferred to call it, with its prime position at the back of the house looking out over Lake St. Clair.

The main gardens were to the west of the house, including the rose terraces for which the house was named. Although no copies of Trumbauer's main plans survive, virtually identical ones showing the electrical layout do, and it is these that allow a thorough understanding of the house.

then found in most American houses of this type. Mrs. Dodge must have been deeply impressed by the delicacy and elegance of the interiors of Miramar, as well as by their sense of authenticity. A surviving photograph of the main salon of Miramar shows that it was furnished in much the same manner as would be the Music Room of Rose Terrace.[22]

The working plans for the new Rose Terrace were begun by Trumbauer's office during the first half of November 1930. By the following January, the location of the house had been plotted out, and by February the George A. Fuller Company, a New York construction firm of note that had also built the Stotesburys' Whitemarsh Hall, had broken ground and was pouring concrete.[23] At about the same time, the contract with Alavoine was signed for the interior woodwork and decoration, to the obvious pleasure of Trumbauer, who seems to have recommended his favorite decorator to Mrs. Dodge.

For most of his career, Trumbauer collaborated on the interiors of his private residences with L. Alavoine and Company, the most prestigious firm producing French period rooms in America.[24] Their partnership was so extensive that Alavoine's work is often considered to be synonymous with Trumbauer's. However, whereas the Philadelphia architect rarely worked with other decorators, Alavoine often executed commissions independently for private clients, decorating large New York apartments and houses that had been designed by other architects.

The function of decorating firms such as Alavoine was to take complete charge of the interior of a new house. In some cases, as with Rose Terrace, they worked in close consultation with the owners and architect to realize a personal vision; in others, they were given carte blanche to create a grand interior appropriate to the architecture. Often they were retained

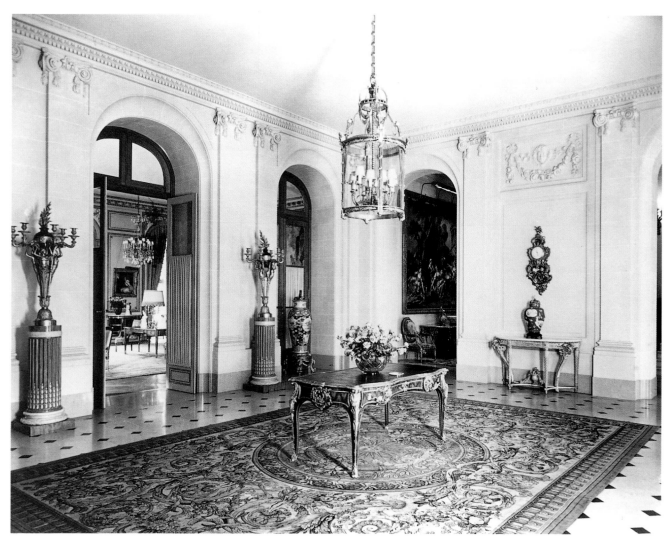

VESTIBULE. The interiors of Rose Terrace were designed and executed by L. Alavoine and Company of New York and Paris, under the direction of Édouard Hitau. Upon entering the house, one was struck by the great elegance of the decor. The vestibule walls were surfaced with Caen stone as befitted an eighteenth-century French-style house. Through the doorway at left can be seen the Music Room. The portal at the extreme right led into the stair hall and in turn through a low passageway under the landing into a small reception room. The portal to its left led through a more spacious hallway to the library, which occupied the central portion of the west wing of the building. The Detroit Institute of Arts was bequeathed the contents of the Music Room only, as well as an additional financial bequest, and part of this was used to purchase the splendid pair of candelabra shown here which, along with the other principal remaining contents of the house, were placed at auction in London in 1971. At this auction J. Paul Getty acquired several important pieces for his museum in Malibu: the *bureau plat* in the center of the room, once thought to have belonged to Catherine the Great, the gilt-bronze cartel clock by Charles Cressent and Jean-Joseph de Saint-Germain seen on the right wall, and the Boucher painting partially visible in the hall leading to the library. The hanging lantern by Baguès of Paris and the Aubusson carpet in the Savonnerie style were made especially for the house.

after their initial work was done to oversee the upkeep of the interior.[25]

Alavoine's preeminent position in America was due for the most part to the fact that the firm had a large office in Paris, with easy access to fine French designers and craftsmen as well as to first-rate materials. Being Paris-oriented, the firm produced superb interiors much more authentically French than any of its American rivals, which included P.W. French and Company and William Baumgarten and Company. The continuing success of Alavoine must also be credited to its French-born director, Édouard Hitau, a man who combined great talent with charm and efficiency.

The correspondence between Horace Trumbauer and Mrs. Dodge during the construction of Rose Terrace makes it obvious that his success was due not only to the fine designs his firm was able to produce but also to his correctness in every detail and to the graciousness of his manner. He could bring out the best in his clients, making them feel as aristocratic as the houses he was designing for them. He made the building of Rose Terrace a smooth and pleasurable experience for Mrs. Dodge. When Trumbauer assumed the commission to design and oversee the building of Rose Terrace, he was sixty-two years old. It was his last major project,[26] and one of which he was justly proud: not only had

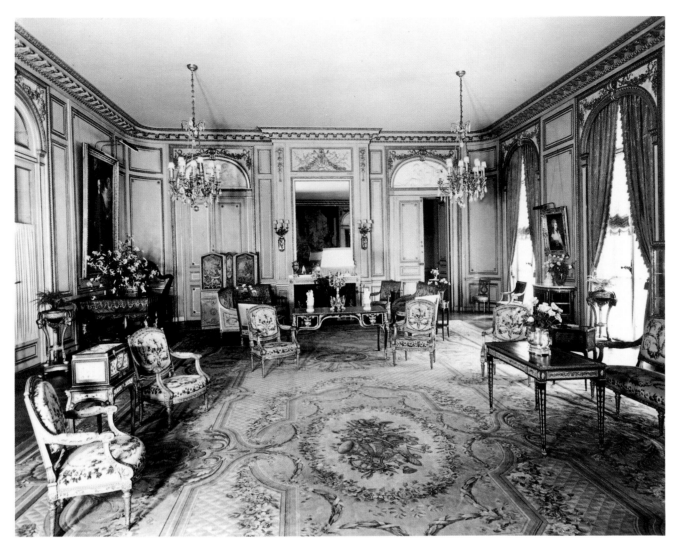

MUSIC ROOM. Mrs. Dodge had a passion for music, as did her deceased husband Horace. She loved the piano and the organ (although after suffering a fall many years earlier she was unable to play), and so she named the main salon of the house the Music Room. Here she would host musical performances. It was the contents of this room that were bequeathed to the Detroit Institute of Arts. Anna Thomson Dodge had Horace Dodge's organ reinstalled from the original Rose Terrace, an earlier house which had been torn down to make way for the new one. The keyboard console was situated in a small room behind the double doors to the left of the fireplace. This room was decorated with paneling similar to the Music Room itself. The main pipes were housed in a two-story chamber behind the far end of the room, their sounds passing through a tapestry-covered opening in the wall. Antiphonal pipes were housed in a chamber behind the fireplace, the sounds also passing through a tapestry in the anteroom between the Music Room and the dining room. The doors to this room can be seen on the right. A further echo organ (also known as a celestial organ) was situated in the attic floor above the two-story stair hall, down through the ceiling of which could pass its sounds. Its function was to answer the pipes of the main floor from on high. The piano placed against the left wall, a highly redecorated Broadwood of c. 1831, had allegedly been played by the children of George III. The harp positioned in the corner bears a paper label marked *Renault et Chatelain / Paris 1795*. The white and gold *boiseries* were executed under the direction of L. Alavoine and Company in Paris and were among the remaining fittings auctioned *in situ* in 1976 (lot 1116), just before the house was razed. The four chandeliers were made for the room by Baguès of Paris. The Aubusson carpet, a pastiche of a Savonnerie one of c. 1750, but with a more open field in keeping with contemporary tastes, was also specially made for the room and was used by the museum for the display of the Dodge Collection. The Music Room was the largest room of the house, measuring 62 by 32 feet, with 18-foot ceilings. The windows to the right looked out over the marble terrace and lawn, to Lake St. Clair where Mrs. Dodge's yacht, the 257-foot *Delphine,* was often docked.

his portion of the work turned out so well, but Mrs. Dodge had followed through completely on every other aspect of the house, so that the building was beautifully complemented by its decoration and landscaping.

The new Rose Terrace was carefully situated on an east-west axis on the grounds that had previously been the site of the first Rose Terrace, built twenty years earlier. Set far back from Lake Shore Drive, it was designed with its principal rooms looking out over Lake St. Clair. Approached by a long circular driveway ending in a slightly elevated, balustraded court, the seventy-room limestone mansion consisted of a central rectangular core flanked by two smaller pavilions of

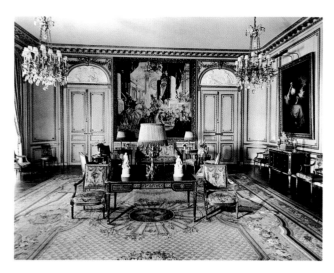

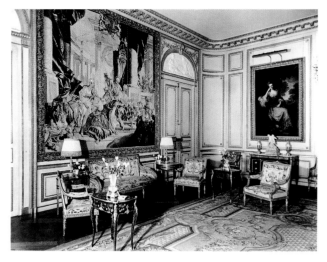

MUSIC ROOM (looking west). In a somewhat *retardataire* manner, Mrs. Dodge continued the late nineteenth- and early twentieth-century fashion of furnishing her salon with tapestry-covered chairs. Shown here are examples from two of the three suites she acquired for this room. The only table lamps in the Music Room were those incorporating gilt-bronze candelabra and candlesticks (cat. nos. 29 and 32), fitted with pleated silk shades by Edward I. Farmer, the New York antique dealer who specialized in beautiful lamps and shades, and who apparently furnished virtually all of the 615 lamp-shades in the house. Many of these were fitted with jade, rose quartz, or carnelian finials. The present photo was taken in 1938. Comparison between it and those taken in 1971 after Mrs. Dodge's death shows the room still arranged exactly as it originally was. Indeed, this proved to be the case in rooms throughout the house.

MUSIC ROOM (northwest corner). Behind the Beauvais tapestry, somewhat appropriately representing *Psyche Displaying Her Treasures to Her Sisters* (cat. no. 37), was a thirty-foot-high chamber extending down into the basement for the pipes of Horace Dodge's organ, the tapestry serving as a screen for the opening into the Music Room. Above the Riesener commode (cat. no 15) can be seen Gainsborough's portrait of *Anne, Countess of Donegall* (cat. no. 65). The dealer Joseph Duveen had convinced Mrs. Dodge to buy at least five British portraits, which had been in the height of fashion at the end of the nineteenth and early twentieth centuries, but were then on the wane. Although as English paintings they would seem inappropriate for a French salon, they here give it a sense of weight. There were four portraits in the Music Room and another in the dining room.

similar shape. The lakefront facade was essentially like that on Lake Shore Drive except that the two pavilions extended farther toward the water, forming wings. The house had two principal stories and an attic. The ground-floor facade comprised a series of rusticated piers alternating with arched floor-to-ceiling windows, each window surmounted by a voluted keystone decorated with swags. Directly above these on the second floor was a series of rectangular windows separated by carved trophies, and these were surmounted in turn by a continuous frieze of acanthus leaves, shells, and vines. The mansard-roofed third floor, or attic, was set back and partially hidden by a balustrade.[27]

On the main floor, the house contained a magnificent series of reception rooms. The visitor proceeded from the driveway and terrace into a vestibule of Caen stone and marble, and beyond this into the Music Room, which spanned five windows of the building's central core, facing the lake. This floor also housed a formal dining room, a reception room, a library, a breakfast room, a loggia or morning sitting room, a bar, and a kitchen-pantry.

The personal apartment of Mrs. Dodge and her second husband—with their separate bedrooms, dressing rooms, baths, shared sitting room, and an office—occupied the west

end of the second floor. This floor also contained six guest rooms and baths, a second office, and another sitting room. The two main floors were connected by a large, square marble staircase with wrought-iron railings in the French manner and by an elevator decorated with delicately painted Directoire woodwork inset with Chinese silk panels and mirrors and containing a Transitional-style bench.

The attic floor was devoted to servants' quarters: an apartment for the housekeeper, twelve maids' rooms, a valet's room, and six rooms for other menservants. The basement level housed such service areas as a kitchen, a dining hall for servants, an ice-cream room, a flower room, a large gymnasium, a boiler room, and separate storage rooms for trunks, furs, rugs, silver, and bottled water.

The walls of the ground-floor rooms were all lavishly decorated. The Music Room, the small reception room, and the breakfast room were all fitted with carved and painted paneling, or *boiserie,* while the library and dining room walls had *boiseries* that were carved but not painted. The *boiseries* of these rooms, as well as those of the principal bedrooms, were designed and carved in Paris under the supervision of Alavoine. In addition to the vestibule, the stair hall, the axial hallways, and the loggia were also faced with Caen stone.

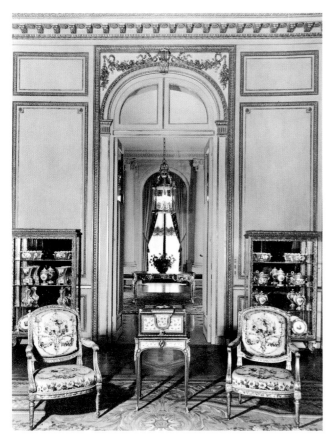

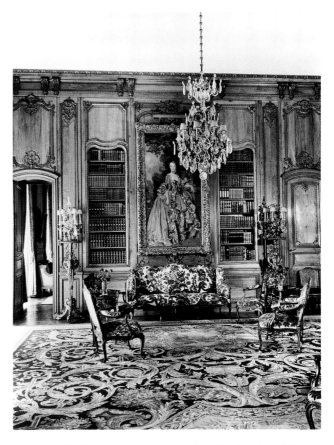

MUSIC ROOM (looking north into the vestibule). Mrs. Dodge kept most of her collection of Sèvres porcelain in four gilt-wood vitrines, the latter forming a handsome decoration against the piers of the room. These were acquired, complete with the porcelain they contained, in November of 1939, although they may have been at Rose Terrace on approval for a considerable time before that. Standing in front of the door is a Sèvres-mounted *Jewel Coffer* (cat. no. 8) which formerly belonged to Maria Feodorovna at the palace of Pavlovsk, and which was among many important pieces of French decorative art that Duveen purchased from the Soviet Government in 1931 (see also cat. nos. 14, 29, 34, 45, 46, 48, and 52). Seen on the far side of the vestibule are the glazed doors of the entrance to the Music Room.

LIBRARY. The library was the most comfortable of all the public rooms on the ground floor, its relaxed elegance being a great tribute to the taste of Édouard Hitau of Alavoine and Company. The main area for conversation was the group of *canapés* and *fauteuils* clustered around the fireplace on the long wall to the right. In keeping with the natural oak paneling made specially for the room, the chair frames were all of waxed beech or walnut. Hanging at the center of the north end of the room was Sir Gerald Kelly's portrait of Mrs. Dodge executed in 1932 (see p. 34), almost certainly specifically for this spot, as it fits so well. Mrs. Dodge's pose was inspired by Boucher's standing portrait of Madame de Pompadour in The Wallace Collection, London, while her dress was copied from Boucher's 1756 seated portrait of the Marquise, a 1758 version of which was in the Royal Academy of Art's French exhibition of 1932. The many beautifully bound books, comprising sets of English and French classics, as well as histories, diaries, and memoirs, were most likely supplied by Alavoine, who were responsible for virtually all the other appurtenances required to complete the house. The Aubusson carpet, specially woven for the room, is a pastiche of a seventeenth-century Savonnerie made for the Grand Gallery of the Musée du Louvre. Through the door on the left can be seen the small Reception Room.

The ample window areas throughout the house (there were eighty-one windows in all on the first two floors) gave great light and a sense of airiness to each room.

Surrounding the house were elaborate floral and vegetable gardens, sculpture gardens, an eight-car, colonnaded garage with an apartment for the chauffeur, a swimming pool and pavilion, and a boat pavilion with a pier large enough to accommodate the 257-foot *Delphine*.[28]

During the planning and building of Rose Terrace, Mrs. Dodge and Hugh Dillman involved themselves in the minutiae of its design, construction, decoration, and landscaping, often by means of correspondence as the couple moved from Detroit to New York and Palm Beach, to Paris and to London, and back again. Surviving documents show that from the beginning Mrs. Dodge had a highly evolved idea of what she wished to achieve at Rose Terrace. At her death, the

Dodge archives contained voluminous correspondence with Trumbauer, in which she and Dillman concerned themselves in great detail with such disparate matters as the location of the house on the site; the proportions of the architectural details; the placement of doors and fireplaces; the selection of marbles for the vestibule, hallways, and bathrooms; fittings for the kitchen, pantry, and laundry; heating and cooling systems; safes for jewelry, jade, and silver; the installation off

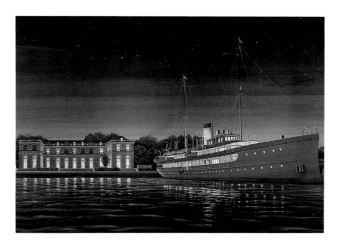

William Moss, *The Delphine Docked at Rose Terrace,* late 1930s (?), color lithograph, 45 × 60 cm (17¾ × 23½ in.). The Detroit Institute of Arts.

the Music Room of Horace Dodge's organ;[29] the cold-storage room in the basement for rugs and furs; the placement of a freezer in the ice-cream room; the size and ventilation of the wine cellar; and the refrigeration for the flower room. Among the many subjects they discussed with Alavoine were the design and finishing of the *boiseries;* the placement of the furniture and selection of color schemes for every room; the reproduction of several of their antique tables and chairs to furnish the lesser rooms; designs for drapery, upholstery, and Savonnerie carpets that were to be woven in France for the principal rooms; the built-in radio system; the decoration of the elevator; the purchase of eighteenth-century French silver; the selection of kitchen hardware; and the design and manufacture of bedspreads and linens.

Mrs. Dodge and Hugh Dillman had strong opinions about all these details and were quick to let it be known when they were dissatisfied. After seeing *in situ* the reproduction chandeliers he and Mrs. Dodge had selected in Paris at the highly respected Baguès Frères—makers of reproduction lighting fixtures and other metal works—Dillman wrote to Édouard Hitau of Alavoine:

> She [Mrs. Dodge] felt exactly as I do that the chandeliers in the music room and library and passageways to the library and dining room are all out of proportion, and those in the music room sadly lacking in crystal as well as being much too small. They fail to achieve what they should and only succeed in being a very frail and unsuccessful accomplishment. They detract from the room rather than adorn it.[30]

The chandeliers in question were replaced with more satisfactory examples, despite the fact that Baguès had initially provided exactly what had been agreed upon.

Among the many subjects thoroughly discussed with the New York landscape architect Ellen Shipman (c. 1870–1950)[31] were the choice and placement of flowering trees; the shape and size of the balusters for the balustrade around

the terraces; and even the drapery treatment, linen, and dressing gowns needed for the pool house.

On their numerous trips to Europe between 1931 and 1934, the Dillmans toured the *antiquaires* of Paris, selecting pieces of furniture and decorative objects, of which they acquired some directly and others through the Paris and New York branches of Alavoine. At the same time, they continued to be courted by Joseph Duveen, who significantly had worked for many years with the Stotesburys to fill Whitemarsh Hall with important English and French furniture, paintings, and sculpture. On November 13, 1931, when construction of the new Rose Terrace was well under way, Duveen wrote to Mrs. Dodge: "You will have been told of my purchases made last summer in Russia from the Emperor's and Pavlovsk Palaces, and I am looking forward to the pleasure of showing them to you upon your return to America."[32] In another letter of the same month, probably in response to one he had received from Hugh Dillman stating that "Mrs. Dillman feels the house is costing beyond her expectations and rather hesitates on expenditures at this time," Duveen wrote: "There is no great French house in Detroit, so may I suggest that you have here a wonderful opportunity, by indulging yourselves, to show Detroit what such a house would really mean. After all, suppose you do spend a little more than you intended; does it really matter?"[33]

Ultimately, Anna Dodge made $2,500,000 worth of purchases from Duveen, paying him over a period of five years. These acquisitions included not only seven of the works Duveen had acquired in Russia, but also the entire collection of Sèvres porcelain that now belongs to The Detroit Institute of Arts, as well as other major examples of furniture, sculpture, paintings, and tapestry that formed part of the inventory of his gallery in New York. It is interesting to note that the only non-French objects Mrs. Dodge purchased for her house (other than a group of Chinese porcelains and hardstone objects) were portraits by the great English painters Thomas Gainsborough, Joshua Reynolds, and John Hoppner (cats. 65–68), which Duveen sold to her, able as he was to point to the precedent of the Stotesburys and others, who had mixed English and French objects of quality. Indeed, the works Mrs. Dodge purchased from Duveen are far superior to those she had bought in Paris on her own or through Alavoine, and they gave her collection its special eminence. Her investments in this sphere were made wisely, for their beauty was to provide her with great pleasure for more than thirty-five years.

The basic structure of Rose Terrace was completed in early 1932, and by 1934 most of the furniture and decorations were in place. Yet another year and a half were needed to acquire all the fittings necessary for so perfectly appointed a house. In October 1934 the housekeeper was chosen, and shortly thereafter the rest of the personnel were hired; even here, the advice of Édouard Hitau of Alavoine was sought as to the

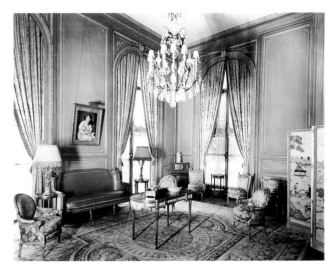

RECEPTION ROOM. Situated on the ground floor at the northwest corner of the house, this relatively small room (24 by 15 feet) was intended as a waiting room, although it could also be used for entertaining. Painted blue and beige, it was sometimes referred to as the ladies reception room, as opposed to the small oak bar on the opposite side of the vestibule, which was intended for men. In the center of the room stood the most important piece of eighteenth-century French furniture outside the Music Room, and which thus did not form a part of Mrs. Dodge's bequest to the museum. Mounted with blue-bordered Sèvres porcelain plaques, this *bureau plat* by Martin Carlin once stood in the bedroom of the Empress Maria Feodorovna at Pavlovsk, and was among the pieces of furniture that Duveen bought from the Soviet government in 1931. The museum attempted to buy the table when it appeared at the Dodge auction in London in 1971, but was outbid at a world-record price by an Iranian collector. It was later bought by the J. Paul Getty Museum. The two Louis XVI giltwood chairs seen in the background were made for Marie-Antoinette's Hameau at the Petit Trianon and were acquired at the 1971 auction by J. Paul Getty for his Malibu museum.

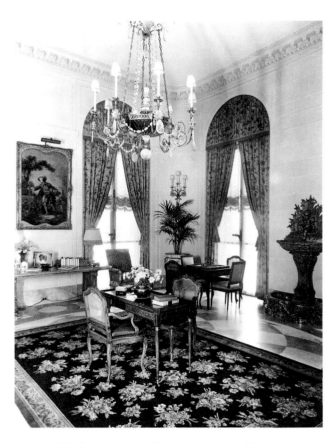

LOGGIA. The loggia occupied the southwest wing of the ground floor; its walls were faced with Caen stone. It was here that Anna Thomson Dodge liked to entertain her friends at cards. On the wall can be seen *The Reaper* by Fragonard (cat. no. 64), one of the series of four paintings that the Detroit Institute of Arts was to purchase at the 1971 auction of Mrs. Dodge's estate. Two of the other paintings of this series hung on the adjacent walls of this room, and the fourth in the breakfast room. The elegant chandelier was one of the many beautiful lighting fixtures supplied by Baguès of Paris. Photographs of several of Mrs. Dodge's grandchildren can be seen on the marble console table below *The Reaper*. At the time of this 1938 photograph she had six grandchildren: Christine Cromwell (b. 1922) and Yvonne Baker (b. 1933) by her daughter Delphine (1899–1943); and Delphine (b. 1922), Horace E., III (b. 1923), David E. (b. 1930), and Diana (b. 1932) by Horace E., Jr. (1900–1963). Another grandson, John Francis, was born to Horace, Jr., in 1954.

necessary composition of the staff. At that time the house was scheduled to be ready for Mr. and Mrs. Dillman in March 1935, and although surviving correspondence does not indicate whether this deadline was met, the Dillmans did give a gala housewarming reception for Detroit society the following November.

The sheer lavishness of Rose Terrace must have had an extraordinary effect on the guests, no doubt prompting a considerable amount of sniping among Detroit's old guard. Its furniture was much grander than anything that had been seen in the city—many of the pieces having historic pedigrees. Among these were a *bureau plat* said to have been made for Catherine the Great of Russia; a commode made for the palace at Fontainebleau (cat. 15); a jewel cabinet (cat. 8) and a *bureau plat* that had belonged to Maria Feodorovna of Russia; four chairs bearing the inventory brand of Marie-Antoinette; a pair of chairs with the brand of Versailles; a piano said to have been played by the children of George III; a clock that had belonged to the daughters of Louis XV (cat. 31); and much highly important porcelain (cats. 39–63).

The quantity of the furnishings was prodigious: there were, among other works, thirty-seven sofas, more than one hundred tables, one hundred and sixty chairs, more than forty French doors, fifteen fireplaces, and six hundred and fifteen silk lampshades. Certainly no other house in Detroit was decorated even down to its minor guest bedrooms with paneling in the eighteenth-century style, fine upholstery and drapery fabrics, and eighteenth-century furniture. And this, the costliest house ever built in Detroit, was intended for occupancy by its owners only from September through December of each year.

The successful completion of Rose Terrace gave immense pleasure to those who had worked hard on it. As early as December 1932, Trumbauer could write to Mrs. Dodge:

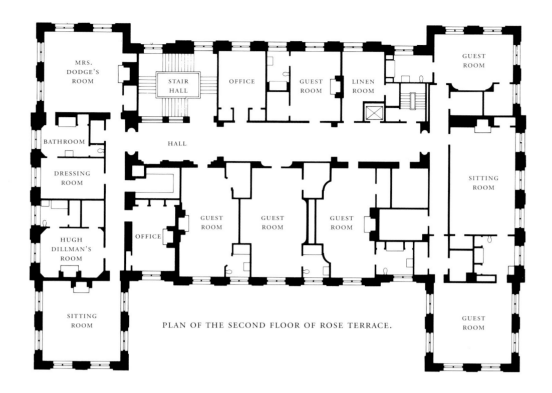

PLAN OF THE SECOND FLOOR OF ROSE TERRACE.

At the time of my last visit to Detroit your house gave me great satisfaction. I think you have displayed wonderful taste in the selection of the interior decorations and particularly the colorings. I know of no house in America where better taste has been displayed. Several people who are qualified to judge by comparing this house with the famous houses of France have expressed their opinion that it is equal to the best of French eighteenth-century architecture, and I trust that when you finally occupy the house it will give you great satisfaction.[34]

In 1937, after a visit to Rose Terrace, Ellen Shipman wrote to Mrs. Dodge's secretary: "The place was looking beautifully and the garden really is superb. I was never prouder of a piece of work nor more appreciative of the care that it is having."[35] Last but not least, Duveen wrote about Mrs. Dodge and Rose Terrace in an undated typescript:

It is both a pleasure and a privilege to speak of the achievement of Mrs. Dillman in assembling such a magnificent collection of works of art of the Eighteenth century. The greatest patience and finest taste have been required in order to select only the most perfect works. Necessarily, therefore, Mrs. Dillman has been obliged to spend several years on her search, devoting to it a considerable part of her time on each of her visits to Europe.

The house itself is most fitting for the display of these treasures of art. Its architecture and decoration represent the very highest of French Eighteenth century taste, and form such a wonderful background for the works of art. In my opinion, the house and its contents are unsurpassed as an expression of French Eighteenth century achievement. What is so extraordinary is the combination of beauty and comfort—one rarely found and so difficult to achieve.

Mrs. Dillman is to be heartily congratulated upon her magnificent accomplishment.[36]

These statements, though perhaps a little flattering, contain the essential truth. Rose Terrace was indeed an extraordinary achievement. Anna Thomson Dodge from Dundee had taken careful aim and had hit her mark.

But Rose Terrace was not the only focus of Mrs. Dodge's creative activities. The Dodge archives do not conserve many papers from the early 1920s and are really not complete until after 1930. However, from what survives it is apparent that beginning in 1925 Mrs. Dodge was involved in a number of building and remodeling projects. In 1926 she began the redecoration of her recently purchased Palm Beach estate, Playa Riente, on North Ocean Boulevard. About the same time, a fire on the *Delphine* occasioned extensive remodeling of the yacht. In late 1930, shortly before Rose Terrace was begun, Mrs. Dodge commissioned from Trumbauer and Alavoine a house on Foxhall Road in Washington for her daughter, by then married to Raymond T. Baker (1879–1935).[37] After the completion of Rose Terrace in 1935, she undertook with Alavoine a second redecoration of Playa Riente. And about 1937 she initiated, also with Alavoine, the remodeling of St. Leonard's, the large, crenelated house she had purchased for her son, Horace, Jr., in Windsor, outside London.[38] The advent of World War II seems to have stopped any further undertakings of this magnitude, and one can sense the void that entered the life of Anna Thomson Dodge when she had to give up all this activity.

Anna Dodge divorced Hugh Dillman in 1947, after a separation of seven years—the two having led gradually more

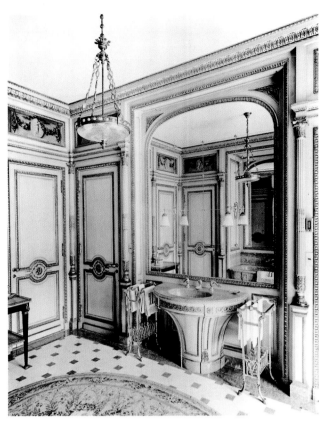

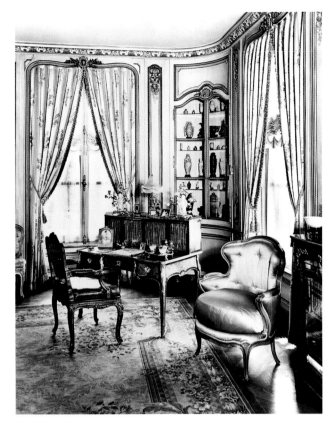

MRS. DODGE'S BATHROOM. Great luxury pervaded every room of the first two floors of the house, but the most exquisitely fitted one was Mrs. Dodge's elegant bathroom on the second floor. For this room Alavoine and Company had made a beautiful set of white and gold Louis XVI *boiseries.* Within an alcove opposite to the wall shown here was a free-standing tub carved from a block of cream-colored marble. On the checkered marble floor was an oval beige-ground Aubusson carpet decorated with sprays and garlands of flowers, while in front of the window was a Louis XVI marble and gilt-bronze tripod jardiniere, flanked by a pair of small Louis XVI chairs.

SECOND-FLOOR SITTING ROOM. Mrs. Dodge's private suite, which could be closed off from the rest of the house, was situated in the west wing of the building on the second floor, and contained her bedroom at the front of the house, with her bathroom and dressing room just behind. Her husband Hugh Dillman's separately contained bedroom, bathroom, and large closet were further down the corridor, and at the back above the loggia was this very comfortable sitting room. Furnished with relatively simple Louis XV furniture, this lovely room was surrounded on three sides by windows facing east, south, and west. It was in this room that Mrs. Dodge spent the majority of her time during the thirty-five years she lived at Rose Terrace. Seen here in the corner vitrine (matched by another in the contiguous corner) is part of her collection of Chinese jade and other hardstone objects that she acquired with Hugh Dillman on a visit to China in 1929.

independent lives since 1934.[39] In 1956 she sold her Palm Beach house (it was subsequently demolished) and withdrew into an increasingly private and isolated life at Rose Terrace. But even as her entertaining diminished, and with it the need for a large staff, she insisted on the strict maintenance of the house and on the continuation of certain daily routines. Thus, the furniture and *objets d'art* arranged by Duveen and Alavoine around the spacious rooms of Rose Terrace in 1933 and 1934 were to be found in exactly the same places in 1970, although many of the pieces were under the fitted damask dust covers that had been ordered between 1932 and 1934. Rose Terrace remained a pure statement untouched by time.

It is not known what Mrs. Dodge had originally intended as the eventual fate of her beloved house. Duveen had spoken to her in the 1930s about leaving her collection to the public as a memorial to Horace Dodge.[40] Sometime before her death, her grandson David Dodge spoke of her desire to maintain the house as a museum of French eighteenth-

century decorative arts.[41] It has also been said that she offered the entire collection and the building to The Detroit Institute of Arts but that she dropped the idea when the museum stipulated that she provide an endowment large enough to maintain the property.[42] No definite decision was made until 1964, when at age ninety-three she drafted a codicil to her will leaving the contents of the Music Room, which contained many of her most important works of art, to The Detroit Institute of Arts, along with a sizable sum of money to exhibit, conserve, and publish the collection.

After Mrs. Dodge's death at Rose Terrace on June 3, 1970, the most valuable contents of the house, with the exception of those in the Music Room, were placed at auction at Christie's in London in June of 1971.[43] The proceeds were to go to her estate. The greatest number of important works at the sale were purchased by J. Paul Getty for his museum in

Malibu, California.[44] Habib Sabet, the Iranian collector, bought at a record price the Sèvres-mounted *bureau plat* that had once belonged to Maria Feodorovna at Pavlovsk,[45] as well as a number of small tables and decorative objects. And The Detroit Institute of Arts used some of its bequest to purchase a small number of important works (cats. 34, 64), being underbidder on the above-mentioned *bureau plat*. A second sale consisting of the lesser works was held at Rose Terrace the following September.[46] Very quickly the superb collection of French eighteenth-century decorative art, formed by Anna Thomson Dodge with great determination and enthusiasm—and at enormous expense—had been dispersed into new and varied settings.

The disposal of the house posed a larger problem. No one in the Dodge family could afford to maintain it. At first, the commercial firm that purchased the property expressed the hope of preserving the house by dividing it into luxury apartments. However, this proved financially unfeasible, and Rose Terrace seemed slated for destruction. For more than five years the building stood empty, a limestone and marble reminder of a dream that Anna Thomson Dodge had realized, a way of life that could be maintained only by a handful of the world's wealthiest. Finally, in preparation for demolition, a third sale of the valuable architectural elements was held in June 1976.[47] One month later Rose Terrace, one of America's most beautiful and most luxuriously appointed residences, and certainly the last of its kind to be built, was leveled to the ground. What had seemed timeless was gone.

NOTES

1. The Dodge archives, from which much of the information in this introduction was drawn, remained intact until 1990 in the Detroit offices of Mrs. Dodge's lawyers, Butzel Long. When the offices moved during that year, many of the documents were dispersed or destroyed. The author is particularly grateful to George H. Zinn, Jr., of this firm for his generous cooperation in making the correspondence available, and for his interest in this study.

2. In the press (obituaries in the *Detroit News, Detroit Free Press,* and *New York Times* on June 4, 1970), Mrs. Dodge's age was placed at 103. However, her secretary, Gertrude Draves, revealed to The Detroit Institute of Arts in a letter of April 17, 1970 (Registrar's Office, Dodge Bequest file), that Mrs. Dodge's passport had been changed to read 1867 instead of 1871, increasing her actual age by four years.

3. On Horace Dodge, see Burton 1922, IV: 308–13; McPherson 1975; Pitrone and Elwart 1981; Latham and Agresta 1989.

4. Burton 1922, IV: 311.

5. The first Rose Terrace was designed by the Detroit architect Albert J. Kahn; see Ferry 1980: 297, fig. 323; Latham and Agresta 1989: 95–101.

6. The estate, worth $59,000,000, was placed in trust for the Dodge children and grandchildren and immediately invested in municipal bonds. For the duration of her life, Mrs. Dodge received a sizable yearly income that was never subject to federal taxation. Nevertheless, the annual stipend was subject to certain limitations, which is probably why she paid for her purchases from Duveen in quarterly installments over a five-year period rather than in one or two lump sums.

7. Although Anna Thomson Dodge used the surname Dillman for the twenty-one years that she remained legally married to Hugh Dillman, she is referred to in this work principally as Mrs. Dodge, as that was the name she bore for fifty-four years and under which she has historical importance.

8. *New York Times,* June 4, 1970: 43.

9. See Curl 1984: 108, 111.

10. Platt 1976: 272. For an interesting study of the Stotesburys, see Maher 1975: 2–88.

11. When Eva Stotesbury found herself in financial straits after the death of her husband in 1938 (they had depleted his large estate with remarkable speed during his last years), Mrs. Dodge rented to her at a very small fee the house in Washington that she had had Horace Trumbauer design in 1930 for her daughter (Maher 1975: 87).

12. All correspondence between Duveen and Mrs. Dodge disappeared from the Dodge archives (see note 1) shortly after 1971, although some such correspondence is preserved in the Duveen archives at The Metropolitan Museum of Art, New York, where access is restricted until the year 2020. Therefore, it has not been possible to chronicle very accurately the development of the relationship between the two.

13. Duveen had already been instrumental in assembling much of the French furniture and decorative art in The Frick Collection, New York; the Widener Collection at the National Gallery of Art, Washington, D.C.; the Rice Collection at the Philadelphia Museum of Art; the Huntington Collection in the Henry E. Huntington Library and Art Gallery, San Marino, California; and the Collis P. Huntington Memorial Collection at the California Palace of the Legion of Honor, San Francisco.

14. Reproduced by Platt 1976: 121–23.

15. Maher 1975: 64–68, reprod. 2–13, figs. I-1–I-18.

16. Born in Philadelphia to a family of modest means, Trumbauer was for the most part self-educated, having left school at the age of sixteen. He quickly found work as an office boy with the Philadelphia architectural firm of George W. and William D. Hewitt, where he proved to be a capable draftsman with an exceptional talent for architecture, though he had no formal education in this field. As Maher (1975: 47) has noted, "his intuition for the classical, for orderliness, logic, and rectitude in design, had grown out of a background completely innocent of theory and classrooms." It is this orderliness, above all else, that was to give Trumbauer's works their characteristic serene beauty. In 1892, at the age of twenty-four, Trumbauer opened his own office in Philadelphia, and two years later he designed for William Welsh Harrison a large, castellated country house, outside the city, called Grey Towers. Soon afterward, a pleased Harrison introduced Trumbauer to the Philadelphia transportation magnate P.A.B. Widener. The relationship between Widener and Trumbauer quickly blossomed, and the architect produced a whole series of buildings for the Widener family and their financial allies, the Elkinses, including Lynnewood Hall (1898); Miramar, the Newport house of Mrs. George Widener (1913); and the Widener Library at Harvard University (1914).

17. Wayne Andrews, "Horace Trumbauer," in *DAB* 1974: 667–68.

18. Maher 1975: 369. Maher, especially pp. 369–75, gives complete information on Abele.

19. See Tadgell 1978: 122–23.

20. It is probable that Abele never met Mrs. Dodge and Hugh Dillman. Of the thirty-five documented trips made by Trumbauer and his staff to Detroit and elsewhere in connection with Rose Terrace between November 1930 and January 1933, Abele seems to have been on only one, and that at a time (January 1931) when Mrs. Dodge and Dillman were likely to have been in Palm Beach. That Abele was intimately involved with the project, however, is certain; and he worked closely with the other professionals associated with Rose Terrace, such

as the landscape architect Ellen Shipman (see note 31, below), who met with Abele and Trumbauer to discuss the final details of her design (Ellen Shipman to Hugh Dillman, January 26, 1932).

21. Horace Trumbauer to Mrs. Dodge and Hugh Dillman, November 21, 1930.

22. Platt 1976: 122.

23. Horace Trumbauer to Hugh Dillman and Trumbauer to the George A. Fuller Company, January 22, 1931, and telegram to Dillman from Frank E. Upton, February 9, 1931.

24. After working many years in Paris for various decorating firms, Lucien Alavoine established his own business there in 1890. That he was a man of great talent for both business and design was proved by his firm's immediate success. He soon gained a foothold in America when he started working as a subcontractor for the Parisian decorators Jules Allard et Fils, who had been collaborating for a number of years with America's most important architect of grand houses, Richard Morris Hunt (1827–1895). Alavoine collaborated with Allard in 1892 on Marble House, built in Newport for William K. Vanderbilt, dispatching a crew from Paris to Rhode Island. After opening an office in New York in 1893, he worked with Allard on such other Newport houses as The Breakers for Cornelius Vanderbilt II (1895) and The Elms, which Trumbauer designed for Edward Julius Berwind in 1899. The firm's real prominence in America, however, stems from its purchase in 1905 of Allard's business both in Paris and in New York. It is said that Trumbauer and Alavoine had collaborated as early as 1892, but not until after the acquisition of Allard did Trumbauer rely upon Alavoine almost exclusively to execute the interiors of his houses. The firm enjoyed great success until the advent of World War II, when building and decorating projects of this type all but ceased. But the firm survived until the mid-1960s, mainly looking after the more modest needs of its old clientele. For a more detailed account of the firm, see Maher 1975: 57–59.

25. Alavoine maintained floors, paneling, and hardware, cleaned the upholstery and touched up the gilding of chairs, polished furniture, and repaired clocks. In some instances, the firm was retained to open and close houses as the owners moved from one residence to another. Until Alavoine shut its doors, the firm kept scale models of the principal rooms at Rose Terrace, which allowed it to solve maintenance problems more easily from its New York office. For information provided on the firm, the author is grateful to the late Matthew Schutz, who purchased a large portion of Alavoine and Company's inventory in the mid-1960s, after the death of its last director, Martin Becker.

26. After Trumbauer's death in 1938, his firm was taken over by Abele and William O. Frank, operating as The Office of Trumbauer. Abele died twelve years later at the age of sixty-eight.

27. For a more complete architectural description of Rose Terrace, see Coles and Mead 1973.

28. Reproduced *in situ* by Latham and Agresta 1989: 320.

29. Mrs. Dodge insisted that Horace Dodge's organ be given a central place in the new Rose Terrace. It was eventually situated next to the Music Room, with its pipes concealed by a Beauvais tapestry after designs by Boucher (cat. 37).

30. Hugh Dillman to Édouard Hitau, September 3, 1932.

31. Ellen Shipman had been running her architectural landscape firm for more than thirty years when she was approached by Anna Dodge to work on Rose Terrace. She seems to have been particularly popular among residents of the Grosse Pointe communities. Coinciding with the later stages of her work on Rose Terrace, she laid out the formal gardens of the Mrs. Russell A. Alger house, designed by Charles A. Platt, in 1934 (Ferry 1968: 306).

32. Excerpt of a letter published by Christie's (London 1971: foreword) before the disappearance of the Dodge archives' Duveen papers. Coles and Mead (1973: 41) cite a false rumor that Duveen sold Mrs. Dodge a collection that he had amassed for Fiske Kimball, director of the Philadelphia Museum of Art, which the museum was unable to purchase because of the deepening of the Depression. A number of the works that Mrs. Dodge had bought from Duveen's Russian acquisitions were initially on loan to the Philadelphia Museum of Art in 1932 for the opening of its Louis XVI gallery. No doubt Duveen would have been delighted if the loan had turned into a sale.

33. Duveen Brothers archives. In this letter, Duveen was attempting to lure Mrs. Dodge into the purchase of a set of Boucher tapestries (cat. 37).

34. Horace Trumbauer to Mrs. Dodge, December 13, 1932.

35. Ellen Shipman to Frank Upton, June 2, 1937.

36. The Detroit Institute of Arts, Dodge Bequest file.

37. Based on the Hôtel de Charolais, 101, rue de Grenelle, Paris (reproduced by Miller and Baptie 1969: 136–44).

38. Exterior reproduced by Latham and Agresta 1989: 260.

39. Trouble in the marriage can be detected as early as 1932.

40. Mentioned in a letter from John H. Allen, treasurer of Duveen Brothers, New York, to Lady Duveen, December 30, 1941.

41. According to the Detroit architectural historian W. Hawkins Ferry. The author is grateful to the late Mr. Ferry for having shared his experiences concerning Rose Terrace and the Dodge family.

42. After Mrs. Dodge's death, the executors of her estate offered the house and its contents to The Detroit Institute of Arts as an adjunct museum in Grosse Pointe Farms. The Institute had to refuse for both practical and philosophical reasons.

43. See London 1971.

44. J. Paul Getty's purchases from the Dodge estate included, from the sale of June 24 (London 1971), the previously mentioned four chairs made for Marie-Antoinette (lot 66), the two Boucault chairs with the brand of Versailles (lot 65), a pair of folding stools made for the Tuileries (lot 69), the *bureau plat* said to have been made for Catherine the Great (lot 95), the Louis XV commodes by Bernard Vanrisamburgh previously in the Schloss Moritzburg near Dresden (lot 102), a pair of Louis XIV gilt-wood *torchères* (lot 75), a Louis XVI inkstand (lot 33), a pair of firedogs (lot 18), a marble bust of Louis XV after J.-B. Lemoyne (lot 9), a clock and barometer by Cressent and St. Germain (lot 40), a Louis XV desk chair (lot 48), and a Beauvais tapestry of *The Toilet of Psyche* (lot 137); from the sale of June 25 (London 1971a), Getty bought two large paintings by Boucher.

45. Acquired by The J. Paul Getty Museum at auction in 1983 (London 1983b: lot 54).

46. See Grosse Pointe Farms 1971.

47. See Grosse Pointe Farms 1976.

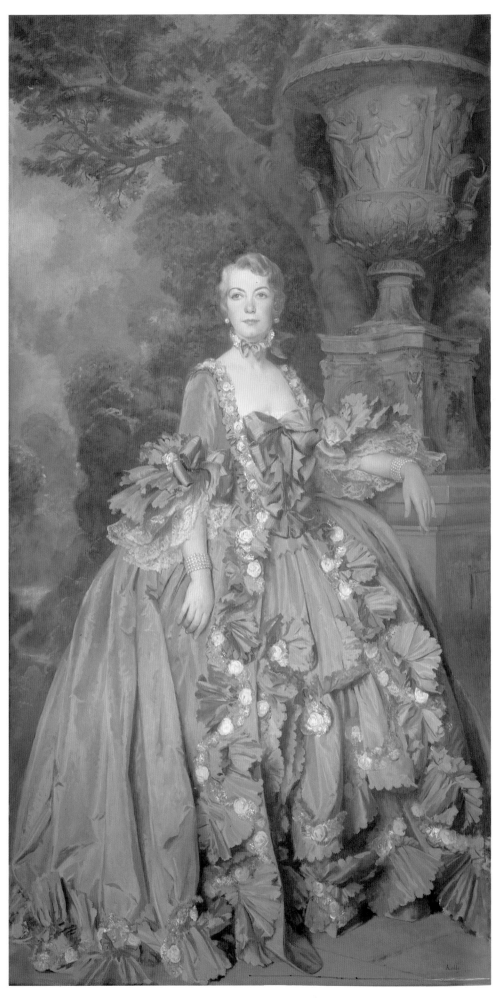

Mrs. Horace Elgin Dodge. Gerald Festus Kelly (English), 1932. Oil on canvas.
Gift of the grandchildren of Mr. and Mrs. Horace E. Dodge. (F72.93).

Catalogue of the Collection

NOTES TO THE CATALOGUE

ORGANIZATION

The catalogue is organized by medium, related type, then chronologically by the date of each work. A concise biography is provided for each artist represented and precedes the first entry under his name in the catalogue. Works by, or associated with, a particular artist are generally discussed in chronological order.

Although most pieces are treated individually, sets or works *en suite* are presented in single entries.

ATTRIBUTION

If a work is listed as "by" an artist, it is either documented or established by long art historical tradition, or the author is absolutely certain about the ascription.

If it is listed as "attributed to" an artist, the author, although not absolutely certain about the artist, fully supports the association of the work with the artist's invention and/or participation.

"Workshop of" an artist indicates that the work was executed by an unidentified artist in the master's studio and possibly based on his invention, whether or not the master himself participated to some degree in the execution of the work.

"Style of" denotes that the work is either similar stylistically to the work of the master, or else replicates a documented model or design by the master.

"Follower of" indicates that the work is similar stylistically to that of the master, but direct influence is lacking. The latter two phrases imply some distance in either time or place from the work of the master.

MEASUREMENTS

Measurements are given in centimeters to the nearest millimeter, followed by inches (in parentheses); height precedes width, precedes depth, unless otherwise noted. For circular objects, measurements are height followed by diameter.

Measurements for paintings are exclusive of their frames. Except where otherwise indicated, the height given for a sculpture is exclusive of the base or socle, unless the base is an integral part of the sculpture.

REFERENCES AND EXHIBITIONS

References are given in the form of author, year, and page number; full citations appear in the Bibliography in alphabetical order. Exhibition catalogues are cited under city and year.

References at the beginning of each catalogue entry include only publications that specifically discuss the Dodge work, other examples of the same model, or objects from the same series or cast, and, when known, directly related drawings and designs or preparatory studies. Catalogues for exhibitions in which the Dodge object appeared are listed under Exhibitions. The category Additional Bibliography includes sources which provide useful supplementary information on the artist, commission, model, or function.

References cited in parentheses in the commentary discuss works only generally related to the Dodge object, explain the object's function, or place it in the artist's activity.

APPENDICES

The sixty-eight entries in this catalogue treat the most significant French and English works of art owned by Anna Thomson Dodge. Appendix I lists other works either given by her to the museum beginning in 1925 or else owned by her and bought by the museum after her death. Appendix II lists those works of art partly or wholly purchased by the museum with funds provided from the Mr. and Mrs. Horace E. Dodge Memorial Fund. Appendix III provides a concordance of accession numbers and their corresponding catalogue entries.

FURNITURE

Theodore Dell

GASPARD FEILT

Active Paris c. 1735–63

Like many eighteenth-century Parisian ébénistes, Feilt was of German origin. It is not known when he came to Paris, but he apparently was established there as a member of the cabinet-makers' guild by the mid-1730s. Two surviving inventories of the contents of his workshop—one made after the death of his first wife in 1753 and another after his own death ten years later—indicate that he enjoyed considerable success producing furniture, like the Dodge table, veneered with marquetry of colored woods.

[1]

Gaspard Feilt

Combination Writing Table and Worktable, c. 1755

Carcass of oak with marquetry veneer and gilt-bronze mounts, 74 (29⅛) × 65.4 (25¾) × 44.5 (17½)
Bequest of Mrs. Horace E. Dodge in memory of her husband (71.200)

INSCRIPTIONS: Stamped on the underside of the back rail are the signatures: G. FEILT and C.M. COCHOIS, accompanied by three JME guild marks.

ANNOTATIONS: Inside the drawer are three labels, an older one inscribed in ink: *This beautifully executed Marquetrie writing Table purchased at the Chilton Sale of Household Furniture, & effects, on 8th of March 1871;* and two more recent Duveen labels, one typed with: *From the Collection of the Duc [sic] de Gramont, and the "Chilton" Sale of March 8th 1871;* the other inscribed with the inventory number: *29678.*

CONDITION: The normal shrinking and shifting of the carcass boards as they aged, aggravated by the excessively dry atmosphere maintained during the winter months at Rose Terrace, have resulted in the partial detachment of many of the pieces of marquetry decorating the top, with losses occurring in several places. The dryness at Rose Terrace also caused the detachment or loss of veneer from the inner surfaces of the legs, leaving the oak carcass exposed in many areas. Probably not long after the table was constructed, the two shallow drawers that originally extended from either end were replaced by the single long one that now opens from the right; the original left drawer-front has been glued permanently in place. Much of the marquetry was originally brightly stained, but the only color now visible is a pale green found on the leaves of the flowers, on some of the acanthus scrolls, and on the ground of the trellis marquetry cartouches decorating the top.

PROVENANCE: Chilton House (possibly the Chilton House in Wiltshire that was demolished in 1965). Chilton sale, March 8, 1871 (no catalogue of this sale is recorded). Comte de Gramont, Paris. Sale, Galerie Jean Charpentier, Paris, June 15, 1934, lot 87. Duveen Brothers (dealer), New York. Acquired by Anna Thomson Dodge from Duveen Brothers, 1935.

REFERENCES: Paris 1934: lot 87; Detroit 1939, I: n.p.

ADDITIONAL BIBLIOGRAPHY: Nicolay 1956–59, I: 115, 180, fig. A; Salverte 1962: 63, 116–17; Strong, Binney, and Harris 1974: 190.

Designed in the late Louis XV style, the table consists of an undulating drawer-case supported by four pentagonal cabriole legs. Extending from the right side of the case is a single long drawer of oak, fitted toward its front with two smaller drawers beneath a compartmentalized shelf and toward its rear with a large, removable sliding tray. Set just under the top of the case and opening from the front is a writing slide covered in green leather.

The intricately curved top, which swells out and widens toward the rear, is veneered with an elaborate marquetry composition depicting a musical trophy hung by a large ribbon bowknot from a scrolling strapwork frame. Comprising the trophy are a violin, four horns, a tambourine, and two pages of music crossed by branches of palm and laurel and by sprays of flowers, the lighter components executed principally in Hungarian ash; at lower right is a single playing card marked with nine stars and three fleurs-de-lis. The strap-

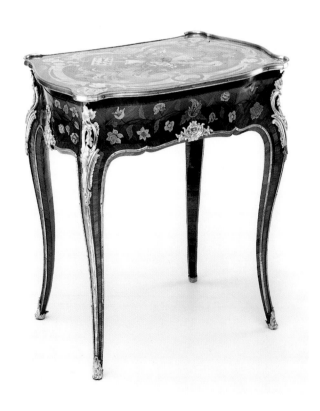

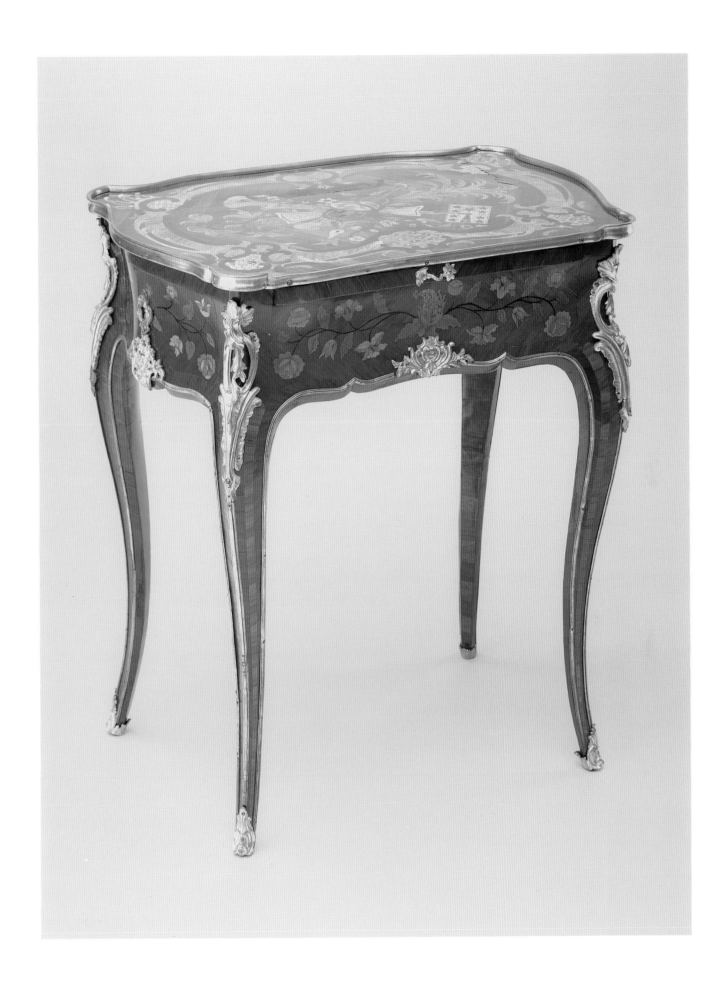

work frame is executed in amaranth and tulipwood on a *bois satiné* ground and is overlaid along both the inner and outer edges with scrolls of acanthus. Interrupting the tulipwood ground at the center of the frame in front and back and at all four corners are amaranth strapwork cartouches, those at the front corners and at center rear inset with panels of shaded scale marquetry and those at the rear corners and at the center front filled with panels of trellis marquetry. Curling out from the rear corners are flamelike foliated motifs.

On all four sides of the drawer-case, panels of marquetry depict trailing branches of flowers, including roses, carnations, tulips, and daffodils, principally executed in engraved and shaded Hungarian ash on a *bois satiné* ground. On the front and back the branches emanate from asymmetrical pomegranate motifs. The two outer surfaces of each leg are veneered with narrow panels of horizontally grained tulipwood framed by amaranth.

The top of the table is bordered all around by a plain gilt-bronze molding. At each corner of the case is a vertical *rocaille* cartouche made up of foliated scrolls; a leafy vine issues from its top, trails down across its open center, and ends over the knee of the cabriole leg. At center on all four sides of the drawer-case, just above the lower edge, are additional mounts formed by foliated scrolls. The intricate, finely detailed mounts on the ends frame pomegranate motifs, and the broader compositions in front and back enclose simple cartouches. Another cartouche forms the keyhole escutcheon, and the feet are mounted with cartouches framed by rising foliage. The curved undersides of the drawer-case and the legs are outlined with gilt-bronze fillets.

The exceptionally harmonious relationship created by the shape of the carcass, the pattern of the marquetry, and the design and placement of the mounts makes the Dodge table one of the finest Louis XV tables known. This unity enables the eye to assimilate the entire work at a glance, while the complexity of its detail invites closer inspection, yielding further visual pleasure.

Although the table bears the signatures of both Gaspard Feilt and Charles-Michel Cochois (d. 1764), it is almost certainly the product of Feilt alone. Cochois, a master cabinetmaker about whom little is recorded, must have signed the work, as he seems to have done a number of others, in his capacity as dealer. Another table identical to the Dodge example, except for its leather top, and signed only by Cochois—probably again as a dealer—is in the Rijksmuseum, Amsterdam.

Unfortunately, too few pieces by Feilt are known to permit a stylistic analysis of his work. Certainly the various types of marquetry encountered on the Dodge table were not exclusive to him. The musical trophy found on the top of the table appears in more or less modified form on the works of a number of other *ébénistes,* suggesting that the variations either were based on a common drawing or engraving, were

cut from somewhat different designs commissioned from the same artist, or were in some instances purchased from the same marquetry specialist. Tables veneered with such trophies include: an example similar in general appearance to the Dodge table in the Musée du Louvre, Paris, delivered by Gilles Joubert for the use of Marie-Antoinette at Fontainebleau in 1770 (Pradère 1989: 219, fig. 216); a nearly identical unsigned table sold in Paris in 1933 (Paris 1933: lot 117); a table signed by Christophe Wolff, sold in New York in 1954 (New York 1954: lot 488) and now in the Robert Lehman Collection at The Metropolitan Museum of Art, New York; a sliding-top table attributed to Jean-François Oeben in the Huntington Library and Art Gallery, San Marino (Wark 1979: fig. 77); another sliding-top table attributed to Oeben in the Widener Collection in the National Gallery of Art, Washington, D.C. (Boutemy 1973: 220); and a table signed by Brice Péridiez in the Severance Collection in The Cleveland Museum of Art. The significance of the playing card incorporated in the trophy is not known.

The elaborately scrolled strapwork frame surrounding the Dodge trophy is found in varied forms on the tops of a number of other tables, in conjunction either with trophies or with sprays of flowers. It appears on the above-mentioned tables by Joubert, Wolff, and Péridiez; on the Vandercruse table with floral marquetry in the Dodge Collection (cat. 3); on a parlor organ with floral marquetry signed by Jean-Pierre Latz in the Frick Art Museum, Pittsburgh (Hawley 1970: 258, no. 67); on a table similar to the Dodge Vandercruse table but signed by Denis Genty and Jean-Pierre Latz at Waddesdon Manor, Buckinghamshire (Hawley 1970: 258, no. 65; Bellaigue 1974, I: 394–97, no. 82); and on the slant-top section of a *secrétaire en pente* by Latz in the collection of Stavros Niarchos, Hôtel de Chanaleilles, Paris (Hawley 1970: 254, no. 26; Pradère 1989: 152).

The stylized floral marquetry on the sides of the Dodge table is of a type popular in the 1750s, characterized by evenly spaced flowers on dark stems that usually emanate from central seedpods. The drawing of the marquetry is deliberately childlike in an effort to charm, much like the pictoral marquetry on the small circular worktable by Topino in the Dodge Collection (cat. 6).

The other signed works by Feilt comparable in general style to the Dodge table are a *secrétaire en pente* with similar marquetry elements, auctioned in London in 1980 (London 1980b: lot 118; Kjellberg 1989: 304) and now in the Minneapolis Institute of Arts, and a *bureau plat* veneered with panels of *bois de bout* floral marquetry in the Jones Collection of the Victoria and Albert Museum, London (Brackett 1922: no. 24, pl. 15; incorrectly described as "signed G. Petit").

JEAN-FRANÇOIS OEBEN
1721 Heinsberg–Paris 1763

German by origin, Oeben was one of the most inventive and influential cabinetmakers working in eighteenth-century Paris. He was born near Aachen in 1721 (Stratmann 1971: 9) and probably came to Paris sometime during the mid-1740s. He is known to have rented part of the Louvre workshops of Charles-Joseph Boulle, son of André-Charles Boulle, in 1751, and by 1754 his reputation was such that he had gained the position of ébéniste du roi, *moving in 1756 to the Arsenal in the Gobelins. He was much favored by Madame de Pompadour and counted among his other fashionable clients the duc de La Vallière, the duchesse de Villars-Brancas, the marquis de La Vaupalière, and the* fermier-général *Grimod de La Reynière.*

Oeben was a man of extraordinary energy, always striving to push beyond existing limits. His furniture was sumptuously beautiful. No other cabinetmaker used woods to such fine effect, and he excelled at producing naturalistic floral marquetry and various types of trellis and geometric patterns.

But Oeben was not just a master of aesthetics. An extraordinary inventor and mécanicien, *he can be credited with the introduction or perfection of many new forms, among them the tambour roll-top desk, tambour-fronted cabinets and secretaires, tables with sliding tops, and tables and cabinets with compartments that could be raised by spring action or crank. His intention was to delight in every way.*

Oeben's innovations also extended to the area of construction, and he was perhaps the first maker to slot the bottoms of drawers into their sides, so that they would not split as the wood shrank over the years; this method has since become almost universal. Because of his meticulous attention to detail, his pieces usually survive in excellent condition. Many have suffered more through inept restoration than from the deterioration of their materials.

Oeben's most famous piece is a roll-top desk now at Versailles, which he began for Louis XV in 1761 and which was finished posthumously in 1769 by his assistant, Jean-Henri Riesener (Verlet 1955: no. 10, pls. 8–11; Pradère 1989: 372, fig. 448). Other outstanding works by Oeben include a series of highly sculptural sliding-top tables, prime examples of which are in the Linsky Collection at The Metropolitan Museum of Art, New York (Rieder, in Baetjer et al. 1984: 210–12), The J. Paul Getty Museum, Malibu (Wilson 1983: 54–55), and the Musée du Louvre, Paris (Frégnac and Meuvret 1965: 150–51, figs. 3, 4; Alcouffe, Dion-Tenenbaum, and Lefébure 1993: no. 53). The only major bureau plat *that survives bearing his signature is also in the Louvre (Frégnac and Meuvret 1965: 152, fig. 1; Alcouffe, Dion-Tenenbaum, and Lefébure 1993: no. 55). Oeben died in his prime at the age of forty-one, leaving behind a relatively small but highly impressive oeuvre, which fueled the imagination of his two most illustrious assistants, Jean-Henri Riesener and Jean-François Leleu.*

[2]

Attributed to Jean-François Oeben or an associate

Writing Table, c. 1755–60

Carcass of oak with marquetry veneer and gilt-bronze mounts, 77.5 (30½) × 155 (61) × 73.6 (29)
Bequest of Mrs. Horace E. Dodge in memory of her husband (71.208)

INSCRIPTIONS: On the back of each of the military trophies, probably incised into the models from which the mounts were cast, are: the number *7* behind the tassels on both front trophies; and the number *2* behind the left banner on the rear trophies. Affixed to the bottom of the upper right drawer is a label inscribed in ink: *28665,* a Duveen Brothers inventory number; nearby is a fragment of a round label inscribed: *551/. . . .* On the side of the upper left drawer is a blue-bordered label inscribed: *Fr. U80xxx,* evidently a dealer's price in code. On the underside of the top at center is a circular French customs label.

CONDITION: Despite its sumptuous appearance, the table has suffered considerably over the years. The present rectangular top almost certainly replaces one whose curvilinear edges were more appropriate to the overall sculptural conception; the gadrooned molding on the present top was probably made in England during the nineteenth century. The lack of a central drawer is unusual. Horizontal channels cut into the interior walls of the carcass above the kneehole apparently once housed a wooden panel that formed the bottom of a well, probably one from which a hinged book support could be raised. The table's veneer was at some time coated with a dark varnish that penetrated deep into the pores of the wood, irreversibly altering the contrasts of the marquetry. The veneer on the legs and that flanking the marquetry panels has cracked and curled slightly, possibly from the dry atmosphere at Rose Terrace. Most of the mounts' heavy mercury gilding survives in good condition, but close inspection of the corner trophies reveals that the gold there has flaked from a number of small areas; overzealous cleaning probably was responsible for these losses, as it was for removing the patination from the backs of the mounts, giving them an unattractive, greenish cast. The right rear foot mount is missing, and the end of a laurel branch on one of the rear drawers has become detached from its panel frame. A missing 15-cm section of the gadrooned molding surrounding the top has been recast.

PROVENANCE: Duveen Brothers? Arnold Seligmann (dealer), Paris. Acquired by Anna Thomson Dodge through L. Alavoine (agent), New York, 1932.

ADDITIONAL BIBLIOGRAPHY: Vial, Marcel, and Girodie 1922: 57–60; Salverte 1962: 246–48; Stratmann 1971: 5–28; Pradère

1989: 253–63; Alcouffe, Dion-Tenenbaum, and Lefébure 1993: 174–88.

The table consists of a rectangular case housing two drawers at each end and resting on four cabriole legs; in the area customarily occupied by a middle drawer, the bottom of the case rises sharply to form a high kneehole. Though the piece is designed in the Transitional style, with a sinuous profile accentuated by curvilinear mounts of Neoclassical character, its sides are flat in plan, curving only slightly at the kneehole. The present rectangular top replaces an earlier one that was almost certainly of a shape more in keeping with the table's sculptural qualities (see Condition). The four cedar drawers have bottoms that are not only slotted into their fronts and rather thick sides (1.42 cm) in a manner typical of Oeben, but are also slotted, most uncommonly, into their backs.

The ends of the table, the fronts of the drawers, and the corresponding areas on the back of the case are each veneered with dark-stained marquetry panels (see Condition) depicting ribbon-bound swags of laurel leaves executed in holly on an amaranth ground, each panel framed by a pair of light and dark fillets. The remaining surfaces are veneered with tulipwood.

The boldly scaled mounts are of unusually fine quality. Those decorating the ends are exceptionally beautiful, swelling up from the feet to meet at the apron in handsome symmetrical scrolls surmounted by laurel branches. The long slender foliated mounts on the front and back are somewhat similarly conceived, but the manner in which they meet at the kneehole is curiously awkward.

Mounted on the drawer-fronts and the corresponding panels of the back are slightly different military trophies, those in front incorporating crossed banners, a military drum, a bugle, and laurel branches; those in back including banners, laurel branches, horse drums, horns, and an oval shield. Above each trophy are entwined laurel branches that form drawer-pulls on the front. Draped down the table's four corners are heavy ribbon-bound trophies emblematic of learning, with a globe, calipers, a scroll, and an open book, all intertwined with floral pendants. Plain moldings, some of them merging with foliage, frame the marquetry panels.

The present desk belongs to a distinctive group of *bureaux plats,* all with two drawers on each side flanking the central kneehole rather than the conventional one, virtually all with gilt-bronze tendrils ascending up from the feet to either side of the kneehole, and all with heavy mounts of one of two forms at the corners. Although only one such desk bears makers' marks, and these by other *ébénistes* (see below), all fit stylistically into the oeuvre of Jean-François Oeben, who made a number of signed *bureaux à cylindre* whose lower sections repeat the full-face profiles of these pieces (Siguret 1965: 106; North Mymms Park 1979: lot 231; London 1982: lot 77; Monaco 1983: lot 510). This same profile, coupled with similarly conceived tendril mounts, can be seen on the far richer *bureau du roi,* the roll-top desk at Versailles (Verlet 1955a: no. 10, pls. 8–11; Pradère 1989: 372, fig. 448) started by Oeben in 1760 for the *cabinet-intérieur* of Louis XV at that palace and finished by J.-H. Riesener nine years later.

The prototype of the Dodge group of *bureaux plats* was almost certainly that delivered by J.-F. Oeben in August 1756

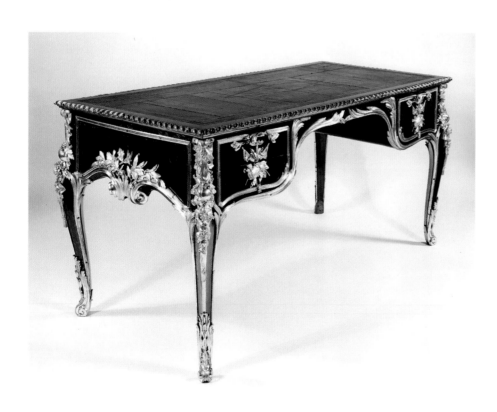

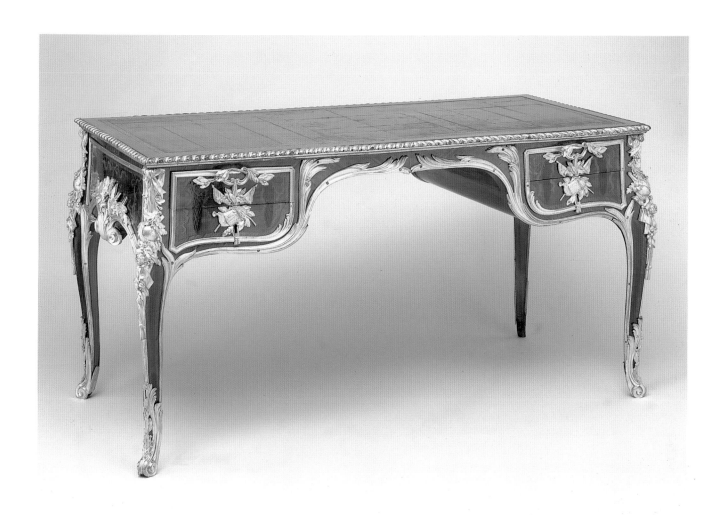

for the newly decorated *cabinet-intérieur* at Versailles of Louis, the Dauphin (1729–1765), son of Louis XV and father of the future Louis XVI, Louis XVIII, and Charles X. That piece (Baulez 1990: 98–99), which has recently been returned to Versailles, has unfortunately lost nearly all its original gilt-bronze decoration, though its shape and veneering clearly show it to be a member of this group. Its description recorded in 1756 in the *Journal du Garde-Meuble* indicates that it was originally mounted at the corners with dolphins and cattails and was thus virtually identical to an unsigned *bureau plat* in the collection of the Earl of Rosebery at Dalmeny House, West Lothian, Scotland (Buckland 1972: pl. 38a; Stratmann 1971: 386, no. 136)—once thought to have been the Dauphin's desk. Except for the corner dolphins, the shape and mounts of the Rosebery desk are identical to those of three further *bureaux plats* mounted at the corners, like the Dodge bureau, with gilt-bronze trophies. These include a bureau veneered with red lacquer panels and supporting a low *serre-papiers* belonging to Dalva Brothers, New York (Buckland 1972: pl. 37; Stratmann 1971: 387, no. 137); a somewhat wider *bureau plat* with red lacquer panels in the Hôtel de Ville, Paris (Boutemy 1973: no. 34; Stratmann 1971: 389, no. 139); and a *bureau plat* veneered with panels of quartered tulipwood within kingwood borders, sold from the col-

lection of Baron Cassel van Doorn (New York 1955: lot 172; Stratmann 1971: 388, no. 138). Further versions catalogued as reproductions have appeared, including those with the Dodge trophy corner mounts and their tops supporting *serres-papiers* (Paris 1972a: lot 117; Paris 1974: lot 121; New York 1993a: lot 65; London 1995: lot 171) and that with dolphin corner mounts and no *serre-papiers* (New York 1981: lot 335). Another version with these latter corner mounts and veneered with trellis-and-fleuret marquetry was auctioned from the collection of Mrs. Henrietta Montefiore in 1915 (Worth Park 1915: lot 357), at which time it was believed to be eighteenth century, but its catalogue illustration suggests otherwise. A desk of this model of unspecified date with trophy corner mounts, quartered tulipwood veneer and its top supporting a *serre-papiers,* was formerly in the Château d'Abondant, Eure-et-Loire (Soulange-Bodin 1925: pl. 7).

As the Dauphin's desk was delivered by Oeben five years before his admittance to the cabinetmakers' guild and the official granting of his stamp, it is understandable that it does not bear his mark. What is puzzling, however, is that it bears the mark of his brother-in-law Roger Vandercruse (master·in 1755) and that of his younger brother Simon Oeben (master in 1769). Possibly Vandercruse was involved in the making of the piece and signed it in that capacity, or possibly he signed

it as a repairer, but Simon Oeben, who did not register as a full member of the guild until thirteen years later, could have signed it only as a repairer.

Nevertheless, although the style of these desks is that of J.-F. Oeben, the possibility that two or more cabinetmakers in his circle were involved with their manufacture cannot be ignored. That both Vandercruse and the younger Oeben did indeed make a considerable amount of furniture in J.-F. Oeben's style—some of it no doubt considerably after his death—is known from the number of such pieces bearing their signatures.

The Dodge table differs from the others of this group in that its carcass is flat-sided rather than swelling and its two ends have been radically redesigned to curve up rather than down. These variations combine to make a much less voluptuous piece of furniture.

The iconography of the decorative elements—the gilt-bronze military trophies mounted on the drawer fronts, the prominent sprays of gilt-bronze laurel leaves decorating the two ends, and the now barely visible ropes of laurel depicted in each of the marquetry panels—indicates that the Dodge bureau must have been commissioned for someone with a distinguished military career or perhaps a member of the royal family holding a high honorary rank. Neither the marquetry nor these mounts are repeated elsewhere.

The bold symmetrical scrolls forming an integral part of the two ends of the table suggest the work of the decorative sculptor Jean-Claude Duplessis, *père* (see p. 152), who was both *orfèvre du roi* and *fondeur du roi,* and who was responsible for some, but not all, of the mounts on the previously mentioned *bureau du roi.* Although little else is known of Duplessis's involvement with Oeben's work, he was listed among the principal creditors after Oeben's death.

ROGER VANDERCRUSE, called LACROIX
1728 Paris – Paris 1799

The son of a Flemish cabinetmaker who moved to Paris and changed his family name, Vandercruse, to its French equivalents, Delacroix and Lacroix, Roger Vandercruse was related by marriage to some of the greatest ébénistes *of his day. One of his sisters was married first to Jean-François Oeben and then to Oeben's successor, Jean-Henri Riesener; a second sister married Simon Oeben, younger brother of Jean-François and* ébéniste du roi *in his own right; a third sister married the cabinetmaker Simon Guillaume. Vandercruse himself became a* maître ébéniste *in 1755.*

Throughout his career, Vandercruse produced furniture of very high quality, though it was often, especially during his earlier years, derivative in style—perhaps due in part to the specifications he received from the various furniture dealers for
whom he worked, or from their designers. Vandercruse was a particularly fine marqueteur, and it is his veneers especially that raise his works above those of most of his contemporaries. He produced furniture not only for the crown, but also for such notables as the duc d'Orléans and Madame du Barry. During the 1780s, Vandercruse devoted much of his time to guild administration, and he seems in consequence to have made less furniture. At the onset of the Revolution he retired from business, though it is said he continued to make some pieces for his own amusement.*

[3]

Roger Vandercruse, called Lacroix

Mechanical Writing Table, c. 1755

Carcass of oak with marquetry veneer and gilt-bronze mounts, 71.1 (28) × 64.8 (25½) × 46 (18⅛)
Bequest of Mrs. Horace E. Dodge in memory of her husband (71.198)

INSCRIPTIONS: Stamped under the left side of the table near the front: the signature R.V.L.C., accompanied by the JME guild mark.

ANNOTATIONS: Inscribed in ink on the underside of the narrow drawer that opens from the right: *January 1846. About four years ago was lost in ye fielde before the house a silver watch belonginge to Narbrough Hughes D' Aeth [1822–1886] of Knowlton Courte Kent, Esq. / W. Spotteswoode Jan 12th 1846 on his twenty first Birthday, on which day there was a great Ball and other festivities given. Given under our hand this 12th day of January A.D. 1846.*

CONDITION: The table shows extensive damage and repair. Drying and shrinkage have caused the boards that form its top to warp—giving a slight undulation to the surfaces toward the rear—and to split in several places. On the section that forms the top of the rising cabinet, these splits have resulted in three sizable cracks in the marquetry, one running somewhat erratically from front to back for almost 12.5 cm at left, one to the right of center extending about 7.7 cm, and a fine crack passing from side to side toward the front. On the section that forms the top of the hinged writing surface, one crack runs from front to back, passing to either side of the keyhole, and a second fine crack extends from side to side toward the rear.

Although simple neglect and abuse have taken their customary tolls, resulting most notably in the loss of many pieces of veneer from the insides of the legs and the front edge of the top, the most serious damage is the product of inept restoration. In what must have been an attempt to restore the table's

original coloring and perhaps to remove superficial blemishes, the marquetry surfaces were scraped down so strenuously that much of the engraved detail has been lost, and in certain areas the oak of the carcass now shows through. Such scraping has almost totally obliterated the engraved scallop-shell detail from the light sycamore areas of the marquetry frame on the top. On the front section of the top, a sizable area of marquetry at right rear seems to have been abraded away, since two flowers, a leaf, and part of the background are replacements. Bits of background wood have also been pieced into this section at the rear edge, one just right of center, the other at the left. Though the process of scraping has caused less damage to the rear section of the top, a number of pieces of replacement veneer are visible, including several large bits along the crack in the marquetry at left and replacements in a bud nearby and in two berries at right. On the front of the table, scraping has removed much or all of the engraved detail from the leaves and several of the flowers and has worn through to the carcass in the area of a leaf at center; in addition, the ground veneer at the extreme lower left is a replacement.

The engraved detail on the back of the table is less worn, but bare carcass wood is visible in the area of a rose in the upper right quadrant; in the lower left quadrant near the center, a large section of the tulipwood ground and the lower part of a leaf have been replaced. On the left side, fragments of the tulipwood ground have been replaced at left, in an area where one of the leaves was abraded away, and at right next to the seedpod.

On the right side, replacements include the lower central leaves of the seedpod, a triangle of veneer at the lower left edge of the drawer, and two fragments to the right of the drawer. The normally protected surfaces of the rising cabinet, though abraded, retain much more of their engraved detail.

On the back of the cabinet, small sections of the tulipwood ground at left and right have been scraped through (possibly during the manufacture of the piece) and are skillfully repaired with wood filler, and several fragments of framing veneer have been replaced at the top. Elsewhere, replacement veneer fills in a large abraded area on the left side of the left front leg.

The central section of the rising cabinet originally housed two drawers, a larger one over a smaller one. At some time, the positions of the drawers were reversed, as a result of which the floral marquetry on the lower drawer is now abruptly truncated along its lower edge. The upper drawer, which probably was fitted with an adjustable bookrest, is missing, and its cavity is now treated as a pigeonhole. The drawer that opens from the right side of the carcass seems meant for writing or toilet utensils. A circular depression about 7.5 cm across is cut into the center of its bottom, and nail holes around the inner surfaces of its sides indicate that it probably was once fitted with a frame that supported a sliding tray. The upper part of the drawer's back is a later addition, and the fabric that almost certainly lined it is missing.

PROVENANCE: Mrs. Walter Burns, North Mymms Park, Hatfield. Her sale (anonymous), Christie's, London, July 8, 1930, lot 78. Duveen Brothers (dealer), New York. Acquired by Anna Thomson Dodge from Duveen Brothers, 1932.

REFERENCES: London 1930: lot 78; Detroit 1933: n.p.; Detroit 1939, I: n.p.

ADDITIONAL BIBLIOGRAPHY: Salverte 1962: 184–85; Plas 1975: 32–41; Pradère 1989: 280–89.

The present table, of a model known variously as *secrétaire* or *table à la Bourgogne* or *table à capucin* (see Reyniès 1987, II: 1140–41), is conceived as a highly sculptural case supported by four cabriole legs. Its outward appearance is deceptively simple in an attempt to delight and amuse; though the piece appears to be purely decorative, it can quickly be converted into a highly functional writing table. By turning a key in the lock situated in the forward section of the top, a cabinet of drawers concealed within the rear section of the carcass can be made to rise automatically. The same lock frees the hinged front section of the top so that it can be folded forward to form a leather-covered writing surface.

The mechanism operating the cabinet is housed directly beneath it and consists primarily of a spring-driven axle that projects the cabinet upward along vertical steel channels, through whose centers run chains looped over pulleys. The pairs of drawers at either side of the cabinet can also be opened automatically: pressing upward on steel levers concealed under the overhang of the top at the sides releases springs that cause the drawers to be projected forward; the single drawer at the center of the cabinet (see Condition) has no lock. The cabinet drawer at lower right contains compartments designed to house a metal inkwell, sponge box, and sand shaker—all now missing. The other storage areas include a velvet-lined well beneath a second hinged flap toward the front of the top and a long narrow drawer below the well, opening from the right side of the carcass.

All four sides of the table are decorated with stylized marquetry sprays of roses, tulips, and other flowers executed in stained, shaded, and engraved woods on a quartered tulipwood ground, framed by handsomely figured kingwood. The sprays on the back and the two sides each emanate from a single large seedpod, while that on the front has two seedpods at lower center.

The principal marquetry composition, that of the top, is decorated on a dark wood ground with a large naturalistic bouquet, including daffodils, roses, and carnations, the flowers executed in shaded and engraved holly and the leaves in stained sycamore. Surrounding the bouquet is an elaborate Rococo frame composed of strapwork scrolls executed in

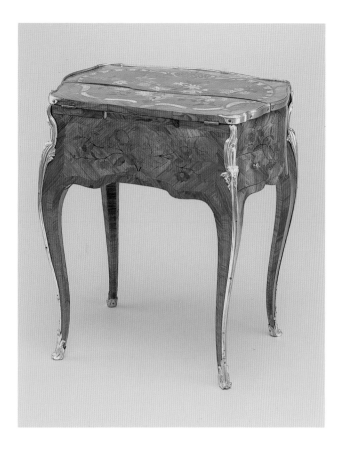

The sculptural form of the present table indicates that it was made during the early years of Roger Vandercruse's career, at a time when he was working almost exclusively in the style of his eminent brother-in-law, Jean-François Oeben. Indeed, Oeben may have commissioned the piece from Vandercruse expressly in order to help him meet the demand for such furniture both from his own clientele and from such furniture dealers as the *marchand-mercier* Simon-Philippe Poirier. That Oeben originated the design is suggested by the shape of the table's carcass, its mechanism, and the close relationship it bears to a documented *table à la Bourgogne* by Oeben in the Musée du Louvre, Paris (Alcouffe, Dion-Tenenbaum, and Lefébure 1993: 184–85), a rather tall, commodelike piece of furniture with a cabinet that rises up from the carcass at the rear. However, since no signed table by Oeben that might have served as a prototype has yet come to light, it is impossible to attribute the form of the Dodge table definitively to him.

The other known examples of this model include: a table with chevron parquetry veneer bearing the signature of Vandercruse and the inscription of Poirier, now in the Musée Nissim de Camondo, Paris (Janneau 1970: 103, figs. 110, 111; Gasc and Mabille 1991: 28); a table with marquetry resembling that on the Dodge piece but bearing the signatures of Jean-Pierre Latz and Denis Genty, now at Waddesdon Manor, Buckinghamshire (Bellaigue 1974, I: 394–97); a second, larger table at Waddesdon Manor, tentatively attributed to Christophe Wolff (Bellaigue 1974, I: 398–407), veneered with exceptionally fine marquetry depicting trophies, floral bouquets, and scenes of villages and classical ruins; a somewhat larger unsigned table veneered with floral marquetry on a light wood ground, in the possession of Dalva Brothers, New York (New York 1968a: lot 166); an unsigned table of the larger size formerly in the collection of Barbara Hutton, veneered around the sides with trophies and flowers on a dark ground and on the top with an elaborate trellis-work garden scene in the style of Lajoue (Packer 1956: fig. 61; Boutemy 1964: 220, figs. 37–39); another, identical table formerly in the collection of Akram Ojjeh (Monaco 1979: lot 191); another, also identical, table sold anonymously in New York (New York 1982a: lot 187); and a table signed by René Dubois similar in size to the Dodge example but less sculptural in form and veneered with lacquer, in the Linsky Collection at The Metropolitan Museum of Art, New York (Rieder, in Baetjer et al. 1984: 213–14). A larger table of this type, clearly outside this group and appearing to date c. 1740–45, is in the Musée des Arts Décoratifs, Paris (Janneau 1970: 104, fig. 112). Though it could be a prototype for all the above, it could also be a contemporary interpretation by an *ébéniste* working in a *retardataire* style.

That the Dodge table was produced shortly after Vandercruse entered the cabinetmakers' guild in 1755 is suggested by the fact that the closely similar table at Waddesdon

what under a microscope appears to be East Indian rosewood and enclosing lighter areas of sycamore engraved with vestiges of a scallop-shell motif. Flamelike projections of East Indian rosewood cross over the holly toward the rear, and at center rear a cartouche frames a trellis of curved dark fillets with florets at their intersections. The reserves outside the frame are veneered with kingwood.

All four sides of the rising cabinet are veneered with finely executed sprays of flowers, seedpods, and berries in stained, shaded, and engraved holly similar in design to those on the sides of the carcass but finer in scale and execution. The lid of the storage well is veneered on both surfaces with quartered tulipwood framed by amaranth.

At the four corners of the table are heavily gilded mounts that originate as upright acanthus at the feet, ascend in the form of ribbed moldings, develop into additional acanthus leaves and berries, and end above in concave cartouches composed of partially open foliage. The chasing and finishing of these mounts are sensitively executed, with the foliage crisply punched in some areas and softly burnished in others to impart a wide range of lifelike textures. Surrounding the sides and back of the top are plain gilded frames.

Mechanical furniture containing concealed compartments and writing sufaces was in vogue in Paris during the 1750s and 1760s. Such furniture owes its popularity in great part to Jean-François Oeben (see p. 41), *ébéniste du roi,* an accomplished *mécanicien,* and locksmith who throughout his career evolved new types of furniture, styles of decoration, and techniques of manufacture and assembly.

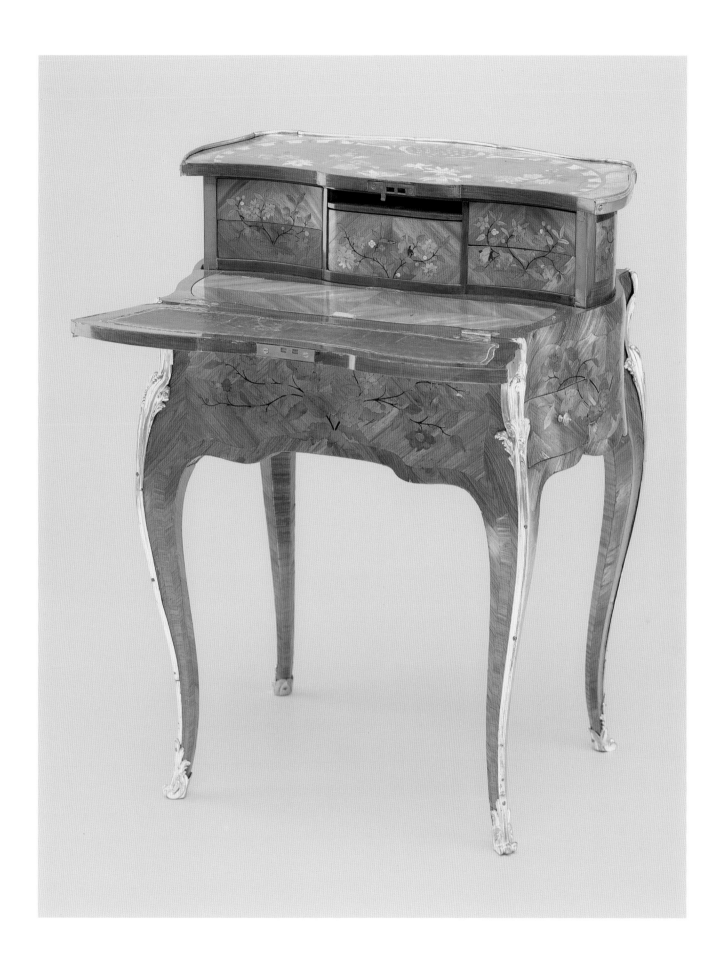

Manor bearing the signature of Latz could have been produced no later than December 1756, when Latz's workshop was closed permanently after the death of his widow (Latz himself having died in August 1754). Furthermore, a provincial copy of one of these tables, constructed without a rising mechanism so that the cabinet at the back is permanently positioned above the tabletop to form a *bonheur-du-jour,* bears an inscription stating that it was completed by François Hache in Grenoble on May 6, 1755 (New York 1949: lot 114).

[4]
French Maker

Combination Writing Table and Worktable, c. 1770

Carcass of fir, poplar, and oak with marquetry veneers and gilt-bronze mounts, 72.7 (28⅝) × 47 (18½) × 35 (13¾) Bequest of Mrs. Horace E. Dodge in memory of her husband (71.199)

INSCRIPTION: A small paper label affixed to the bottom of the middle drawer is inscribed in ink: *C 5719* (probably an inventory number, perhaps of Duveen Brothers).

CONDITION: The table is in fair condition. The separation and splitting of the carcass boards have caused several large cracks to develop in the marquetry, one running all across the top just forward of center, another running erratically across the shelf toward the back, and a third running horizontally across the left side just above the center of the marquetry panel. The shrinkage and movement of the boards have also caused the marquetry on the shelf to fracture along the juncture of the right clamping board toward the front, and the amaranth bands of the panel frame on the back to buckle at either side toward the bottom. The excessively dry atmosphere to which the Dodge furniture was subjected at Rose Terrace not only accelerated this deterioration but also caused the table's glue to dry out, loosening a number of pieces of veneer on the insides of the legs. A fragment of amaranth veneer about 2 cm square is missing from the back of the right front leg just above the shelf, and several other sections of amaranth appear to be replacements. In addition, a pair of light and dark fillets is missing from the lower right edge of the middle drawer-front. Other losses include the metal inkwell, sand shaker, and pen tray once housed in the front compartments of the upper drawer and the casters originally fitted on the legs. The sliding oak panel of the top drawer is inexpertly finished and is probably a replacement. As on virtually all furniture of this type, the staining of the marquetry has faded almost completely, though tinges of green are still visible in the trellis marquetry and its frame on the shelf and in the stems and leaves of the floral bouquets. Only traces of the original gilding remain on the mounts.

PROVENANCE: Madame de Fournières, Paris. Duveen Brothers (dealer), New York. Acquired by Anna Thomson Dodge from Duveen Brothers, 1932.

REFERENCES: Detroit 1933: n.p.; Detroit 1939, I: n.p.

The table is conceived as a rectangular drawer-case and shelf supported by four cabriole legs. Housed within the case are three oak drawers, the lower two opening from the front and the upper one from the right; the interior of the upper drawer is covered with a sliding panel behind three compartments intended for writing accessories. Set beneath the top and opening from the front is a writing slide covered in green leather.

The top is veneered with a panel of elaborate trellis marquetry, its bands executed in what appears to be *bois satiné rubané* and their junctures marked by small rectangles of green-stained burl veneer. The bands enclose a series of hexagons, each filled with a stylized quatrefoil executed in shaded and engraved holly. Framing the panel is a wide band of amaranth inset with strips of burl veneer and with circles of green-stained burl at the centers on each side. At the corners of the frame are small lobed panels decorated with single florets executed in natural holly on a ground of green-stained holly engraved with a trellis design.

All four sides of the table are veneered with marquetry panels depicting floral bouquets executed in stained holly on light grounds of sycamore maple; surrounding each panel is a narrow green-stained frame with incurvate corners. The shelf is veneered with a panel of trellis marquetry much simpler in design than that on the top, consisting of straight bands of green-stained wood defining lozenge-shaped areas inset with quatrefoils; green-stained bands again form a narrow frame. The areas surrounding the framed panels on the drawer-case and shelf are veneered with amaranth, as are the legs, except for a green-stained veneer on their narrow outermost surfaces.

The simple gilt-bronze mounts consist of a shaped frame around the top, a round, diagonally ridged pull for the writing slide, and feet in the form of foliated cartouches. The flush keyhole surrounds are executed in ivory.

Writing in 1772, Roubo (3, 2: 757) defined *tables en chiffonnière* of the same form as the Dodge example as small, commodelike tables designed to be used by women for sewing and embroidery as well as for writing. Light in weight and easily portable, they could be placed beside the user's chair and shifted about the room, along with the chair. Otherwise, they were kept inconspicuously out of the way, up against a wall or in a corner, an alcove, or a closet.

A 1751 watercolor by Chardin visually affirms the eighteenth-century usage of *tables en chiffonnière* (Janneau 1970: 89, fig. 94). It shows a table of very similar design placed haphazardly in an alcove, as if hurriedly moved aside,

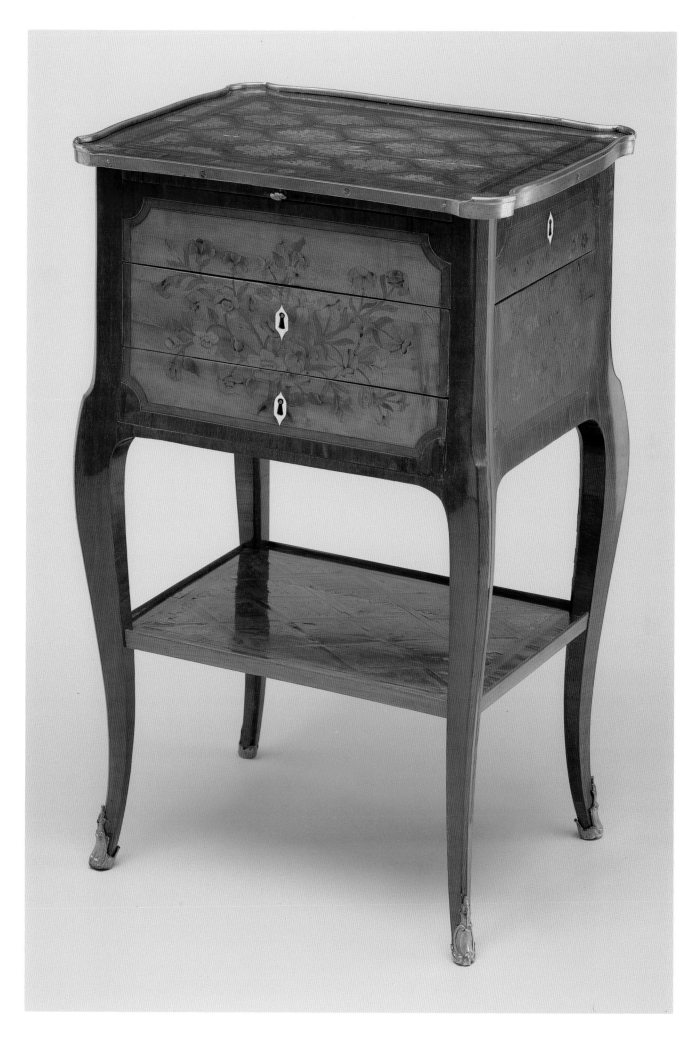

accompanied by the owner's small dog, the dog's cushion, and a bowl of water. On top of the table rest a drawstring sewing bag, two balls of yarn or thread, and a closed fan. Hanging over the front of the partially opened bottom drawer are a pair of gloves and several loops of yarn.

The overall style of the present table is not distinctive enough to warrant an attribution to any specific maker. The trellis-and-floret marquetry of the top is a more elaborate variation of a form developed by Jean-François Oeben (p. 41) in the early 1750s and used by him until his death in 1763. The employment of this type of marquetry, combined with the way the bottoms of the drawers are sharply chamfered along their sides—a convention of both Oeben and a number of his followers—suggests that the Dodge table may have been made by an *ébéniste* once associated with Oeben's atelier.

An unsigned *table en chiffonnière* of similar shape and with similar trellis-and-floret marquetry on its sides was sold from the Paris collection of George Blumenthal in 1932 (Paris 1932: lot 156, pl. LXXII).

[5]
French Maker

Worktable, c. 1780

Carcass of fir and oak with marquetry veneer and gilt-bronze mounts, 73.7 (29) × 49.8 (19⅝) × 40 (15¾)
Bequest of Mrs. Horace E. Dodge in memory of her husband (71.209)

CONDITION: Although the table's structural condition is sound, the unattractive color of the veneer gives it a rather poor appearance. Evidently at some point the veneer had been strongly bleached by sunlight, and in order to restore color to the piece it was inexpertly stained its present golden orange. Unsightly dark concentrations of stain have accumulated in many areas where slight depressions exist in the veneer, and the original multicolored staining of the marquetry is now only barely perceptible. The veneer is otherwise intact except for a small section missing from the lower edge of the right side. Although most of the structural members of the carcass are tunneled with wormholes—fir being particularly vulnerable to such attack—virtually none of these have penetrated the veneer. The mounts retain little of their original gilding.

PROVENANCE: L. Lourie (dealer), Paris. Acquired by Anna Thomson Dodge through L. Alavoine (agent), New York, 1932.

ADDITIONAL BIBLIOGRAPHY: Salverte 1962: 110.

The table is designed as an oval drawer-case and shelf supported by four cabriole legs. Housed within the case and opening from the right is a single drawer. The carcass is constructed entirely of fir, the drawer of oak with a fir front.

The top, the shelf, and all four sides of the drawer-case are veneered with a trellis marquetry of green-stained sycamore on a citronwood ground. The junctures of the bands of the trellis are marked with florets. In the center of the top, the trellis is interrupted by a large oval marquetry panel executed in sycamore on a sycamore ground, depicting a bouquet of roses, carnations, daisies, and other flowers, with their stems bound by a ribbon tied in a large bow; the components of this panel were once brightly stained (see Condition). At the top of each leg is a small marquetry panel depicting a single flower with stem; moving clockwise from the left front panel, the flowers represented are a daisy, a daffodil, a tulip, and a rose. The rest of the table is veneered with tulipwood, except for amaranth on the two narrow sides of each leg.

The plain, functional mounts comprise: a gallery of alternating large and small ovals extending halfway around the top; a gallery of identical design extending entirely around the shelf; a keyhole escutcheon in the form of an oval shield with a ribbon bow at the top and ropes of laurel leaves running down the sides; and feet in the form of foliated cartouches.

Both the shape and the marquetry decoration of this piece are in the Transitional style and are closely related to the works of Jean-Pierre Dusautoy, an *ébéniste* who produced many tables of this type (Nicolay 1956–59, I: 171, fig. A; Paris 1969: lot 132; Paris 1986a: lot 115). However, the choice of woods, as well as the techniques of construction, indicate that the Dodge table is almost certainly the product of another maker. The combination of a fir carcass with a marquetry veneer of fruitwood suggests that the table was made in one of the lesser French cabinetmaking centers by an *ébéniste* adept at reproducing Parisian styles. Too little is known about provincial cabinetwork to warrant proposing either a maker or a city of origin for the piece.

The Detroit Institute of Arts possesses a table of related design, acquired in 1958, that may be the work of Dusautoy (Detroit 1961: 16, fig. 6).

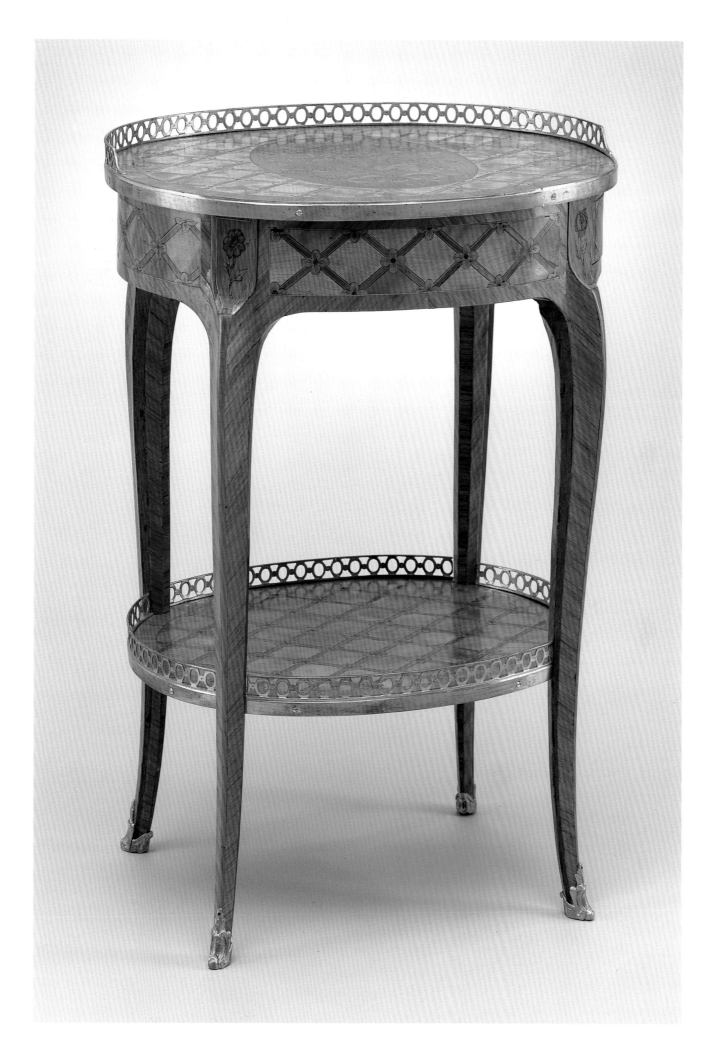

CHARLES TOPINO
Active Paris c. 1760–89

A prolific cabinetmaker, Topino produced furniture of many types, but his specialties were small tables and bonheurs-du-jour noted more for charm than for magnificence. The early details of his career are obscure. Born in 1742, he is known to have worked as a free craftsman before he was admitted to the guild of menuisiers-ébénistes in 1773. Although he had a number of private clients for whom he designed and produced special commissions, most of his pieces were intended to be either sold in his own showroom or supplied to other ébénistes who sold them in theirs. Acting in the latter capacity, Topino furnished finished pieces to Denizot, Moreau, Delorme, Pelletier, Héricourt, Boudin, Tuart, and Migeon. He also sold unmounted marquetry panels produced in his shop to other ébénistes, who veneered them onto their own carcasses. Because of the large number of pieces he supplied to other ébénistes who subsequently stamped them with their own signatures, it is difficult to assess the full extent of Topino's oeuvre.

[6]
Charles Topino

Worktable, c. 1775

Carcass of oak and fir with marquetry veneer and lacquered bronze mounts, 80 (30½) × 32.4 (12¾)
Bequest of Mrs. Horace E. Dodge in memory of her husband (71.205)

INSCRIPTIONS: The table is stamped on the underside of the drawer-case at left: C. TOPINO, accompanied by the JME guild mark. Nailed to the underside of the case at right is an oval brass plaque engraved with the Rose Terrace inventory number: *136.*

CONDITION: The table is in fair condition. On the marquetry panel forming the top, spilled liquid has caused the veneer in the area of the sky to curl, discolor, and become partially detached, with a section toward the top broken off and lost; several of the pieces forming a stone wall toward the bottom of the panel have also become partially detached and curled, with three sections missing. The stone wall on the door panel has suffered a somewhat similar fate, though none of the veneer is completely detached. In the right rear panel much of the veneer of the lower section has buckled, and in

the left rear panel part of the edge of the tower roof is lost. Holes drilled into the bottom of the legs show that the piece was once fitted with casters. A number of small holes indicating woodworm infestation are visible in the right and left rear panels, the shelf, and all three legs. The coloring of the piece has altered drastically; the original bright staining of the marquetry panels is now only faintly perceptible in certain areas, and the lacquered bronze mounts have oxidized to an unattractive dark hue.

PROVENANCE: E. Couvert (dealer), Paris. Acquired by Anna Thomson Dodge through L. Alavoine (agent), New York, 1932.

ADDITIONAL BIBLIOGRAPHY: Nicolay 1956–59, I: 459–67; Salverte 1962: 317–18.

The table consists of a drum-shaped drawer-case and a low, circular shelf supported by three quadrangular cabriole legs. The curved door that forms the front of the case opens to reveal three small oak drawers, also with curved fronts, housed in a rectangular inner case.

The principal decoration consists of five marquetry panels depicting village scenes executed in various stained woods. The panels on the top and the door depict fanciful Roman ruins rising among later buildings, while the two rear panels on the case and that on the shelf each show a peaked-roof tower flying a banner amid a cluster of gabled houses, some of which also fly banners. In the foreground of each scene is a river.

All the pictorial panels are surrounded by dark marquetry frames, of which those on the drawer-case are indented at the corners. The drawer fronts are veneered with crudely executed crossed floral sprays done in stained woods on grounds of vertically grained tulipwood, and the three stiles are veneered at the level of the case with narrow panels representing rising and falling bellflowers. The areas of the case outside the marquetry frames are veneered with tulipwood, as are the two outer surfaces of the legs. The inner surfaces of the legs are surfaced with amaranth.

Small drum-shaped tables of the present form were produced in Paris during the 1770s. Although all have virtually the same shape, the group can be divided into two distinct subcategories according to function (Reyniès 1987, I: 348–51, 362–63). Those whose door enclosed an open cupboard were intended to be used as night tables, with their interiors being meant to house chamberpots. An example of this form, signed by Topino, can be found in the Musée Nissim de Camondo, Paris (Reyniès 1987, I: 350, fig. 1250; Paris 1973: 75, 78, no. 349). Those fitted like the Dodge example with a nest of drawers on the interior were intended to be used as ladies' worktables. Their relatively light weight, as well as the casters with which many of them were fitted (see Condition), enabled them to be easily shifted, along with the user's chair,

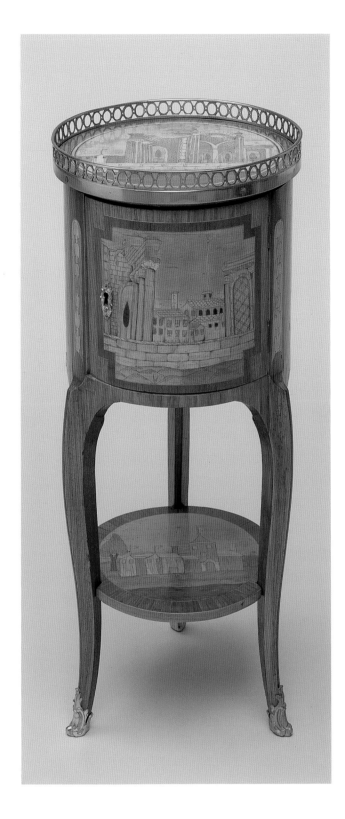

storage for small needlework supplies. Larger materials were customarily kept in a sewing bag that could be slung over the back of a chair or placed on the floor nearby.

Such tables were surfaced with a variety of veneers, but most often they bore pictorial panels of naive marquetry, depicting architectural compositions of several types, including village scenes with classical ruins, classical ruins by themselves, and turreted medieval buildings. Less frequently they were veneered with panels showing groups of vases, jars, and other vessels, or with panels depicting pastoral scenes. With each of these forms of marquetry, the awkward, childlike quality of the drawing was intended to amuse. Topino produced tables in all three styles.

The fact that the Dodge table bears Topino's signature as well as the JME guild stamp indicates that it was made after 1773, when he became a guild member. Other tables of this form signed by Topino and veneered with panels of architectural marquetry include: one with the London dealer Blumenthal in 1927 (*Connoisseur* 1927: LI, ill.); an example lacking a shelf formerly with the dealer J. Cordonnier, Paris (*Connaissance des Arts* 1953: 55, ill.); a table from the collection of Mrs. P. de Mio auctioned at Sotheby's in 1962 (London 1962: lot 228); a table lacking a shelf with Frank Partridge and Sons, London, in 1962; and another, also lacking a shelf, auctioned in Paris in 1981 (Paris 1981: lot 164).

Tables of this form not signed by Topino but veneered with similar marquetry and thus possibly supplied by him include: an example with an identical marquetry scene on its door signed by Benoit Butte, auctioned at Drouot Rive Gauche in 1978 (Paris 1978a: lot 173); an example in the Forsyth Wickes Collection at the Museum of Fine Arts, Boston (Packer 1956: fig. 128; Rathbone 1968: fig. 106); two tables, one with the stamp of Léonard Boudin and the other with that of Jean-Baptiste Tuart, illustrated by Nicolay (1956–59, I: 71, fig. AD, 469, fig. B); a second table signed by Boudin, lacking a shelf but veneered with a door panel identical to that of the Dodge example, formerly in a Parisian collection (Faniel 1957: 53, fig. B); a table signed by Pierre Migeon in the Marjorie Merriweather Post collection at Hillwood, Washington, D.C.; and a table signed by André-Louis Gilbert auctioned from the collection of Robert von Hirsch at Sotheby's in 1978 (London 1978: lot 608). In addition to selling marquetry panels to other *ébénistes,* Topino often supplied them with finished pieces to sell in their own showrooms, and some of the above tables may therefore be by him, despite other signatures.

to a window for light, to a corner for protection from drafts, or to a fireplace for warmth.

Although tables of this type were meant to serve a variety of functions, such as supporting a candlestick by which to read or providing a surface on which to rest a cup of tea, coffee, or chocolate, the high gallery of the Dodge example suggests that it was intended primarily for sewing and other forms of needlework with which women of leisure occupied themselves. The function of the gallery was to keep materials from falling to the floor, while the drawers could serve as

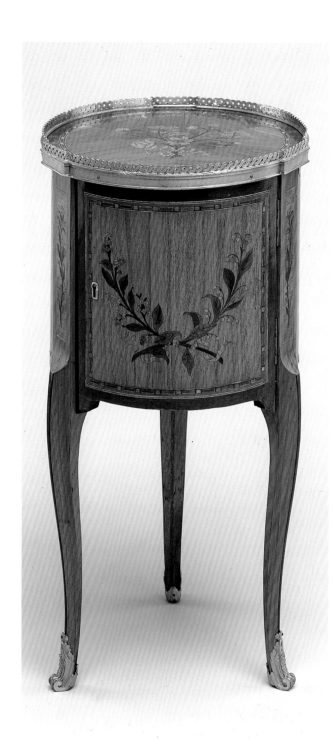

French Maker

Worktable, c. 1775

Carcass of oak, fir, and poplar with marquetry veneer and
gilt-bronze mounts, 71.1 (28) × 34.7 (13⅝)
Bequest of Mrs. Horace E. Dodge in memory of her
husband (71.206)

INSCRIPTION: Nailed to the underside of the carcass is an
oval brass plaque engraved with the Rose Terrace inventory
number: *137.*

CONDITION: Both the carcass and the veneer are sound, but
the piece has suffered a number of losses. Nail holes on the
inner surfaces of the legs 16.5 cm up from the floor reveal that
the table was originally fitted with a shelf. Other such holes
show that the piece once had different gilt-bronze feet,
different pulls on the interior drawers, mounts decorating its
now bare knees, and probably a different gallery. Both the
bottom of the carcass and the door have been attacked by
woodworm, and the damage done by this insect may explain
why the shelf was removed. The drawers have been given a
gray wash to increase their appearance of age.

PROVENANCE: Pierre Minet (dealer), Paris. Acquired by Anna
Thomson Dodge through L. Alavoine (agent), New York,
1932.

The cylindrical body of the table is raised up on three cabri-
ole legs. A door opens from one side of the carcass to reveal
an inner case fitted with three drawers. The walls of the car-
cass and probably the door are constructed of fir; the stiles,
the legs, and the top are of oak, while the bottom is poplar.
Each of the oak drawers is constructed with its bottom slot-
ted into its sides.

Veneered to the body are marquetry panels depicting
crossed sprays of bellflowers tied at the bottom with ribbon,
with the foliage executed in what appears to be green-stained
sycamore-maple and the flowers in holly. Each composition
is displayed on a tulipwood ground made up of a number of
vertical strips butted side by side so that the graining changes
direction repeatedly across the width of the panel, giving it
a very satiny appearance. Surrounding each panel is a pre-
cisely cut checkered banding, bordered along its outer edge
by amaranth.

Decorating the top is a composition consisting of a ribbon-
tied bouquet of flowers executed principally in dyed, shaded,
and engraved holly on a vibrant ground of tulipwood — the
matched quarter-sawn wood arranged in six quadrants so
that its grain runs at a variety of angles. This panel is sur-
rounded, like those of the sides, by a checkered banding bor-
dered with amaranth.

The legs and stiles are veneered with tulipwood, except for
the forward edge of each leg, which is veneered with a nar-
row strip of amaranth, and the back surface, which is bare
oak, stained dark. Adorning the stiles above are vertical pan-
els, each filled with a climbing spray of flowers executed in
stained woods on a ground of horizontally grained tulip-
wood. The drawers are veneered with panels of tulipwood
surrounded by triple fillets of holly bordered by amaranth.

The table is sparingly mounted with feet of a later date in
the form of unfurling acanthus scrolls decorated at center
with ascending piastres and around the top with a cast gilt-
bronze gallery of a twisted-ribbon design. Suspended on the
drawer-fronts are laurel-wreath handles — also replacements.

Like the drum-shaped table by Topino (cat. 6), the present piece was intended to serve as a lady's worktable. Unfortunately, nothing about its style suggests a particular maker.

What does distinguish the table from the many others of this form is the quality of its veneer — not the drawing of the floral elements, which is decidedly stiff, but the great care the *marqueteur* took in choosing, cutting, and laying the ground woods and the meticulous execution of the floral work and bandings. Whoever the *marqueteur*, he had an extraordinary feeling for wood.

One can only speculate why the table has lost its shelf and been fitted with new mounts (see Condition). The reworking was almost certainly carried out at the instigation of an early twentieth-century dealer. Perhaps the shelf, which was positioned low to the floor, had become badly worm-eaten and the mounts were of poor quality. In any event, the intention must have been to increase the table's value.

MARTIN CARLIN
c. 1730 Margravate of Baden – Paris 1785

Martin Carlin belonged to that large group of immigrant German cabinetmakers who attained great success in Paris during the second half of the eighteenth century. Carlin is first recorded in Paris in 1759 as a simple workman, probably then employed by Jean-François Oeben, whose sister, Marie-Catherine, he married in February of that year. Later in 1759 he established himself as an unregistered cabinetmaker in the rue du Faubourg Saint-Antoine, producing furniture that, because it was not allowed to bear a signature, is now unidentifiable. While at the same address in 1766, Carlin was admitted to the guild of master cabinetmakers.

As an ébéniste of great repute, Carlin worked extensively for the marchands-merciers Charles Darnault, Simon-Philippe Poirier, and Dominique Daguerre, producing some of the most exquisite furniture known, chiefly for use by women. For Darnault he created lavish pieces decorated with the finest panels of Japanese lacquer, destined for the apartments of the Mesdames de France, the aunts of Louis XVI, at the Château de Bellevue; a number of these are preserved in the Musée du Louvre, Paris. For Poirier, and later for Poirier and his partner and successor, Daguerre, he made, most notably, a number of small Sèvres-mounted works, a type of furniture with which his name has become closely associated. Also of exceptional quality, but far less well known, are his larger pieces veneered with trellis marquetry.

That Carlin produced furniture for some of the most fashionable persons of the day is evident from the following discussion of the Dodge coffer and the related examples.

[8]
Martin Carlin

Jewel Coffer, c. 1774

Carcass of oak with tulipwood, holly, and amaranth veneer, plaques of soft-paste Sèvres porcelain, and gilt-bronze mounts, 94 (37) × 55.9 (22) × 36.8 (14½)
Bequest of Mrs. Horace E. Dodge in memory of her husband (71.196)

INSCRIPTIONS: Painted on the underside of the drawer-case are: *MN:2583/UN. 6392.* in black; and *1097.* in white. Affixed to the upper surface of the removable tray in the drawer-case is a tan paper label inscribed in ink: *29614* (a Duveen Brothers inventory number) and a typed label reading: *A Jewel cabinet or marriage casket Decorated with Sèvres Porcelain Panels and Ormolu by Martin Carlin French Ebeniste. Period of Louis XV–XVI From the Grand Palace of Pavlovsk, Russia.* Each removable tray within the coffer bears a label on its back marked in ink with an indecipherable description in Russian of what it was meant to contain and a label on its front marked with numbers from one to eight. The Sèvres porcelain plaques are marked in blue on their edges as follows: *R.* on one plaque; *B.* on ten plaques; and *h.* on the oval plaque at the center of the lid. Printed paper stickers prepared at the Sèvres manufactory and inscribed in black ink with the prices of the variously shaped panels remain attached to the undersides of several of the plaques. These read as follows: on the central lappet at the front of the coffer and on the two plaques flanking the lappet: *72″* (livres); on the narrow strip at the front of the lid: *1...″*; on the two plaques of the drawer front: *30″*; on one of the side plaques of the coffer: *66′*; on the plaques at the left and right sides of the stand: *36″*; on the two plaques flanking the central oval of the lid: *54″*.

CONDITION: The piece is in an excellent state of preservation, though its interior has been altered, quite possibly in the late eighteenth century. The drawer of the stand was originally fitted with a velvet-covered writing panel and, along the right side, with compartments containing a silvered- or gilt-bronze inkwell, sand caster, and sponge box; all this has been removed, and the drawer is now fitted with a single removable tray similar to the seven superimposed trays inside the coffer.

PROVENANCE: Friederike Sophie Dorothea, Duchess of Württemberg (1736–1798). Maria Feodorovna, Empress of Russia (1759–1828), Palace of Pavlovsk, near St. Petersburg. Grand Duke Michael Pavlovich (1798–1849). Grand Duke Constantine Nikolaievich (1827–1892). Grand Duchess Alexandra Iossifovna (1830–1911). Grand Duke Constantine Constantinovich (1858–1915). Soviet government. Duveen Brothers (dealer), New York. Acquired by Anna Thomson Dodge from Duveen Brothers, 1932.

EXHIBITION: Grosse Pointe 1981: unnumbered, ill. p. 19, fig. 003.

REFERENCES: Paris 1781: lot 259; Benois and Prakhof 1901–07, III: 373; Roche 1913: pl. XXXIII; Schmitz 1926: pl. 235; Detroit 1933: n.p.; Detroit 1939, I: n.p.; Verlet 1956: fig. 119; Wildenstein 1962: 375; Dauterman, Parker, and Standen 1964: 126–34, nos. 20, 21; Watson 1964: 3–5, pl. II; Watson, Dauterman, and Fahy 1966–73, I: 140–45; Verlet 1967: 276, no. 146; Winokur 1971: 45, 44, fig. 2; *Gazette des Beaux-Arts* 1972: 92, fig. 320; New York 1977: lot 123; Verlet 1982: fig. 119; Pradère 1989: 357, figs. 422–23, 360, 419, fig. 516; Myers 1991: 195–96, no. 116; Paris 1991: lot 153; Verlet 1991: fig. 119: New York 1993a: lot 241.

ADDITIONAL BIBLIOGRAPHY: Benois and Prakhof 1901–07, VII, pl. 108; Salverte 1962: 48–52; Pradère 1989: 342–61; Flit et al. 1993: 11–175.

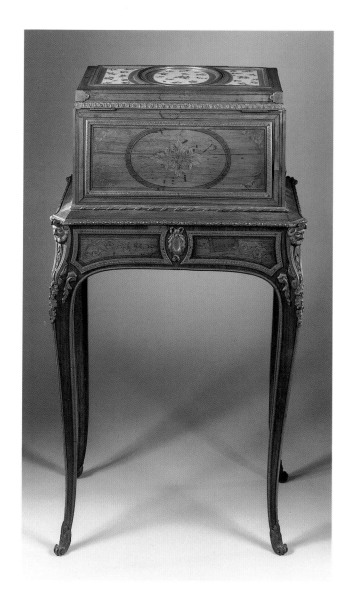

The piece is conceived as two visually distinct but structurally integrated elements: a rectangular coffer with a hinged lid that gives access to seven superimposed storage trays and a tablelike stand that houses a single drawer and rests on four cabriole legs.

The principal decoration consists of thirteen plaques of soft-paste Sèvres porcelain, especially shaped to fit the carcass and varying in thickness from 1.6 cm (central lappet on the front of the coffer) to a minimum of .7 cm. The plaques are painted over their white grounds with scattered sprigs of single and double pink roses and rosebuds, perhaps executed by Jean-Baptiste Tandart (active 1754–1803), a painter of flowers and trophies. Surrounding the roses are turquoise blue bands overpainted with plain gold inner borders and stylized gold bead-and-reel ornament.

The remainder of the carcass is surfaced principally with tulipwood veneer, with stringings of natural and dark-stained holly that emphasize the rectangular lines of the coffer and the sloping sides of the stand. On the back of the coffer is a slightly recessed panel veneered with tulipwood, interrupted at the center by a large quatrefoil of holly, engraved with fine blue lines, and at the corners by curling tendrils; bands of amaranth flanked by holly fillets form an oval medallion around the quatrefoil and frame the edges of the panel. The back of the stand is constructed with two recesses corresponding in shape to those that house the Sèvres plaques on the drawer, but veneered here with marquetry of long, curling tendrils executed in the same woods as those of the coffer.

The mounts are on the whole exceptionally well modeled, chased, and gilded. The fringed border framing the lappet-shaped plaque on the front of the coffer has such extraordinary definition that the wax model from which it was cast must have been made from real fringe. Holding the other plaques in place are frames decorated with a fine-scaled repeating leaf pattern.

Mounted at the corners of the stand are satyr heads set within attenuated C-scrolls; from beneath the satyrs' chins, husks of laurel leaves descend over a horizontally ribbed ground, and from the bottoms of the scrolls hang clusters of oak leaves. Flanking the clusters at the tops of the cabriole legs are foliated sprays, and running along the bottom of the drawer-case and the insides of the legs are cord moldings. Mounted below the lappet-shaped plaque and forming the keyhole escutcheon of the coffer is a pierced shield flanked by laurel branches; the escutcheon of the drawer is formed by an oval shield suspended from a ribbon bowknot and draped along its sides with leafy clusters. Foliated moldings run along the rim of the lid and the top of the stand, and a ribbon-bound molding decorates the base of the coffer. At the outer angles of the legs are ribbed moldings, and the feet are in the form of foliate scrolls.

Furniture mounted with Sèvres porcelain plaques came into fashion about 1760. The brilliance and clarity of the material imparted a precious quality that no other material could match, and works so mounted took on the aspect more

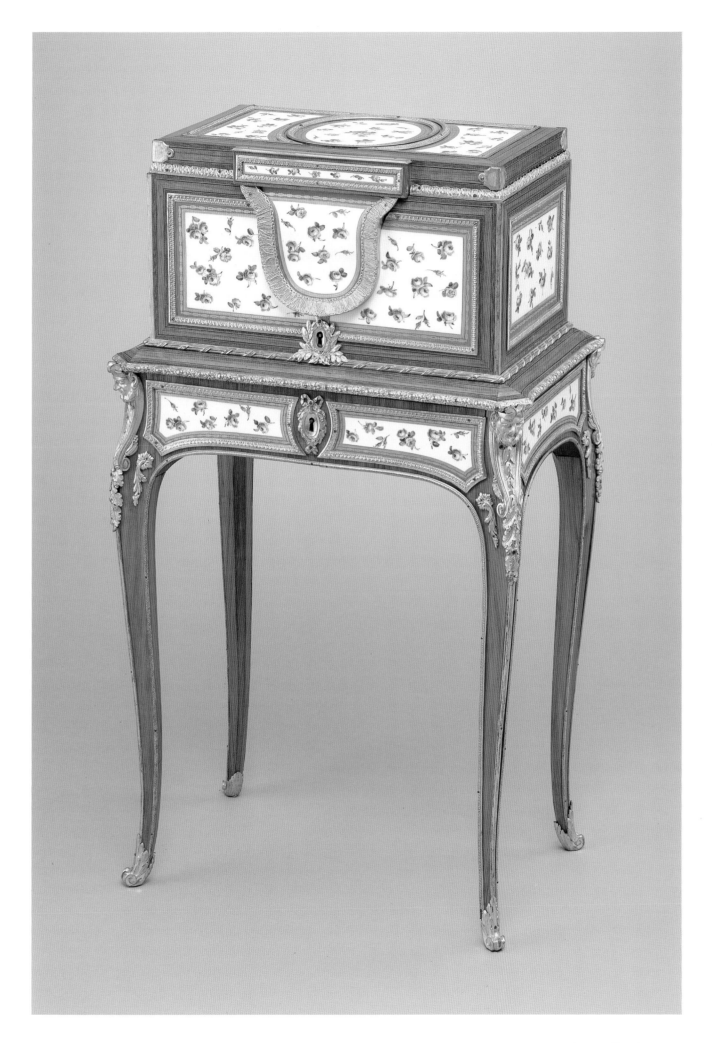

of an *objet d'art* than of functional furniture. Most early Sèvres-mounted pieces were small worktables that could also be used for taking tea, coffee, or light meals, but other forms were soon made, including *bonheurs-du-jour,* jewel coffers, secretaires-on-stands, gaming tables, *bureaux plats,* plant stands, and even commodes. In terms of the total production of the period, Sèvres-mounted pieces are quite rare. The majority that have survived are now in major museums.

There are seven extant jewel coffers by Martin Carlin identical to the Dodge example in almost every respect except for the decoration of the porcelain plaques: what is most likely the prototype for the whole series, a signed coffer bearing date letters on its plaques for 1770 and the crowned *GR/W* inventory brand of Marie-Antoinette at Versailles, auctioned at a record price from the Roberto Polo collection, Paris, in 1991 (Paris 1991: lot 153); two coffers formerly in the Hillingdon collection and now part of the Kress Collection at The Metropolitan Museum of Art, New York (Dauterman, Parker, and Standen 1964: 126–34, nos. 20, 21), seven of the plaques of one bearing the date letter for 1770 and therefore thought by James Parker to be the coffer acquired by Madame du Barry from the dealer Poirier in December of that year; a coffer from the collection of the Duke of Buccleuch, now in the Wrightsman Collection at The Metropolitan Museum of Art, New York (Watson, Dauterman, and Fahy 1966–73, I: 140–45); two coffers formerly in the collection of Alfred de Rothschild, London, later owned by Madame Léon Barzin, Paris (Watson 1964: 3–5, pl. II; Pradère 1989: 357, figs. 422–23; one of these has been identified by Catherine Faraggi as having been originally owned by the duchesse de Mazarin [Faraggi 1995: 94]); and one recorded in a Paris private collection in 1905. An eighth such coffer—formerly in the collection of Baron Alphonse Mayer de Rothschild, Vienna—is identical to those described here, but supported on straight legs joined by shelves and bearing the mark of Gaspard Schneider; it was auctioned in New York in 1977 and again in 1993 (New York 1977: lot 123; Pradère 1989: 419, fig. 516; New York 1993a: lot 241). Three of its plaques bear the date letters for 1778.

The Wrightsman coffer, the two Barzin coffers, and the former Alphonse de Rothschild example are decorated, like the Dodge coffer, with blue-bordered plaques, while the two Kress pieces and that formerly in the Polo collection have green borders. Of all the known surviving examples, only the Dodge coffer has plaques painted over their central white grounds with scattered small roses. The plaques on the other pieces are decorated inside their colored borders with large sprays of fruit and flowers, trophies, and hanging baskets of flowers. The decoration of the coffer recorded in 1905 is unknown.

In cataloguing the Kress pieces, James Parker (Dauterman, Parker, and Standen 1964: 129–30) draws attention to five of the present type that are known from eighteenth-century records. One appears in the 1781 auction catalogue of the famous collector, the duchesse de Mazarin (Paris 1781: lot 259); a second belonged to Madame du Barry at Fontainebleau and is described in a bill to her from Poirier dated December 13, 1770 (Wildenstein 1962: 375); a third belonged to Louise-Bathilde d'Orléans, duchesse de Bourbon—wife of the prince de Condé—and is described in the 1779 inventory of her residence, the Palais de Bourbon, where it stood in her music room (Verlet 1967: 276, no. 146); a fourth is recorded in 1792 in the apartment of the comtesse de Provence at the Palais du Luxembourg (at the time of the publication of the Kress catalogue, James Parker thought that this was the coffer in a Paris private collection [Baronne Edouard du Rothschild] which later was to enter the Polo collection—a view which he no longer holds). A fifth coffer is known through a contemporary pen-and-wash drawing now in The Metropolitan Museum of Art (Dauterman, Parker, and Standen 1964: 128, fig. 99; Myers 1991: 195–96, no. 116). The piece depicted in the Metropolitan drawing, unlike the surviving examples, was fitted with a shelf between its legs. It is believed that the drawing and a number of others in the same series, also at the Metropolitan, were made for Duke Albert of Sachsen-Teschen, son-in-law of Empress Maria Theresa, and his consort Maria Christina, who served as joint governors of the Low Countries from 1780 to 1792; the drawings are thought to represent furniture in, or ordered for, the couple's palace at Laeken near Brussels. Though the stand differs, the porcelain plaques depicted in the drawing look remarkably like those of the Alphonse de Rothschild coffer mentioned above.

It is possible to assign an approximate date to the Dodge coffer by comparing the prices marked on the paper labels attached to the backs of its porcelain plaques (see Inscriptions) with the yearly delivery records preserved in the archives at Sèvres. Svend Ericksen has kindly allowed the author to consult the list he compiled from Sèvres records of the plaques produced each year and their prices. In that list, it is only during the year 1774 that there appears a combination of plaques costing 72 livres, 66 livres, 54 livres, and 30 livres (see also Pradère 1989: 360). This evidence, and the fact that one of the plaques of the nearly identical coffer in the Wrightsman Collection bears the date letter *V* for 1774, make a date of 1774 or 1775 for the Dodge coffer highly probable.

The Dodge coffer was once in the collection of Maria Feodorovna, wife of Czar Paul I of Russia, and formed part of the furnishings of her apartments at the Palace of Pavlovsk, the couple's summer home outside St. Petersburg (see Provenance), built about 1782 on land given them by Paul's mother, Catherine the Great. Known traditionally as the "Mütterchen" ("Mother dear") cabinet, it had belonged previously to Maria Feodorovna's mother, Friederike Sophie Dorothea, Duchess of Württemberg (1736–1798), who gave it to her daughter sometime before 1795.

Maria Feodorovna owned a number of pieces of Sèvres-mounted furniture, which she and her husband presumably bought at Daguerre's shop on the rue Saint-Honoré during their visit to Paris, as the comte and comtesse du Nord, in 1782. (They did not, as is often published, visit the shop of Daguerre with the baronne d'Oberkirch on May 23, 1784. In her memoirs, the baronne states that she visited Daguerre on May 25 of that year [Burkard 1970: 305–06]. Maria Feodorovna and her husband made only one trip to Paris and that was in 1782). Daguerre held a monopoly on the purchase of furniture plaques from the Sèvres manufactory, and he gave the plaques he acquired to such cabinetmakers in his employ as Carlin, Weisweiler, and Saunier. The monopoly thus also earned him the sole privilege of selling Sèvres-mounted furniture.

Other extant pieces of Sèvres-mounted furniture that once formed part of Maria Feodorovna's collection at Pavlovsk include: a signed Carlin *bureau plat,* bearing the label of Daguerre, sold posthumously from Mrs. Dodge's collection in 1971 (London 1971: lot 135) and now in The J. Paul Getty Museum, Malibu (Wilson, Sassoon, and Bremer-David 1984: 201–07, figs. 24a–d); an unsigned secretaire-on-stand in the Wrightsman Collection of The Metropolitan Museum of Art (Watson, Dauterman, and Fahy 1966–73, I: 186–90); a signed Weisweiler secretaire-on-stand (Roche 1913, II: pl. LVII; Alexeieva et al. 1993: 97), auctioned from the collections of Mr. and Mrs. Deane Johnson, Bel Air, California (New York 1972: lot 101) and the British Rail Pension Fund, London (London 1988: lot 33; Lemonnier 1983: 133, 137, 138, no. 57); and a signed Carlin *guéridon* auctioned in Geneva in 1973 (Geneva 1973: lot 61; Pradère 1989: 359, fig. 429). Like the Dodge coffer, the first three of these pieces are known to have been purchased by Duveen from the Soviet government in 1931 (for Duveen's trip to Russia, see Fowles 1976: 191–99). Also surviving from Pavlovsk is a gilt and patinated bronze *guéridon* dating c. 1790–95, its top formed by an octagonal Sèvres porcelain plaque painted with a *trompe l'oeil* composition of a bacchic relief medallion surrounded by a grapevine wreath (Benois and Prakhof 1901–07, VI: 89). That piece was seen on the Paris art market in 1989.

The Dodge coffer and the first three pieces cited in the preceding paragraph are mentioned by Maria Feodorovna in a description she wrote in 1795 of the furnishings in her apartments at Pavlovsk. The account was included as part of a letter to her mother, with whom she kept in constant contact, but whom she did not see after 1782. In this description, she lists the Dodge coffer—"la petite chiffonière de Mütterchen avec son charmant dessin"—as being in her bedroom to the right of her bed; the Getty Carlin *bureau plat* as in the same room to the left of her bed; and the two secretaires as in her boudoir next door. The two Sèvres-top *guéridons* may possibly be the "deux petites tables remplies de porcelaine" she mentions as being in her dressing room,

which was on the opposite side of her bedroom (Benois and Prakhof 1901–07, III: 373–74; Chenevière 1988: 296–97). All these pieces bear inventory numbers in the same series as those found on the Dodge coffer. (These numbers include: on the Getty Carlin *bureau plat, M.N: 2586 / Un. 6397 / 1098;* on the Wrightsman Carlin secretaire, *M.N. 2603 / Un. 6501 / 1017;* on the Carlin *guéridon, M.N. 2569 / 1946;* on the gilt-bronze *guéridon, M.N. 2563 / Un. 6366).*

A photograph of Maria Feodorovna's bedroom made in the first years of the twentieth century and reproduced in a 1952 guide of Pavlovsk shows the Dodge coffer still positioned where it was in 1795, along with the other decorative elements she had described. When the autocratic Paul I was assassinated in 1801 after a reign of only four years, he was succeeded by their son Alexander I (1777–1825). Maria Feodorovna spent the last twenty-seven years of her life as the Dowager Empress. Over the course of her sixty-nine years, she had a fifty-year love affair with Pavlovsk, during which improvements were constantly being made to the palace. Although a fire to the structure in 1803 had necessitated the redecoration of her bedroom—all the movable works had been rescued—she insisted that the furniture in this room be put back exactly where it had been. And she requested before her death in 1828 that nothing ever be changed. For this reason, she bequeathed the palace to her youngest son, the Grand Duke Michael Pavlovich, believing that in his hands it would never have to function as a monarchial residence and thus undergo further alterations.

At Grand Duke Michael's death in 1849, the palace passed to the second son of his brother Nicholas I—who had become emperor in 1825—the Grand Duke Constantine Nikolaievich. Neither of these two owners ever lived in the palace, preferring smaller residences on the estate (Massie 1990: 110–11). Grand Duke Constantine in turn left it to his wife, the Grand Duchess Alexandra, who on her death in 1911 left it to their son, the Grand Duke Constantine Constantinovich. In this way the Dodge coffer stayed in its original position from the end of the eighteenth century, through the Russian Revolution, until 1931, when the Soviet government made what was for Pavlovsk the unfortunate decision to sell works from the palace for hard currency.

But the life of the palace went on. After it had been virtually destroyed by Nazi forces in January 1944, a massive effort was undertaken to rebuild it in every detail. A ceremony marking the completion of the restoration was held in 1977, coinciding with the two-hundredth anniversary of the original deed of land made by Catherine the Great to Grand Duke Paul and his young wife. Maria Feodorovna's bedroom is again furnished just as she described it in 1795 (see Kuchumov 1975: 106–23, figs. 75–91), except for the present coffer and the Sèvres-mounted *bureau plat* now in the Getty, both of which were bought by Mrs. Dodge from Duveen. The jewel coffer now constitutes one of the most important

pieces of French furniture in The Detroit Institute of Arts. Two replicas of the Dodge coffer are known, both made in Russia in the mid-nineteenth century and bearing the labels of the dealer J. Nicolay on Kolokolmaia Street in St. Petersburg: one was offered at auction in Detroit in 1972 (Detroit 1972a: lot 215; advertisement in *Connoisseur* [1972: 84]), and the other was auctioned at Sotheby's in 1992 (New York 1992b: lot 87), its label bearing the date 1853.

GODEFROY DESTER
Active Paris c. 1774–90

Little is known of Dester's life. He was admitted to the guild of menuisiers-ébénistes *in 1774 and worked in the rue du Faubourg Saint-Antoine at least until 1790. Although he produced furniture of many forms, he seems to have specialized in small tables veneered with panels of trellis marquetry.*

[9]
Attributed to Godefroy Dester

Combination Writing Table and Worktable, c. 1770

Carcass of fir and oak with marquetry veneer and gilt-bronze mounts, 72.4 (28½) × 55.7 (22) × 36.1 (14½)
Bequest of Mrs. Horace E. Dodge in memory of her husband (71.210)

INSCRIPTION: Stamped under both the left and right sides of the drawer-case is the signature: P. GARNIER.

CONDITION: The table is in fair condition. The boards forming the top have dried and shrunk with age, pulling apart along a line that runs from side to side near the back and causing the marquetry veneer to fracture along the same line. In addition, the forward-most board of the top has warped upward, causing a split in the marquetry along its juncture with the right clamping board and the resultant loss of several pieces of veneer. The boards forming the hinged writing flap of the drawer have also shrunk and separated, and the forward-most of these has become partially unglued from the left clamping board; the flap is slightly warped at the front. The present covering of the writing surface, pale blue silk bordered by a silver paper galloon, is modern. The marquetry panels on the table's four sides and legs have survived in good condition. The most noteworthy damage is on the front of the table, where the vertical strips of dark veneer at the left and right edges of the drawer are partially detached, and a small triangular section of veneer at the extreme left on

the bottom rail is lost. The appearance of the marquetry has changed considerably. An old restoration has almost totally abraded the engraved detail of the florets on the trellis marquetry panels. The original green stain applied to the trelliswork on the sides, to the diagonally striped frame around the top, and to the interstices formed by the interlinked quatrefoils on the top has largely faded and is now almost undetectable, except for a vivid blue-green on the ellipsoidal interstices on the top. The mounts retain only vestiges of their original gilding.

PROVENANCE: Viscount Powerscourt, County Wicklow. Duveen Brothers (dealer), New York. Acquired by Anna Thomson Dodge from Duveen Brothers, 1932.

REFERENCES: Lunsingh Scheurleer 1952: 341, no. 499; Nicolay 1956–59, I: 149, fig. B.

ADDITIONAL BIBLIOGRAPHY: Nicolay 1956–59, I: 148–49; Salverte 1962: 96, 130–31; Pradère 1989: 246–51.

The table consists of a simple rectangular drawer-case supported by four tapering rectangular legs. Housed within the case and opening from the front is a single drawer fitted at left with a hinged, silk-covered writing flap and at right with a removable box that extends almost the full depth of the drawer; the box contains a silvered metal inkwell, sponge holder, and pen tray over a secret drawer that opens from the back and is visible only when the box is taken from its compartment. The top of the table is of fir, the remainder of the carcass and the drawer are of oak.

The top and all four sides of the drawer-case are veneered with panels of trellis marquetry. The top panel displays, on a sycamore ground, an elaborate pattern of interlaced quatrefoils in amaranth strapwork bordered by pairs of light and dark holly fillets. In the center of each quatrefoil is a four-petaled floret executed in holly and engraved with fine lines filled with white paint to give added definition. Smaller florets of identical design appear in the spaces formed by the intersection of each of four contiguous quatrefoils. The panel is elaborately framed by a checkered banding with a larger band of diagonally striped marquetry, surrounded by an outer frame of partridgewood.

The four sides of the table, including the drawer-front, are veneered with panels of simple trelliswork on a sycamore ground, composed of straight bands of stained holly bordered by pairs of light and dark fillets. In the trellis interstices are florets identical in design to those on the top. All four panels are framed by checkered bandings outlined with fillets of holly within reserves of tulipwood.

The tapering panels on the legs are decorated at each side with three pendant bellflowers. Above these panels, at the level where the legs meet the drawer-case, are three horizontal fillets, one dark between two light, over a row of mar-

quetry guttae. The plain mounts consist of a flat band around the top, surmounted on the back and sides by a simple gallery, a flush keyhole surround, and tapering, slightly incurvate, square feet.

Although the table is struck with the mark of the *ébéniste* Pierre Garnier (active 1742–c. 1798), it is all but certain that he signed it in the capacity of dealer or restorer rather than as its maker. Not only does the table relate to no known Garnier works, but it closely resembles a number of pieces that bear the stamp of Godefroy Dester, to whom it can be safely assigned. A firm basis for this attribution is supplied by two almost identical tables bearing Dester's signature, one in the Rijksmuseum, Amsterdam (Lunsingh Scheurleer 1952: 341, no. 499, not ill.), the other illustrated by Nicolay (1956–59, I: 149, fig. B).

In addition, the table resembles a number of smaller ones by Dester that are of different shape but are veneered with similar trellis-and-floret marquetry and incorporate related design characteristics. These include a signed three-drawer *table en chiffonnière* from the collection of the vicomtesse Louis d'Andigné, sold in Paris in 1929 (Paris 1929: lot 96); an identical table from the collection of Mrs. Alexander Hamilton Rice, sold in 1965 (Paris 1965: lot 92); and a signed example formerly in the collection of the Earl of Rosebery at Mentmore, Buckinghamshire. Furthermore, the quatrefoil trellis marquetry on the top of the Dodge table resembles that around the sides of a Transitional commode signed by Dester and sold from the collection of Mrs. Benjamin Stern in New York in 1934 (New York 1934: lot 888).

Unsigned tables attributable to Dester that have both carcass shapes and marquetry side panels identical to those of the Dodge table include an example from the collection of Madame de Polès (Paris 1927: lot 291); one sold from the collection of Victor Rothschild in 1937 (London 1937: lot 292); one sold from the Wimpfheimer collection in 1957 (New York 1957: lot 278); and one sold from the collection of Robert Goelet in 1966 (New York 1966a: lot 424). Another table identical in many respects to the Dodge piece and almost certainly by Dester, though it bears the stamp of Charles Topino (see p. 52), was formerly in the collection of Mary Strong Shattuck and was sold in New York in 1935 (New York 1935: lot 558).

Still other tables of this form, with tapering legs similarly decorated with bellflower pendants, were produced by the *ébéniste* Mathieu-Guillaume Cramer (active 1771–90). The legs of Cramer's tables often differ from those of Dester's in the chamfering of their corners. A table of this type signed by Cramer, sold from the collection of the comte de G. in Paris in 1934 (Paris 1934a: lot 135), is illustrated by Nicolay (1956–59, I: 111, fig. B), and a related *bonheur-du-jour* was formerly in the collection of Daniel Wildenstein, New York (Pradère 1989: 326, fig. 373). In addition, Cramer often veneered his furniture with trellis marquetry panels close in style to those

on both the top and sides of the Dodge table. The proximity in design of certain works by Dester and Cramer suggests that they may have produced furniture for the same dealer.

[10]

Russian Maker (St. Petersburg)

Worktable, c. 1780

Carcass of oak, fir, and poplar with marquetry veneer, lacquered bronze mounts, and *brèche d'Alep* marble top, 66.4 (26⅛) × 38.1 (15) × 23.5 (9¼)
Bequest of Mrs. Horace E. Dodge in memory of her husband (71.207)

INSCRIPTION: Nailed to the underside of the carcass is an oval brass plaque engraved with the Rose Terrace inventory number: *139.*

CONDITION: The table is in fair condition. There are no losses, but the wood is discolored, making the details of the marquetry somewhat difficult to see.

PROVENANCE: Maison Dreifuss (dealer), Paris. Acquired by Anna Thomson Dodge through L. Alavoine (agent), New York, 1932.

REFERENCES: Berlin 1929: lot 177; Jackson-Stops and Rieder 1976: 97, 125, fig. 87; Chenevière 1988: 33–35, fig. 18, 39, fig. 22; Phomin 1989: 80–87, 91, 94, 177, figs. 100–04.

Of exceptionally small size, the body of the carcass is supported by four square tapering legs and houses two shallow drawers extending from one long side and a 5.1-cm-deep cupboard with a fall-down front opening from the other. The legs, the bottom, and the upper front and back rails of the drawer-case are constructed of oak. The two ends and the board forming the wall between the cupboard and the drawer compartment are poplar. The top of the carcass and the drawers are constructed of fir, the drawers being of rather simple construction with their bottoms nailed to the undersurfaces of the sides.

The principal decoration consists of five small-scale marquetry panels, executed in holly and various fine-grained fruitwoods on a boxwood ground, depicting townscapes on the banks of a lake or river. Conspicuous in the scapes are exceptionally tall church spires and buildings with stepped-gable facades. The bodies of water are engraved with clusters of horizontal lines. Each panel is surrounded by tulipwood.

The legs and stiles are veneered with boxwood panels within tulipwood borders, with engraved paterae filling the panels of the stiles. Decorating the legs are lacquered bronze collars and foot mounts cast with repeating leaves, while surrounding the extremely small keyholes are symmetrical escutcheons formed by stylized foliage.

When Anna Thomson Dodge acquired the present table on a trip to Paris in 1932, it was thought to be French of the Louis XVI period; with this identification she lived happily for nearly forty years, with the table as part of the furnishings of her French salon at Rose Terrace. However, examination of the piece reveals that although it is Louis XVI in form, and indeed veneered with a type of naive pictorial marquetry popular in Paris during the 1770s and 1780s, it is almost certainly not French.

Its uncharacteristic features are numerous. The small body and exceptionally thin legs make it seem almost a parody of Parisian ladies' worktables of the period. The table also incorporates a number of anomalies in its construction. Its carcass includes fir, which was used relatively rarely in Parisian furniture during the latter half of the eighteenth century, and poplar, which was almost never used; Parisian carcasses during this period were almost always constructed completely of oak. Its drawers are constructed of fir at a time when oak was the overwhelming wood of choice, with walnut and very occasionally mahogany used for small drawers in finer pieces. And its drawer bottoms are nailed to the undersurfaces of the sides, when the standard technique from about 1750 was to slot them into grooves cut into the sides. In addition, the keyholes are far smaller than was customary for even very small works.

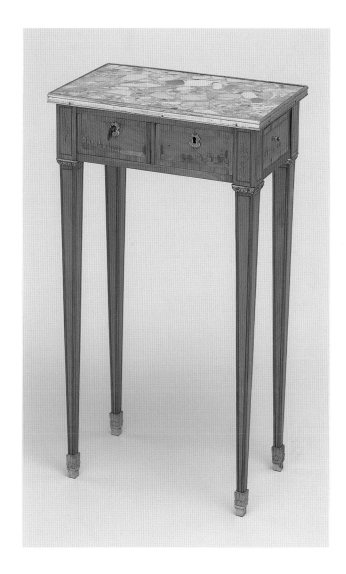

Examination of the buildings depicted in the panels reveals that they are neither French nor Italian, as typically appear in Parisian townscape panels of this type. Many of the buildings have the type of stepped-gable facade found in a number of Northern European cities, and there are also church towers with uncommonly tall spires, one such tower topped by an onion dome.

The study of European furniture is far from complete, so that many smaller cabinetmaking centers have never been properly examined. Two recently published works on Russian furniture, however, illustrate two pieces veneered with extremely similar panels that incorporate buildings virtually identical in style and which make use of the same engraved cluster of lines to represent water. Both works are identified as having been made in St. Petersburg: a dressing table dated 1779 in the Kalinin Museum, Kalinin (Phomin 1989: 70–73, 176, figs. 60–66); and a roll-top desk of c. 1780 in the Kuskovo Estate Museum, Moscow (Phomin 1989: 91, 94, 177, figs. 100–04; Chenevière 1988: 39, fig. 22). Phomin suggests that the table and desk were made by the serf cabinetmaker Nikifor Vasilyev, who signed a large table veneered on top with an elaborate marquetry tableau depicting Count Peter Sheremetev's palace and gardens at Kuskovo and now in the Kuskovo Estate Museum (Phomin 1989: 80–87, 176, figs. 80–88; Chenevière 1988: 33–35, fig. 18). But this latter table seems to share only a general style with the dressing table and roll-top desk.

Also almost certainly by the same hand as the Dodge table is another roll-top desk, nearly identical in all features, including the design and execution of its townscape panels; it was auctioned by the Soviet government at Lepke's in 1929 (Berlin 1929: lot 177). At the time of auction, this piece was described as having been made for Czar Paul I (1754–1801). Now at Anglesey Abbey, Cambridgeshire (Jackson-Stops and Rieder 1976: 97, 125, fig. 87), its traditional history has been expanded to include the name of David Roentgen as cabinetmaker, but this piece bears no relationship to that maker's style other than its use of fine-scale pictorial marquetry.

What can be said about the Dodge table then is that it is almost certainly of St. Petersburg manufacture, by a cabinetmaker whose style has been identified but whose name remains unknown. Moreover, in the hierarchy of that maker's known works, the Dodge table ranks at bottom.

DAVID ROENTGEN
1743 Herrenhaag–Wiesbaden 1807

David Roentgen was born on August 11, 1743, in the Rhineland town of Herrenhaag. He received his early training from his father, the cabinetmaker Abraham Roentgen, who had established a furniture workshop in Neuwied on the Rhine, near Koblenz, around 1750. In its early years, the Roentgen workshop supplied a local clientele, selling primarily at the Frankfurt fairs. In 1769, however, David Roentgen organized in Hamburg a highly successful lottery of furniture that both solved the workshop's financial difficulties and spread its reputation throughout Germany. By the time he succeeded his father as director in 1772, the Roentgen workshop enjoyed a widespread reputation, with clients in Saxony, Prussia, Bavaria, and other German states. The Neuwied workshop continued to expand during the 1770s and 1780s, employing more than one hundred workmen and associates in the years before the French Revolution.

Roentgen visited Paris first in 1774 and again in 1779, when he exhibited a selection of furniture at the Salon des Artistes et Savants. Among his Parisian clients were the comte and comtesse d'Artois, Marie-Antoinette, and Louis XVI, who acquired in 1779 a large, elaborate mahogany and marquetry secrétaire à tombeau *for 96,000 livres, the highest price paid for a piece of furniture in the eighteenth century. In 1780 he was appointed* ébéniste-mécanicien du roi et de la reine. *Envious of his tremendous success, the Parisian cabinetmakers' guild forced him to obtain his mastership in 1780. By January 1781 he had set up a shop in Paris specializing in mahogany furniture and also providing marquetry panels to other cabinetmakers to incorporate into their own pieces.*

In the 1780s Roentgen also traveled to Brussels, Berlin, Vienna, St. Petersburg, and other European centers and established workshop assistants as his agents in a number of cities. Between 1783 and 1789, he visited the Russian imperial court at St. Petersburg five times and in 1786 alone delivered more than fifty pieces of furniture to Catherine II's palaces at the Hermitage and Pella.

Efficiently organized on the factory model, the Neuwied workshop comprised specialized groups of craftsmen responsible for specific components—the carcass, marquetry, locks, gilt-bronze mounts, and even the clockworks. The output of the workshop was vast and of exceptional quality, though Roentgen's international reputation was largely due to his intricate, often ingenious, mechanisms and the marquetry decorations.

The French Revolution seriously curtailed Roentgen's activities. In 1790 his agent in Paris closed the shop and the stock was confiscated. In 1795 Roentgen fled the French armies approaching Neuwied and moved his equipment east. The Napoleonic wars further eroded his clientele, hampered commerce, and ultimately forced him to sell his stock in 1805. Roentgen died in Wiesbaden on February 12, 1807.

[11]
Workshop or Former Employee of David Roentgen

Mechanical Writing Table, c. 1775–80

Carcass of oak, birch, cherry, and mahogany with marquetry veneer and lacquered and gilt-bronze mounts, 73.7 (29) × 74 (29⅛) × 51.5 (20¼)
Bequest of Mrs. Horace E. Dodge in memory of her husband (F71.65)

INSCRIPTIONS: Pasted to the bottom of the central drawer are two paper labels of Duveen Brothers origin, one inked with the inventory number *29193* and the other typed with the description AN OLD FRENCH 18TH CENTURY OVAL OCCASIONAL TABLE, INLAID MARQUETERIE OF , THE TOP INLAID WITH LANDSCAPE & FIGURES, & RUINS. LOUIS XVI PERIOD (1774–1789).

CONDITION: The table has suffered a number of losses, most notably the gilt-bronze pendants of husks tied with ribbon which originally hung down the three outer surfaces of the legs. The nail holes for these have all been expertly filled with small wooden plugs. Also missing on the legs are a number of fragments of tulipwood crossbanding. The automatic spring mechanism that operated the drawers no longer functions, so that the central drawer must now be opened by hand. Similarly, the unlocking mechanisms for the pivoting side drawers must now be tripped manually by removing the central drawer in order to activate the steel levers positioned beneath it. The unattached spring for one of these survives. Pale green staining can still be detected in the holly veneer of the stiles, just below the top where the table has received less light, indicating that the stiles and possibly the panels of the legs were originally stained blue-green. Pale green can also still be detected in some of the components of the military trophies decorating the sides of the table, and in even fainter hues in some of the elements of the top. Originally, the marquetry compositions would have been stained in a variety of colors; as usual, only the greens and the blue-greens are still evident.

PROVENANCE: J. Pierpont Morgan (1837–1913), New York. Duveen Brothers (dealer), New York, 1915. Acquired by Anna Thomson Dodge from Duveen Brothers, 1935.

EXHIBITION: Detroit 1956: no. 59.

REFERENCES: Feulner 1927: 558–59, figs. 462–63; Huth 1928: fig. 56; Detroit 1939, I: n.p.; Lunsingh Scheurleer 1952: 366–67, no. 538, figs. 85a–b; Kreisel and Himmelheber 1973: 9, fig. 9; Greber 1980, I: 232, II: 62, fig. 91, 310–11, figs. 613–15; Fabian 1982: 60, 62–63, figs. 91–92; Ramond 1989: 42; Zurich 1992: lot 545.

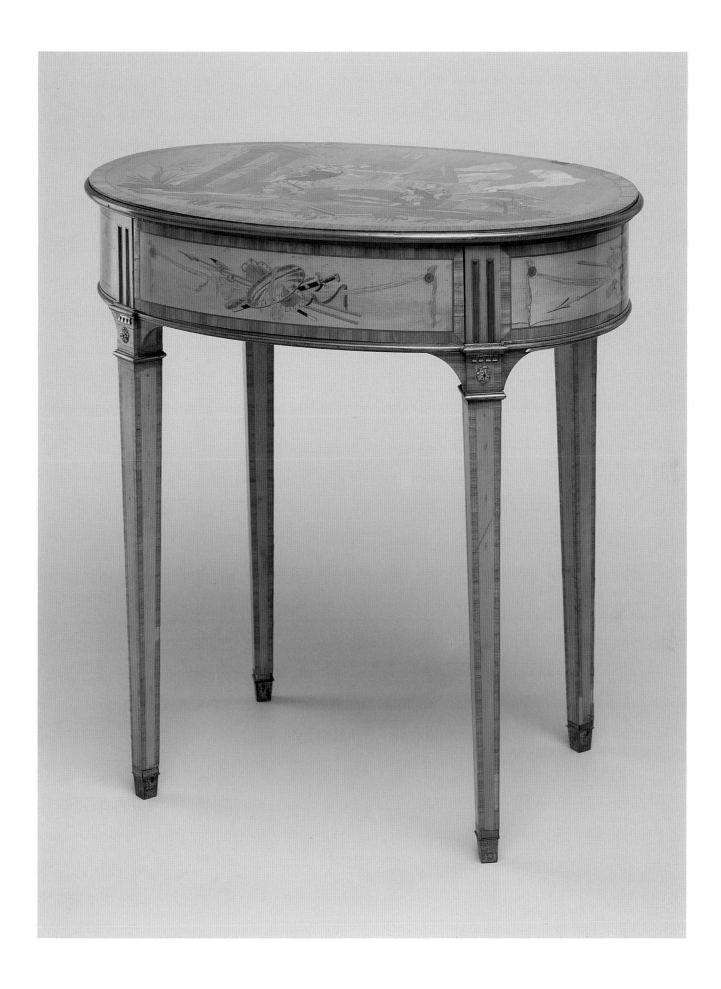

ADDITIONAL BIBLIOGRAPHY: Vial, Marcel, and Girodie 1922: 126–28; Huth 1955: inclusive; Salverte 1962: 266–89; Frégnac and Meuvret 1965: 292–99; Pradère 1989: 412–18.

Oval in plan, the drawer-case is supported by four square tapering legs and houses three spring-activated drawers. That at center is released by a button-latch mounted under the bottom at front, which when pressed causes the drawer to be propelled forward by means of an elliptical spring screwed to the back of the carcass. The forward movement of this drawer in turn trips the latches of the spring-driven drawers at either side, causing them to swing out.

The central drawer is fitted at top with a blue leather-covered writing slide which, when slid to the rear, reveals a storage well, housing at back four small drawers veneered on their fronts with cherry. Each of the pivoting compartments in turn is fitted with a pair of drawers below an open well.

The drawer-case and the legs are constructed of oak, with the curved fronts of the drawers and the back of the drawer-case pieced together from long blocks of wood glued in a brickwork pattern. The central drawer proper is constructed of birch, its bottom slotted into its sides; the bottom edges of the sides and the drawer bottom are flush. The six interior drawers are constructed of birch, with their bottoms rabbeted into their sides. The boards forming the top are of mahogany veneered on their undersides with hard maple—probably to give the top stability.

Veneered to the upper surface of the top is an elaborate marquetry tableau, executed in a variety of stained and natural woods, depicting the flight of Aeneas and Anchises from the burning city of Troy. Each of the four sides is veneered with a Roman military trophy bound to a drapery swag suspended from a marquetry stud on either side and executed in stained and natural woods on a ground of holly. The trophies at front and back comprise identical compositions of crossed shields and weapons and those at the sides crossed helmets, breastplates, and weapons. Each of these marquetry panels, as well as the plain panels of the legs, is crossbanded with tulipwood.

Decorating the four stiles dividing the drawer-case are modified triglyphs taken from the Doric order, each formed by two lacquered bronze channels on a ground of green-stained holly, the whole surmounting bronze guttae. Mounted on the transition blocks below are gilt-bronze rosettes. Convex moldings of lacquered bronze simulating mercury-gilding surround the rim of the top, the lower edge of the drawer-case, and the tops of the legs. The bottoms of the legs are mounted with lacquered bronze feet.

David Roentgen was the finest *marqueteur* of his era—some argue the finest who ever lived. He delighted in making panels that invited close inspection, whether simple floral compositions or elaborate tableaux. His goal was to amaze. Whereas other German and French *marqueteurs* made exten-

sive use of engraving and acid or sand-scorched shading to give definition to their components, Roentgen often cut his pieces to minute size so that every gradation of tone and shadow was represented by a different piece of wood. The smallness of detail is extraordinary, with the quality remaining consistent no matter how unimportant the piece. The result was a painterly effect achieved by no other maker.

The anomaly of the present table is that although the body is totally convincing as a product of the Roentgen manufactory, the quality of the top is poor, and there is no sign that it was ever altered. Comparison of the top to others of this model shows it to be inferior in virtually every category: poorer in its drawing; less intelligent in its use of wood, with many of the elements (most noticeably the ground and architectural components) made up of large sections of wood, which on the other examples are pieced together from a great many smaller sections; overreliant on engraved detail, and that detail poorly executed; and highly unorthodox in its use of ink to represent such elements as the lower palm leaves on the left, the tufts of grass on the right, and the details of the earthwork. On the other panels of this model, these latter details are represented with separately cut pieces of wood. After initially being drawn to the Dodge top, one quickly recoils.

With so little evidence surviving one can only speculate how a genuine table could have such a top. Roentgen's workshop was large and its production prodigious. Possibly the Dodge top was the product of a young *marqueteur* and the piece somehow slipped past the shop's inspectors, though indeed another table with a top of similar quality is known (see below). Or possibly the Dodge table and its companion were made by one of the craftsmen who had left the Roentgen establishment to set up business elsewhere and who continued to produce furniture in the Roentgen style. Hans Huth (1974: 71) mentions that one such craftsman, Christian Meyer, court cabinetmaker in St. Petersburg, was able to copy Roentgen's furniture so well that it was impossible to distinguish his pieces from the originals.

Mechanical writing tables were a stock-in-trade item for the Roentgen workshop, combining at relatively low cost the two features for which David Roentgen was most noted: mechanical actions, here of the simplest form, and exquisitely detailed marquetry. For his marquetry tableaux, Roentgen relied on two main sources: engravings after contemporary artists, with those after François Boucher and Jean-Baptiste Pillement apparently the most favored; and the drawings of his friend Januarius Zick (1732–1797), court painter to the Elector of Trier.

The top of the present table copies the painting by Zick now in the Mittelrhein-Museum, Koblenz (Fabian 1982: 60, 62–63, fig. 92). Inspired by Virgil's *Aeneid* (Book II, lines 634–804), it depicts Aeneas bearing his blind father, Anchises, followed by his son Ascanius, as they flee the burning city of

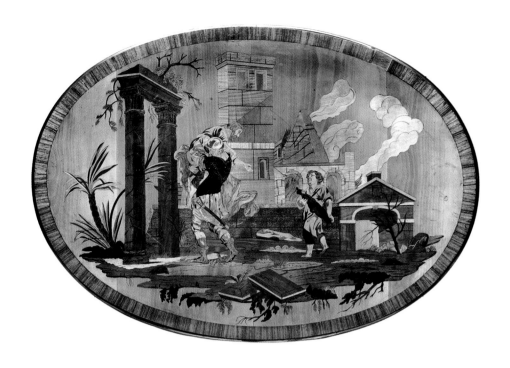

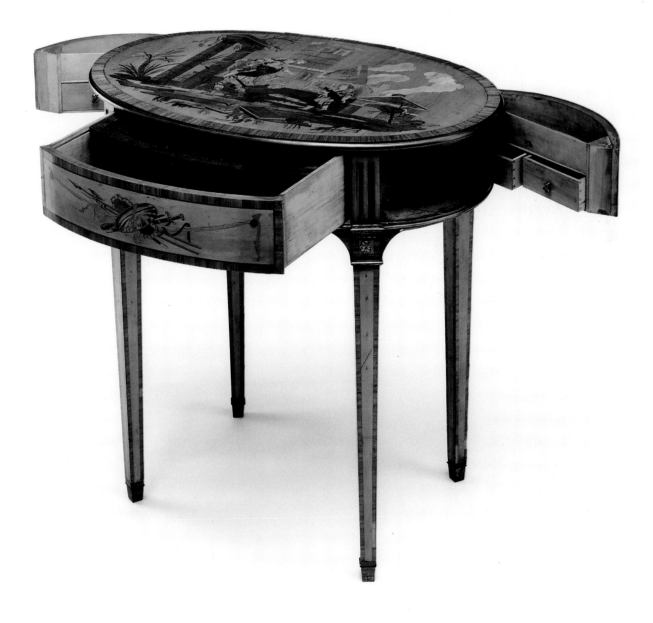

Troy. Ascanius carries with him the rescued figure of a household god. The pose of the Dodge figures is identical to the Zick painting, but the architectural elements are arranged differently.

The first mechanical tables of oval form were produced by Roentgen about 1770. A documented version was sold to Frederick the Great in July of that year for his Neues Palais at Potsdam, where it survives today (Huth 1974: fig. 153; Greber 1980, II: 165, fig. 320). These early examples were curvilinear in profile, with cabriole legs and sides that flared out and dipped down. Surviving examples are veneered on their tops and sides with floral sprays (Greber 1980, II: 167, fig. 324). As few such tables are known today, it is probable that relatively few were made. About five years after the introduction of the type, the carcass was redesigned in the form of the present table, probably the result of Roentgen's first trip to Paris in 1774, where he came up against the fully entrenched Neoclassical style.

In this form the table was produced repeatedly, veneered in a number of marquetry styles: chinoiserie subjects, of which examples exist at Versailles (Verlet 1956, II: xxix, 132, no. 2) and in the Mannheimer Collection at the Rijksmuseum, Amsterdam (Greber 1980, II: 171, figs. 332–33); pastoral subjects, of which an example was formerly in the Hillingdon collection, Messing Park, Essex (London 1979: lot 254); floral subjects with bouquets of roses linked with string and ribbon, of which examples exist in the Jones Collection of the Victoria and Albert Museum, London (Brackett 1922: 24–25, no. 76, pl. 42; Greber 1980, II: 172–73, figs. 335–36) and the Kress Collection at The Metropolitan Museum of Art, New York (Dauterman, Parker, and Standen 1964: 100–02, no. 17, figs. 87–88; Greber 1980, II: 173, fig. 337); and the richest, and along with the floral themes, the most common of all, classical subjects as represented by the Flight of Aeneas and Anchises from Troy. In the continuing evolution of this table form, later versions were surfaced with mahogany veneer set off with more severe Neoclassical mounts (Huth 1974: fig. 154; Greber 1980, II: 312–13, figs. 618, 620–21).

Including the Dodge table, eight, possibly nine eighteenth-century versions of the Aeneas and Anchises table are known. Two are in the Victoria and Albert Museum: one, forming part of the Lyne Stephens Bequest (inv. 381–1874), is mounted virtually identically to the Dodge example and still retains the gilt-bronze husk pendants on its legs (top ill. by Greber 1980, II: 311, fig. 615); and the other, forming part of the Jones Collection (inv. 1060–1882), has somewhat finer triglyph and guttae mounts and ridged panel frames around its drawer-case (body ill. by Kreisel and Himmelheber 1973: fig. 9; top ill. by Fabian 1982: fig. 91). Both Fabian and Kreisel/Himmelheber confuse the two Victoria and Albert Museum tables, probably based on Dilke's mistake of 1901 (Dilke 1901: 190–91). The other examples of the Aeneas and Anchises tables include one with plain veneer on the panels

around its drawer-case and mounted with horizontally ridged panels down its legs, forming part of the Mannheimer Collection at the Rijksmuseum (Lunsingh Scheurleer 1952: 366–67, no. 538, figs. 85a–b; Greber 1980, II: 310–11, figs. 613–14); an example with unmounted legs, the drawer-case panels mounted with gilt-bronze trophies suspended from sashes and surrounded by frames identical to those on the second of the Victoria and Albert Museum tables (inv. 1060-1882), forming part of the McIllhenny Collection at the Philadelphia Museum of Art (body ill. by Huth 1928: fig. 56, then in the Abdy collection, Paris); an example with its drawer-case mounted identically to the preceding, but with the addition of gilt-bronze husk pendants suspended down its legs, formerly in the collections of Robert von Hirsch of Frankfurt and Basel (Feulner 1927: 558–59, figs. 462–63) and Sigrid Katharina Schwarz, Basel (Zurich 1992: lot 545); an example in a private collection mounted identically to the Dodge table and still retaining its pendant leg mounts (Ramond 1989: 42); and another example mounted identically to the preceding with Frank Partridge and Sons, London, in 1946 and 1978, the marquetry components of its top cut in the same configuration as those on the Dodge table and embodying similar shortcomings. Very possibly these two latter works were made together. Greber (1980, I: 232) mentions what is perhaps a ninth table in the J. Rosenbaum collection, Berlin, but this may repeat the Partridge table or that illustrated by Ramond.

ADAM WEISWEILER
Active 1778–1809

One of the leading ébénistes of the last quarter of the eighteenth century, Weisweiler produced some of the most perfectly balanced pieces of his day. The quality of his materials and his craftsmanship were of the highest order. Like so many Parisian cabinetmakers of the time, he was German by birth and by training, according to tradition having served as an apprentice in the workshop of David Roentgen at Neuwied, near Koblenz. It is not known exactly when he came to Paris, but he was admitted to the guild of menuisiers-ébénistes there in 1778. From that year until the Revolution he worked largely for the dealers—principally Dominique Daguerre, who appears to have had a great influence on his style. It was almost certainly under Daguerre's direction that he produced most of his celebrated pieces, lavishly mounted with Sèvres porcelain plaques and panels of Japanese lacquer. And it was through the intermediary of Daguerre that Weisweiler supplied furniture for Marie-Antoinette and Louis XVI at Versailles and Saint-Cloud. For the dealer Julliot he seems to have produced primarily pieces inset with pietre dure plaques. Unlike the careers of most ébénistes,

Weisweiler's survived the Revolution, and he continued to make furniture up until the time of his wife's death in 1809.

[12]
Adam Weisweiler

Combination Writing, Working, and Eating Table, c. 1785

Carcass of oak and fir with mahogany veneer, gilt-bronze mounts, and marble top, 74.9 (29½) × 66.4 (26⅛) Bequest of Mrs. Horace E. Dodge in memory of her husband (71.172)

INSCRIPTION: Stamped on the underside of the drawer-case near the right leg is the signature: A. WEISWEILER.

ANNOTATIONS: A blue-bordered paper label affixed nearby, probably dating from the nineteenth century, is inscribed in ink: *S8*; and a small, serrated, rectangular twentieth-century label on the bottom of the writing drawer is printed: *33*.

CONDITION: The condition of the table is excellent. Thanks to the intelligent construction of the carcass, none of the boards to which the veneer is applied have split. Only the mahogany of the legs has been scarred, and this no doubt by repeated scuffing. Although the gilding is still quite heavy on some of the mounts, a number of small areas of exposed bronze are visible on others, including the rims around the top and bottom of the drawer-case, the feet, the shelf struts, and the shelf frame. The marble top bears several faint greenish blue stains, probably caused by spilled ink. Losses to the table include the leather-covered writing slide and the gilt-metal pounce box with which one of the drawers was originally fitted; the present brass pounce box, of crude quality, is a replacement. When the table was restored in 1971, scrolling mounts approximately 13 cm long were removed from the centers of the four mahogany panels on the sides of the drawer-case, on the assumption that they were later embellishments. However, as inappropriate as these mounts appear, the possibility that they were original to the piece cannot be discounted. Identical mounts are found on the tops of two pairs of firedogs, one in The J. Paul Getty Museum, Malibu, and the other in the Cooper-Hewitt Museum, New York. The model for these firedogs is documented as having been made by Pierre Gouthière (see p. 125) for both Madame du Barry and the duchesse de Mazarin. Since Gouthière is thought to have produced mounts for some of Weisweiler's furniture, it is not inconceivable that he supplied the mounts—including the scrolling ones—for the Dodge table.

PROVENANCE: Grazia (dealer), Paris. Acquired by Anna Thomson Dodge through L. Alavoine (agent), New York, 1932.

REFERENCES: *Gazette des Beaux-Arts* 1972: 92, fig. 319; Lemonnier 1983: 92, 96, 186, no. 174.

ADDITIONAL BIBLIOGRAPHY: Vial, Marcel, and Girodie 1922: 199–200; Salverte 1962: 329–30; Lemonnier 1983: 15–21; Pradère 1989: 388–403.

The table is conceived as a drum-shaped drawer-case supported by four tapering legs, mounted between which is a circular shelf. Housed within the case and opening from the front and the back are two drawers, one of them fitted at right with a gilt-brass inkwell, pen tray, and pounce box and cut with channels to accommodate a writing slide (see Condition). Set just below the top and opening from the right and left sides are mahogany candleslides. The carcass is constructed of oak and fir, and the drawers are of oak.

The table's coloring is a handsome contrast between the deep brown of the veneer and the gold of the mounts. The drawer-case frieze, the shelf, and the legs are veneered with mahogany, that on the frieze panels and the shelf cut from the crotch section of the tree and highly figured.

The mounts, severely rectilinear in design, include: ribbed frames running around the upper and lower edges of the drawer-case; pearl-beaded frames surrounding each of the four frieze panels; deeply grooved frames set flush into the mahogany just within the pearl-beaded frames; grooved plaques mounted flush with the mahogany on the frieze above the legs; capitals at the tops of the legs, their projecting collars decorated with a repeating vertical cord design; tapering, fluted feet adorned with ascending acanthus leaves; reverse-curve struts supporting the shelf, their surfaces embellished with acanthus leaves and with recessed, horizontally grooved panels; and a frame around the shelf decorated with bold egg-and-dart ornament. Each of the flutes of the legs is mounted with a concave brass insert. The top is fitted with a slab of white Carrara marble.

Round mahogany tables of this type were made in Paris during the 1780s and early 1790s. The marble tops with which they were invariably fitted indicate that among other functions they were intended for taking beverages such as tea, coffee, or chocolate as well as light meals. The leather-covered slide that was originally housed in one of the drawers of the Dodge example shows that the table was also meant to serve as a writing table.

Pieces of this form are commonly described as *bouillotte* tables, in reference to the popular French card game. However, this term seems for the most part a misnomer. In the eighteenth century, the tops of gaming tables were covered with baize, velvet, or sometimes leather, the cold, hard surface of marble being considered unsuitable for playing cards.

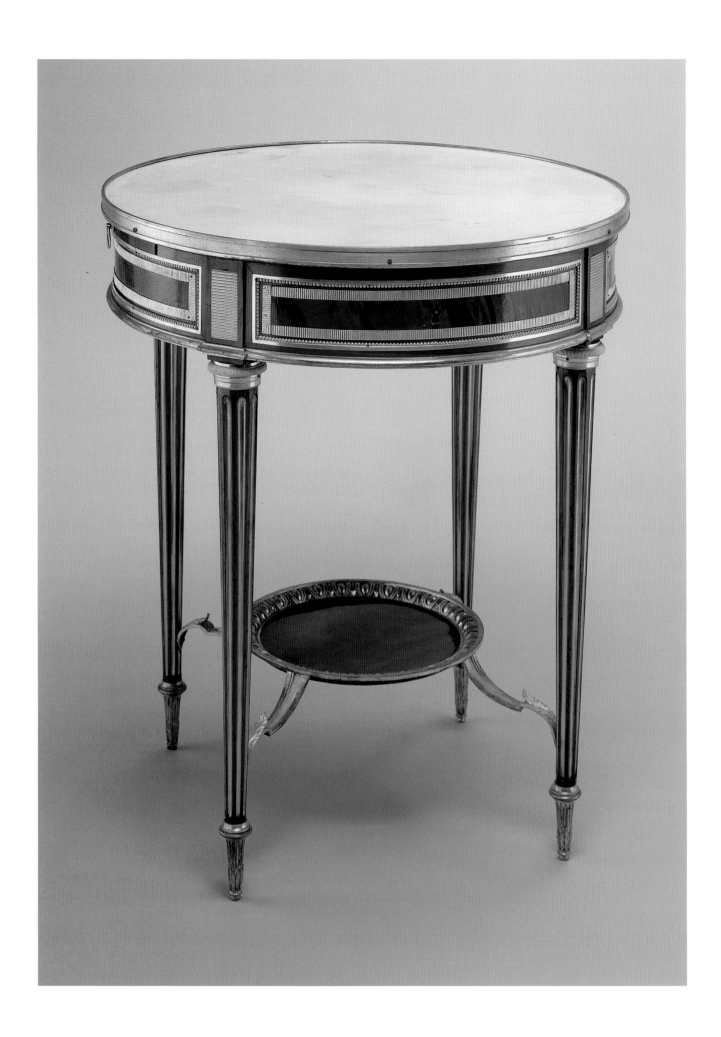

Marble-topped tables also intended to be used for gaming were fitted with reversible tops that rested above the stationary stone ones; but such tables were proportionately few in number, compared to the tables with marble tops alone.

Mahogany furniture mounted with rectilinear moldings and frames like those on the Dodge table was in vogue in France from the 1780s until the time of the Empire. The severity of its form may be seen as a normal cyclical reaction to the elaborately decorated furniture that preceded it. Furniture of the newer type was often described as *à l'anglaise,* in reference to the long-standing English taste for mahogany, which dated from the 1740s. Weisweiler was perhaps the most successful cabinetmaker working in this new style.

Although no other round tables by Weisweiler duplicating the Dodge example are known, several marble-topped versions with different legs and stretchers are recorded: one signed by Weisweiler and fitted between its legs with a wide shelf with incurvate sides was auctioned in Paris in 1982 (Paris 1982: lot 118); another unsigned one, with an elaborate pierced stretcher centered by a mahogany vase, was auctioned from the Espirito Santo Silva collection in Paris in 1955 (Frégnac and Meuvret 1965: 288, fig. 2); while a similar table was with Frank Partridge and Sons, London, in 1964 (London 1964: pl. 1). An unsigned table of very similar form, but veneered with panels of trellis marquetry, was auctioned in Paris in 1988 (Paris 1988: lot 112).

Certain decorative mounts on the Dodge table are encountered repeatedly on Weisweiler's mahogany-veneered works. The grooved plaques above the legs and the grooved panel frames were particularly favored by him. The former are found on such pieces as: a signed rectangular *console-desserte* in The Cleveland Museum of Art (Cleveland 1964: no. 59; Lemonnier 1983: 111, 199); a signed D-shaped *console-desserte* in the Musée Nissim de Camondo, Paris (Lemonnier 1983: 73); an identical pair of signed *consoles-dessertes* sold in London in 1938 (London 1938: lot 43); and a signed D-shaped *console-desserte* in the Walters Art Gallery, Baltimore (Lemonnier 1983: 113). The grooved panel frames appear on: a signed mahogany *encoignure* acquired by the Garde-Meuble in 1787 and now at Versailles (Pradère 1989: 400, fig. 494); the above-mentioned *console-desserte* in Cleveland; an unsigned table by Weisweiler in The Wallace Collection, London (Watson 1956: no. F328, pl. 105); a commode in the collection of Stavros Niarchos, Paris (Frégnac and Meuvret 1965: 288, fig. 1); and a large *bureau plat* from the T. Broët collection, auctioned in Paris in 1909 (Ricci 1913: 114).

CLAUDE-CHARLES SAUNIER
1735 Paris – Paris 1807

Saunier's grandfather, father, and uncle were all registered members of the guild of menuisiers-ébénistes, and he himself was given papers for guild membership at the exceptionally early age of eighteen, though he registered them only after the death of his father in 1765, when he was thirty. Most of Claude-Charles's furniture is rather feminine in appearance, with precise lines and delicate proportions. His works are rarely surfaced with marquetry, the more sober pieces being veneered with fine tulipwood, mahogany, and satinwood, and the more lavish ones mounted with panels of Japanese lacquer or inset with plaques of Sèvres porcelain. Saunier's style was very much influenced by the dealers Simon-Philippe Poirier and his successor, Dominique Daguerre, for whom Saunier worked. It is probably for Daguerre that the Dodge table was made, as its brightly painted metal panels are thoroughly in keeping with that dealer's taste for furniture mounted with exotic and costly materials. Saunier was last listed in the Parisian almanacs as a practicing cabinetmaker in 1799.

[13]
Claude-Charles Saunier

Combination Gaming and Writing Table, c. 1775

Carcass of oak with tulipwood and amaranth veneer, polychrome steel plaques, ivory and ebony inlays, and gilt-bronze mounts, 74 (29⅛) × 114.6 (45⅛) × 60.7 (23⅞)
Bequest of Mrs. Horace E. Dodge in memory of her husband (71.197)

INSCRIPTION: The table is stamped under one of the side rails: C.C. SAUNIER, accompanied by the JME guild mark.

ANNOTATIONS: Two tan labels affixed to the bottom panels at either side are inscribed in ink: *28554,* a Duveen Brothers inventory number. Under the central bottom panel is a fragment of a label used by the Parisian packing firm of Chenue, with only the letter *N* remaining.

CONDITION: The table is in good condition overall, though the drying, shrinkage, and consequent movement of its boards have resulted in some damage and loss. On the removable top, the leather writing surface has split from front to back along the junctures of the clamping boards at either end, and the veneer surrounding the leather has fractured and buckled, resulting in losses at two of the corners, one of which has been repaired with new veneer.

The shrinkage of the wood forming the bottom of the carcass, over which the *tric-trac* board is veneered, has caused fissures running from front to back along one side of the board. The metal inkwell, sand caster, and sponge box, originally housed in wooden compartments within one of the drawers, have been lost, as have all the game pieces and the table's removable candleholders.

PROVENANCE: Henry M.W. Oppenheim, London. His sale, Christie's, London, June 10–12, 16–17, 1913, lot 181. Bought by Duveen Brothers (dealer), New York. Mrs. George D. Widener? (see room view, Platt 1976: 122). Acquired by Anna Thomson Dodge from Duveen Brothers, 1932.

REFERENCES: London 1913: lot 181; Detroit 1933: n.p.; Detroit 1939, I: n.p.; Platt 1976: 122.

ADDITIONAL BIBLIOGRAPHY: Vial, Marcel, and Girodie 1922: 141–42; Salverte 1962: 297–98; *Gazette des Beaux-Arts* 1972: 93, fig. 330; Reyniès 1987, I: 392–427; Pradère 1989: 364–69.

The table consists of a shallow rectangular case supported by four slightly splayed rectangular legs and fitted with a removable top covered on one side with a brown leather writing surface and on the other with a green felt playing surface. A central well within the case is veneered on an ebony ground with slender points sawed from bone, alternately left natural and stained green, to form a backgammon board. Flanking the well at either end of the table are two drawers, one opening from one side and the other from the opposite.

The table's principal decoration comprises eight steel plaques — three on each side and one at each end — delicately painted on a white ground with pink-and-blue rinceaux intertwined with small leafy green vines, all emanating from central acanthus clusters. Each panel is bordered by a gilt band within a narrow frame of apple green.

The exterior of the table is veneered around the frieze plaques with tulipwood and on all four sides of the legs with recessed panels of horizontally grained tulipwood framed by amaranth. The leather-covered writing surface is veneered around its edges with tulipwood framed by bands of amaranth flanked by light wood fillets. The top of the table to either side of the backgammon well is also veneered with tulipwood panels within bands of amaranth. In the center of each panel is an oval amaranth frame, and around the panel's perimeter runs a rectangular frame with notched corners.

The mounts are simple in outline, though elaborately modeled in detail. At the corners of the case are foliate rosettes, and down the recessed panels of the legs hang long pendants of laurel-leaf clusters. An *entrelac* molding of alternating large and small ovals, the former centering on rosettes, borders the removable top; each leg bears a collar of similar *entrelac* design. The feet are mounted with foliage rising from a band of ovals.

Gaming was a favorite pastime among the leisured classes in eighteenth-century France, and of the many games played, *tric-trac,* a form of backgammon, was one of the most popular. The history of backgammon can be traced through nearly five millennia to the civilization of Sumer in Mesopotamia

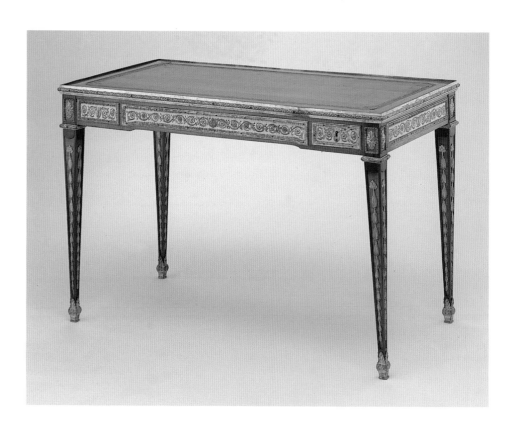

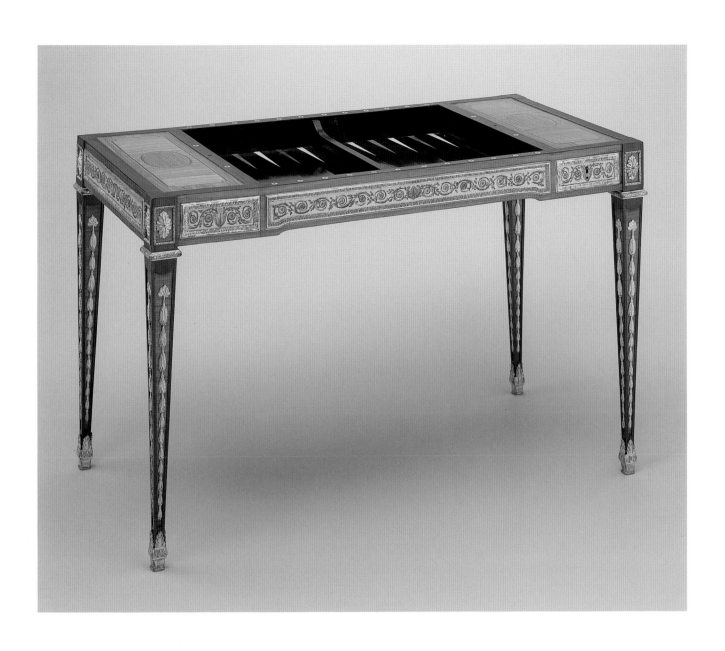

(Jacoby and Crawford 1970: 7–54). Plato commented on a form of the game played in classical Greece, and its great popularity in ancient Rome is attested by the excavations at Pompeii, which revealed carved stone backgammon boards in the courtyards of almost every villa. In Northern Europe, the game does not seem to have taken hold until the eleventh century, when it was introduced by Crusaders returning from the Near East. From then on it flourished.

In France, *tric-trac* gained precedence over other versions of backgammon beginning about 1500. Usually the game was played on a portable board contained in a hinged box that could be opened and placed on a table. However, about 1710 the first tables were produced with permanent boards as integral parts of their design. Almost from the outset these tables were made as multipurpose pieces: they could be used as writing tables when their reversible tops were placed with the leather-covered surface turned upward; as card tables for playing such games as piquet when the baize or felt surface was exposed; or as *tric-trac* tables when the top was removed altogether. Occasionally, one side of the top was veneered with a checkerboard.

During the Neoclassical period, from about 1760 through the time of the Empire, virtually all such tables were rather simply surfaced with plain wood veneer, usually mahogany, and embellished with few mounts (Watson 1960: fig. 147). On rare occasions, they were decorated with Sèvres porcelain plaques, as were the tables recorded in the collections of Madame du Barry in 1771 (Wildenstein 1962: 376; Marly-le-Roi-Louveciennes 1992: 69, 79, n. 118) and the duchesse de Mazarin in 1779 (Faraggi 1995: 87). Japanese lacquer seems never to have been used.

In design, the Dodge table appears to be unique. *Tôle* panels such as those found here are very rare and seem to be confined almost exclusively to a few works by Saunier. The technique had been perfected by Samousseau in 1767. *Tôle* panels imitating white-ground Japanese lacquer appear again on a small *bureau à cylindre* signed by Saunier, sold from the Paul Eudel collection in 1898 (Paris 1898: lot 288) and from the Vagliano collection in 1955 (London 1955: lot 110), and on an identical signed *bureau à cylindre* formerly with the Paris dealer Samy Chalom (Frégnac and Meuvret 1965: 224, ill.). *Tôle* panels imitating black-ground Japanese lacquer appear on a *commode à l'anglaise* signed by Saunier, auctioned from the Biron collection in 1914 (Paris 1914: lot 367) and in the possession of the Paris dealer Aveline in 1978 (Pradère 1989: 368, fig. 441). No other panels bearing the polychrome rinceaux of the Dodge example are known, although the rinceau motif itself was highly popular in France during the Neoclassical period.

JEAN-HENRI RIESENER
1734 Gladbeck – Paris 1806

Jean-Henri Riesener was the most renowned cabinetmaker of the Louis XVI era. Like many of his Parisian contemporaries, he was of German origin, having been born in Gladbeck, near Essen. It is not known exactly when he came to Paris, but he is believed to have entered the Gobelins workshop of the illustrious Jean-François Oeben around 1754 and to have moved with Oeben to the latter's new quarters in the Arsenal in 1756.

When Oeben died at the age of forty-one in 1763, his widow, Françoise, sister of the ébéniste *Roger Vandercruse, assumed legal control of the workshop and continued its operation, soon choosing Riesener from among several talented workers as its chief* ébéniste *and general director. Presented with an opportunity of such magnitude, Riesener was able to develop his skills to the fullest, though the work produced in the shop continued to bear the name of Oeben. However, in quick succession in 1767 and 1768, Riesener married Madame Oeben and was admitted to the guild of* menuisiers-ébénistes, *so that he gained full and legal title to the workshop, enabling him to use his own signature. The following year he finished and delivered to Louis XV the celebrated* bureau du roi, *the desk started in 1760 by Oeben and widely considered to be the most important piece of furniture made in France.*

With the accession of Louis XVI in 1774, Riesener was appointed ébéniste ordinaire du roi, *replacing the aged Gilles Joubert. During the next ten years, the most brilliant of his career, he produced for the Crown a large quantity of furniture of extraordinary richness. The amount spent on royal furniture in this decade was more than double that paid to Joubert during the latter part of Louis XV's reign.*

But in 1785 Riesener was dealt a serious blow. Alarmed by the worsening condition of the treasury, Louis XVI became determined to reduce the expenses of the royal household, and especially those of his Garde-Meuble. Thenceforth the number of pieces ordered from Riesener was so greatly reduced that his average yearly payments fell from approximately 100,000 livres to 15,000 livres. Nevertheless, Riesener still received extensive orders from the queen, who had her own Garde-Meuble, providing her with furniture principally for the Château de Saint-Cloud, which the king bought for her in 1785, and for the Petit Trianon at Versailles. Riesener also continued to produce furniture for his private clientele, which included many of the most distinguished people of the day.

Beginning in 1789, the enormous social and political upheavals caused by the Revolution proved disastrous to Riesener's business. He was late to appreciate the significance of the Revolution, persisting in the illusion that the old order and its taste would be restored. When the Convention decided to sell much of the royal furniture at auction in the mid-1790s, Riesener seized the opportunity to buy back a number of his most important pieces, with

the intention of selling them again privately. But by then not only had fashion drastically changed, but most of his sophisticated clientele had either been killed in the Terror, forced to flee the country, or financially ruined. His efforts met with little success. Riesener continued in business until the first months of 1800, serving mainly as a court-appointed arbiter in commercial lawsuits.

[14]
Jean-Henri Riesener

Writing Table, c. 1780–85

Carcass of oak and fir with tulipwood, holly, and amaranth veneer and gilt-bronze mounts, 75 (29½) × 162.5 (64) × 81.8 (32³⁄₁₆)
Bequest of Mrs. Horace E. Dodge in memory of her husband (71.195)

INSCRIPTION: The table is stamped under the right side rail: J.H. RIESENER.

ANNOTATIONS: Stamped under the right kneehole rail: *10488* (the 4 inverted) with the same number painted in white under the central front rail. A paper label affixed to the bottom of the right drawer is inscribed in ink: *29622,* a Duveen Brothers inventory number. On a second Duveen label nearby is typed: *AN OLD FRENCH WRITING TABLE OF THE PERIOD OF LOUIS XVI (1774–1789) BY J.H. RIESENER, FRENCH EBENISTE. FROM THE STIEGLITZ MUSEUM AT LENINGRAD. ILLUSTRATED IN MOBILIER FRANCAIS EN RUSSIE.* Two twentieth-century French customs labels are affixed to the underside of the carcass at left rear.

CONDITION: Like most of Riesener's surviving work, the table is in good condition. The veneer is still firm, and the gilding, except for that on the frame around the top, is relatively unworn, though there are indications that some of the mounts have been regilded using the electroplating process. Like many *bureaux plats* with large unsupported spans, the table has sagged slightly in the center at the back; this, combined with a slight upward buckling of the writing slide that opens from the rear, gives the piece a somewhat awkward appearance when viewed from behind. The boards forming the top have shrunk as they dried, causing their leather covering to split at the left rear corner. The present green leather surface is probably a replacement, as virtually all of the *bureaux plats* by Riesener described in the *Journal du Garde-Meuble* were covered with black leather—as is the writing slide on the present piece. Two of the gilt-bronze thyrsi

mounted on the corners of the drawer-case are inferior in quality to the others and appear to be later castings. The lowest leaves have been broken off the floral pendants on the sides of both left legs and the right front leg, and the laurel wreath pulls originally mounted on the false drawer-fronts at the back are now missing, leaving only the florets surmounted by bows.

PROVENANCE: Stieglitz Museum, St. Petersburg (Roche 1913, II: pl. LXIV). Duveen Brothers (dealer), New York. Acquired by Anna Thomson Dodge from Duveen Brothers, 1932.

REFERENCES: Roche 1913, II: pl. LXIV; Detroit 1933: n.p.; Detroit 1939, I: n.p.; Winokur 1971: 45, 46, fig. 3; *Gazette des Beaux-Arts* 1972: 93, fig. 329.

ADDITIONAL BIBLIOGRAPHY: Vial, Marcel, and Girodie 1922: 116–19; Salverte 1962: 279–84; Frégnac and Meuvret 1965: 182–97; Pradère 1989: 370–87.

The table consists of a rectangular case housing three longitudinal drawers and resting on four tapered, rectangular legs; the bottom of the case is raised at center to form a kneehole. Just under the top is a writing slide that extends the full length of the table and can be pulled out from the back. Both the top, which is covered with elaborately tooled green leather (see Condition), and the writing slide, covered with tooled black leather, are constructed of long fir boards secured at either end by a traverse fir clamping board. The remainder of the carcass is oak, as are the drawers. The drawers' bottoms, which in the manner typical of the period are slotted into their sides, have the additional Riesener refinements of being cut with double chamfers along the left and right edges and being fastened to the backs by steel screws.

The subsidiary panels on the two ends of the table, the lateral drawer-fronts, the corresponding false drawer-fronts at the rear, and the lower legs are all veneered with panels of horizontally grained tulipwood bordered by fillets of light- and dark-stained holly. The kneehole drawer, the corresponding area at the back, the central areas of the sides, and the upper areas of the legs that form the corners of the drawer-case are veneered with panels of green-stained holly. All these tulipwood and holly panels are framed with highly contrasting amaranth.

The principal mounts are those on the kneehole drawer, the corresponding area of the back, and the central panels at the sides. The mounts on the front and back consist of intertwined acanthus scrolls centering on florets and flanked at left and right by separate scrolls similar in design but smaller in scale. The larger scrolls set within projecting amaranth frames were designed, in typical Riesener fashion, to appear as though they are superimposed on the smaller scrolls behind them. The mounts in the end plaques, which are similarly framed, are in the form of crossed rose branches superim-

posed on crossed branches of laurel. The finish of the mounts on the rear of the table is inferior to that on the front.

Mounted at all four corners of the drawer-case are small gilt-bronze thyrsi rising from florets and flanked by separate moldings of ascending laurel leaves. Immediately below these, at the level of the bottom of the drawer-case, the legs are fitted with collars of repeating acanthus leaves. Below the collars, the two outer surfaces of each leg are mounted with finely modeled pendants of leaves and flowers, and along the indented corners of the legs run moldings of twisted rope and pearl strings. The feet are in the form of ascending acanthus leaves emanating from tapering square blocks.

The lateral drawers on the front of the table are mounted with pulls in the form of ribbon-bound laurel wreaths suspended from bowknots of crimped ribbon and centering on keyhole escutcheons in the form of finely modeled florets. The corresponding panels on the back of the table are similarly mounted but lack the laurel wreaths (see Condition). Each of the slightly projecting panels of the drawer-case and drawers is surrounded by a frame of *feuilles d'eau,* and the same motif is incorporated into the upper edge of the simple, broad frame that surrounds the top.

Although the quality of the Dodge table would seem to suggest a royal commission, no *bureau plat* fitting its description has been found in the *Journal du Garde-Meuble,* the registry of furniture for the French royal household. The great majority of the many bureaux by Riesener mentioned in the royal delivery records were intended for ministerial or secretarial use, and their descriptions, though brief, leave no doubt that they were considerably less ornate than the Dodge table. One such bureau, delivered to Versailles in April 1783 for a member of the king's household staff and now in the Musée du Louvre, Paris (Verlet 1945: no. 11, pl. XIII; Alcouffe, Dion-Tenenbaum, and Lefébure 1993: no. 91) serves as an excellent example of what the majority of these works must have looked like. That piece, which is veneered with mahogany, is similar in shape to the Dodge table, with taper-

ing legs indented at the corners and the same curved and notched sides to the kneehole opening. Its few mounts consist of lacquered bronze drawer-pulls, feet, and leg collars.

Most of the important desks commissioned for male members of the royal family were *bureaux à cylindre,* whose writing surfaces and contents could be conveniently and securely locked when not in use. The greater mass and more expansive surfaces of such roll-top desks also lent themselves more readily to elaborate marquetry and mountings. Nevertheless, Riesener did produce a small number of important *bureaux plats* for the Crown. Only one of these has so far come to light—a table, much more rectilinear in form, delivered on August 6, 1777, for the use of Louis XVI at the Petit Trianon and now in The J. Paul Getty Museum, Malibu (Verlet 1990: no. 17).

Two other surviving *bureaux plats* by Riesener relate closely in size, shape, and veneered decoration to the Dodge table; like the Dodge piece, neither of them is listed in the *Journal du Garde-Meuble.* Both are much more simply mounted, lacking the acanthus scrolls on the front and back, the laurel and rose branch mounts on the ends, and the thyrsi and floral pendants on the legs. The more imposing of these two tables, now at Waddesdon Manor, Buckinghamshire (Bellaigue 1974, I: no. 90), is almost exactly the size of the Dodge example but is surmounted at one end by a *cartonnier* supporting a clock flanked by candelabra. The other piece, in the Mary Frick Jacobs Collection of The Baltimore Museum of Art, is 10 cm wider and deeper than the Dodge table and has no *cartonnier.* Both tables have leather-covered slides that open from the side rather than the back (that on the Waddesdon table opening from the right, that on the Baltimore example from the left) as well as adjustable reading stands extending from the front of the table above a false kneehole drawer (Breckenridge 1958: 4, 14, ill.).

Two further *bureaux plats,* but with more elaborate veneering, include a somewhat smaller example with floral marquetry plaques at the centers of the four sides, flanked by panels of lozenge parquetry, in the Musée du Louvre (Alcouffe, Dion-Tenenbaum, and Lefébure 1993: no. 90), and an example virtually identical in size to the Dodge bureau, with plain panels centering the four sides which were originally decorated with elaborate gilt-bronze mounts, formerly in the Lévy-Bauer collection, Paris (Paris 1979a: lot 88), and the Keck collection, Bel Air, California (New York 1991a: lot 173).

Other Riesener *bureaux plats* of the same shape as the Dodge table but veneered with mahogany and fitted with simpler mounts include: a somewhat smaller signed example formerly in the collection of Mr. and Mrs. Deane Johnson, Bel Air, California (New York 1972: lot 113), and later in the collection of Commandant Paul-Louis Weiller, France; a *bureau plat* formerly in the collection of Alfred de Rothschild, London (Davis 1884, II: no. 113); a signed *bureau plat* for-

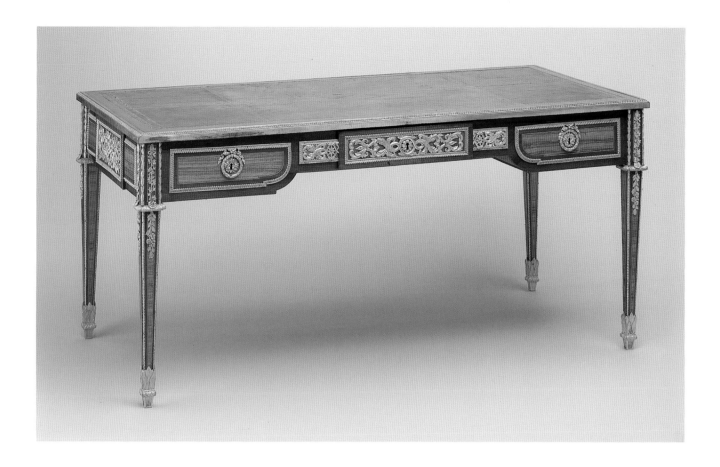

merly in the collection of Madame Renée de Becker and now owned by Stavros Niarchos, Paris; a signed, richly mounted *bureau plat* with turned and fluted legs auctioned from the collection of John T. Dorrance, Jr., at Sotheby's in 1989 (New York 1989a: lot 819); a large signed *bureau plat* in the Musée Nissim de Camondo, Paris (Gasc and Mabille 1991: 36–37); another large signed example belonging to the Mobilier National and placed in the Ministry of Finance, Paris (Revel 1959: 48); and the previously mentioned *bureau plat* delivered to Versailles in 1783.

The mounts on the Dodge table are all drawn from Riesener's large stock of specially designed bronzes and appear repeatedly on his works. The smaller acanthus scrolls on the kneehole drawer, the laurel-leaf moldings at the corners of the drawer-case, and the twisted rope and pearl moldings set within the indented corners of the legs are found again on a *bureau plat* without a raised kneehole formerly in the Seligmann collection, Paris (Frégnac and Meuvret 1965: 197, fig. 5), and on an almost identical signed *bureau plat* formerly in the collection of Viscount Harcourt (London 1954: lot 141).

The acanthus scrolls also appear on a number of datable royal pieces delivered by Riesener, including: a table delivered in 1777, originally *en suite* with the previously mentioned Getty *bureau plat,* now at Waddesdon Manor (Bellaigue 1974, II: no. 103; Verlet 1963: no. 15b); a table delivered in 1781 for the *cabinet* of Marie-Antoinette at Versailles and now in The Metropolitan Museum of Art, New York (Verlet 1963: no. 19); a table delivered in 1783 for the *cabinet-intérieur* of Madame Elisabeth, the younger sister of Louis XVI, at Versailles and now in the Philadelphia Museum of Art (Verlet 1963: no. 22); and a table delivered for the use of Marie-Antoinette at Marly in 1783 and also now in Philadelphia (Verlet 1963: no. 23). The legs of the Marly table are mounted like those of the Dodge *bureau plat* with floral pendants.

The exceptionally fine mounts of crossed laurel and rose branches on either end of the Dodge table are a truncated version (several inches of foliage have been removed from either side) of a mount found on the central drawer of the Getty *bureau plat* delivered in 1777. A less abbreviated version appears on the front of a lean-to desk delivered by Riesener for the use of Madame Élisabeth at Fontainebleau in 1779 and now in a private collection, Paris (Verlet 1955: no. 14, pl. XIV), and again on the ends of a mechanical table in the Metropolitan Museum delivered by Riesener in 1778 to Marie-Antoinette in preparation for the birth of her first child, Madame Royale (Verlet 1963: no. 17; Frégnac and Meuvret 1965: 193, fig. 3). An even more abbreviated version, with a slightly redesigned bow, appears on a small mahogany secretaire by Riesener in the collection of Stavros Niarchos, Paris (Frégnac and Meuvret 1965: 197, fig. 6), as well as on a similar secretaire on the Paris market in 1975–76. The *feuilles d'eau* frames surrounding the projecting panels on the drawer-case are found repeatedly on Riesener's works of this period.

In addition to his work for the Crown, Riesener produced furniture for many of the most illustrious persons of the day.

Salverte (1962: 280) states that he included among his clients members of the royal family, such as the duc d'Orléans and the duc de Penthièvre, as well as the duc de Praslin, the duc de La Rochefoucauld, the duc de Biron, the comte de Buffon, and the *fermier-général* Grimod de La Reynière. It was probably for someone of such stature that the Dodge table was made. Certainly the large slide extending from the back of the table—out of reach of the user at front and intended to be used by a secretary or an assistant—suggests that the bureau belonged to a man of power rather than an idle aristocrat. A *cartonnier,* possibly made for either the Dodge table or the Mary Frick Jacobs table, is with the Parisian dealer Kraemer.

[15]

Jean-Henri Riesener

Chest of Drawers, 1783

Carcass of oak with marquetry veneer, gilt-bronze mounts, and marble top, 92.7 (36½) × 144.8 (57) × 60.4 (23¾)
Bequest of Mrs. Horace E. Dodge in memory of her husband (71.194)

INSCRIPTIONS: Stamped on the top of each front stile: J.H. RIESENER. Stenciled in black paint on the back: the letter *F* surmounted by a crown; and *No 35* over the number *3.* On the top of the carcass appear the following: the letter *E* stenciled in black paint near the right edge; a nearby painted letter *E;* the number *191* or *161* in black wax crayon; the letter *L* in red wax crayon; a faint *No 3* near the front; and the incised mark *3 1 X.* Inside the central frieze drawer are two Duveen Brothers labels, one inscribed in ink: *27569,* a Duveen inventory number; the other inscribed in pencil at the top: *EX GARDE MEUBLE FONTAINEBLEAU;* and typed below this in blue the following: *27569 / AN OLD FRENCH 18TH CENTURY ORMOLU MOUNTED COMMODE OF THE LOUIS XVI PERIOD* inlaid with parqueterie. Stamped on the top *"J.H. RIESENER". FROM THE GARDE MEUBLE, FONTAINEBLEAU, AND THE COLLECTION OF EDWARD*

ARNOLD, THE GROVE, DORKING, ENGLAND. The modern gilt-bronze apron mount is engraved on its back: *COPY FROM FRICK 19.5.76 PARIS, 1993 PEYRUSEIGT.*

CONDITION: The commode's overall condition is good. However, the shrinkage and separation of the vertical boards forming its sides have caused many components of the overlaying trellis marquetry to become partially detached; though these panels appear intact from a distance, close inspection reveals that almost all the lozenges along the vertical lines of the fissures have lifted. Fir boards with their grain running horizontally have been glued across these fissures on the inside of the carcass in an attempt to prevent the splits from widening. Elsewhere, shrinkage of the boards forming the bottom of the carcass has resulted in a wide crack extending from side to side. Excessive strain on the carcass, probably occurring during shipment, has caused a fracture about 20 cm long at the right rear corner of the top, as well as damage to the upper left corner of the frame of the back. Bits of amaranth veneer are missing from the frieze areas on both the left and right sides. The commode had lost both its apron mount and its frieze drawer pulls by the time the first known photograph of it was taken in 1920 (London 1920: lot 90). The present replacements were made in Paris in 1993 from molds taken from the Riesener commode formerly belonging to Marie-Antoinette and now in The Frick Collection, New York (Dell 1992: 75). The screw holes for the apron mounts on both pieces correspond exactly. Apron mounts of this model were used repeatedly by Riesener from c. 1783 until the early 1790s. The dovetail joints that united the left side of the central frieze drawer to its front have broken, and these members are now connected by an angled metal brace. The present top of Sarrancolin marble is a recent replacement; the commode still had its original white marble top when it appeared in the Edward Arnold sale in 1920.

PROVENANCE: Madame Elisabeth de France, Château de Fontainebleau, 1783–86. Louis XVI, Château de Fontainebleau, 1786–92. Garde-Meuble National, Paris, from 1792. Edward Arnold, The Grove, Dorking, Surrey. His sale, Christie's, June 8, 1920, lot 90 (the contents of the collection are identified in the catalogue as having been bought chiefly from the London dealers Samson Wertheimer and William Boore). Duveen Brothers (dealer), New York. Acquired by Anna Thomson Dodge from Duveen Brothers, 1932.

REFERENCES: London 1920: lot 90; Clouzot 1925: pl. xx; Detroit 1933: n.p.; Detroit 1939, I: n.p.; Verlet 1955: 87–90, no. 15, pl. XV; *Jours de France* 1970: 104; *Gazette des Beaux-Arts* 1972: 93, fig. 327; Verlet 1990: 100; Dell 1992: 75.

ADDITIONAL BIBLIOGRAPHY: Vial, Marcel, and Girodie 1922: 116–19; Salverte 1962: 279–84; Frégnac and Meuvret 1965: 182–97; Pradère 1989: 370–87.

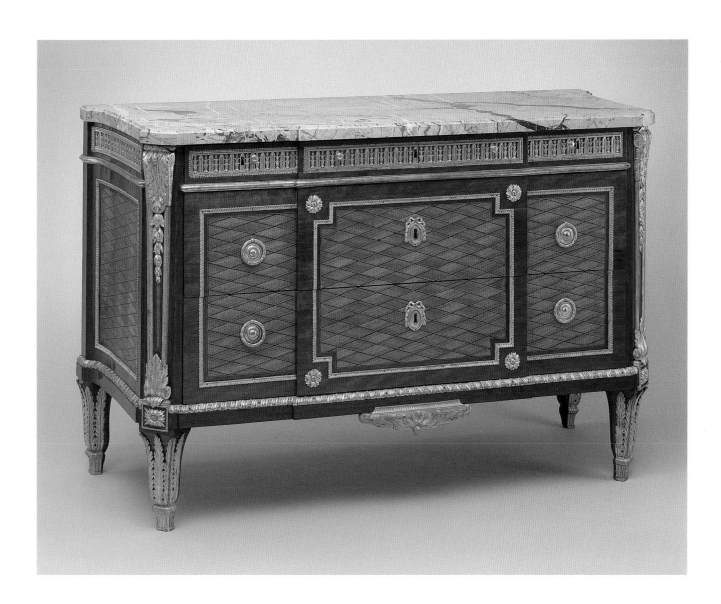

The commode is in the form of a rectangular case housing two large drawers below a frieze of three small ones and resting on four short, tapered feet. The drawers, each of which has its own lock, are constructed of oak in a manner typical of Riesener, with the sharply double-chamfered bottoms slotted into the sides and fastened to the backs with steel screws. Like virtually all of Riesener's work, the commode manifests a near-perfect accord among its carcass shape, its marquetry, and its mounts. And as befits a piece of royal furniture (see below), its slightly heavy proportions give it an air of importance.

The principal decoration on the commode's front and sides consists of five panels of trellis marquetry, with trellis bands composed of paired ebony and holly fillets and the enclosed lozenges of diagonally grained tulipwood; defining the edges of each panel are paired fillets identical to those comprising the trellis. The areas surrounding the panels are veneered with contrasting amaranth, and the five recessed compartments on the fronts of the frieze drawers and at the sides are veneered with holly stained blue (now discolored to

green). The central section of the front projects forward slightly from top to bottom, in order to give the illusion that it is superimposed on the surfaces flanking it.

The gilt-bronze mounts are of the highest quality. The five front and side marquetry panels and the tall vertical panels at the corners are each framed by finely detailed bands of repeating-leaf design. The frame of the central marquetry panel is indented at its corners in order to accommodate large rosettes executed with remarkable naturalism. The drawer-pulls mounted on the flanking marquetry panels, which are more in keeping with the rather sober spirit of the commode, are in the form of ribbon-bound laurel wreaths surrounding bosses whose centers are framed by corded circlets. The key-hole escutcheons, which on Riesener's works are normally of elaborate design and act as focal points, are here comparatively simple oval shields hung at the top from ribbon bowknots and draped down the sides with laurel-leaf pendants.

The mounts on the frieze areas are of a design found frequently on works of this period by both Riesener and several other cabinetmakers: pierced bands composed of arched flutes

(*canneaux*) alternating with stalklike compositions (*tigettes*), the whole framed by plain moldings decorated around their outer edges with pearl beading.

At the tops of the canted front corners are heavy consoles that function visually as supports for the marble top. Decorating their fronts are pendant acanthus leaves, and incorporated into their sides are small flowers from whose centers fall tiny acanthus leaves. Pendants of larger acanthus hang from the consoles' tips. Rising from the bottoms of the front corners, and echoing the motif of the mounts at the top, are unfurling acanthus volutes. Just below these, at the meeting of the horizontal plinth with the vertical corner stiles, are rectangular frames mounted with carefully modeled rosettes.

The foot mounts are in the form of slender, fernlike leaves that rise from small fluted blocks; typical of Riesener's work, they encase only three sides of the legs. The molding running along the top of the narrow plinth is cast with gadroons interspersed with *tigettes*. Surmounting the commode is a slab of modern Sarrancolin marble (see Condition).

The Dodge commode has an interesting and complicated history. In 1955 Pierre Verlet, who did not then know its whereabouts, published the documents relevant to its early years in connection with a companion commode in a private collection in Paris (Verlet 1955: 87–90, no. 15, pl. XV). That piece, which Verlet had first seen ten years earlier among a group of confiscated items being returned to France from Germany, had at some time undergone alterations to its front, including the introduction of a central gilt-bronze plaque of billing doves. Nevertheless, it was marked on its back, like the Dodge example, with the crowned *F* of Fontainebleau and the numbers *35.3*, and it bore in addition a delivery number not found on the Dodge commode: DU NO 3251.2. By comparing the latter number with the entries in the *Journal du Garde-Meuble*, Verlet (1955: 87; see also Verlet 1990: 100) discovered that on July 26, 1783, Riesener delivered the following two items for the use of the king at Fontainebleau: "Dudit jour 26 juillet 1783. Livré par le S. Riézener pour le service du Roy à Fontainebleau... No 3251.—Deux commodes de marqueterie à placcage de bois de rose et frise d'amarante formant plusieurs compartimens avec dessus de marbre blanc veiné, à 5. tiroirs fermant à clef, ornées d'entrées de serrures, consoles, chutes, rainceaux, moulures et anneaux de bronze doré d'or moulu, ayant 4 pieds de large."

A summary of the deliveries made in July 1783 to Fontainebleau indicates that the pieces designated as for the king's use were in fact intended for members of his family, whose apartments he was responsible for furnishing. As published by Verlet (1955:87), the pertinent passage reads as follows: "Juillet 1783. 3238... 3251.—2 commodes de marqrie. Pour le service de M. le Dauphin, de Made fille du Roi et de Made Élisabeth à Fontainebleau." Verlet states that the two commodes designated *3251* were meant specifically for the

apartment of Madame Élisabeth, Louis XVI's younger sister, where they were to be used with two others of similar design.

The lack of a delivery number on the Dodge commode makes it impossible to determine whether it is one of the two pieces delivered under the number *3251* on July 26, 1783, or one of two similar commodes that are known to have been in Madame Élisabeth's apartment at Fontainebleau but whose delivery records cannot be identified with certainty. It is also possible that the Dodge commode was one of four other commodes, not cited by Verlet, that were delivered on that same date and given the numbers *3238* and *3239:* "Dudit jour 26 juillet 1783. Livré par le S. Riézener pour le service du Roy à Fontainebleau... No 3238.—Deux commodes de marqueterie à dessus de marbre blanc veiné, ayant 5 tiroirs & fermant à clef, la marqueterie de bois de rose et frises d'amarante formans des compartimens à mozaique, ornées de consoles, chutes, rainceaux, moulures et cadres godronnées, entrées de serrures, anneaux, socles et sabots, le tout de bronze cizelé et doré d'or moulue, ayant 4 pieds ½ de large, vingt deux pouces de profondeur et 34 pouces de haut.... No 3239.—Deux commodes de marqueterie de 4 pieds de large, pareille à la precedente." Whatever the case, four commodes, of which the Dodge piece is one, are known to have been in the apartment of Madame Elisabeth at Fontainebleau from about 1783 until 1786.

In that latter year, the apartment of Louis XVI at Fontainebleau underwent extensive alterations. The *salon des jeux* was refurnished, and, again according to Verlet (1955: 88), Thierry de Ville d'Avray, general administrator of the Crown furniture and someone who did not think highly of the king's sister, decided to take three of the commodes from Madame Élisabeth's apartment, including the Dodge piece, and move them to the king's *salon des jeux,* exchanging for them three older and less desirable commodes that had furnished the latter room: "Service de Fontainebleau, le 21 août 1786. Devis de depence en suplement.... Les trois comodes necessaire pour le Sallon du Jeu du Roi seront prises de l'appartement de Made Elizabeth en 1786, la 4e comode servira pour la Chambre de Madame Elisabeth." "19. 9bre 1787. Fontainebleau... Na. Les 3 commodes que l'on retirera du Salon des Jeux du Roi suffiront pour garnir convenablement les 3 principales pièces de Madame Elizabeth."

The relocated Dodge commode and its two companions were then renumbered *35* under a new inventory system established at Fontainebleau in 1787, while the fourth commode, which remained in the bedroom of Madame Elisabeth, was numbered 270 (Verlet 1955: 88): "Le Roi... Petits Appartemens... Salon des Jeux... 35.—3 commodes de marqueterie, les trois panneaux du devant et des cotés plaqués en mosaique fond bois roze, filet noir et blanc, lesdits panneaux encadrés d'une moulure de bronze, rosace de bronze dans les 4 encoignures des panneaux du milieu, tous les chants plaqués de bois violette, la frize du haut de bronze

sur fond bois bleu, les chutes et sabots en feuilles d'orne-mens, rosaces dans les cases sur fond bois bleu, l'agrafe du milieu en feuilles d'ornemens, le tout de bronze doré d'or moulu, 2 grands tiroirs et 3 petits dans la frise, dessus de marbre blanc de 4 pieds de large, à l 400 l. . . . *4 200 l.*" "Appartement de Madame Elisabeth . . . Cabinet . . . 270.— Une commode [etc.]."

However, the Dodge commode and its two companions were not to remain long in the king's *salon des jeux*. A nota-tion in the margin of the new inventory signals an alteration in their positioning, referring to a page in the register that has unfortunately been lost. What is more, the Revolution was soon to follow, and in January 1796 the four commodes were removed from their various positions and sent to the Garde-Meuble National in Paris (Verlet 1955: 88): "Le 23 nivose an 4e. Etat des meubles rentrés du cy-devant chateau de Fontainebleau au Gardemeuble national à Paris et delivrés par le citoyen Longroy cy devant gardemeuble dudit chateau, ex-gardien desdits meubles. Ebenisterie. . . . 35.—Une com-mode de marqueterie. . . . 35.—Une commode idem. 35.— Une commode idem. 270.—Une commode idem."

After this point the history of the Dodge commode is uncertain. One of the three commodes from the king's *salon des jeux* was sent in 1797 to furnish the Maison Monaco, a mansion decorated in June of that year to receive the Ottoman ambassador to the newly formed French Republic (Verlet 1955: 88–89): "Garde-Meuble national. Le six du mois de Messidor, l'an cinq de la République française, une et indivisible. Service de l'Ambassadeur de la Porte ottomanne. Envoyé des Magasins du Garde-Meuble national . . . F. no 35.3.—Une riche commode en ouvrage de marquetterie d'ebenisterie, chams en bois acajou, les panneaux à mosaïque de bois rose à fillets noir et blanc, les pieds en pans coupée, deux grands tiroirs et petit dans la frise du haut, la ditte ornée de sabots de pieds à palmettes, cases et feuilles d'a-cante au dessus, moulures montante des pieds et volutes au haut avec feuilles et chutte au centre, moulure et ornements du bas à gaudrons, cadre de panneaux, rosasses et entrées cizelé, moulure unie au haut surmonté par la frize à anneaux et tigettes avec cadres à jours, le tout en bronze richement cizelé et doré or moulu, la table du dessus en marbre blanc veiné de 4 pieds 6 pounces sur 24 po., le tout portant 35 pounces de haut."

References in the records of the Garde-Meuble thereafter (Verlet 1955: 89) almost certainly relate to the other three commodes, as they mention inventory numbers that do not appear on the Dodge piece. One of those commodes was sent first to the Palais du Luxembourg in February 1798 for the use of the Directorate; then, during the First Empire (1804–15), to the Château de Saint-Cloud, where it was placed in the apartment of général Duroc; then, during the Restoration, to the apartment of the *premier maître d'hôtel* in the same château; and then to the apartment of Madame de Gontaut. It is recorded as leaving the Garde-Meuble in 1828, probably in the form of a royal gift. The other two com-modes entered the Tuileries at the end of the eighteenth cen-tury (Verlet 1955: 89; Verlet 1990: 100). During the Second Empire (1852–70) they were removed to the bedroom of Napoleon III at Saint-Cloud (one is partially visible in a room view published by Clouzot 1925: pl. xx). After this they are no longer mentioned in the records of the Garde-Meuble. Verlet speculates that they were probably either pillaged or destroyed in the burning of Saint-Cloud during the Franco-Prussian War in 1870. In any case, they have disappeared without a trace.

The Dodge commode, which forms the fourth of this group, cannot be located in the records of the Garde-Meuble after the end of the eighteenth century. However, as the large letter *E* stenciled on the top of its carcass appears to be a Garde-Meuble mark, postdating the eighteenth century, it seems probable that the commode remained in the French national collection at least into the early decades of the nine-teenth century. Probably it too left this collection in the form of a royal or state gift.

Trellis marquetry of the type found on the Dodge com-mode is the simpler of two basic patterns used by Riesener. The more elaborate design consists of wider trellis bands with circles, diamonds, or rectangles at their intersections and with florets filling the lozenge-shaped reserves. This more elaborate marquetry was usually used only for Riesener's most important pieces, though the present type also appears on some of his premier works. In addition to the commode *en suite* with the Dodge example now in a private Paris col-lection (identified in *Jours de France* 1970: 104), extant com-modes with this type of marquetry include: one with slightly more elaborate trellis work and with several of the same mounts as the Dodge piece, delivered in 1784 for the bed-room of Marie-Antoinette at the Tuileries and now in the Musée du Louvre, Paris (Verlet 1990: no. 26, 102–04; Alcouffe, Dion-Tenenbaum, and Lefébure 1993: no. 93); one of somewhat simpler design made for Marie-Antoinette's use at the Petit Trianon and recently reacquired for that palace (Meyer 1974: 282, nos. 4–5, fig. 4; Pradère 1989: 382, fig. 467); a nearly identical commode, also probably a royal com-mission, in the collection of the duc d'Audiffret-Pasquier at the Château de Sassy in Normandy (Frégnac 1966: 115, visi-ble in a room view); another commode, nearly identical, in the collection of the Earl of Rosebery at Dalmeny House, West Lothian, Scotland (Bourne 1984: 408, pl. I, visible in a room view); a well-proportioned commode said to have been made for Marie-Antoinette and now in the Rice Collection at the Philadelphia Museum of Art (Rieder 1984: no. 20); a D-shaped commode with open shelves on its curved ends and central drawers enclosed by doors, formerly with Arnold Seligmann and Fils, Paris (*Burlington Magazine* 1927: no. 40; Pradère 1989: 383, figs. 468–69); and a small Transitional

commode with the trellis ground of spotted mahogany and with the same keyhole escutcheons as the Dodge commode, now in the Jones Collection of the Victoria and Albert Museum, London (Brackett 1922: no. 40, pl. 26; Buckland 1980: 36, fig. 16).

Because the descriptions of many pieces in the *Journal du Garde-Meuble,* including a few of the most important, are so brief, it is impossible to determine exactly how many commodes veneered with the present type of marquetry were delivered for the Crown. Like the commodes *en suite* with the Dodge example published by Verlet, many such pieces are simply described as "de marqueterie." Nevertheless, there are some commodes whose *Journal* descriptions are detailed enough to indicate that they were veneered with similar trellis marquetry. Among these are such lost pieces as: a commode that must have resembled the Dodge example delivered in June 1783 for the apartment of Madame Elisabeth at the Petit Trianon; a pair of commodes made to fit within the window embrasures of the commissioner-general's apartment at the Garde-Meuble and delivered there in June 1784; an elaborately mounted commode delivered in October 1784 for Louis XVI's use at Fontainebleau; and two lavishly mounted commodes delivered for Marie-Antoinette's use at the Tuileries on December 21, 1784, the same day as the abovementioned commode in the Louvre.

Trellis marquetry of the present type was also veneered by Riesener on other forms of furniture. Among such works that have survived are: a toilet table delivered in 1784 for the bedroom of Marie-Antoinette at the Tuileries and now in the Petit Trianon (Verlet 1955: no. 17, 93–95, pl. XVI, fig. 17); several bedside tables, the best-known being one in the Louvre, which was delivered in 1784, like the preceding piece, for the bedroom of Marie-Antoinette at the Tuileries (Paris 1968b: lot 120); a *bureau à cylindre* delivered in December 1784 for the *cabinet-intérieur* of Marie-Antoinette at the Tuileries and now in the Louvre (Verlet 1945: no. 12, 27–29, pls. XIV–XV); a pair of *encoignures* (Hamburg 1950: lot 248; London 1952: pl. xi); and a *console-desserte* sold in London in 1983 (London 1983a: lot 109; Kjellberg 1989: 713). The coloring of the marquetry panels on most of these pieces originally differed markedly from that on the Dodge commode: the fillets forming the trellis on the Dodge piece are set against grounds of pink-hued tulipwood, whereas those of most of the other pieces are seen against gray-stained grounds of speckled wood, probably sycamore-maple.

ÉTIENNE LEVASSEUR
1721 Paris–Paris 1798

As a youth, Levasseur is said to have worked in the atelier of André-Charles II Boulle, called Boulle de Sève, who was regarded as the ablest of the sons of the illustrious André-Charles Boulle. Such an apprenticeship seems highly credible since, after his admittance to the guild of menuisiers-ébénistes *in 1767, Levasseur devoted much of his energy to the repair and restoration of late seventeenth- and early eighteenth-century Boulle marquetry furniture, which he often stamped with his own signature, and to making reproductions to satisfy the demand for such pieces from late eighteenth-century connoisseurs. In addition to marquetry furniture incorporating tortoiseshell and brass, Levasseur produced fine pieces veneered with mahogany and precisely outlined by rectilinear gilt-bronze mounts, furniture veneered with satinwood outlined in amaranth, and pieces surfaced with lacquer and ebony. During the course of his career he provided furniture—probably through such dealers as Daguerre, Julliot, and Darnault—for notables, among them the daughters of Louis XV, the comte d'Artois (later Charles X), and the fermier-général* Mulot de Pressigny.

[16]

Étienne Levasseur

Pair of Cabinets, c. 1785

Carcass of oak with ebony veneer, Japanese lacquer panels, gilt-bronze mounts, and white marble tops and shelves, 95 (37⅜) × 121 (47⅝) × 48.3 (19)
Bequest of Mrs. Horace E. Dodge in memory of her husband (71.203, 71.204)

INSCRIPTIONS: Both cabinets are stamped on each rear corner of the top: E. LEVASSEUR, accompanied by the JME guild mark. Painted in red on the upper back rail of each at right is: *No 3.-962.* Painted in black on the central back panel of each piece are: *CEBD* in Cyrillic script over the number *1836* crossed out in red, accompanied on 71.203 by a second number *1836* and on 71.204 by what appears to be the number *1926* both also crossed out in red. Scrawled in blue wax crayon on the tops are: *237.* on 71.203 and *238.* accompanied by the penciled notation *2 W/2,* on 71.204. Paper labels attached to the lower front rails are inscribed in ink: *N 2003* on 71.203 and *N 2002* on 71.204. The undersides of the marble tops are inscribed in blue crayon: *K 2003* on 71.203 and *VN 2002* on the pendant. Scratched on the upper rail of the back of 71.204 is: *KP. KOO.* Also on the upper rail of the back of 71.204 is a round paper label with scalloped edges and the printed inscription in purple: *REICHSFINANZ VERWALTUNG* (the letters strung together), encircling an eagle. Both cabinets bear labels of the Parisian packing and shipping firm of Chenue, along with circular French customs stamps. When

they entered The Detroit Institute of Arts, one of them bore under its marble top the label of the Parisian shipping firm of Pottier.

CONDITION: The cabinets are in excellent condition. The only appreciable deterioration is in the lacquer panels on the doors, each of which has developed several vertical cracks. When the cabinets were cleaned and restored after they entered The Detroit Institute of Arts in 1971, a strip of ebony veneer on the bottom rail of 71.203 that had buckled in several places, notably on the foremost curved section of the right side, was reattached. All four of the marble slabs surfacing the corner shelves have cracked.

PROVENANCE: Russian Imperial Collection, Anichkov Palace, St. Petersburg. Sold by the Soviet government at auction, Lepke's, Berlin, June 5, 1929, lots 211, 212. Founès (dealer), Paris. Acquired by Anna Thomson Dodge through L. Alavoine (agent), New York, 1931.

EXHIBITION: Grosse Pointe 1981: unnumbered, ill. p. 26, fig. 010.

REFERENCES: Berlin 1929: lots 211, 212; *Gazette des Beaux-Arts* 1972: 93, fig. 328.

ADDITIONAL BIBLIOGRAPHY: Vial, Marcel, and Girodie 1912: 312–13; Salverte 1962: 206–07.

Each cabinet, D-shaped in plan, comprises a central cupboard with an adjustable shelf and two open-end sections with fixed shelves, the whole supported by four slender, hexagonal, tapering legs.

Mounted on the cupboard doors and forming the principal decoration are two exceptionally fine panels of Japanese *takamakie* lacquer depicting baskets filled with lilies, peonies, chrysanthemums, and asters, their leaves covered with dewdrops executed in raised pewter. Each panel is framed in turn by a gilt-bronze molding decorated along its inner edge with a repeating leaf design, by a wide band of copper-colored *nashiji* lacquer, and by an outer egg-and-dart molding that serves as a frame for the door. Rectangular plaques of the same *nashiji* surrounded by gilt-bronze frames are applied to each of the exposed shelf walls of the end sections. The remaining surfaces of the cabinets are veneered entirely with ebony, except for the legs, which are inlaid with narrow vertical channels of brass.

Although of a quality encountered only rarely, the gilt-bronze mounts play a relatively minor role in the ensemble, confined as they are to areas of secondary importance. Their principal visual function is to emphasize the rectilinear lines of the piece. Forming a wide band across the frieze are upright acanthus leaves interspersed at intervals of 6.4 cm with clusters of berries. Along the frieze's lower edge runs a flat molding decorated with a central band of very fine concave punching. Adorning the upper areas of both the front and rear stiles are acanthus pendants, from which fall graduated clusters of laurel leaves. The remaining mounts, mostly moldings and panel frames, include: plain, narrow frames defining the front and rear stiles; egg-and-dart moldings, identical to those that frame the cupboard doors, surrounding the shelf openings; acanthus-leaf galleries along the open shelves; moldings of alternating ovoids and florets along the upper edges of the plinth; collars decorated with tongue-and-dart motifs at the top of the legs; and tapering hexagonal feet.

The top and open shelves of each cabinet are surfaced with faintly striated slabs of white marble that contrast handsomely with the overall dark coloring.

When the Dodge cabinets first came before the public, in the 1929 Berlin sale of Russian state treasures from Leningrad (see Provenance), they were listed without provenance. However, by comparing the marks that appear on the backs of both pieces (see Inscriptions) with those on the back of the Riesener *console-desserte* now in the Wrightsman Collection at The Metropolitan Museum of Art, New York (Watson, Dauterman, and Fahy 1966–73, I: 236–39), it can be determined that the Dodge cabinets were formerly together with that piece in the Anitchkov Palace at St. Petersburg, and probably in the same room. For in addition to having nearly identical marks, the Wrightsman console also bears two paper labels printed with Cyrillic inscriptions for which Watson (Watson, Dauterman, and Fahy 1966–73, I: 239) provides the following translation: "The Anitchkov Palace, Blue Room / of Her Highness / No. 1837, French table"; and "The Town Museum (Moscow) Historical Treasures from Anitchkov Palace No. 2008."

Watson suggests that the phrase "Her Highness" in the first inscription refers to Maria Feodorovna (1759–1828), wife of Czar Paul I, who ruled from 1796 until his assassination in 1801. But as she never lived at Anichkov, this provenance does not seem likely. The Anichkov Palace, a handsome, colonnaded building on the Fontanka in St. Petersburg (Kennett 1973: 70–73), was built by Empress Elizabeth for her lover, Alexis Razumovsky, and was presented to him in 1750. It became a royal residence about 1807, when it was given to the Grand Duchess Yekaterina Pavlovna, one of the sisters of Alexander I, on the occasion of her marriage. At that time, it underwent extensive redecoration, much of which was destroyed by fire in 1812. The palace underwent further alteration and decoration in 1816 to make it a suitable residence for the heirs to the throne, and from 1817 onward it was inhabited successively by the future Nicolas I and his wife, Alexandra Feodorovna, who lived there until 1825; the future Alexander II and his wife, Maria Alexandrovna, who

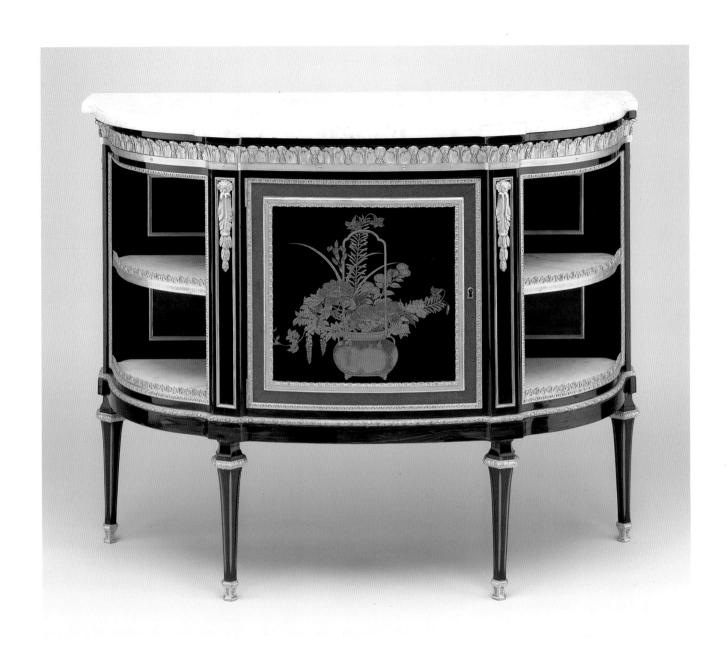

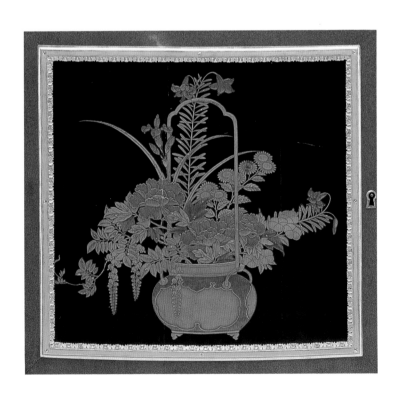

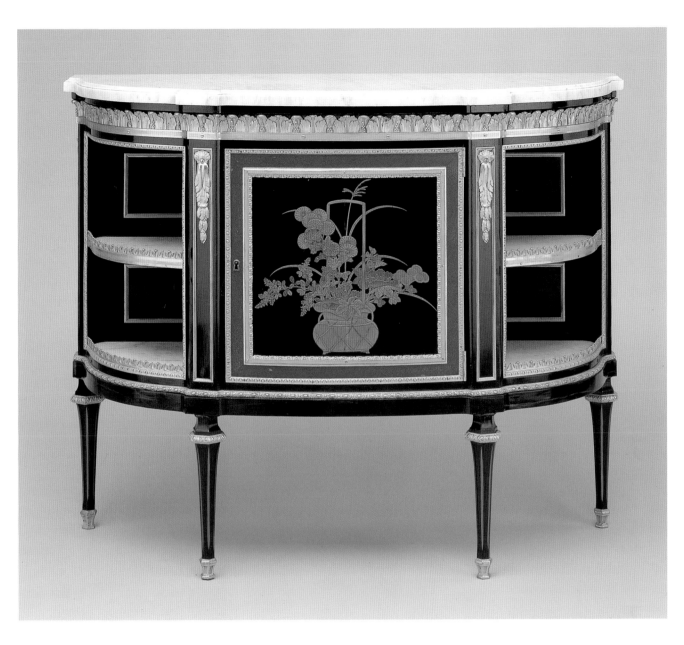

lived there from 1841 until 1855; Alexander III and his wife, Maria Feodorovna, the second empress of that name, who lived there both as heirs apparent and as rulers from about 1866 until the czar's death in 1894; and Nicolas II, who lived there from his birth and then with his wife, Alexandra Feodorovna, also the second of that name, until 1895. Maria Feodorovna, wife of Alexander III, continued to live at Anichkov as dowager empress until the Revolution in 1917.

Both the style of the label on the Wrightsman console and the history of the Anichkov Palace suggest that the term "Her Highness" more likely refers to the second Maria Feodorovna, who lived at Anichkov for some fifty years beginning in 1866, although it could also refer to any of the other empresses who resided there during the nineteenth century. Nevertheless, it is possible that the two Dodge cabinets did originally belong to the first Maria Feodorovna and once formed part of her furnishings at some other palace. Fine furniture and porcelain intended for Pavlovsk Palace, outside St. Petersburg, were acquired by Maria Feodorovna and Paul I from the dealer Daguerre during their trip to Paris in 1782 (see p. 59), and the Dodge cabinets, with their open curvilinear shelves, are very much in the style of other works sold by that dealer.

The Japanese lacquer panels set into the doors of the present pieces were probably cut from a chest, since they are too wide to have formed the doors of a conventionally sized cabinet. The *nashiji* panels decorating the outer areas of the doors and the shelf walls probably came from the inside surfaces of such a chest. No similar cabinets by Levasseur are known, although a very closely related example signed by Martin Carlin, mounted on the door with a circular lacquer panel, is in the Grog-Carven collection in the Musée du Louvre, Paris (Alcouffe, Dion-Tenenbaum, and Lefébure 1993: no. 73). It seems likely the Dodge and Grog pieces had a common denominator in Daguerre, for whom Carlin is known to have worked.

Other pieces by Levasseur that incorporate lacquer panels include: a secretaire with panels depicting baskets of flowers, with Alexander and Berendt, London, in 1971 (Pradère 1989: 316, fig. 359); a *commode à vantaux,* formerly in the Château d'Ermenonville, Oise, with the stamps of both Levasseur and Bernard Molitor (Nicolay 1956–59, I: 302, fig. B; Leben 1992: 178, no. 2); and a four-drawer commode formerly in the collection of the Earl of Rosebery (London 1964a: lot 51; Pradère 1989: 317, fig. 360).

[17]
French Maker

Pair of Jardinières in the Form of Athéniennes,
c. 1775–80

Carved and gilded oak and lime with bronze bowls and gilt-bronze mounts
71.201: 94 (37) × 45.1 (17¾)
71.202: 94.6 (37¼) × 45.7 (18)
Bequest of Mrs. Horace E. Dodge in memory of her husband (71.201, 71.202)

INSCRIPTIONS: Incised on the underside of the base of 71.201: the Roman numeral *II;* on that of 71.202: the Roman numeral *IV.* The modern zinc liners of both pieces have affixed to their undersides a blue-bordered paper label with the printed legend: *MADE IN FRANCE* and the inked inscription: *4 BACS EN ZINC VIEILLI;* these are accompanied by *No3* on 71.201 and *No4* on 71.202.

CONDITION: The gilded surfaces of both jardinières are in fragile condition. Before their restoration in 1992, large sections of gesso had flaked away from several areas, exposing the bare wood beneath; these losses had been disguised with gold paint. In other places the gold leaf had worn thin, exposing the reddish-brown bole. Much of this surface deterioration has now been repaired. Within the structure of the two pieces, cracks and fissures have developed : . points where the wooden components were glued together before carving. On 71.201 the end of one of the cloven hooves has been partially broken away, and a crack runs across the base from one side to the other; at one end of this crack, a triangular section of the wood with carved decoration has been broken off and reattached, and at the other end a similar section has become loose. The base of 71.202 is similarly cracked, though without the loosening of any triangular sections. The circular wooden friezes were pieced together from a number of elliptically cut segments; over the years, several of these have warped somewhat, with the result that a number of cracks have formed in the gessoed and gilded surfaces on 71.201, while on 71.202 the segments have separated to such a degree that many of them protrude markedly from the intended line of the curve. A number of the rams' horns on both jardinières have been broken and repaired, and all but one of the floral garlands have broken off and been reattached. Holes drilled on the undersides of the feet indicate that the jardinières were at one time fitted with casters. The present zinc liners are modern replacements.

PROVENANCE: Edmond Blanc, Paris. Duveen Brothers (dealer), New York. Acquired by Anna Thomson Dodge from Duveen Brothers, 1935.

REFERENCE: Detroit 1939, I: n.p.

The design of these jardinières, in the fully developed Neoclassical style, is inspired by Greco-Roman braziers. The components of the jardinières are for the most part of oak with the intricately carved floral elements executed in much softer lime. At the top of each piece is a bronze bowl fitted with a removable zinc liner intended to hold floral arrangements; the bowl is mounted at its lip with a wide gilt-bronze band and at its base with a pendant seedpod from which rise acanthus leaves.

Cradling the bronze bowl is a circular wooden frame carved on its frieze with rinceaux of ivy tied at the centers with crimped ribbon. This frame is supported by three incurvate legs carved down the outer surfaces with piastres; at the top of each leg is a ram's head with horns that curl over the sides of the circular frame, and at the bottom is a cloven hoof from which rise acanthus leaves. Suspended between the rams' heads are garlands of roses, orange blossoms, cornflowers, lilacs, and other blooms. The legs are united about two-thirds of the way down by a fluted collar. The whole of the tripod section rests on a heavy trilobate base decorated along its upper edges with a repeating leaf motif and raised up on three bun feet.

Giltwood stands such as these were generally referred to in the eighteenth century as *athéniennes.* Their history has been extensively researched by Dacier (1932) and by Eriksen and Watson (1963), with additional information being published by Haug (1965: 93–97).

Dacier was able to establish the probable date of introduction of the *athénienne* through an advertisement printed in the *Avant-Coureur* for September 27, 1773, in which the nature and various uses of this new form of furniture were described in detail. Fashioned in the antique taste from the designs of a well-known art lover, the advertisement states, the *athénienne* was intended for use in the salon or boudoir, where it could be easily moved around on casters to perform a number of functions.

About 80 cm tall, the prototype *athénienne* was composed of three carved and gilded wooden consoles supporting a patinated copper cassolette with gilt-bronze decoration. The interior of the cassolette was silvered and contained a removable spirit lamp, above which was set a tin-plated double boiler. On top of this rested a small marble slab surmounted by a patinated copper cover.

Eight uses of the *athénienne* were enumerated: (1) as an ornament and focal point in the middle of a room; (2) as a table under a pier mirror, or in a corner, or as a pedestal to support a candelabrum or a piece of sculpture; (3) as a perfume burner—by removing the marble slab and filling the container above the spirit lamp with perfume; (4) as a heater for making coffee, tea, or chocolate; (5) as a goldfish bowl— by removing the spirit lamp and filling the basin with water; (6) as a planter to grow bulbs in winter; (7) as a bowl for cut flowers; and (8) as a device for keeping bouillon or other

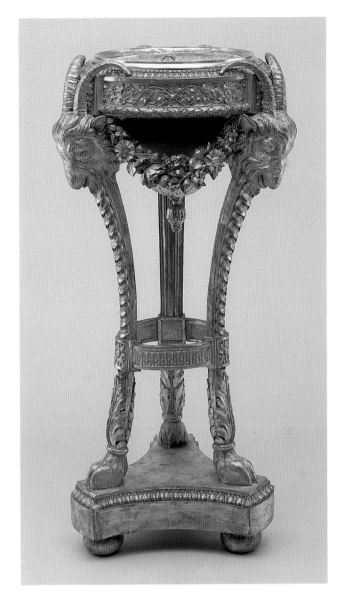

71.201

drinks warm—by placing a pierced metal plate above the spirit lamp. The reader was invited to examine a group of *athéniennes* in the studio of M. Watin, painter, gilder, and varnisher, with premises near the porte Saint-Martin.

The art lover referred to in the advertisement as the designer of the *athénienne* was the banker Jean-Henri Eberts (1726–1803), well known in the late eighteenth century for having published a book of engravings titled *Le monument du costume*. It is almost certain that Eberts got both the inspiration for the piece and the name for it from the 1762 painting he owned by Joseph-Marie Vien entitled *La vertueuse athénienne*—now in the Musée des Beaux-Arts, Strasbourg (Haug 1965: 94, fig. 8). That work depicts a classical maiden pouring the contents of a bowl into a flaming tripod cassolette similar in form to the Dodge *athéniennes.*

In addition to the advertisement published in the *Avant-Coureur,* there survives a single copy, preserved in the library of the University of Warsaw, of an engraved leaflet that illustrates the exact form of Eberts's *athénienne* (Eriksen and Watson 1963: 16, ill.). Of the same basic shape as the Dodge

examples, it differs primarily in that it lacks the rams' heads, with the tops of its legs ending in volutes overlaid with acanthus leaves; a pine cone finial ornaments the center of its base; and it has a conical brazier cover.

The large number of *athéniennes* that survive indicates that the invention was a considerable success. In an era of Neoclassical mania, certainly little else could have added more tone to an interior. Unlike various other pieces of furniture that in essence were merely standard French forms with an overlay of Neoclassical decoration, the *athénienne* was based directly on the antique tripod cassolette. Widely known in the eighteenth century through such publications as the comte de Caylus's *Receuil d'antiquités* of 1752–67 (II: pl. LIII), cassolettes had also been part of the classical repertoire in the Baroque era. A four-legged cassolette is depicted by the seventeenth-century designer Jean Lepautre (active 1645–82) in an engraved design for a fireplace, above which hangs a painting that shows a Roman soldier standing by a flaming cassolette (Guérinet n.d.: pl. 8). And a tripod cassolette can be seen in the Gobelins tapestry known as *Saturne—L'Hiver* from the series titled *Les portières des dieux,* designed by Claude III Audran in 1699–1700 (Fenaille 1904–07, IV: ill. opp. p. 14).

At present it is not possible to identify the maker of the Dodge *athéniennes.* Examples signed by Georges Jacob and by A.-P. Dupain are known (see below), but not enough stylistic similarities exist to warrant an attribution to either of these makers. It seems likely that *athéniennes* were produced by a number of teams of *menuisiers* and *sculpteurs* and that many were never fitted with the various accessories described by Watin but were meant instead to serve as small decorative tables or jardinières. Indeed, it is probable that the Dodge examples were intended from the beginning for use as flower stands.

None of the many surviving *athéniennes* duplicates the Dodge pair. Examples that are nearly identical to the one in Eberts's engraving include: a pair in the Wrightsman Collection at The Metropolitan Museum of Art, New York (Watson, Dauterman, and Fahy 1966–73, I: 103–05); a pair formerly in the collection of René Fribourg, New York (London 1963a: lot 794); and a pair in a Paris private collection. All three pairs have legs overlaid at the top with acanthus leaves, friezes decorated with Vitruvian scrolls, and no lids.

Slightly different types with floral swags hanging from the scrolled tops of their legs and with rinceaux on their friezes include: an example in the Cincinnati Art Museum (paired with a later copy) with no bowl or lid, its top fitted with a white marble slab to form a *guéridon;* a pair in the Musée Nissim de Camondo, Paris (Paris 1973: 16, no. 37, ill.; Verlet 1982: fig. 39; Gasc and Mabille 1991: 49), formerly in the collection of Madame Louis Burat; a pair formerly in a New York private collection (New York 1949a: lot 330); a pair raised up on marbleized plinths, sold in Paris in 1963 (Paris

1963: lot 32); and a pair raised up on giltwood plinths, sold in Paris in 1993 (Paris 1993: lot 97).

More divergent *athéniennes* with scroll-top legs include: a pair signed by Georges Jacob with *entrelac* friezes and legs carved behind their tops with oak-leaf clusters, formerly in the collection of Georges Lurcy (New York 1957a: lot 202) and probably identical with the pair signed by Jacob sold in Paris in 1974 (Paris 1974a: lot 59); a similar pair with marble tablets fitted to their tops, formerly in the collection of the marquise de Ganay (Paris 1922a: lot 273); a pair carved with *entrelac* friezes and unfurling acanthus in place of the oak-leaf clusters, formerly in the collection of Camille Lelong (Paris 1903: lots 433, 434); a similar example auctioned from a New York collection in 1943 (New York 1943: lot 367); a similar pair with a Vitruvian-scroll frieze, formerly in the collection of the dealer J. Payet (Lyons 1921: lot 634); and three *athénienne*-type *guéridons* of bolder form with oak-leaf swags suspended between their legs, one with a Vitruvian-scroll frieze, with French and Company, New York, in 1958 (photograph preserved in the photographic archives at the Getty Center for the History of Art and the Humanities, Los Angeles), the others, a pair with *entrelac* friezes and identified as Italian, auctioned from the inventory of Bernard Steinitz in 1993 (Saint-Ouen 1993: lot 755).

Various models carved with rams' heads at the tops of their legs include: a single example with Greek-key feet acquired in 1983 by The Metropolitan Museum of Art, New York (New York 1984a: 33–34); a single example formerly in the collection of Philippe Wiener, Paris (Réau, Féral, and Mannheim 1929: no. CVIII), probably identical with the one now in the Musée Lyonnais des Arts Décoratifs, Lyons (Reyniès 1987, II: 1148–49; Whitehead 1992: 67); an almost identical pair formerly in the Dubois Chefdebien collection (Paris 1941: lot 96; see also Paris 1950: lot 95); and a signed pair by A.-P. Dupain nearly identical to the cassolette in the Vien painting, formerly in the collection of K.J. Hewitt (Watson 1960: fig. 226). All these pieces lack the floral garlands of the Dodge *athéniennes.* Finally Haug (1965: 96, fig. 9) illustrates a finely carved example from a private collection near Strasbourg decorated at the tops of its legs with garland-draped lions' heads.

Gilt-bronze *athéniennes* of quite different form also exist (Paris 1912: lot 264; Paris 1937a: lot 91; London 1964a: lot 108; London 1966a: lots 125, 126; London 1973b: lot 74; Paris 1977: lot 113).

Giltwood *athéniennes* can be seen in such late eighteenth-century paintings as Louis-Léopold Boilly's *La dame aux roses,* formerly in the Fribourg collection, New York (London 1963: lot 71); in Joseph Melling's portrait of a father and daughter in the Musée des Beaux-Arts, Strasbourg (Haug 1965: 96, fig. 10); and in Louis-Rolland Trinquesse's *Interior Scene,* dated 1776, on the New York art market in 1983–84 (Atlanta 1983: no. 56).

French Maker

Set of Six Lyre-Back Side Chairs, c. 1785

Carved and gilded beechwood, 90.9 (35¾) × 45.4 (17⅞) × 50.2 (19¾)
Bequest of Mrs. Horace E. Dodge in memory of her husband (71.188–71.193)

CONDITION: The gessoed and gilded surfaces of the chairs have undergone much restoration, especially in the vulnerable areas of the legs; the original gilding that does survive is heavily worn, revealing the brown bole beneath. The delicate frames have also suffered considerable structural deterioration over the years. The crosspieces forming the tops of the lyres on 71.190–71.193 have each broken vertically, and the front rails of several of the chairs have bowed downward. To avoid collapse of the chairs, support blocks have been fastened to the frames at the junctures of the seat rails with the legs. Carved rosettes are missing from the right end of the top rail on 71.190 and from the block above the left rear leg of 71.188. The chairs' original web-support upholstery has been replaced with modern steel springs, and the present seat coverings also are modern.

EXHIBITION: Grosse Pointe 1981: unnumbered.

PROVENANCE: Grazia (dealer), Paris. Acquired by Anna Thomson Dodge through L. Alavoine (agent), New York, 1931.

REFERENCE: *Gazette des Beaux-Arts* 1972: 93, fig. 324.

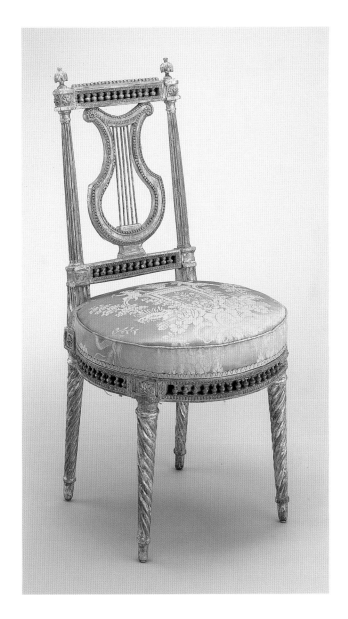

Each frame comprises two tall rear uprights joined by an upper and lower rail and an openwork splat to form a rectangular back, with the lower sections of these uprights forming the rear legs; four seat rails, all curved except for a straight rail at the rear; and two turned uprights that form the front legs. The elements are joined together with pegged tenons and are gilded in the standard eighteenth-century manner, with successive layers of gesso, bole, and gold leaf.

The slightly canted rear uprights of the backs are treated as fluted colonnettes, with a central splat mounted between them in the form of a large lyre carved along its outer edges with a repeating leaf motif and around its inner edges with pearl beading. A strip of much bolder pearl beading is nailed to the upper rail of the back and is flanked at the top of each stile by a finial carved in the form of a panache.

Decorating both the seat and back rails are balustrades set against silvered panels varnished a robin's-egg blue; the individual balusters are turned separately and are held in place by nails driven through the rails from below. All four of the tapered legs are carved with spiral fluting. At each point where one of the chair's uprights meets a rail, there is a small rosette that has been carved separately and glued in place.

Chairs with lyre backs were popular in France during the last quarter of the eighteenth century. Their decoration made them eminently suitable as seat furniture for music rooms, but they were no doubt used as well in other rooms when auxiliary chairs were needed to expand seating capacity during large social gatherings. The small size and delicate construction of these chairs necessitated a more careful upright sitting position, and they were thus not comfortable for long periods of time. But their light weight gave them the advantage of being easily movable from one position in a room to another as the need arose.

Among such chairs, the Dodge examples are particularly noteworthy for their fine proportions, for the quality of their carved detail, and especially for their elaborate closed balustrades backed with varnished silvered panels, the execution of which entailed considerable additional labor.

The curious fact that lyre-back chairs are very rarely signed renders attribution difficult. Both Georges Jacob and Jean-Baptiste-Claude Sené, the most renowned chairmakers of the last quarter of the eighteenth century, produced finely

carved chairs of this quality, but there is nothing in the design of their signed works to specifically suggest either of them as maker of the Dodge examples. Chairs of this type were also made by Jean-Baptiste-Bernard Demay. A suite of six side chairs stamped by Demay, which incorporate lyres in their backs and have similarly conceived circular seats, spirally fluted legs, rosettes, and colonnette back stiles, were in the collection of Thelma Chrysler Foy (New York 1959: lot 303), while a pair of lyre-back chairs also bearing his mark and formerly in the collection of Mademoiselle Marcelle Lender (Paris 1927a: lot 363) has similar rounded seats and rosettes marking the junctures of the legs with the seat rails. The Dodge chairs are clearly related to the two Demay sets; but since chairmakers of the period commonly shared a whole range of decorative motifs, the existence of these signed suites does not provide a firm enough base for an attribution.

Of the many extant lyre-back chairs of this general type, the following examples should be singled out for comparison: an unsigned pair in the Museum of Fine Arts, Boston; a mahogany example signed by Henri Jacob in the C.L. David collection, Copenhagen (Del 1953: 229); four chairs signed by Georges Jacob auctioned in Paris in 1936 (Paris 1936: lot 92); an unsigned pair from the collection of Mrs. Theodore A. Havemeyer auctioned in New York in 1952 (New York 1952: lot 348); an unsigned pair with panache finials formerly in the collection of Countess Sala (New York 1961: lot 243); an unsigned suite of sixty chairs formerly in the collection of princesse Cécile-Caroline Murat (Schlumberger 1961: 38–39); an unsigned pair sold in New York in 1962 (New York 1962: lot 116); an unsigned pair auctioned in Paris in 1969 (Paris 1969: lot 95); and an unsigned set of six from the Gutiérrez de Estrada collection auctioned in Paris in 1905 (Paris 1905: lot 154; Ricci 1913: 247, ill.). Of all the chairs in this group, only those of the last-named set have the comparatively rare spirally fluted legs of the Dodge examples.

The highly unusual balustraded seat and back rails provide even less evidence as to the maker of the Dodge chairs, since not one of the known examples so decorated bears a signature. Chairs with such rails include: a *bergère* with spirally fluted legs in the collection of Marcel Boulanger, Paris, in 1913 (Contet 1913: pl. 36); a side chair with straight fluted legs and an open colonnaded back in the Centraal Museum, Utrecht (Haarlem 1989: 31, no. 132, as possibly made in Amsterdam); four chairs, very similar to the preceding, auctioned in Paris in 1961 (Paris 1961a: lot 101); a *fauteuil* with a similar colonnaded back auctioned in Paris in 1989 (Paris 1989: lot 154); and a suite of six *fauteuils* with upholstered backs and round seats auctioned in Monaco in 1992 (Monaco 1992: lot 107).

GEORGES JACOB
1739 Cheny – Paris 1814

Georges Jacob was perhaps the most successful businessman among the furniture makers of the eighteenth century. Born into a humble family in the Burgundian village of Cheny, he came to Paris at about the age of sixteen and, according to Pallot (1993: 194), apprenticed for one year in the workshop of the chairmaker Jean-Baptiste Lerouge and, after the death of Lerouge, in that of his widow for another six, perhaps spending the three years of his compagnonnage *there as well.*

In 1765, at the age of twenty-six, Jacob was admitted to the guild of menuisiers-ébénistes. His obvious talent and industry soon won recognition, and by 1773 he was receiving commissions from the Garde-Meuble, apparently at first for the restoration of older pieces, but, by 1777, for important original works as well. A highly accomplished chairmaker, he was a proficient cabinetmaker as well, and later in life was responsible for a number of pieces finished with veneer.

Jacob produced seating furniture and other forms of menuiserie for the most fashionable figures of the day, including Marie-Antoinette; the king's two brothers, the comte de Provence (later Louis XVIII), and the comte d'Artois (later Charles X); the king's sister, Madame Elisabeth; the prince de Condé; the ducs de Penthièvre, Liancourt, and de la Rochefoucauld d'Enville; as well as such foreign luminaries as Gustavus III of Sweden and the Prince of Wales (later George IV).

In 1796 Jacob gave over his business to his two sons, Georges II and François-Honoré-Georges, who ran it as Jacob Frères. However, after the death of Georges II in 1803, the elder Jacob formed a new association with his surviving son, François-Honoré-Georges, under the name of Jacob-Desmalter et Cie. When that son was named ébéniste *to Emperor Napoleon, the business began developing into an enormous enterprise employing close to three hundred men in fifteen workshops: seven for menuiserie, ébénisterie, and wood turning; three for carving, painting, and gilding wood; three for bronzeworking; one for upholstery; and one for locksmithery. From Jacob-Desmalter et Cie poured out a vast quantity of case furniture and chairs for the many palaces the emperor was having redecorated in France as well as in Italy and Holland; among these were the renowned imperial throne at Fontainebleau and the jewel cabinet of Empress Marie-Louise in the Louvre.*

However, in 1813, with the gradual financial collapse of the Empire following the long wars and the campaign in Russia, the firm of Jacob-Desmalter et Cie failed. The next year Georges Jacob died, one day short of his seventy-fifth birthday. Although François-Honoré-Georges was able to reconstitute the business, which remained in operation until 1847 under his son Georges-Alphonse Jacob-Desmalter, it never regained its former greatness.

Georges Jacob

Set of Six Flat-Backed Fauteuils Upholstered with
Beauvais Tapestry Covers, c. 1780–85

Frames of carved and gilded beechwood, upholstered with
tapestry-woven panels, 91.1 (35⅞) × 64.2 (25¼) × 64.8 (25½)
Bequest of Mrs. Horace E. Dodge in memory of her
husband (71.182–71.187)

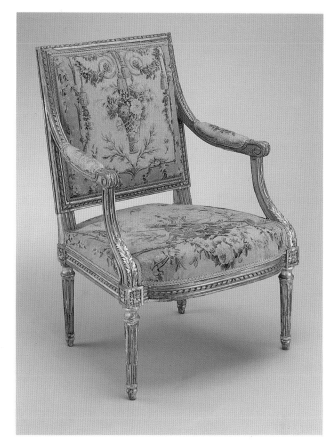

INSCRIPTIONS: Stamped under the rear seat rail of each chair
except 71.187 is the signature: G. JACOB. Affixed inside the
rear seat rail of each chair except 71.183 is a blue-bordered
label inscribed in ink: *1391 / FAUTEUIL.* Affixed to the back
rail of 71.184 is a paper label inscribed in ink: *1393.* Under the
webbing of each seat is a circular Paris customs label. Marked
in blue wax crayon on the left seat rails of several of the chairs
are one-digit numbers apparently meant to differentiate
them; as these appear under a semitransparent coat of light
gray paint, they probably were applied at the time of manu-
facture, when the frames were still unfinished.

CONDITION: The frames are still structurally sound, but their
gessoed and gilded surfaces are in poor condition, presenting
an unattractive appearance at close range. Most of these sur-
faces appear to be modern; when the chairs were sold in 1923
(see Provenance), they were described in the catalogue
as having been regilded. The tapestry panels have faded
considerably.

PROVENANCE: Madame Billout-Desmarets, Galerie Georges
Petit, Paris, June 1, 1923, lot 20, sold to Vagliano. André J.
Seligmann (dealer), Paris. Acquired by Anna Thomson
Dodge through L. Alavoine (agent), New York, 1932.

REFERENCES: Paris 1923: lot 20; *Gazette des Beaux-Arts* 1972:
93, fig. 325; Ledoux-Lebard 1975: 36–38.

ADDITIONAL BIBLIOGRAPHY: Vial, Marcel, and Girodie 1912:
258–59; Lefuel 1923: 13–108; Nicolay 1956–59, I: 193–96, 213,
228–32, 237–42; Salverte 1962: 164–69; Frégnac and Meuvret
1965: 228–41; Ledoux-Lebard 1984: 267–93; Pallot 1993:
194–96.

The rather ample frames of these *fauteuils* consist entirely of
straight members except for arms, which curve gracefully
downward and outward from the back, incurvate supports
set between the handrests and the seat, and a bowed front

seat rail. The flat, square back is slightly splayed toward the
rear, and the side rails of the seat splay outward as they
approach the front legs. All the elements are joined by pegged
tenons and are gilded in the standard manner, with their sur-
faces covered by successive layers of gesso, brown bole, and
gold leaf.

The carved ornament consists of the following: plain cap-
itals over stop fluting on the turned, tapered legs; blocks
carved with rosettes at the junctures of the legs and the seat
rails; upright acanthus below plain ribs on the arm supports
and the scrolled handrests; and deeply carved twisted rib-
bons running along the seat rails, on the upper sections of the
arms, and entirely around the back.

Upholstered to the frames are identical sets of tapestry pan-
els executed in polychrome on a beige ground within a pale
green border. The back panels represent baskets of flowers
hung by tasseled ropes from stylized frames draped with floral
garlands; beneath the baskets rise crossed olive branches sym-
bolic of peace. The seat covers depict trophies emblematic of
love, incorporating Apollo's lyre, Cupid's bow and quiver, a
clarinet, a tambourine, and crossed oak branches symboliz-
ing love's durability; around the edges of the panels runs a
floral frame, with a garland of flowers spilling over the seat
in front.

Although Georges Jacob's vast pre-Revolutionary oeuvre
included *fauteuils* of many different forms, square-backed
examples with bowed front seat rails and arms curving down

from the back rank among his most frequent productions. The ample proportions of the backs and seats of such chairs, known in the eighteenth century as *fauteuils à carrée à la Reine,* made them ideal frames on which to upholster tapestry panels. In order to impart individuality to similar sets of frames, variations were made in the carved detail; by replacing the twisted ribbon seen here with plain moldings or a repeating-leaf or *entrelac* motif, and by altering the decoration on the arms and legs, strikingly different effects could be achieved.

Most chairs of this type seem to have been produced during the 1780s, with documented pieces dating from both the first and the last years of that decade. For example, among the vast number of chairs made by Jacob for the various residences of the comte de Provence are four of the same type as the Dodge chairs, which were delivered to the Palais du Luxembourg in 1781: "Quatre fauteuils à la Reine de forme carrée; ornés et profilés de doubles moulures, et des feuilles d'ornements sur la face des consoles; les pieds tournés en gaîne et cannelés et des rosaces dans les cases; à 24 livres" (Lefuel 1923: 175). Two similar chairs made by Jacob for the use of the comte de Provence's head stablemaster at Versailles are recorded as follows: "Deux fauteuils carrés à la Reine; ornés et profilés de doubles moulures; les accotoirs entaillés dans les montants et régnant ensemble avec des feuilles d'ornements sur la face des consoles; et les pieds en gaîne, cannelés; et des rosaces dans les cases, à 24 livres" (Lefuel 1923: 265).

A large number of square-backed armchairs by Jacob of the Dodge model, adorned with various types of carved decoration and upholstery panels, have survived into the twentieth century. Representative signed examples by Georges Jacob include: a set comprising eight *fauteuils,* along with two *bergères* and a *canapé,* decorated like the Dodge chairs with twisted ribbon and upholstered with Aubusson tapestry panels, formerly in the Helena Rubinstein collection, Paris (New York 1966: lot 502); a set comprising ten *fauteuils,* two *canapés,* a *marquise,* and a fire screen, all carved with twisted ribbon (some of the pieces signed by Jacob and some stamped *I.B.*) and upholstered with Aubusson tapestry panels, formerly in the collection of Sir Richard Wallace, Bart., at 2, rue Laffitte, Paris (Watson 1956: pl. 120), and now in the Museé Nissim de Camondo, Paris (Paris 1973: 29, ill., no. 135); a set comprising six *fauteuils,* two *marquises,* and a *canapé* carved with piastres and a simple repeating-leaf motif and upholstered with brocatelle, formerly in the collection of Fernand and Jules Jeuniette (Paris 1919: lot 441); a pair of *fauteuils* carved with a repeating-husk motif and upholstered with Beauvais tapestry panels in the Frick Art Museum, Pittsburgh (Hovey 1975: 99, ill.); a single *fauteuil* with repeating-leaf decoration and damask upholstery sold in Paris in 1937 (Paris 1937: lot 30); a single *fauteuil* with *entrelac* decoration and pressed-velvet upholstery formerly in the Zambaux collection, sold in Paris in 1921 (Paris 1921: lot 194); a large set of seating furni-

ture, including sixteen *fauteuils,* made by Jacob in 1787–88 for the *salon des jeux* of Louis XVI at Saint-Cloud and decorated with elaborate *entrelac* carving and brocade upholstery, parts of which are now in The Metropolitan Museum of Art, New York (Verlet 1963: 181–82, no. 38a, ill. opp. p. 188), the Musée du Louvre, Paris (Verlet 1955a: 152–54, no. 36, pls. XXXVI, XXXVII; Pallot 1993: no. 58) and elsewhere (Monte Carlo 1988: lot 45); a set of two *fauteuils* and two side chairs richly carved with twisted floral garlands and upholstered with embroidered panels, formerly in the collections of the duc de Penthièvre and of Louis-Philippe and now in the Kress Collection at The Metropolitan Museum of Art (Dauterman, Parker, and Standen 1964: no. 7, figs. 41–50); and a related set of two *fauteuils* and a *marquise* carved with bound floral garlands and ropes of flower clusters, similarly upholstered, also formerly in the collection of Louis-Philippe and now in the Kress Collection at The Metropolitan Museum of Art (Dauterman, Parker, and Standen 1964: no. 8, figs. 51–53). Additional Jacob chairs of this type are illustrated by Nicolay (1956–59, I: 229, fig. R, 239, fig. AY, 242, fig. BG). Though the carved decoration on the Dodge chairs is not of the same high quality as that on the examples in the Metropolitan Museum and the Louvre, it more accurately represents the level found on the majority of chairs of this type.

Other chairs signed by Jacob that are of the same overall form but have slight variations in their shapes include: a pair with straight front seat rails and Aubusson tapestry panels sold in Paris in 1928 (Paris 1928: lot 130); a set of eight *fauteuils,* two *marquises,* and a *canapé* with Beauvais tapestry panels in The Wallace Collection, London, the *fauteuils* differing in form from the Dodge examples in that they have carved decoration on the cresting rail of the back (Watson 1956: nos. F193–200, pl. 29); and a set of six *fauteuils* and a *canapé* with Beauvais tapestry panels, also in the Wallace Collection, those carved with twisted ribbon decoration but differing in form from the Dodge chairs in that the cresting rails of the *fauteuils* are arched rather than straight (Watson 1956: nos. F185–191, pls. 30, 31).

The tapestry panels of the Dodge chairs give every appearance of being original to the frames, though when the suite appeared at auction in 1923 (see Provenance), the expert for the sale, Marius Paulme, stated in the catalogue that the frames had been reupholstered. This seems highly unlikely. The large square backs of the chairs appear to have been intended for such panels, and, indeed, as can be seen from the related suites cited here, the majority are so upholstered.

The present tapestry panels are of a rare design. That they were made at the Beauvais manufactory seems confirmed by the existence at Versailles of six *fauteuils* upholstered with identical panels documented as coming from Beauvais and woven during the last years of the eighteenth century. The Versailles *fauteuils* are part of a set of thirty-three pieces made

in 1805 by the firm of Jacob-Desmalter et Cie for the *grand salon* of Pauline Borghèse, sister of Napoleon, at the Petit Trianon. The panels on the *fauteuils,* which along with twenty-one other pieces from the set are now in the Grand Trianon (Ledoux-Lebard 1975: 36–38), differ from the Dodge examples in that their borders are brown rather than green. Four more related *fauteuils,* with back panels reversing the composition on the Dodge examples, were sold from the Henry Morgenthau collection in New York in 1947 (New York 1947: lots 773, 774, catalogued as work of the nineteenth century).

The Dodge chairs may have originally belonged to a larger set including, like several of the suites mentioned here, *bergères, marquises,* and one or more *canapés.*

[20]

Set of Beauvais Tapestry Chair Covers, c. 1785

Upholstered onto three modern *canapés* and eight modern *fauteuils*
Covers of tapestry-woven silk and wool, frames of carved and gilded beechwood
Canapés F71.47–F71.49: 106.4 (41⅞) × 176.2 (69⅜) × 82.5 (32½)
Fauteuils F71.50–F71.53: 100 (39⅜) × 77.5 (30½) × 67.3 (26½)
Fauteuils F71.54–F71.57: 97.8 (38½) × 72.4 (28½) × 66 (26)
Bequest of Mrs. Horace E. Dodge in memory of her husband (F71.47–F71.57)

INSCRIPTIONS: Written in pencil under the rear seat rail of *fauteuil* F71.52: *ANDRE VIZAN,* presumably the name of a late nineteenth-century chairmaker or upholsterer. Stamped under the rear seat rails of *fauteuils* F71.53, F71.55, and F71.56: the letter D. Marked in orange wax crayon on each piece are the letters *PM,* followed by numbers running from *47* to *54* on the *fauteuils* and from *55* to *57* on the *canapés;* these refer to an inventory system used in 1912 when J. Pierpont Morgan's furniture was shipped from London to New York (see Provenance).

CONDITION: The covers are on the whole in unusually good condition, suggesting that they might have been kept in storage for much of their history. Nevertheless, some deterioration is evidenced both in the fabric itself, which shows repair in a number of areas, and in the colors. The degree to which fading has occurred can be gauged by comparing the covers today with a photograph made of one of the *canapés* about 1914 (see Exhibition). The modern frames are in excellent condition, apart from small losses of gesso and gilding on the most vulnerable surfaces of the legs, a break in the cresting rail of *canapé* F71.47, and a fragment missing at center from the front seat rail of *fauteuil* F71.57.

PROVENANCE: Comte Boni de Castellane, Château de Rochecotte, Indre-et-Loire. Charles Wertheimer (dealer), London. J. Pierpont Morgan, London and New York. Duveen Brothers (dealer), New York, 1915. Acquired by Anna Thomson Dodge from Duveen Brothers, 1932.

EXHIBITION: New York 1914: ill. opp. p. 115.

REFERENCES: Darcel and Guichard 1878–81, I: no. 87; Robinson 1913: 117; Detroit 1933: n.p.; Paris 1935: lot 118; Detroit 1939, I: n.p.; Paris 1973: no. 233.

Conceived in the Neoclassical style, the Beauvais tapestry covers are all decorated with trophies of pastoral love surrounded by scrolling arabesques on a cream ground. Though they form a coherent group in terms of overall design, those on the *fauteuils* vary in ornamental details and are of two different widths—one set of four being about 5 cm wider than the other. These variations suggest that the covers may have been assembled from at least two different sources before they were mounted onto their present modern frames.

The back of each piece shows a hanging trophy flanked by rinceaux and floral garlands and framed above by swags of fringed blue drapery over which pass leopard skins entwined with additional garlands. The trophy on the *canapé* backs depicts two doves fluttering about a basket of flowers, with a shepherd's hat visible in the basket, a crook passing behind it, small floral wreaths hanging above, and Cupid's quiver and torch hanging below. The trophy on the smaller *fauteuils* includes a pair of doves alighting on a musette, while that on the large armchairs shows two doves over a lute and a book of music.

The seat covers are decorated with central floral bouquets flanked by rinceaux and garlands like those on the backs. On the *canapés,* the bouquet is depicted in a stylized vase, with two pairs of doves hovering above at left and right. On the *fauteuils,* the bouquet spills from a basket in which two fluttering doves have built their nest. The front edges of the *canapé* seats and those of the four smaller *fauteuils* are all upholstered with separately woven strips depicting leopard skins entwined with flowers; the sides of the smaller *fauteuil* seats also were woven separately, but these are pieced to the main surfaces without the galloons used on the fronts.

The enclosed sides of the *canapés* below the arms are decorated with fringed drapery and other motifs borrowed from the backs. The armrests all depict floral sprays within leopard-skin borders.

The late nineteenth-century frames are generally similar in construction to those of the Dodge tapestry-covered seating furniture by Georges Jacob (cat. 19), but the sides of the *canapés* are enclosed instead of open, and each has four additional inner legs to support its greater length. The frames represent a *tour de force* of the carver's art.

Decorating all the seat rails are deeply carved chains of flower-filled rings joined by straight bands, with foliage above and below each band; running under the chain is a molding of finely carved pendant leaves. The legs are carved with rope moldings below their collars, pendant acanthus on their upper shafts, flutes filled with pearls on their lower shafts, and pearl beading at their bases. Above each leg at the level of the seat rail is a block decorated with a rosette.

The cresting rail of each piece is carved with a floral garland that forms a wreath at center and trails off to either side. The framing members of the backs and the upper arms are richly carved with an outer band of repeating leaves and a narrow inner molding of pearls interspersed with husks. Ascending acanthus decorates the lower arm supports, and above this rises a plain fillet flanked by repeating leaves.

The quality of the tapestry covers is exceptionally fine. Traditionally, they and several closely related examples have been attributed to the Beauvais manufactory, but the documents published by Badin (1909) are insufficient to justify absolute ascriptions. That the Dodge covers are not from the Gobelins works can be assumed from Fenaille's exhaustive study (1904–07), which lists no chair covers of this type. Their fine quality seems to preclude their being products of Aubusson or Felletin, whose workshops are relatively unresearched.

Although Badin (1909: 67–75) records many sets of covers with floral decorations, the descriptions of these are not detailed enough to link them positively with the Dodge covers. In any case, since the covers of the Dodge *fauteuils* are of two variant types (see above), it seems probable that the present set was assembled from two or more weavings.

Badin's first record of Beauvais chair covers with drapery motifs dates from 1782 (Badin 1909: 72), when sets with green and red drapery were woven. Another set, whose colors are not mentioned, is described as *en suite* with two blue drapery *cantonnières* (tapestry window hangings): "2 cantonnières, chutes et pentes à effet de draperies bleue et franges de diverses couleurs. Canapé, dossier, siège et joues; 8 fauteuils. Commande 136." The first specific mention of blue drapery chair covers with "tigre" decoration—that is, with spotted skins—is in 1785 (Badin 1909: 73): "4 canapés. —4 fauteuils à carreaux et effets de draperies bleues et tigre. —6 fauteuils garnis, à effet de draperies et tigre. —Commande no 203." In 1786 are recorded, with no reference to color (Badin 1909: 73): "2 bergères. Dossiers: fleurs, draperies, ornements. 12 dossiers et sièges de fauteuils à carreaux. —Commande no 92."

Of the designers whom Badin lists, only Pierre Ranson (1736–1786) and Jean-Baptiste Huet (1745–1811) are mentioned in conjunction with covers incorporating flowers or arabesques (Badin 1909: 91). In 1793, when the Beauvais manufactory was transferring a group of painted cartoons to the State, among Ranson's work were "1 sopha complet, 2 dossiers, 3 sièges de fauteuils à fleurs par Rançon"; among

Huet's were "5 dessins arabesques, ornements et fleurs, cantonnières, fauteuils et bergères par Huet." Other designers no longer recorded at the manufactory may also have been employed for such work.

A seat-cover cartoon repeating exactly the central decoration on the Dodge *canapé* seats is in the Mobilier National, Paris. Darcel and Guichard (1878–81, I: n.p., no. 87, III: ill., no. 87) describe the cartoon as being after Maurice Jacques, who provided floral designs for the Gobelins manufactory from 1756 until 1784.

A late nineteenth-century *canapé* in the Louis XVI style upholstered with identical covers, which may originally have been *en suite* with the Dodge set, was formerly in the collection of Willy Blumenthal (Paris 1935: lot 118). A set of covers of the same design but without drapery swags and with different borders is now also in the Dodge Collection (cat. 21). No additional covers of this design are known.

Other tapestry covers with backs depicting fringed drapery above flowers and arabesques, all of them less fine in varying degrees than the Dodge examples, include: one attributed to Beauvais that has been reupholstered onto a square-backed *bergère* signed by Georges Jacob, now in the Musée des Arts Décoratifs, Paris; a set reupholstered to four *fauteuils* in a private collection at Versailles (Whitehead 1992: 87); a set reupholstered to a suite of Louis XVI *fauteuils* and a *canapé* signed by F.-C. Menant, auctioned in Paris in 1980 (Paris 1980a: lot 147; Kjellberg 1980: 41, fig. 34); a set reupholstered to an early Louis XV *fauteuil*, now in the Hermitage Museum, St. Petersburg (Sokolova 1967: 73); and another set upholstered to a suite of Louis XV *fauteuils* signed by Nicolas Heurtaut, part of which survives in the collection of the Duke of Marlborough at Blenheim Palace, Oxfordshire (Gill and Zerbe 1973: 191) and part of which was auctioned from the collection of Alan P. Good, Glymton Park, Oxfordshire (London 1953: lot 309; Siguret 1965: 18, fig. 3). Drapery back covers with figures also are mentioned in the Beauvais records. Most notable among the surviving examples is a set with pastoral scenes after Huet in the Museu Calouste Gulbenkian, Lisbon (Gomes Ferreira 1982: 116, 312, nos. 689, 690; New York 1928: lot 273), upholstered to frames by Jean-Baptiste-Claude Séné.

A set of Beauvais *cantonnières* with leopard-skin decoration close enough in design to have been *en suite* with the Dodge covers decorates the windows of the Salon des Huet in the Musée Nissim de Camondo, Paris (Paris 1973: no. 233, not ill.).

The late nineteenth-century frames of the Dodge suite are in the style of Georges Jacob. No exact prototype is known, though an unsigned *fauteuil* bought by the Garde-Meuble in 1788 from the hard-pressed comte de Vaudreuil and copied by Séné and the sculptor Laurent for Marie-Antoinette's *grand cabinet* at the Tuileries (Verlet 1945: no. 39) has identically carved legs, seat rails, and arm supports. That *fauteuil*

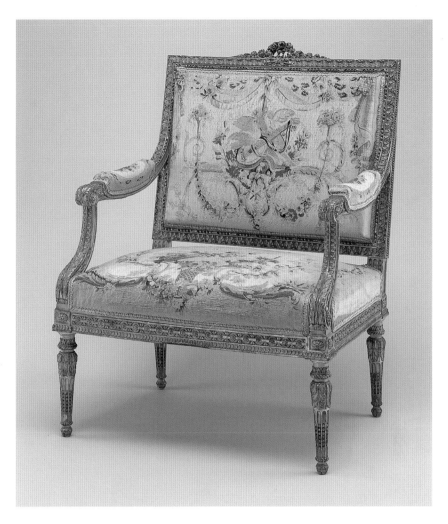

F71.50

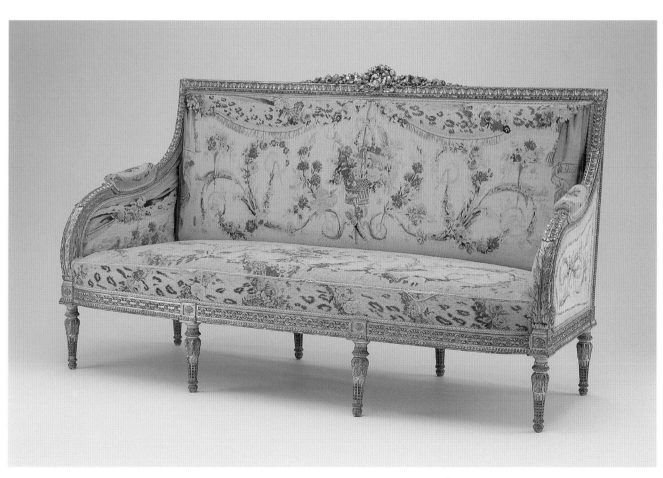

F71.49

differs very little from a suite of *fauteuils* supplied by Jacob in 1788 for the *salon des jeux* of Louis XVI at Saint-Cloud (Verlet 1955: no. 36, pls. XXXVI, XXXVII; Pallot 1993: no. 58). No Jacob prototype for the carving of the back is known.

It cannot now be determined what became of the original chair frames of the Dodge suite. Most eighteenth-century tapestry chair covers are no longer associated with their original frames but have been reupholstered either to reproductions, to pastiches, or to other surviving eighteenth-century frames, which sometimes predate the originals. The present consensus is that such covers must have fallen out of fashion during the first part of the nineteenth century and been dismounted and placed in storage. In the latter part of the century, tapestry covers became *de rigueur* for the well-appointed European salon, and demand was so great that many new sets were woven—sets now often confused with eighteenth-century originals. Newly rich Americans quickly followed suit and bought tapestry-covered suites from wealthy Europeans as they became available. Demand for important suites kept prices high. In 1918 Henry Clay Frick paid nearly a quarter of a million dollars for a set of seating furniture with Beauvais covers, dating about 1760, upholstered to Louis XV frames signed by Nicolas Heurtaut.

Other American collectors who acquired important eighteenth-century tapestry-covered suites include: Peter A.B. Widener, for his residence, Lynnewood Hall, in Elkins Park, north of Philadelphia (now in the National Gallery of Art, Washington, D.C.); Mrs. Henry E. Huntington (now in the Huntington Library and Art Gallery, San Marino); John D. Rockefeller, Jr. (now in The Metropolitan Museum of Art, New York); both John L. Severance and his sister Elisabeth Severance Prentiss of Cleveland (now in The Cleveland Museum of Art); and Mrs. George Widener, later Mrs. Alexander Hamilton Rice, of New York and Newport (now in the Philadelphia Museum of Art). The last of this generation was Anna Thomson Dodge, who filled the Music Room at Rose Terrace with three such suites (see cats. 19, 21) and employed three lesser tapestry-covered suites elsewhere.

[21]

Set of Beauvais Tapestry Chair Covers, c. 1785

Upholstered onto one modern *canapé* and six modern *fauteuils*
Covers of tapestry-woven silk and wool, frames of carved and gilded beechwood
Canapé F71.58: 98.1 (38⅝) × 170.2 (67) × 80 (31½)
Fauteuils F71.59–F71.64: 95.3 (37½) × 64.2 (25¼) × 68.3 (26⅞)
Bequest of Mrs. Horace E. Dodge in memory of her husband (F71.58–F71.64)

CONDITION: Like those on the preceding pieces, the covers are still in relatively fresh condition, indicating that they may have been stored for much of their history. The deeper colors noticeable on the back of *fauteuil* F71.62 suggest that it may be a nineteenth-century replacement. There is a shaped strip of tapestry added to the rear of the *canapé* seat cover, which evidently was once upholstered to a shallower *canapé* with a central back support. Strain on the covers caused by having been stretched too tightly has led the weft to separate in a number of places, and wear can be seen on the especially vulnerable front edges of the seats. The back covers of *fauteuils* F71.60 and F71.61 have been upholstered upside down, and it is curious that they were allowed to remain so at Rose Terrace.

PROVENANCE: Duveen Brothers (dealer), New York. Acquired by Anna Thomson Dodge from Duveen Brothers, 1932.

REFERENCES: Detroit 1933: n.p.; Detroit 1939, I: n.p.; New York 1992a: lot 90.

The central decoration of the tapestry covers is virtually identical to that of the covers discussed in cat. 20. Here, however, the pastoral trophies, rinceaux, and garlands are seen against a cream ground that merges almost imperceptibly along the edges into pale blue. The drapery swags and leopard skins that decorate the backs of the preceding suite are missing, and bordering each of the covers is a boldly scaled rope of pink roses of Sharon.

On the back of each *fauteuil* is a central hanging trophy flanked by garland-draped rinceaux that end above at either side in trumpet-shaped vases of flowers. The trophy consists of a pair of doves hovering over a nest built in an upturned shepherd's hat, with a musette lying over the hat below the nest. Each *fauteuil* seat depicts a similar pair of doves, who have built their nest in a trumpet-shaped basket of flowers, again with rinceaux scrolling outward at the sides. The back and seat covers of the *canapé* differ from those on the preceding *canapés* only in their rose-of-Sharon borders.

The frames are also similar in construction to those of the preceding set but are markedly more curvilinear in outline. In addition, the *canapés* have open instead of closed sides, their backs are raised above their seats instead of joined to them, and all the pieces have seedpod finials atop their rear uprights.

The framing members of the backs and the upper areas of the arms are all identically carved with laurel ropes interspersed with flowers and bordered along the outer edges with pearl beading. Similar ropes of laurel and flowers decorate the seat rails, where they are bordered above by stylized leaves. The scrolling arm supports are richly decorated with upright acanthus below and with ivy bordered by pearl beadings above. A sense of weightlessness is given to the bodies by their slender, spirally fluted legs, carved with delicate oak-wreath collars and feet of ascending laurel. At the junctures of the

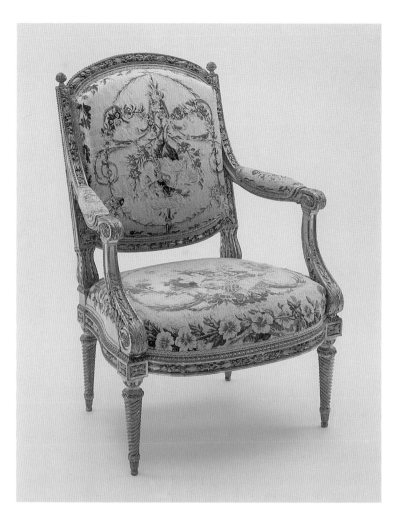

F71.59

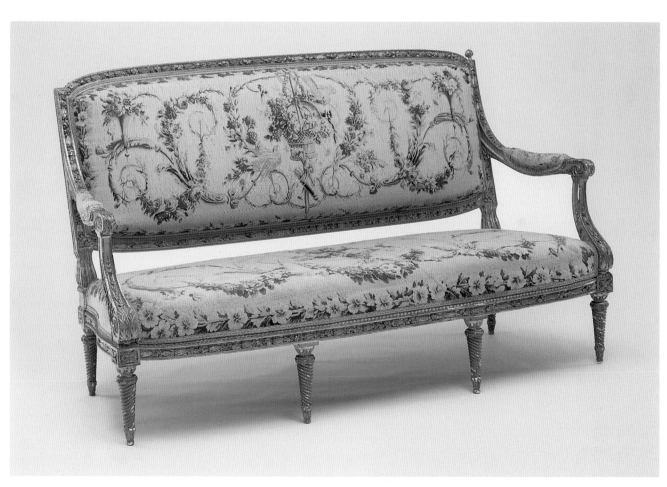

F71.58

legs with the seat rails are projecting blocks decorated with quatrefoil rosettes.

Since the central decoration of the present covers is identical to that of cat. 20 and the quality of their execution is equally fine, these too may be attributed to the Beauvais manufactory and assigned a similar date. The late nineteenth-century frames of the Dodge *fauteuils* duplicate those of a suite signed by Jean-Baptiste Boulard (active 1754–89), formerly in the collection of Jaime Ortiz-Patiño, Geneva (New York 1992a: lot 90), with the minor exception that the backs of the former are slightly less arched to follow the borders of the tapestry covers.

TERRACOTTA SCULPTURE

Alan Phipps Darr

CLAUDE MICHEL, called CLODION
1738 Nancy–Paris 1814

Claude Michel was one of the most inventive and productive French sculptors of the second half of the eighteenth century. He was the tenth child of Thomas Michel, employed as First Sculptor to Frederick II of Prussia, and Anne Adam, sister of the famous French sculptors Lambert-Sigisbert, Nicholas-Sebastien, and François-Gaspard Adam (New York 1984: 3; Paris 1992: 51). To distinguish the young Claude from an older brother, he was soon known as Clodion ("little Claude"). At the age of seventeen, Clodion went to Paris to study sculpture with his uncle Lambert-Sigisbert, and later with Jean-Baptiste Pigalle, each a master in terracotta and marble sculpture. In 1759 Clodion competed for and won the Prix de Rome. He then enrolled in Paris in the royal École des Élèves Protégés until 1762 in order to study Greek and Roman history, life drawing, painting, and sculpture from plaster casts.

After laying a solid intellectual and artistic foundation, Clodion left in late 1762 for the Académie de France in Rome, where he remained for nine critical years. Antique sculpture as well as Roman Baroque art, especially that of Bernini, inspired him. He became a virtuoso at creating classical terracotta figures and vases (a terracotta vase decorated with seven women making a sacrifice, signed and dated "CLODION Roma. 1766," is also in The Detroit Institute of Arts, inv. 69.295). Clodion distinguished himself among important collectors, such as the duc de la Rochefoucauld and Catherine the Great of Russia, and his works appeared in the sales of such significant French collections as that of Lalive de Jully (1769).

In 1771 Clodion was ordered by the king's agent, the marquis de Marigny, to return to Paris. His reputation had grown and his works, especially in terracotta, were actively sought. At the Salon of 1773, Clodion presented a figure of Jupiter in plaster as the model for his morceau de reception *for the Académie; however, since he never translated this into a marble version, he never became a full* académicien. *Nevertheless, his reputation was such that he continued to receive major commissions.*

Between 1772 and 1777, Clodion created various sculptures for the altar of Rouen Cathedral. In 1773 he made a second voyage to Italy, traveling to Rome and to Carrara to acquire blocks of marble for the cathedral. During the 1770s and 1780s, he produced many delightful small terracotta groups and statuettes of arcadian subjects for important patrons, such as the Abbé Terray, director of the Bâtiments du Roi, the comte d'Artois, and the comtesse d'Orsay. Clodion also created distinguished large monuments, such as his marble statue of Montesquieu *(Salon of 1783, now Musée du Louvre, Paris), considered the finest of the series known as the Great Men of France. With the architect Alexandre-Théodore Brongniart, Clodion and his workshop made decorative ensembles featuring large plaster or stone reliefs for Parisian buildings of French nobility and* grands amateurs,

among them those for the Hôtel Bouret de Vézelay (1776), the Hôtel de Bourbon-Condé (1782), and the superb salle de bain *of the Hôtel de Besenval on the rue de Grenelle (1782). Many of these relief groups have been acquired, some recently by the Musée du Louvre, and were featured in an important exhibition and catalogue devoted to Clodion (Scherf 1991; Paris 1992).*

In 1784, for a competition, Clodion executed two large models in terracotta (one of which is now in The Metropolitan Museum of Art, New York) for the monument commemorating the ascension of J.-A.-C. Charles and the Robert brothers in a hot-air balloon over the Tuileries.

It is now thought that even during the prosperous years before the Revolution, Clodion primarily worked independently. On occasion, he may have been assisted by one or more of his brothers, such as Pierre Michel, whose work is better known than that of the other brothers, or by Joseph Charles Marin, often called in old sales catalogues "élève de Clodion" (Paris 1992: 47–49, 405–07). Clodion probably also influenced other younger sculptors, such as Pierre Surugue, Jean-Guillaume Moitte, and the mysterious Jacques-Philippe Dumont. New research also demonstrates that Clodion and his brothers did not live together in one atelier and that Clodion did not leave Paris for Nancy between 1792 and 1798. Clodion had homes first on the rue Royale, then the rue Chaussée d'Antin (among others), and later he also owned a country house in Vincennes. During and after the Revolution, he remained in Paris and Vincennes.

After the Revolution, under Napoleon and the Empire, Clodion found new patrons, for whom he created superb terracotta groups, such as the Zephyrus and Flora *of 1799 (The Frick Collection, New York). His style became more heroic, austere, and Neoclassical, as witnessed by his model for the* Scène du Déluge *(Museum of Fine Arts, Boston), the life-size plaster of which he exhibited in the Salon of 1801. During his last years, he produced some portrait busts and reliefs for the Arc de Triomphe du Carrousel, now at the Louvre. However, the public's interest in his small terracottas faded dramatically, and his works realized low prices during the years before and after his death in 1814.*

Although Clodion died nearly forgotten, interest in him revived during the second half of the nineteenth century under the Second Empire, and many copies and forgeries of his works were made in editions by Barbedienne, Thiébaut, and others in Paris. These have often presented difficult problems of attribution, even for the Clodion connoisseur and scholar.

[22]

Claude Michel, called Clodion

Bacchante and Satyr with Young Satyr, c. 1775–80

Terracotta with warm pink buff, with self-base and without pedestal, 47.6 (18¾) × 30.5 (12) × 22.2 (8¾)
Louis XVI–style pedestal: 15.2 (6) × 36.8 (14½) × 28.6 (11¼)
Bequest of Mrs. Horace E. Dodge in memory of her husband (71.173)

INSCRIPTION: Signed in wet clay on rock at rear left of group: *Clodion.*

ANNOTATION: Pasted to the back edge of the terracotta, a paper label with an inked number: *29542*, a Duveen Brothers inventory number.

CONDITION: The group is in excellent condition except for one possible old break and repair on the left leg of the satyr.

PROVENANCE: François-Michel Haranc de Presle, Paris. His sale, Paris, April 16, 1792, lot 159. Robit, Paris. His sale, Paris, December 6, 1800, lot 159 (sale did not take place), and May 11, 1801, lot 190. Coquille, Paris. Baron and baronne Roger, Paris. Their sale, Paris, January 29, 1842. Charles Ledyard Blair, Peapack, New Jersey. Duveen Brothers (dealer), New York. Acquired by Anna Thomson Dodge from Duveen Brothers, 1935.

EXHIBITION: Grosse Pointe 1981: unnumbered, ill. p. 20, fig. 004.

REFERENCES: Detroit 1939, I: n.p.; Detroit 1972: 14; *Gazette des Beaux-Arts* 1972: 96–97, fig. 341; Paris 1992: 440.

As affirmed in the recent Clodion exhibition catalogue (Paris 1992: 440), it seems reasonable to suggest that the Dodge group is the terracotta by Clodion described in the April 16, 1792, sale of the prominent Parisian banker and collector, François-Michel Haranc de Presle, lot 159:

> Un groupe de trois figures: un faune tient une bacchante qui tient elle-même un petit faune par la main; divers accessoires enrichissent ce morceau qui est de la composition la plus heureuse et du plus beau faire de cet habile artiste. Hauteur 16 pouces, diamètre 12. Haranc de Presle, 16 avril 1792, no 159.

Since one pouce equals about 2.7 cm, Haranc de Presle's group measured approximately 43 × 32 cm, which is very close to the dimensions of the Dodge terracotta group. The description, as will be shown, is even more precise.

In 1800 and 1801 a terracotta group of identical dimensions and description is listed in two subsequent sales in Paris of the collection of M. Robit:

> —Terre cuite: Un groupe de trois figures; un Faune tient une Bacchante, près d'elle est un petit Faune qu'elle tient par la main; divers accessoires enrichissent ce morceau qui est d'une

composition agréable et du beau faire de cet habile artiste. Haut. 42 c., diamètre 32 c. (16 pouces sur 12 pouces). Robit, December 6 1800, no 159 [sale did not take place].

> —Terre cuite: Un groupe de trois figures, par Clodion, faunes et bacchante. Divers accessoires enrichissent ce morceau, qui est d'une composition agréable et du meilleur temps de cet artiste. Haut. 42 c., diamètre 32 c. (16 pouces sur 12 pouces). Robit, May 11 1801, no 190 [acquired for 81 livres by Coquille].

In a letter of October 15, 1991 (DIA curatorial files), Guilhem Scherf, curator of sculpture at the Musée du Louvre, Paris, and coauthor of the 1992 Clodion exhibition catalogue, substantiated my earlier hypothesis for the provenance of the Dodge group, adding also that in eighteenth-century Paris the collection of Haranc de Presle was celebrated. In fact, some of the Clodion terracottas in his cabinet were cited in 1787 by Luc-Vincent Thiéry in his *Guide des amateurs* (Thiéry 1787, II: 323), although this group is not specifically mentioned.

The Dodge group is composed of three figures and represents a young bacchante and satyr running with their infant satyr. The figures are nude, except for a strip of goatskin passing over the satyr's left shoulder and covering his loins. The satyr embraces the bacchante, placing his right arm around her waist so that their torsos touch. He draws her right arm around his back, holding her wrist with his left hand above his shoulder. With her left hand, the bacchante leads an infant satyr by his right hand.

Each figure's weight rests on one foot. From the front, the satyr's face is seen in right profile. He has a youthful wisp of a beard, and grapes and vine leaves layer his hair. He smiles at the bacchante, who looks playfully away and down toward the infant satyr, who happily returns her glance.

The three-figured group, made of a gray-beige terracotta with a warm pinkish buff, stands on a rectangular self-base with carefully modeled and tooled decorative accessories of the same terracotta color and material. On the right side of the group lie a thyrsus and a tambourine, around and over which spill grapes and vine leaves. Centered behind the two elder figures is a toppled urn with wine pouring out; nearby a foliate-covered tree stump rises to support them. To the left of the vase rests a small rock with the signature *Clodion* incised in the wet clay. The abundant hair of the bacchante cascades and meets the rising foliage of the stump. The entire group rests on a rectangular, gray marble fluted base carved in the Louis XVI style.

The technique, signature, and arcadian subject of this group are representative of much of Clodion's work from the second half of the 1770s. As Scherf and Poulet noted (Paris 1992: 46; Scherf, letter to the author, October 15, 1991, DIA curatorial files) with regard to the Detroit and other terracotta groups, Clodion often utilized a combination of modeling and molded techniques for accurate and efficient

production. This mixture of techniques was traditional in eighteenth-century France and finds analogies with practices used then at the Sèvres manufactory; however, it was perfected by Clodion and his atelier. In brief, the figures of the Dodge group are made of molded body parts (i.e., arms, legs, hands, torsos) fashioned of wet "terracruda" (the semi-hard malleable clay before firing). These molded parts were formed into the composition before the clay dried and hardened. With a modeling tool in fresh wet clay, the artist (or a specialist) then added and worked in the animated details, i.e., the many accessories, such as the hair, the grapes, the tambourine, thyrsus, decorated overturned vase, goatskin, and abundant foliage surrounding the stump. Finally, certain parts of the overall composition were also tooled to provide nuances to the modeling or accentuate the "nervousness" of the detail. The group was then signed in the damp clay and fired in the kiln. As Scherf points out, this technique had many advantages: it permitted the efficient production of additional new work—created from assembling molded body parts to which modeled elements from nature and other fresh modifications were added. One finds similar examples of this mixture of techniques in the terracotta figure of *Erigone* (Nationalmuseum, Stockholm; Paris 1992: no. 54), dating c. 1783. It also stands on a similar rectangular terracotta self-base and is cast but has a very high quality of modeled surface detail. Although taller than the Dodge group, the Stockholm *Erigone* is an autograph reduction cast from the related version at the Château Maisons-Lafitte, Paris (Paris 1992: no. 52).

While the signature of Clodion in lowercase letters is not absolutely definitive for dating or attributing the group (Paris 1992: 461), the specific treatment of the letters is virtually identical to signatures found on documented Clodion terracottas of the 1770s: the two infant *Satyrs* at The Cleveland Museum of Art; the reliefs of the *Allegories of the Arts* in the Musée Thomas Henry, Cherbourg, and The Metropolitan Museum of Art, New York; the *Mausoleum for Ninette* in the Musée Historique Lorrain, Nancy; and the Bourbon-Condé terracotta reliefs from the beginning of the 1780s, now at The Metropolitan Museum of Art (Paris 1992: nos. 16, 17, 30–36, 61, 42, and 43, respectively).

Twenty years ago, Terence Hodgkinson (1974: 13–21) broadly divided Clodion's terracottas into three chronological groups: (1) his early works, produced during his years in Rome (1762–71); (2) his most prolific and popular middle period (1771–95), until recently not well known since he signed but seldom dated his works of these years; and (3) his late period of activity (1795–1810). Works from Clodion's first and last periods are often much better understood because there are more certain signed and dated examples to serve as touchstones for the dating of the related works. Although Hodgkinson's fundamental article, which concentrates on Clodion's terracottas of the 1790s, has now been superseded

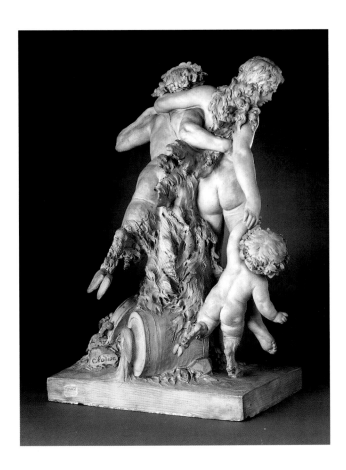

by the recent 1992 Clodion exhibition and catalogue, Hodgkinson was the first to indicate that the Dodge Clodion terracotta dates from early in Clodion's "second period" (verbal communication with the author, May 1979). The opinion was reiterated by Anne Poulet, coauthor of the 1992 Clodion exhibition catalogue and curator of the exhibition "Clodion Terracottas in North American Collections" (New York 1984). In correspondence (letter to the author, June 19, 1979, DIA curatorial files), Poulet stated: "The [Dodge] Clodion terracotta group is very beautiful. In my opinion it is autograph and compares favorably in quality with those in other major museum collections." Two years later (verbal communication with the author, May 1981), Poulet dated the Dodge Clodion to the mid-1770s. Most recently, Guilhem Scherf stated that the group should be dated c. 1775–80 (letter to the author, October 15, 1991, DIA curatorial files; verbal communication with the author, March 1992).

It is especially during the 1770s that Clodion explored the compositions and iconography of arcadian subjects such as bacchantes, satyrs, and their infants. His lifelong interest in bacchanalian themes originated with his study of antique sarcophagus reliefs during his years in Rome and was fused with his further appreciation of the dynamic energy and movement of French and Roman Baroque works of the seventeenth century. In Paris Clodion studied Poussin's paintings, *The Triumphs of Bacchus and Pan* (1635–36), and he was also inspired by his own set of engravings made after Annibale Carracci's ceiling painting of the *Triumph of Bacchus and*

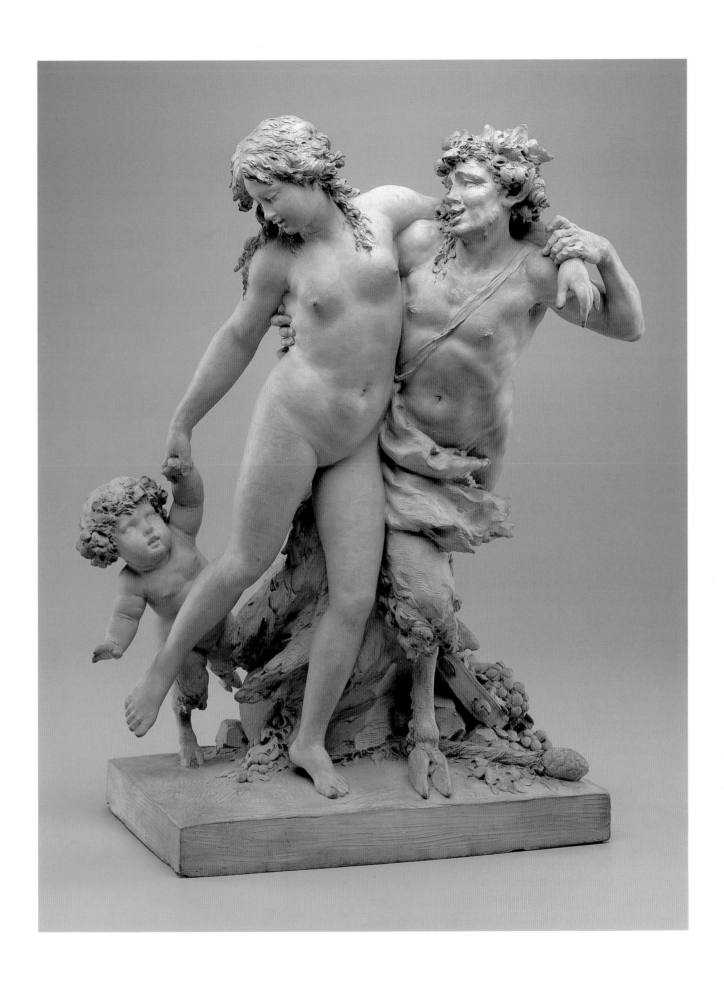

Ariadne (New York 1984: 18). A full discussion of Clodion's exploration of arcadian themes is found in the Paris 1992 Clodion catalogue, whose entries provide a context for dating the Dodge group to the decade of the 1770s. Clodion's superb terracotta relief of a *Bacchic Scene,* signed and dated 1773, in the Los Angeles County Museum of Art (inv. M.80.127; Paris 1992: no. 24), signals a clear departure in the direction of the lush arcadian themes he would explore further during the 1770s. This terracotta was modeled during his second and brief trip to Italy at the end of 1773. During the same year he exhibited at the Salon a small marble, *Infant Satyr Holding an Owl in His Arm,* which has disappeared but is known in several terracotta versions called *Birdnesters* (or *Dénicheurs*). Among the best of these is the signed terracotta pair at The Cleveland Museum of Art, which is very similar to the pair formerly in the collection of the prince de Conti and sold in 1777 (Paris 1992: nos. 16, 17). Upon examination, the superb *Infant Satyr* in Cleveland or a nearly identical *Infant Satyr* at the Philadelphia Museum of Art (inv. 39–41–32) directly compares to the infant satyr in the Dodge group. All derive from the same model, which was replicated in the 1770s.

Clodion's signed terracotta model of *Poetry and Music,* commissioned by Abbé Terray in 1774 and now in the National Gallery of Art, Washington, D.C. (inv. A-1774; Paris 1992: no. 63), may be compared to the Dodge group in its similar rectangular self-base and in the composition of the standing lute-playing putto, which is clearly related to the infant satyr. Moreover, a similar spilled wine urn, a tambourine laden with grapes, a foliage-covered tree stump, and other decorative accessories may be found on other Clodion terracotta groups featured in the 1992 Paris exhibition (Paris 1992: nos. 53, 54, 68, 70).

Among the most convincing comparisons for the dating of the Dodge Clodion group to c. 1775–80 are those found in *The Triumph of Galatea,* a large terracotta relief now in Copenhagen (Paris 1992: no. 29). As Scherf observes, this relief, which was exhibited in the Salon of 1779, was undoubtedly made around 1775 for the decoration of the Hôtel Bouret de Vézelay. The torso and head of the nereid to Galatea's right, as well as the group of nereids to her left, are closely related to the Dodge bacchante in facial and body types and in the precise treatment of hair and the hair style. Similar treatment of the male torso and facial, beard, and hair types can also be found in the Dodge satyr and in the triton blowing a conch shell to the right of Galatea. The Dodge infant satyr finds closest affinities with the infant holding an owl, standing next to an approaching panther, on one Copenhagen relief, and with the pair of infant satyrs to the right of the rampant goat in a second relief for the pair of terracotta models for the Hôtel de Bourbon-Condé, now in The Metropolitan Museum of Art (Paris 1992: nos. 42, 43). These reliefs, also signed like the Dodge group with lower-case letters incised in the terracruda, were made c. 1780–81, i.e., after the 1780 contract with the prince de Condé and the architect Alexandre-Théodore Brongniart and before Clodion's completion of the project in 1782 (Paris 1992: 216–22; Scherf 1991: 49–51).

These various comparisons of documented Clodion terracottas with the Dodge group demonstrate, along with the scholarship of Poulet, Scherf, and others, that Clodion made the Dodge group around 1775 using the mixture of molded and modeled techniques that he perfected during this time. Further, the Dodge Clodion was made in Paris. Contrary to the earlier literature, Scherf and Poulet have established that in 1777 Clodion did not live in rue Royale but in the rue Chausée d'Antin in Paris. Moreover, it is now virtually certain that during this and the next two decades, Clodion did not return to his native Nancy but remained and worked in Paris or in his country home in Vincennes. During the 1790s Clodion produced similar terracotta compositions but in the Directoire taste, as seen in his *Bacchus and Nymph* at The Metropolitan Museum of Art (inv. 14.40.679; Draper 1991–92: 28–29).

It should be stated here that the new research by Scherf and Poulet has caused several other terracottas, once accepted as autograph, to be rejected from Clodion's oeuvre (Paris 1992: 361–413; Scherf, letters to the author, DIA curatorial files). According to Scherf, one can now distinguish between the nineteenth-century terracotta versions made after certain Clodion models or molds (Type A) and those made as pastiches (fakes made from new models or molds, here called Type B). Those in Type A include the following: *The Satyr Crowning a Bacchante* in the Musée du Louvre (inv. R.F.2986); the pair at the Musée National de la Renaissance, Écouen, and those in the Bowes Museum, Barnard Castle, England; and the *Fauness Holding an Infant Satyr with a Putto* at the Virginia Museum of Fine Arts, Richmond (inv. 77.77). On the other hand, Type B includes the *Nymph and Satyr* in The Fine Arts Museums of San Francisco (inv. 57.17.1); the *Triumph of the Infant Bacchus* relief in the Wrightsman Collection, The Metropolitan Museum of Art (Watson, Dauterman, and Fahy 1966–73, V: no. 54); and certainly the *Satyr with Two Bacchantes and an Infant Satyr,* falsely signed and dated 1766, in The Frick Collection, New York (New York 1984: no. 3).

In contrast to these nineteenth-century versions, Clodion's relatively unknown lyrical, arcadian group in the Dodge collection exhibits the technical virtuosity of a genius, unsurpassed in the medium of terracotta in the last years of the Ancien Régime.

JOSEPH-CHARLES MARIN
1759 Paris–Paris 1834

Joseph-Charles Marin was the most important maker of small decorative terracottas after Clodion. Born in Paris in 1759, he enrolled in 1778 at the Académie as a student of Augustin Pajou, whose daughter Clodion married in 1781. Later, Marin became Clodion's friend and is considered his most famous pupil and successor. Between 1782 and 1787 Marin attempted to win the coveted Prix de Rome on six different occasions; however, he was not successful until 1801.

The decade of the 1790s was Marin's most brilliant period. He exhibited for the first time in the Salon of 1791 and continued showing in the annual Salons through the Revolutionary era and until 1833. Following upon the popularity of Clodion's Rococo terracottas, Marin produced elegant, technically precise terracotta inventions of vestals, bacchantes, and satyrs that evoked the Rousseau-like absorption in nature so characteristic of this decade.

In 1796 Marin was among a group of commissioners who followed Napoleon's armies to Italy to select works of art to be taken back to the Louvre as booty. He remained in Rome until 1799. Upon returning to Paris, he won various prizes for his sculpture. The coveted Prix de Rome, which he won in 1801 with a Neoclassical bust of a woman representing Dejection, *granted him a five-year subsidy at the Académie Française in Rome. There he secured the important patronage of Lucien and Joseph Bonaparte, Murat, and Châteaubriand. In Rome, Marin's style became more severe, elongated, and markedly Neoclassical.*

Marin returned to Paris in 1810. In 1813, at the École Impériale de Dessin in Lyons, he replaced Joseph Chinard as professor of sculpture. Marin retained his relationship with Clodion until the master's death in 1814. Around 1810, however, it had become strained because Marin and Clodion's natural daughter, and only child, ran off together. Nevertheless, documents record that she later married someone else and Clodion subsequently bequeathed to Marin, "sculpteur, moulleur et ami," part of the title to his furniture and possessions.

Marin went on to receive several commissions, some for monumental sculpture, such as the Admiral of Tourville *(1816), one of the colossal statues of Great Men that Louis XVIII ordered (Marin's terracotta model for this is now in The Metropolitan Museum of Art, New York). Marin spent several more years in Lyons; however, in 1818, toward the end of his career, he returned to Paris, where he died in poverty on September 18, 1834.*

[23]
Joseph-Charles Marin

Maternity, c. 1793–95

Terracotta with light pink buff, 35.5 (14) × 28 (11)
Gift of Mr. and Mrs. Alvan Macauley, Jr., and Mr. and Mrs. Theodore O. Yntema (71.294)

INSCRIPTIONS: Signed on the lower band of the drum held by the child seated on the base: *MARIN*. On the Louis XVI–style plinth: *758B*, probably a Duveen Brothers inventory number.

CONDITION: The front edge of the terracotta base, the outer, top edge of the drum, and the drumstick in the infant's left hand have been repaired.

PROVENANCE: M. Pillot. Marquis de Karrefort (?). Jacques Seligmann (dealer), Paris (purchased by him in 1911, according to Paul Vitry, former curator of sculpture, Musée du Louvre). Sold to George Blumenthal, New York (again according to a note from Paul Vitry). Mortimer L. Schiff (d. 1931). His son, John Mortimer Shiff, New York. The Mortimer L. Schiff estate sale, Christie's, London, June 22–23, 1938, lot 29. Bought at that sale for 950 guineas by Jacques Seligmann and Company, Paris, from whom Duveen Brothers, New York, bought it. Acquired by Anna Thomson Dodge from Duveen Brothers, c. 1938–39. Her sale, Christie's, London, June 24, 1971, lot 6.

EXHIBITIONS: Paris 1795: no. 1062; New York 1935a: no. 117; Grosse Pointe 1981: unnumbered, ill. p. 22, fig. 005.

REFERENCES: Paris 1869–72, XXXVIII (1871): 69 (Salon of 1795), no. 1062; Lami 1910–11, II: 109, 112; New York 1935a: no. 117; London 1938a: lot 29; Quinquenet 1948: 13–14, 55–56; London 1971: lot 6; Detroit 1972: 12, 14; Paris 1992: 405, 407, fig. 222; Paris 1992a: 14.

Seated on a vine-covered rockwork bench, a young woman in a sleeveless décolleté gown tenderly cares for three playful infants. The maternal figure is finely modeled from a pink terracotta and forms the central vertical axis of a pyramidal composition placed on a cylindrical terracotta self-base. The underside of the base has been excavated in the wet clay for support before firing. The two tresses of the woman's long wavy hair, delicately modeled so that one can see each strand, fall across each shoulder, while the rest of her hair is classically tied by a fillet and pinned in a loose bun *à la grecque*. Her ankles are casually crossed; the right leg is draped and the left is bare, as are her shoulders and right breast. In each braceleted arm she holds a naked infant. The smallest infant

is seated on her right thigh, and from the look of surprise on his face appears to have just been interrupted from nursing. The mother looks gracefully down at the standing older male child, whom she gently embraces with her left arm. He reaches forward, putting his weight on his right foot, and with his right hand offers her a rose. This child wears a garland in his hair. In front of him on the ground is an intricately modeled terracotta basket abundantly filled with roses, grapes, apples, and other fruits and vegetables. Seated on the ground at the opposite side of the composition is a third naked child; with a stick in each hand, he beats on a small toy tambour or drum that is lying against a rocky ledge. The entire terracotta group is set in a painted and gilded socle with variously carved acanthus leaves, scrolls, egg-and-dart motifs, and other decorations in the Louis XVI style.

The Dodge *Maternity*, an accepted masterpiece by Marin, is very probably the famous work he exhibited in the Salon of 1795 (Paris 1795: lot 1062; Guilhem Scherf, letter to the author, October 15, 1991, DIA curatorial files; Paris 1992: 405). However, issues of date, related versions, and provenance merit discussion for this particularly attractive terracotta group. The Dodge *Maternity* appears to derive directly from, if not itself be, the famous group Marin made for Citizen Pillot, which was shown in Paris in the Salon of 1795. According to Lami (1910–11, II: 109) and based on a document in the French national archives (F17 1055, dossier 3), this group was shown as *La maternité représentée par une femme avec ses enfants* in the Salon of 1795, where it was damaged in the exhibition. Marin then sent a letter to the Commission d'Instruction claiming and later receiving the sum of 5000 livres. Quinquenet (1948: 13–14) summarizes the document and comments:

> C'est à ce Salon qu'il fut victime d'une mésaventure que nous connaissons par une lettre, rédigée dans le style ampoulé en honneur à l'époque, qu'il addressa le 19 vendémiaire an IV à la Commission d'Instruction. Une des oeuvres qu'il exposait avait été brisée au Salon. C'était un groupe en terre représentant la Maternité sous la forme d'une figure de femme entourée de ses enfants, dont les jeux "partageaient son attention sans l'affaiblir." Ce groupe avait value à son auteur, nous dit-il, les plus flatteuses félicitations de Fragonard et de Pajou. Sans doute l'accident avait-il été provoqué, puisque les têtes des personnages avaient disparu. Marin n'hésitait pas à soupçonner quelque confrère, jaloux de copier les expressions des visages, d'être l'auteur de l'accident et du vol. Le plaignant, qui habitait alors 3, rue du Colombier, joignait à sa lettre un certificat signé par Fragonard, Hubert Robert, Pajou et Joubert. Il réclamait, et il obtint, la somme de cinq mille livres come indemnité.

From this passage three things are clear: that Marin impressed Hubert Robert, Fragonard, Pajou, and other prominent French artists with his ability to create a composition "with figures able to divide their attention without

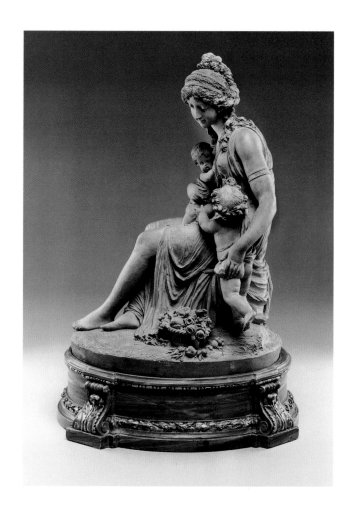

weakening" the effect; that the heads of the figures had disappeared, perhaps resulting from a theft by a jealous fellow artist; and that although Marin reclaimed 5000 livres he presumably retained an obligation to replace the original group he had made for Citizen Pillot. Consequently, the Dodge *Maternity* is analogous to and probably the original replacement of the version exhibited in the Salon of 1795.

Over the decades two other terracotta groups signed *marin* have been proposed as that shown in the 1795 Salon. The first, formerly in the collection of French and Company, was sold in 1968 (New York 1968: lot 138). It has a seated male figure as well as a female figure and two infants and therefore does not fit the precise description of the Salon piece. The second, and more convincing, version (although undoubtedly later in date) was sold in Monaco (Monaco 1980: lot 1167). However, as can be determined by further examination of the documents and from the more elongated, severe style of Marin's later terracottas, this group is almost certainly the later Marin *Maternity*, described by Lami (1910–11, II: 112) as "Une mère avec ses enfants. Groupe. Salon de 1819." A smaller terracotta study (h. 34.3 cm), probably for the 1819 group and also signed *marin,* has been on the international art market (Paris 1964a: lot 109). Only two *Maternity* groups in Salon exhibitions are recorded. The formality and relative rigidity of the Monaco group (purchased by a private collector in

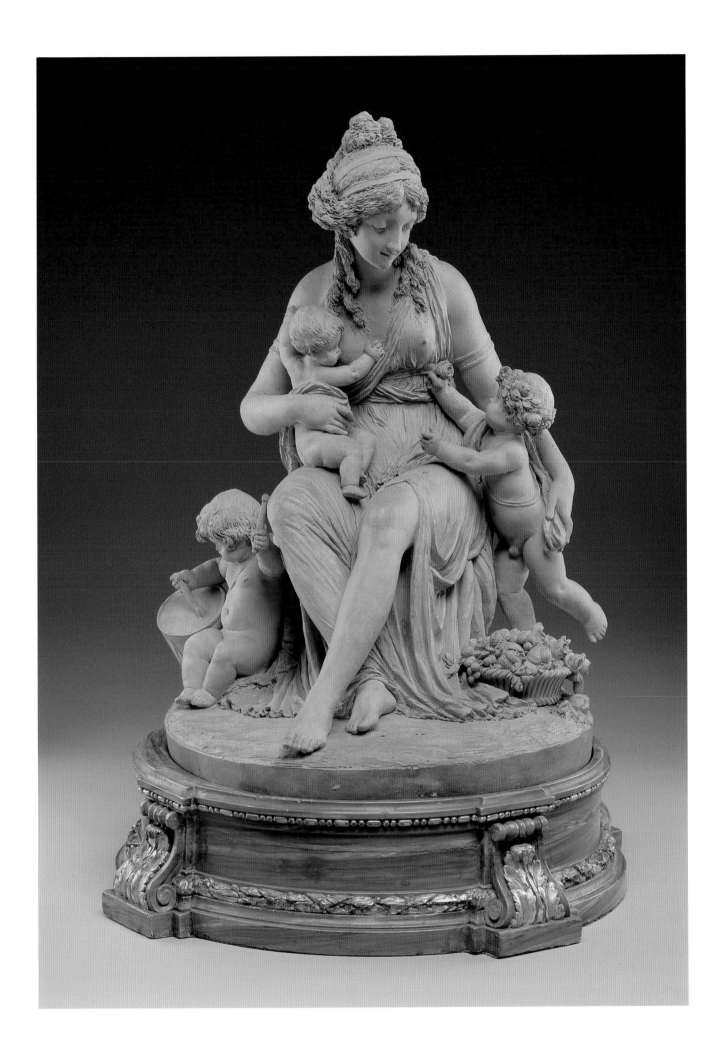

Paris), combined with Marin's interest during the early nineteenth century in reviving compositions that he and Clodion had created in the eighteenth, strongly suggest that this version is an 1819 Neoclassical revival of the 1795 composition represented in the Dodge *Maternity.*

Moreover, comparisons of the particular female faces and classical hairstyles on signed and dated terracottas by Marin establish that the Dodge group unquestionably dates to the same years as the more delicate compositions in terracotta that Marin made before and just after the Revolution (Paris 1992: 405–07; Paris 1992a: nos. 5–12). Specific comparative examples are: *Bacchante and Three Infants,* signed *marin 1789* (Monaco 1984: lot 401); *Reclining Bacchante Surrounded by Five Infants,* signed *marin 1790* (Musée du Petit Palais, Paris, inv. PPS 0941; Paris 1992a: no. 34); *Young Woman with a Dove,* signed *marin 1791,* shown in the Salon of 1793 (Musée du Louvre, Paris, inv. R.F. 1683); *The Naiad Supporting a Shell on Her Head,* signed *marin* and discovered by Olga Raggio to have been in the Salon of 1793 (The Metropolitan Museum of Art, New York, inv. 1975.312.5; New York 1976: no. 7; Draper 1991–92: 44); the pair of *Reclining Bacchante with Infants,* signed *marin* and probably shown in the Salons of 1793 and 1795 (The Metropolitan Museum of Art, inv. 1983.185.5 and 185.6; Draper 1991–92: 44–45); and especially the *Bacchante with Cupid and a Child,* signed *marin 1793* and now in the Victoria and Albert Museum, London (inv. A.42–1954). Although this superb latter group is dated 1793, it does not appear to have been exhibited until two years later, at the Salon of 1795 (Quinquenet 1948: 56). Similar circumstances may well have affected the Dodge *Maternity,* as it also was made c. 1793. Marin's masterful treatment of the modeling of the hair, facial expressions, and drapery of the figure is more closely linked to his earlier terracottas, particularly to those from the 1790s mentioned above, which were sometimes not exhibited until a few years later. Some of these groups by Marin are inspired of course by Clodion's own terracottas, although Marin's style is often more personal and refined in details of modeling.

Finally, regarding the provenance of this terracotta, it is known from photographs that Mrs. Dodge especially treasured the group and had it placed on the center of her *bureau plat* by Martin Carlin (now in The J. Paul Getty Museum, Malibu), which she prominently positioned in the middle of her Music Room at Rose Terrace. She acquired the *Maternity* presumably from Duveen, who had acquired it from Jacques Seligmann and Company, Paris, the successful bidders at the Mortimer L. Schiff sale in London in 1938 (London 1938a: lot 29). (*Maternity* was published in 1935 as in the New York collection of John Mortimer Schiff, the son of Mortimer L. Schiff [New York 1935a: no. 117].) According to Jean Cailleux (verbal communication with the author, 1979), the delicately carved and gilded wooden socle in the Louis XVI style may have been made by a former member of his firm, Auguste

d'Bouet, well known for his superb craftsmanship. Paul Vitry also thought that the wooden base was modern; however, to date no trace has surfaced of the previous owner, "le marquis de Karrefort," listed by Paul Vitry and Christie's in 1938. Over the past two decades, this name and variants, such as "Karrefor" "Carrefort," "Kerrefort," and "Cerrefort," have been searched in a dozen major reference works but to no avail.

Cailleux, Scherf, and Michèle Beaulieu believe that the "marquis de Karrefort" may well be a fantasy created for Mortimer Schiff when he purchased this work.

JEAN-JACQUES CAFFIÉRI
1725 Paris–Paris 1792

Son of the sculptor and bronzemaker Jacques Caffiéri, Jean-Jacques studied first under his father and later in the atelier of the sculptor Jean-Baptiste Lemoyne. In 1748 he won the first prize for sculpture at the École Académique and in 1750 went to Rome for four years. Admitted to the Académie in 1751, he became a full académicien in 1759 and a professor in 1773. He exhibited regularly at the Salons.

Although he sculpted several monumental allegorical groups, it was as a portraitist that Caffiéri excelled, in conscious rivalry with Jean-Antoine Houdon. Not only did he portray the living—writers and artists in particular—but he also sculpted the distinguished dead from portraits and engravings. He gave a number of busts of playwrights to the Comédie Française in exchange for life subscriptions. Caffiéri's reputation has suffered because a number of eighteenth- and nineteenth-century pastiches of his work have been attributed to him, obfuscating a clear understanding of his oeuvre. Caffiéri was one of the most important sculptors of the late eighteenth century, and it is the splendid lifelike portrait busts that rank highest in his oeuvre.

[24]
Follower of Jean-Jacques Caffiéri

Bust of a Man, *mid-nineteenth century*

Terracotta fired to a light yellow-ocher color, 46 (18⅛) × 45 (17¹¹⁄₁₆) × 31 (12³⁄₁₆); height with base, 58 (23¹³⁄₁₆)
Gift of Mr. and Mrs. Lee Hills (71.295)

ANNOTATION: With pen and black ink on adhesive tape on base: *241,* probably a Duveen Brothers inventory number.

CONDITION: There are firing cracks in the ceramic material of the bust. Major ones occur at the proper right shirt front, on the chest at the base of the neck, and on the back underside of the bust. A hole, 1 cm in diameter, has been made in the top of the head. The head has been broken off and reattached at the neck. Repairs and fills also exist at the tip of the

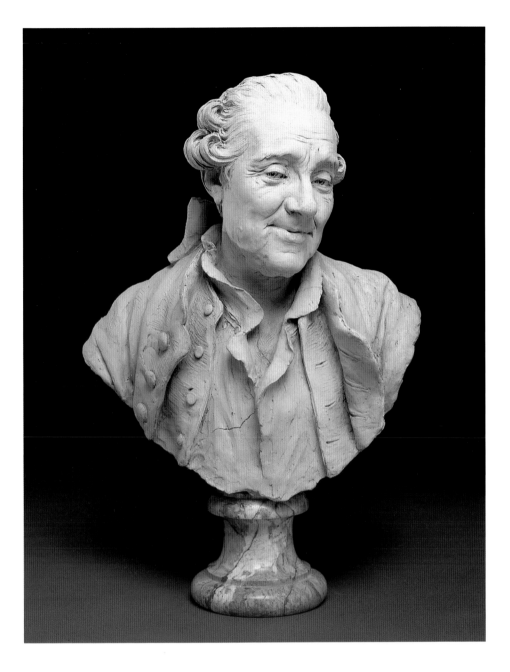

nose, on the bottom front edge of the bust, and on the knot in the bow at the back of the head.

PROVENANCE: Duveen Brothers (dealer), New York. Acquired by Anna Thomson Dodge from Duveen Brothers. Her sale, Christie's, London, June 24, 1971, lot 7.

REFERENCES: London 1971: lot 7; Detroit 1972: 14, 25.

The sitter in this informal portrait modeled in yellow-ocher terracotta faces to his left in a three-quarter pose. His hair is curled back and tied into a queue. Shallow wrinkle lines on his forehead and deeper lines on the outside corner of each eye and between his furrowed eyebrows create a whimsical yet distinguished appearance, almost approaching a caricature. Indications of loose flesh around his jowls and a wart centered on his right cheek evoke a relaxed natural portrait. His mouth is slightly open as if to speak and is drawn at the corners into the beginning of a smile.

The head is more sensitively modeled than the torso and drapery, which are summarily treated and were broken and cracked in various places during the firing process. Informally dressed in the French style of c. 1780, he is depicted as an artist or an actor, wearing a shirt open at the neck, a waist-coat with four buttons, and a top coat with three buttons, each of which is also open. The truncated torso of the bust is unusually rough and unevenly defined for a French portrait of the late eighteenth century, a date previously given to this bust. The lower edge of the proper right side of the torso has been chipped. A medium-size horizontal firing crack midway down the proper right side of the open shirt and one large vertical unfilled firing crack on the back of the modeled bust indicate the relatively poor techniques utilized during the firing processes of the terracotta. On the drapery and especially on the back of the bust, claw tool marks and the fingerprints of the artist are apparent everywhere. The bust sits upon a waisted grayish white, pink, and mauve marble

socle, flecked with red of a type often associated with nineteenth-century sculpture.

This bust was attributed to Jean-Jacques Caffiéri or labeled as "in his manner" and dated to the eighteenth century while it was in Mrs. Dodge's collection (London 1971: lot 7). It retained this attribution when it first entered the museum (Detroit 1972: 14). While the bust was created with spirited modeling and tooling and an almost caricatured expression, all characteristics of terracottas by Caffiéri, the modeling is not as adventurous as Caffiéri's authentic terracotta portraits, all of which are signed—for example, his 1772 bust of *Helvetius* in The Metropolitan Museum of Art, New York (Laurence B. Kantor, letter to the author, June 18, 1979, DIA curatorial files).

The Dodge bust may be considered as a later study, or even a pastiche, of Caffiéri's style of the late 1770s or 1780s. Since the head is of relatively higher quality and has been severed from the torso, one could argue that the torso is a nineteenth-century replacement for one that supported a head of c. 1780. But the homogeneous quality of the clay suggests that the entire bust was fired together and broken in the kiln. Although a thermoluminescent examination was made of a small piece of the terracotta in order to date it more precisely, no useful information was yielded.

Nearly as many specialists have informally indicated their belief that the Dodge bust may be by an unidentified follower of Caffiéri and date from the eighteenth century (Geoffrey de Bellaigue, Henry Hawley, and others) as those who think it dates from the mid-nineteenth century. Most opinions, however, have been formed only from the study of photographs rather than of the actual work. On the basis of direct study, Michèle Beaulieu, Terence Hodgkinson, François Souchal (letter to the author, July 29, 1980), Olga Raggio (verbal communication with the author, 1980), Anthony Radcliffe (verbal communication with the author, 1986), and Guilhem Scherf (letter to the author, October 15, 1991) have suggested that the Dodge bust is most likely from the nineteenth century, variously dating it between c. 1840 and the period of Napoleon III (1852–70)(all notes and correspondence in the DIA curatorial files).

The eccentric spirit and caricatured expression of the bust indicate that it may be a nineteenth-century pastiche made by a terracotta specialist. Unfortunately, no convincing attribution for the sculptor has yet been proposed. Moreover, although the yellow-ocher color of the terracotta and the gray, white, and pink socle are associated more with nineteenth-century than eighteenth-century terracottas, it is difficult to propose an attribution to a talented French nineteenth-century modeler of terracottas such as Jean-Baptiste Carpeaux (1827–1875), Albert-Ernest Carrier-Belleuse (1838–1902), Aimé-Jules Dalou (1838–1902), or one of their students, all of whom would have been interested in and able to create a

work in the earlier style of Caffiéri. As Scherf has observed (letter to the author, October 15, 1991), the artistic personality of Caffiéri has suffered because of the number of pastiches that have been attributed to him.

Even though the subject of the Dodge bust has been previously suggested as "one of the encyclopaedists and . . . similar to Buffon" (George-Louis Leclerc de Buffon, 1707–1788, the famous Parisian actor), the busts of Buffon by Pajou and Houdon, versions of which exist in the Musée du Louvre, Paris, and the Hermitage, St. Petersburg, are not sufficiently similar to warrant the identification. However, the Dodge bust does appear to represent an eighteenth-century literary or visual artist and this may be a clue to its enigmatic identity.

The portrayal of famous artists by sculptors, as well as painters, was especially popular in eighteenth-century France, and several late eighteenth-century terracotta busts of eighteenth-century artists survive: Jean-Baptiste Pigalle's *Self-Portrait* (1776–77; Musée du Louvre, Paris, inv. R.F. 2670); Caffiéri's bust of *Helvetius*; Augustin Pajou's busts of *Basan* (1768; Musée du Louvre, inv. R.F. 1928) and of *Madame Vigée-Lebrun* (1783; Musée du Louvre, inv. R.F. 2909); Jean-Baptiste Lemoyne's bust of *Coypel* (1730; Musée du Louvre, inv. R.F. 1400); and Philippe-Laurent Roland's busts of *Suvée* (1788; Musée du Louvre, inv. N. 15534) and of *Pajou* (1797; Musée du Louvre, inv. R.F. 778).

Throughout the Second Empire in France and immediately afterward, there was a revival of interest in expressive terracotta portraits of the artist (Paris 1980: n.p.; Paris 1986: 42–48). Carpeaux's *Portrait of His Brother with a Violin* (Kimbell Art Museum, Fort Worth) or Carrier-Belleuse's *Self-Portrait* (Museum of Fine Arts, Boston) are just two nineteenth-century terracotta examples of this portrait genre. At least one contemporary Italian sculptor, Urbano Lucchesi (1844–1906), also created similar expressive terracotta portrait busts of artists. Moreover, during the 1880s a national French museum for "Portraits d'Artistes" was planned by Henry Jouin, Paul Mantz, and Castagnary. The proposed museum was to house artists' self-portraits and artists' portraits by other artists, in all media and techniques, drawing its collection from the Académie, the Louvre, Versailles, and the École des Beaux-Arts. One hundred portraits of artists were shown together in 1888 in the Louvre, and Jouin published his *Musée des portraits d'artistes,* which contained three thousand portraits (Jouin 1888). Although the project was never developed further, we know from Jouin's publication that the place of honor was given to the eighteenth-century portrait. The genre of the artist's portrait became important not only for young painters, but also for young sculptors entering the Académie. In this way, it is possible that a talented young sculptor in the Académie may have modeled the Dodge bust as a portrait of an artist in reference and homage to the virtuosity of Caffiéri's eighteenth-century oeuvre.

MARBLE SCULPTURE

Henry H. Hawley

Anonymous French Sculptor

Two Children Personifying Music, c. 1775–1800

White marble
Sculpture: 23.8 (9⅜) × 14 (5½) × 13.3 (5¼)
Socle: 9.5 (3¾) × 13 (5⅛)
Bequest of Mrs. Horace E. Dodge in memory of her
husband (71.174)

Two Children Personifying Poetry, c. 1775–1800

White marble
Sculpture: 24.1 (9½) × 12.7 (5) × 12.1 (4¾)
Socle: 9.5 (3¾) × 13 (5⅛)
Bequest of Mrs. Horace E. Dodge in memory of her
husband (71.175)

INSCRIPTIONS: 71.174: Beneath the group: *29213/2.* Beneath
the socle: *29213/2.* Both are inventory numbers, perhaps of
Duveen Brothers. 71.175: Beneath the group: *29213/2,* an
inventory number, perhaps of Duveen Brothers, and *C4854.*
On the scroll: *L'ODYSSÉE / D'HOMÈRE.*

CONDITION: 71.174: The right hand of the winged figure
once held a now missing object, perhaps a baton. The large
toe of his right foot is also missing. His left wing has been
broken and repaired in two places. The left hand of the other
figure and an adjacent part of the instrument he plays have
been broken and repaired. 71.175: The winged figure's right
hand has been damaged; one finger and part of his stylus are
lost. His right wing has been broken and repaired, as has the
right arm of the child holding the torch, and the central toe
is chipped on the left foot.

PROVENANCE: George Jay Gould (d. 1923), Lakewood, New
Jersey. Duveen Brothers (dealer), New York. Acquired by
Anna Thomson Dodge from Duveen Brothers, 1935.

REFERENCES: Lami 1910–11, II: 147–48; London 1924, II: 97,
no. 375, pl. 71; Detroit 1939, I: n.p.; Hodgkinson 1970: 40–41,
no. 13.

The marble group *Two Children Personifying Music* shows a
winged figure holding a musical manuscript in his left hand,
with his right, which once held some object, raised above his
head. His mouth is open, perhaps in song. At the top of his
head there is a flamelike protrusion. In a book probably
printed only a few years before this group was made, the
Abbé de Petity (Raymond 1770, II: 125) describes "le bon
génie" as represented by a winged child with a small flame on
his head. Thus, the present figure should probably be inter-
preted as the genius of music. Beside him kneels another
child who plucks a stringed instrument. At his feet are a lyre
and another manuscript.

The group *Two Children Personifying Poetry* includes a
winged child, probably representing the genius of poetry,
who is seated on a cloud and has inscribed on a manuscript
the words *l'Odyssée d'Homère.* The manuscript is supported
by the left arm of another child, who holds a torch aloft with
his right hand.

In their catalogue compiled for Mrs. Dodge (Detroit 1939,
I: n.p.), the agents of the Duveen firm recorded these two
groups as by Clodion. A group of similar subject, *Poetry and
Music Personified by Two Children* in the National Gallery of
Art, Washington, D.C. (Washington 1951: 260–62), was con-
ceived by Clodion; but stylistically the Dodge groups bear
only a generic relationship to documented Clodions. In addi-
tion, the quality of carving seems inferior to what one would

That ascription seems reasonable, but since neither sculpture is documented before the mid-nineteenth century, the possibility should be left open that they are of a later date.

ÉTIENNE-MAURICE FALCONET
1716 Paris – Paris 1791

Born in Paris, Falconet was a pupil of the sculptor Jean-Baptiste II Lemoyne between about 1734 and 1745. Although he became a member of the Académie in 1754, he never visited Italy. He served as director of sculpture at the Manufacture Royale de Porcelaine at Sèvres from 1757 to 1766. From 1766 to 1778 he was in St. Petersburg, where he executed, on commission from Catherine the Great, an over-life-size bronze equestrian monument of Peter the Great. Falconet's last years were spent in Paris.

JEAN-PIERRE-ANTOINE TASSAERT
1727 Antwerp – Berlin 1788

Jean-Pierre-Antoine Tassaert was born in Antwerp in August 1727. Following a short visit to England, Tassaert arrived in Paris around 1744 and entered the workshop of the sculptor Michelange Slodtz. He was agréé *by the Académie in August 1769 and began to exhibit his work at the Salon. In 1774 he was appointed court sculptor to Frederick the Great of Prussia and settled in Berlin. After the death of Frederick, Tassaert continued in the service of his successor Friedrich-Wilhelm, until his own death in Berlin in 1788.*

[26]
Style of Étienne-Maurice Falconet

Probably based on a design by Jean-Pierre-Antoine Tassaert

Flora, c. 1775–1800

White marble
Sculpture: 26 (10¼) × 14.6 (5¾) × 16.5 (6½)
Socle: 13 (5⅛) × 20 (7⅞)
Bequest of Mrs. Horace E. Dodge in memory of her husband (71.176)

INSCRIPTION: On the base: *29338*, a Duveen Brothers inventory number.

CONDITION: The toes of both feet have been broken and repaired; the base has been chipped.

PROVENANCE: George Jay Gould (d. 1923), Lakewood, New Jersey. Duveen Brothers (dealer), New York. Acquired by Anna Thomson Dodge from Duveen Brothers, 1935.

REFERENCES: Gonse 1904: 286–87; Hildebrandt 1908: 23, n. 3, pl. XIII, fig. 21; Vitry 1912: 62–63; Réau 1922, I: 165–70, II: 505; Detroit 1939, I: n.p.; Wark 1959: 72, pls. XXIX, XXXI; Courajod 1965, I: ccli; Hawley 1994: 100–06.

expect of a sculptor of Clodion's acknowledged ability. A small marble group of three nude children in the Jones Collection of the Victoria and Albert Museum, London, and an *Infant Bacchus* at Waddesdon Manor, Buckinghamshire, display a distinct stylistic relationship to the Dodge groups. Perhaps all of them came from the same studio. The Victoria and Albert group was described in a catalogue of the Jones Collection (London 1924, II: 97, no. 375, pl. 71) as "mid-eighteenth-century . . . school of Bouchardon." Its relationship to Bouchardon's personal style seems too vague to make this a useful ascription. Unfortunately, at the present time, no more persuasive attribution for these sculptures is available.

On the basis of style, these pieces have consistently been presumed to be of eighteenth-century French workmanship.

A nude female figure sits close to the ground, her ankles crossed and her left knee raised. In her right hand she holds a garland of flowers toward which her gaze is directed.

Despite the flowers held by the figure, the identification of the subject as Flora is far from certain. Other versions of the work have been called simply *Bather.* The subject seems merely to have provided an excuse for the depiction of an attractive female nude.

Flora is paired in the Dodge Collection with *Venus* (cat. 27). The socles of the two figures are of the same design; however, the figures differ significantly in scale and technique, the *Venus* more delicately carved and the surface of her body brought to a higher finish.

Falconet, following a design by Boucher, is known to have produced a stone *Flora* or *Jardinière* for Madame de Pompadour's Château de Crécy (Lami 1910–11, I: 330; Ananoff and Wildenstein 1976, I: 59–60; Posner 1990: 93). A plaster model of this work was shown at the Salon of 1753 (Paris 1753: no. 15). In the *livret* of that exhibition, the *Flora* is described as "une jeune fille," and from other additional sources we know that this sculpture almost certainly represented a child, not a woman. Neither the sculpture made for Pompadour nor any visual record of it seems to have survived. In 1750 Falconet had already exhibited at the Salon another model of a statue of *Flora* (Paris 1750: no. 120). Levitine (1972: 44, figs. 63–66) has identified the composition of small marble figures holding flowers in one hand and a quiver in the other with the Falconet *Flora* that was exhibited at the earlier Salon, but there is evidence that the figure exhibited in 1750 may have been depicted standing, not seated, and that the seated figure with flowers and a quiver may have on occasion been entitled *Venus*, rather than *Flora* (Hawley 1994: 100–06). Versions of this seated figure exist at the Hermitage, St. Petersburg (Kosareva 1975: 445, pl. III; Hawley 1994: 101, fig. 1), the Musée Cognacq-Jay, Paris (Levitine 1972: figs. 63–64), and the Walters Art Gallery, Baltimore (Levitine 1972: figs. 65–66; Hawley 1994: 105, fig. 6). It seems probable that the composition of this *Flora* or *Venus* is not directly related to a work by Falconet, but rather to a popular design by one of his chief imitators, Jean-Pierre-Antoine Tassaert (Lami 1910–11, II: 353–54). Réau (1934: 289–309) described Tassaert's *Flora,* presumably on the basis of the catalogue of the 1776 Blondel de Gagny sale (Paris 1776: lot 116), as "une figure de femme assise tenant d'une main des fleurs et de l'autre une carquois." This sculpture is almost certainly identical to that exhibited by Tassaert in the Salon of 1769 and illustrated by Gabriel de Saint-Aubin in his copy of the *livret* of that year (Hawley 1994: 102, fig. 3). Furthermore, a "flore figure assise, par Tassart," in plaster, was included in the sale of works of art owned by the painter Peters in 1779, at which time Saint-Aubin made another small, rough sketch of it (Dacier 1909–21, IX: 108, no. 642;

Hawley 1994: 102, fig. 4) which conforms rather closely to the statuettes illustrated by Levitine.

The composition of the *Flora* in the Dodge Collection is quite close to the above-mentioned statuette given to Tassaert. The quiver in that piece is here replaced by a garland of flowers. The position of the figure's left leg and her head are also different. Several sculptures virtually identical in design to the Dodge *Flora* are known, one in the Huntington Library and Art Gallery, San Marino (Wark 1959: 72, pls. XXIX, XXXI) and another bequeathed by Madame Masson to the Musée du Louvre, Paris (Vitry 1912: 62–63; Réau 1922, II: 505). On the basis of photographs, these sculptures seem to resemble one another technically and probably come from the same studio.

The *Flora* in the Dodge Collection, and the many small marble sculptures to which it is related technically and stylistically, pose a difficult question concerning their precise relationship to Falconet and his studio. On the one hand,

there can be little doubt that Falconet played a significant role in popularizing small marbles and their ceramic equivalents, the Sèvres figures and groups in biscuit porcelain, during the years from roughly 1757 to 1766. His personal contribution to the genre is well documented in the records of the Sèvres manufactory and contemporary Salon catalogues. On the other hand, in addition to the documented small sculptures by Falconet, which frequently exist in several versions, there are many extant small marble figures and groups—chiefly female nudes—that are generically related to Falconet's work, but that are both unsigned and undocumented. Such works appear frequently in the catalogues of eighteenth-century collections, where they are unattributed or sometimes identified as the work of Tassaert or of the brothers Broche (Lami 1910–11, I: 140–41), all of whom are known to have been imitators of Falconet. The Dodge *Flora* is an excellent illustration of the problems often encountered in attempting to trace the lineage of these sculptures. It resembles compositionally Tassaert's *Flora* or *Venus* as described in contemporary catalogues and as depicted in Saint-Aubin's sketches. Its execution is precise but rather dry and lifeless, and the facial type is piquant, with large eyes, a smallish nose and mouth, and a pointed chin. It is these technical and stylistic characteristics that both distinguish the *Flora* from Falconet's more realistic, documented works and relate her to the large extant group of white marble statuettes, of which the two Venus and Cupid groups in the Dodge Collection (cat. 28) are also part. That the Dodge *Flora* is related compositionally to Tassaert's sculpture seems incontrovertible. That it reflects a style instigated by Falconet in the 1750s as executed by an independent workshop also seems correct.

JEAN-BAPTISTE PIGALLE
1714 Paris – Paris 1785

A Parisian by birth, Pigalle was an apprentice first of Robert Le Lorrain and later of Jean-Baptiste Lemoyne. From 1736 to 1739 he was in Rome. After a short period in Lyons, he returned to Paris in 1741. He became a member of the Académie Royale in 1744 and soon thereafter received several royal and other official commissions, as well as the patronage of Madame de Pompadour. Perhaps his greatest work was the tomb of the maréchal de Saxe, executed between 1753 and 1770.

[27]
Follower of Jean-Baptiste Pigalle

Venus, c. 1750–75

White marble
Sculpture: 31.8 (12½) × 13.3 (5¼)
Socle: 13.3 (5¼) × 18.1 (7⅛)

Bequest of Mrs. Horace E. Dodge in memory of her husband (71.177)

INSCRIPTION: On the base: *293(5?)3/ . . . 53,* probably inventory numbers, perhaps of Duveen Brothers.

CONDITION: The tips of the four fingers of the left hand are broken; the thumb has been reattached.

PROVENANCE: George Jay Gould (d. 1923), Lakewood, New Jersey. Duveen Brothers (dealer), New York. Acquired by Anna Thomson Dodge from Duveen Brothers, 1935.

REFERENCES: Detroit 1939, I: n.p.; Charageat 1953: 217–22; Courajod 1965, I: cclxii; Hodgkinson 1970: 68–71, nos. 24–25.

ADDITIONAL BIBLIOGRAPHY: Lami 1910–11, II: 242, 244–46; Rocheblave 1919: 162–73.

Venus is shown seated on a piece of drapery which in turn rests on a bank of clouds. Two doves, an attribute of Venus, are billing at her right, near the base. With her left hand she beckons languidly. The object of her gesture was a pendant Mercury, attaching his heel-wings. The subject of these two sculptures is based on an episode described by La Fontaine, following Apuleius, in which Venus asks Mercury to find Psyche.

In 1741 Pigalle had created the *Mercury,* which was very successfully received in Paris. The following year he produced a pendant *Venus,* and models of both appeared at the Salon of 1742. By 1745 a full-scale marble *Mercury* had been completed, while work on the *Venus* went more slowly. It is recorded that as late as the spring of 1747 Pigalle wanted to make some changes in her pose. Presumably these alterations were embodied in the full-scale plaster version, which was exhibited at the Salon of 1747, and in the full-scale marble completed a year later. The large finished marbles of both *Mercury* and *Venus* were purchased by Louis XV, who gave them to Frederick II of Prussia in 1750; they are now in Berlin. (For the history of Pigalle's *Mercury* and *Venus,* see Rocheblave 1919: 162–73; Réau 1950: 36–38, 152; Charageat 1953: 217–22; and Le Corbeiller 1963: 22–28.)

Several smaller versions of the *Venus* exist today, among them a terracotta and a stone sculpture in the Louvre, the latter signed and dated 1750; a damaged stone version from the Château de Millemont; a marble at Waddesdon Manor, Buckinghamshire (Hodgkinson 1970: 70–71, no. 25); statuettes in Sèvres biscuit porcelain (Sainsbury 1956: 46–51) and Wedgwood ceramic (Reilly and Savage 1980: 352); and the small marble in the Dodge Collection. All these smaller versions are clearly dependent on the same model, though they differ in detail. They are stylistically related to Pigalle's Berlin *Venus,* but the pose has been significantly altered, chiefly by a reversal of the hand gestures. Presumably, therefore, these smaller versions are compositionally dependent upon

Pigalle's first conception of *Venus,* that exhibited in 1742 and altered in 1747 before the execution of the Berlin marble.

In the Dodge Collection, *Venus* is paired with *Flora* (cat. 26). Though their socles are of the same design, differences in scale and technique indicate that they were probably not made as a pair. Of the two, the *Venus* is more delicately carved and, where the marble surface represents the body, it has been brought to a higher polish than in the *Flora* and sculptures related to it. Additionally, if the Dodge *Venus* is compared to other extant smaller versions of the Pigalle composition, one can also notice differences, particularly in the facial type. In the Dodge version, the nose and chin seem smaller and more pointed, and the lips thinner and more tightly closed. The facial type of the Dodge *Venus* appears to be closer to that of the *Flora* and other sculptures traditionally, but probably mistakenly, ascribed to Falconet and his workshop rather than to the Pigalle model. Therefore the possibility cannot be discounted that the Dodge *Venus,* though dependent on a Pigalle composition, was made in the same workshop that produced the *Flora* and other related small sculptures.

[28]
Style of Étienne-Maurice Falconet (see p. 113)

Venus Chastising Cupid, c. 1775–1800

White marble
Sculpture: 37.8 (14⅞) × 18.4 (7¼) × 15.9 (6¼)
Socle: 9.5 (3¾) × 19.1 (7½)
Bequest of Mrs. Horace E. Dodge in memory of her husband (71.178)

Venus Instructing Cupid, c. 1775–1800

White marble
Sculpture: 34.3 (13½) × 17.2 (6¾) × 17.8 (7)
Socle: 9.8 (3⅞) × 19.1 (7½)
Bequest of Mrs. Horace E. Dodge in memory of her husband (71.179)

INSCRIPTIONS: 71.178: On the base: *29393/2.* 71.179: Beneath the base: *29393/2.* Both are inventory numbers, perhaps of the Duveen Brothers.

CONDITION: 71.178: The left hand and right wrist of Cupid have been broken and repaired. 71.179: The left foot of Venus has been broken and repaired at the ankle. There is a fill on her left shoulder that probably disguises an intrinsic imperfection in the marble.

PROVENANCE: Sir Samuel Edward Scott (1873–1943), Bart., M.P., Westbury, Northamptonshire, or Lytchet Minster, Dorset. Duveen Brothers (dealer), New York. Acquired by Anna Thomson Dodge from Duveen Brothers, 1932.

REFERENCES: Réau 1922, I: 235–38, pl. XV, II: 506; New York 1928: lot 252; Mann 1931: 11–12, no. S28, pl. 9; Detroit 1933: n.p.; Detroit 1939, I: n.p.; Washington 1948: 133, no. A-110; Adams 1950: 7; Paris 1966: lot 95; Levitine 1972: 44–45.

ADDITIONAL BIBLIOGRAPHY: Hawley 1994: 100–06.

In *Venus Instructing Cupid,* Venus sits on a tree stump with her legs crossed. On her left thigh rests a book, partially supported by her right hand. At her left side stands Cupid, who grasps the book with his left hand while concentrating his attention on the open page.

The pendant group, *Venus Chastising Cupid,* shows Venus holding the partially clothed Cupid across her left thigh. Her right arm is raised, and in her right hand is a small bunch of flowers with which she is preparing to strike the child's buttocks.

Although as Gordon (1968: 249–53) has pointed out, the subjects of the education of Cupid by Venus and/or Mercury and the chastising of Cupid by Venus took on symbolic meaning in some eighteenth-century sculpture, it is doubtful that the themes have been employed here as more than a pretext for the representation of a scene of intimacy between mother and child.

A number of versions of *Venus Instructing Cupid* are known. In addition to that published by Adams (1950: 3–10) and another in the Baron James de Rothschild sale (Paris 1966: lot 95), there are versions in the Altman Collection at The Metropolitan Museum of Art, New York, and in the Rice Collection at the Philadelphia Museum of Art. None of the known versions of *Venus Instructing Cupid* is signed or dated, and none has a provenance before the end of the nineteenth century. Primarily on the basis of photographs, it appears that the best executed of these groups now in public hands is the Altman example, though all the versions closely follow the same model and otherwise appear to have emanated from the same shop.

Venus Chastising Cupid seems to be a typically eighteenth-century choice of an Anacreontic subject with ambiguous connotations. The subject is not without precedent. It had been previously employed, for example, by Giovanni Francesco Susini in a bronze group dated 1639 (Montagu 1963: 70, 68, fig. 92).

Though the subjects of the above two groups are related, their relationship is not always fixed, as is demonstrated by the several extant versions of each group that are paired with other themes.

Many versions of the Venus chastising Cupid theme are known. Réau (1922, I: 235–38, pl. XV, II: 506) mentions one in the collection of Baron Robert de Rothschild, which he lists as inscribed with the name of Falconet and a date of 1760. Mann (1931: 11–12, no. S28), on the other hand, states that the Rothschild version was unsigned but that one in the

collection of J. Vinmer, Paris, was so inscribed, though no illustration of a signed or dated version of this subject seems to have been published. Those that are published include one in the Wallace Collection, London (Mann 1931: 11–12, no. S28); another in the Widener Collection at the National Gallery of Art (Washington 1948: 133, no. A-110); and a third in the Museum of Fine Arts, Boston, formerly in the J. Pierpont Morgan and Judge Elbert H. Gary collections, both in New York (for the Gary sale, see New York 1928: lot 252). Mann's claim that a version existed in The Frick Collection, New York, seems to be incorrect; the museum has no record of the work. The whereabouts of at least four versions are known today, and two others have been described. In qualitative terms, the three aforementioned versions and the Dodge example seem, on the basis of photographs, approximately equal, and there are no significant variations in their design.

The various versions of *Venus Chastising Cupid* and *Venus Instructing Cupid* can be related stylistically to a large number of Venus and Cupid groups as well as single female figures. All these works are in white marble and relatively small. The facial type of the female figure is characterized by large eyes and a very broad forehead. The lower part of the face narrows pronouncedly to a small pointed chin, and the comparatively full mouth is somewhat pursed. Although these small marble groups and figures undoubtedly owe their inception to the great popularity of such works by Falconet as his small *Bather,* exhibited in the Salon of 1757 (Réau 1922, I: pl. X), their facial type is less realistic, more obviously mannered than in Falconet's documented works. Moreover, despite the fact that the *Venus Chastising Cupid* and *Venus Instructing Cupid* and related sculptures exist in large numbers today, no mention is made in eighteenth-century inventory and sale catalogues of such subjects by Falconet. Since his was such a famous name in France in the eighteenth century, it seems highly improbable that such works from his hand or his studio would have passed unnoticed.

Among the ample evidence of these works in the eighteenth century are the sketches that Gabriel de Saint-Aubin made in the 1774 catalogue of the sale of art belonging to the vicomte Adolphe du Barry, which document the ownership of several sculptures of this type (Dacier 1909–21, III: 49–50), though in that catalogue they are all listed anonymously.

Lami (1910–11, I: 140–41, 333) mentions that a work by the Broche brothers, *Venus fouettant l'Amour,* was included in a sale of 1777. Réau (1922, II: 483) lists the Broche brothers, along with Jean-Pierre-Antoine Tassaert, as among the imitators of Falconet's style, and a work signed by the Broche brothers, which was sold in 1968 (Paris 1968a: lot 38), may be rather close in style to the present statuettes. Unfortunately, too little is known today of their style to permit sculptures to be attributed to them with any certainty.

Réau and Levitine (1972: 43–45), among others, have indicated the need for caution in ascribing sculptures to Falconet in the absence of firm documentation. On the basis of available evidence, it seems best to presume that the *Venus Instructing Cupid,* the *Venus Chastising Cupid,* and the sculptures related to them were made under the inspiration of Falconet's style but in a shop quite independent of his own. They probably date from the last half of the eighteenth century, but they may have continued to be made well into the following century. It seems likely that all the known versions of the *Venus Instructing Cupid* and *Venus Chastising Cupid,* and many of the related groups and figures, emanated from a single shop, but that source cannot at present be identified.

In the catalogues compiled for Mrs. Dodge by the Duveen firm (Detroit 1933: n.p.; Detroit 1939, I: n.p.), the provenance of the two *Venus* statuettes is given as "Sir Samuel Edward Scott, Bart., M.P., Westbury, Northamptonshire, England." The provenance of a similar statuette in The Frick Collection was given in the museum's 1954 catalogue as "Duc de Guise; Sir Edward Henry Scott, Fifth Bart., d. 1883, Westbury Court, Northamptonshire; inherited by his son Sir Samuel Edward Scott, Sixth Bart." (Hodgkinson and Pope-Hennessy 1970: 96, n. 4). In the volumes of *Burke's Peerage* consulted (1893, 1900, and 1932), this family is recorded as Scott of Lytchet Minster, but no residence at Westbury or Westbury Court is mentioned. In mid-twentieth-century editions of Burke, this family is omitted, indicating extinction of the male line. Several London sales of the 1920s and early 1930s included material offered by the trustees of Sir Edward Henry Scott, but the Dodge statuettes do not seem to have been among them. Thus there is no documented support for the provenance advanced by the Duveen firm at the time of the sale to Mrs. Dodge.

METALWORK

Henry H. Hawley

JEAN-LOUIS PRIEUR
c. 1725?–? after 1785

Prieur became a maître-sculpteur *and a member of the Académie de Saint-Luc in 1765. In 1769 he was also granted an appointment as a* maître-fondeur en terre et sable. *About 1775 he made the bronze mounts for the coronation coach of Louis XVI after the designs of Bellanger. In 1783 he described himself as* sculpteur, ciseleur et doreur du roi.

LOUIS-NICOLAS VICTOIRE,
called VICTOR LOUIS
1731 Paris – Paris 1807

Victor Louis won the first prize for architecture from the Académie Royale in 1755 and then went to Rome, where he remained from 1756 to 1759. His first important patron was Stanislas II, King of Poland, whose architect he became in 1764. He executed designs for decorative work in the Royal Palace at Warsaw in 1765–66. His best-known architectural achievement is the design for the theater at Bordeaux, 1772–80.

[29]

Probably made by Jean-Louis Prieur,
after a design by Victor Louis

Pair of Candelabra, designed c. 1766

Gilt bronze, 66 (26) × 35.6 (14)
Bequest of Mrs. Horace E. Dodge in memory of her husband (71.213, 71.214)

INSCRIPTIONS: 71.213: Inside the base: *A.* 71.214: Inside the base: *D.* Many parts of each candelabrum are stamped with numbers and letters combined with numbers, undoubtedly to assist in assembling the pieces correctly.

CONDITION: The pair has been wired for electricity. On 71.214, a wreath near one eagle head has been repaired and there is repair near one goat hoof.

PROVENANCE: Prince Frodrow (or Feodrov), St. Petersburg. Soviet government, until about 1932. Duveen Brothers (dealer), New York. Acquired by Anna Thomson Dodge from Duveen Brothers, 1935.

EXHIBITION: Grosse Pointe 1981: unnumbered, ill. p. 17, fig. 001.

REFERENCES: Iskierski 1929: 22, no. 7; Detroit 1939, I: n.p.; Lorentz 1958: 233–37; Pariset 1962: 135–55; Pariset 1963: 201–09, pl. 22; London 1972: no. 1766; Eriksen 1974: 352, 390–92, pls. 205, 405, 408; London 1980: no. 68; Ottomeyer and Pröschel 1987, I: 166–67, II: 556.

ADDITIONAL BIBLIOGRAPHY: Le Brun 1776: 131, 189; Le Brun 1777: 105, 189; Pariset 1956: 281–97; Pariset 1959: 41–55; Cohen 1991: 75–98.

These candelabra are supported on three animal-paw feet. An eagle perches above each foot, holding in its beak a garland of flowers. Tightly clustered acanthus leaves form the stems of the candelabra. At the top of the stems small platforms provide a place for the attachment of three candle branches and garlands of flowers. From these platforms rise tripod perfume burners with rams' heads at the top of each leg.

The candelabra in the Dodge Collection very closely resemble a pair published by Iskierski (1929: 22, no. 7), when they were in the Royal Palace in Warsaw, and more recently by Pariset (1963: 201–09). The Warsaw candelabra, which are now in the Muzeum Narodowe, are the remaining pair of an original set of six. Since the two in the Dodge Collection came from Russia, it seems possible that they are also from this set of six. There is evidence that objects were transferred in the nineteenth century from Warsaw to Russia, where they remained into the present century (Cohen 1991: 88). There are, however, several significant differences between the pair in the Dodge Collection and those in Warsaw. In the latter, the legs of the tripod perfume burner appear to be more widely spaced and to rise to a greater height than in the Dodge examples. There is no evidence that these elements were altered on the Dodge candelabra, but the finials of the covers of their perfume burners, absent from the pieces in Warsaw, are clearly modern and technically unrelated to the candelabra as a whole. The Warsaw candelabra appear to have been unaltered. It should be pointed out that the profile of the perfume burners of the Dodge candelabra is closer to that of an extant preparatory drawing illustrated by Pariset (1963: pl. 22) than is that of the Warsaw example. The color of the gilding also differs, that of the Warsaw pair being distinctly greenish, while that in the Dodge Collection is yellow gold. On the basis of documents, we know that two of the six candelabra then in Warsaw were gilded in 1786 (Ottomeyer and Pröschel 1987, I: 166). Finally, the system of numbering the whole and parts of the Dodge candelabra is not present on those in Warsaw. If the Dodge pair is part of the set of six made for the Royal Palace in Warsaw, one must presume that their gilding and inscriptions were applied after their removal to Russia.

In the 1950s and 1960s a great deal of information on the Warsaw candelabra was published by Lorentz and Pariset. These candelabra are part of the surviving elements of a redecoration of the Royal Palace in Warsaw, which was designed by the French architect Victor Louis. Only a relatively small portion of this extensive project was ever executed, and only some of the furnishings survive and can be identified today.

Although the precise circumstances remain unclear, Stanislas II Poniatowski, King of Poland, and his Parisian

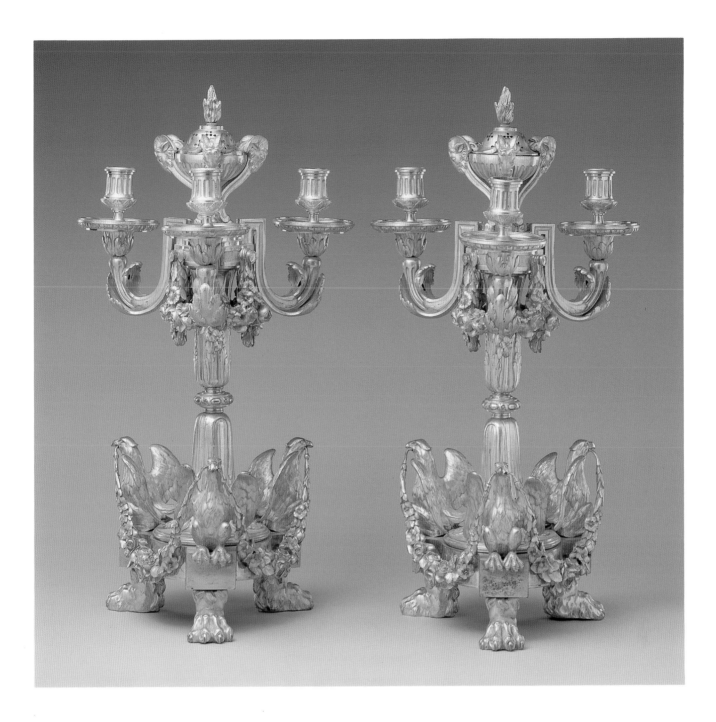

agent, Casimir Czempinski, contacted the promising young architect Victor Louis either through the famous Madame Geoffrin or the silversmith François-Thomas Germain. In the summer of 1765, Louis traveled to Warsaw in order to study firsthand the problem of redesigning the major interior spaces of the Royal Palace. After his return to Paris, he developed his ideas into presentation drawings, prepared probably with the assistance of other hands. He also commissioned from the decorative sculptor Jean-Louis Prieur finished drawings for furnishings, which were almost certainly based upon sketches he himself provided. In 1766 these drawings were sent to Poland. A catalogue of the large number of these drawings that survive in Polish archives was published by Lorentz (1958: 233–37). Among them are two drawings (nos. 89, 90), included with those presumed to be by Prieur, which are directly related to the Dodge candelabra. The first

(figure 1), inscribed *Paris 1766,* shows a console table with a large clock flanked by a pair of rather roughly sketched candelabra that can nevertheless be clearly seen to be related to those in the Dodge Collection. It is further indicated on the drawing that this assemblage of furnishings was intended for the king's bedchamber. Pariset (1962: 135–55; Pariset 1963: following 199, fig. 27) republished this drawing in 1962 as by Prieur and in 1963 as "Victor Louis (?)." Stylistically, this drawing seems at variance with the more detailed renderings given to Prieur. If not by Louis himself, it probably originated in his studio.

The second drawing (figure 2), Lorentz's no. 90, is a more detailed rendering of one of the candelabra alone. With very minor variations, this drawing shows the design of the candelabra in Warsaw and in the Dodge Collection. It is inscribed with the letter *J* and a notation that it is intended

FIGURE 1 J.-L. Prieur, *Pair of Candelabra and a Clock on a Console Table.* Pen, brown ink, and watercolor, 342 × 274 mm. Warsaw University Library, Zb.Krol. P183 nr 141.

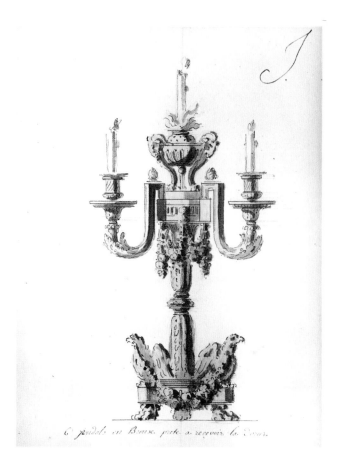

FIGURE 2 J.-L. Prieur, *Candelabrum for the King's Bedroom,* 1766. Pen, gray ink, gray and yellow wash, over traces of pencil, 316 × 235 mm. Warsaw University Library, Zb.Krol. P183 nr 245.

for six girandoles in bronze that were to be gilded. On the basis of style, the drawing seems clearly related to the group produced by Prieur at the behest of Louis for the King of Poland.

The date of the design of these candelabra is clearly established by the date of 1766 on one of the drawings. However, the execution of the candelabra for the King of Poland was, as Lorentz has documented, much delayed, probably for economic and political reasons. In the winter of 1776–77, Poniatowski's secretary, Maurice Glayre, went to Paris to resolve a financial matter that had arisen in regard to various furnishings ordered by the king on the basis of designs supplied through Louis. Pariset, in 1963, quoted the king's instructions concerning "six girandoles *sub littera J,*" the letter inscribed on the drawing related to the Dodge and Warsaw candelabra, which were to be prepared for gilding, but only the ornaments were actually to be gilded in Paris. Presumably, in order to reduce expenses, it was intended that the gilding would be completed after the candelabra had arrived in Poland. Lorentz (1958: 233–37) published a list of furnishings sent to Poland toward the end of 1777, among them "six girandolles de bronze ciselé et non doré." Almost certainly these were the candelabra in question which, contrary to the king's instructions, had been left entirely ungilded at the time of the shipment.

The question of the maker of these candelabra remains to be answered. That Prieur executed the detailed rendering of the design in about 1766 seems clear. He is known to have been a maker, as well as a designer, of gilt-bronze objects. Eriksen (1974: 352) has pointed out that candelabra of this description do not appear in the list of works supplied to the King of Poland by the Parisian bronze founder Philippe Caffiéri, and it can therefore be hypothesized that they were made by Prieur. Little is recorded about Prieur's life, and among the missing facts is the date of his death. Since, however, an ornamental engraving signed by him is dated 1783, he can be presumed to have been still working in 1777. The circumstantial evidence certainly points to Prieur as the maker of these candelabra, but there is unfortunately no available documentary evidence specifying clearly that he did so.

The design of these candelabra was to some degree determined by their original intended use in the bedchamber of the Polish king. The eagle, a dominant motif of their decoration, was the chief heraldic symbol of Poland. Poniatowski was the last king of an independent Poland; for all practical purposes that nation had ceased to exist as a political unit by the end of the eighteenth century.

The Dodge candelabra are recorded in the catalogue prepared by Duveen (Detroit 1939, I: n.p.) as having come from the collection of Prince Frodrow (or Feodrov), St. Petersburg.

Although no person bearing these names has been discovered, one Romanov named Feodor (1898–1968), who bore the title of prince, is recorded. He was married to his cousin, Irina, Princess Paley, daughter of Grand Duke Paul Alexandrovich of Russia.

PIERRE GOUTHIÈRE
1732 Bar-sur-Aube – Paris 1813/14

Born at Bar-sur-Aube, Gouthière is thought to have been an apprentice at Troyes. By 1758 he had moved to Paris and in that year married the widow of his master, thereby enabling himself to become a maître-doreur. *It was as a gilder that he enjoyed his first successes. He became as well the most famous* ciseleur *of his day, working for the Crown and for great courtiers, especially the duc d'Aumont. His distinguished clients were slow to pay their bills, and as a consequence he became bankrupt in 1788 and died in poverty in a home for the aged.*

[30]
Pierre Gouthière

Pair of Firedogs (Chenets), c. 1770–80

Gilt bronze, 49.5 (19½) × 47.6 (18¾) × 16.5 (6½)
Bequest of Mrs. Horace E. Dodge in memory of her husband (71.211, 71.212)

INSCRIPTION: On a circular paper label affixed to the back of each firedog: *P/255/29204/2.*

CONDITION: Good.

PROVENANCE: Marquis da Foz, Lisbon. José Guedes de Queiroz. His sale, Christie's, London, June 10, 1892, lot 57. George Jay Gould (d. 1923), Lakewood, New Jersey. Duveen Brothers (dealer), New York. Acquired by Anna Thomson Dodge from Duveen Brothers, 1932.

REFERENCES: London 1892: lot 57; Detroit 1933: n.p.; Detroit 1939, I: n.p.; *L'Oeil* 1970: 54–55; Winokur 1971: 49, 51; Paris 1987: lot 102; Marly-le-Roi-Louveciennes 1992: 59, 69, 80, n. 122.

The bases of these gilt-bronze firedogs are conceived as parapets which, as they approach the outer extremities, expand to form circular plinths. From these plinths rise flaming urns supported on four outcurving legs. The circular plinths beneath the urns are decorated with small rectangular reliefs of boys with a goat. At the ends of the parapet opposite the flaming urns are smaller, two-handled vases of antique form with pinecone finials. On the parapet immediately beneath them are small reliefs of thunderbolts. Decorating the central portion of each parapet are acanthus leaves framing small circular reliefs of a boy with a flaming brazier.

Three other pairs of firedogs of virtually the same design as that in the Dodge Collection have been discovered. At the time of its illustration in *L'Oeil* (1970: 54–55), the owner

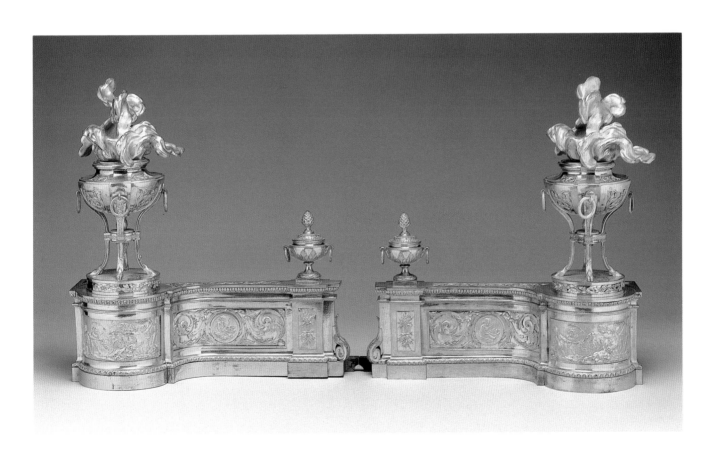

of one was the firm of Étienne Levy, Paris. A second was sold in 1987 at the Nouveau Drouot, Paris (Paris 1987: lot 102). In the brief caption accompanying the illustration of the Levy firedogs, they were attributed to Pierre Gouthière. The same attribution was put forth for the Dodge firedogs in the 1892 Christie's catalogue (London 1892: lot 57) and in the Dodge Collection catalogues in 1933 and 1939 (Detroit 1933: n.p.; Detroit 1939, I: n.p.). It is a third pair, almost identical in design to the pair in Detroit, that offers decisive evidence about the probable origins of all these firedogs. In the Musée National du Château de Compiègne is the pair that Christian Baulez has identified as one of two pairs originally made for the use of Madame du Barry at her famous Pavillon at Louveciennes (Marly-le-Roi-Louveciennes 1992: 59, 69, 80, n. 122). Baulez identifies these firedogs with two pairs mentioned in a memorandum of 1771 from Pierre Gouthière to Madame du Barry:

> Plus pour avoir fait faire plusieurs dessins et modèles pour les feux du salon carré [at Louveciennes], dont un modèle étant trouvé du goût de Madame, a servi à l'exécution des 2 feux des 2 cheminées du dit salon; lesquels sont très riches et sont décorés de bas-reliefs (Ottomeyer and Pröschel 1987, II: 626).

These two pairs of firedogs can be further identified in an inventory of the contents of Louveciennes made on February 11, 1794, where in the "Grand salon du milieu" of the Pavillon were found "deux feux dorés d'or moulu, des plus riches, avec bas relief, en forme de cassolette" (Molinier n.d.: 178). The unusual circumstance of the existence of two pairs of firedogs decorated with bas-reliefs and including the motif of perfume burners in the Salon Carré or Salon du Milieu at Louveciennes makes possible the almost certain identification of those now at Compiègne with one of the pairs supplied by Gouthière to du Barry at Louveciennes in 1771, despite the apparent lack of post-Revolutionary documents tracing their removal from one locale to the other. It further suggests that all extant firedogs of similar design emanated from Gouthière's shop and that they were probably made in the 1770s.

Eriksen (1974: 279, 360) has published two pairs of firedogs that are stylistically related to those in the Dodge Collection. He dates these firedogs "about 1770–75," almost certainly because they resemble pieces described in a list drawn up in 1770 of the stock of bronzes and models belonging to the Parisian bronze founder Philippe Caffiéri.

In her book on Stefano della Bella, Massar (1971: 132) has related the relief on a late eighteenth-century French design for a clock to the della Bella etching *Putti and Goat*. The reliefs on the Dodge firedogs bear at least a generic relationship to these compositions. Perhaps of greater relevance is the influence of the work of the early seventeenth-century Italo-Netherlandish sculptor François Duquesnoy, whose marble relief of a *Bacchanal* in the Galleria Doria-Pamphili, Rome, is similar in subject and design to the reliefs of the firedogs

(Faldi 1959: 52–63; Fabianski 1985: 40–49). That Duquesnoy's design was known and admired in mid-eighteenth-century Paris is indicated by the fact that Chardin made a painted copy of a bronze version of the *Bacchanal* composition, then in the collection of the painter Jean-Baptiste Vanloo (Paris 1979: no. 33).

Playful designs of nude children in low relief, which had their ultimate source in ancient sculptures and paintings, were widely employed for the decoration of architecture and furnishings in late eighteenth-century France. Clodion is particularly associated with such subjects, but they were certainly made by other artists as well. Unfortunately, no specific source has been discovered for the composition of the reliefs on the Dodge firedogs. The same composition, in a horizontally expanded version, appears as the central decoration of the base of a gilt-bronze and marble clock case owned by the Musée des Arts Décoratifs, Paris (Paris n.d.: pl. 112). On the basis of its style, this clock appears to have been made a decade later than the Dodge firedogs.

The catalogues of the Dodge Collection prepared by the Duveen firm (Detroit 1933: n.p.; Detroit 1939, I: n.p.) list in the provenance of these firedogs the collection of the marquis de la Fosse, Lisbon. There seems to have been no Portuguese nobleman of that title, but there was a marquis da Foz who lived in Lisbon and is recorded as having owned some important eighteenth-century French furniture. His collection is listed as the source of the material in the 1892 José Guedes de Queiroz sale at Christie's (London 1892: lot 57). Since this is approximately the time that George Jay Gould was furnishing his New Jersey home, it seems likely that these firedogs came to him from that sale, probably through the dealer Jacques Seligmann, who purchased lot 57, which was probably these firedogs.

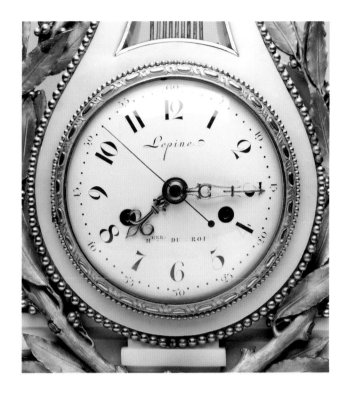

JEAN-ANTOINE LEPINE
1720 Paris – Paris 1814

CLAUDE-PIERRE RAGUET, called LEPINE
1753 Dôle – Paris 1810

Jean-Antoine Lepine became a maître-horloger *in 1762 and after that date was one of the leading Parisian clockmakers. In January 1783 he formed a partnership with his son-in-law, Claude-Pierre Raguet, which lasted until July 5, 1784, when Raguet assumed all responsibility for producing clocks, which continued to be marked "Lepine."*

ÉTIENNE MARTINCOURT
Died Paris after 1791

Martincourt was born in Paris at an unknown date. In 1763 he became a member of the Académie de Saint-Luc as a sculptor. In addition, he was active as a founder and finisher of metal sculptural projects, such as candlesticks and furniture mounts.

[31]
Case attributed to Étienne Martincourt
Movement probably by Jean-Antoine Lepine and by Claude-Pierre Raguet, called Lepine

Mantel Clock, c. 1784

White marble and gilt bronze, 63.2 (24⅞) × 69.2 (27¼) × 20.3 (8)
Bequest of Mrs. Horace Dodge in memory of her husband (71.215)

INSCRIPTIONS: On the central dial: *LEPINE*/*HGER DU ROI*. On the left dial: *INVENIT*. On the right dial: *ET FECIT*. On the mechanism: *LEPINE*/*HGER DU ROI, A PARIS NO4052*. On the back of each subsidiary dial: *G.MERLET*. On the gilt-bronze mount: EU.

CONDITION: Good.

PROVENANCE: Acquired by the Mesdames de France, Adélaïde and Victoire, Château de Bellevue, delivered July 15, 1786. Last recorded at Bellevue, January 16, 1795. Not included in the sale of the contents of Bellevue, March 23– August 31, 1795. Gift of Napoleon in 1808 to Jean-Jacques-Regis de Cambacérès, his *archichancelier,* Hôtel d'Elbeuf, Paris, then transferred the same year to the Hôtel Molé, rue Saint-Dominique, Paris. Sold in 1816 with this house to the dowager duchesse d'Orléans. Inherited by her son, King Louis-Philippe, Château d'Eu. By descent to his son, the duc de Nemours (d. 1896), then to the latter's two sons, the duc d'Alençon (d. 1910) and the duc de Vendôme (d. 1931). Duc de Vendôme's sale, Galerie Georges Petit, Paris, December 4, 1931, lot 95. Remion-Samary (dealer), Paris. Acquired by

Anna Thomson Dodge through L. Alavoine (dealer), Paris, 1931–32.

REFERENCES: Maze-Sencier 1885: 264, 282; Paris 1886: lot 309; Molinier 1902: 5, pl. 64; Dreyfus 1922: 76, no. 374, pl. XXXI; Dreyfus 1923: no. 18; Baillie 1929: 224; Paris 1931: lot 95; Britten 1932: 787; Biver 1933: 252, 256, 260–61, 266, 270; Morris 1939: 71; Verlet 1967: 205; Bellaigue 1968: 166–67; *Art Quarterly* 1971: 500, 505; Paris 1971a: no. 87; Paris 1984: 164–76; Ottomeyer and Pröschel 1987, I: 252; Dumonthier n.d.: pl. 18, no. 1, pl. 22, no. 2, pl. 24, no. 1; Paris n.d.: pls. 33, 34; Tardy n.d.: 115.

This astronomical clock consists of three separate mechanisms with appropriate dials that record not only the time of day but also the day of the week, phase of the moon, and date and month of the year. They are contained in a white marble and gilt-bronze case. The central dial is encased by a lyre-shaped form surmounted by a pinecone. The subsidiary dials are surrounded by marble drums. Gilt-bronze branches of laurel are tied beneath the central dial with a ribbon of the same material. These branches spread upward to enframe the central lyre and the subsidiary circular cases. The clock stands on a white marble plinth, in the center of which is set a long rectangular gilt-bronze bas relief with putti playing musical instruments. On either side of this relief are three gilt-bronze rosettes. The clock is supported on eight short legs of gilt bronze. The dials of the subsidiary movements are enameled in pale colors on metal.

When the partnership of Jean-Antoine Lepine and his son-in-law, Claude-Pierre Raguet, called Lepine, was dis-

solved in 1784, listed among the merchandise then owned by them were "une pendule astronomique à trois cadrans et à secondes, boîte de marbre garnie de bronze doré mat, en forme de lyre . . . 8,000 livres" and "une autre idem d'un quart plus petite . . . 6000 livres." The Dodge clock certainly resembles this description and may well be, in fact, one of these two clocks.

Biver (1933: 252, 256, 260–61, 266, 270) has published the documents that identify the clock in the Dodge Collection as that delivered by Lepine for the use of Louis XVI's aunts, Mesdames Adélaïde and Victoire, at the Château de Bellevue on July 15, 1786. A detailed description of that clock conforms in every particular to that in the Dodge Collection, and to no other known clock. It is described as:

> une pendule à trois cadrans, le principal dans sa boëtte de marbre blanc statuaire de forme de lyre, marquant les heures et minutes, et les deux autres dans leurs boëttes de forme circulaire aussi en marbre blanc statuaire et marquant les phases de la lune et les jours de la semaine, et l'autre les mois de l'année et jours de la semaine sur son socle de meme marbre ornée de bas reliefs representant des Enfans avec ornemens en feuillages et branches de lauriers, dorés or mat (Archive Seine et Oise, A1477, 1806).

When first received at Bellevue, the clock was placed in the *grand salon,* but sometime after March 18, 1787, it was replaced by a more important clock and moved to the billiard room. Its design must have been particularly appropriate to the latter room, which contained chairs with backs in the form of lyres. The cost of the clock was 10,000 livres, which was paid in eleven installments, the last in 1789. At Bellevue the clock was supplied with a case in the form of a glass dome, which, however, had been broken by 1794. The last mention of this clock at Bellevue was in an inventory made on January 16, 1795, where it was valued at 4,000 livres. It cannot be found listed among the contents of Bellevue sold between March 23 and August 31, 1795. It presumably disappeared from the château at that time. Christian Baulez (Paris 1984: 176) has traced the ownership of this clock through Cambacérès and the dowager duchesse d'Orléans to Louis-Philippe at the Château d'Eu. More specifically, Augarde (letter to the author, July 30, 1993) has stated that in 1808 this clock was installed in the *grand salon* of Cambacérès's Paris residence, the Hôtel d'Elbeuf. In the same year, it was transferred to the Hôtel Molé in the rue Saint-Dominique, Paris, and passed with this house to the dowager duchesse d'Orléans, widow of Philippe Égalité, in 1816, and thence to the King of France, Louis-Philippe, at the Château d'Eu (see Provenance). The letters EU, which are stamped into the metal mount of the clock case, record its presence at the Château d'Eu, a residence of members of the Orléans branch of the Bourbon family during the nineteenth century. Biver, who illustrates this clock (1933: pl. 21), mentions that it was sold at a 1931 auction of the possessions of the duc de Vendôme at the Galerie Georges Petit, Paris (1931: lot 95), shortly before it was purchased by Mrs. Dodge. The catalogue description of this clock fits that in the Dodge Collection, but the measurements given for it are much greater (90 × 88 cm). Presumably these dimensions are erroneous. Though it is possible that another clock of precisely the same design as that in the Dodge Collection may actually have been the one at Bellevue, no other such example is known. Biver mentions a clock in the Charles Stein collection, perhaps identical to that sold in 1971 with the collection of Georges Heine (Paris 1971a: lot 87), which resembles the Dodge clock, but it does not conform to the description of that at Bellevue. Furthermore, one of the dials of the Stein

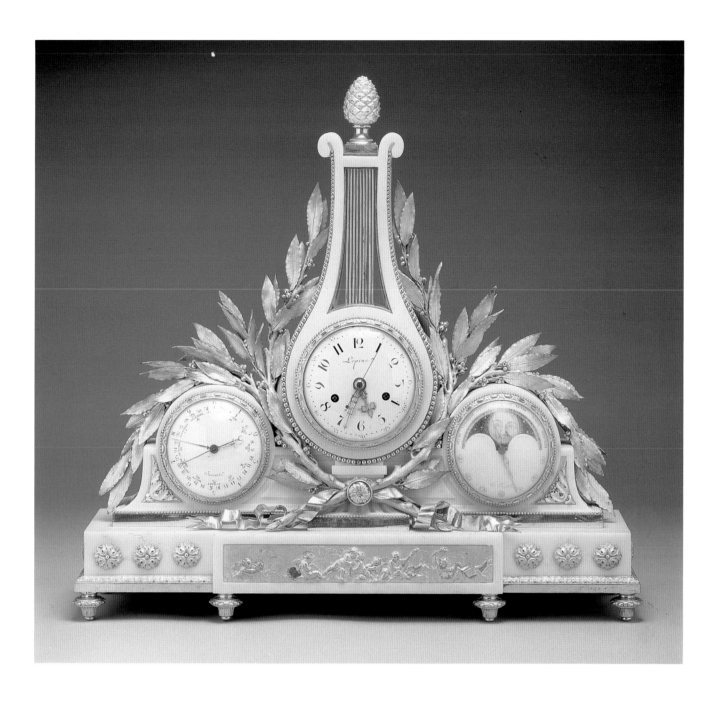

and Heine clock (or clocks) is dated 1789, several years later than the delivery of the Lepine lyre-shaped clock to the château. Under the circumstances, the chances that the Dodge clock actually came from Bellevue seem very good, but absolute proof of that provenance is lacking. The clock from the Stein and Heine collection is probably identical to one that sold anonymously in 1983 (Monaco 1983: lot 463) and in the sale of the collection of Mr. and Mrs. Franklin N. Groves (New York 1988a: lot 40). This clock was given to the Minneapolis Institute of Arts in 1989 by Mrs. Carolyn Groves.

The Lepine firm was one of the best-known Parisian clock-makers of its day. A number of clocks made by the firm were owned by the Mesdames at Bellevue. Verlet (1967: 205) has identified one of his clocks as having been owned by Marie-Antoinette. Astronomical clocks with three dials seem to have been Lepine's specialty: all the known examples of such clocks dating from the end of the eighteenth century were

made by his firm. Bellaigue (1968: 166–67) has published an example at Buckingham Palace and mentions another owned by the Mobilier National, which has been published by Dreyfus (1922: 76, no. 374, pl. XXXI) and Tardy (n.d.: 115). Still another clock by Lepine with three dials, apparently unpublished, is in the Royal Spanish Collections at the Palace at Aranjuez. The most complicated of these clocks is that in Minneapolis, where twelve small dials surround the central dial and give the time of day in twelve different latitudes.

The cases that house Lepine's mechanisms seem, in a number of instances, to have been supplied to him from a single shop. The cases of the Dodge and Minneapolis clocks are of almost identical design, the only important difference being the substitution of the head of Apollo in the Minneapolis example for the pinecone of the Dodge clock. Molinier (1902: 5, pl. 64) has published another clock by Lepine that seems to have legs of the same model as that in

the Dodge Collection. In several cases the gilt-bronze mounts of Lepine clocks have been attributed to Pierre Gouthière. However, Augarde has discovered thirteen bills, made payable by the Lepine firm between October 31, 1784, and December 31, 1787, to the maker of bronzes, Étienne Martincourt. It seems likely, on the basis of the evidence offered by the stock of the Lepine firm during these years, that mounts for the Dodge clock were among those supplied by Martincourt. This supposition is reinforced by the similarity of design between the central relief of music-making putti on the Dodge clock and the relief on the base of an elaborate clock in the Wallace Collection, London (Watson 1956: no. F264). The latter, in turn, resembles the verbal description of a clock made for the duchesse de Mazarin but unfinished at her death in 1781. Its central figure was created by Augustin Pajou and its bronzes finished by Martincourt, who was presumably responsible for the creation of its subsidiary cast ornaments (Verlet 1987: 222, 335).

An anonymous drawing for a clock in the collection of the École des Beaux-Arts, Paris, is illustrated by Ottomeyer and Pröschel (1987, I: 252). Its general form resembles the Lepine clocks, but it has only one dial flanked by putti. It should also be mentioned that Dumonthier (n.d.: pl. 18, no. 1, pl. 22, no. 2, pl. 24, no. 1) has published several clock cases with mounts of the same design as some of those on the Dodge clock, but with mechanisms by other clockmakers. Therefore, it can be assumed that the maker of cases for Lepine's clocks, probably Martincourt, supplied them to other clockmakers as well.

The two subsidiary dials of the Dodge clock are enameled in pale colors. The back of each is inscribed *G. Merlet*, undoubtedly the name of the enameler. This name is also inscribed on a late eighteenth-century clock with enamel decoration in The J. Paul Getty Museum, Malibu (inv. 72.DB.57). Unfortunately, very little is known about Merlet, except that he was active in Paris from the early 1780s until after 1800.

JEAN-DÉMOSTHÈNE DUGOURC
1749 Versailles–Paris 1825

The son of an important member of the household of the duc d'Orléans, Dugourc was appointed draftsman on the duke's staff in 1780 and four years later was promoted to intendent des bâtiments to the duke and attached to the Garde-Meuble de la Couronne. After the Revolution he went to Spain, where, in 1800, he was appointed a royal architect. Upon the restoration of the Bourbon monarchy in 1815, he was again employed by the French Crown.

[32]

After a design attributed to Jean-Démosthène Dugourc

Pair of Candlesticks, c. 1850–1900

Gilt bronze, 37.8 (14⅞) × 15.2 (6)
Bequest of Mrs. Horace E. Dodge in memory of her husband (71.216, 71.217)

CONDITION: While in the Dodge Collection, these candlesticks were electrified and small wafer feet were added. These additions have been removed.

PROVENANCE: Gerald Henry, Baron Foley, Ruxley Lodge, Claygate Surrey (1898–1927). Duveen Brothers (dealer), New York. Acquired by Anna Thomson Dodge from Duveen Brothers, 1935.

EXHIBITION: Detroit 1956: no. 130a–b.

REFERENCES: Detroit 1939, I: n.p.; Hautecoeur 1952: 495; Watson 1956: 97, nos. F174, F175, pl. 22; Bottineau and Lefuel 1965: 251; Paris 1968: no. 207; Frégnac 1975: 178, 182–83; Ottomeyer and Pröschel 1987, I: 258, 286–87.

Four female term figures are grouped together to form the stem of these gilt-bronze candlesticks. Garlands of flowers are suspended in front of each figure. Above their heads is an octagonal member on whose faces satyr masks alternate with acanthus leaves. The stem then diminishes in diameter to create a candle socket and base recalling in form an antique vase. The term figures stand on a bell-shaped base decorated with acanthus leaves.

The design of these candlesticks is clearly based on a late eighteenth-century French model, of which there are several extant variants. However, the quality of the finishing of these bronzes and the color of their gilding, as well as slight variations in design from examples that appear to be eighteenth century, indicate that the Dodge candlesticks were actually made in the second half of the nineteenth century.

The Dodge candlesticks resemble closely in design a pair in the Wallace Collection, London (Watson 1956: F174, F175). There are, however, variations in the tasseled scarves around the necks of the figures, in the satyr masks, and in the

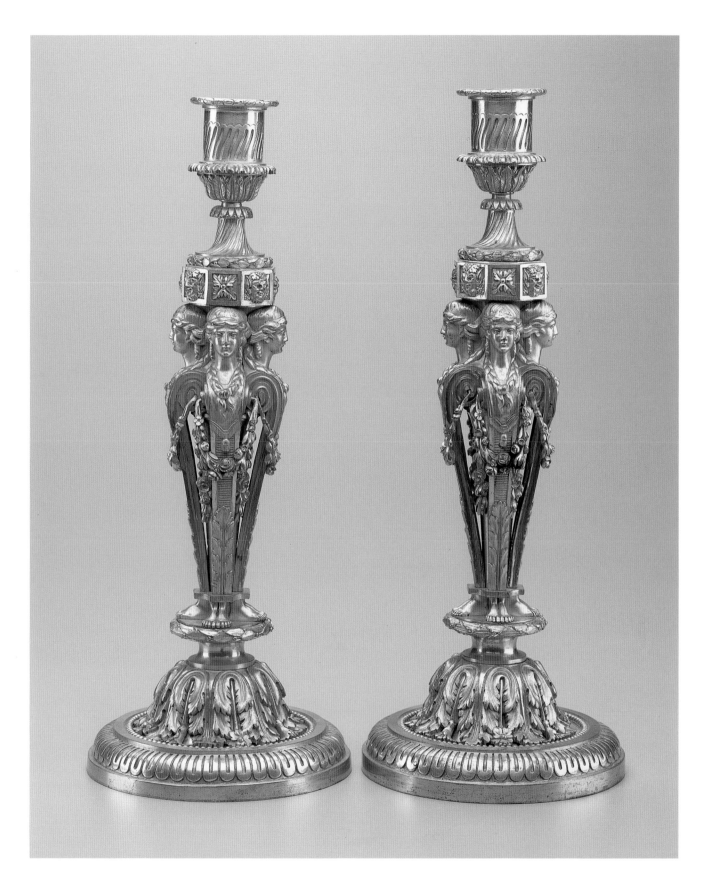

volutes at the top of the terms. Virtually identical to the pair in the Wallace Collection are those from the Bouvier Collection at the Musée Carnavalet, Paris (Paris 1968: no. 207). Mrs. Dodge owned a second pair of related candlesticks, which were in the sale of her collection in London (London 1971: lot 27). Still another pair was also sold at auction in London (London 1976: lot 81). These, like the pair

from the Thelma Chrysler Foy collection (New York 1959a: lot 665), differ from the Wallace Collection candlesticks in the design of the support of their sockets. Another pair sold at Sotheby's in 1964 (London 1964a: lot 104) differs from the standard model in the substitution of stars for the alternating acanthus leaves and satyr masks of the octagonal member immediately above the figures. Of all these candlesticks,

only the pair from the Dodge Bequest seems clearly to be of the later nineteenth century. Another, with some variations of design and presumably also nineteenth century, was recently offered in London (London 1990: lot 160).

Several suggestions have been made for the attribution of these and related candlesticks to particular designers or makers. The pair from the Foy collection was attributed to Étienne Martincourt, presumably because of a stylistic similarity to a group of candlesticks stamped with his name, of which examples are to be found in the Huntington and Wallace collections (Wark 1959: 100–01; Watson 1956: F166, F167). In the Duveen catalogue compiled for Mrs. Dodge (Detroit 1939, I: n.p.), these candlesticks were attributed to Jean-Louis Prieur, an attribution maintained when they were exhibited at The Detroit Institute of Arts in 1956 (Detroit 1956: no. 130a–b). But there seems to be no significant stylistic or documentary evidence to suggest that these candlesticks or related examples can be associated in any way with Prieur.

A drawing discovered by Verlet and published by Hautecoeur (1952: 495) as well as by Bottineau and Lefuel (1965: 251) bears an interesting, if not altogether clear, relationship to the design of the Dodge candlesticks. This drawing depicts a large console table, upon which are displayed several ornaments, including a pair of candlesticks virtually identical in design to those in the Dodge Collection. The drawing is included in an album of designs by Dugourc, and he is presumed to have been its author. This drawing is dated 1790, and in the margin there is a note that the work was to be executed by Pierre Gouthière. The problem of this drawing in relation to these candlesticks is chiefly that of the date inscribed. It seems too late to account for the number and variations of this model that exist. Presumably most, if not all, such candlesticks would have been made before the end of the eighteenth century, for after 1800 their style would no longer have been very fashionable. Ottomeyer and Pröschel (1987, I: 258) specifically mention an auction catalogue entry of 1787 that seems to record this model.

The concept of a candlestick with its stem formed of one or more female figures goes back at least to the seventeenth century. Bouilhet (1908–12, I: 48) published a drawing given to Le Brun of such a candlestick. An extant pair in the Wallace Collection has been assigned an early eighteenth-century date (Watson 1956: F22). The use of term figures in candlesticks seems to have been revived in the 1760s. A design by Piranesi for such a piece was published in 1769 (Piranesi 1769: pl. 23) but may have been conceived a few years earlier. A silver candelabrum by Robert-Joseph Auguste consists of three term figures grouped to form the stem (Eriksen 1974: pl. 262). It bears the Paris hallmark of 1767–68. At almost the same moment, Jean-François Forty made an engraving of a candlestick with two term figures (Eriksen 1974: pl. 433). Candlesticks with term figures con-

tinued to be made by Auguste in the 1770s and 1780s. A gilt-bronze pair in the Wallace Collection (Watson 1956: F164, F165) has been identified by Verlet (1950: 154–57; Verlet 1987: 38) with candlesticks supplied in 1781 by Jean-Baptiste Pitoin for the use of Marie-Antoinette. The term figures of the latter are stylistically close to those related in design to the Dodge candlesticks. Because of the existence of these various examples of candlesticks with term supports dating from the 1760s onward, it seems not unlikely that in making a presentation drawing of his design for a console table, Dugourc chose to depict it ornamented with a pair of candlesticks of a model already in existence, perhaps for more than a decade. Thus, while the design of the console table can be safely assigned to Dugourc, that of the candlesticks can be attributed to him only cautiously. Caution further dictates that the note that the work is to be done by Gouthière be presumed to refer only to the console table, not to the candlesticks, though Ottomeyer and Pröschel (1987, I: 258, 286–87) have suggested that eighteenth-century examples of the model are perhaps by Gouthière.

[33]

Anonymous, formerly attributed to Pierre Gouthière
(see p. 125)

Pair of Sconces, c. 1875–1900

Gilt bronze, 81.3 (32) × 38.1 (15)
Founders Society Purchase, Mr. and Mrs. Horace E. Dodge Memorial Fund (73.218a,b)

CONDITION: The cupids, which function as caryatids on these gilt-bronze sconces, were apparently raised by the repoussé technique from thin sheets of metal with a high copper content. In the process of raising these reliefs through hammering, the metal became too thin in a number of places and had to be patched on the reverse. They perhaps sustained further damage at a later time, which caused the portions in highest relief partially to collapse. They may have been removed from the back plate for repair, and their positions reversed when replaced. In their present arrangement, the cupids of each sconce face in the opposite direction from the medallion portraits of Marie-Antoinette and Louis XVI above them. These sconces have been wired for electricity.

PROVENANCE: Oakleigh Thorne, Paris. Duveen Brothers (dealer), New York. Acquired by Anna Thomson Dodge from Duveen Brothers, 1935.

EXHIBITION: London 1933: no. 540.

REFERENCES: Paris 1892: lots 480–83; Detroit 1939, I: n.p.; Dauterman, Parker, and Standen 1964: 277–79; New York 1966a: lot 390; Monaco 1982: lot 507; New York 1985: lot 161; New York 1988: lot 86; New York 1991: lot 19.

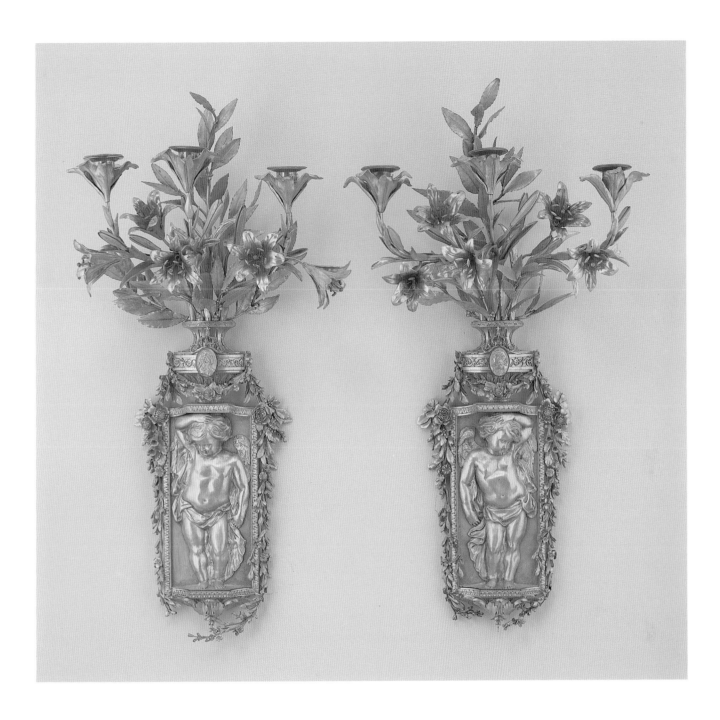

These gilt-bronze sconces include rectangular wall plates with protruding sections above and below to create niches, within which stand cupids functioning as caryatid figures. Above the niches rise urnlike forms, each decorated with an oval medallion profile portrait, one of Marie-Antoinette, the other of Louis XVI. Garlands of flowers are suspended from the urns and enframe the rectangular wall plates. From the top of the urns rise lily blossoms and sprays of leaves. Three of the blossoms of each sconce include sockets for candles at their centers.

A number of sconces of the same design are known—a pair from the Kress Collection at The Metropolitan Museum of Art, New York (Dauterman, Parker, and Standen 1964: 277–79, nos. 69a–b), and a pair belonging to Baron Édouard de Rothschild, Paris. James Parker kindly brought to my attention a set of four sconces of the same design, but lack-

ing the royal portrait medallions, which were in the sale of the Robert Goelet collection (New York 1966a: lot 390). One pair from the Goelet collection was later sold in Monaco (Monaco 1982: lot 507). The other Goelet pair may be that later in the Linsky collection (New York 1985: lot 161). A single sconce was sold at Sotheby's, New York (New York 1988: lot 86). The pair sold in Monaco in 1982 was recently on the block again in the sale of the Keck collection (New York 1991a: lot 19). According to the catalogue of that sale, all these sconces have holes for the attachment of the royal portrait medallions, whether or not the portraits are actually present.

Both the pair in the Dodge Collection and those at the Metropolitan Museum passed through the hands of Duveen Brothers. The provenance and exhibition history as provided by that firm are apparently the same. Only two sconces of this pattern were exhibited in London in 1933 (London 1933:

no. 540), but it is impossible to determine whether it was the New York or the Detroit pair. It is possible that some or all of the sconces now known may be identical with eight of similar design that were in the Madame d'Yvon sale (Paris 1892: lots 480–83), kindly brought to my attention by Theodore Dell. Curiously enough, in the 1892 catalogue the sconces are described as decorated "avec medaillons à bustes de personnages," with no mention of their specific subjects. Technically, however, all these sconces are not the same, since the cupid reliefs on the pair in the Metropolitan Museum appear to have been created by casting, rather than by hammering, as is the case with those in the Dodge Collection. The catalogue of the Wrightsman Collection (Watson, Dauterman, and Fahy 1966–73, II: 420, no. 232A–D) records a set of four sconces that are related stylistically to these, including cupids that are particularly close. Another pair *en suite* with those in the Wrightsman Collection was sold at Christie's in 1979 (London 1979a: lot 122).

The sconces in the Dodge Collection are technically accomplished. The garlands of flowers, in particular, exhibit the jewelrylike precision associated with the best gilt bronzes of the 1780s, notably those of Pierre Gouthière. We know from contemporary descriptions that Gouthière made sconces that included flowers in which candle sockets were imbedded (Robiquet 1920–21: 109, 123). None of these can, however, be certainly identified today. Despite the technical and stylistic characteristics of the Dodge sconces, the attribution of these bronzes to Gouthière and even to the last quarter of the eighteenth century cannot be sustained. Though the finishing of the bronzes is very precise, it is also a bit dry and mechanical. The cupids in relief, raised by the repoussé technique, are unusual in terms of eighteenth-century practice. Sconces of this model cannot be identified from known descriptions of the eighteenth century, nor has the provenance of any of the fairly numerous extant examples been traced back farther than the late nineteenth century. The sconces of similar design in the Madame d'Yvon sale of 1892 were described in the catalogue of that sale as "style Louis XVI," indicating that the compiler of that catalogue did not consider them antique (Paris 1892: lots 480–83). The presence of eight sconces of the same design in that sale would also suggest that at least some of them were of recent manufacture. For these reasons it appears that the sconces in the Dodge Collection are technically refined nineteenth-century pastiches imitating the style of the 1780s. Though judgments of quality are difficult to make without direct physical comparison, those in New York seem superior to the Detroit examples. It is possible that the former, or other sconces of the same or similar designs, may be genuine examples of late eighteenth-century craftsmanship.

The catalogue of Mrs. Dodge's collection, prepared by the Duveen firm (Detroit 1939, I: n.p.), reports that this pair came from the collection of Oakleigh Thorne, Paris. According to

Who's Who in America, a person of this name was a member of the National Academy of Design and resided in Millbrook, New York. He was last listed in the 1930–31 edition.

CHARLES-LOUIS CLÉRISSEAU
1721 Paris – Auteuil 1820

Clérisseau, the son of a merchant who specialized in perfumed gloves, was a pupil of Jacques-François Blondel and won the Académie's first prize in architecture in 1746. From 1749 until 1754, Clérisseau was a student at the Académie Française in Rome with, among others, the painter of classical ruins, Giovanni Paolo Panini. Clérisseau was returning to France in 1755 when he met the young British architect Robert Adam in Florence, and he stayed on in Italy to act as Adam's mentor and companion. He did not return to France until 1767; two years later he became a member of the Académie. Although he designed a few buildings in their entirety, Clérisseau is primarily known for his renderings of ruins and for his schemes for interior decoration.

JEAN-CLAUDE-THOMAS CHAMBELLAN, called DUPLESSIS *fils*
c. 1730 Paris – Paris 1783

Son of a famous designer of metalwork and ceramics who was artistic director for models at Vincennes and Sèvres, the younger Duplessis was assisting his father as early as 1752. In 1765 he was registered as a maître-fondeur en terre et sable, *but already in 1763 he was recorded as being owed money by the famous cabinetmaker Jean-François Oeben, presumably for gilt-bronze furniture mounts. Duplessis published engraved designs for vases about 1775–80. Candelabra of the design of those in Detroit are among the very few works of his that can be identified today.*

[34]

Design attributed to Charles-Louis Clérisseau
Made by Jean-Claude-Thomas Chambellan, called
Duplessis *fils*

Pair of Candelabra, c. 1775

Gilt and *gros bleu* enameled bronze, 149.9 (59) × 76.2 (30)
Founders Society Purchase, Mr. and Mrs. Horace E. Dodge Memorial Fund (71.394, 71.395)

INSCRIPTIONS: 71.394: On a tan label: *29621/2,* a Duveen Brothers inventory number. On a red label: *9T.* On a green label: *9.* On an orange label: *9/2.* On the base: *5* or *S16174.* All labels are affixed underneath the base. 71.395: Within the shaft is a penciled notation on paper: *127/1917.*

CONDITION: The blue-black enamel-like surface of the central urns appears to have been recently applied. Traces of the

original surface of these urns are revealed at their edges, a transparent blue lacquer glaze overlaying the silvered body.

PROVENANCE: Russian Imperial Collection, Gatchina Palace. Maria Feodorovna, Empress of Russia (1759–1798). Soviet government, until c. 1930. Duveen Brothers (dealer), New York. Acquired by Anna Thomson Dodge from Duveen Brothers, 1932. Her sale, Christie's, London, June 24, 1971, lot 30.

REFERENCES: Le Brun 1777: 84–86; Paris 1797: lot 137; Florence 1880: lot 1567; Réau 1922, I: 253; Réau 1931–32: 1–206; Detroit 1933: n.p.; Detroit 1939, I: n.p.; Courajod 1965, I: ccii-cciii, ccci; London 1971: lot 30; Stillman 1971: 35; *Gazette des Beaux-Arts* 1972: 93, fig. 326; Eriksen 1974: 105, 175, 310–11, 355–56, pls. 82, 218; London 1980: no. 44; Voronikhina 1983: pl. II; Ottomeyer and Pröschel 1987, I: 256–57; Verlet 1987: 203–05.

ADDITIONAL BIBLIOGRAPHY: Winckelmann 1781: 215, n. 1; Thiéry 1787, I: 103, 186–87; Champeaux 1886 II: n.p.; Lami 1910–11, I: 310; Lejeaux 1928, LIII: 225–31, LIV: 125–36; Réau 1937: 7–16; Hautecoeur 1952, IV: 483–84; Croft-Murray 1963: 377–83; McCormick 1971: 179–99; Gallet 1972: 57, 141, 169–72; Levey and Kalnein 1972: 326–27, pl. 284.

These gilt-bronze candelabra consist of bases composed of acanthus leaves from which rise a central support for the urns. A wide band ornamented with a rinceau of acanthus decorates these urns, and from their tops emerge three female caryatid figures with arms raised. Each of the figure's hands supports one of the six candle branches that constitute the functional elements of these candelabra.

The design of the Dodge candelabra bears a remarkable resemblance to that of the candelabra depicted in corners of the salon of the Hôtel Grimod de la Reynière in drawings of that room made by the Polish architect Kamsetzer during a visit to Paris in 1782 (figure 1). Réau (1922, I: 253) remarked upon this relationship in his monograph on Falconet but, curiously enough, did not refer to it in his later article on the decoration of the hôtel. Eriksen (1974: 175, 355–56, pl. 218) has independently established that a pair of candelabra in a European private collection resembles those from the salon of Grimod de la Reynière. The relationship in design of the Dodge candelabra to those from the salon is of more than passing interest, since a considerable body of information is available from contemporary sources on the houses of Grimod de la Reynière and their decorations. It seems certain that the Dodge candelabra are not identical with those belonging to Grimod de la Reynière, since his were contemporaneously described as having seven, not six, lights. Candelabra with seven lights appear in Kamsetzer's renderings of Grimod's salon. On these a socket for a candle takes the place of the flamelike finials of the Detroit examples.

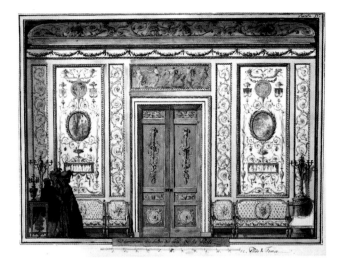

Furthermore, Grimod's candelabra were described as entirely gilt, while the pieces from the Dodge Collection are only partly so. Nevertheless, the resemblance between the extant pair in Detroit and the visual and verbal descriptions of those belonging to Grimod de la Reynière in the eighteenth century is sufficiently close to suggest that the two sets were created in a related fashion.

Most previous writings on the residences of Grimod de la Reynière and their decorations have been confused because in the 1770s he simultaneously owned two properties in Paris, both of which contained salons designed by Charles-Louis Clérisseau. McCormick (1971: 179–99) has published the note in the 1781 French edition of Winckelmann's letters that clarifies this situation (Winckelmann 1781: 215, no. 1). It states that Clérisseau decorated two salons for M. de la Reynière, the first in his old house in the rue Grange-Batelière, with figure paintings by the *pensionnaire du roi*, M. Peiron [*sic*], the second in his new house on the Champs Élysées, with figure paintings by M. le Chévalier Poussin. "M. Peiron" was almost certainly the young Jean-François-Pierre Peyron (1744–1814), who won the Prix de Rome in 1773. He was in Rome from 1775 to 1783 (Locquin 1912: 215–16), so that the decorations in the house in the rue Grange-Batelière must have been executed before his departure in 1775, perhaps in that very year, if Stillman (1966: 39–40) and McCormick (1971: 164–78) are correct in presuming that Clérisseau resided in England from about 1771 to about 1775. On the other hand, the painter Lavallée-Poussin, elsewhere identified as the executor of decorations for Grimod de la Reynière following a scheme created by Clérisseau, was in Rome from 1762 to 1777 (Mourer 1974: n.p.).

Desnoiresterres (1877: 21–22) has published some interesting documents concerning the Paris residences of Grimod de la Reynière. In 1768 or 1769 Grimod purchased property at the corner of the rue Boissy-d'Anglas and the Champs Élysées, near the point where the latter opens into the Place

de la Concorde (then the Place Louis XV). He planned to build a magnificent residence there, but in order to house himself during the construction, or because of indecision about undertaking that construction, he also purchased at approximately the same time, probably about 1770, a house in the rue Grange-Batelière. The latter had been designed by the architect Le Carpentier for the financier Bouret de Vézelay shortly after 1750. Grimod purchased it from another financier and land speculator, de Laborde (or La Borde). As late as 1780, the *Almanach royal* (1776–82) continued to list Grimod de la Reynière's address as the rue Grange-Batelière. When Thiéry's guide appeared in 1787 (Thiéry 1787, I: 103, 186–87), the house was recorded as having belonged to the late M. le duc de Choiseul, though he does not appear to have resided there. Certainly it was the salon of this house that was described in the *Almanach des artistes* of 1777 as having been decorated by Clérisseau in a new and agreeable style (Le Brun 1777: 84–86). It is noted specifically that Clérisseau had to adjust his designs to an already existing order and to replace ornaments in bad taste by ones better chosen. Not only was this clearly a remodeling job, but Kamsetzer's 1782 drawings, which are certainly of the house in the Champs Élysées, show that the salon there had no order in the form of columns or pilasters to which Clérisseau's designs would have had to be adjusted.

About the house in the Champs Élysées considerable information is available. Its appearance is well recorded by Kamsetzer's drawings, which have been published by Réau (1937: 7–16). The house itself existed in a mutilated form into the twentieth century. Its site is now occupied by the United States Embassy (Dumolin 1928: 138–39). Croft-Murray (1963: 377–83) has identified a set of room decorations in the Victoria and Albert Museum, London, as having come from this house. Jean-Benoît-Vincent Barré has consistently been identified as its architect, and Clérisseau's contribution to its decoration has been reported by several contemporary sources. Dumolin and Rochegude (1923: 258, 276) and Croft-Murray (1970: 91), perhaps following their lead, report that François-Joseph Bélanger cooperated with Barré in the design of this building. The evidence for this claim is unknown, but it is perhaps correct, since both architects were working at Méréville in the 1780s, though apparently on independent projects (Cayeux de Sénaport 1968: 127–33). It is also known that Clérisseau had cooperated with Bélanger in the design of a casino for the marquis de Lauraguais in 1769 (Stern 1930: 16–21). What we do not know about Grimod de la Reynière's house is the date of its construction. He purchased the land in 1769. Dumolin (1926: 143–44) has pointed out that in November 1775, Grimod received permission to vary the design of the facade of his house from that of the Hôtel de la Vrillière (de St.-Florentin) on the corresponding northeast corner of the Place de la Concorde.

The chief facade of Grimod's house did reflect, at a reduced height, the design established by Ange-Jacques Gabriel for the Hôtel de la Vrillière. In any case, construction of the former cannot have been begun until after November 1775. Lavallée-Poussin returned to Paris in 1777. Grimod de la Reynière's address in the *Almanach royal* was given as the rue Grange-Batelière as late as 1780. As noted, the new house with its decorations by Clérisseau and Lavallée-Poussin was mentioned in the 1781 edition of Winckelmann's letters. When Kamsetzer made his drawings in 1782, the house was largely complete and Grimod was living there, though Kamsetzer notes that the "salon de madame" was not finished in that year. On the basis of this information, it seems likely that the decorations executed after Clérisseau's designs were carried out about 1780.

The *Almanach des artistes* of 1777 (Le Brun 1777: 84–86) describes not only the salon decorated by Clérisseau in the house in the rue Grange-Batelière but also some of its furnishings, specifically four gilded candelabra in the corners of the room. These candelabra accorded perfectly with a marble chimneypiece with bronze mounts in that room. Furthermore, it is stated that the candelabra were executed by M. Duplessis, famous *ciseleur* of Paris. Elsewhere in the same book (Le Brun 1777: 188), in a listing of *fondeurs* and *ciseleurs*, Duplessis is described as a good designer who works after his own designs. It is further stated that it was he who had "cizelé" the beautiful candelabra in the salon of M. de la Reynière. Though proof is lacking, it seems reasonable to suppose that Grimod de la Reynière took these candelabra with him when he moved from the house in the rue Grange-Batelière to that in the Champs Élysées, and that they are the candelabra depicted in the Kamsetzer drawing of the salon of the latter. They can further be identified as lot 137 in the sale of the possessions of Grimod de la Reynière held in 1797 (Paris 1797). They are the only such set included in that sale.

If it can be accepted that Grimod de la Reynière owned one set of four candelabra, it follows that those depicted by Kamsetzer were made by the well-known decorative sculptor in metal, Jean-Claude-Thomas Chambellan, known as Duplessis *fils*. It remains to ask whether the design of these candelabra was formulated by Duplessis himself or by the designer of the decorations of the room as a whole, Clérisseau. Since little is known of the style of either Duplessis or Clérisseau in the designing of such objects, one is forced to rely on the text of the *Almanach des artistes* of 1777 for guidance. Unfortunately, the text is not entirely clear on this question. On the one hand, it remarks on the close relationship in design between the candelabra and the chimney piece of the salon. One can safely assume that Clérisseau would have designed so important an element in the room's decoration as the chimney piece. It further states that the candelabra had been "exécutés" by Duplessis, rather than designed by him. The implication would seem to be that the cande-

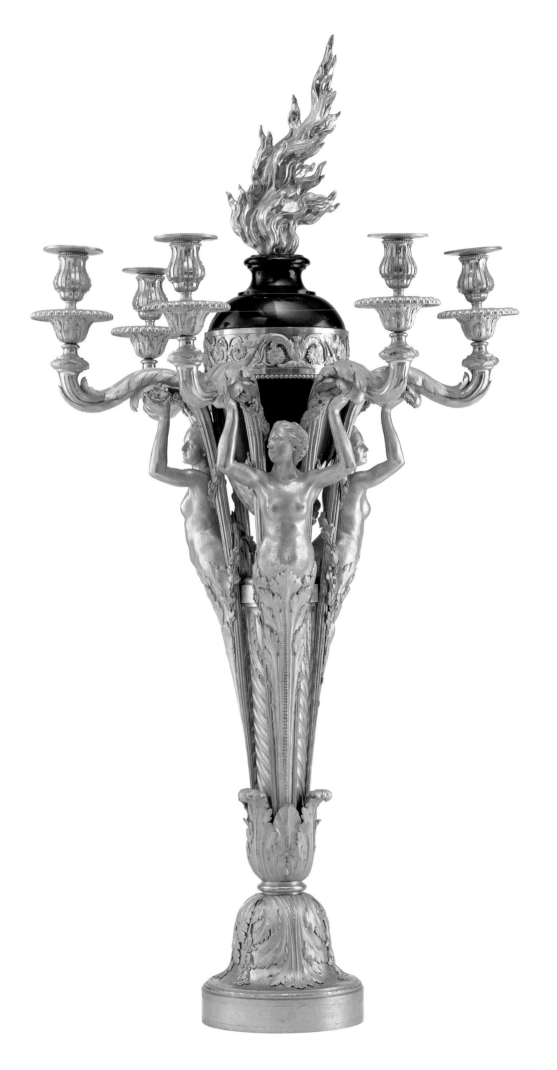

labra were designed by Clérisseau. However, we have seen that elsewhere in the *Almanach,* Duplessis is described as a good designer who works after his own designs. It goes on to state that Duplessis had "cizelé" the candelabra of M. Reynière, which certainly establishes the execution of them, but not necessarily the authorship of their design.

Because of these ambiguities of the text of the *Almanach des artistes,* a precise identification of the designer of these candelabra is impossible. On the basis of the *Almanach* text and in light of knowledge about the customary relationship between the design and manufacture of such objects in the eighteenth century, it seems safe to presume that Clérisseau participated to some degree in the design. He probably provided a rough sketch for them, which was amplified in his own studio or in Duplessis's shop. A model of the candelabra would then have been produced by Duplessis and approved by Clérisseau before casting them in bronze. Though the candelabra in the Dodge Collection seem clearly not to be those once in the salons of Grimod de la Reynière, their design is so close to those depicted by Kamsetzer that one may presume them to have originated from the same source, that is, to have been made by Duplessis, probably on the basis of a design by Clérisseau.

According to the catalogues of Mrs. Dodge's collection prepared by the Duveen firm (Detroit 1933: n.p.; Detroit 1939, I: n.p.), these candelabra came from the Demidoff collection at the Palace of San Donato near Florence. A similar pair was at San Donato, but in the catalogue of the sale of that collection, their caryatid figures and central urns are described as being of green bronze (Florence 1880: lot 1567). Since there is no indication on the Dodge candelabra that any part of them was patinated green, it seems unlikely that they are identical with those at San Donato. The provenance of the San Donato candelabra was given in the sales catalogue as Versailles, and they were attributed to Falconet. The evidence for these statements is not supplied by the catalogue, but perhaps the attribution was made in an effort to identify the San Donato candelabra with plaster models by Falconet that were exhibited at the Salon of 1761 and were intended to be executed in silver by François-Thomas Germain. Whatever the reason, the attribution is clearly incorrect, for a drawing by Gabriel de Saint-Aubin illustrating the catalogue of the 1761 Salon indicates that Falconet's design consisted of two women holding a cornucopia (Levitine 1972: fig. 74). It thus seems reasonable to discard the attribution of the San Donato and related candelabra to Falconet (Réau 1922, I: 253).

Though they were not at San Donato, there seems no reason to doubt the rest of the provenance of the Dodge candelabra as reported by the Duveen firm; that is, that they had been at Gatchina Palace near St. Petersburg. Although the candelabra cannot be placed with certainty at Gatchina, it is very likely that they were in the Russian Imperial Collection, for candelabra of precisely the design of those now in Detroit

appear in a pen drawing of 1839 by Julius Friedenreich of the Oval or Round Room in the Old Hermitage in St. Petersburg (Voronikhina 1983: pl. II). These candelabra seem certainly to have been acquired from the Soviet government by Duveen in the early 1930s (see p. 28 for Duveen's purchasing trips to Russia). Their earliest history is not known. Catherine II bought a large group of Clérisseau's drawings of antique ruins, and Clérisseau supplied the empress with designs for some structures that remained unexecuted or were greatly modified during construction (McCormick 1971: 200–11). It seems doubtful, however, that these candelabra were acquired through Clérisseau. In the extensive published correspondence between Catherine and Friedrich Melchior Baron von Grimm (Réau 1931–32: 1–206), Clérisseau's name and work are frequently mentioned, but there is no indication that he had anything to do with supplying furnishings for the Imperial household. Catherine's son, the future Czar Paul I, visited Paris in 1782 (see p. 59). He saw Grimod de la Reynière's new house and had an unpleasant meeting there with Clérisseau. It is unlikely that the two would have had any dealings with one another after that occasion, but the comte du Nord, as Paul was called at the French court, might have acquired these candelabra on that visit. Though precise evidence of the circumstances is lacking, it seems likely that these candelabra entered the Russian Imperial Collection in the eighteenth century.

JEAN-BAPTISTE-CLAUDE ODIOT
1763 Paris – Paris 1850

Scion of a well-established family of Parisian silversmiths, Odiot became a master in 1785. It was after the Revolution that he came into his own. At the 1802 Exposition, the first to include silver as a category, he and Henry Auguste shared the gold medal. When Auguste retired in 1806, Odiot acquired his designs, many of them the work of distinguished artists. Odiot's silver is characterized by the abundant use of sculptural elements, both three dimensional and in low relief. The Odiot firm became the most important Parisian silversmithing workshop of the first half of the nineteenth century, supplying a distinguished French and foreign clientele with well-designed and executed domestic silver, frequently of great elaboration.

ADRIEN-LOUIS-MARIE CAVELIER
1785 Paris? – Paris? 1867

Although trained as an architect, Cavelier is remembered today as a designer of metalwork who was employed by the silversmith Odiot and by the bronze founder Thomire in the opening decades of the nineteenth century.

[35]
Jean-Baptiste-Claude Odiot

Probably designed by Adrien-Louis-Marie Cavelier

Pair of Wine Coolers, c. 1817

Silver gilt, 36.8 (14½) × 29.2 (11½)
Gift of Mrs. Roger Kyes in memory of her husband
(71.296a–c; 71.297a–c)

INSCRIPTIONS: On the foot rims: JBCO in lozenge-shaped punch; J.B.TE C./ODIOT in rectangular punch. These are Paris first standard silver marks and medium assay office marks in use 1809–19.

MARKS: On the covers: an *A* and *L* interlaced (owner's initials) engraved in conjunction with unidentified coats of arms beneath a count's or earl's coronet.

CONDITION: Good.

PROVENANCE: Supplied by the Odiot firm to Count Nicholas Demidoff (1774–1828) on December 5, 1817. Said to have been given by him to a Madame de la Chappelle. Unidentified noble family residing in England, 1863. Anonymous Englishman of title who had inherited them from his grandfather. His sale, Anderson Galleries, New York, December 15, 1928: lot 32 or 33. Anna Thomson Dodge. Her sale, Christie's, London, June 24, 1971, lot 53.

EXHIBITION: Grosse Pointe 1981: unnumbered.

REFERENCES: Soyer 1822: pls. 62, 70; New York 1928a: lot 32 or 33; London 1971: lot 215; *Gazette des Beaux-Arts* 1972: 101, fig. 359; Davidson 1973: 441; New York 1978: no. 157; New York 1982: lot 141; Pinçon and Gaube du Gers 1990: 84–85, 87; Geneva 1990: lot 86; Paris 1991a: no. 38; New York 1993: lot 358; Geneva 1994: lot 136.

ADDITIONAL BIBLIOGRAPHY: H.H. 1955: 52–57; Coste-Messelière 1969: 40–47, 75; Le Corbeiller 1981: 195–98.

The shape of these wine coolers follows closely that of the volute-handled krater of antiquity, but with handles that assume the form of mermaids. The necks are ornamented with trailing grapevines. At the center of each side are reliefs of cupids and centaurs playing musical instruments. Beneath each handle is a small armorial relief. The lower portion of the bodies and the feet are ornamented with stylized leaf forms. An engraved coat of arms appears on each cover.

The pair of wine coolers in the Dodge Collection is part of a set of four that was included in a service of 119 pieces supplied to Count Nicholas Demidoff by the Odiot firm in 1817 and 1818. When this service was divided and sold at the Anderson Galleries auction in 1928 (New York 1928a: lot 32 or 33), a photograph of a page from a ledger of the Odiot firm was used as the frontispiece of the sales catalogue. On this page is listed a number of items acquired by "Mr. de Demidoff" on December 5, 1817, among them "4 Seaux Camées Centaures anses Sirènes avec dble fonds," which cost 4,200 francs. In that auction were two pairs of wine coolers corresponding exactly to that description. One of those pairs subsequently entered the Dodge Collection, along with other pieces from the same service, all of them later sold at Christie's in 1971 (London 1971: lot 215). The second pair of wine coolers belonged to the Audrey B. Love Foundation, New York, and was exhibited at The Metropolitan Museum of Art, New York, in 1978 (New York 1978: no. 157). Recently, this second pair was included in sales in New York (New York 1982: lot 141) and Geneva (Geneva 1990: lot 86).

The catalogue of the Anderson Galleries sale in 1928 certainly followed the tradition of ownership that had accompanied the Demidoff service, stating that it had been given by Count Nicholas Demidoff to Madame de la Chapelle, whose arms it bears. It was acquired from her descendants by the grandfather of its 1928 owner. The latter was described as "an anonymous English gentleman of title." In one respect, it seems difficult to reconcile this tradition of ownership with pieces from the Demidoff service. The coats of arms with which they are decorated, both in engraving and cast in silver in low relief, are surmounted by the coronet of a count or an earl and accompanied by the initials *A* and *L* conjoined. It has, unfortunately, not been possible to identify the name of the persons associated with the arms, but they are not among the arms of the several families surnamed Chapelle. Furthermore, there seems to have been no one of this name who was a count in the nineteenth century. Among the pieces from the Demidoff service formerly owned by the Audrey B. Love Foundation is a cruet frame. Clare Le Corbeiller (1981: 195–98) found that when this frame was dismantled, the armorial silver plaques in low relief proved to be fully marked by the London firm of C.F. Hancock and dated 1863. These armorial plaques, which are bolted to the bodies of pieces from the Demidoff service, may have replaced similar plaques with the Demidoff arms that originally decorated these objects. The firm of C.F. Hancock, which became Hancock and Co. in 1870, is still in existence. In the most recent sale of the matching pair of wine coolers (Geneva 1994: lot 136), an entry from the ledger of the Hancock firm made c. 1863 is reproduced. It reads: "A Silver Gilt Desert [*sic*]

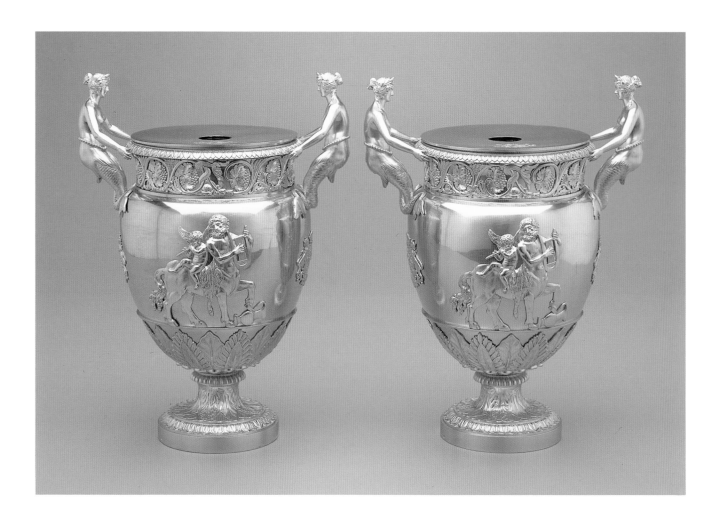

Service made for & purchased from Prince Demidoff," a statement contradicting the tradition of ownership offered in 1928. At the present time, all that can be said with certainty about the Demidoff service between its purchase in 1817 and 1818 and its sale in New York in 1928 is that it was supplied with new armorials in London in 1863. Mrs. Dodge also owned a pair of dishes with covers from this service (cat. 36).

These wine coolers are related in style and design to several works by the Odiot firm. Mermaid handles occur on Odiot sauceboats in the Hermitage, St. Petersburg, and the Musée des Arts Décoratifs, Paris. The latter museum also owns a wine cooler, illustrated by Bouilhet (1908–12, II: 115) and Hautecoeur (1953: 99), which is similar in form and decoration to the Dodge examples, but with handles in the form of satyrs rather than mermaids.

Bottineau and Lefuel (1965: 194–95) illustrate a drawing for a ewer with a handle in the form of a mermaid, which rather closely resembles those of the Dodge wine coolers. At the time of publication in 1965, the drawing belonged to the Odiot firm. It was sold at auction in 1979 (Monaco 1979a: lot 610) and acquired by The J. Paul Getty Museum, Malibu (inv. 79.GA.180). Bottineau and Lefuel attributed this drawing to the Parisian silversmith Robert-Joseph Auguste, or to his son Henry, who was also a silversmith, and dated it "1775–80." Certainly the style of this drawing indicates that

it was made some years earlier than the wine coolers, though it might reasonably be dated to the very end of the eighteenth century. Another drawing in the 1979 sale (Monaco 1979a: lot 614) was signed "Auguste" and included the signature of approval "N. Demidoff." It was also for a ewer, but with a winged figure of Victory holding a trumpet that forms the handle. Although the motif is different, the style of this Victory is quite close to the mermaids of the Dodge wine coolers, especially the facial types and coiffures. This second drawing has been attributed to Henry Auguste. In the Mentmore sale (Buckinghamshire 1977: lot 675), there was a ewer, close in design to this second drawing, signed *I. P. Auguste fi. à Paris, 1808*. Since there is no recorded Parisian silversmith of this name, it has been presumed that the ewer was made by Henry Auguste, who was perhaps hiding behind a false name or that of a relative because he had declared bankruptcy in 1806. Although far from conclusive, these various bits of evidence suggest that the elements of the design of the Dodge wine coolers may have been based on forms originated by one of the Augustes or by a designer working for them.

When the matching pair of wine coolers from the Demidoff service was sold by the Audrey B. Love Foundation at Christie's (New York 1982: lot 141), the sale catalogue reproduced a drawing from the Odiot firm archives that is

clearly related to these pieces. The drawing was published more recently by Pinçon and Gaube du Gers in their monograph on Odiot (1990: 87, fig. 128), where it is given to Cavelier, presumably on the basis of its style, since no inscription or other evidence for attribution is recorded. Of special interest in relation to the design of the four wine coolers are two *verrières*—vessels for cooling wine glasses. In the Odiot account of the sale to Demidoff in 1817, they are listed immediately after the four wine coolers. All these pieces have in common elements of design, most notably the handles in the form of mermaids, but also the bands of trailing grapevines near their rims and trumpet-shaped feet decorated with overlapping leaves. For the *verrières,* there exist a preliminary drawing and a contemporary verbal description, both of which state that they were designed by Cavelier in 1817 (New York 1987: lot 165). So similar are these six pieces that it can be hypothesized that all were probably by the same hand. Recently Cavelier has been credited with other designs for pieces from the Demidoff service (Paris 1991a: no. 38). The attribution was based on Soyer (1822) and on drawings for the Demidoff service owned by the Odiot firm. That firm clearly relied on a variety of sources for its designs, and hence Cavelier cannot be allotted sole responsibility for the appearance of every piece in the Demidoff service, but he was very likely its major author, especially for examples with figural elements.

Also reproduced in the 1982 catalogue of the Christie's sale (New York 1982: lot 141) was a photograph of bronze models of the reliefs of cupids riding on the backs of male and female centaurs. These reliefs were part of a gift made in 1835 by Odiot to the Musée des Arts Modernes du Luxembourg, Paris (Bouilhet 1908–12, II: 104–11). In the letter that accompanied his gift, Odiot stated that, in the creation of these works, he had been aided by the designs of "Prudhon, Moreau, Garneray et Cavelier" and, for the modeling, by "Académiciens Chaudet, Dumont, et Roguier, artistes de la plus grande distinction." Models similar to those in the 1835 gift are reproduced in Pinçon's and Gaube du Gers's monograph (1990: 87, fig. 126), where they are attributed to Pierre-Philippe Thomire, but without evidence cited for this assertion. There is, however, evidence that Odiot and Thomire did sometimes work closely together (Geneva 1994: lot 136).

[36]

Jean-Baptiste-Claude Odiot

Pair of Covered Dishes, c. 1817

Silver gilt, 22.2 (8¾), height of dishes and covers;
29.8 (11¾), diameter of dishes
Founders Society Purchase, Mr. and Mrs. Horace E. Dodge
Memorial Fund (73.251a,b; 73.252a,b)

INSCRIPTIONS: On foot rims: JBCO in lozenge-shaped punch; ODIOT. Paris first standard silver marks and medium assay office marks in use 1809–19.

 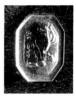

MARKS: On the dishes: *A* and *L* interlaced (owner's initials) in relief in conjunction with unidentified coats of arms beneath a count's or earl's coronet.

CONDITION: Good.

PROVENANCE: Supplied by the Odiot firm to Count Nicholas Demidoff (1774–1828) on December 5, 1817, or at a slightly later date. Said to have been given by him to a Madame de la Chapelle. Unidentified noble family residing in England, 1863. Anonymous Englishman of title who had inherited them from his grandfather. His sale, Anderson Galleries, New York, December 15, 1928, lot 53, 54, 55, or 56. Anna Thomson Dodge. Her sale, Christie's, London, June 23, 1971, lot 54. Frank Partridge and Sons, Ltd. (dealer), London.

REFERENCES: New York 1928a: lot 53, 54, 55, or 56; London 1971: lot 54; Pinçon and Gaube du Gers 1990: 116, fig. 186.

ADDITIONAL BIBLIOGRAPHY: H.H. 1955: 52–57; Coste-Messelière 1969: 40–47, 75; Le Corbeiller 1981: 195–98; Paris 1991a: no. 38.

The dishes and their bell-shaped covers are decorated with narrow borders of leaves at their edges. A wide band of ornament in relief, consisting of grape clusters and rosettes, encircles the covers, each of which is topped by a knop in the form of a pinecone. The dishes bear engraved coats of arms; on each side of the covers, the same arms have been applied, cast in silver in relief.

This pair of dishes with covers is part of a set of eight that was included in a service supplied to Count Nicholas Demidoff by the Odiot firm in 1817 and 1818. When this service was divided and sold at the Anderson Galleries auction in 1928 (New York 1928a: lot 53, 54, 55, or 56), a photograph of a page from a ledger of the Odiot firm was used as the frontispiece of the sales catalogue. On this page are listed a number of items acquired by "Mr. de Demidoff" on December 5, 1817, among them "4 Cloch[es?] à Bandeau," which cost 600 francs, and "4 plate d'entrée. . . . " In the 1928 auction there were four pairs of covered dishes that seem to correspond to that entry, so others must have been added to the service at some time. One of the four pairs subsequently

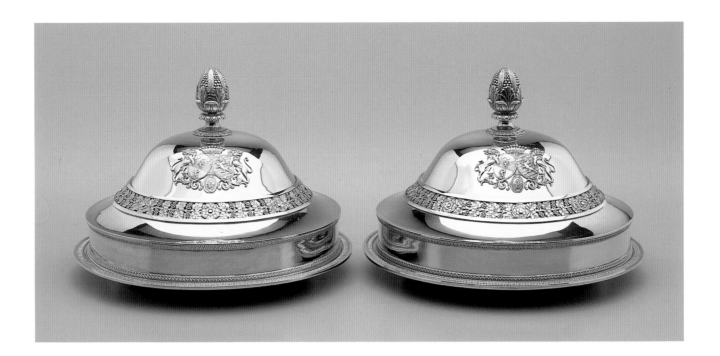

entered the Dodge Collection, along with other pieces from the same service, all of them later sold at Christie's in 1971 (London 1971: lot 54). The vicissitudes of the Demidoff service between its purchase in 1817–18 and the 1928 sale are uncertain (see cat. 35).

The design of the pieces in the Demidoff service is generally credited to Adrien-Louis-Marie Cavelier (1785–1867), but the basic form of these dish covers can already be found in silver made by Odiot between 1794 and 1797 (Paris 1972: lot 61). A design for a dish cover with an almost identical ornamental band of grapes, grape leaves, and rosettes and a similar finial is dated 1806 (Pinçon and Gaube du Gers 1990: 116, fig. 186). The design of these covers appears to have relied on a well-established repertoire of forms and decoration customarily employed by the Odiot firm when they were made about 1817.

TAPESTRIES

Henry H. Hawley

FRANÇOIS BOUCHER
1703 Paris–Paris 1770

François Boucher was born on September 29, 1703. Although at the time of his birth his father was only recorded as a dessinateur *(draftsman), all records thereafter refer to Nicolas Boucher as a* maître peintre. *It is therefore likely that François Boucher worked first under his father's tutelage before he began his rather short (1721–23) apprenticeship to François Lemoyne (1688–1737). In 1723 Boucher won first prize for painting from the Académie Royale, but was denied the customary trip, by scholarship, to Rome to continue his training. For the next five years, he supported himself by making etchings and drawings for engravings; his most notable work of this period was a number of etchings for the* Figures de différents caractères, de paysages, et d'études dessinées d'après nature par Antoine Watteau. . . . *Finally, funded by his own savings, Boucher made the trip to Rome in the spring of 1728. It does not seem that he produced many works there, nor was he greatly influenced stylistically by his trip to Italy. He returned to Paris, at the very latest, by 1731.*

Shortly after his return, Boucher was accepted into the Académie Royale as a peintre d'histoire *and in 1734 was elevated to full membership. By this time, his aptitude for decorative design had been revealed in several projects. He began providing tapestry cartoons to the Beauvais manufactory in 1734. This first series was entitled* Fêtes italiennes; *three years later he designed* L'histoire de Psyché.

At this point, Boucher's reputation was well established. He had received the first of his many royal commissions (four grisaille Virtues *for the ceiling of the* chambre de la reine *at Versailles), and student artists were already making engravings after his works. In July 1737 he was elected full professor at the Académie. He also began providing designs for the Académie Royale de Musique; he continued these services through the 1740s.*

By then Boucher's fame had reached beyond the borders of France. Despite the important purchases made by or commissions received from Swedish patrons in particular, however, Boucher's main commitment was to the French Crown. Boucher was held in high esteem by Madame de Pompadour and by her brother, the marquis de Marigny, the Superintendant of the King's Buildings and, as such, the provider of the most-sought-after commissions. These supporters helped Boucher to secure the preeminent position he occupied in the arts until his death. Not since Charles Le Brun—the official painter to Louis XIV— had an artist controlled so many aspects of the artistic life of the nation. Like his predecessor, his role in providing cartoons and designs for tapestries was an essential one. Although his projects for the Gobelins Manufactory were not always accepted or executed, his association with the celebrated manufactory culminated in his appointment in 1755 as Inspecteur sur les ouvrages de la Manufacture des Gobelins, *a position that forced him to sever all connections with the rival tapestry manufactory of Beauvais, for which Boucher had provided some of his finest*

tapestry cartoons. By the early 1750s, he was also providing designs for the porcelain manufactory at Vincennes and later at Sèvres; Vincennes-Sèvres figurines were principally modeled after figures from Boucher's oeuvre.

Even after the death of Madame de Pompadour in 1764, Boucher continued to obtain important commissions and posts. He declined the position of dessinateur du cabinet du roi *offered by the Académie but in 1765 accepted the appointment as premier peintre du roi. Only two weeks later, Boucher was elected director of the Académie. Even though he suffered periods of poor health in the late 1760s, he continued his decorative projects and entered works in the Salon up until his death in May 1770.*

[37]
Beauvais Manufactory
Designed by François Boucher

Psyche Displaying Her Treasures to Her Sisters,
design c. 1740, manufactured 1744–46

Wool and silk, 8–9 warps per cm; 364.5 (143½) × 405.8 (159¾)
Bequest of Mrs. Horace E. Dodge in memory of her husband (71.180)

INSCRIPTION: Woven on the step: *F. BOVCHE.*

CONDITION: In very good condition overall. There are some color losses in the sky and the flesh has gone brown; loss of yellow creates an overall bluish visual effect. Each side had a pleat taken in: on the left, the pleat was 9.5 cm deep, on the right 8.3 cm deep; therefore, 19 cm were lost on the left side and 16.6 cm on the right. During conservation treatment in 1995–96, the pleats were opened up and the tapestry extended to its full width. There are repairs in the lower right and left corners. The borders are original. The vertical border is intact; the top and bottom horizontal borders were cut to accommodate the two pleats.

PROVENANCE: Reggio e Branciforte family, Naples. E. Cronier, Paris. His sale, Galerie Georges Petit, Paris, December 4–5, 1905, lot 164. George Jay Gould (d. 1923), Lakewood, New Jersey. Duveen Brothers (dealer), New York. Acquired by Anna Thomson Dodge from Duveen Brothers, 1932.

REFERENCES: Seidel 1900: 190–91; Alexandre 1905: 22, 26–27; Paris 1905a: lot 164; Macfall 1908: 136; Badin 1909: 33, 60; Göbel 1928, I: 226; Spretti 1933: 643; Detroit 1933: n.p.; Weigert 1933: 230, 232; Detroit 1939, I: n.p.; Rice 1939: n.p.;

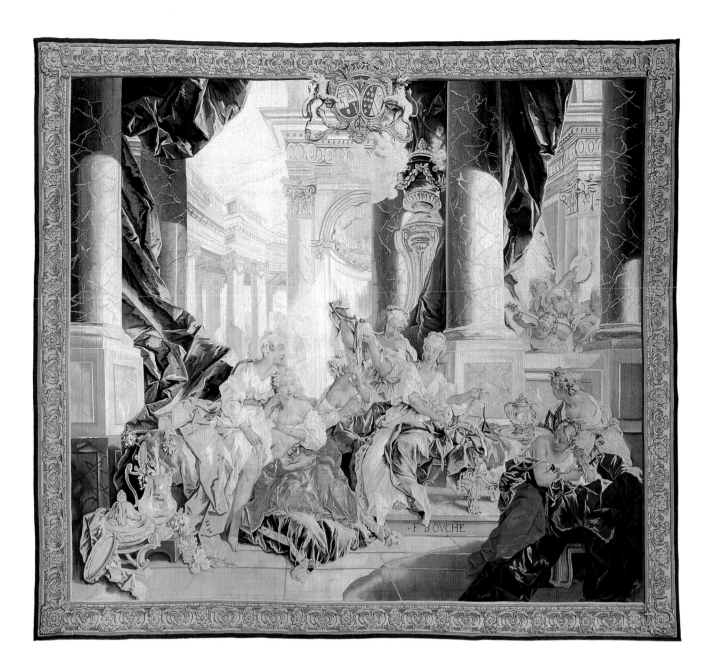

Salet 1946: pl. 29; *Art Quarterly* 1971: 500, 504; Malmbourg 1971: 80, ill. opp. p. 80; Winokur 1971: 48–49; *Gazette des Beaux-Arts* 1972: 96, fig. 338; Ananoff and Wildenstein 1976, I: 20, no. 160, 149, 311–12, no. 193, figs. 606–09; Hiesinger 1976: 7–23; Forti Grazzini 1993, II: 393, 492.

ADDITIONAL BIBLIOGRAPHY: Vaucaire 1902: 10–17; Hunter 1925: 166–70; Block 1933: 13–14; Voss 1953: 81–93; Bjurström 1959: 138–52; Weigert 1962: 131; Hussman 1977: 45–50.

Psyche Displaying Her Treasures to Her Sisters is one of five scenes from the story of Psyche for which Boucher made cartoons to be woven in tapestry at Beauvais. This was the second series made at the Beauvais manufactory after his designs. A minister of Louis XV wrote to the director of the manufactory in 1737, asking that two new series be woven for the king, the subjects to be chosen in consultation with Boucher. Later it was decided that the second should be the

story of Psyche; the first cartoon was exhibited in the Salon of 1739. Three pieces were woven by 1741 and a complete set of five by 1742. Boucher's cartoons were recorded at Beauvais in 1754 (Weigert 1933: 230, 232) and again in 1820 (Ananoff and Wildenstein 1976, I: 149). In 1829 they were sold; the *Psyche Displaying Her Treasures* was then in five parts to enable it to be woven on the horizontal looms used at Beauvais. It and the other cartoons sold in 1829 have since disappeared. A pair of grisaille sketches sometimes attributed to Boucher, which, with some variations in composition, are clearly related to the scenes of the *Toilet of Psyche* and *Psyche Displaying Her Treasures,* were exhibited in 1968 at the Royal Academy in London (London 1968: nos. 35, 36). The former is now in the Fitzwilliam Museum, Cambridge.

Three sketches by Boucher related to the Psyche tapestries were exhibited at the Galerie Cailleux in 1964 (Paris 1964: nos. 14–16). They are *Cupid and Psyche Received by the Gods,* to which no tapestry corresponds, *Psyche Receiving Divine*

seven times in the eighteenth century, beginning in 1742. A drawing for the nymph who raises both her arms is in the Daniel Wildenstein collection, New York (Ananoff and Wildenstein 1976, I: 311–12, no. 193, fig. 607).

Boucher set the scene for this episode in the story of Psyche within a richly decorated, columnar portico open to the sky in the distance. Slightly to the right of center, Psyche is removing jewels from a casket, while around her are grouped her sisters and ladies-in-waiting, observing her actions and admiring her treasures. Most authors writing about Boucher's designs for the *Psyche* tapestry series have stated that Boucher, in choosing the scenes and mode of representation, heeded the advice of the *littérateur* Bachaumont. In a letter to Boucher, Bachaumont suggested that the artist rely primarily upon La Fontaine's retelling of the legend of Cupid and Psyche, originally recorded by Apuleius. He further suggested that Boucher read the opera of Philippe Quinault and the comedy of Molière and examine the engravings of Marcantonio Raimondi after Raphael to learn more about the legend and its representation. A copy of Bachaumont's letter is preserved among his papers at the Bibliothèque de l'Arsénal, Paris, and is extensively quoted in his biographical sketch by the Goncourts (n.d.: 83–84). The specific incident of *Psyche Displaying Her Treasures to Her Sisters* is, however, mentioned neither by Molière nor Bachaumont. Hiesinger (1976: 15) has suggested that for this composition Boucher relied on Charles-Joseph Natoire's depiction of the same subject in his decorations at the Hôtel de Soubise in Paris.

Certain documentation of the Dodge tapestry begins with its appearance in the Cronier collection early in this century. In that collection it was accompanied by two other tapestries from the series of the story of Psyche, but these had become separated by the time *Psyche Displaying Her Treasures* entered the Gould collection. The three tapestries in the Cronier collection all bore the same coat of arms and can thus be presumed to have been made for the same patron. The style of the mantling of these arms and of the borders of the tapestries indicates that the three *Psyche* tapestries were probably among the early weavings of this series at the Beauvais manufactory, made before 1760. During the past twenty years, several pieces of Meissen porcelain have been sold at auction that bear armorial decoration consisting of the same coat of arms as that seen in the dexter, or male, coat of arms on the three *Psyche* tapestries (London 1973a: lot 56; London 1974: lot 134; London 1975: lot 104; London 1986b: lot 248; New York 1992: lot 15). Many of these ceramics are decorated with the arms surrounded by the collar and badge of the Order of St. Januarius, an order established by Charles (1716–1788), King of the Two Naples and Sicilies, in 1738. In these sale catalogues, the coat of arms has been identified as that of the Neapolitan noble family Mauro, styled Mauro d'Averso. That identification was erroneous, and the arms are certainly those of Luigi Reggio e Branciforte and his wife, Caterina Gravina.

Honors, which is related, but with several compositional variations, to the tapestry entitled *The Arrival of Psyche;* and *The Toilet of Psyche,* which is compositionally close to the tapestry of the same title. Slatkin (Washington and Chicago 1973: 49–50, no. 38) has twice published a drawing entitled *Zephyr Leading Psyche into the Palace of Love,* which is a preparatory study by Boucher for the central figures of the tapestry *The Arrival of Psyche* but differs from those figures as depicted in the sketch exhibited by Cailleux. An aquatint entitled *Psyche refusant les honneurs divins* by Parizeau, exhibited at the Louvre in 1971 (Paris 1971: no. 90), is, despite its altered title, related compositionally to the painted sketch *Psyche Receiving Divine Honors* from the Musée du Château de Blois which was in the Detroit Boucher exhibition of 1986 (Detroit 1986: no. 36). According to Michel (1906: 33, no. 585), this aquatint follows a pen-and-wash drawing, included in an eighteenth-century sale. Finally, a painting entitled *Psyché conduite par Zephire dans le palais de l'amour,* which was almost certainly Boucher's cartoon for the tapestry *The Arrival of Psyche,* was exhibited at the Salon of 1739.

According to the published records of the Beauvais manufactory, which may be incomplete, the design of *Psyche Displaying Her Treasures to Her Sisters* was woven at least

He was made a knight of the Order of St. Januarius in 1740, served as the Spanish ambassador to France, and died in 1757. According to records of the Beauvais manufactory, five tapestries illustrating the Psyche legend were ordered by the Spanish ambassador in 1744. Final payment for the Detroit *Psyche Displaying Her Treasures to Her Sisters* was made on February 12, 1746. It is possible that this set is identical to that mentioned by Badin (1909: 60) as having been made in 1748 "pour Naples."

Psyche Displaying Her Treasures to Her Sisters exists in several recorded versions, some of them parts of complete sets of the series. Among the latter are those in the Royal Palace, Stockholm, the Rice Collection at the Philadelphia Museum of Art, and the Kunstgewerbemuseum, Berlin. *Psyche Displaying Her Treasures* is also found in a group of four tapestries from the series in the Palazzo Quirinale, Rome, and, joined with another scene from the series into a single large design, in a tapestry from the Edward Tuck collection, now in the Petit Palais, Paris. As reported by Duret-Robert (1972: 35–36), a single tapestry of this subject was sold at auction in Paris in 1970; it is probably that recorded as in a private collection, Paris, in 1976 (Ananoff and Wildenstein 1976, I: 312, no. 193/4).

[38]
Gobelins Manufactory
Designed by François Boucher

Four Tapestry Panels Mounted in a Screen

Panels: c. 1755–65
Screen: twentieth century
Wool and silk, 11 warps per cm, each panel, 81.9 (32¼) × 47.9 (18⅞), inside frame dimension of tapestries; 179.1 (70½) × 233.7 (92), frame
Bequest of Mrs. Horace E. Dodge in memory of her husband (71.181)

INSCRIPTION: On the back of the frame, a paper label: *29116*, a Duveen Brothers inventory number.

CONDITION: The panels are generally in good condition. They are well supported and very secure in the frames. The damask backing is twentieth century and in excellent condition. The panels are soiled overall; there is some fading, but no notable staining. Flesh tones are browner than one would expect, some of the purples are lost, and the sky has lost the colors that would have given it refined shading, but this is normal. On the tops of the pink borders there appear to be wear and possibly some repair. First panel: there are repairs in the pink in the perimeter that show up as lighter, shinier areas, and there is a dark stain to the right of the bottom center and in the pink area. Second panel: there is slight rippling

across the bottom. Third panel: no conspicuous damage. Fourth panel: no conspicuous damage; in the pink area there are repairs that show up as lighter, shinier areas, notably in the lower right-hand edge; the lower right-hand corner shows a bit of wear, exposing some of the warps. These panels, in another frame, were formerly in the Wertheimer collection and must have been mounted in their present screen format sometime between their publication in 1902 and their acquisition by Mrs. Dodge in 1935 (see Provenance and References).

PROVENANCE: Charles Wertheimer, London. Herbert Stern. Baron Michelham (before 1912; see London 1912: 42). Duveen Brothers (dealer), New York. Acquired by Anna Thomson Dodge from Duveen Brothers, 1935.

REFERENCES: Le Blanc 1856, II: 153, nos. 190–92; 411, no. 3; Michel 1906: 111, no. 1979, 140, no. 2545; Molinier 1902: 19; Molinier 1902a, I: no. 4, pl. 56; Fenaille 1904–07, IV: 348–49, 387–88; London 1912: 42; Detroit 1939, I: n.p.; Ananoff 1966, I: 24–25, no. 5, fig. 1; Jarry 1969: 115, fig. 7; Ananoff and Wildenstein 1976, II: 68, no. 367, 70, no. 267/15, 103–04, no. 414, 125, no. 437, 134, no. 5a; Paris 1978: 76–77, no. 196, 207–09, no. 780, 240–41, no. 933, 294, no. 1194; Standen 1994: 111–33.

The tapestry panels are vertical rectangles with arched tops. Each includes the figure of a child dressed in simple contemporary costume and placed in a landscape setting, all in naturalistic colors. The ground color of the tapestries is pink. As presently mounted, the subjects, from left to right, are a girl making a wreath of flowers, a boy with a lamb, a boy playing bagpipes, and a milkmaid. The central scenes are framed by C-scrolls, plant forms, and garlands of flowers. The design of the enframement is similar in the four panels, but there are some variations, most obviously in the direction taken by sprays of flowers beneath each scene. The screen's frame, made of giltwood, in the *Régence* style, is modern.

Although the designs of figural subjects obviously based on the same models as those of the Dodge screen have occasionally been attributed to other artists, for example, to Jean-Baptiste Huet in the Cronier sale (Paris 1905a: lot 158), most authors have correctly ascribed them to François Boucher. Engravings exist for the four figural subjects, and their designs are attributed to Boucher by inscriptions on the plates: for the bagpiper, *L'innocence* by François-Antoine Aveline; for the boy with a lamb, *L'enfant berger* by Gilles Demarteau and *Le petit pasteur* and *Le berger* by Claude-Augustin Duflos; for the girl making a wreath of flowers, *L'amusement de la bergère* by Marie-Madeleine Igonet; and, for the girl eating from a bowl, *La petite beurière* also by Igonet. Ananoff (1966, I: 24–25, no. 5, fig. 1; also Ananoff and Wildenstein 1976, II: nos. 367/15, 414, 437, 456/5) has identified all four compositions with paintings or drawings by Boucher or prints after his designs.

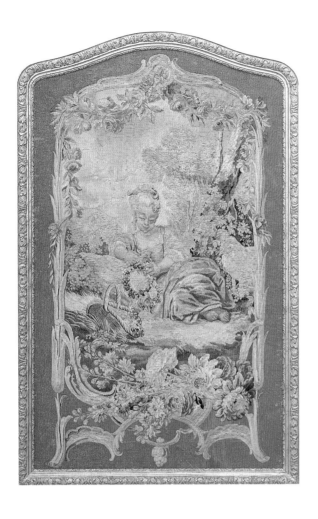

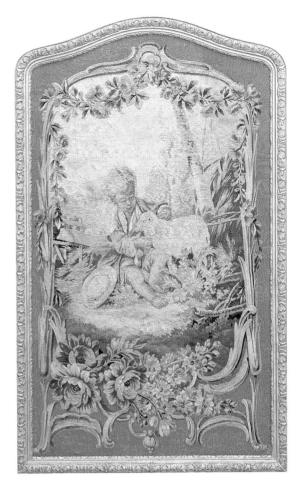

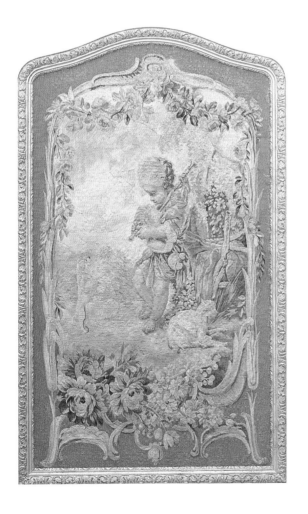

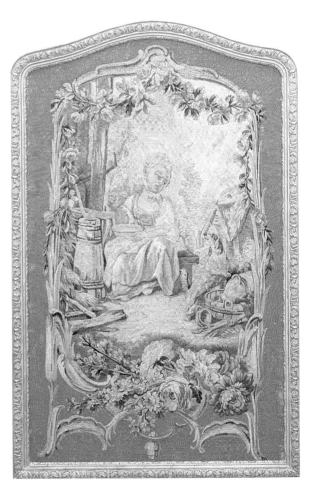

der extending downward like the legs of a chair alters the proportions of the panels, making them suitable for screens rather than chairbacks; similarly decorated panels are found in the Musée du Louvre, Paris, the Huntington Library and Art Gallery, San Marino, and in several sales. Many are signed by Neilson.

Jarry (1969: 115, fig. 7) has published a maquette by Boucher that includes the composition of the girl making a wreath of flowers, which can only have been intended for reproduction by the Gobelins. A panel of this girl is on a chair seat in a set of furniture formerly in the George A. Cooper collection, London (Standen 1994: 112–13; London 1966: lot 95; London 1968a: lot 66) and on a sofa at Osterley Park, near London (Standen 1994: 116, fig. 19). She was also used for the painted decoration of a Vincennes cup, dated 1753, in the Musée des Arts Décoratifs, Paris (Standen 1994: 116, fig. 17), and on another in the Wadsworth Atheneum, Hartford. The boy with the lamb has not been found on other tapestries, though a drawing attributed to Boucher from the Gilbert Lévy collection, sold in Paris (Paris 1987a: lot 10), shows him tying an arrow-filled quiver around the lamb's neck. The boy playing the bagpipes to a dog is found on many chairback covers and fire screens, including one in The Carnegie Museum of Art, Pittsburgh (Owsley 1972: 194–95). The little girl in a dairy, eating out of a bowl, appears on a fire screen in the Rijksmuseum, Amsterdam, which has Neilson's name, and as a Vincennes porcelain figurine in the Musée des Arts Décoratifs, Paris (Standen 1994: 115, figs. 15 and 14, respectively).

The intended function of these panels is not entirely clear. Tapestry panels for *écrans* (small fire screens) are fairly numerous in eighteenth-century inventories. Taller screens of several leaves (*paravents*) and covered with tapestry panels are much rarer, though Davillier (1876: 146–56) and Badin (1909: 67–75) have offered evidence that they were made at both Beauvais and the Gobelins. Low screens of several leaves were also sometimes used in front of French fireplaces in the eighteenth century, but no evidence seems to exist that they were ever covered with tapestry. That the Dodge panels were intended to be used on a screen of some sort seems likely because of their size and shape.

Fire screens are often included in sets of eighteenth-century French seat furniture. Only very rarely do French rooms have more than one fireplace, and hence the need for no more than one fire screen in a given set of furniture. Sets of four matching fire screens are unrecorded in eighteenth-century documents and unknown in other surviving examples. The panels in this screen do follow cartoons that were intended for fire screens. Since the design of their borders and their ground colors are similar, it is clear that they were made as a set. The chance of a set of four separate fire screens or tapestry panels for fire screens having been kept together since the eighteenth century seems small. It appears most likely that they were originally mounted in a single screen of multiple leaves.

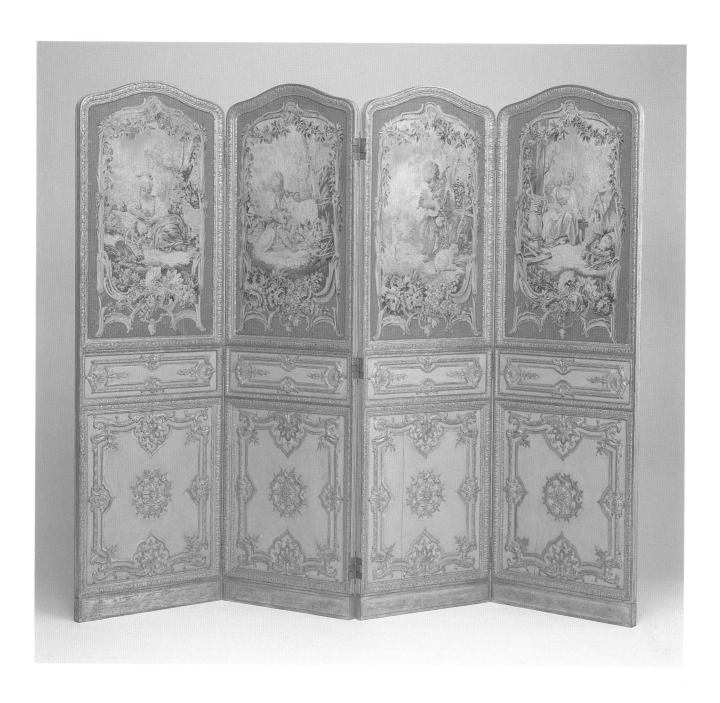

As Badin (1909: 67–75) and Fenaille (1904–07, IV: 348, 387–88) have made clear, relatively small pieces of tapestry intended for use on furniture were made in the eighteenth century at both Beauvais and Gobelins. It seems equally clear, as Watson (1961: 166–69) has pointed out, that furniture tapestries were much more popular, and hence abundant, at the end of the nineteenth and the beginning of the twentieth centuries than they had been in the eighteenth. Watson's main argument, which is based on the amount of upholstery recorded as woven at the Beauvais manufactory and very inadequately published by Badin, does not apply to furniture covers woven at the Gobelins; these were almost always made for private customers and do not appear in official records. The dyes used at a later period were different from those of the eighteenth century and these panels can therefore be dated, on both stylistic and technical grounds, to the third quarter of the eighteenth century. A copy of the Dodge

screen with five leaves is listed by Ananoff and Wildenstein (1976, II: no. 414/2) as in the former Krieger collection; Maison Krieger was a firm of furniture makers in Paris in the nineteenth century. No other recent weavings of the Boucher subjects of the Dodge screen have been recorded.

The place of manufacture of the Dodge panels is certainly the Gobelins manufactory, though most authors, including Molinier (1902: 19; Molinier 1902a: I, no. 4, pl. 56), have given them to Beauvais. Fenaille (1904–07, IV: 388) has pointed out that the design of the borders of the Dodge panels follows a pattern that he attributed to Maurice Jacques and that is to be found on several tapestry panels signed "Neilson," who was head of a workshop at the Gobelins from 1751 to 1788.

Panels signed "Neilson" are in the Camondo collection (Paris 1922: 16, no. 84, pl. XIV) and in the Victoria and Albert Museum, London (Savage 1969: fig. 50). The scrolling bor-

SÈVRES PORCELAIN

Clare Le Corbeiller

JEAN-CLAUDE DUPLESSIS, *père*
c. 1690 Turin–Paris 1774, active 1745–74

A native of Turin, Duplessis was a goldsmith, bronze founder, and designer whose original name was Ciamberlano. He came to Paris before 1742, and from 1748 on was regularly engaged by Vincennes (and later Sèvres) to design models for the manufactory. At the same time, he continued to design and execute gilt-bronze mounts for Chinese porcelains; in 1758 he was named orfèvre du roi. A number of models can be assigned to Duplessis on the evidence of drawings in the Sèvres archives; many others are attributed to him on grounds of style and plausibility.

PIERRE-JOSEPH ROSSET, *l'aîné*
1735 Paris–? after 1799

Born in Paris, Rosset entered Vincennes in 1753 as a flower painter, gradually increasing his repertoire to include ornamental borders, landscapes, commemorative decorations, and, in 1791, chinoiseries in colored golds on black-ground plates and ice cups. He stopped painting in 1795 but is recorded on the manufactory payroll until 1799 in an administrative capacity.

[39]
Designer probably Jean-Claude Duplessis, *père*
Painted by Pierre-Joseph Rosset, *l'aîné*

Vase (vase à oreilles, shape A, third size), c. 1755

Soft-paste porcelain, 18.7 (7⅜) × 9.5 (3¾)
Bequest of Anna Thomson Dodge (71.256)

INSCRIPTIONS: Inside the foot: interlaced *L*'s and the mark of Rosset, opposite each other.

CONDITION: One handle has been broken and repaired, and there is a chip at the tip of the other. The gilding is worn throughout.

PROVENANCE: Comte de Saint-Léon, Château de Jeure (unidentified; by tradition). Duveen Brothers (dealer), New York. Acquired by Anna Thomson Dodge from Duveen Brothers, 1939.

The body of inverted pear shape rises from a low, stemmed circular foot. The rim is separated into leafy scrolls that curve down to the shoulder, forming handles. The turquoise *(bleu céleste)* ground is reserved on each side with a large circular panel enclosing a bouquet of mixed flowers. A plain gold band encircles each reserve, the top of the stem, and the foot.

The model was produced in six sizes, of which the first three were introduced in 1754 (Savill 1988, I: 135). The only difference between shapes A and B is the presence on the latter of a molded cartouche frame of scrollwork and foliage. A subtle and distinctive feature of its design is a triangular section formed of molded lines, its apex at the point where the rim branches into handles. This was normally emphasized by gilding, and the curved base of the triangle served to define the size of the reserve. All this has been uncharacteristically ignored here, the reserve and its border extending well beyond the usual scale, thus giving the vase a somewhat potbellied appearance. This disproportion, the plainness of the gilding, and the somewhat tentative painting all suggest inexperience. As evidenced by three vases in the Wallace Collection, London (Savill 1988, I: nos. C234–36), Rosset had become an accomplished flower painter by 1759, and several of his compositional mannerisms can be seen here. This piece, however, should perhaps be dated toward the beginning of Rosset's career and viewed more as an essay than as a mature example of his work.

ANDRÉ-VINCENT VIELLIARD, *père*
1717 Paris–Sèvres 1790, active 1752–90

Vielliard was born in Paris and worked as a fan painter before coming to Vincennes in 1752; he was the half-brother of the bird painter Étienne Evans. A large number of pieces, representing each stage of his career, survives. He began as a painter of Boucher-like children in the 1750s but is best known for his Flemish peasant scenes of c. 1759–64, whose figures are misproportioned and stilted, but whose domestic landscapes, painted in a light, misty palette, are attractive. Between the late 1750s and 1770s, Vielliard produced Boucher-like pastoral scenes and landscapes and, in the years just before his death, Neoclassical decorations.

[40]
Painted by André-Vincent Vielliard, *père*

*Set of Three Flower Vases
(vase hollandois*, first and second sizes), 1760

Soft-paste porcelain
71.249 and 71.250: 19 (7½) × 19.7 (7¾) × 13 (5⅛)
71.251: 21.6 (8½) × 29 (11⁷⁄₁₆) × 15.9 (6¼)
Bequest of Anna Thomson Dodge (71.249a,b; 71.250a,b; 71.251a,b)

INSCRIPTIONS: Underneath the stand of 71.251b, in blue enamel: interlaced *L*'s enclosing an *H* for 1760 and the mark of Vielliard. Incised beneath the vase and stand of 71.251a,b and beneath the stand of 71.249b: *CN*.

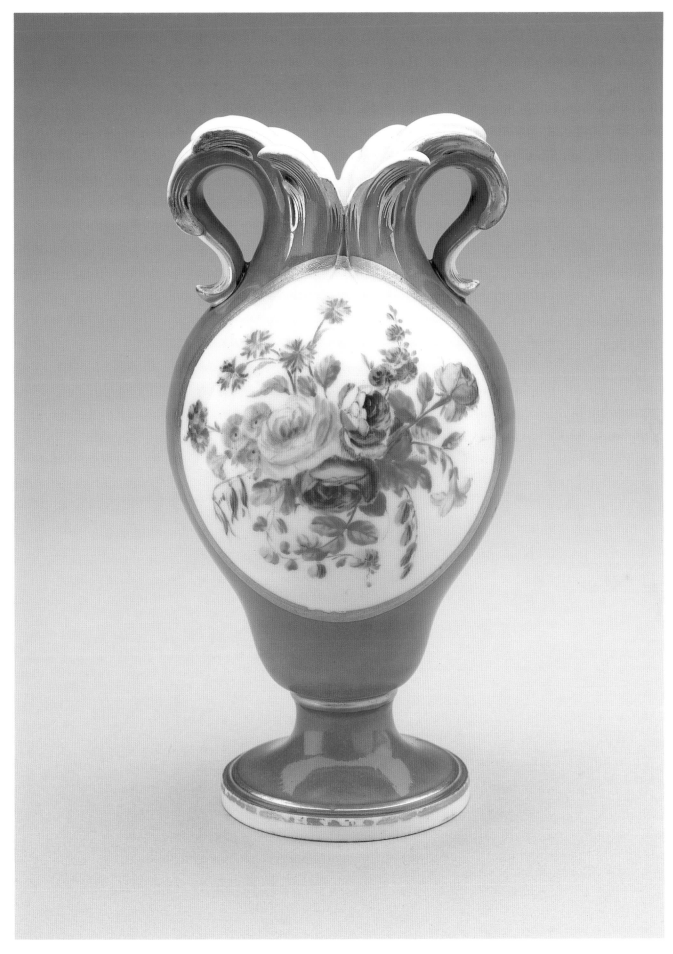

CONDITION: The gilding is slightly worn on the stand of 71.249. 71.250a has been broken and repaired along the front left corner, with repainting and regilding. Both the vase and stand of 71.251 have been broken and repaired and have areas of discolored overpaint on undecorated surfaces.

PROVENANCE: Baroness Mathilde von Rothschild (1832–1924), Frankfurt (by tradition). George Blumenthal (1858–1941), New York. His sale, Galerie Georges Petit, Paris, December 1–2, 1932, lot 64. Duveen Brothers (dealer), New York. Acquired by Anna Thomson Dodge from Duveen Brothers, 1939.

REFERENCES: Bloch 1930, VI: pls. XLIX–L; Paris 1932: lot 64, pl. XXXIII; Dauterman 1976: 758, figs. 36, 37, 39; Savill 1988, I: 38; Sassoon 1991: 50.

Each vase is of oval section, comprising a fan-shaped vase, waisted at the bottom, and with a recessed extension that fits into a low stand of conforming shape. Set against a light turquoise ground overlaid in gold with a trellis and rosette pattern are three reserves. These enclose an outdoor peasant scene on the front and domestic furniture and utensils on the sides, also depicted outdoors. The backs of the vases are undecorated. The shoulders of the stands are pierced on four sides with scroll-framed openings, and below are four reserves painted with landscapes. Flat panels at the corners of the vases and stands are gilded with intertwined garlands above a rosette and leaf-tip pattern. On the larger vase, gilt garlands are suspended inside from the front and back rims.

The model was produced in three sizes, of which the first two appeared in December 1754. Sets composed of three vases of the first and second sizes are recorded from 1754 to 1783 (Savill 1988, I: 70). They were used for growing plants—water being supplied through the openings in the stands—and also for porcelain flowers (Savill 1988, I: 72).

The scenes on these vases mark the height of the fashion for rustic scenes copied or adapted from paintings by David Teniers the Younger (1610–1690), a fashion already established by 1759, when sets of *vases hollandois* of these two sizes, painted with Flemish scenes, were supplied to members of

the court (Savill 1988, I: 70). Vielliard himself painted these scenes repeatedly, mostly in 1760, but also as late as 1764 (Dauterman, Parker, and Standen 1964: no. 41; London 1965: lots 16, 17; Savill 1988, II: nos. C361, C442; Munger et al. 1992: no. 127). Other vases and small tablewares dating between 1759 and 1764 were painted by Charles-Nicolas Dodin (cat. 41), Antoine Caton, and Jean-Louis Morin (cat. 42).

Most of the scenes are derived from one of two paintings. The first is a *Village Festival* by Teniers, dated 1646, now in the Hermitage, St. Petersburg, and formerly in the collection of Catherine the Great, having been acquired from Étienne-François, duc de Choiseul (1719–1785), who had owned it from 1754 (Klinge 1991: 157). The other painting, from which excerpts appear on these vases, has been described as the pen-

71.251

71.250

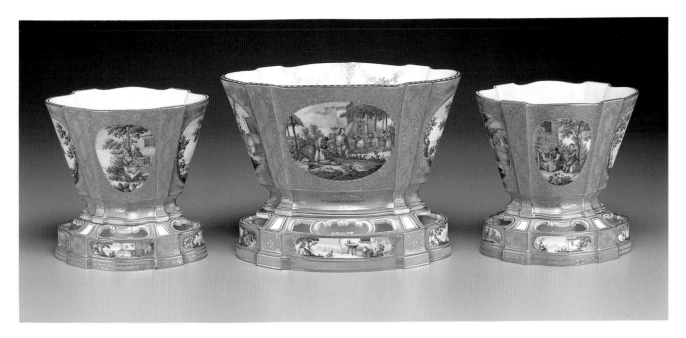

71.249–71.251

dant, also owned by Choiseul and bought by the empress, but this is not the case, since the companion painting from Choiseul's collection in the Hermitage is a quite different composition (Klinge 1991: 177). This second painting may once have belonged to Choiseul, since an engraving of it by J.-B. Le Bas in the Sèvres archives, dedicated to Madame de Pompadour, is described as being in the collection of the "Comte de Choiseul" (Pope and Brunet 1974: 250). There seems to have been no such title in the family, but Étienne-François's grandfather styled himself "comte," and he may have done so as well before becoming duc in 1758. By 1771, when the painting was again engraved by Le Bas, with the title *Village Festival,* it was in the collection of Choiseul's distant cousin, Rénault-César-Louis de Choiseul, duc de Praslin (1735–1791), whose collection of Flemish and Dutch pictures—together with other works of art—was sold the year after his death (Guigard 1890, II: 142).

The earlier engraving of Praslin's painting undoubtedly served as the source of the vignettes on these vases, since the figure of the drunken peasant is sketched in ink on the reverse. It is not a scene to be found in Teniers's work (Margret Klinge, letter to the author, January 18, 1994) and, as Wilson (1977: 5) suggested, was very likely inspired by the vignette of a woman hauling up her drunken spouse seen in the background of Le Bas's print.

Dauterman attributed the sketch to Charles-Nicolas Dodin even though, as it is unsigned and as several artists were engaged in painting Teniers subjects, the attribution cannot be considered certain. Whatever its origin, the composition on the central *vase hollandois* was clearly a set piece, since it appears with only minor variations on vases marked by Morin and Dodin as well as by Vielliard (Wilson 1977: fig. 14; Savill 1988, I: no. C209), and on an unmarked vase at Boughton House (Murdoch 1992: fig. 147).

71.251

The design of the *vase hollandois* allowed for numerous flat, or near-flat, surfaces suitable for painting, and it is noticeable that examples of the model—particularly those with Teniers subjects—are regularly decorated in a thematically unified manner, the vignettes in the secondary panels continuing the subject of the principal one.

The elaborate trellised gilding that surrounds the panels on the vases is, like the scenes themselves, characteristic of the period. Simpler geometric variations occur on a pair of flower vases with Teniers scenes by Caton, dated 1760 (Savill 1988, I: nos. C205, C206), and on three others from the Harewood collection, also of 1760 and painted by Vielliard after Teniers (London 1965: lot 17).

The incised marks CN and a script *CN* have in the past been tentatively assigned to the *répareur* Charles Cejourné (active 1738–68), although the mark he used is not recorded

(Eriksen 1968: 320; Savill 1988, III: 1096). Dauterman, in his manuscript for this catalogue, distinguished between the two marks and proposed *CN* for Cejourné and CN for Henri-Florentin Chanou, *le jeune*. From the manufactory records, however, it is not at all clear when or whether the designation *Chanou jeune* refers to Henri-Florentin or his brother, Jean-Bonaventure, nor are the dates of their respective careers certain (Tamara Préaud, letter to the author, January 7, 1994).

CHARLES-NICOLAS DODIN
1734 Versailles–Sèvres 1803, active 1754–1802

Born in Versailles, Dodin came to Vincennes after having studied military engineering. He was a painter of exceptional skill and was probably the manufactory's most versatile artist. He began by painting Boucher-like infants but after c. 1758 explored a wide repertoire, including pastorales after Boucher, genre scenes after French and Flemish painters, and Chinese subjects. A great deal of his work survives, on vases, tablewares, and plaques. His color sense was original and daring, particularly in his juxtapositions of shades of red.

[41]
Model attributed to Jean-Claude Duplessis, *père* (see p. 152)
Painted by Charles-Nicolas Dodin

Pair of Potpourri Vases
(*vase pot pourri triangle*, third size), 1761

Soft-paste porcelain, 29.2 (11½) × 17.7 (6¹⁵⁄₁₆) × 17.8 (7)
Bequest of Anna Thomson Dodge (71.246a,b; 71.247a,b)

INSCRIPTIONS: Underneath each vase, in blue enamel: interlaced *L*'s enclosing an *I* for 1761, and Dodin's mark below. Incised underneath 71.246: *LI* (in script). Incised under 71.247: a square.

CONDITION: The gilding is slightly worn on both, and there is some regilding to the covers. The flowers of both finials were damaged and have been reattached.

PROVENANCE: Louis XV (?). Duveen Brothers (dealer), New York. Acquired by Anna Thomson Dodge from Duveen Brothers, 1939.

REFERENCES: Dauterman 1976: 757, figs. 29–31; Brunet and Préaud 1978: 64, 72; Marandel 1986: 34, fig. 5; Detroit 1986: no. 114; Sassoon 1991: 46.

Of triangular section, the swelling body consists of three bulb or flower holders; above them rises a tall incurved neck pierced with latticework. At the angles of the neck are panels molded with laurel pendants and, below, scrolls that terminate in scrolling feet. The form-fitting cover, also pierced, rises to a flower cluster finial. Each container is molded with a kidney-shaped panel reserved against a light turquoise ground, one enclosing a chinoiserie scene and the two others clusters of orientalizing flowers.

Both chinoiserie scenes have been excerpted from engravings by Gabriel Huquier, *père* (1695–1772) after compositions

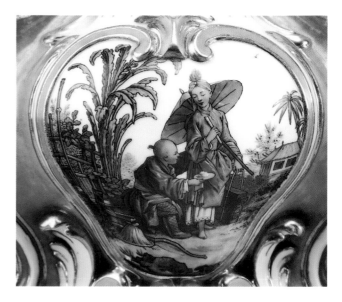

71.246

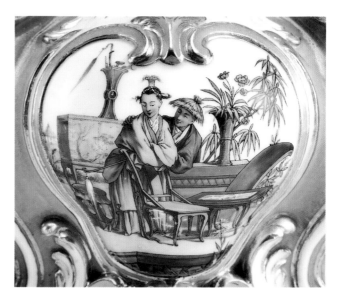

71.247

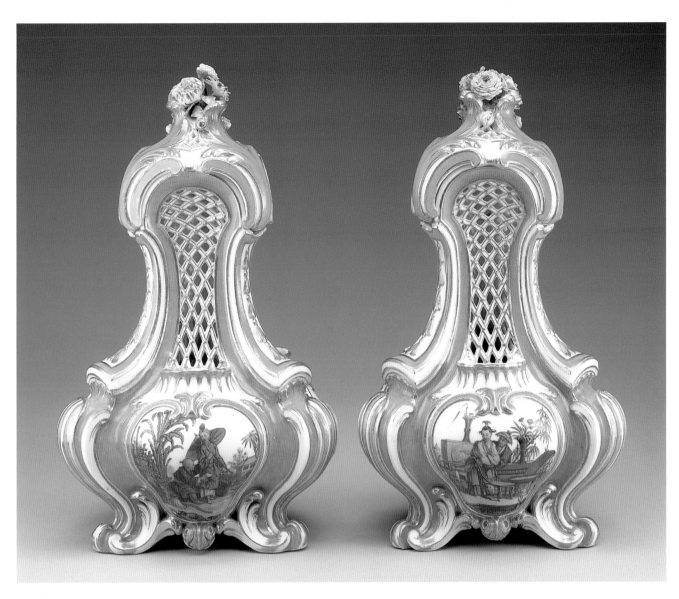

71.246–71.247

by François Boucher, scenes of Chinese life perhaps associated with Boucher's tapestry cartoons of 1742. The highly chromatic and stylized manner of painting, which seems inconsonant with Boucher's gentle and humanistic chinoiseries, characterizes Dodin's treatment of Oriental subjects between 1760 and 1763. The style is best suited to the pieces with subjects clearly based on a Chinese source, probably polychrome porcelains of the Yung Cheng period (1722–35). These include a *cuvette Courteille* of 1761 in The Metropolitan Museum of Art, New York (inv. 54.147.24); a *plateau carré,* also of 1761 (Paris 1938: lot 97); and a pair of *vases hollandois nouveau* of 1763 in the Rijksmuseum, Amsterdam. A pair of *vases à têtes d'éléphant,* dated 1760, in the Walters Art Gallery, Baltimore, and an undated *vaisseau à mat* in the Musée du Louvre, Paris, are, like this pair, based on Boucher's compositions but are painted a little more freely.

Invariably accompanying these scenes are flower sprays painted with brisk definite outlines and bright unshaded layers of color. Asymmetrically grouped with sharply angular branches and a combination of European and Oriental flora,

they are undoubtedly of Dodin's own invention, although they strongly evoke designs on the Japanese lacquer that was enjoying its greatest vogue in Paris in the years around 1750.

Dodin's sudden, limited, and exclusive foray into this idiom must have been prompted by a patron or collection. Tamara Préaud (1989: 43) has suggested two possible catalysts, Madame de Pompadour and Henri Bertin (1720–1792). The former was the unofficial patroness of the manufactory and a collector of Chinese porcelains; Bertin, also a collector of Chinese porcelains, was a secretary of state, who later lent pieces from his collection to the manufactory. However, Bertin's connection with Sèvres seems to have started after the onset of Dodin's orientalism, and what we know of Madame de Pompadour's collection indicates a decided preference for celadon and other monochromes rather than polychrome genre porcelains, so we should perhaps look for a collection formed somewhat earlier which, by some agency, had become accessible to Dodin.

The model was introduced in this, its smallest size, in 1761, and in the largest size the following year. Two other pairs,

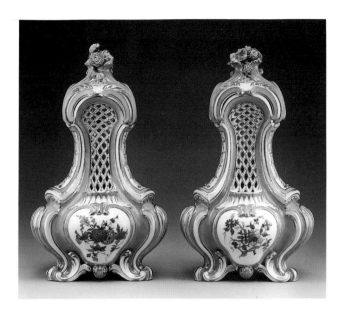

71.246–247

both undated, survive (stock lists 1/1/62 and 1/1/63: MNS Archives, carton I, 7; Préaud, information provided to Alan Darr, 1992, DIA curatorial files). One, in The Metropolitan Museum of Art (inv. 58.75.118, 58.75.119), New York, is decorated with trophies reserved on a *bleu céleste* ground; the other, each vase lacking its cover, was formerly in the collection of Baron Gustave de Rothschild and also bore trophies, painted against a *rose marbré* ground (Paris 1991: lot 30). The cover is all that remains of a turquoise example, incorporated into an eclectic centerpiece recently on the art market (Monaco 1990: lot 27). According to manufactory records, "3 pot pourris triangles et Choisy" were delivered to Louis XV at Versailles in December 1762, and two more, with a rose ground, were acquired by Madame Louise six years later.

Whether these vases were originally part of the royal garniture of 1762, as has been suggested (Sassoon 1991: 46), cannot be decided with any certainty. Neither the ground color nor the decoration was mentioned in the sale records. It is tempting to associate the Dodge pair with a pair of *pots pourris à bobêches* in the Musée du Louvre, which, like these, are dated 1761, are light turquoise, and are painted by Dodin with Chinese scenes after Boucher (Paris 1995: no. 80). But if indeed they originated as an ensemble and were all part of Louis XV's purchase, it is curious that the Louvre vases were not mentioned in the records along with the Dodge ones.

The incised mark of a square has not been identified with certainty. Eriksen (1968: 176) proposed that it was the personal mark of an especially skilled *répareur,* since it so often appears on vases of considerable intricacy, including one of the pair of this same model in The Metropolitan Museum of Art, New York. Savill (1988, III: 1134) has suggested that the symbol is a pun on the name Carrette, the mark thus possibly referring to François Carrette, *l'aîné* (active 1754–70) and his son, François (active 1768/69–87). She notes, however, that Eriksen has proposed the letters *ca* as Carrette's mark.

JEAN-LOUIS MORIN
1732 Vincennes–Sèvres 1787, active 1754–87

A native of Vincennes, Morin was the son of an army surgeon and studied surgery himself but entered the manufactory in 1754, being recorded the next year as a painter of "enfants colorés" (Savill 1988, III: 1051). His mark appears most often on vases and tablewares depicting military or harborside shipping scenes, elements of the two sometimes combined in a single composition. A large number of pieces in this repertoire survive, dating between 1761 and 1781. Painted with vivacity and narrative flair, some of Morin's scenes may have been inspired by Dutch or French prints, but sources for the majority remain untraced, and the scenes therefore appear to be original.

[42]
Model probably by Jean-Claude Duplessis, *père* (see p. 152)
Painting attributed to Jean-Louis Morin

Pair of Potpourri Vases
(*vase pot pourri feuilles de mirte,* shape C, second size), c. 1762

Soft-paste porcelain
71.242: 26.7 (10½) × 16.8 (6⅝) × 13 (5⅛)
71.243: 25.7 (10⅛) × 16.5 (6½) × 12.7 (5)
Bequest of Anna Thomson Dodge (71.242a,b; 71.243a,b)

INSCRIPTIONS: Inside the foot of 71.242: traces of the manufactory mark in blue. Incised underneath 71.242: *L1* (in script). Incised in the foot rim of 71.243: *FR.*

CONDITION: The feet of both vases have been repaired, with overpainting that may conceal additional marks. There is a small repair to the neck of vase 71.243.

PROVENANCE: Sir Samuel Edward Scott (1873–1943), Bart., Lytchet Minster, Dorset (by tradition). Duveen Brothers (dealer), New York. Acquired by Anna Thomson Dodge from Duveen Brothers, 1939.

REFERENCES: Dauterman 1976: 758, 761, fig. 43; Savill 1988, I: 201.

The inverted pear-shaped body rests on a short stem above a domed circular foot. The shoulder and domed cover are pierced, the openings framed by wide, gold-bordered, scrolling bands interlaced with molded myrtle branches. On

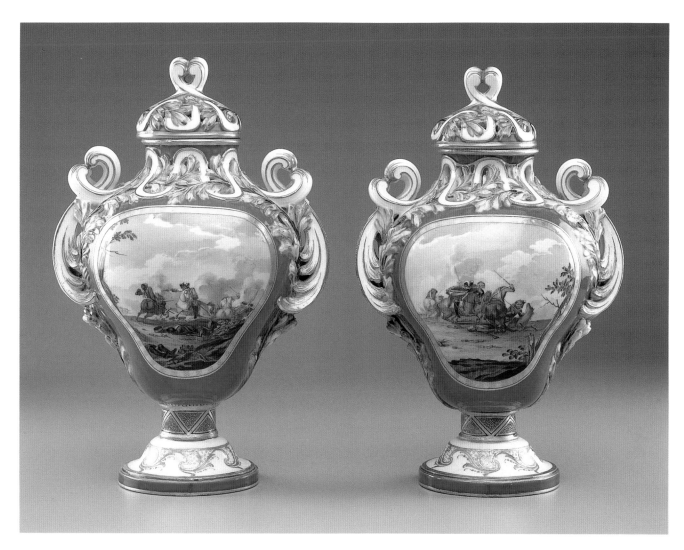

71.242–71.243

the shoulder, these bands sweep outward and meet S-curved foliate scrolls along the sides, forming handles. On the cover, the bands extend upward to form a finial of opposing scrolls. Reserves of conforming outline on the front of each vase enclose battle scenes with cavalry; on the back are clusters of flowers and fruits.

The model can be equated with the "pot pourry feuillages," introduced in 1761 and evidently not made after 1768; according to manufactory records, it was always sold in pairs (Savill 1988, I: 198). The Dodge pair is the only known example of shape C, which differs from the others principally in the manner in which the finial is formed out of the scrolling bands.

The profile of the body recalls both the *vase à oreilles* and the *pot pourri Hébert* first seen in 1757, but Savill's suggestion (1988, I: 198) that this model derives from a design by Pierre Germain (1716–1783) for an ecclesiastical lamp, published in 1748 in his *Eléments d'orfèvrerie,* is a plausible one that would account for the ebullient Rococo character of the design at this date.

The exceptionally lively battle scenes appear again, identically, on a pair of *vases à oreilles* dated 1762 in the Walters Art Gallery, Baltimore (inv. 48.575, 48.576), bearing the

marks of Jean-Louis Morin and Charles-Louis Méreaud, seemingly both inscribed by Méreaud, as Morin's *m* is unusually measured and calligraphic. Curiously, it is less easy to recognize Morin's hand in the simplified linear painting of the Walters vases than in the more fully modeled and livelier figures seen on the Dodge pair.

The compositions have not been identified. Vigorous cavalry battles similarly disposed are found on Meissen porcelain of the 1740s and have been tentatively attributed to George Philipp Rugendas (1666–1722), but Rugendas was not the only artist working in this genre. Eriksen (1968: 104) has suggested that such scenes are copied or adapted from work by François Casanova (1727–1803), who exhibited a large battle scene (possibly the *Battle of Lens,* now in the Musée du Louvre, Paris) in the Salon of 1761 to great acclaim (Diderot 1761: 107, 139–40). The scenes on the Dodge vase bear an uncommon resemblance to the animated drawings of Francesco Simonini (1686–1753) and Giuseppe Zais (1709–1784), both Venetians in the Casanova circle, but prints of their work have not been discovered.

The incised mark *FR* occurs on other *vases de mirte* of the same period: in The Frick Collection, New York (Pope and Brunet 1974: 246); at Waddesdon Manor (Eriksen 1968:

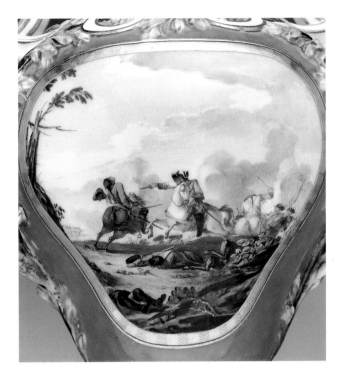

71.242

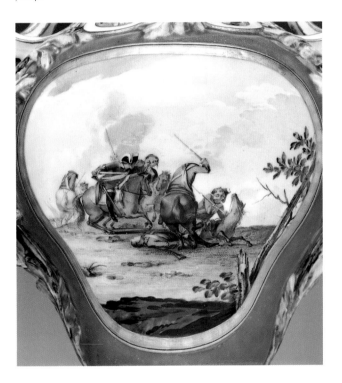

71.243

no. 52); and in the Philadelphia Museum of Art (Pope and Brunet 1974: 252). The mark also appears on both soft- and hard-paste pieces dating 1757 to 1768 and 1774 to 1781. It is considered by Savill (1988, III: 1102) to be possibly the mark of either of two *répareurs,* François-Firmin Fresne or Dufresne (1739–1767, active 1756–67) or François-Denis Roger (active 1755/56–83/84).

Figure decoration attributed to Jean-Louis Morin (see p. 158)

Pair of Flower Vases
(*vase hollandois nouveau ovale,* second size), c. 1762

Soft-paste porcelain, 25.7 (10⅛) × 19.7 (7¾) × 16 (6⁵⁄₁₆)
Bequest of Anna Thomson Dodge (71.244a,b; 71.245a,b)

INSCRIPTIONS: Underneath 71.244: interlaced *L*'s in blue enamel. Incised underneath both stands and on underside of vase 71.245: *AE* conjoined. 71.244: inscribed on barrel head in harborside scene, a partially legible name, *DASQUER* (?), and a number sign [#] in gold.

CONDITION: The stand of 71.245a has been extensively broken and repaired with inpainting; the surfaces of the reserves are scratched and there is some retouching. The gilding is slightly worn throughout and there are firecracks near all feet.

PROVENANCE: Baron Lionel de Rothschild (1808–1879), London. Alfred Charles Rothschild (1842–1918), Seamore Place, London. Almina, Countess of Carnarvon, London. Her sale, Christie's, London, May 19–21, 1925, lot 257. Bensimon (dealer), London. Baron Albert von Goldschmidt-Rothschild, Schloss Grüneburg, Frankfurt. His sale, Hermann Ball-Paul Graupe, Berlin, March 14, 1933, lot 112. Duveen Brothers (dealer), New York. Acquired by Anna Thomson Dodge from Duveen Brothers, 1939.

REFERENCES: Davis 1884, II: no. 84; London 1925: lot 257; Berlin 1933: lot 112; Dauterman 1976: 761, fig. 45; Savill 1988, I: 216, n. 2e.

Each vase is composed of two parts of oval section, the upper one a trumpet vase with an undulating rim. A recessed lower extension pierced around its lower rim fits into the stand. The concave shoulder of the stand is pierced with four pairs of C-scrolls flanked by rayed piercings and is raised on four feet. Unifying the two sections are concave panels at the corners extending from the rim to the feet. Reserved against a light turquoise *(petit verd)* ground are three panels on each vase and four each on the stands. On the front of each vase is a harborside shipping scene; the remaining reserves are painted with bouquets of mixed flowers. On the backs of the vases, bouquets in tooled gold are applied directly on the ground, as are the garlands that trail down the corner panels.

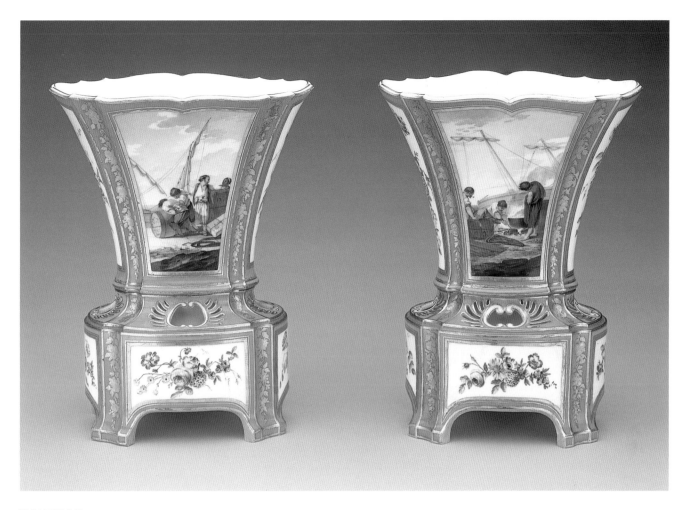

71.244–71.245

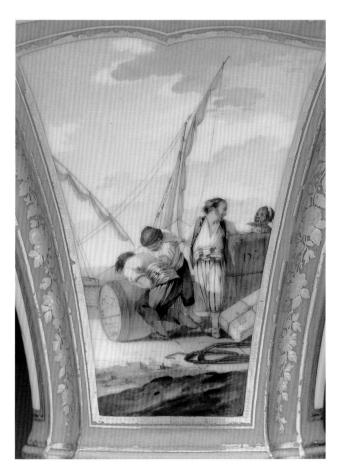

71.244

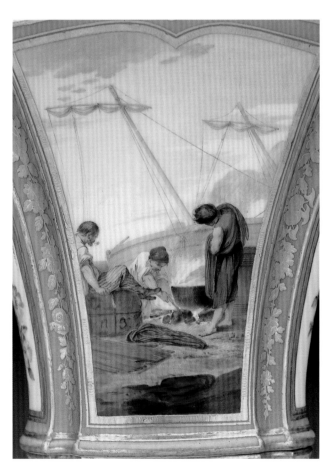

71.245

The *vase hollandois nouveau ovale* was introduced in five sizes in 1758 (Savill 1988, I: 109), its form differing from the original *vase hollandois* of 1754, which was fan-shaped with straight walls. According to Savill, the upper section was designed to hold planted flowers, receiving water through the pierced extension from the stand.

The quayside scenes have been attributed to Morin without qualification by Bernard Dragesco (verbal communication with the author, 1995). The composition on 71.245 repeats one on a *vase hollandois* at Waddesdon Manor bearing his mark and dated 1762 (Eriksen 1968: no. 54). Morin began to specialize in marine subjects about this time, and a substantial number of vases and tewares, both marked and unmarked, survive. For all their superficial variety, the compositions are in large part variations in which several stock figures appear in slightly different settings or groupings, suggesting a nucleus of sketches available to the manufactory's painters. Morin is not the only one to have worked in this genre: a *vase hollandois* of 1758 with a harborside scene in the Museum of Fine Arts, Boston, is marked by Dodin (Munger et al. 1992: no. 119). Jean-Baptiste-Étienne Genest (see p. 170) is also recorded as having painted harbor scenes in 1779, and could presumably have done so earlier.

The cases and barrels are variously inscribed, as is usual with these scenes; the barrel head seen in 71.244 bears a partially legible name that may be Dasquer. In that same scene, there also appears the number sign in gold that Dauterman tentatively proposed as the signature of the gilder Charles-Barnabé Chauvaux (Dauterman 1986: 761). Such an unconventional placement of a mark is not impossible, but it may be noted that the same sign occurs in a similar scene on a *vase ferré* of c. 1770 (one of the garniture believed to have been painted by Genest), marked by the gilder Jean-Pierre Boulanger (see p. 178; Savill 1988, I: nos. C300–302), and on a bowl and stand of c. 1776–81 with the mark of Étienne Henry le Guay (Savill 1988, II: nos. C436, C437).

From information in the Rothschild archives kindly provided by Michael Hall, these vases can be identified as the "pair of Turquin Évantail [*sic*] jardinières" included in the portion of Lionel de Rothschild's collection that was inherited by Alfred in 1882, when a division of property among Lionel's three sons took place. When published two years later as part of Alfred's collection (Davis 1884, II: 84), the Dodge vases were considered part of a garniture with three *vases de mirte* painted with genre scenes of seventeenth-century character. This was presumably based on a similarity of ground color since there was no other correspondence between them. At that time, the vases and stands of these two had been reversed, and they were set on modern gilt-bronze stands. These modern stands had been discarded by 1925, when the pair was sold by the Countess of Carnarvon (London 1925: lot 257). The positions of the vases and stands had again been changed by the time they were sold in 1933 (Berlin 1933: lot 112).

[44]

Flower Vase
(*vase hollandois nouveau ovale,* fifth size), c. 1761–63

Soft-paste porcelain, 17 (6¹¹⁄₁₆) × 13 (5⅛) × 11 (4⁵⁄₁₆)
Bequest of Anna Thomson Dodge (71.254a,b)

INSCRIPTION: Incised underneath the stand, near the foot: *AE* conjoined.

PROVENANCE: Édouard Chappey (d. 1906). His sale, Galerie Georges Petit, Paris, May 27–31, 1907, lot 1102. Duveen Brothers (dealer), New York. Acquired by Anna Thomson Dodge from Duveen Brothers, 1939.

REFERENCES: Massar 1905: 22; Paris 1907: lot 1102; Savill 1988, I: 116.

The vase is the fifth and smallest size of the model described earlier (cat. 40). The very light turquoise ground is considered to be the color referred to as *petit verd*. Reserved against it are three panels each on the vase and stand, framed with double gold borders, the inner one with a pattern of alternately matte and burnished squares, the outer one with leafy scrolls. On the front of the vase, a putto holding an arrow is seated amid clouds; below, on the stand, is a trophy of love surrounded by clouds. In the side reserves are flower sprays, and the back is undecorated.

Given the ground color, the vase cannot date before 1760 or 1761, when *petit verd* is first seen and first mentioned in the manufactory's records (Savill 1988, II: 536). By this date, cloud-borne putti after, and in the manner of, François Boucher had largely gone out of fashion, although they can be seen as late as 1763 on a pair of vases of this same model in The Metropolitan Museum of Art, New York (inv. 50.211.157a,b, 50.211.158a,b) and on the *vases pot pourris,* c. 1764, in the present collection (cat. 47). In all these later examples, the putti have lost the cherubic bounce of Boucher's drawings and, though carefully painted, lack the verve of the earlier figures.

The unidentified incised mark has been found on a wide range of vases and tablewares dating from the mid-1750s to the 1780s.

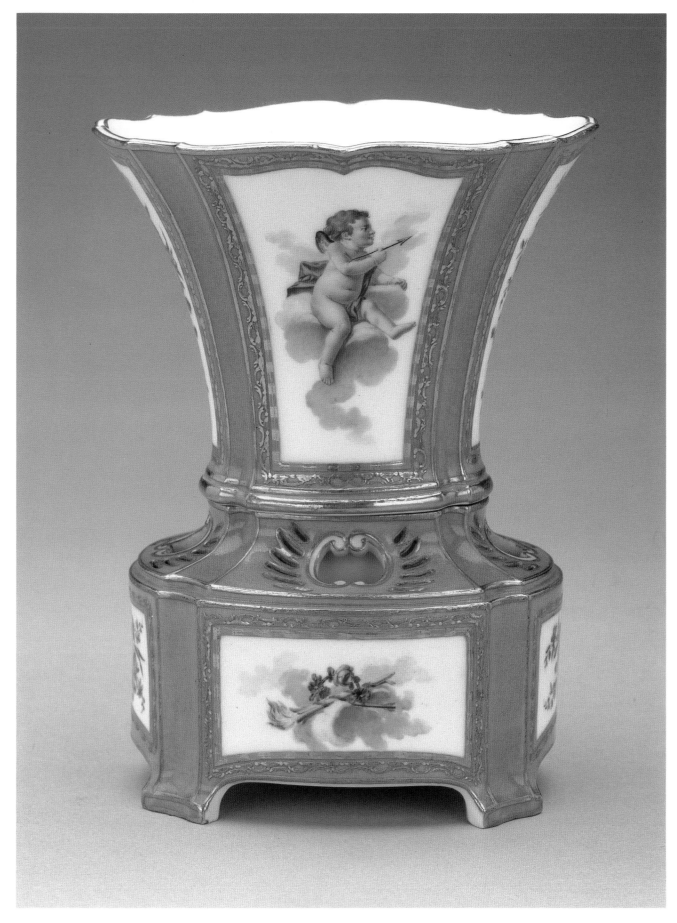

71.254

NICOLAS-LAURENT PETIT, *l'aîné*

1735 Paris–Sèvres 1814, active 1756–1800

Born in Paris, Petit was a soldier and a dancing master before entering the Sèvres manufactory in 1756. As a flower painter, he executed most of his work before 1769, when he became head of the burnishers' studio. He was pensioned in 1800.

JEAN-JACQUES SIOU, *le jeune*

Active 1752–60

Siou had been a fan painter before entering Vincennes in 1752. During his short career there, he worked as a flower painter and was described in 1758 as painting camaïeu *garlands.*

[45]

Flower decoration by Nicolas-Laurent Petit, *l'aîné,* and Jean-Jacques Siou, *le jeune?*

Pair of Flower Vases
(*vase hollandois nouveau ovale,* second size), 1764

Soft-paste porcelain
71.258: 25.7 (10⅛) × 19.7 (7¾) × 16.2 (6⅜)
71.259: 25.2 (9¹⁵⁄₁₆) × 20 (7⅞) × 16.4 (6⁷⁄₁₆)
Bequest of Anna Thomson Dodge (71.258a,b; 71.259a,b)

INSCRIPTIONS: On the base of each vase and stand, in dark blue: interlaced *L*'s enclosing an *L* for 1764. Underneath each vase: a dot in a circle. Underneath each stand, in blue: the mark of Petit, *l'aîné*. Written under each stand, in gray: *1129*. Incised underneath 71.258a: *5*. Incised underneath 71.259b: *CN* and an indecipherable monogram.

CONDITION: Excellent

PROVENANCE: Palace of Pavlovsk, near St. Petersburg, until c. 1907. Duveen Brothers (dealer), New York. Acquired by Anna Thomson Dodge from Duveen Brothers, 1932.

EXHIBITION: Grosse Pointe 1981: unnumbered, ill. p. 18, fig. 002.

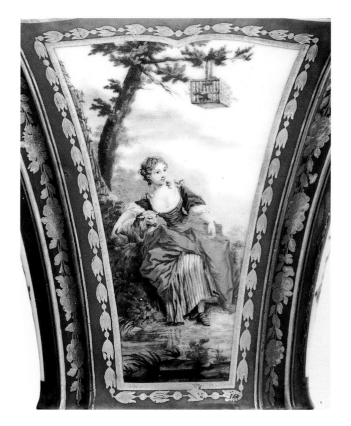

71.258

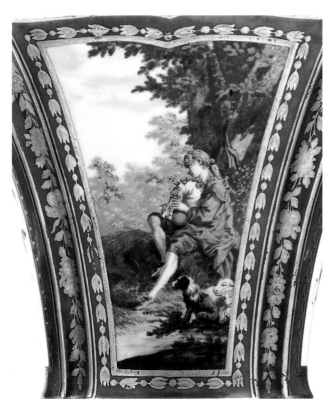

71.259

REFERENCES: Benois 1901–07, VII: pl. 120; Detroit 1933: n.p.; Dauterman 1976: 754, 757; Savill 1988, I: 111, III: 1058; Sassoon 1991: 140.

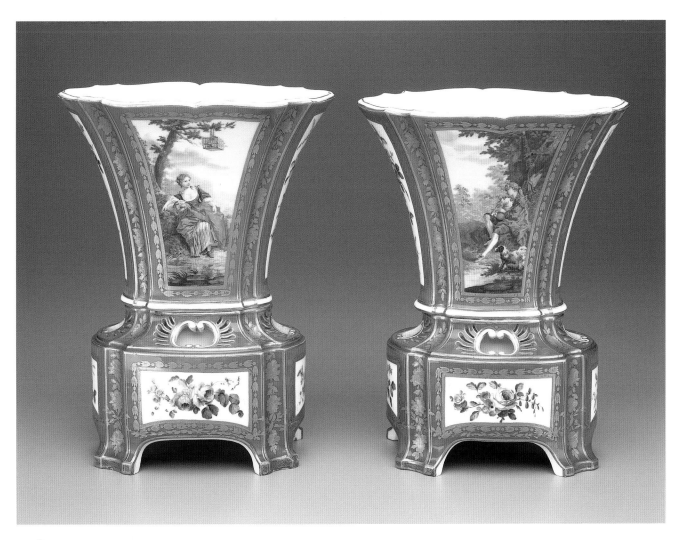

71.258–71.259

Each vase and stand is decorated with four panels reserved against an apple green ground. On the front of each vase is a pastoral scene. In one, a young girl holding a lamb is seated under a tree branch from which a bird cage is suspended; on the other, a seated youth, his dog standing beside him, plays the bagpipes. The remaining panels are filled with flower sprays. The simple borders of the reserves are enframed on the front by bands of laurel and berry, and on the sides with a scalloped edging, while the reserves on the backs are left plain. An oak leaf garland runs beneath the reserves on the front and sides of the stands, crossing at the front corners. For a note on the model, see cat. 40.

The individual figures have been isolated from a single composition, one of François Boucher's four *Amours Pastorales,* engraved c. 1742 by Claude Duflos, *le jeune* (Paris 1978: no. 929). The complete composition appears on a *vase ferré* of 1763 in the Walters Art Gallery, Baltimore, bearing Morin's mark, and is one of a number of Boucher pastoral scenes painted on vases in the 1760s. Several are by Charles-Nicolas Dodin (see p. 156; Eriksen 1968: nos. 55, 56; Savill 1988, I: nos. C292, C293), and those that are unmarked are usually attributed to him. But the style of painting on the

Dodge vases is so different from Dodin's smooth, impassive manner that it is probably by another hand.

The brilliance of color and painting of the bouquets on the backs of the vases somewhat eclipses the competent, but less dramatic flower work on the stands. Two painters named Siou came to work at Vincennes the same year and have been recorded as using similar marks. Most recently, the mark of a circle—with or without a central point—has been assigned to Jean-Jacques and the mark of a dotted circle (which also occurs with a central point) to Jean-Charles (Préaud and d'Albis 1991: 213).

These vases, together with the *cuvette Courteille* discussed in cat. 46, were photographed together at the Palace of Pavlovsk in 1907 and might therefore be presumed to have been among the Sèvres porcelains acquired by the Grand Duke Paul and his wife, Maria Feodorovna, during their visit to Paris in 1782. The vases do not, however, figure in the lists of the porcelains officially presented or purchased on that occasion (Ennès 1989: 221–22), nor are they mentioned in the empress's memoir of Pavlovsk written in 1795 (Benois 1901–07, III: 371–82). From documented pieces it is apparent that the grand ducal acquisitions were all in the latest

taste, that is, dating approximately to the time of the visit, while the pair of vases and the *cuvette Courteille* are considerably earlier and in an entirely different idiom. If acquired in 1782, they would have been bought from one of the Parisian *marchands-merciers.* In any case, there is no reason to consider this pair as part of a garniture with the *cuvette Courteille,* since there is no correspondence between them either in subject matter or border decoration.

[46]

Model attributed to Jean-Claude Duplessis, *père* (see p. 152)

Flower Vase (*cuvette à fleurs Courteille,* first size), 1765

Soft-paste porcelain, 19.1 (7½) × 30.2 (11⅞) × 15.9 (6¼)
Bequest of Anna Thomson Dodge (71.257)

INSCRIPTIONS: On the base, in blue enamel: interlaced *L*'s enclosing an *M* for 1765. Incised underneath the foot: a triangle. Written on the base, in gray: *1138.*

CONDITION: The vase was broken through the base and lower part of the body and has been repainted and regilded in the repaired areas.

PROVENANCE: Palace of Pavlovsk, near St. Petersburg, until c. 1907. Duveen Brothers (dealer), New York. Acquired by Anna Thomson Dodge from Duveen Brothers, 1932.

EXHIBITION: Grosse Pointe 1981: unnumbered, ill. p. 18, fig. 002.

REFERENCES: Benois 1901–07, VII: pl. 120; Detroit 1933: n.p.; Dauterman 1976: 757–58, figs. 32–34; Savill 1988, I: 45, 52.

The vase is of oval form with a swelling front and sides and a flat, slightly concave back. Acanthus-leaf scrolls at the ends curve up and outward to form handles, and the vase rests on four C-scrolled feet. Against the green ground are reserved two large rectangular panels. On the front is a street scene with a chestnut vendor amid a group of children; on the back, a trophy displays the paraphernalia of a street vendor, including toys, musical instruments, pictures, and broadsides. At the canted front corners are panels of trelliswork and flowerheads beneath an oak-leaf wreath. Oak-leaf branches enframe the panel on the front and are pendent down the front sides of the handles.

The model was produced in three sizes, the first being introduced in 1753. It was named for Jacques Dominique de Barberi, marquis de Courteille (1696–1767), Louis XV's *intendant des finances* and, from 1751, financial and administrative adviser to the manufactory.

The scene on the front is copied from an engraving by Jean-Firmin Beauvarlet (1731–1797) after a drawing by Jean-Baptiste Greuze (1725–1805), *La marchande des marrons,* one of several street-vendor scenes by Greuze and apparently the only one not turned into a painting. When exhibited in the Salon of 1761, the drawing was described as "enfans qui derobent des Marrons" (Diderot 1761: 98). Given the date of this vase, Beauvarlet's engraving—of which an example was acquired by Sèvres at an unknown date—must have followed immediately after.

There was a minor vogue for Greuze subjects from the 1760s to at least 1782, marked examples being by Charles-Nicolas Dodin (see p. 156) or Charles-Eloi Asselin (see p. 178). Examples can be found in The Metropolitan Museum of Art, New York (inv. 43.100.31 and 1974.356.591), as well as in the Wallace Collection, London (Savill 1988, II: nos. C454, C391), and in the Royal Collection, Great Britain (Laking 1907: nos. 223–25). The manner of painting on the Dodge vase is unlike that of either of those artists, however, differing most conspicuously in the curly-headed children with their round faces and wide-eyed expressions.

Variations of the trophy occur on vases dating c. 1765 to c. 1780 in the Wallace Collection, the Royal Collection, and at Firle Place, Sussex (Savill 1988, I: 226, 228, 248; Paris 1985: fig. 81c). This trophy is possibly from the same hand as that on a *vase ferré* of c. 1779 in the Wallace Collection (Savill 1988, I: no. C270), which features the same pinwheels and a similar brilliance and sharp definition of coloring. The Wallace trophy, though lacking a decorator's mark, is tentatively attributed to Louis-Gabriel Chulot on archival evidence. It is the view of Bernard Dragesco (verbal communication with the author, 1995), however, that the painting of the Dodge trophy is probably the work of Charles-Nicolas Buteux. The trophy on the Dodge vase appears to be the only one to include pictures and broadsides. One, placed upside down beneath the parasols, reads *MAISON/A/ V[E]NDRE Cette.* . . . The two in the embroidered bag below read, respectively, *COMPLAINTE sur la bete du Gevaudan* and *chanson nouvelle, sur un air nouveau, La bergere.* . . . The former is a topical reference to what was clearly a sensational event, an attack of wolves in the Gevaudan region of Provence from 1764 to 1766. After unsuccessful attempts to repel the wolves—attempts that brought hunters from Normandy and a petition to the king—the wolves were finally destroyed by poisoned bait (Dauterman 1976: 757–58).

With its flat back, this vase form was presumably designed to be seen on a chimneypiece against a wall or mirror; the backs were usually decorated with flower sprays, bouquets, or

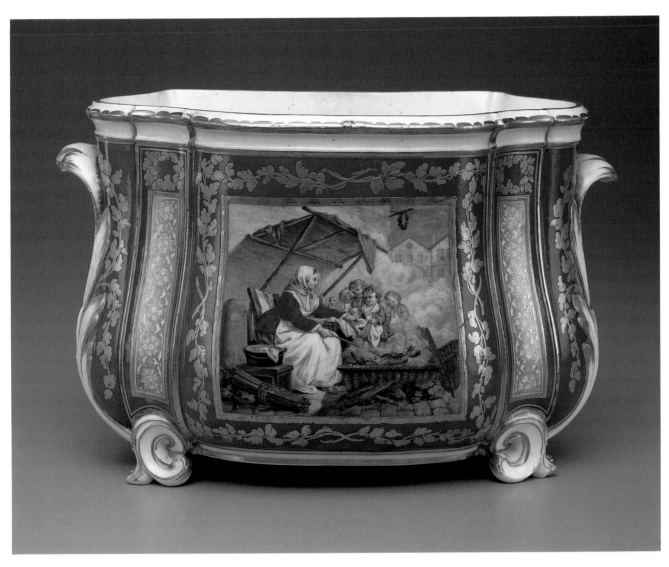

71.257

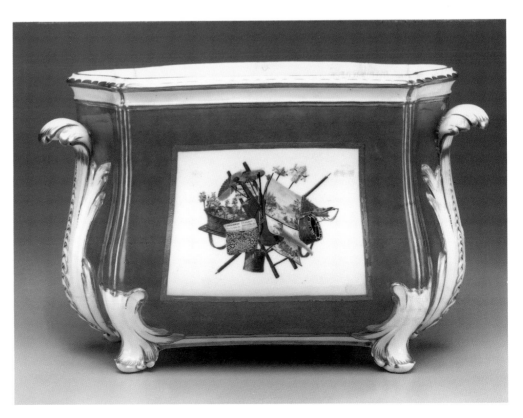

71.257

an embellished gold circle that could be read easily in a mirror. Here, however, the legends would be in reverse, and their recognition delayed, so perhaps another type of placement is implied by the decoration.

Savill (1988, III: 1135) records the unidentified incised mark of a triangle as occurring chiefly on flower vases dating 1754–67 and 1772–82.

These vases were in the Palace of Pavlovsk in 1907 but are not included among the Sèvres porcelains either presented to or acquired by the Grand Duke Paul and his wife, Maria Feodorovna, in 1782, nor can they be identified from the description of the palace written by Maria Feodorovna in 1795 (see cat. 45). Since all the porcelains traceable to the 1782 visit were in styles current in 1782, it may be questioned whether the Dodge vases were acquired at that time.

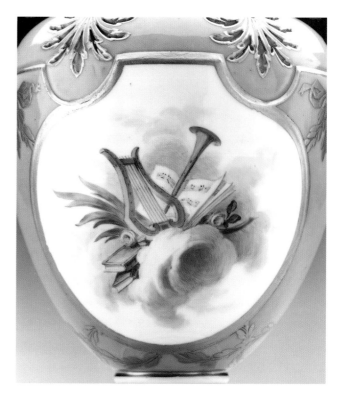

71.240

[47]

Model attributed to Jean-Claude Duplessis, *père* (see p. 152)

Pair of Potpourri Vases
(*vase pot pourri Pompadour,* shape C, third size),
c. 1764

Soft-paste porcelain, 25.1 (9⅞) × 13.4 (5¼) diameter
Bequest of Anna Thomson Dodge (71.240a,b; 71.241a,b)

INSCRIPTIONS: Inside each foot, in pale blue enamel: interlaced *L*'s. Incised inside the foot of 71.241: *L* and an illegible letter or monogram.

CONDITION: The cover of 71.240 has a hairline crack in the rim, and a crack runs through the foot rim and up the stem of 71.241. Both finials have been broken and repaired, with regilding.

PROVENANCE: Sir Lionel Faudel-Phillips (1877–1941), Balls Park, Hertfordshire (by tradition). Duveen Brothers (dealer), New York. Acquired by Anna Thomson Dodge from Duveen Brothers, 1939.

REFERENCES: Dauterman 1976: 754, fig. 25; Savill 1988, I: 132.

The egg-shaped body is supported on a short-stemmed circular foot and is fitted with a stepped, domed cover topped by a flower finial. The cover and shoulder are pierced with foliate palmettes, those on the vase underlined by a molded band. Shield-shaped panels are reserved on the front and

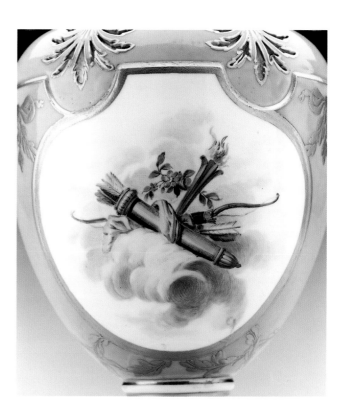

71.241

back against the turquoise ground; linking them on the sides is a gold floral wreath suspended from ribbon-tied laurel swags. A laurel wreath encircles the foot. On the front of each vase is a putto amid clouds, one (71.240) with a quiver and a tethered dove fluttering above its open cage, the other

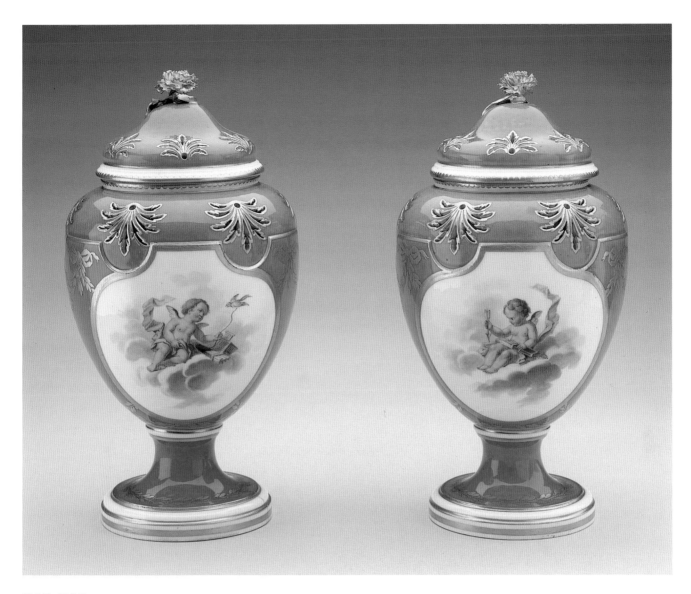

71.240–71.241

with a book and an arrow. On the reverse of 71.240 is a tro-
phy of musical instruments, on the other a trophy of love
with quiver, flaming torch, bow, and arrow.

Shape C is known from 1764 to 1770, with the earliest
example, according to Savill (1988, I: 129), being a single vase
sold from the collection of Mrs. Henry Walters (New York
1941: lot 648). It is distinguished from shapes A and B by the
palmette, or fanlike openings, instead of circular ones or
none, and by a higher stemmed foot. Savill (1988, I: 128)
assigns the model to Duplessis on the evidence of his signed
drawing for the design of shape A. The vase is one of several

models named for Madame de Pompadour and was so des-
ignated when shape A was introduced in 1752. The term was
still being used in connection with the model in December
1764, several months after her death, but Savill (1988, I: 128)
surmises that this model was probably commonly known
simply as *vase pot pourri*.

Although lacking a date letter, the vases should be dated
to the first period of production of the model, when cloud-
borne putti were still, if lingeringly, popular. The figures
themselves are reminiscent of Boucher but are not traceable
to his work.

JACQUES FONTAINE
1735 Paris–Sèvres 1807?, active 1752–1800

Born in Paris, Fontaine painted fans before coming to Vincennes, where he started as a flower painter. What little of his work that survives is chiefly in grisaille, but he is recorded as having painted polychrome decorative patterns and flowers. He is presumed to have died in 1807, after which date he no longer received a pension.

JEAN-BAPTISTE-ÉTIENNE GENEST
1731 Paris?–Sèvres 1789, active 1752–89

Genest had been a painter in Paris before entering Vincennes and must have demonstrated unusual abilities, since he was appointed head of the painters' workshop within a year. He supervised the choice of decoration and painters and also provided paintings of his own composition, as well as engravings, for the painters to follow. Identification of his work is difficult because he evidently did not use a mark and must be made circumstantially through descriptions in the manufactory archives.

[48]
Decoration probably by Jacques Fontaine or Jean-Baptiste-Étienne Genest

Pair of Covered Vases
(*vase carrache,* second size), c. 1768–69

Soft-paste porcelain
71.260: 38.7 (15¼) × 13 (5⅛) diameter
71.261: 39.1 (15⅜) × 13 (5⅛) diameter
Bequest of Anna Thomson Dodge (71.260a,b; 71.261a,b)

INSCRIPTIONS: Inside the foot of 71.260: a fragmentary label, stamped in puce, and the number *1059* in gray. Incised underneath 71.261a: *R.*

CONDITION: There is some overpaint visible on the foot of 71.260. Both the vase and cover of 71.261 have been extensively broken and repaired.

PROVENANCE: Palace of Pavlovsk, near St. Petersburg, c. 1907. Soviet government, until c. 1930. Duveen Brothers (dealer), New York. Acquired by Anna Thomson Dodge from Duveen Brothers, 1932.

EXHIBITION: Grosse Pointe 1981: unnumbered, ill. p. 25, fig. 009.

REFERENCES: Benois 1901–07, VII: 226, pl. 131; Detroit 1933: n.p.

The tall cylindrical body with a bright green ground tapers to a knopped, low-stemmed circular foot and is fitted with a high domed cover, radially fluted beneath a knop finial, and with a rim molded with ribbon-tied reeding. Pendant from the broad, white-ground shoulder are molded triglyphs that separate the body into six arcaded panels, the triglyphs being linked above by gilt bowknots alternating with leafy branches, and below by molded gilt laurel swags looped through rings. At the top of each panel, framed by a laurel festoon, is a medallion enclosing a profile classical head—alternately male and female—painted in grisaille against a light sepia ground. Three of the heads on 71.260 repeat, but on 71.261 each is different.

The name of the model, *vase carrache,* is unexplained. Undated drawings for it in the manufactory archives indicate that the vase was produced in two sizes. Two examples ready for glazing were noted in 1768 (SL 1769 [for 1768]) and four more were fired between April and October 1769 (Bibliothèque de l'Institut/GKR, f. 48). These were presumably among the vases cited in Jean-Baptiste-Étienne Genest's work records for the same years. In 1768 he painted twelve "medaillons coloris" on *vases carraches* and, in 1769, thirty-six heads on six more of the same model, thus accounting—at six heads a vase—for eight vases (Eriksen 1968: 252). Ten examples of the model, all painted alike, are now known: a pair of each size at Waddesdon Manor (Eriksen 1968: nos. 87, 88); a pair of the first size in the Philadelphia Museum of Art (Kimball 1944: no. 36a and b, pl. VIII); a pair of the second size in the Victoria and Albert Museum, London (London 1924: no. 144); and the Dodge pair. All but the Dodge vases have a *bleu nouveau* or, like the Philadelphia pair, a *bleu céleste* ground.

The Dodge vases were unknown to Eriksen, and he was thus able to make an exact correspondence between the other eight and Genest's work records. This did not take into account, however, the possibility that each Waddesdon vase was one of a pair, nor did it allow for the Dodge pair. Since neither size nor ground color was mentioned in the records, it is not gainful to speculate as to which eight *vases carraches* were being described in the documents. Moreover, Genest was not the only decorator working in this manner in 1769. Jacques Fontaine painted 160 grisaille medallions and trophies that year, and his style, as evidenced by a cup and saucer and teapot in the Wallace Collection, London (Savill 1988, II: nos. C347, C381), is very close to that of the *vases carraches.* Genest evidently had no mark—Eriksen (1968: 326) observed that he would not have needed one as head of the painting studio. The only work that can certainly be assigned to him are the vases he painted in grisaille, also in 1769, for the court (Savill 1988, I: nos. C311–13). A comparison of these

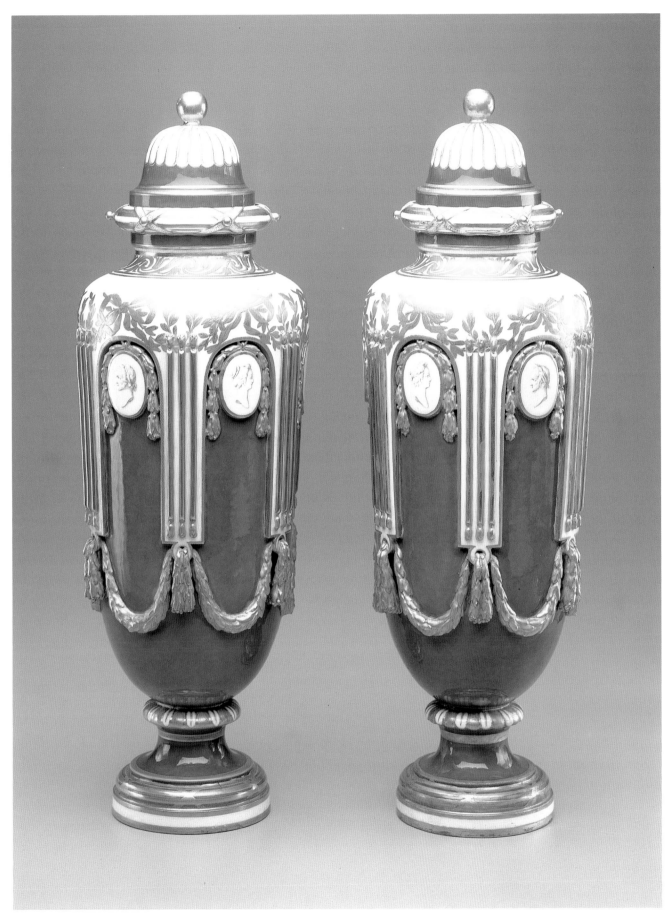

71.260–71.261

and Genest's work would probably clarify the attribution of the *vases carraches.*

The vases were in the Palace of Pavlovsk in 1907 but are probably not among the Sèvres porcelains acquired by Grand Duke Paul and his wife, Maria Feodorovna, in 1782, nor can they be identified from the description of the palace written by Maria Feodorovna in 1795 (see cat. 45).

NIQUET
Active 1764–92

Nothing of Niquet's life, including even his given names, has yet been discovered. He is recorded at Sèvres as a flower painter from 1764 until his departure in 1792.

[49]
Model probably by Jean-Claude Duplessis, *père* (see p. 152)
Flower painting by Niquet

Vase
(*vase à oreilles,* shape A, second size), probably 1777

Soft-paste porcelain, 22 (8¹¹⁄₁₆) × 12.5 (4¹⁵⁄₁₆)
Bequest of Anna Thomson Dodge (71.255)

INSCRIPTIONS: Inside the foot, in blue enamel: interlaced *L*'s enclosing an illegible date letter, and Niquet's mark below. Label inside the foot inscribed in ink: *C9071 / D.B. PARIS.*

PROVENANCE: Comte de Saint-Léon, Château de Jeure (unidentified; by tradition). Duveen Brothers (dealer), New York. Acquired by Anna Thomson Dodge from Duveen Brothers, 1939.

REFERENCE: Savill 1988, I: 145.

The body of inverted pear shape rests on a stemmed circular foot. The short neck divides into foliate scrolls that curve down to the shoulder, forming handles. Reserved on each side against a turquoise ground is a circular panel enclosing a bouquet of fruits and flowers, including—on the front—hydrangea, tulips, and peonies, and—opposite—apples, gooseberries, and anemone. The reserves are framed with tooled gold ribbon-tied bands which, in turn, are encircled by an intricate border of rose sprays at the top and laurel branches below. Beneath each handle, tooled in gold on the ground, is a water bird within a wreath of arrowhead leaves: a heron on one side, a goose on the other. For the model, see cat. 39.

A pair of *vases à oreilles* of the third size, identically decorated and bearing Niquet's mark and the date letter *Z* for 1777, was sold from the Chester Beatty collection (London 1955a: lot 110). Savill (1988, I: 138, 145, n. 16) thought they were probably two of a three-piece set recorded as having

been painted by Niquet that year. Although it is difficult to make a Z out of the fragmentary date letter seen here, the three clearly form an ensemble, and the Dodge vase, being slightly taller than the Beatty pair, would have fitted suitably as the central piece of the garniture.

VINCENT TAILLANDIER
1737 Sceaux–Sèvres 1790, active 1753–90

Taillandier was born at Sceaux and was recorded at that faience manufactory in 1752. He entered the Vincennes manufactory the following year and, according to manufactory records, executed landscapes, monograms, and birds, in addition to the floral patterns invariably found with his mark. Known examples of his work are all small, useful wares or plaques, ranging in date from his first years at the manufactory to at least 1783. He is credited with having designed a ground pattern, the fond Taillandier, *introduced about 1765, which consists of small circles reserved against a ground of color and framed by one or more dotted circles in a different color and gilding.*

CLAUDE-ANTOINE TARDY
1733–1795, active 1757–95

Very little work is known by Tardy, who was employed at Sèvres from 1757 as a painter of flowers and garlands that were sometimes, as in 1784, fashioned into monograms.

[50]
Painting of bowl by Claude-Antoine Tardy, painting of stand by Vincent Taillandier

Covered Bowl and Stand
(*écuelle ronde tournée,* shape A, third size, and *plateau nouvelle forme*), 1777 and 1782

Soft-paste porcelain
Bowl: 11.5 (4½) × 17 (6¹¹⁄₁₆)
Stand: 19.5 (7¹¹⁄₁₆) diameter × 21.2 (8⅜) at handles
Bequest of Anna Thomson Dodge (71.253a–c)

INSCRIPTIONS: Underneath the bowl, in blue enamel: interlaced *L*'s enclosing an *ee* for 1782 and the mark of Tardy below. Underneath the stand, in puce enamel: interlaced *L*'s enclosing a *z* for 1777 and the mark of Taillandier below. Incised underneath the bowl, near the foot rim: *8* and *43.*

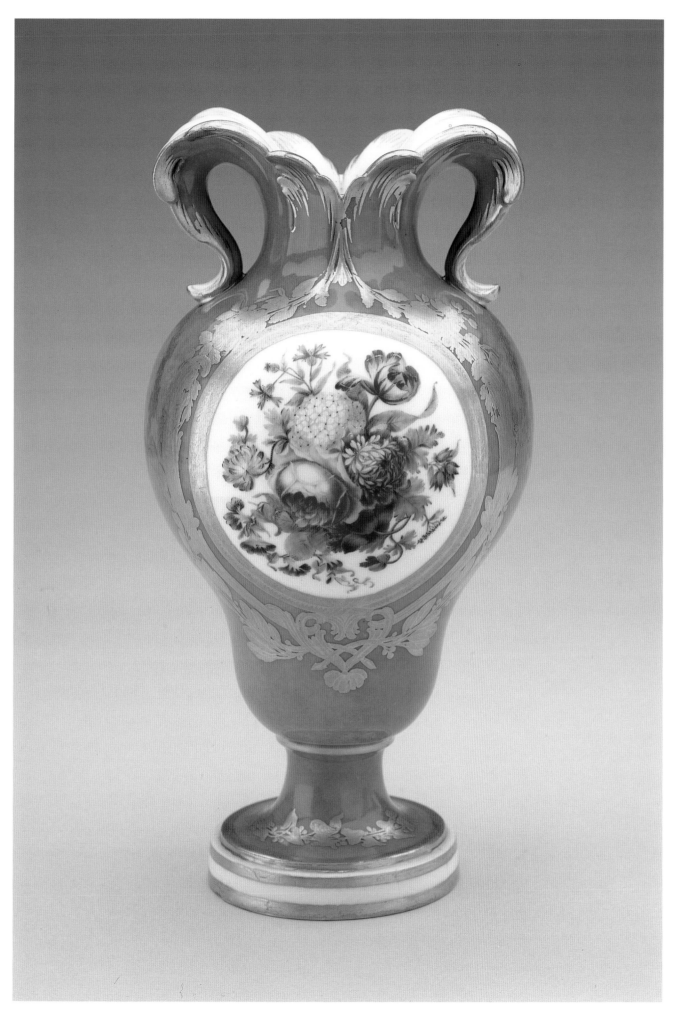

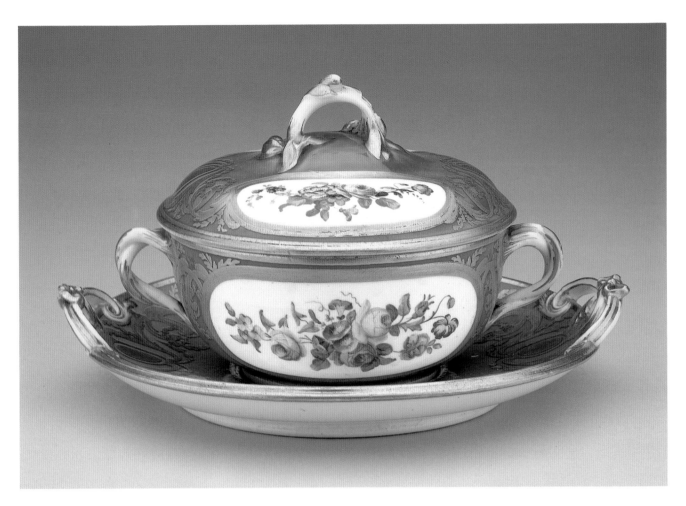

71.253

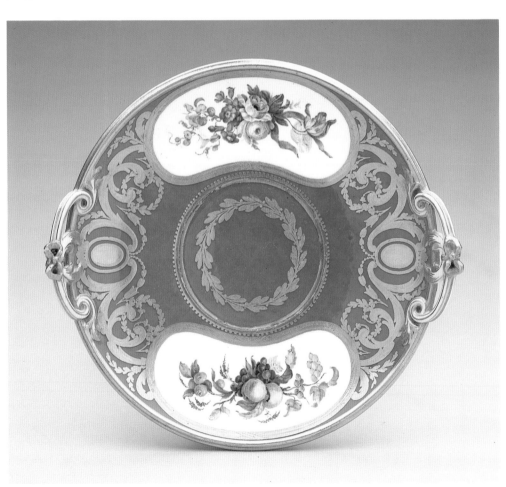

71.253

CONDITION: Excellent

PROVENANCE: Sir Samuel Edward Scott (1873–1943), Bart., Lytchet Minster, Dorset (by tradition). Duveen Brothers (dealer), New York. Acquired by Anna Thomson Dodge from Duveen Brothers, 1939.

The low circular bowl is fitted with intertwined branch handles, and a leafy twig forms the finial of the shallow domed cover. The stand has a slightly sloping rim and handles formed of overlapping scrolls tied with ribbon at their join. On each piece, two oval or kidney-shaped panels are reserved against a turquoise ground and are painted with bouquets of fruit and flowers. Between the panels is a wide band of gilding composed of an oval panel flanked by foliate scrolls and garlands.

For the shape of the bowl, see cat. 51. The stand is one of the few of this size to be fitted with handles and is a smaller variant of the *plateau nouvelle forme* with openwork clustered reed handles (Savill 1988, II: no. C437). Other examples of this version are in The Art Institute of Chicago (dated 1779; Wardropper and Roberts 1991: no. 166), the Musée National de Céramique, Sèvres (dated 1780; Dragesco 1994: 45), the Wadsworth Atheneum, Hartford (dated 1784; Roth 1987: no. 75), and formerly in the Van Slyke collection (New York 1989: lot 319).

As the painted and gilded decoration is uniform throughout, it follows that the bowl was made as a replacement for the original one. Curiously, despite the consistency of decoration, the cover seems to have been fired separately; its ground color is considerably bluer and runnier than that of either the bowl or stand, and the flower painting is in a hand different from that of the other two.

MICHEL-BARNABÉ CHAUVAUX, *l'aîné*
1731 Paris–after 1788, active 1752–88

Chauvaux, the son of a painter and vernisseur, *began his career as a decorator of boxes in* carton vernis. *He came to Vincennes in 1752 and, according to manufactory records, worked as both a painter and a gilder. Few examples of his painted decorations are known, but he must have been a steady and useful gilder, since his mark in gold occurs frequently on useful wares, particularly in the 1770s and up to the year he left the manufactory.*

ANTOINE-TOUSSAINT CORNAILLE
(or CORNAILLES)
1735 Écouen–Sèvres 1812, active 1755–1800

Cornaille came to Vincennes in 1755 from Chantilly, where he was recorded the previous year as a flower painter. Both painter and gilder, he specialized in varied floral decorations and is also

recorded as having painted friezes, ground patterns, and, toward the end of his career, arabesques. Except for a year between 1793 and 1794 he worked uninterruptedly at Sèvres until his retirement in 1800.

[51]
Painting by Antoine-Toussaint Cornaille
Gilding by Michel-Barnabé Chauvaux, *l'aîné*

Covered Bowl and Stand
(*écuelle ronde tournée,* shape A, first size, and *plateau rond,* shape D, third size), 1781

Soft-paste porcelain
Bowl: 14 (5½) × 19.4 (7⅝) at handles × 14.1 (5⁹⁄₁₆)
Stand: 20.3 (8⅛) diameter
Bequest of Anna Thomson Dodge (71.248a–c)

INSCRIPTIONS: Underneath the bowl, in gold: interlaced *L*'s, the marks of Cornaille and Chauvaux below. Underneath the stand, in blue enamel: interlaced *L*'s enclosing a *DD* for 1781, the mark of Cornaille below, and the mark of Chauvaux in gold below Cornaille's. Incised underneath the bowl: *K*, near foot rim, *A 38,* on the opposite side.

CONDITION: Excellent

PROVENANCE: Sir Samuel Edward Scott (1873–1943), Bart., Lytchet Minster, Dorset. Duveen Brothers (dealer), New York. Acquired by Anna Thomson Dodge from Duveen Brothers, 1939.

The circular bowl is fitted with two intertwined branch handles, and the finial of the low domed cover is in the form of a looped branch with molded berries and leaves. The bowl rests on a circular stand with an upcurved, twelve-lobed rim. The bowl, cover, and stand are each decorated with a wide, undulating panel, reserved on a turquoise ground and enclosing looped garlands of flowers. Edged in narrow tooled gold

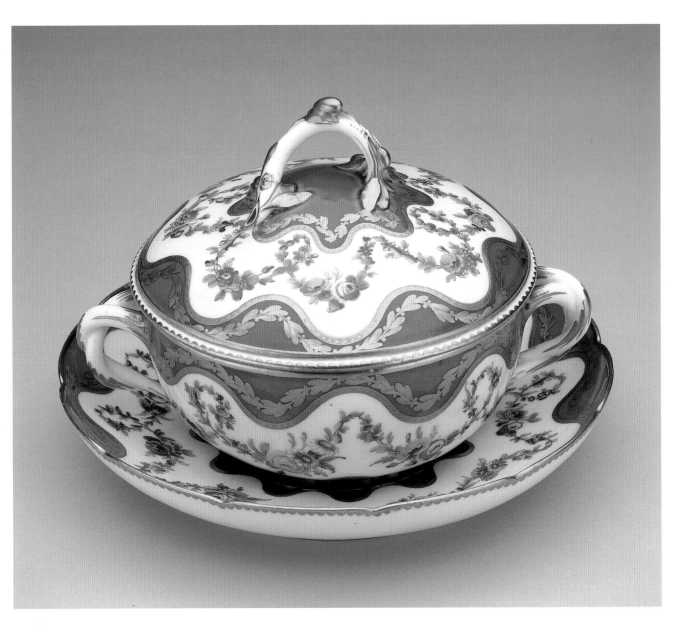

71.248

bands, the panels are further bordered by a continuous laurel leaf and berry vine.

The *écuelle ronde tournée* is recorded from 1753 and was in production until the end of the century. The three shapes of the model differ principally in the profile of the bowl and cover; shape C, introduced in 1773, was called *nouvelle forme* to distinguish it from the earlier Dodge version, which was thereafter referred to as *ancienne forme* (Savill 1988, II: 644). The *plateau rond,* so specified in 1755, was in production by 1753, the year of the earliest known examples, and was made in four sizes. Other stands used with this form of bowl were oval, or circular with a straight rim and handles (Savill 1988, II: 647).

In use by the fourteenth century at the dining table as an eating bowl for broth or soup, the *écuelle* began to appear among plate for the bedchamber by 1700. The change was not exclusive, since *écuelles* both for private and public eat-

ing appear in Louis XIV's inventories. Although none is listed among the major Sèvres services, two were included as late as 1772 in the dessert service made for Louis-René-Édouard, prince de Rohan (Dauterman 1970: 270–71). Through the first half of the eighteenth century, the shape was dictated by silver examples, characterized by flat-eared handles. In an uncommon reversal of the pattern of imitation, it is this form, of porcelain origin, that began to be adopted by the Parisian silversmiths, an example of 1769–70 by J.-P. Marteau being a virtual copy of the Dodge model (Dennis 1960, I: no. 239).

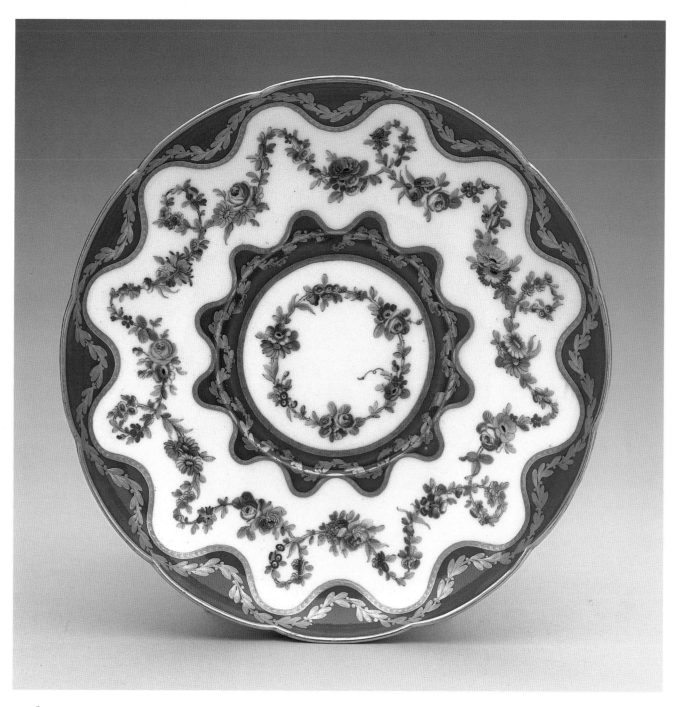

71.248

CHARLES-ELOI ASSELIN
1743 Paris–Sèvres 1804, active 1765–98, 1800–04

Asselin was perhaps trained as a painter, since his work for the manufactory included paintings in oil and gouache, as well as on porcelain. He was primarily a figure painter, his subjects ranging from adaptations of contemporary paintings to chinoiseries, portraits, and classical figures. He worked on vases, plaques, and tablewares, and according to manufactory records contributed designs for the latter in 1793. In 1800 he was appointed head of the painters' workshop.

JEAN-PIERRE BOULANGER
1722 ?–Sèvres 1785, active 1754–85

Boulanger came to Vincennes from Saint-Cloud in 1754, working as a gilder. He also appears in the manufactory records as a painter, but no enameled decoration by him has been recorded. His mark appears in his work as a gilder, even though it is in blue enamel rather than gold, as would be expected.

JACQUES-FRANÇOIS PARIS, or DEPARIS
1735 Aumale–? 1797, active 1746–97

Starting as a student at the manufactory, Paris became a répareur *and an assistant to Jean-Claude Duplessis,* père (see p. 152), *whom he succeeded in 1774 as head of the* répareurs *and of the soft-paste workshop. He began designing vases and tablewares the following year and left Sèvres in 1797.*

HENRI-MARTIN PRÉVOST
c. 1739–1797, active 1757–97

Prévost was one of several manufactory artists with this surname, and his biography has not been clearly established. He is recorded as having occasionally worked as a painter, but his known work is as a gilder. His skill was clearly recognized, since his mark often appears on porcelains of importance to the manufactory, such as the service ordered in 1783 by Louis XVI for his own use at Versailles.

[52]
Model by Jacques-François Paris
Painting by Charles-Eloi Asselin
Gilding by Jean-Pierre Boulanger and Henri-Martin Prévost

Pair of Covered Vases
(*vase Paris enfants* or *colonne de Paris,* second size), probably 1781

Soft-paste porcelain, 40 (15¾) × 18.7 (7⅜) × 13.3 (5¼)
Bequest of Anna Thomson Dodge (71.262a,b; 71.263a,b)

INSCRIPTIONS: Underneath each plinth: interlaced *L*'s above the mark of Boulanger in blue enamel and the mark of Prévost in gold. Incised on base of the plinth of 71.262: *10.A.* Incised inside the neck of each vase: *10.A.*

CONDITION: The right-hand putto on vase 71.262a has been broken off, reattached, and regilded. The left-hand volute on 71.263a has been repaired.

PROVENANCE: Maria Feodorovna (1759–1828), Empress of Russia. Grand Duke Michael Pavlovich (1798–1849). Grand Duke Constantine Nikolaievich (1827–1892). Grand Duchess Alexandra Iossifovna (1830–1911). Grand Duke Constantine Constanivich (1858–1915). Soviet government (until c. 1930). Duveen Brothers (dealer), New York. Acquired by Anna Thomson Dodge from Duveen Brothers, 1932.

EXHIBITION: Grosse Pointe 1981: unnumbered, ill. p. 25, fig. 008.

REFERENCES: Sèvres Archives Vj, 2.f.16, VI 1. f.169, Vy8, f.181; Benois 1901–07, VII: 226, pl. 131; Detroit 1933: n.p; Dauterman 1976: 761, fig. 46; Savill 1988, I: 437, 445, n. 21; Ennès 1989: 222.

The ovoid body narrows above to a fluted columnar neck and tapers at its base to a high spread foot attached to a square plinth. The neck is draped with molded laurel swags, held at the sides by children kneeling on the shoulder, their feet supported by volutes that sweep up from the base. The shallow domed cover with a pinecone finial is rimmed with gadrooning. Ovoid panels on the front and back are reserved on a dull green ground and are encircled by sprays of ribbon-tied oak leaves and acorns repeated on the foot and cover. On the front are rustic scenes, one (71.262) of a woman and child rocking a tree-hung cradle, the other of an elderly shepherd beguiling a young shepherdess with music from his lute in a mountainous landscape. The reserves on the backs enclose trophies of toys and music, respectively.

The model is one of many vases named after Jacques-François Paris. Versions without figures and with a different treatment of the handles were in production by 1776; this

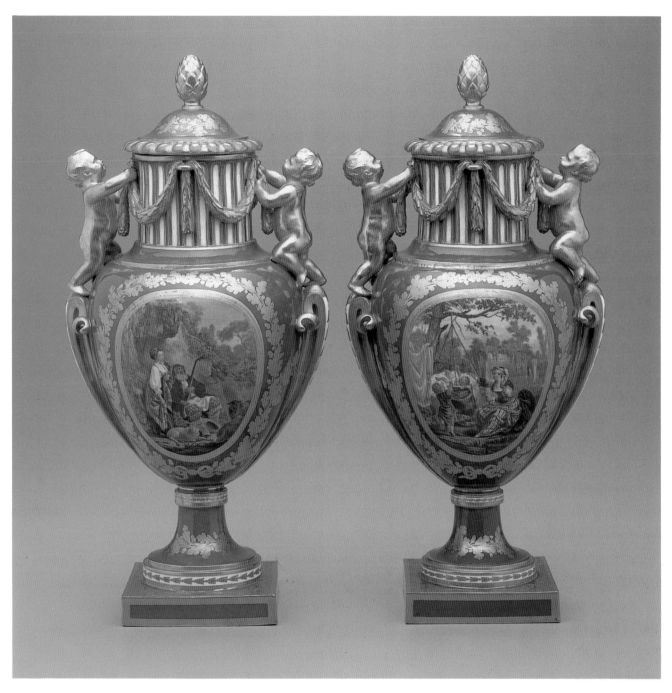

71.262–71.263

model dates from 1778 and was included in garnitures with other *vases Paris* (Savill 1988, I: 436–37).

Although lacking both a painter's mark and a date letter, these vases are certainly two of a garniture of three *vases Paris* described in the manufactory records on July 30, 1781, as decorated with miniatures by Asselin and Prévost (whose mark is present) (Savill 1988, I: 437). They may thus, in turn, be equated with the "garniture de trois vases Paris fond vert Mignature" (Ennès 1989: 221) purchased the next year by Prince Ivan Sergeyevich Bariatinsky, Catherine II's ambassador to France, on behalf of the Grand Duke Paul and his wife, Maria Feodorovna, whose visit to Paris has been described previously (cat. 8). Purchased for 1940 livres on June 25, 1782, after the departure of the imperial couple on June 19, they would have been selected by Bariatinsky with an eye to the grand ducal taste. The subject matter of the decoration would surely have been recognized and been considered particularly appropriate by the minister. Both scenes are based on the Russian sketches of Jean-Baptiste Le Prince (1734–1781). After an apprenticeship with François Boucher, an unsuccessful marriage, and an apparently unstimulating visit to Italy, Le Prince set out for Russia in 1758 and remained there until 1763. Returning to Paris, he quickly established his reputation through his first-hand depictions of the still exotic Russia. Between 1764 and 1768, he issued several sets of etchings depicting Russian customs and dress;

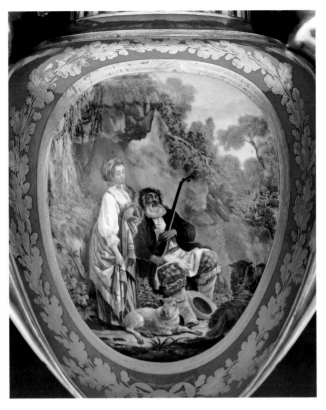

71.263

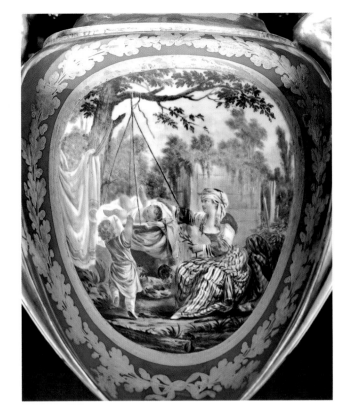

71.262

71.263

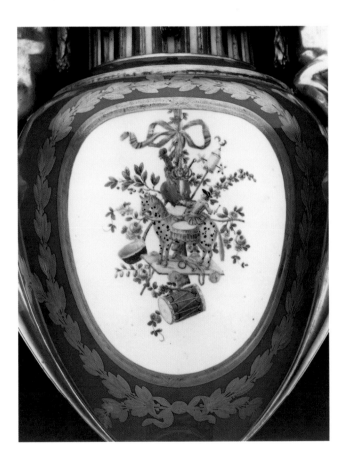

71.262

in the latter year, engravings of thirty-two of his drawings were published in the *Voyage en Sibérie,* an account by the Abbé Chappe d'Auteroche of his travels to Tobolsk to witness the Transit of Venus on June 6, 1761. Further, Le Prince exhibited over two dozen paintings with Russian themes in the Salons of 1765, 1767, and 1769 (Rorschach 1986: 15).

The scenes on these vases are each based on, and considerably altered from, engravings of larger compositions by Le Prince. In the domestic scene, engraved by P.-L. Pariseau (1740–1801) as *Le berceau russe,* an elderly grandmother with her spinning has been transformed into a pretty young woman, and three other figures have been suppressed altogether. On the second vase, the air of seduction is more apparent here than in the engraving by J.-B. Tilliard (1740–1813), which includes a pipe-playing shepherd boy and numerous sheep.

Despite the popularity of Le Prince's work, there was no vogue for Russian subjects at Sèvres as there had been for *enfants de Boucher* or for Flemish peasant scenes after Teniers. In addition to these vases, others with pictorial scenes after Le Prince are known: a pair of *vases à panneaux* dated 1777,

in the Royal Collection, Great Britain (London 1979b: no. 33), and a pair of *vases à trois cartels* of 1774, in the Philadelphia Museum of Art.

The trophy of toys on the reverse of 71.262 is one of several such compositions found on vases dating between c. 1765–70 and c. 1781, the date of the Dodge pair (Savill 1988, I: nos. C264, C270). None bears a decorator's mark, they are considerably varied in their component elements, and seem to be by different hands, but they usually include a windmill and a musical instrument and are suspended from berried branches.

The incised mark *10* has been read both as the number 10 and as letters. It appears principally on vases of the 1780s, sometimes accompanied by one or two dots and/or the letters A and B. Since it also appears with proper names, its significance is difficult to establish and remains undecided.

The Sèvres records of 1781 mention only Prévost, despite the presence of Boulanger's mark as well. It would not have been usual for two gilders to have worked on a single piece, and we must suppose that Prévost completed work begun by Boulanger, and his mark was applied later.

SÈVRES PORCELAINS FROM THE CHÉREMÉTEFF COLLECTION

The following twenty-two pieces have been grouped together because they have in common the representation of recognizable species of birds identified by inscriptions. They are part of an assemblage of 520 pieces owned at the end of the nineteenth century and until about 1906 by Count A.D. Chéréméteff. Although said at the time to have been ordered from Sèvres by his grandfather, Count Nicolas Petrovitch Chéréméteff (1751–1809), this cannot have been the case, since at least six different services are represented here, ranging in date from 1766 to 1787; the date range of the complete collection extended to 1791 (Spilioti 1904: 158). The Russian provenance of these individual services has not been established. There is no evidence that they were ever at Nicolas Petrovitch's palace at Ostankino, which he built in the 1790s (G.V. Vdovin, Ostankino Museum, letter to the author, February 22, 1994); they were more likely assembled in the Chéréméteff Palace in St. Petersburg. The collection appears to have been divided up in 1874 when a portion was delivered to the Hermitage Museum; a group of pieces was lent to the "Art Treasures Exhibition" held in St. Petersburg in 1904, and in 1906 part of the collection was exhibited by the London dealer Asher Wertheimer in his shop on New Bond Street (*Connoisseur* 1906: 243). The Dodge porcelains were subsequently acquired by Duveen Brothers and sold to Mrs. Dodge in 1939.

The Chéréméteff bird-painted porcelains are tablewares appropriate to a dessert service and feature a *bleu céleste* ground. The majority of the marked pieces are by François-Joseph Aloncle and Antoine-Joseph Chappuis, two painters whose names are most closely associated with this type of work. Aloncle had been painting birds of generalized exotic appearance for several years before turning to a naturalistic manner copied, or recomposed, from paintings and prints. Jean de Cayeux has made an intriguing case for the influence of Madame de Pompadour in this enterprise, through such painters as Jean-Baptiste Oudry and the manufactory's artistic director, Jean-Jacques Bachelier, both of whom executed paintings of birds for the marquise (Cayeux 1993: 7–9). Bachelier included a portrait of her white cockatoo in an *Allegory of America* painted in 1760 (Eriksen 1968: 122; Clément-Grandcourt 1994: 34), and perhaps it was one of her parrots—for which the *marchand-mercier* Lazare Duvaux provided cages in 1754—that is seen on a flower vase of 1753–54 in The J. Paul Getty Museum, Malibu (Eriksen 1968: 122; Sassoon 1991: no. 2). The genre took on a more methodical character in 1766, when both Aloncle and Chappuis were paid for copying "oiseaux différents d'après des tableaux pour servir de modèle à la Manufacture." The next year, Chappuis earned 168 livres for "112 cartouches peints en oiseaux sur différents pièces" (Pope and Brunet 1974: 260). This activity

coincides with the production of most of the pieces in the present collection; of a service at Waddesdon Manor, made in 1766–67 for Alexis Razoumovsky or his brother Cyril (Eriksen 1968: no. 75); and of three services painted with unnamed birds at Goodwood House, seat of the Dukes of Richmond.

In November 1766 Charles Lennox, third Duke of Richmond, arrived in Paris as the English Ambassador Extraordinary to the Court of Versailles, a short-lived and interrupted appointment that ended a year later. A few days after his arrival, he visited Sèvres and ordered £500 of porcelain, one or perhaps all three of the services still at Goodwood (Zelleke 1991: 10). Most of the birds depicted on the Goodwood services are based on illustrations appearing in either of two publications by the English naturalist George Edwards (1694–1773): his *Natural History of Birds,* first published in two volumes in 1743 and 1751; and his *Gleanings of Natural History,* published in three volumes between 1758 and 1763. In the latter, the identifications and descriptions of the birds are given both in English and French, in parallel columns. For the French names of the birds drawn from *Natural History of Birds,* however, a translation would have been necessary. Ghenete Zelleke has shown (1991: *passim*) that a French edition of 1745 and 1748 owned by the Duke of Richmond must have been available to the Sèvres painters, since only in this edition are several of the plates reversed, as they are on the Goodwood services. The reversed images are also seen among the Dodge porcelains, and the association with the Duke of Richmond is emphatically reinforced by the inscription that appears on the ice-cream cooler (cat. 55, 71.220), which identifies the right-hand bird on one side as *Le touraco de Mr. de Richemond.*

Although some of the birds painted on the Dodge porcelains are fairly true to their printed sources, the Sèvres painters exercised considerable freedom. The compositions themselves are complete inventions, since only in very few instances did Edwards illustrate two birds (and those of the same species) on a single plate. Sometimes pose or coloring has been altered, sometimes birds and names have been transposed or the same bird appears under different names. All this suggests that while Richmond's copy of Edwards may have been a source of inspiration, the finished decoration was based on a collection of sketches made from it that were mixed and altered with little concern for ornithological accuracy.

The inscriptions identifying the birds on the Dodge porcelains are by distinctly different hands, and it was proposed by Carl Dauterman in his manuscript of the Dodge catalogue that these hands could be used to identify the painters—particularly in the case of unmarked pieces—by establishing correspondences with their handwriting as recorded in the

Sèvres archives. On the premise that it was the decorators who painted their own as well as the manufactory mark on each completed piece, it is logical to assume that Aloncle and Chappuis, for example, would also have written the names of the birds they had just painted. (We do know, however, that in 1770 Pierre-Antoine Méreaud was engaged to write the names of the birds on two punchbowls painted by Edmé-François Bouillat [Munger et al. 1992: 202–03].) The calligraphy that accompanies the marks of Aloncle and Chappuis on these pieces is, for each artist, as consistent in its characteristics as is the rendition of the manufactory and the painter's mark.

If an analysis of handwriting is useful for purposes of assigning an attribution in the absence of a painter's mark, it should also be useful in the opposite case: an unmarked piece with unfamiliar handwriting is not likely to have been painted by an artist associated with a recognized script.

The first wave of ornithological painting—which encompassed numerous smaller sets derived from the same pictorial sources, but with the birds unnamed—was followed by a second one, inspired by the *Histoire naturelle des oiseaux* of Georges-Louis Leclerc, comte de Buffon (1707–1788), published in several editions between 1770 and 1786. A service of named birds dating 1779–81 was acquired in 1782 by the comte d'Artois (Munger et al. 1992: 202–03); Louis XVI presented William Eden with one in 1787 (Dawson 1980: 285–92); and a third of 1782–86 was given by the duc de Chartres to Mrs. Nathaniel Parker Forth (Hall 1986: 386–89). In 1792 an armorial service with named birds after Buffon was purchased for a member of the Sudell family, possibly Henry Sudell of Wiltshire (Bellaigue 1986: 87). The last of these eighteenth-century encyclopedic services are one of about 1792, *à fond écaille* (Lahaussois 1992: fiche 259D) and another with a yellow ground of 1794–95 (Roth 1987: no. 79).

FRANÇOIS-JOSEPH ALONCLE
1734 Versailles–Sèvres 1781, active 1758–81

Aloncle worked as a painter in Paris before coming to Sèvres in 1758. The appearance of his or a similar mark on earlier pieces or pieces decorated in an unfamiliar manner has somewhat obscured identification of his repertoire. He is known principally for his paintings of birds, from his first years at the manufactory until about 1771; but he also painted trophies and, in the late 1770s, tablewares with groups of animals from fables.

ÉTIENNE EVANS
1733/35–1809, active 1752–1800

Like many of his colleagues, Evans had been a fan painter before coming to Vincennes, where he seems to have worked exclusively as a painter of birds, executed with a vivid sketchiness. In addition to his work seen here, he contributed to the Razoumovsky and Goodwood services and, later, the Artois service and a yellow-ground service in 1794.

[53]

Painting by François-Joseph Aloncle and Étienne Evans

Three Plates (assiette à palmes), 1767 and 1768

Soft-paste porcelain, 24.8 (9¾)
Bequest of Anna Thomson Dodge (71.235–71.237)

INSCRIPTIONS: 71.235: Underneath in blue: interlaced *L*'s enclosing a *P* for 1768 and the mark of Aloncle below. Written in black: *La Bergerounette* [sic] *D'amerique.* 71.236: Underneath in blue: interlaced *L*'s enclosing an *O* for 1767 and the mark of Aloncle below. Written in black: *Canard des indes.* 71.237: Underneath in blue: interlaced *L*'s enclosing a *P* and the mark of Evans below. Written in black: *La pie a courte queüe de Ceilan.*

CONDITION: The gilding is worn from all three, with the foliate sprays below the inner rim on 71.236 entirely effaced. The rim of 71.236 has been repaired in one area, with repainting and regilding; its foot rim has been broken in several places.

PROVENANCE: Chérémèteff family, until c. 1906. Asher Wertheimer (dealer), London. Duveen Brothers (dealer), New York. Acquired by Anna Thomson Dodge from Duveen Brothers, 1939.

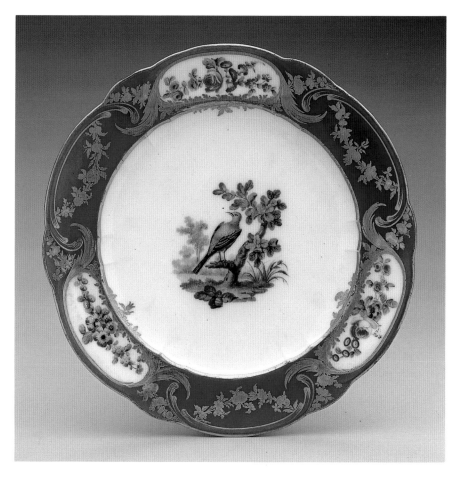

71.235

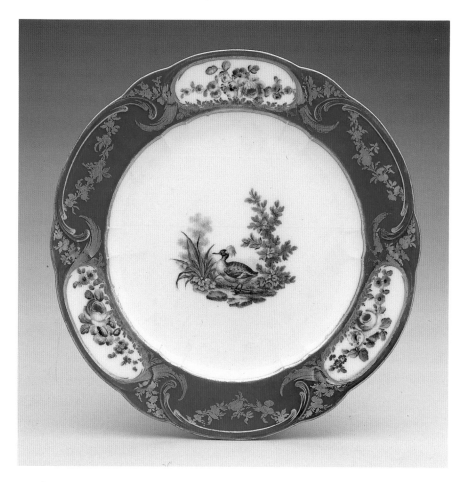

71.236

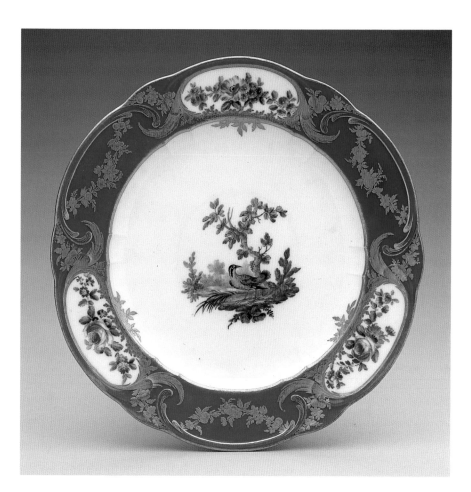

71.237

REFERENCES: Edwards 1758–63, II: pl. 324 (short-tailed pye). Cayeux 1993: 29, no. 7 (71.235), 30, no. 21 (71.236), 34, no. 182 (71.237).

The flat rim with turquoise ground is divided into six large lobes, three oval flower-filled reserves framed by palm-leaf sprays alternating with gilded C-scrolls. The panels are linked by a continuous undulating garland. Below the inner edge of the rim is a narrow band of gilding interrupted by three leaf sprays. In the center is a single bird in a landscape.

The model is first mentioned in course of production in 1753 and is the only one used for the recorded plates made between 1766 and 1768 for the named bird services. Forty-five plates comprise part of the Razoumovsky service (Eriksen 1968: no. 75); twenty-six were sold at auction in 1980 (Monaco 1980: lots 319–21, 324). A single plate by Evans dated 1768 is in the Musée du Louvre, Paris (Paris 1990: 190–91) and one by Chappuis, also 1768, is in a private collection (Marly-le-Roi-Louveciennes 1992: 49). Pierre Ennès (in Paris 1990: 191) has suggested that the Louvre plate might have originated in either of two services recorded in 1769, one of twenty-four plates "Bleu celeste oiseaux" acquired by Madame du Barry.

The *Water-wagtail* (*la Bergeronnette*) is illustrated by Edwards (1743–51, I: pls. 258, 259), but in very different poses from the bird seen on 71.235. The *Short-tailed Pye* follows Edwards's print except for the head, which is here turned back.

ANTOINE-JOSEPH CHAPPUIS
1743 Broc–Sèvres 1787, active 1756–87

Starting as an unpaid apprentice, Chappuis rose to the position of head of the kilns in 1786 but also worked as a painter at least until 1784. Like Aloncle, he specialized in bird painting and contributed to both the first fashion for such decoration in the late 1760s and the second after 1782. According to manufactory records, he also painted bouquets and floral-border patterns on small tablewares.

[54]
Painting by Antoine-Joseph Chappuis

Two Liqueur Bottle Coolers
(*seau à liqueur ovale*), 1767

Soft-paste porcelain
71.233: 12.1 (4¾) × 31.1 (12¼) × 14.6 (5¾)
71.234: 12.4 (4⅞) × 31.1 (12¼) × 14.4 (5¹¹⁄₁₆)
Bequest of Anna Thomson Dodge (71.233, 71.234)

INSCRIPTIONS: 71.233: Underneath in blue: interlaced *L*'s enclosing an *O* for 1767, the mark of Chappuis above. Incised: *FI* near the foot rim at one end, *DD* [script] opposite. Written underneath in black: *LA PERRUCHE AUX AILES ROUGES* / *LA PONPADOUR* [sic] *DE CAYENNE, COULOU* [sic] *DE CAYENNE* / *CACATUA NOIR.* 71.234: Underneath in blue: interlaced *L*'s enclosing an *O*, the mark of Chappuis above. Incised near foot rim (see below). Written underneath in black: *FAISAN DE LA CHINE* / *GAI BLEU D'AMERIQUE, PELICAN* / *CANARD D'AMERIQUE.*

CONDITION: The gilding is worn on the outside rim of 71.233 and is mostly missing from the rim of 71.234. Each cooler lacks its removable partition.

PROVENANCE: Chérémeteff family, until c. 1906. Asher Wertheimer (dealer), London. Duveen Brothers (dealer), New York. Acquired by Anna Thomson Dodge from Duveen Brothers, 1939.

REFERENCES: Edwards 1743–51, II: pls. 92 (pelican), 100 (duck); Edwards 1758–63, I: pl. 239 (blue jay), III: pls. 316 (cockatoo), 341 (Pompadour); Cayeux 1993: 30, no. 16 (71.233, as a *cuvette à fleurs*), 31, no. 48 (71.234, as a *cuvette à fleurs*), no. 57 (71.234), 33, no. 151 (71.234, as a *cuvette à fleurs*); London n.d.: nos. 68, 69.

The oval body with undulating rim curves to a recessed foot rim. The ends are fitted with leaf-tip and scrolled bracket handles. On each side, two birds in a landscape are painted in a kidney-shaped reserve framed below by ribbon-tied palm branches and above by a garland that continues under the handles. The inside is fitted in the middle with a frame for a partition.

Models and molds for this form date from 1754, when it was first put into production. Liqueur bottle coolers were fitted either with pierced or solid partitions, the former an indication that the bottles were kept cool in water, which could flow easily through the holes, thus keeping the cooler in balance.

Although 71.233 depicts Edwards's *The Great Black Cockatoo (Le Grand Cacatua Noir)* (Edwards 1758–63, III: 316), it is seen here in a quite different pose. The red-winged parakeet does not correspond to either of the short-tailed birds in *Gleanings* (Edwards 1758–63, II: pl. 293) and is not found in Edwards's *Natural History of Birds*. The pelican on 71.234 is seen in reverse, as is *The Little Black and White Duck*. The *Pompadour* on 71.234 also occurs on a *plateau*

losange in the Dodge Collection (cat. 60, 71.223). Properly a Cotinga, this name was bestowed on it by Edwards, who wrote (1758–63, III: 276):

> This is one of those Birds taken in a French prize by the now Right Honourable Earl Ferrers. They were said to be for Madam Pompadour. It being a bird of excessive beauty, I hope that Lady will forgive me for calling it by her name.

This passage and the rose pink color of the bird provide an unexpected legitimacy for the historical association of the marquise with the Sèvres "roze," as that ground color was simply referred to in the manufactory records. The Rev. William Cole, however, visiting Paris with Horace Walpole in 1765, gives the color a darker hue, describing a new "Great Coat of a Pompadour Colour as we call it, that is a kind of colour between a Purple & Red" (Cole 1931: 179).

The incised marks are unidentified, although all three have been recorded. The mark *fi* appears on a cooler in the Razoumovsky service at Waddesdon Manor and on other pieces cited by Eriksen (1968: 207) and Savill (1988, III: 1101). The incised mark on 71.234 also appears on the Dodge *plateau losange* (cat. 60, 71.223) and has been noted on a number of pieces dating between 1766 and 1773 (Eriksen 1968: 196). Dauterman's proposed identification of *dd* as the mark of the *répareur* Aimé Déduit, based on a plate dated 1773, must be reconsidered since Déduit only began working that year (Dauterman 1986: 67, 190).

[55]

Two Ice-Cream Coolers (seau à glace, first size), c. 1767

Soft-paste porcelain, 19 (7½) × 22.9 (9) at handles × 19 (7½)
Bequest of Anna Thomson Dodge (71.220a,b; 71.221a,b)

INSCRIPTIONS: 71.220a: Written in dark blue on the underside: LE COLIBRI / LE TOURACO CHÉ MR. DE RICHEMOND, MANAQUIN DE CAYENNE / FAISAN NOIR DE LA CHINE. 71.221a: Written in dark blue on the underside: PERRUCHE AUX AILES ROUGE / ROI DES VEAUTOURS, [BONANA] DE LA JAMAIQUE / FAISAN DE LA CHINE.

CONDITION: The finial of 71.221b has been broken and re-attached, with repainting, and the interior of the cover is considerably pitted. The liners of both coolers are missing.

PROVENANCE: Chéréméteff family, until c. 1906. Asher Wertheimer (dealer), London. Duveen Brothers (dealer), New York. Acquired by Anna Thomson Dodge from Duveen Brothers, 1939.

REFERENCES: Edwards 1743–51, I: pls. 2 (vulture), 7 (touraco), 66 (pheasant); Edwards 1758–63, I: pl. 236 (red-winged parakeet); Cayeux 1993: 13, 30, no. 12 (71.221, as Armand), no. 34 (71.220), 31, no. 48 (71.221, as Aloncle), no. 51 (71.220), 32,

no. 95 (71.220), 34, no. 164 (71.221, as Aloncle), 36, no. 235 (71.220), no. 238 (71.221, as Aloncle).

The cylindrical bowl with rounded base rests on three pad feet and is fitted with squared handles. The flat-topped lid is encircled by a collar and a flanged rim, and the finial is formed of opposing scrolls. A reserve on each side framed with palm branches and garlands is painted with two birds in a landscape.

The model for this, the first size, was in production from 1758. A mold and a model for a second size were in existence by October 1759 but apparently not produced (BKR/GKR, I.F. 5673, 5674, Inv. 1er octobre 1759). The cooler, of which at least one pair was a regular component of a dessert service, was designed to keep a semiliquid ice cream or sorbet cold in a liner or *écuelle* above a bed of ice. A second layer of ice for extra insulation filled the cover.

Although identified as *Le Colibri,* the bird shown in 71.220 with the touraco is not the *Ruby-Crested Humming Bird* illustrated by Edwards (1758–63, III: pl. 344) and is not found in his works. The two pheasants that face in opposite directions are both based on Edwards's *Black and White Chinese Cock Pheasant:* on 71.221 the pheasant appears exactly as published, but on 71.220 it is reversed and considerably varied in details. The touraco and the vulture have also been reversed. The same two birds appear, in different compositions, on two wine coolers at Goodwood House, part of a green-ground service made for the third Duke of Richmond in 1766 (Zelleke 1991: *passim*). Zelleke has pointed out that the direction of the two birds on the Goodwood coolers corresponds only to the colored etchings in the French edition of Edwards's *Natural History of Birds,* also at Goodwood—evidence enough that the Duke lent it to the manufactory for copying. This connection is reinforced here by the inscription on 71.220, which directly connects the duke with the touraco.

[56]

Painting by François-Joseph Aloncle (see p. 183) and Antoine-Joseph Chappuis (see p. 185)

Four Monteiths (seau à crennelé), 1767 and 1768

Soft-paste porcelain, 12.7 (5) × 29.9 (11¾) × 20.3 (8)
Bequest of Anna Thomson Dodge (71.227–71.230)

INSCRIPTIONS: 71.227: Underneath, in blue: interlaced *L*'s enclosing a *P* for 1768, the mark of Chappuis above. Incised near the foot rim: *5,* and opposite: *19.* Written underneath in black with red flourishes: MARTIN PECHEUR DE CAYENNE/ CANARD D'ÉTÉ D'AMÉRIQUE. Written in black: LA PIE DES INDES / MANAKIN A GORGE POURPRÉ. 71.228: Underneath, in blue: interlaced *L*'s enclosing an *O* for 1767, the mark of

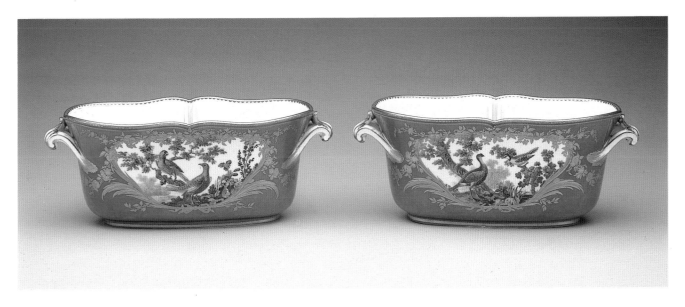

71.233–71.234

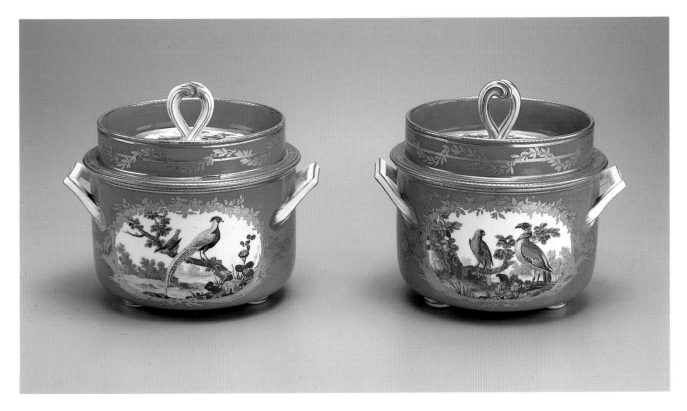

71.220–71.221

Chappuis above. Incised near the foot rim: *5*. Written underneath in light purple: *PÉLICAN D'AMERIQUE / MARTIN PECHEUR DE CAYENNE, GORGE ROUGE D'AMERIQUE/ L'OUTARDE*. 71.229: Underneath, in blue: interlaced *L*'s enclosing an *o* for 1767, the mark of Chappuis above. Incised near the foot rim: *5*. Written underneath, in black: *MOUCHEROLE / LA PERDRIX DE BARBARIE, L'OUTARDE MALÉ / PINSON D'AMERIQUE*. 71.230: Underneath, in blue: interlaced *L*'s enclosing an *o* for 1767, the mark of Aloncle below. Written underneath, in purple: *MARTIN PECHEUR ET LE CANARD D3E PERSE, MANAKIN ET PERROQUET*.

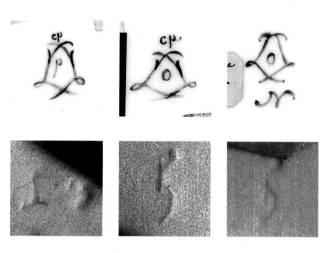

CONDITION: Small areas of gilding on 71.227 and 71.228 have been retouched and the gilding is worn from the rims of 71.228 and 71.229. The interior of 71.229 is heavily pitted, the underside less so.

PROVENANCE: Chéréméteff family, until c. 1906. Asher Wertheimer (dealer), London. Duveen Brothers (dealer), New York. Acquired by Anna Thomson Dodge from Duveen Brothers, 1939.

REFERENCES: Edwards 1743–51, II: pls. 70 (partridge), 73 (bustard cock), 74 (hen bustard), 93 (pelican), 101 (summer duck); Spilioti 1904: 140, fig. 4 (71.229); St. Petersburg 1907: 29 (71.229); Cayeux 1993: 30, no. 21 (71.227, as 1766), no. 25 (71.230), 31, no. 61 (71.228), 32, no. 88 (71.230), no. 90 (71.227), no. 103 (71.230), no. 106 (71.227, 71.228), 33, no. 127 (71.229), no. 144 (71.229, as Chappuis or Aloncle), no. 152 (71.228), 34, no. 153 (71.229), no. 155 (71.230), 35, no. 191 (71.227), no. 201 (71.229, as 1766); London n.d.: 79–81 (71.228, 71.229).

The oval bowl, its rim with incurved notches, tapers slightly to a low, recessed, flat base. Handles at the ends are formed of turned-out acanthus leaves. On each side is an oval reserve enclosing two birds in a landscape. The reserves are edged below by ribbon-tied palm branches and are linked at the top by a continuous garland. Molds and models for coolers for six and twelve glasses were made in 1758 (MNS Archives Carton I.7). The form is derived from the monteith introduced in England in silver in 1683–84, designed to cool glasses, suspended upside down by the notches in iced water. But this usage was apparently not exclusive: a drawing of this model in the Cooper-Hewitt Museum, New York, is inscribed "Seau Crenelé pour contenir vases et Liqueurs" (London 1973: no. 146).

The bustard cock (Edwards 1743–51, II: pl. 73) and *The Summer Duck of Catesby* (Edwards 1743–51, II: pl. 101) on 71.227 appear in reverse and the *Red-Legged Partridge, from Barbary* (Edwards 1743–51, II: pl. 70) on 71.229 differs in minor details from the prints. The *Cock Purple-Breasted Manakin* illustrated by Edwards (1758–63, III: pl. 340) may be the source for the bird on 71.227, but the image here is somewhat removed from the print. Although Edwards illustrates the *Little Indian Pye* (1743–51, III: pl. 181), that bird

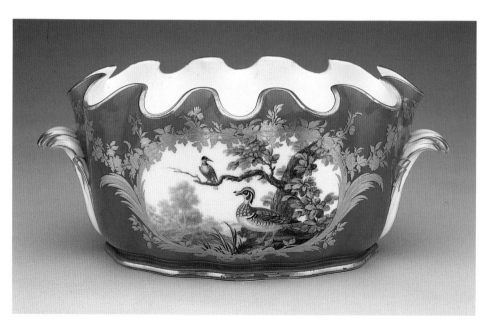

71.227

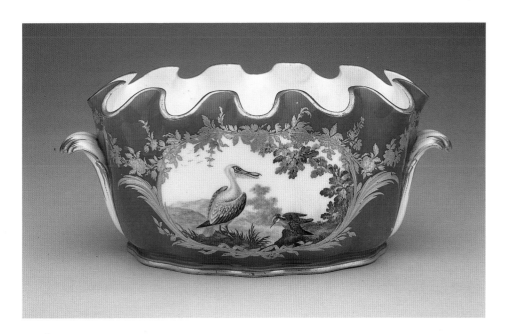

71.228

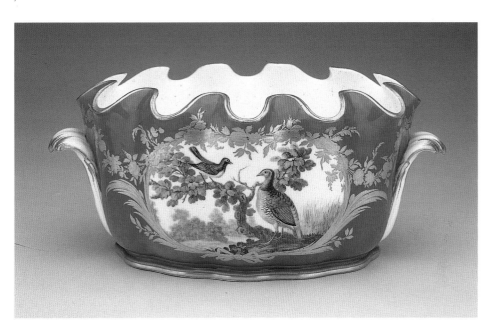

71.229

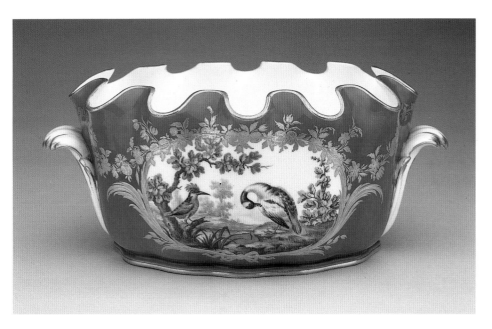

71.230

71.227

71.228

71.229

71.230

bears no resemblance to the one so named on 71.227 but may correspond to Brisson's *la pie griesche noire du Bengale,* as Cayeux has suggested (1993: 35, no. 191). The *Canard de Perse* on 71.230 is the same bird that appears on the liqueur bottle cooler 71.234 (cat. 54), there identified as *Canard D'amerique,* both corresponding to Edwards's illustration of the *Little Black and White Duck* (1743–51, II: pl. 100).

PHILIPPE XHROWET
1725 Beauvais–Sèvres 1775, active 1750–75

Xhrowet came to Vincennes in 1750 after having worked as a fan painter. According to the manufactory records, he specialized in flowers but also painted cherubs, birds, and ornamental friezes on vases and useful wares. That he played some role in the development of the rose pink ground color first put into production in 1758 is evident from a payment to him on January 1 of that year for having discovered "un fond couleur de rose très frais et fort agréable" (Pope and Brunet 1974: 192)

[57]
Painting attributed to Philippe Xhrowet (71.224)

Two Salad Bowls
(saladier feuille de choux, first size), 1768

Soft-paste porcelain, 9.5 (3¾) × 27 (10⅝) diameter
Bequest of Anna Thomson Dodge (71.224, 71.225)

INSCRIPTIONS: 71.224: Underneath in black: interlaced *L*'s enclosing a *P* for 1768, probably the mark of Xhrowet above. Written underneath in black (abraded): LE [PI]NÇON / DAMERIQUE, [CAI]LLE DE LA / CHINE, LE MANAKIN / [GORGE R]OUGE. 71.225: Written underneath in black: CANARD NOIR ET BLANC / DES AILES, MARTIN PECHEUR, LA PIE VERTE DES INDES / ORIENTAL.

CONDITION: Good. The inscriptions on 71.224 are considerably worn.

PROVENANCE: Chéréméteff family, until c. 1906. Asher Wertheimer (dealer), London. Duveen Brothers (dealer), New York. Acquired by Anna Thomson Dodge from Duveen Brothers, 1939.

REFERENCES: Edwards 1743–51, II: pl. 98 (black and white duck); Edwards 1758–63, III: pl. 336 (crested kingfisher);

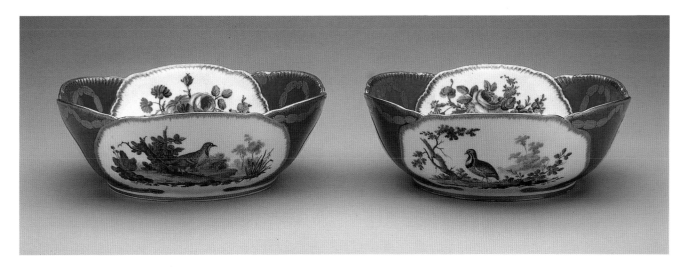

71.224–71.225

Cayeux 1993: 30, no. 17 (71.224), 32, no. 103 (71.225), 34, no. 185 (71.225, as Aloncle, 1768), 35, no. 201 (71.224); London n.d.: nos. 3, 33.

The circular bowl is shaped with a six-lobed rim and tapers to a low foot ring. The inside and outside are each molded with three low-relief *feuille de choux* reserves, their cabbage-leaf form emphasized by feathered gilding. Each of those on the outside encloses a single bird in a landscape, while the reserves inside enframe flower sprays. Laurel festoons link each set of reserves. In the center of the bottom is a gilded leaf-entwined circle.

The model was produced in two sizes from 1756 (GKR, 27 août 1756).

A purple-throated manakin is illustrated by Edwards (1758–63, III: pl. 340), but it does not seem to be the same bird shown on 71.224. The *Great black and white duck* on 71.225 appears in reverse, while the *Crested King's-fisher* or *Le Martin-Pecheur Hupé* faces the same direction as in Edwards.

The bird painting on the two bowls is not by the same hand. The Latin cross and two other marks—a saltire and a saltire potent cross—have been attributed both to Xhrowet and to his contemporary, Jacques-François Micaud (active 1757–1801; see Savill 1988, III: 1049–50, 1077), but as far as can be determined, Micaud was never a bird painter, specializing instead in luxuriant textilelike patterns of ribbons, garlands, and shellwork and in floral compositions. Like Micaud, Xhrowet is recorded as having painted "frizes riches," but the mark of the Latin cross also appears on a sugar bowl painted with birds around 1753, four years before Micaud's arrival at the factory (Dauterman 1970: cat. 72). A pair of glass coolers of 1770 at Waddesdon Manor, painted with birds in a similar manner and bearing the same mark of a Latin cross, was tentatively assigned by Eriksen to Micaud (Eriksen 1968: no. 91), but it seems more reasonable to attribute this small group of pieces to Xhrowet.

[58]
Painting by François-Joseph Aloncle (see p. 183)

Plate (assiette à palmes), 1768

Soft-paste porcelain, 24.8 (9¾)
Bequest of Anna Thomson Dodge (71.226)

INSCRIPTIONS: Underneath in blue: interlaced *L*'s enclosing a *P* for 1768, the mark of Aloncle below. Incised near the foot rim: *CT*. Written underneath in black: *GRINPEREAU DE MUR.*

CONDITION: There are minor areas of regilding.

PROVENANCE: Chéreméteff family, until c. 1906. Asher Wertheimer (dealer), London. Duveen Brothers (dealer), New York. Acquired by Anna Thomson Dodge from Duveen Brothers, 1939.

REFERENCES: Cayeux 1993: 31, no. 67; London n.d.: nos. 95–167.

For the model, see cat. 53. The reserves on the rim enclose flower sprays, and they are linked by a laurel festoon. In the center is a bird in a landscape.

The inscription is an incomplete identification of *Le Grimpereau de muraille de Surinam,* or *Wall-Creeper of Surinam* illustrated by Edwards (1758–63, III: pl. 346). If the bird seen here is indeed the same species, it is a very free version.

Another plate, evidently from this service and formerly in the Wrightsman Collection at The Metropolitan Museum of

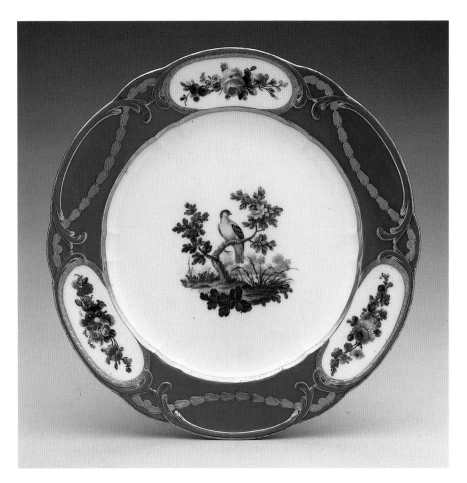

71.226

Art, New York (Dauterman 1970: no. 104), was also painted by Aloncle the same year.

The incised *CT,* which is recorded by Dauterman (1986: 187) for two members of the Collot family, is likely to be that of Collot (I), a *répareur* active between 1756 and 1772.

[59]
Painting by François-Joseph Aloncle (71.219) (see p. 183)

Two Monteiths
(*seau à crennelé,* first size), 1768 and c. 1768

Soft-paste porcelain, 12.7 (5) × 18.8 (7⅜) × 20.6 (8⅛)
Bequest of Anna Thomson Dodge (71.218, 71.219)

INSCRIPTIONS: 71.218: Incised near the foot rim: *BP.* Written underneath in black: *LE DUC, ET LA PÉTITE* [sic] *PERRUCHE, LE TOUÇAN DU BR[A]SIL / ET LE LORIOT DES INDES.* 71.219: Inscribed underneath: interlaced *L*'s enclosing a *P* for 1768, the mark of Aloncle below. Incised together

near the foot rim: *5* and *IP.* Written underneath in black: *GROS ARAS VERT ET / GRINPEREAU DE MUR DAMERIQUE, LA PIE A COURTE QUEÜ DE CEILAN / ET MOUCHEROLE DU CAP FRANCOIS.*

CONDITION: Some of the gilding on 71.219 has been restored.

PROVENANCE: Chéréméteff family, until c. 1906. Asher Wertheimer (dealer), London. Duveen Brothers (dealer), New York. Acquired by Anna Thomson Dodge from Duveen Brothers, 1939.

REFERENCES: Edwards 1743–51, II: pl. 60 (the owl); Edwards 1758–63, III: pl. 324 (the short-tailed pye); Cayeux 1993: 29, no. 5 (71.219), 30, no. 46 (71.218, as Aloncle), 31, no. 68 (71.219), 32, no. 86 (71.218, as Aloncle), 33, no. 132 (71.219), 34, no. 173 (71.218, as Aloncle), no. 177 (71.218, as Aloncle), no. 182 (71.219), 36, no. 230 (71.218, as Aloncle); London n.d.: nos. 14, 15.

For the model, see cat. 56.

An oval reserve on each side is painted with two birds in a landscape. The decoration is completed by a gold border tooled with a wavelike pattern and by a continuous laurel leaf and berry festoon.

The unmarked bowl is not by Aloncle but by an unidentified painter who makes his only appearance among the Chéréméteff porcelains with this piece. The drawing is

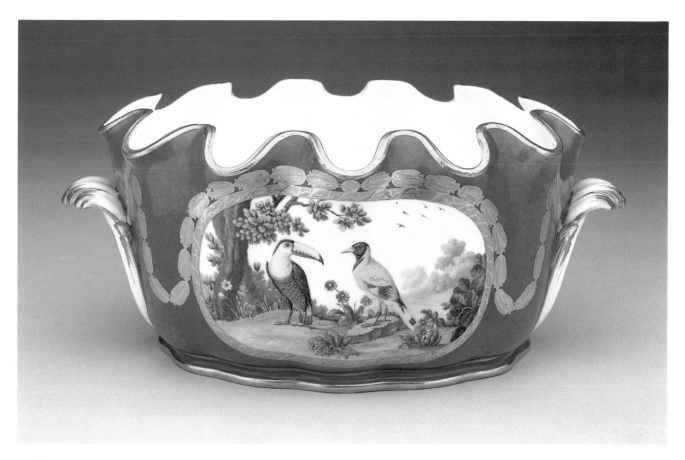

71.218

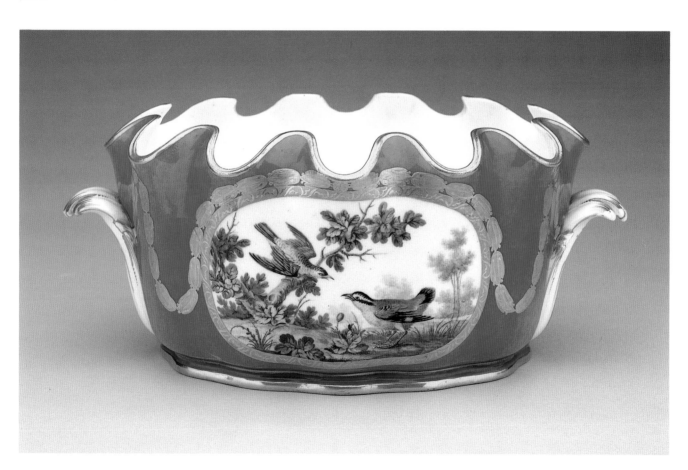

71.219

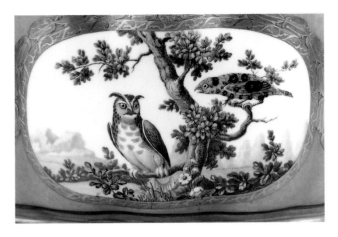

71.218

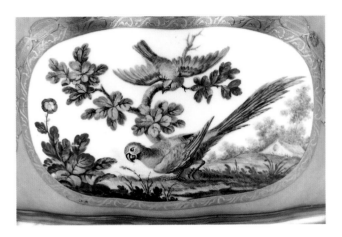

71.219

[60]

Painting by François-Joseph Aloncle (see p. 183) and
Antoine-Joseph Chappuis (see p. 185)

Two Trays (plateau losange), 1768

Soft-paste porcelain, 5.1 (2) × 30.5 (12) maximum width
Bequest of Anna Thomson Dodge (71.222, 71.223)

INSCRIPTIONS: 71.222: Underneath in blue: interlaced *L*'s
enclosing a *P* for 1768, the mark of Aloncle below. Incised
near the foot rim: *R*. Written underneath in black:
MANAQUIN ET LORIOT DES INDE. 71.223: Underneath in
blue: interlaced *L*'s enclosing a *P* for 1768, the mark of
Chappuis above. Incised near the foot rim (see below).
Written underneath in black: *GORGE JEAUNE DE MARI-
LAND / LA PONPADOUR* [sic].

CONDITION: A firecrack across one corner of 71.222 was filled
before the glaze firing. One of the palmettes on 71.223 has
been regilded.

PROVENANCE: Chéréméteff family, until c. 1906. Asher
Wertheimer (dealer), London. Duveen Brothers (dealer),
New York. Acquired by Anna Thomson Dodge from Duveen
Brothers, 1939.

REFERENCES: Edwards 1758–63, I: pl. 237 (yellow-throat), III:
pl. 341 (Pompadour); Cayeux 1993: fig. 1 (71.223), 31, no. 60
(71.223, as 1769), 32, no. 86 (71.222), 35, no. 211 (71.223, as
1767); London n.d.: nos. 12, 13.

precise, the painting brightly colored and highly finished,
and the birds themselves are vividly conversational.

The Great Horned Owl on 71.218 is varied only slightly
from Edwards (1743–51, II: pl. 60), but in such a manner as
to give greater animation; the accompanying bird bears no
relation to the parakeets illustrated by Edwards (1758–63, III:
pls. 235, 236) and appears to be an invention. The wall-creeper
(grimpereau de muraille) on 71.219, which occurs several times
in this collection, differs with each representation, and none
follows Edwards's depiction (1758–63, III: pl. 361). *The Great
Green Maccaw (le gros Arras vert)* of Edwards (1758–63, III:
pl. 313) is certainly the source of the bird on 71.219, but
Aloncle has devised a very free version.

An incised mark BP with very similar calligraphy to the
mark on 71.218 is recorded by Dauterman for the *répareur*
Nicholas Brachard, *père,* active from 1756 to 1772 (Dauterman
1986: 182). Savill (1988, III: 1092) records what may be the
same mark as possibly that of Baptiste Paris, a *répareur* active
1754–64, remarking that its appearance on pieces with later
dates indicates that they were decorated from plain pieces in
stock. What appears to be the same unidentified incised IP as
on 71.219 occurs on numerous vases and larger tablewares
dating between 1757 and 1778 (Savill 1988, III: 1110).

The lozenge-shaped stand is framed by a pierced bracket-
shaped gallery, the sides with curving fronds, each section
bending toward a central pierced foliate palmette. An oval
reserve framed in a tooled gold band encloses a scene of two
birds in a landscape and is surrounded by a laurel festoon.

Despite the inscription, the manakin depicted on 71.222
is not the same bird seen on the salad bowl (cat. 57, 71.224);
in appearance and pose it corresponds exactly to the *Black
and White Flycatcher (La Moucherolle Noire et Blanc)* of
Edwards's *Gleanings* (1758–63, III: pl. 348). Edwards identifies

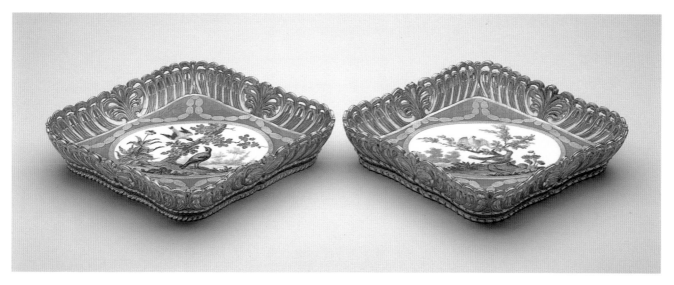

71.222–71.223

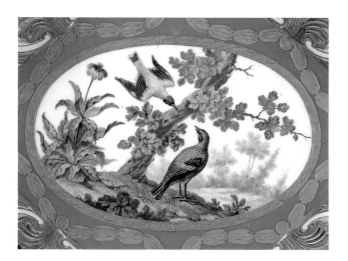

71.222

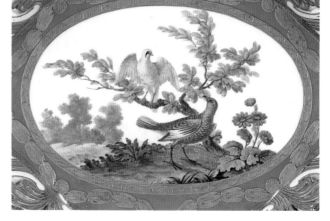

71.223

Le Gorge jaune de Maryland as the Maryland yellow-throat, but, while the bird is perfectly recognizable from his illustration, the pose seen here is quite different. For the Pompadour, see cat. 54 (71.233).

The tray is one of several models referred to by a variety of names, this one sometimes known as a *plateau losange corbeille à jour*. The same model, with the pattern of the gallery shifted so as to place the palmettes at the corners, becomes a *plateau carré à jour*. Depending on their size, these trays were designed to support a single cup and saucer or, as part of a *déjeuner*, several pieces from a tea service, but the *plateau losange* also appears in the manufactory's sales registers in 1768 and 1773 as a stand for a sauceboat (Peters 1985: 7, 9). David Peters has speculated that this same form may possibly be equated with one of the "Grand Corbeilles" added in 1755 to the service begun for Louis XV two years before, since an example—which does not fit the description of any other pieces listed in the service—survives among portions of that service now at Boughton House (Peters 1985: 13). It is quite likely that these two trays are the turquoise *plateaux losanges*

painted by Aloncle and Chappuis, mentioned in the manufactory archives in 1768 (Tamara Préaud, letter to the author, March 30, 1994). A set of four trays of this model, painted with birds by Étienne Evans in 1770, is in the Palazzo Quirinale, Rome (D'Agliano 1986: 68–69).

The unidentified incised mark on 71.223 occurs on a pair of flower vases at Waddesdon Manor and on a number of other pieces recorded by Eriksen (1968: 196).

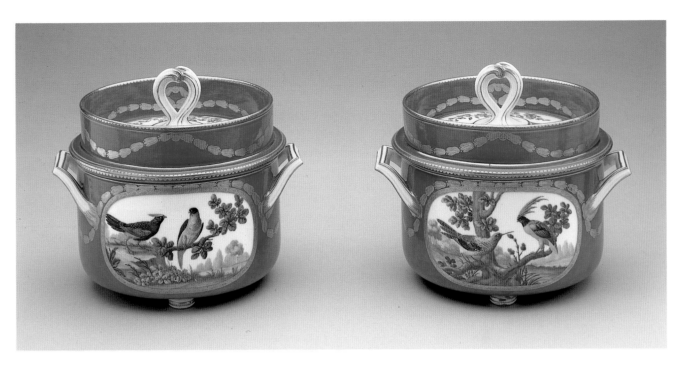

71.231–71.232

[61]
Two Ice-Cream Coolers (seau à glace), 1769

Soft-paste porcelain
71.231: 19.4 (7⅝) × 19.1 (7½) × 22.5 (8⅞)
71.232: 19.4 (7⅝) × 19.1 (7½) × 22.9 (9).
Bequest of Anna Thomson Dodge (71.231a,b; 71.232a,b)

INSCRIPTIONS: Each marked underneath in dark blue: inter-laced *L*'s enclosing a *Q* for 1769.

CONDITION: Good.

PROVENANCE: Chérémeteff family, until c. 1906. Asher Wertheimer (dealer), London. Duveen Brothers (dealer), New York. Acquired by Anna Thomson Dodge from Duveen Brothers, 1939.

REFERENCE: London n.d.: nos. 29, 30.

A large oval reserve on each side depicts two birds in a land-scape, while a kidney-shaped reserve on the cover encloses a flower spray. The decorative scheme is completed by tooled gold bands and laurel festoons. For the model, see cat. 55.

Although the decoration of these coolers conforms to that of the previous three entries, they may not have belonged originally to the same service. In addition to dating a year

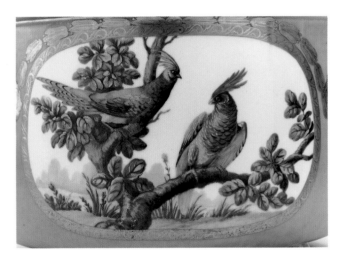

71.231

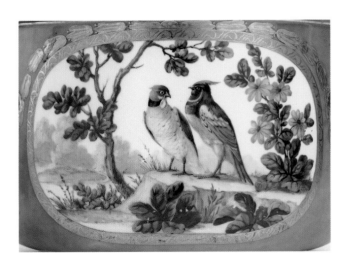

71.232

later, the birds, which are not identified, have a more gener-alized exoticism than do those of the named services. The

bird painter is the same artist on both coolers; Bernard Dragesco has suggested it is Armand, *l'aîné,* and observed that the manner in which the manufactory mark is painted is characteristic of that artist (letter to Alan Darr and Bonita LaMarche, December 14, 1992, DIA curatorial files).

[62]

Painting by François-Joseph Aloncle (see p. 183) and Antoine-Joseph Chappuis (see p. 185)

Two Monteiths (seau à crennelé), 1770 and c. 1770

Soft-paste porcelain
71.238: 12.5 (4¹⁵⁄₁₆) × 29.3 (11⁹⁄₁₆) × 20.3 (8)
71.239: 12.4 (4⅞) × 28.9 (11⅜) × 19.7 (7¾)
Bequest of Anna Thomson Dodge (71.238, 71.239)

INSCRIPTIONS: 71.238: Incised near the foot rim: *NC.* Written underneath in black: *LE ROI BLEU DE L'AMERIQUE / L[E] FAISAN NOIR ET BLANC DE LA CHINE, LE TOUCAN DE LA RIVIERRE DES AMAZONE / MARTIN PECHEUR DE CAYENNE.* 71.239: Underneath in blue: interlaced *L'*s enclosing an *R* for 1770, the mark of Aloncle below. Written in black: *LA POULE SULTANE ET LA MOUCHEROLE D'AMÉRIQUE, VAUTOUR D'ARABIE ET CANARD D'AMERIQUE.*

CONDITION: Excellent.

PROVENANCE: Chéréméteff family, until c. 1906. Asher Wertheimer (dealer), London. Duveen Brothers (dealer), New York. Acquired by Anna Thomson Dodge from Duveen Brothers, 1939.

REFERENCES: Edwards 1743–51, II: pls. 66 (pheasant), 87 (water hen); Edwards 1758–63, II, pl. 290 (vulture); Cayeux 1993: 32, no. 106 (71.238, as Chappuis), 35, no. 214, 36, no. 233 (71.238, as Aloncle), 33, no. 129 (71.239, as Chappuis), 35, no. 212 (71.239), 36, no. 237 (71.239, as Chappuis); London n.d.: nos. 170, 171.

For the model, see cat. 56.

On each side, two birds in a landscape are enclosed in an oval reserve, above which is a continuous oakleaf and acorn garland.

Neither the bird paintings nor the inscriptions are by the same hand; 71.238 can be assigned to Chappuis not only on stylistic grounds but through the calligraphy, which is consistent with pieces bearing his mark.

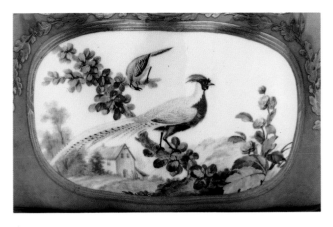

71.238

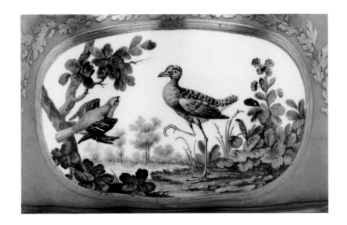

71.239

Edwards identifies the vulture depicted on 71.238 as *The Crested or Coped Black Vulture (Le Vautour Noir Couronné).* The *Purple Water-hen (La poule Sultane)* on 71.239 appears in reverse; the pheasant is varied only slightly from the image seen on the ice-cream cooler 71.220 (cat. 55).

The incised mark is not recorded.

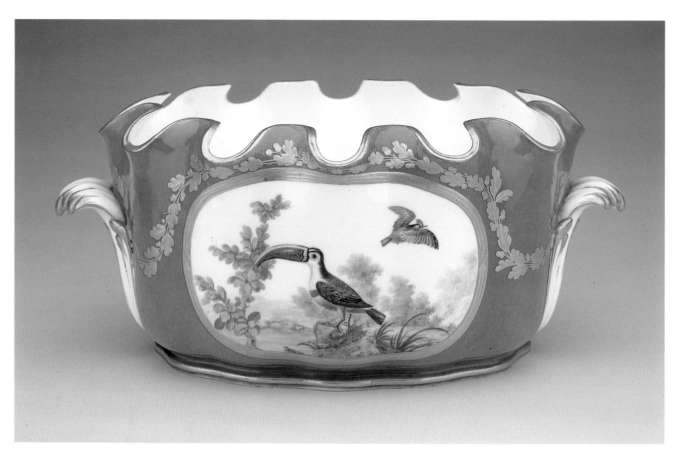

71.238

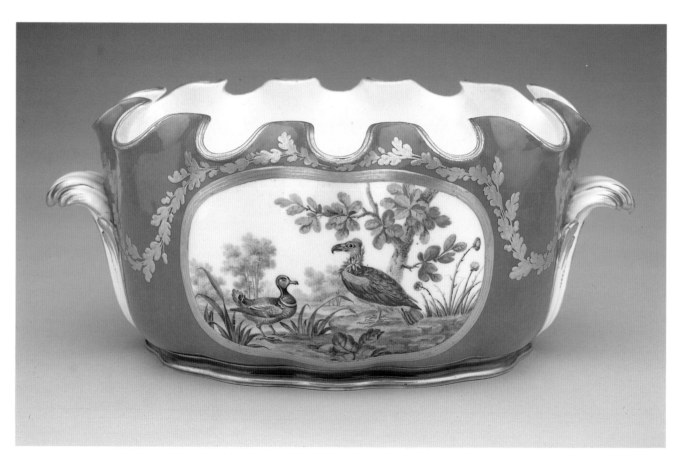

71.239

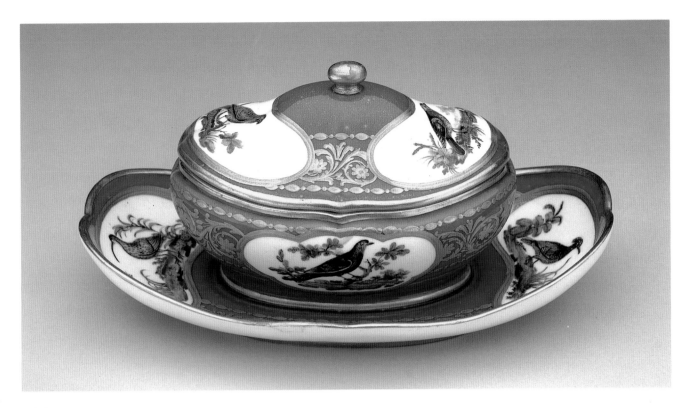

71.252

PHILIPPE BOUCOT
Active 1785–91

That Boucot was not exclusively a bird painter during his short career is evident from a shell-shaped dish of 1790 painted with bunches of lilies, in the Royal Collection, Great Britain.

ANDRÉ- (or AUGUSTE-) JOSEPH FOINET, called LA FRANCE
1758 Château de Meudon–? 1839, active 1773–1803, 1813/15–25

Foinet was first a gilder at Sèvres, but for several years, beginning about 1777, he also worked as a painter of flowers and decorative patterns. Manufactory records imply that his work was not always satisfactory, and he was dismissed in 1800, although he returned the same year.

ÉTIENNE-GABRIEL GIRARD
Active c. 1785–95

Only recently identified, Girard's mark occurs on porcelains dating c. 1785–95.

[63]
Painting by Philippe Boucot
Gilding by André- (or Auguste-) Joseph Foinet, called La France, and Étienne-Gabriel-Girard

*Sugar Bowl and Stand
(sucrier de Monsieur le Premier et plateau),* 1787

Soft-paste porcelain
Bowl: 11.2 (4⁷⁄₁₆) overall
Stand: 23.5 (9¼) × 14.6 (5¾)
Bequest of Anna Thomson Dodge (71.252a,b)

INSCRIPTIONS: Underneath the stand: interlaced *L*'s enclosing a *KK* for 1787, the mark of Boucot below, in blue. In gold: marks of Girard and La France. Incised: *34.* Written in blue: COURLY DE / MADAGASCAR, MOINEAU DE CAYENNE, HARLE HUPE MALE / DE CAYENNE, LE PÈRE NOIRE DE LA MARTINIQUE. Underneath the cover, written in blue: PETITE PERUCHE A / GORGE JAUNE DE / CAYENNE, LE GRAND-TRAQUER / DES PHILIPPINES.

CONDITION: The rim of the stand has been broken in one place and repaired.

PROVENANCE: Chéréméteff family, until c. 1906. Asher Wertheimer (dealer), London. Duveen Brothers (dealer), New York. Acquired by Anna Thomson Dodge from Duveen Brothers, 1939.

REFERENCE: London n.d.: no. 413.

The oval bowl, with lightly bowed rim, is attached to its boat-shaped stand and is fitted with a low-domed cover topped by a knop finial. Shaped oval reserves on opposite sides of the bowl and at the ends of the cover and stand are each painted with a single bird in a landscape. The reserves are connected by a large gilded foliate palmette between bead-and-reel borders.

Models and molds for the shape were made in 1758 (SL 1759 for 1758), and several examples are listed in the biscuit and glaze kilns beginning in August of that year (Paris, Bibliothèque de l'Institut de France, Mss. IF 5673, IF 5674). The designation occurs on a gouache drawing in the Cooper-Hewitt Museum, New York, inscribed "sucrier tenant au plateau dit Mr le Premier" (Brunet and Préaud 1978: no. 191).

None of the birds depicted appears in the earlier inscribed series; they are presumably copied from Buffon's *Histoire naturelle*. The painter's records for Boucot show that he was paid for painting birds after Buffon engravings on turquoise-ground porcelains in 1787; these included two sugar bowls in May and a third in September, for which he was paid 15 livres each. It is possible that this bowl is one of the two, but neither can be identified in the kiln records (Tamara Préaud, information provided to Alan P. Darr, 1992, DIA curatorial files).

It is unusual to encounter the marks of two gilders on a single piece, and the relatively uncomplicated, though bold, pattern of gilding seen here would hardly seem to require two artists. The inference is that one executed the borders of the reserves and the other the more decorative pattern.

FRENCH AND ENGLISH PAINTING

J. Patrice Marandel and Hilarie Faberman

JEAN-HONORÉ FRAGONARD
1732 Grasse – Paris 1806

Jean-Honoré Fragonard was born in 1732 in Grasse in southern France. The events surrounding his family's transfer to Paris — probably in 1738 — as well as the actual facts concerning his apprenticeship and beginnings are poorly documented. Oral family traditions, such as the artist's brief training under Chardin, have often been repeated but cannot be confirmed. In 1752, however, Fragonard is described in a register of the Académie Royale as a "pupil of Boucher." The same year, in spite of his lack of formal academic training, Fragonard won the Académie's Grand Prix for Jeroboam Sacrificing to the Idols *(École Nationale des Beaux-Arts, Paris). After this initial success, Fragonard was allowed in 1753 to enter the École Royale des Élèves Protégés, an institution established in 1749 to complete the education of young artists prior to their departure for Rome. At the time, the school was under the direction of Carle Van Loo, whose influence on Fragonard then replaced that of his former teacher Boucher (see, for example,* Psyche Showing Her Sisters the Gifts She Has Received from Cupid, *National Gallery, London).*

Fragonard left Paris for Italy in 1756. Following the usual curriculum of the pensionnaires *at the Académie Française there, he executed copies after Old Masters. In 1759 the artist was granted an extension of his stay. In 1760 and 1761, still in Italy, he befriended the Abbé de Saint-Non, in whose company he visited Naples and returned to France by way of Florence, Bologna, Venice, Parma, and Genoa, thus completing his knowledge of the different schools of the Italian peninsula. Numerous drawings of this period, both copies and original compositions, attest to the artist's enthusiastic response to the examples of the Old Masters on the one hand and to the picturesque qualities of the Italian* campagna *on the other.*

Although he was back in Paris in September 1761, Fragonard did not appear in the public eye until 1765, when he was agréé *at the Académie with his large* Coresus and Callirhoë *(Musée du Louvre, Paris), shown with immense success at the Salon of 1765. (Fragonard, however, never submitted a "reception piece" that would have conferred on him the title of* académicien.*) A period of intense activity followed. His* Figures de fantaisie *(Musée du Louvre; The Metropolitan Museum of Art, New York; and other locations) were executed apparently between 1765 and 1773. There was no shortage of commissions. Between 1771 and 1773, Fragonard completed his most famous decorative cycle,* The Progress of Love *(The Frick Collection, New York), commissioned — and rejected — by Madame du Barry for her new pavilion at Louveciennes. This rejection may in part have been the reason for Fragonard's decision to return to Italy. He set off in October 1773 in the company of the* fermier-général *Pierre-Jacques-Onésyme Bergeret de Grancourt. Although the two men eventually argued, the journey was once again one of extreme importance for Fragonard, whose interest was, this time, particularly focused on the Italian landscape. Yet genre scenes, depictions of local types and costumes, and again copies after Old Masters were also part of Fragonard's output during these years. However, the technique of these drawings — with their astonishingly free application of brown wash — sets them apart from his earlier productions. The journey was extensive and allowed Fragonard to visit for a second time most of the major Italian centers. On his return to Paris, he also passed through Vienna, Prague, Dresden, Leipzig, Frankfurt, and other cities but did not leave visual records of them.*

Upon his return to Paris, Fragonard found a different city. Louis XV had died. The Superintendent of the King's Buildings, the marquis de Marigny, Madame de Pompadour's brother and Fragonard's former sponsor, had been replaced by the comte d'Angiviller, a man whose ideas were radically different from those of his predecessor. Official and private taste had changed, but Fragonard never embraced the stern canon of early Neoclassicism. Nevertheless, his paintings changed drastically in both style and subject matter. The allegorical and mythological worlds of his youth gave way to sensual images loaded with emotion and desire. Fragonard's private life had also changed. His sister-in-law, the artist Marguerite Gérard, took on an accrued importance in the professional — and probably also the emotional — life of Fragonard.

The French Revolution was to bring to a close the career of the artist. Most of his patrons had emigrated. The artist's reduced circumstances forced him to seek from the painter Jacques-Louis David a position at the newly created Musée du Louvre in Paris. His death in 1806 was hardly noticed.

[64]
Jean-Honoré Fragonard

The Shepherdess, c. 1754–55
Oil on canvas, 147.3 (58) × 93.9 (37)

The Grape Gatherer, c. 1754–55
Oil on canvas, 147.3 (58) × 93.9 (37)

The Reaper, c. 1754–55
Oil on canvas, 147.3 (58) × 85 (33⁷/₁₆)

The Gardener, c. 1754–55
Oil on canvas, 147.3 (58) × 93.9 (37)

Founders Society Purchase, Mr. and Mrs. Horace E. Dodge Memorial Fund (71.390–71.393)

CONDITION: All four paintings were treated in 1971. Prior to treatment, they had a layer of dirt embedded into the paint layer. This layer gave the surfaces a dull, gray appearance. The dirt was removed, and inpainting was carried out. The paintings have a synthetic varnish surface coating. No structural work was required on any of them. All the paintings have a cutout area on the top and bottom. Decorative molding

would have covered these areas. During a previous lining these were fitted with a canvas insert and repainted. *The Shepherdess,* 71.390: Overpaint and excess fill were removed from a large repainted loss in the foreground. This area was then reconstructed as based on the existing paint. Prior to treatment, the sky and structure of the right side of the painting were disfigured by ingrained dirt. *The Grape Gatherer,* 71.391: Prior to treatment, this painting had the most disfigured surface as a result of the ingrained dirt that was obscuring the color and brushstrokes. The paint is applied more thinly than on the other paintings of this cycle. *The Reaper,* 71.392: Before removal of the ingrained dirt, the wheat along the left side was excessively disfigured. *The Gardener,* 71.393: This painting proved to be in the best condition of the four. Less ingrained dirt was present on the surface.

PROVENANCE: Possibly Hôtel de Mortemart-Rochechouart, Paris, in the eighteenth century. Private collection, northern France (?). Baron Roger Portalis, Paris. Eugen Kraemer, Paris. His sale, Paris, May 5–6, 1913, lots 32–35 (with two other canvases of the same series). Wildenstein (dealer), New York. Judge Elbert H. Gary, New York. Duveen Brothers, New York. Acquired by Anna Thomson Dodge from Duveen Brothers, 1935. Her sale, Christie's, London, June 25, 1971, lots 6–9.

EXHIBITIONS: Paris 1907a: nos. 113–16; New York 1914a: nos. 22–25; New York 1977a: nos. 36 *(The Gardener),* 37 *(The Shepherdess);* Grosse Pointe 1981: unnumbered, ill. p. 22, figs. 006 *(The Grape Gatherer)* and 007 *(The Gardener);* Paris 1987b: nos. 1–4; Tokyo 1989: nos. 42 *(The Shepherdess),* 43 *(The Reaper);* Tokyo 1990: nos. 31 *(The Gardener),* 32 *(The Grape Gatherer).*

REFERENCES: Dayot and Vaillat 1907: 134–37, ill; Apollinaire 1914: 14–21; Réau 1956: 172; Wildenstein 1960: nos. 36–39; *Gazette des Beaux-Arts* 1972: 94–95, figs. 334–37; Cuzin 1988, nos. 11, 12; Rosenberg 1989: nos. 30, 31; Sheriff 1990: 95–116.

There is little information concerning the origin of these paintings, which appeared on the French art market in the early years of this century. They have always been considered to be important paintings done at a time Fragonard may still have been apprenticed in Boucher's studio. (The only dissident opinion was that of the French poet Guillaume Apollinaire who, in an incidental piece of art criticism, denounced them as blatant fakes done for the American market [Apollinaire 1914: 14–21]. The poet's opinion—perhaps triggered by an animosity toward some people involved in the sale of these works—has never been taken seriously.)

Their origin in the Hôtel de Mortemart-Rochechouart is nebulous and was first advanced by one of the early owners of these paintings, Baron Portalis, himself the author of a book on the artist. It is quite clear, however, that the paintings belonged to a single decorative ensemble and that they formed two pairs in the room they originally adorned.

Rosenberg (Paris 1987b: nos. 1–4) has noted the vague iconography of these paintings, pastoral subjects that allude to the seasons or the joys of nature. Sheriff (1990: 95–116), in contrast, has forcefully attempted to "decode" the paintings. Her theory is based on the belief that the four works constitute a complete ensemble representing the four seasons. (This may, however, be contradicted by the fact that the painting *The Joys of Motherhood* [Indianapolis Museum of Art], of the same period and dimensions and with close iconography, could easily be construed as having belonged to the series.) Furthermore, Sheriff proposes a reading of the paintings within a wider framework she calls the "Erotics of Decoration" and sees hidden sexual symbolism in many details of the four works. Provocative as it may be, the proposition seems oddly farfetched and hardly applicable to Fragonard, who was able to express passion and sexual desire as explicitly as the conventions of the day allowed.

The dependence of these paintings on models by Boucher has often been noted. In particular, *The Shepherdess* (for which there is a study in the Robert Hull Fleming Museum, University of Vermont, Burlington; Tokyo 1990: no. 33) seems to have been based quite literally on an engraving by Fragonard's master (Rosenberg 1989: 74). Yet it would be difficult to mistake these paintings for works by Boucher. Fragonard may well have been inspired by Boucher's pastoral themes, but there is something more naturalistic in his rendition of the figures and of the landscape. Above all, the virtuoso brushwork and personal color scheme set these pictures apart from Boucher's world.

These paintings have been variously dated. Usually they were thought to have been executed prior to or around 1752, but more recent critics (Cuzin 1988: nos. 11, 12; Rosenberg 1989: 74) seem to favor a later date, around 1754–55, based on the already mature style and sureness of handling.

A four-panel painted screen, possibly nineteenth century, featuring these four figures was in the collection of Elizabeth Parke Firestone, Newport, Rhode Island (New York 1991: lot 763).

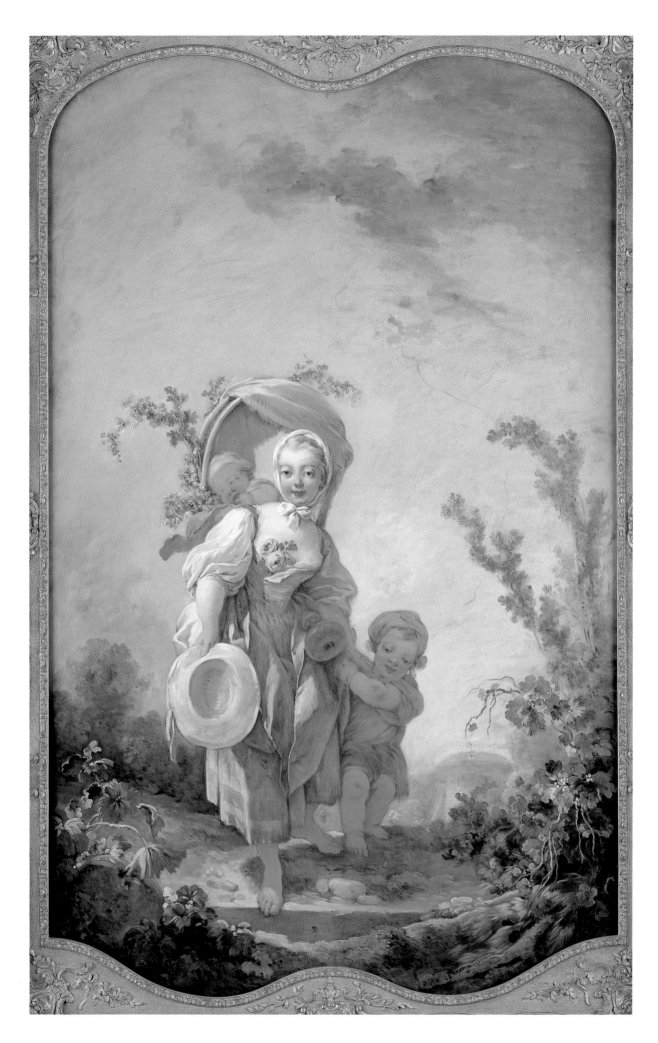

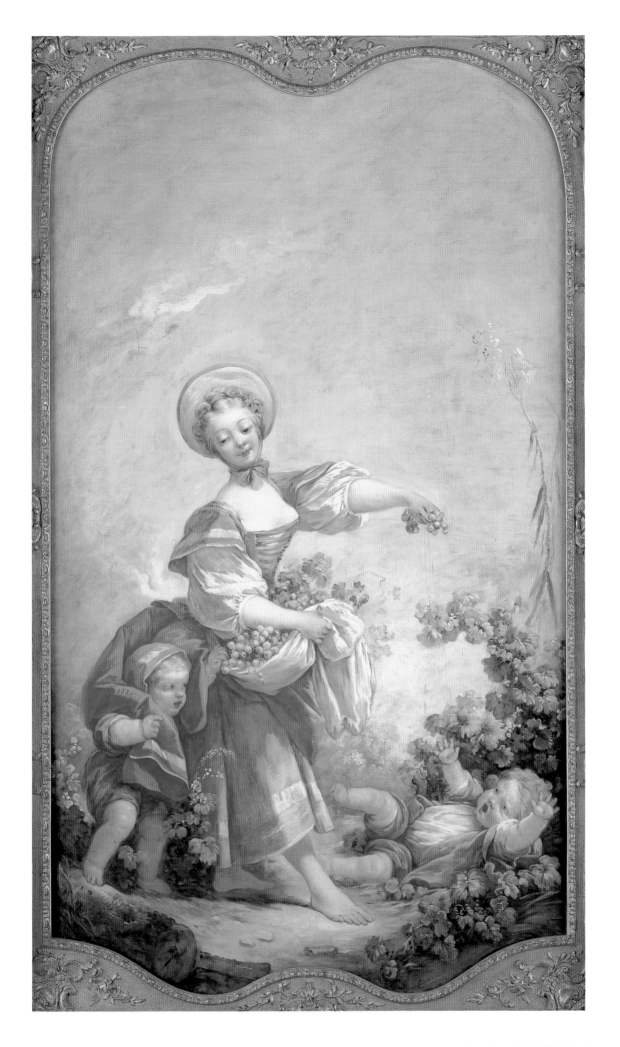

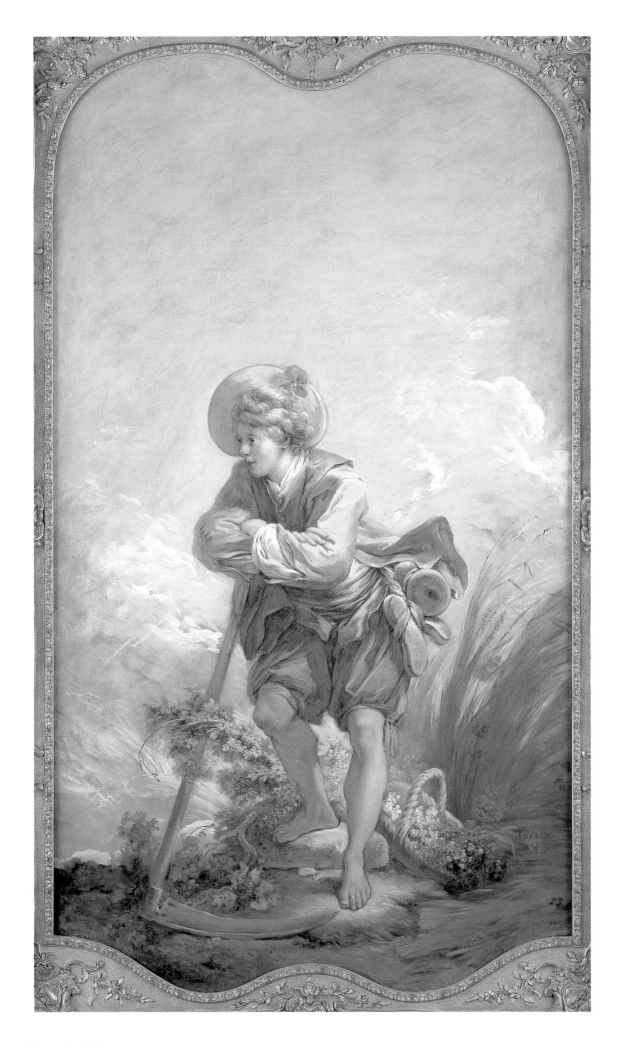

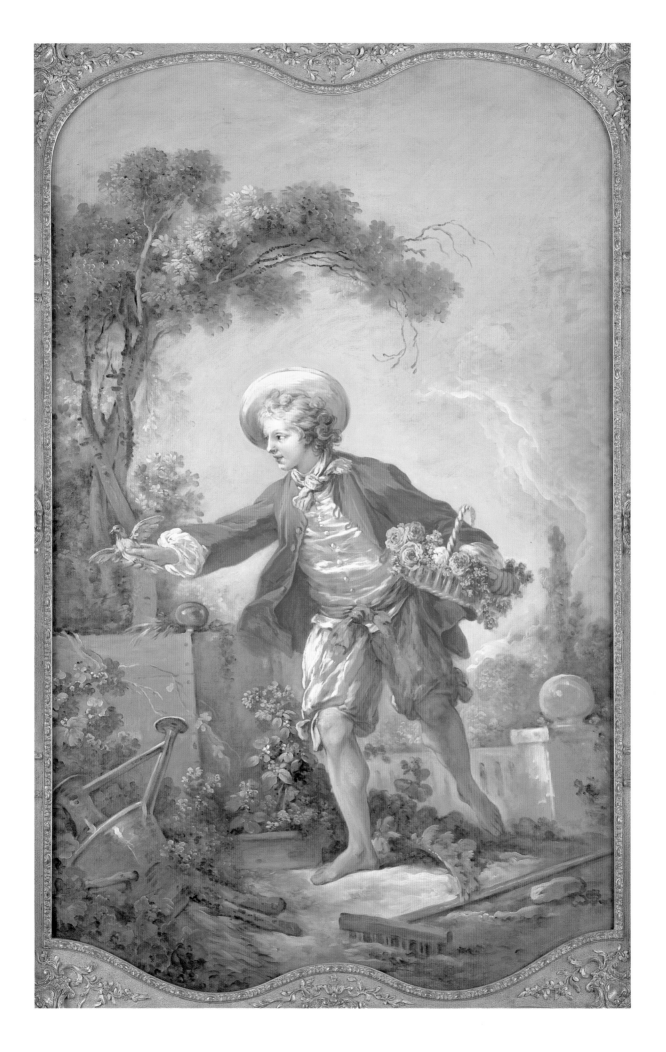

THOMAS GAINSBOROUGH
1727 Sudbury, Suffolk–London 1788

Thomas Gainsborough was the fifth son and youngest child of Mary Burroughs and John Gainsborough, a successful cloth merchant and manufacturer. As a youth of thirteen, the talented Gainsborough was sent to London, where he studied with Hubert-François Bourguignon, known as Gravelot, who had been a pupil of François Boucher. In addition to his immersion in the French Rococo style in London (then an international art capital), Gainsborough met important English artists of the St. Martin's Lane Academy, such as Francis Hayman, who specialized in small-scale group portraits known as conversation pieces. By the mid-1740s, Gainsborough had set up his own studio in London, where he helped support himself by copying seventeenth-century Dutch landscape paintings, then popular with English collectors. Gainsborough's early or first style, which he developed in the late 1740s, was the confluence of Dutch naturalism with the charm of the French Rococo, as shown in his marvelous portrait of Mr. and Mrs. Andrews, 1748 (National Gallery, London).

Married in 1746 to Margaret Burr, Gainsborough returned in 1748 to Sudbury, where his daughter Mary was born. Following the birth of his second daughter, Margaret, in 1752, the family settled in Ipswich, a port city near Sudbury, where they remained until 1759, when they moved west to Bath, the prosperous and fashionable resort. With access in Bath to a wealthy clientele and the opportunity to view nearby collections of Old Master paintings, Gainsborough's career and reputation flourished. Paintings such as his first large-scale portrait painted in Bath, Ann Ford, Later Mrs. Philip Thicknesse, *1760 (Cincinnati Art Museum), featured a new informality in pose and a fluidity of handling that characterized his mature style. Gainsborough's assimilation and transformation of the Old Masters was evident in Bath-period paintings such as* The Road from Market, *1767–68 (Toledo Museum of Art), with its recollection of landscapes by Peter Paul Rubens, and in his portrait,* The Blue Boy, *1770 (Huntington Library and Art Gallery, San Marino), his triumph in the manner of Sir Anthony Van Dyck. From 1761 to 1768, Gainsborough contributed to the Society of Artists exhibitions in London, and he was elected one of the forty original founding members of the Royal Academy in 1768, where he was a regular contributor until 1773, and then from 1777 to 1784.*

In 1774 Gainsborough returned permanently to London, where he leased the west wing of Schomberg House, Pall Mall. His career thrived, and he became the favored Court painter of King George III, Queen Charlotte, and the royal family. Later in his life, Gainsborough continued his innovative work. He developed a novel category of paintings, his "fancy pictures"—full-length, sentimentalized portrayals of rustic beggars and children in landscapes. He also invented a "peep-show box"—a kind of early slide viewer with candles and a magnifying lens into which he placed his small landscapes painted on glass. In his last paintings from the 1780s, such as the portrait of newlyweds Mr. and Mrs. Hallett, known as The Morning Walk, *1785 (National Gallery, London), Gainsborough created an atmosphere that was as palpable and yet as evanescent as its subject, the painting possessing a poetry of air and light, color and brushwork that was as refined and as lyrical as the sitters' youth, beauty, and love. Unlike Sir Joshua Reynolds, whose friends included the great literary men of his time, Gainsborough's closest companions were musicians and artists, of whom he painted numerous sympathetic portraits.*

Gainsborough died on August 2, 1788, and was buried in Kew Churchyard. His lifelong rival, Sir Joshua Reynolds, the first president of the Royal Academy, dedicated his fourteenth Discourse in 1788 to his deceased opponent, a posthumous tribute from one famous painter to another that (despite their differences) recognized Gainsborough as one of England's most original artistic geniuses.

[65]

Thomas Gainsborough

Anne, Countess of Donegall (Lady Anne Hamilton), c. 1777–80

Oil on canvas, 235 (92½) × 154 (60⅝)
Bequest of Mrs. Horace E. Dodge in memory of her husband (71.170)

CONDITION: The painting was last treated in 1980 when overpaint around the sitter's mouth was removed. The original canvas is strip-lined, and the painting is restretched onto a Lebron expansion-bolt stretcher. The paint layer is in good condition. Inpainting was done to minimize the wide crackle pattern in the leaves and dark brown sections of the lower half of the painting. Areas of pentimenti are located in the band of pearls on Anne's right arm; on the extension of the left border of the ermine mantle; changes in the red drapery; changes in the left breast. The synthetic varnish is slightly uneven and has a matte appearance.

PROVENANCE: Arthur Chichester, first Marquess of Donegall (d. January 5, 1799), Fisherwick, near Lichfield, Staffordshire. To his third son, Spencer Stanley Chichester (d. February 22, 1819), Dunbrody Park, Arthurstown, Co. Wexford. To his son, Arthur Chichester, first Baron Templemore (d. September 26, 1837), Dunbrody Park, Arthurstown, Co. Wexford. To his son, Henry Spencer Chichester, second Baron Templemore (d. June 10, 1906), Dunbrody Park, Arthurstown, Co. Wexford. To his son, Arthur Henry Chichester, third Baron Templemore (d. September 28, 1924), Dunbrody Park, Arthurstown, Co. Wexford. To his son, Arthur Claude Spencer Chichester, fourth Baron Templemore. Sold through Arthur Ruck (?), c. 1925, to Duveen Brothers (dealer), New York. Acquired by Anna Thomson Dodge from Duveen Brothers, 1935.

EXHIBITIONS: London 1859: no. 159 or 170; London 1877: no. 118; Detroit 1926: no. 4, ill.

REFERENCES: Shaw 1798–1801, I: 369; *Athenaeum* 1877: 25; *Athenaeum* 1877a: 87; Armstrong 1898: 197; Menpes and Greig 1909: 84–85; Graves 1913–15, I: 375, 383; Detroit 1939, I: xv, n.p., ill.; Waterhouse 1953: 29–30, 53; Waterhouse 1958: 72, no. 337, pl. 199; Winokur 1971: 46; *Gazette des Beaux-Arts* 1972: 98, fig. 347; Detroit 1979: 83, no. 53, ill.

In the eighteenth century, this stunning portrait and the equally handsome male portrait in the Dodge Collection (cat. 66) comprised two of the five full-lengths (two female and three male, of nearly identical size) by Gainsborough in the collection of the first Marquess of Donegall at Fisherwick near Lichfield, Staffordshire. From the time of the first publication of the portraits and for nearly two hundred years, the identification of the five paintings has remained confused and problematic. However, present research and recent evidence make it possible to state with reasonable certainty that the Dodge female portrait represents Anne, Countess of Donegall (Lady Anne Hamilton) (1738–1780), and that it can be dated c. 1777–80. The male portrait of a gentleman in red also dates from approximately the same time, but the sitter remains a mystery.

The first publication of the Dodge portraits appeared in 1798, in *The History and Antiquities of Staffordshire,* by the Reverend Stebbing Shaw. Shaw wrote about Fisherwick, the estate of Arthur Chichester, first Marquess of Donegall, Earl of Belfast, and Baron Fisherwick (1739–1799), and husband of the Countess of Donegall, and identified four portraits at the seat, without providing the artist's name (or names) or the sizes of the canvases: "the marquis of Donegal *[sic]* in a shooting dress and the present lady Donegal *[sic],* . . . Anne, duchess of Hamilton and Brandon, grandmother of the first lady Donegal *[sic];* also of the duke of Hamilton, father of lord Archibald Hamilton." Scholars fruitlessly have tried to match the five Gainsborough pictures in the ensemble to these four sitters, but Shaw probably alluded to portraits other than the Gainsboroughs, since there were also portrayals of a number of these same subjects at Fisherwick by George Romney and Francis Cotes, in addition to family portraits by other artists, including Francis Wheatley. In the early nineteenth century, Fisherwick was closed and the five pictures by Gainsborough were cut from their frames, rolled, stored, and their identities forgotten (Waterhouse 1953: 29; Waterhouse, letter, May 24, 1972, DIA curatorial files). Five pictures by Gainsborough reemerged nameless at the British Institution exhibition of Old Masters in 1859 (London 1859: nos. 159 and 170 were titled simply *Portrait of a Lady,* and nos. 131, 158, and 161 were titled *Portrait of a Gentleman.* The five portraits were lent to the British Institution exhibition by Baron Templemore, great-grandson of the first Marquess of Donegall.

In 1877, at the Royal Academy Winter Exhibition (London 1877), the paintings were again exhibited and appeared with new identifications:

no. 23: *Portrait of Arthur, 1st Marquess of Donegall.* Standing cross-legged under a tree, leaning left elbow on a stile, gun in right hand, green coat and waistcoat, breeches, short gaiters, two dogs at feet. Life size [private collection; London 1936: 35, ill.; Waterhouse 1958: 63, no. 199].
no. 94: *Portrait of James, 5th Duke of Hamilton.* Standing; red coat, waistcoat and breeches; stick in left hand; dog lapping water; wooded and rocky background. Life size [Waterhouse 1958: 72, no. 336, pl. 198; see cat. 66].
no. 104: *Portrait of Lord Archibald Hamilton.* Standing cross-legged, leaning on a stick, in landscape; green coat, yellow waistcoat, black breeches, three-corned hat in right hand. Life Size [Ulster Museum, Belfast; London 1936: 39, ill.; Waterhouse 1958: 63, no. 200].
no. 118: *Portrait of Anne, Duchess of Hamilton.* Seated, in a landscape, light cinnamon-coloured dress, red cloak trimmed with fur; right arm leaning on a pedestal, on which stands an urn; high head-dress. Life size [the present picture; Waterhouse 1958: 72, no. 337].
no. 123: *Portrait of Anne, Marchioness of Donegall.* Standing, in a garden, plucking rose with right hand; blue dress, white shawl over left arm, black ribbon round neck. Life size [private collection; London 1936: 31, ill.; Waterhouse 1958: 63, no. 201].

In 1898 Walter Armstrong reiterated the identifications of 1877. Then, in 1906, the Templemore family consulted a committee of experts (including Sir Charles Holroyd, Claude Phillips, Sir Lionel Cust, and others), who examined the family miniatures, and who reidentified the portraits as follows: no. 23 as *George, Earl of Belfast* (although a minority still thought it was the Marquess of Donegall); no. 104 as *First Marquess of Donegall;* and no. 123 as the *Duchess of Hamilton.* It is not clear what names the committee assigned at that time to nos. 94 and 118, the two Dodge portraits (Waterhouse 1953: 30), although Waterhouse later opined (letter, May 24, 1972, DIA curatorial files) that the male portrait in the Dodge Collection had been identified in 1906 by the Templemore committee as Richard Savage Nassau. At any rate, three years later, in 1909, Mortimer Menpes and James Greig (1909: 84–85)—probably in consultation with the Templemore committee—repeated the opinions of 1906 and published the remaining female portrait as *Anne, Marchioness of Donegall,* and the male portrait as the *Hon. Richard Savage Nassau* (see cat. 66).

Around 1925, shortly after the death of his father, the fourth Baron Templemore sold the two portraits in the Dodge Collection—possibly through Arthur Ruck (Waterhouse, letter, May 24, 1972, DIA curatorial files)—to Joseph Duveen, who lent them to the second loan exhibition of Old Masters at The Detroit Institute of Arts in 1926 (Detroit 1926: no. 4). Duveen Brothers sold the portraits on August 27, 1935, to Mrs. Dodge, and the paintings formed part of the

ensemble in Mrs. Dodge's Music Room at Rose Terrace. In the Duveen catalogue of 1939 (Detroit 1939, I: xv, n.p.), the female portrait was identified as *Anne, Duchess of Hamilton, Countess of Donegall*, and the male portrait as the *Hon. Richard Savage Nassau de Zuylenstein. M.P.* [sic].

Another phase of investigation was opened by Ellis Waterhouse in the 1950s. In 1953 he hesitantly called the Dodge male portrait *James, Sixth Duke of Hamilton*, while he named the woman *Anne, Duchess of Hamilton* (Waterhouse 1953: 29–30, 53). The possibility is unlikely, however, since the duchess died in 1771, and the painting, on the basis of Gainsborough's style and the sitter's costume and hairstyle, dates from the later 1770s. In 1958 Waterhouse changed his opinion (Waterhouse 1958: 72, no. 337), identifying the Dodge portraits as pendants, possibly as marriage pictures of 1778 of the eighth Duke and Duchess of Hamilton (although he correctly added that if these identifications were accurate, then the provenance through the Templemore family was unusual). Finally, in correspondence (May 24, 1972, DIA curatorial files), Waterhouse offered his last solution to the problem, stating that the female sitter was Anne, Marchioness of Donegall. However, Waterhouse added the caveat that the picture bore no resemblance to another full-length in the Templemore collection, reputedly a portrait of Lady Anne Hamilton by Francis Cotes, a picture that Waterhouse dated to c. 1769, but in which, he said, the sitter's head had been repainted by Gainsborough in the 1780s (Johnson 1976: 82, no. 203; London 1983: lot 83, ill.). In fact, it is this Cotes portrait with the head repainted by Gainsborough—the picture an autograph replica of the Cotes portrait of Lady Anne Hamilton, signed and dated 1766, in the National Gallery of Ireland, Dublin—that provides the key to establishing the identity of the Dodge sitter (Johnson 1976: 81, no. 197; Graves and Cronin 1899–1901, I: 422, IV: 1329).

Lady Anne Hamilton was born in November 1738, the daughter of James, fifth Duke of Hamilton and second Duke of Brandon (1702/03–1742/43), and his third wife, Anne Spencer (d. 1771), daughter and co-heir (with her sister Elizabeth) of Edward Spencer of Rendlesham, Suffolk. According to John Hayes (letter, January 14, 1986, DIA curatorial files), the portrait of Lady Anne Hamilton by Cotes in Dublin bears favorable comparison with the other Gainsborough female full-length, dated c. 1764, which was originally in the Templemore collection (Waterhouse 1958: 63, no. 201; London 1972a: lot 100, ill., identified as Anne Spencer). Cotes's replica of the Dublin work with the head repainted by Gainsborough and dated c. 1778–80 on the basis of the coiffure and Gainsborough's style (Johnson 1976: 82, no. 203), bears remarkable similarity to the Dodge picture, which dates from about that time. Furthermore, the sitter's age is around forty in both the Cotes/Gainsborough painting and the Dodge portrait, in keeping with Lady Anne's actual age in 1778–80. As John Hayes has pointed out,

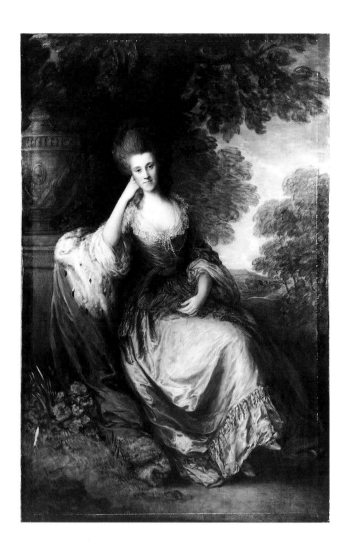

although the Cotes portrait in Dublin and the Cotes portrait with the Gainsborough head have different provenances, they have traditionally been identified as the Marchioness of Donegall or Lady Donegall. Hayes believes that these facts should be taken into account, as it is unlikely that portraits of the same individual bearing identical identifications from different sources would have the same title if it were not true (letter, January 14, 1986, DIA curatorial files).

The reason that Waterhouse may have refuted a link between the Templemore Cotes with the Gainsborough head and the Dodge portrait may be explained by the fact that in 1972, at the time of Waterhouse's comparison between the two works, the Dodge portrait had been heavily overpainted and did not appear as it does today. In July 1980, during the removal of this overpainting, the area around the countess's mouth was restored to its original appearance, giving her thinner lips and accentuating the bulge below the lower lip, imbuing her with an older appearance. A comparison between the portrait today and photographs taken before these 1980 treatments clearly illustrates the considerable differences in the sitter's physiognomy before and after conservation (fig. 10).

It would be profitable to interject a note concerning the sitter's proper title. Anne, Countess of Donegall (Lady Anne Hamilton), was never called the "Countess of Hamilton," nor did she possess the title "Marchioness of Donegall." Lady Anne Hamilton married Arthur Chichester, the fifth Earl of Donegall (born June 13, 1739), on November 16, 1761, and she died on November 11, 1780, some ten years before he received the title of Baron Fisherwick (July 3, 1790) and eleven years before he was created the Earl of Belfast and Marquess of Donegall (July 4, 1791). Thus there was no Marchioness of Donegall until the earl's marriage to his third wife, Barbara Godfrey, on October 12, 1790. Arthur Chichester succeeded his uncle as Earl of Donegall in 1757. Following his marriage to Lady Anne Hamilton four years later, he and the countess had seven children. Their four daughters were born before 1769 (none survived her twenties), and three sons followed: George Augustus, born August 13, 1769, who succeeded his father as second Marquess of Donegall and Earl of Belfast; Arthur, born May 3, 1771, died September 13, 1788; and Spencer Stanley, father of the first Baron Templemore, born April 20, 1775 (through whose descendants the five Gainsborough portraits later passed). The Earl of Donegall took his place in the House of Lords in 1765 and sat in Commons for Malmesbury from 1768 to 1774. Following the death of Lady Anne, he remarried twice: first to Charlotte Spencer Moore on October 24, 1788 (d. September 19, 1789), and then in 1791 to Barbara Godfrey (d. December 28, 1829). The earl died on January 5, 1799. (Cokayne 1910–59, IV: 391–92, VI: 269–70; Namier and Brooke 1964, I: 211; Burke 1967: 767–68).

Anne, Countess of Donegall (Lady Anne Hamilton) is a splendid example of Gainsborough's mature style and consummate skill as a colorist. The countess is seated in an evocative landscape, the sun illuminating the distant hills in colors of opalescent mauve and yellow. Her cinnamon-colored gown, with lace around its low-cut neckline, is streaked with complementary blue shadows, the color of her sash. A string of pearls adorns her décolletage and extends over her left shoulder and breast. She wears a scarlet robe trimmed with ermine—perhaps the robe of a peeress—and she leans against a pedestal supporting a classicizing urn decorated with ornamental motifs. The pensive posture, with her hand supporting her cheek and chin, recalls numerous portraits of individuals in the outdoors personifying melancholy or contemplation. Her figure is placed along a diagonal extending from the upper left to the lower right of the composition. The interplay of the soft curves of her body along this diagonal is underscored by a series of off-axis ellipses—the predominant geometric design of the work—that emphasize her femininity. These include the oval created by her head and her high, powdered coiffure; the area of her head and the low neckline of her dress and pearls; the arc formed by her right hand, supporting her chin, and the curve of her left

hand and wrist in her lap; and the shape of her bell-like skirt and the grandiose sweep of her scarlet fur-trimmed robe, which lead the eye back to the lighter area of her upper torso. The counterpoise of her hands and arms, drawing attention to the ellipse in the center of the figure, is an essential feature of the center of the composition and recalls Gainsborough's similar treatment in the half-length portrait of his wife, Margaret Burr, which is also dated c. 1778 (Courtauld Institute Galleries, London; Waterhouse 1958: no. 299, pl. 209; London 1980a: 132, 134, no. 124, ill.).

A replica of the picture by the Victorian painter Frederick Percy Graves, dated 1864, was formerly in the collection of the Earl of Shaftesbury.

[66]
Thomas Gainsborough

Portrait of a Gentleman (formerly *The Hon. Richard Savage Nassau de Zuylestein, M.P.*), c. 1778–80

Oil on canvas, 239 (94) × 154.9 (61)
Bequest of Mrs. Horace E. Dodge in memory of her husband (71.169)

CONDITION: The painting was last treated in 1980. Due to the weakened state of the original canvas, the painting was lined onto a Belgian linen fabric. The painting is stretched onto a Lebron expansion-bolt stretcher. The paint layer is structurally secure. Paint losses are present in the red suit and along the painting's edges. Pentimenti are evident in the sitter's coat and white shirt. The synthetic varnish is slightly uneven and has a matte appearance.

PROVENANCE: See cat. 65.

EXHIBITIONS: London 1859: no. 131, 158, or 161; London 1877: no. 94; Detroit 1926: no. 7, ill.

REFERENCES: Shaw 1798–1801, I: 369; *Athenaeum* 1877: 25; *Athenaeum* 1877a: 87; Armstrong 1898: 197; Menpes and Greig 1909: 84–85; Graves 1913–15, I: 375, 382; Detroit 1939, I: xv, n.p., ill.; Waterhouse 1953: 29–30, 79; Waterhouse 1958: 72, no. 336, pl. 198; Winokur 1971: 46, ills. 42, 47; *Gazette des Beaux-Arts* 1972: 98, fig. 346.

The identity of this splendid male portrait by Gainsborough remains enigmatic. The painting can be dated c. 1778–80 on the basis of Gainsborough's style and the sitter's costume and hairstyle, but its subject is unknown. The painting's provenance, the names of the likely sitters, the dates of their births and deaths, and comparative portraits of these prospective candidates, when considered in conjunction with the style and date of the Detroit painting, have not yielded an irrefutable identification of this gentleman in red.

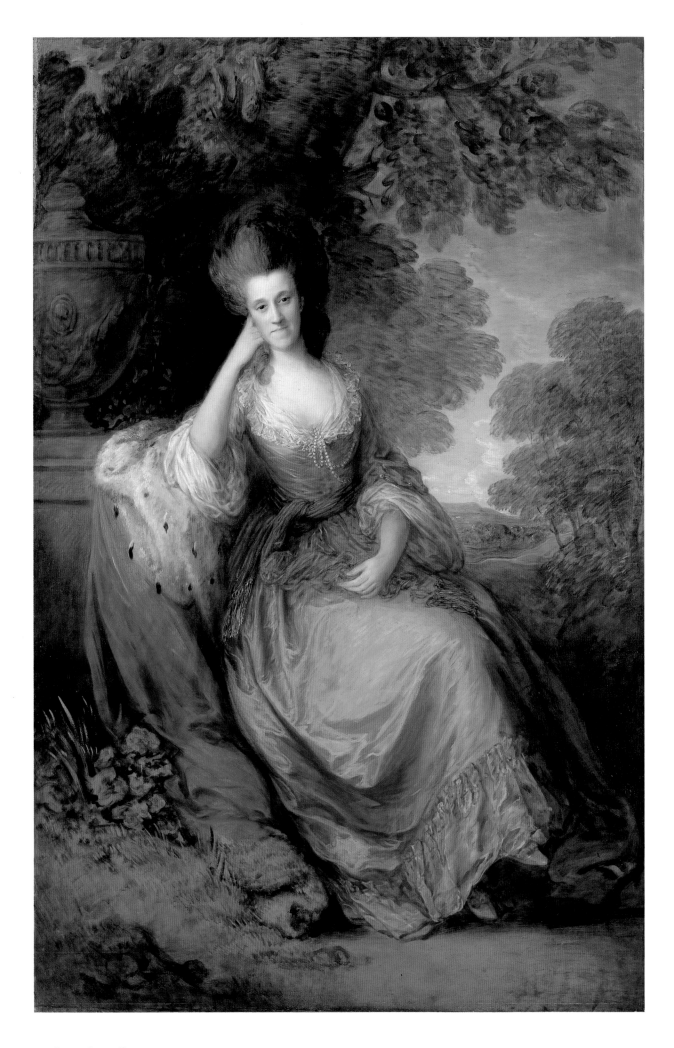

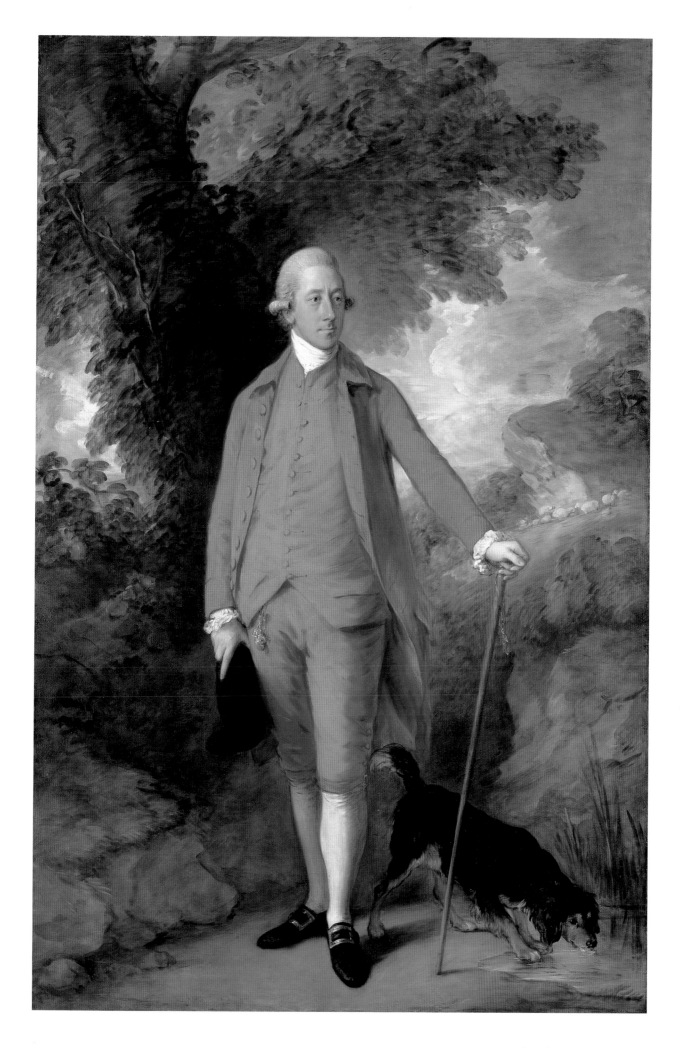

The provenance and history of the portrait parallel that of *Anne, Countess of Donegall (Lady Anne Hamilton)* (cat. 65). In the late eighteenth century, the male portrait descended from the Marquess of Donegall to his third son, Spencer Stanley Chichester, after which time it passed through the family of the Barons Templemore. It was exhibited at the British Institution in 1859 as *Portrait of a Gentleman* (London 1859: no. 131, 158, or 161). At the Royal Academy in 1877 (London 1877: no. 94), it was called *James, Fifth Duke of Hamilton,* an incorrect identification (reiterated by Armstrong 1898: 197), since the fifth Duke died in 1742/43 and the portrait dates from the late 1770s.

The committee consulted by the Templemore family in 1906 (see cat. 65) may have proposed the name of Richard Savage Nassau as the likely sitter (according to Ellis Waterhouse, letter, May 24, 1972, DIA curatorial files). In 1909 the name of Richard Savage Nassau was also offered by Menpes and Greig (1909: 84–85), probably after consultation with the experts with whom the Templemore family had conferred three years earlier. Menpes and Greig suggested that the "magnificent portrait of the gentleman in red," then hanging in Lord Templemore's house in Portman Square in London, could not possibly be the fifth Duke of Hamilton, but instead, the painting might represent the Hon. Richard Savage Nassau (1723–1780), second husband of Anne, widow of the fifth Duke of Hamilton and second Duke of Brandon (and hence the stepfather of Anne, Countess of Donegall). This man, known by his complete name, Richard Savage Nassau de Zuylestein, M.P., had married Anne, Duchess of Hamilton, on December 24, 1751. Menpes and Greig ingeniously proposed this identification based on the family resemblance they saw between the Dodge painting and a mezzotint by Richard Houston after the portrait by Domenico Dupra of Richard Savage Nassau de Zuylestein's older brother, William Henry Nassau de Zuylestein, fourth Earl of Rochford (1717–1781). The Duveen catalogue of 1939 (Detroit 1939, I: xv, n.p.) repeated this assumption, but misspelled "Zuylestein" as "Zuylenstein," a common error (Namier and Brooke 1964, III: 193; *DNB* 1967–68, XXI: 1343, 1346).

In the 1950s Waterhouse suggested a variety of names for the sitter. In 1953 he tentatively proposed that the subject might be James, sixth Duke of Hamilton, but since the sixth duke died in 1758, this opinion was insupportable (Waterhouse 1953: 29–30, 79). In 1958 Waterhouse wrote that the portrait represented the eighth Duke of Hamilton at the time of his marriage in 1778, and that the female portrait in the Dodge Collection might depict his duchess (Waterhouse 1958: 72, no. 336). However, this identification was also untenable, since the eighth duke was born in 1758 and the Dodge portrait, which dates from the late 1770s, represents a man at least forty years old. The Dodge portrait also bears no resemblance to other portraits of the eighth duke, such as Sir

Joshua Reynolds's portrait of the eighth duke and duchess, 1779 (Graves and Cronin 1899–1901, I: 419–20, IV: 1328, ill. opp. 1504), and the engraving of the eighth duke on horseback by W. Ward after G. Ganard (British Museum, London). Waterhouse acknowledged the suggestion by other scholars that the painting's sitter was Richard Savage Nassau, but he pointed out that the Dodge painting bore little similarity to an earlier portrait by Gainsborough of Richard Savage Nassau (Brodick Castle, The National Trust for Scotland), which he dated to the mid-1760s (letter, May 24, 1972, DIA curatorial files). The Brodick Castle portrait of Richard Savage Nassau (Waterhouse 1953: 79; Waterhouse 1958: 83, no. 512; and London 1980a: 82, no. 64, ill.), has been dated c. 1757 by John Hayes, who agreed with Waterhouse that the Dodge picture and the Brodick Castle portrait did not represent the same sitter (letter, January 14, 1986, DIA curatorial files). (To muddy matters further, Waterhouse in his 1958 book confused the dimensions of the Brodick Castle portrait with those of the Dodge picture.) Furthermore, while the suggestion that the portrait represented Richard Savage Nassau de Zuylestein, M.P., is tantalizing (especially since the sitter was a Suffolk nobleman), it is not only the existence of the Brodick Castle portrait, but also the issue of the Dodge portrait's date and provenance that call this identification into question. If the portrait does indeed represent Richard Savage Nassau de Zuylestein, the Countess of Donegall's stepfather, then it must have been painted when the sitter was a widower, *after* the death of the countess's mother in 1771, which seems unusual, considering the painting's provenance through the Templemore family.

Finally, a number of other names have been suggested, but none, on closer examination, seems promising. For example, the possibility remains that the Dodge portrait represents the first Marquess of Donegall (1739–1799), and that it was a pendant to the female portrait in the Dodge Bequest. But when the Detroit painting is compared with the two other male full-lengths from the Templemore collection (Waterhouse 1958: 63, nos. 199, 200), now both identified as the Marquess of Donegall, it seems unlikely—on the basis of physical similarity or on the probability of the existence of three Gainsborough full-length portraits of the same sitter—that the portrait could be yet another representation of the marquess.

The suggestion has also been made that the portrait might depict Archibald, ninth Duke of Hamilton (1740–1819), brother of Anne, Countess of Donegall, but as John Hayes has pointed out (letter, August 20, 1986, DIA curatorial files), this too is unlikely, since the Dodge sitter bears no resemblance to portraits of the ninth duke (as seen in the paintings formerly attributed to Pompeo Batoni [Clark 1985: 372] and to George Willison [photograph, National Portrait Gallery, London, archives], or to the portraits of the duke in old age by Richard Cosway [photograph, National Portrait Gallery,

London, archives], and the engraving by G. Clint after J. Lonsdale [British Museum, London]). It might be possible that the sitter is yet another family member of the Dukes of Hamilton or the Earls of Donegall. For example, Lord Spencer Hamilton (1742–1791), youngest brother of Anne, Countess of Donegall, at first seems a likely candidate, but he too can be dismissed, for his two portraits by Francis Wheatley, dated c. 1778–79, are also quite different from the Dodge painting (Collections of Her Majesty the Queen and Lord Templemore; Webster 1970: 124–25, nos. 24, 25, ill.). Perhaps the sitter is in actuality one of the candidates previously considered, or perhaps he is yet another family relation; for the moment, however, his identity remains unknown.

The painting can nevertheless be dated c. 1778–80 on the basis of Gainsborough's style and the sitter's costume and hairstyle. According to Aileen Ribeiro (letter, March 6, 1986, DIA curatorial files), the subject's bright red costume—typical of fashionable dress of the period and tailored in an English style—is reminiscent of garments observable in portraits of gentlemen who had made the Grand Tour, and who had brought back to England red silks and other fabrics from Italy to be made into suits. Such garments appear in Gainsborough's portrait of *John Joseph Merlin*, exhibited at the Royal Academy in 1782 (The Iveagh Bequest, Kenwood; Waterhouse 1958: 81, no. 480), and Pompeo Batoni's portrait of *Sir Thomas Gascoigne*, 1779 (Leeds City Art Gallery, Lotherton Hall; Clark 1985: no. 416, pl. 378). Ribeiro has also noted that the sitter's hairstyle, which is probably a wig, dates from slightly before 1780, with its side curls arranged horizontally above the ear. Since hairstyles around 1780—whether wigs or worn naturally—began to take on a more disheveled appearance, the coiffure on the gentleman in the Dodge portrait indicates a more conservative or middle-aged taste, or at least a sitter with his own definite ideas of elegance.

Regardless of the identity of the sitter, the portrait ranks as one of Gainsborough's most brilliant efforts as a colorist, comparable to his achievement in *The Blue Boy* (Huntington Library and Art Gallery, San Marino). An anonymous reviewer in *The Athenaeum,* in his first notice of the Royal Academy "Winter Exhibition" in 1877, maintained that the portrait was "even a finer study of red than the much praised 'Blue Boy' is of blue" (*Athenaeum* 1877: 25). Two weeks later, in the third notice of the exhibition, the reviewer added that the picture was "a superb study in red . . . which is almost as bright as scarlet," and he further commented: "The harmony is true and noble and made successful by the same means as those employed in 'The Blue Boy'" (*Athenaeum* 1877a: 87).

Not only the color, but the sitter's authoritative pose commands attention. The figure is placed in a sunlit landscape; immediately behind him stands a sturdy tree, while in the background to his left are rocky outcroppings across whose slopes sheep graze. The right angle formed by the slanting tree and the sloping fields in the distance draws the eye to the sitter. His left foot is forward, his weight supported by a walking stick held in his left hand; a dog drinks at a pond at his feet. He is a sort of good shepherd in red; the scene is harmonious, calm, and beautiful. The pronounced X shape created by the diagonal of the tree and the grassy slopes finds an equally strong geometric counterpart in the triangles defining the sitter's posture. His head, his right arm and hand holding a hat, and his gaze along his left arm comprise the triangle of his upper torso—all three corners accentuated by the white of his collar and cuffs. Starting with the white cuffs at his wrist, his lower torso is defined by an inverted triangle in red, whose lateral sides are described by the slope of the walking stick and the sitter's right leg, and whose apex is articulated by the sitter's white stockings and gilt-buckled shoes. Curiously, the Dodge painting is nearly the mirror image of Gainsborough's imposing full-length of the *Reverend Sir Henry Bate-Dudley,* exhibited at the Royal Academy in 1780 (Trustees of the Burton Property Trust; Waterhouse 1958: 53, no. 45, pl. 204), a man whose reputation earned him the nickname "the fighting parson" (London 1980a: 134, no. 125, 137, ill.).

In juxtaposition to the softer, feminine colors and graceful, sinuous curves of the portrait of *Anne, Countess of Donegall,* the male portrait in the Dodge Collection is a bold portrayal of an alert individual standing in the landscape, head erect, his gaze directed along his outstretched left arm, beyond his immediate surroundings. His magnificently colored suit of scarlet, his features and gestures, and the configuration of the design are pointedly male, an appropriate complement to the portrayal of the more retiring and subdued countess.

A replica of the picture by the Victorian painter Frederick Percy Graves, dated 1864, is in the collection of the Earl of Shaftesbury.

JOHN HOPPNER
1758 London–London 1810

John Hoppner was born in Whitechapel to a German woman who worked in the royal service at the Court of St. James. His father, a German physician also in the royal employ, was said to have come to England with the Hanoverian court, but during Hoppner's lifetime rumors circulated that his natural father was actually the future George III, then still a prince. Although this supposition remains unconfirmed, the location of Hoppner's birth outside of the court and the unusual privileges Hoppner enjoyed as a youngster may be explained by this paternity. As a boy he served in the palace as a chorister in the Chapel Royal. King George III took special interest in his education, and the king's librarian served as Hoppner's tutor. According to a manuscript biography prepared by Mrs. Cromarty, Hoppner's granddaughter, the young Hoppner's friends included the Prince of Wales and the Dukes of Kent and Clarence, and as a youth "the carte blanche [was] accorded for all his whims and expenses..." (McKay and Roberts 1909: xv).

Hoppner entered the Royal Academy schools in 1775. Through his friendship with a fellow pupil, the American artist Joseph Wright, son of the sculptor Patience Wright, Hoppner met and married Wright's sister, Phoebe (1761–1827), in 1781. Hoppner's wedding took place without the approval of King George III and abruptly ended their relationship, since Mrs. Wright was a staunch supporter of the colonial cause in the American War of Independence. However, in 1784 Queen Charlotte commissioned Hoppner to paint a portrait of her three youngest daughters, Sophia, Amelia, and Mary (Royal Collection; exhibited at the Royal Academy in 1785), a work celebrated for its sensitivity and charm. Although Hoppner was rejected by George III, he received favor from the Prince of Wales, the Duke of York, and other members of the Whig nobility who (ironically) preferred Hoppner's somewhat plodding technique to that of his more brilliant and flashy younger contemporary, Thomas Lawrence (1769–1830), who was also Hoppner's chief rival.

Hoppner was elected an associate of the Royal Academy in 1793 and a full member in 1795. At the Royal Academy between 1780 and 1809, he exhibited 168 paintings, principally portraits. As Ellis Waterhouse wrote, Hoppner's best works were solid productions that were at times reminiscent of Sir Joshua Reynolds, then of George Romney, and later of Thomas Lawrence and Sir Henry Raeburn (Waterhouse 1969: 215). While lacking the genius of Reynolds, the grace of Thomas Gainsborough, and the bravura of Romney and Lawrence, Hoppner nevertheless enjoyed a successful career, a reflection of conservative Whig taste of the period.

John Hoppner

Susannah-Edith Rowley (née Harland), later Lady Rowley, 1785

Oil on canvas, 76.2 (30) × 63.5 (25)
Bequest of Mrs. Horace E. Dodge in memory of her husband (71.171)

CONDITION: The painting was last treated in 1984. The original canvas is lined onto a secondary fabric. The paint layer is in good condition. Inpainting is minimal. Pentimenti are visible beneath the chin and around the hair. The varnish is thinly and evenly applied. The portrait has suffered the ravages of time, and certain areas, such as the bodice of the dress, appear to be rubbed. Traction crackle is present on the red sofa cushions. Small amounts of inpainting can be found in the long vertical crackles throughout the subject's décolletage.

PROVENANCE: Sir William Rowley, second Bart. (d. October 20, 1832), Tendring Hall, Stoke-by-Nayland, Suffolk. To his daughter, Lady Marianne Sarah Dashwood (d. March 24, 1877), wife of Sir George Dashwood, fourth Bart. (d. September 22, 1861), Kirtlington Park, near Woodstock, Oxfordshire. To their second son, Captain George Astley Charles Dashwood (d. July 26, 1863), Wherstead Park, Ipswich, Suffolk. To his son, Lieutenant Charles Edmund Dashwood, J.P. (d. April 29, 1935), Wherstead Park, Ipswich, Suffolk. Baron Eugen de Rothschild, Paris (?). Charles Davis (dealer), London (?). Sold by P. and D. Colnaghi (dealer), London, April 1926. Bought by Knoedler (dealer), London and New York. Sold by Knoedler, January 1927, to Alfred W. Erickson (dealer), New York. Duveen Brothers (dealer), New York. Acquired by Anna Thomson Dodge from Duveen Brothers, 1935.

REFERENCE: Detroit 1939, I: xv–xvi, n.p., ill.

Since the 1920s, this half-length portrait of a beautiful young woman has been identified as Susannah-Edith, Lady Rowley, by John Hoppner, and dated to 1785. While there is no reason to doubt the attribution, and this date corresponds to the style of coiffure and costume, the dearth of literature about the portrait is somewhat surprising. It is not mentioned in the monograph on Hoppner by McKay and Roberts (1909), and it may never have been exhibited outside the domestic surroundings of its owners. Moreover, there are apparently no comparative portraits to corroborate the identification of the sitter, nor are there documents to secure its provenance. For example, the painting may have been included in the inventory of works of art at Kirtlington prepared by Lady Dashwood in 1879 (Townsend 1922: 44), but this manuscript is untraceable. Nor was the portrait included in any of the sales of works of art formerly owned by the Dashwood fam-

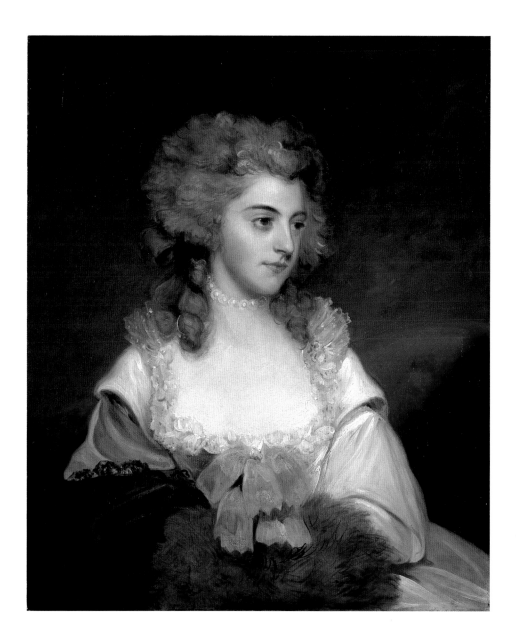

ily (London 1887a; London 1907; London 1909), or at the
auctions of celebrated "Dashwood Heirlooms" (London 1914;
London 1929; London 1934). In fact, the earliest reference to
the painting appears in Knoedler's archives in 1926, infor-
mation later published in part for the first (and only time) in
1939 (Detroit 1939, I: n.p.). According to Knoedler's records,
an old parchment label, no longer extant, on the back of the
picture, "in writing of the late-eighteenth century," bore the
identification of the portrait as: "Susanna Edith Rowley /
Wife to Willm Rowley Esqr. Eldest Son to / Rear Admiral
Sir Jossua [*sic*] Rowley Bart., she was / Third Daughter to
Admiral Sr. Robt. Harland / Bt., by his Second wife, Susanna
Reynolds [*sic*]. / This Picture was painted by Hopner [*sic*]
1785 / when she was two and twenty years of age." Knoedler's
records also note that the letter "H" was visible on seals at the
label's edges (Nancy Little, Knoedler and Co., letter, January
4, 1986, DIA curatorial files).

Susannah-Edith Harland was born in 1763, youngest
daughter of the four children (three daughters and a son) of
Admiral Sir Robert Harland (1715?–1784) and his wife, Susan
or Susanna Reynold, daughter of Colonel Rowland Reynold.
Admiral Sir Robert Harland was a distinguished naval officer
who was granted a baronetcy in 1771 (Charnock 1794–98, V:
454–57; *DNB* 1967–68, VIII: 1275). Just as her parents' mar-
riage consolidated two military families, Susannah-Edith's
union with William Rowley (1761–1832) in March 1785
joined two Suffolk families whose members served with dis-
tinction in the Royal Navy. William Rowley was the eldest
son of Vice-Admiral Sir Joshua Rowley (1730?–1790), who
was created first Baronet in 1786 for his naval activities
(Charnock 1794–98, VI: 107–12; *DNB* 1967–68, XVII:
360–61). Sir Joshua's distinguished father, Sir William Rowley
(c. 1690–1768), was Admiral of the Fleet (Charnock 1794–98,
IV: 63–66) and sat in Parliament for Taunton and Portsmouth

(Namier and Brooke 1964, III: 381; *DNB* 1967–68, XVII: 365–66). William Rowley served as an army officer in 1780, and again from 1782 to 1786. He succeeded his father as second Baronet in 1790, so that in 1785, when the Dodge portrait was painted, Susannah-Edith Rowley would have been known as Mrs. Rowley. In 1791 Sir William was Sheriff of Suffolk, and in 1793 he commissioned John Soane to rebuild Tendring Hall, the family seat (*Gentleman's Magazine* 1819: 247; *Gentleman's Magazine* 1833: 83). Sir William sat in Parliament for Suffolk for eighteen years, from 1812 to 1830 (Thorne 1986, V: 59; *DNB* 1967–68, XVII: 361). Sir William and Lady Rowley had eleven children, five sons and six daughters. Both their second and third sons, Vice-Admiral Sir Joshua Ricketts Rowley, third Baronet (d. 1857), and Captain Sir Charles Robert Rowley, fourth Baronet (1800–1888), succeeded their father. Sir William died at Tendring Hall on October 22, 1832, and was survived by Lady Rowley, who died at Holbecks Hall, near Hadleigh, Suffolk, aged eighty-six, on January 21, 1850 (*Gentleman's Magazine* 1850: 686).

A portrait by Hoppner of William Rowley (private collection) is listed in McKay and Roberts (1909: 220) and is dated to 1785. It depicts the half-length figure of a young man in a powdered wig, his face turned to his right, wearing a brown coat and white cravat. The dimensions are identical to those of the Dodge picture, and it thus seems likely that the portraits were pendants, painted at the time of the marriage of Susannah-Edith Harland to William Rowley. Ellis Waterhouse accepted a connection between the portraits and annotated his personal copy of McKay and Roberts next to the entry on Sir William Rowley's picture: "a portrait of Lady Rowley of the same dimensions is now in the Art Institute [*sic*], Detroit" (The Paul Mellon Centre for Studies in British Art, Library, London).

Documentation about the portrait's provenance is sketchy. Duveen stated that it passed from Sir William and Lady Rowley to their eldest daughter, Marianne Sarah, who, on September 8, 1815, married George Dashwood, later fourth Baronet of Kirtlington Park, Oxfordshire. According to Duveen, the painting was next owned by the second son of Lady Marianne Sarah and Sir George, Captain George Astley Charles Dashwood of Wherstead Park, Ipswich, Suffolk, who gave it to his son, Lieutenant Charles Edmund Dashwood, J.P. (The latter supervised the dispersal of the celebrated "Dashwood Heirlooms" in 1914, 1929, and 1934.) Ultimately, the picture must have left the Dashwood family privately, since, as noted, there is no record of the painting's sale through public auction. According to Duveen, after the portrait left the Dashwood family, it was owned by the Baron Eugen de Rothschild, Paris, and then by Alfred W. Erickson, New York. However, Duveen omitted the names of other dealers who handled the painting: around 1926 it belonged to P. and D. Colnaghi, London, who sold it to Knoedler in April 1926; Knoedler sold it to Alfred W. Erickson in New

York in January 1927 (Nancy Little, Knoedler and Co., letter, January 4, 1986, DIA curatorial files). If the portrait was in the possession of the Baron Eugen de Rothschild, the dates of his ownership are inconclusive—he could have owned it at any point between the time the picture left the Dashwood family and 1926. To further complicate matters, the mount on an old photograph of the portrait in the Witt Library, Courtauld Institute, London, lists Davis as the owner, so it is not impossible that Charles Davis, a London dealer, moved the painting between the Baron de Rothschild and Colnaghi, or through other dealers and private collectors. Finally, it is not certain when Duveen obtained the portrait. Alfred W. Erickson died in 1936, and since the work appears to have been sold privately between Erickson and Duveen, Duveen could have received it from Erickson anytime in the late 1920s or 1930s. Given these facts, it is especially unfortunate that there is no documentation situating the painting with the Rowleys at Tendring Hall or with the Dashwoods at Kirtlington or Wherstead Parks. For the present time, it seems that one must accept Duveen's provenance with skepticism. Curiously, however, even if the painting remained in the Harland family, it would have found its way to Lieutenant Charles Edmund Dashwood, J.P., for he was the great-grandnephew and heir of Lady Arethusa Harland (née Vernon), widow of Lady Rowley's brother, Sir Robert Harland (1765–1848) (*Gentleman's Magazine* 1860: 531) (London 1934: 15–16).

Whatever its provenance, the portrait of Susannah-Edith Rowley captures the bloom, beauty, and elegance of the late eighteenth-century lady. Her head slightly turned toward her left and her dreamy gaze diverted into the distance, the subject is seated on a crimson sofa, whose curving cushions surround her and disappear behind her right shoulder. The slope of the divan, descending from right to left, is reiterated by the sinuous curves of the black silk cloak or pelisse folded across her right arm, which terminate in the fur muff in her lap. The generalized, muted, slate gray background is composed of soft brushstrokes, and the diffuse lighting, emanating from the sitter's left, further complements the portrait's overall delicacy. The treatment of the background and cloak is similar to Hoppner's painting of *Lady Almeria Carpenter* from about the same time (London 1986a: 108–09, no. 49, ill.). Susannah-Edith's figure forms a compact triangle in the middle of the pictorial field. As Aileen Ribeiro commented (letter, March 6, 1986, DIA curatorial files), Susannah-Edith's ivory-colored dress is trimmed with yellow ribbons at the center of the bodice and on the sleeves, which are covered in muslin or silk gauze. With its deeply cut décolletage and its border of lace or tulle, the neckline features the romantic "Medici" collar also found in eighteenth-century masquerade costume. The frizzled and powdered coiffure, with its V-shaped dip at the top, dates from around 1785, or possibly later. A choker of pearls and soft curls descending to the sit-

ter's shoulders emphasize her long, slender neck and exquisite face. With her lightly arched eyebrows, limpid eyes, rosy cheeks, patrician nose, and bow-shaped mouth, Susannah-Edith is the epitome of young womanhood.

By coincidence, one of the matriarchs of the Dashwood family, Lady Elizabeth Dashwood (née Spencer), wife of the second baronet, Sir James Dashwood, was the sister of Anne, Duchess of Hamilton. Thus, Lady Elizabeth Dashwood was the aunt of the Anne, Countess of Donegall, whose portrait by Gainsborough is also in the Dodge Collection (cat. 65).

SIR JOSHUA REYNOLDS
1723 Plympton, Devonshire–London 1792

Joshua Reynolds was born in Plympton, near Plymouth, the third son and seventh of the eleven children of the Reverend Samuel Reynolds, a schoolmaster, and his wife, Theophila Potter. In 1740 Reynolds moved to London, where he served an apprenticeship with the fashionable portrait painter Thomas Hudson. In 1749, at the invitation of Commodore Keppel, Reynolds sailed from Plymouth to the Mediterranean, arriving in Rome in 1750.

Reynolds spent the next two years traveling on a Grand Tour throughout Italy, viewing works of ancient art as well as masterpieces by Raphael, Michelangelo, Titian, Correggio, and Guido Reni, whom he revered. Returning to England in 1752 after visiting Paris, Reynolds secured his reputation by painting the portrait of Commodore Augustus Keppel, *1753–54 (National Maritime Museum, Greenwich), borrowing the striding gesture of the heroic and confident commander from Allan Ramsay's portrait of* Norman, Twenty-second Chief of Macleod, *1748 (Dunvegan Castle, Skye), a work that had been based loosely on the pose of the* Apollo Belvedere *in the Vatican.*

Reynolds's understanding of the Old Masters, particularly the great portrait painters of the past such as Rembrandt, Peter Paul Rubens, and Anthony Van Dyck, led him to develop the elevated manner that became known as the Grand Style, which established the predominant tone for English portraiture for more than a century. Reynolds often depicted his sitters in allegorical guises, such as The Duchess of Manchester and Her Son Lord Mandeville in the Character of Diana Disarming Love, *exhibited at the Royal Academy in 1769 (Wimpole Hall, Cambridgeshire), or he referred to their professions or stations in life with a kind of witty allusion, as in his portrait of the actor,* Garrick between Tragedy and Comedy, *1761 (private collection), and his picture of the noted courtesan,* Miss Kitty Fisher in the Character of Cleopatra, *1759 (The Iveagh Bequest, Kenwood).*

In addition to these works in the Grand Style, Reynolds painted a number of direct, sympathetic portraits of the nobility, such as Anne, Countess of Albemarle, *1758–59 (National Gallery, London), in which the matron is occupied at her work, and* The Countess Spencer with Her Daughter, *1761 (The*

Earl Spencer, Althorp). After great success in the 1760s at the exhibitions of the Society of Artists, Reynolds was elected the first president of the Royal Academy in 1768 and was knighted in 1769. George III later named Reynolds Principal Painter to the King after Allan Ramsay's death in 1784.

Reynolds was an immensely popular, ambitious, and literate artist who included among his friends the writers James Boswell, Edmund Burke, Oliver Goldsmith, and Samuel Johnson, many of whom he immortalized in paint. Reynolds's fifteen Discourses, delivered at the Royal Academy between 1769 and 1790, disseminated his theories about art and also exerted an enormous influence on British aesthetics. His deeply serious history paintings, such as Count Ugolino and His Children, *1770–71 (The Lord Sackville, Knole), and a work commissioned by Catherine II, Empress of Russia, entitled* The Infant Hercules, *1785 (The Hermitage, St. Petersburg), were balanced at the outset by his enchanting portraits of children, such as* Master Crewe as Henry VIII, *1776 (private collection), and* Lady Caroline Scott as Winter, *1777 (Duke of Buccleuch and Queensberry, Bowhill). His late paintings, such as* Georgiana, Duchess of Devonshire with Her Daughter, Lady Diana Cavendish, *1781 (Trustees of the Chatsworth Settlement, Chatsworth, Derbyshire), painted after his trip to the Lowlands in that year, were an indication of a new naturalism, while his famous painting,* Mrs. Siddons as the Tragic Muse, *1784 (Huntington Library and Art Gallery, San Marino), established Reynolds as the father of English academicism. While Reynolds's works have been accused of lacking the grace of those by Thomas Gainsborough, it was Gainsborough who succinctly praised Reynolds's enormous artistic breadth, "Damn the Man; how various he is."*

The paintings of Reynolds became widely known through engravings. Reynolds died on February 23, 1792, and was buried with ceremony in St. Paul's Cathedral.

[68]
Sir Joshua Reynolds

A Girl with a Kitten (Felina), 1788

Oil on canvas, 77 (30⁵⁄₁₆) × 64 (25³⁄₁₆)
Bequest of Mrs. Horace E. Dodge in memory of her husband (F71.68)

INSCRIPTIONS: Stamped on verso of the canvas, lower right: NORMANTON / 1821. On the back of the canvas and the stretcher: a French customs stamp.

CONDITION: The painting is in structurally good condition. The original linen canvas has been lined to a secondary linen canvas with an aqueous-based adhesive. There is severe traction crackle throughout most of the darker colors. These have all been repainted with a thick paint film. Restoration glazes occur throughout the painting in areas of overcleaning as well as areas of pigment fading. The latter occurs mainly in the flesh tones and lighter passages of the background.

PROVENANCE: Probably given by the artist to his niece, Mary Palmer, later Countess of Inchiquin and Marchioness of Thomond (d. September 6, 1820), Taplow, Buckinghamshire. Her sale, Christie's, London, May 18, 1821, lot 64. Bought by Welbore Ellis Agar, second Earl of Normanton (d. August 26, 1868), Somerley, near Ringwood, Hampshire. To his son, James Charles Herbert Welbore Ellis Agar, third Earl of Normanton (d. December 19, 1896), Somerley, near Ringwood, Hampshire. To his second son, Sidney James Agar, fourth Earl of Normanton (d. November 25, 1933), c. 1933, or to Edward John Sidney Christian Welbore Ellis, fifth Earl of Normanton, c. 1934. To Duveen Brothers (dealer), New York. Acquired by Anna Thomson Dodge from Duveen Brothers, 1935.

EXHIBITIONS: London 1788: no. 378; London 1813: no. 41; London 1824: no. 145; London 1887: no. 22.

REFERENCES: Northcote 1819, II: 349; Wheatley 1825: 53; Cotton 1856: 196; Waagen 1857: 371, no. 18; Leslie and Taylor 1865, II: 516; London 1883: 46, no. 92; Hamilton 1884: 147, 191; Stephens 1884: 78; Redford 1888, II: 102; Phillips 1894: 351; Graves and Cronin 1899–1901, III: 1152, IV: 1659; Armstrong 1900: 239; Baldry 1903: xiv; Roldit 1903: 217; Graves 1905–06, VI: 276; Graves 1913–15, II: 1020, 1028, 1063; Graves 1918–21, III: 9; Wind 1931: 194, pl. 17, no. 50; Detroit 1939: xvi, n.p., ill.; *Country Life* 1965: 1724, ill.; Waterhouse 1973: 182; London 1986: 33.

The model for this well-known fancy picture of a young girl embracing her cat has been identified traditionally as Theophila Palmer (1757–1848), nicknamed "Offy," Sir Joshua Reynolds's favorite niece, second daughter of his sister Mary and her husband, John Palmer of Torrington, Devon. From 1770 until her marriage to the Cornishman Robert Lovell Gwatkin in 1781, Theophila and her sister Mary lived with their uncle in London, where Theophila charmed some of the most celebrated literary figures of Sir Joshua's circle, including Edmund Burke, Oliver Goldsmith, and Samuel Johnson. However, by the time Reynolds painted *A Girl with a Kitten (Felina),* Theophila Gwatkin was in her thirties; thus the painting, if indeed of Offy, is a recollection of her childhood years. Offy sat for many of Reynolds's pictures of children, including *Miss Theophila Palmer Reading "Clarissa Harlowe,"* 1771 (Lord Hillingdon, Messing Park), and *The Strawberry Girl,* 1773 (Wallace Collection, London). According to legend, she was so adorable and unforgettable at the age of three or four that she had already inspired Reynolds with the idea for the figure of comedy in his painting *Garrick between Tragedy and Comedy,* 1761 (private collection; Hudson 1958: 150–51; London 1986: 29, 33).

The Dodge picture was engraved in stipple as *Felina* by Joseph Collyer in 1790, during Reynolds's lifetime, and therefore Reynolds may have been responsible for inventing this secondary title. With the sitter's upwardly slanting almond-shaped eyes, pert nose, bow-shaped coquettish mouth, high cheekbones, pointed chin, and frontal pose, the human model is not physically unlike the feline companion she nearly squeezes to death with exuberant juvenile affection.

Despite its bewitching nature, *A Girl with a Kitten (Felina)* in the Dodge Collection has posed vexing problems for scholars. Its history is inextricably enmeshed with numerous replicas of this design (by Reynolds and other artists) and with another, different composition of identical size, which is titled similarly, and which also exists in many variants. Graves and Cronin tried to clarify the problem and to differentiate between the two compositions by calling the Dodge picture *Felina, Girl with a Kitten* and the other design *Girl and Kitten* (Graves and Cronin 1899–1901, III: 1121–22, 1152–53). However, because of the similarity of these two compositions, the popularity of their sentimental subjects, and the morass of literature about them, it has been difficult to determine definitively which variant of which composition was earlier, which paintings were autograph copies by Reynolds, and which were full-size and reduced replicas by Reynolds and by other artists. In fact, the literature about *A Girl with a Kitten (Felina)* is fraught with erroneously repeated and faulty documentation—a history encrusted with accretions of misinformation, muddied provenances, entangled references, and misattributions. Furthermore, the situation is aggravated by the fact that many of the variants cannot be traced, as well as by the ruinous states of the canvases, marred by Reynolds's painting technique (London 1986: 55–70). Suffice it to say that similar problems of attribution and provenance plague many of Reynolds's fancy pictures, since the works were freely copied by Reynolds's pupils during his life and remained immensely popular after his death (Postle 1995: 61).

However, according to Ellis Waterhouse, *A Girl with a Kitten (Felina)* in the Dodge Collection is indeed the primary version of one of the compositions (letters, May 24 and August 15, 1972, DIA curatorial files). Nicholas Penny accepted the Dodge work as the painting that was exhibited at the Royal Academy in 1788 and engraved in 1790 (letter, April 16, 1986, DIA curatorial files). The canvas features the full-length figure of a rosy-cheeked smiling child in a yellowish-pink dress, her auburn hair adorned by a blue ribbon, her face directly confronting the spectator, and her body turned in three-quarter view. She is kneeling on the ground in the landscape, almost smothering her unhappy calico cat with a hug. Behind her is an enormous tree trunk with branches and overgrowth; to her right in the distance is a clearing, more foliage, and a patch of blue sky.

The Dodge picture was probably given by Reynolds to his niece (and sister of the sitter) Mary Palmer and was sold as *A Girl Seated on Her Heels Embracing a Favorite Kitten* at her sale at Christie's (London 1821: lot 64), where it was pur-

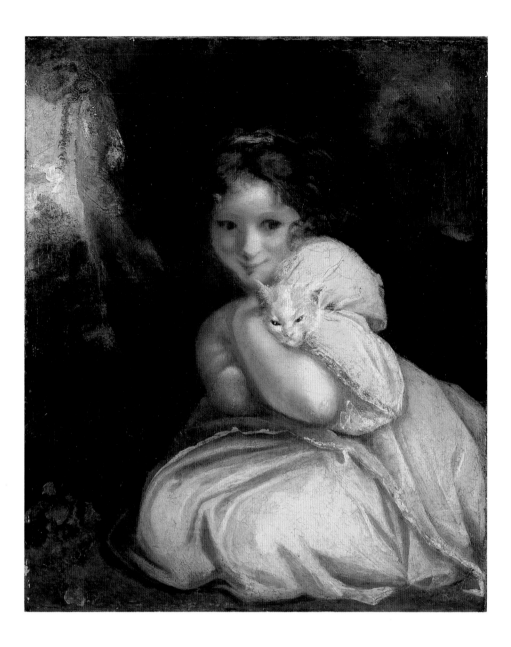

chased by Welbore Ellis Agar, second Earl of Normanton, for £309 15s. He was described as a man "short and thick-set in person, and always dressed in the plainest manner . . . a connoisseur of art" (Cokayne 1910–59, IX: 642). Waagen (1857: 363–64) had high praise for the proportions, decorations, and lighting of the earl's picture gallery, for his collection of paintings by the continental Old Masters, and especially for the more than twenty works by Reynolds at Somerley, for the earl was famous as a connoisseur of Reynolds's paintings. This appreciation for the collection was reiterated by Max Roldit (1903: 217) in his article on the Reynolds ensemble at Somerley. It is not certain precisely when and from which Earl of Normanton Duveen obtained the painting. Duveen lists the fourth earl, who died in 1933, as the seller, but Waterhouse gave the sale date as 1934 in his personal, annotated copy of Graves and Cronin (1899–1901, III: 1152; The Paul Mellon Centre for Studies in British Art, Library, London). While there are no extant sales records at Somerley, the sixth Earl of Normanton has speculated that the canvas

was sold in 1934 to help meet death duties levied on the estate of the fourth earl (letter, June 19, 1991, DIA curatorial files).

The other composition of the subject, *Girl and Kitten* (Graves and Cronin 1899–1901, III: 1121) depicts a different design and has been variously entitled *Girl with a Cat (Felina)* (Northcote 1819, II: 349); *Girl with a Kitten* (Hamilton 1884: 148, 191; Stephens 1884: 78; Armstrong 1900: 240); and *Felina* (London 1883: 46, no. 92). Its principal version was owned first by the prominent dealer and collector Noël Desenfans in the eighteenth century, after which it belonged to Sir John Fleming Leicester, Baron de Tabley, who exhibited it in his Leicester Gallery in the early nineteenth century. This design represents a three-quarter length of a smiling dark-haired girl in a straw bonnet, her forehead and eyes in the shadow of its brim. She is seated frontally, wearing a loose white dress and a scarlet belt, with a black shawl over her shoulders, and she holds up a tiny white kitten in front of her with both hands. In the background, across a diagonal at the upper left of the picture, is a crimson curtain in shadow; to her left in the

distance is a dark, woody landscape and a patch of sky (Carey and Hoare 1819: 59–60, no. 21; Young 1821: 10, no. 21, ill.; Hall 1962: 119, no. 77). The Desenfans/Leicester painting was sold at Christie's at the de Tabley sale (London 1827: lot 141, as *A Girl Holding a Kitten to Her Breast, in Both Hands . . .*), and it passed through a number of British collectors and dealers in the 1870s. According to Graves and Cronin (1899–1901, III: 1121), it was sold by the London dealer Agnew to the American industrialist J. Pierpont Morgan, who exhibited it at the Royal Academy Old Master exhibition in 1896 (London 1896: no. 17). This same picture was probably owned by Mrs. B.F. Jones, Jr. (Pittsburgh 1925: no. 63, ill.), and it may have been in the possession of the John Levy Galleries, New York, around 1934 (see photo in Witt Library, Courtauld Institute, London, and Waterhouse's comments in his annotated copy of Graves and Cronin). Unfortunately, the Desenfans/Leicester picture has not been located.

Each of the two principal compositions was engraved at the end of the eighteenth century. As previously mentioned, the Dodge composition was engraved in stipple and published as *Felina* in a first state in January 1790; it was republished in a third state on March 1, 1790, by William Dickinson, J. Cary, M. Darling, T. Simpson, and J. Collyer, with verses by S. Collings (Hamilton 1884: 147). The Desenfans/Leicester painting was engraved in stipple by Francesco Bartolozzi and was published by William Dickinson on February 20, 1787, as *The Girl and Kitten,* with verses by John Dryden (Baudi de Vesme and Calabi 1928: 324, no. 1239). In the nineteenth century each of the compositions was engraved again, the Dodge version by Alexander Scott in 1877 (Reynolds n.d., I: pl. 37; Graves and Cronin 1899–1901, III: 1152), and the Desenfans/Leicester painting by several different printmakers (Reynolds n.d., I: pl. 41; Graves and Cronin 1899–1901, III: 1121).

Until recently a perplexing question had surrounded the issue of determining which of the two designs was exhibited at the Royal Academy in 1788 as *A Girl with a Kitten.* Graves and Cronin provided no explanation, listing both the Desenfans/Leicester and the Thomond/Normanton/Dodge pictures as the work exhibited there. If the Desenfans/Leicester version was painted in 1785, as some sources maintain (Hamilton 1884: 191; Stephens 1884: 78; Armstrong 1900: 240; Baudi de Vesme and Calabi 1928: 324, no. 1239), and it was engraved in 1787, then a public exhibition in 1788 would reverse the expected sequence of events. In the past, the Dodge picture was dated to 1787 by most Reynolds scholars (Hamilton 1884: 111; Stephens 1884: 78; Graves and Cronin 1899–1901, III: 1152; Armstrong 1900: 239; Roldit 1903: 217). Now generally accepted is the proposal that the Dodge picture was painted and exhibited in 1788 (Nicholas Penny, letter, April 16, 1986, DIA curatorial files) and then engraved in 1790, the publication of the print the final step in securing the popularity of the image. Waterhouse changed his mind

on the matter, believing first, in 1941, that the Desenfans/Leicester design was exhibited at the Royal Academy (Waterhouse 1941: 80), and then, in 1973, that the Detroit version was the exhibited picture (Waterhouse 1973: 182). In his correspondence (May 24 and August 15, 1972, DIA curatorial files), he repeatedly referred to the Dodge painting as "the original"; it is not clear, however, if he meant the term "original" to refer to the earlier of the two designs, or to the picture exhibited at the Royal Academy in 1788, or to each of the two principal works among its variants. Indeed, as Nicholas Penny has pointed out (London 1986: 317–18; letter, April 16, 1986, DIA curatorial files), it is perhaps a mistake to think that there were "originals" of the fancy pictures as there were of Reynolds's portraits, since Reynolds seems to have worked simultaneously and alternately on two versions of some of these pictures, such as *The Strawberry Girl* (Northcote 1819, II: 7). Nevertheless, in this case, Waterhouse commented in the margin of his copy of Graves and Cronin (1899–1901, III: 1121) that *Felina* was the painting shown at the Royal Academy in 1788. Furthermore, in these same annotated volumes, next to the entry for *Felina* (Graves and Cronin 1899–1901, III: 1152), Waterhouse noted that Reynolds himself, on the rear endpaper of the painter's pocketbook for 1788, wrote the words "Girl with a Kitten Mr. Collier" (Mss. Coll. REY/1/25, Royal Academy of Arts, Library, London). Thus Waterhouse found proof that Collyer engraved the work exhibited at the Royal Academy in Reynolds's own pocketbook of 1788.

That Waterhouse had contradictory opinions about the two designs of *A Girl with a Kitten* over a thirty-year period is a reflection of the state of confusion over the subject in the Reynolds literature and in its sale and exhibition histories. For example, James Northcote, Reynolds's pupil and biographer, confused the prints after each design, giving Bartolozzi as the engraver of the Thomond/Normanton/Dodge work, and Collyer as the printmaker of the Desenfans/Leicester design. Charles Robert Leslie and Tom Taylor, Reynolds's Victorian biographers, mistakenly affirmed that *A Girl with a Kitten* at the Royal Academy in 1788 was engraved under the title *Muscipula,* which, in actuality, is an entirely different design of a young girl, possibly of Offy Palmer, holding a mousetrap (London 1986: 33, ill.). Furthermore, a number of sources (Hamilton 1884: 191; Baldry 1903: xiv, xv) wrongly stated that both compositions once belonged to Lord Normanton, and Hamilton misidentified the Desenfans/Leicester picture as a repetition of the Earl of Normanton's work, rather than as a completely different design.

Suffice it to say that errors in the Reynolds literature about *A Girl with a Kitten (Felina)* are the norm rather than the exception. These mistakes are multiplied exponentially because the designs were repeated by Reynolds—as was his practice in replicas, variants, and reduced versions. Graves and Cronin list two replicas of the Thomond/Normanton/

Dodge picture. The most important replica by Reynolds was exhibited by the Earl of Feversham at the Grosvenor Gallery in 1883 (London 1883: 46, no. 92; Graves and Cronin 1899–1901, III: 1152). It does not appear in the sales literature and it has not been traced. Another replica by Reynolds, of the same size and subject but depicted in half-length, was sold in 1875 (London 1875: lot 63) by John Angerstein and was purchased by Colnaghi (Graves and Cronin 1899–1901, III: 1153).

Graves and Cronin also listed variants of the Desenfans/Leicester picture (1899–1901, III: 1121). The main variant seems to be the picture they mentioned as exhibited at the British Institution in 1813 as *Girl and Kitten* (London 1813: no. 43), the property of Samuel Rogers. Later in the nineteenth century, it was the property of William Russell, who exhibited it at the Royal Academy in 1878 (London 1878: no. 60). It has not been traced.

These two compositions were also copied by others, adding the thorny problem of misattribution and/or forgery. The literature on these variants—the versions themselves difficult to attribute with certainty—is rife with mistakes. Many copies and variants of each design are mentioned in the Reynolds references and in the sales literature, and it is by no means clear which of these are autograph works by Reynolds and which are by other artists. Of the copies produced by others after Reynolds, the eighteenth-century pastelist John Russell repeated the composition (London 1807: lot 99; possibly the work seen by Waterhouse in 1971 and mentioned in his annotated copy of Graves and Cronin 1899–1901, III: 1152). Another copy after Reynolds was sold at Christie's in 1861 (London 1861: lot 27, bought by Benjamin). A reduced version of one of the compositions, measuring 22 × 17 inches, was sold at Christie's in 1876 (London 1876: lot 90). Besides these repetitions, reduced replicas, and copies by other artists, there are more than a dozen other entries in Graves and Cronin (1899–1901, III: 1121) that list sketches or versions of the subject, and there are also many other versions of the theme noted in Graves's sales compendium (1918–21, III: *passim*; the relatively low prices that some of these paintings brought at auction may reflect their status as copies by artists

other than Reynolds). The enumerations of the sales of various versions of *A Girl with a Kitten* in Graves and Cronin and in the volumes of art sales by Redford (1888, II: 102) and Graves do not take into account the fact that some of the citations may refer to the same object, whose title may have been changed to enhance marketability. Moreover, these listings (published at the end of the nineteenth and the beginning of the twentieth centuries) do not include versions or copies that have come to light in the last seventy years. A few more variants are mentioned in Waterhouse's annotated copy of Graves and Cronin, while others have appeared more recently in articles (for example, *Country Life* 1965: 1724, ill.).

Despite its deteriorated condition, *A Girl with a Kitten (Felina)* poses interesting problems in understanding Reynolds's working methods. Even in its own time, the critical reception of the painting was mixed. The curmudgeonly Sir Horace Walpole pronounced the picture "bad" (quoted in Graves and Cronin 1899–1901, III: 1152). On the other hand, Waagen (1857: 371, no. 18) thought it "most charming in its Correggio-like flesh tones," and Roldit (1903: 217) found the face painted with great delicacy and clearness, unusual for Reynolds. That the painting once had far more allure than today can only be imagined by looking at the captivating grin of the child as she nearly suffocates her pet with love. But even as Roldit noted in 1903, the background was then severely crackled, owing to an unfortunate use of bitumen, a problem frequent in the preservation of Reynolds's works. Horizontal crackle patterns throughout the canvas also suggest that the work may have been rolled or folded. It is unfortunate that behind its darkened, crackled, and abraded surface once sat an enchanting child.

According to the catalogue of the 1821 Christie's sale of the collection of the Marchioness of Thomond (see Provenance), a pendant to *A Girl with Kitten,* entitled *Portrait of a Female Drawing* (lot 66), was sold to Samuel Rogers. Subtitled *Miss Johnson, Sketching* (Graves and Cronin 1899–1901, III: 1152), the painting was engraved by Joseph Grozer in 1796.

The inked stamp of the French customs bureau on the reverse of the canvas and on the stretcher has not been explained.

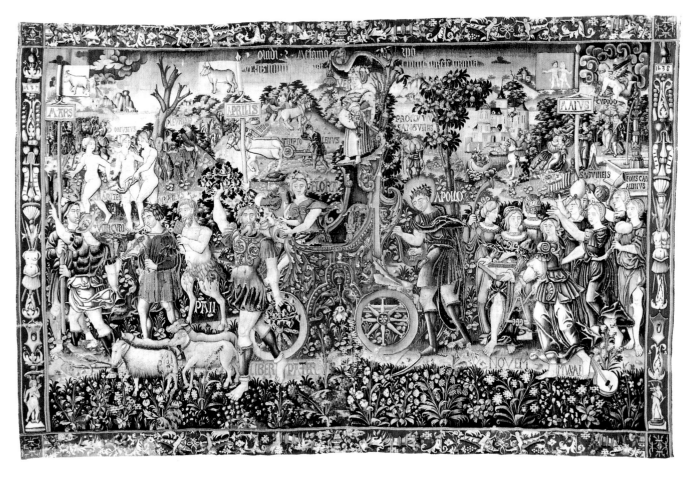

41.40

APPENDIX I

Other Works of Art Given by Anna Thomson Dodge
or Acquired from Her Estate, 1925–1973

CARPETS AND TAPESTRIES

Aubusson, France

Savonnerie-style Carpet, early twentieth century

Wool

14.5 m (47′6″) × 6.6 m (21′7″)

Bequest of Mrs. Horace E. Dodge in memory of her husband (F71.93)

Bruges

Cartoon after a woodcut by Master A.P.

Tapestry: Triumph of Spring, 1537–38

Wool and silk

279.4 (110) × 401.3 (158)

Founders Society Purchase with funds from Mrs. Standish Backus, Mrs. Walter O. Briggs, Mrs. Hugh Dillman, Mrs. Henry B. Joy, Mrs. Joseph Schlotman, Mr. Edsel B. Ford, Mr. John S. Newberry, Mr. Robert H. Tannahill, Mr. and Mrs. Edgar B. Whitcomb (41.40)

EXHIBITION: Detroit 1958: no. 190

REFERENCES: *Bulletin of the Detroit Institute of Arts* 1942: 44, ill. frontispiece; Asselberghs 1974: 24; Grazzini 1982: 62, pl. 18, 87, n. 11; Bruges 1987: 213–17

CERAMICS

English

Coalport manufactory, Staffordshire

Pair of Vases, c. 1840

Soft-paste porcelain with polychrome enamel and gilding

F71.77: 24.8 (9¾) × 11.6 (4¹⁄₁₆) × 9.5 (3¾)
F71.78: 25.2 (9¹⁵⁄₁₆) × 12.1 (4¾) × 9.5 (3¾)

Bequest of Mrs. Horace E. Dodge in memory of her husband (F71.77, F71.78)

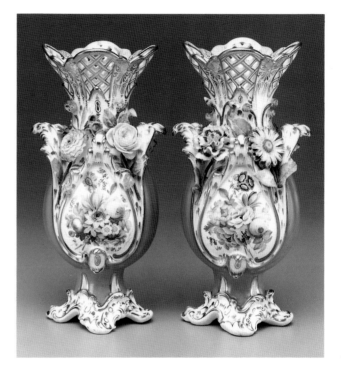

F71.77–F71.78

French

Dancing Couple, late nineteenth century

Hard-paste *biscuit* porcelain, gilt-bronze base, 15.2 (6) × 13 (5⅛) × 9.5 (3¾)

Bequest of Mrs. Horace E. Dodge in memory of her husband (F71.86)

Samson manufactory, Paris

Bust of Louis XVI,
late nineteenth/early twentieth century

Hard-paste porcelain with polychrome enamel, 13.7 (5⅜) × 7.9 (3⅛) × 6 (2⅜)

Bequest of Mrs. Horace E. Dodge in memory of her husband (F71.81)

Samson manufactory, Paris

Figure Group: The Fountain of Love,
late nineteenth/early twentieth century

Hard-paste *biscuit* porcelain, 22.2 (8¾) × 21 (8¼) ×
11.1 (4⅜)
Bequest of Mrs. Horace E. Dodge in memory of her
husband (F71.83)

German

Ernst Bohne Sons manufactory, Thuringia

Figure Group: Two Boys with a Dog,
early twentieth century

Hard-paste porcelain with polychrome enamel, 11.4 (4½) ×
16.2 (6⅜) × 12.7 (5)
Bequest of Mrs. Horace E. Dodge in memory of her
husband (F71.82)

Meissen manufactory, Meissen

Figure of Putto Holding Basket of Flowers,
late nineteenth century

Hard-paste porcelain with polychrome enamel, 13 (5⅛) ×
6.7 (2⅝) × 4.8 (1⅞)
Bequest of Mrs. Horace E. Dodge in memory of her
husband (F71.84)

Meissen manufactory, Meissen

Figure of Cupid, late nineteenth century

Hard-paste porcelain with polychrome enamel, 13.7 (5⅜) ×
7 (2¾) × 5.7 (2¼)
Bequest of Mrs. Horace E. Dodge in memory of her
husband (F71.85)

Oldest Volkstedt Porcelain manufactory, Thuringia

Lady on a Sofa,
late nineteenth/early twentieth century

Hard-paste porcelain with polychrome enamel and gilding,
9.8 (3⅞) × 10.2 (4) × 7.6 (3)
Bequest of Mrs. Horace E. Dodge in memory of her
husband (F71.87)

FURNITURE

French

Four Display Cabinets in the Neoclassical Style,
early twentieth century

Gilded wood and glass, 215.9 (85) × 104.1 (41) × 35.6 (14)
Bequest of Mrs. Horace E. Dodge in memory of her
husband (F71.73–F71.76)

Pair of Jardinières (Athéniennes),
early twentieth century

Carved and gilded wood, gilt bronze, zinc liners, 94.6
(37¼) × 38.1 (15)
Bequest of Mrs. Horace E. Dodge in memory of her
husband (F71.66, F71.67)
En suite with the pair of late eighteenth-century athéniennes,
cat. 17.

Pair of Pedestals in the Neoclassical Style,
early twentieth century

Painted wood, 122.6 (48¼) × 50.2 (19¾)
Founders Society Purchase, Mr. and Mrs. Horace E. Dodge
Memorial Fund (F71.153, F71.154)

HARDSTONES

Chinese

Dish, eighteenth century

Jade, 1 (⅜) × 10.8 (4¼) × 8.3 (3¼)
Bequest of Mrs. Horace E. Dodge in memory of her
husband (F71.88)

Dish, eighteenth century

Jade, 1.6 (⅝) × 8.9 (3½) × 7.6 (3)
Bequest of Mrs. Horace E. Dodge in memory of her
husband (F71.89)

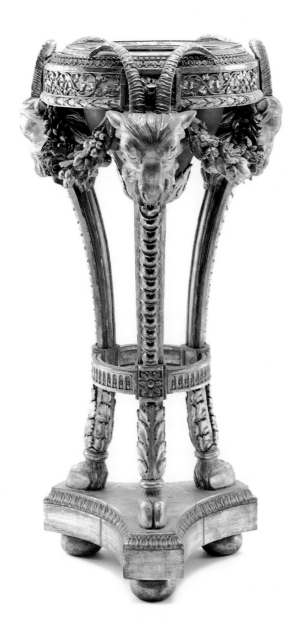

F71.66

Lotus Bowl, eighteenth century

Agate, 3.2 (1¼) × 9.5 (3¾) × 7.6 (3)
Bequest of Mrs. Horace E. Dodge in memory of her
husband (F71.91)

Bowl, nineteenth century

Agate, 4.8 (1⅞) × 7 (2¾)
Bequest of Mrs. Horace E. Dodge in memory of her
husband (F71.90)

METALWORK

French

*An Assembled Set of Fireplace Equipment:
Stand for Fire Irons, Tongs, Shovel, and Broom,*
nineteenth century

Bronze and iron, 97.5 (35⅜) height of stand
Bequest of Mrs. Horace E. Dodge in memory of her
husband (F71.69.1–4)

Baguès Frères (Paris)

Set of Four Chandeliers, c. 1930

Bronze and crystal, 147.3 (58) × 96.5 (38)
Bequest of Mrs. Horace E. Dodge in memory of her
husband (F73.23.1–4)

MUSICAL INSTRUMENTS

English

John Broadwood and Sons
(London)

Grand Piano, c. 1831

Oak, veneered with rosewood and with marquetry and
painted decoration, gilded wood, 96 (37¹³⁄₁₆) × 124.5 (49) ×
248.9 (98)
Bequest of Mrs. Horace E. Dodge in memory of her
husband (F71.72)

French

Renault et Chatelain
(Paris), active 1772–1811

Harp, 1793

Gilded and lacquered wood, gold and silver inlay, 163.8
(64½) height
Bequest of Mrs. Horace E. Dodge in memory of her
husband (F71.71)

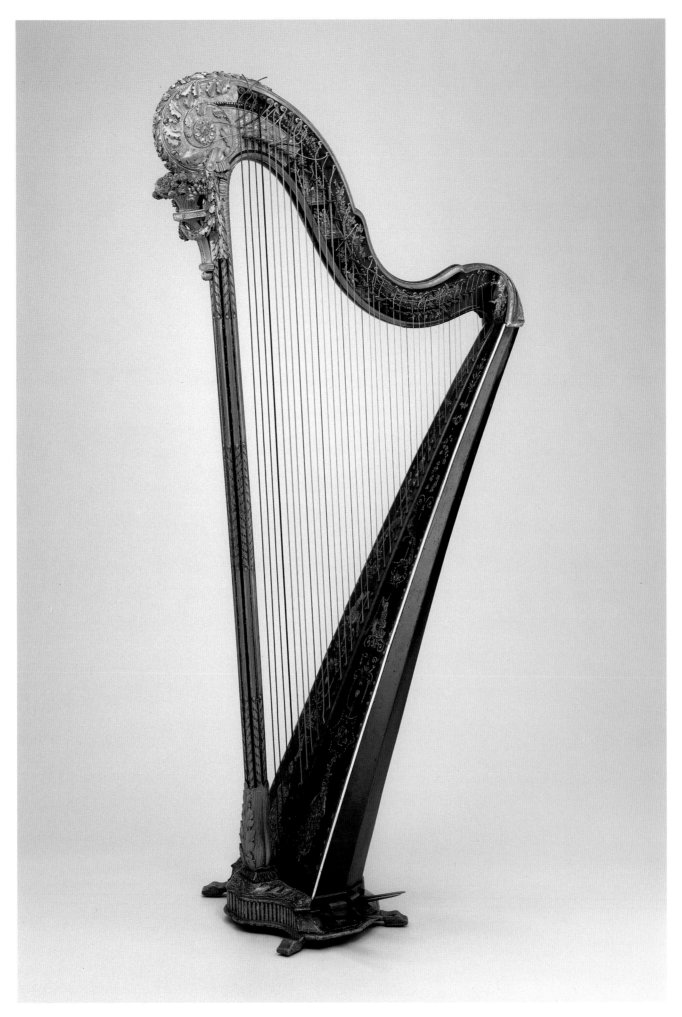

F71.71

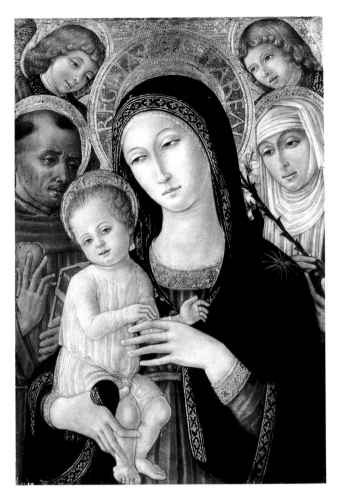

25.24

PAINTINGS

English

Gerald Festus Kelly
(London), 1878–1972

Mrs. Horace Elgin Dodge, 1932

Oil on canvas, 238.1 (93¾) × 123.8 (48¾)
Gift of the grandchildren of Mr. and Mrs. Horace E.
Dodge (F72.93)

REFERENCE: London 1933

Italian

Matteo di Giovanni di Bartolo
(Siena), 1430–1495

Madonna and Child with Saint Catherine and Saint Anthony of Padua, c. 1480

Tempera on panel, 66 (26) × 47 (18½)
Gift of Mrs. Horace E. Dodge (25.24)

REFERENCES: Valentiner 1925: 74, 75, ill.; Berenson 1932: 351; Fredericksen and Zeri 1972: 139

Spanish

Jose Maria Sert y Badia
(Barcelona), 1876–1945

The Story of Sinbad the Sailor, 1923

Sinbad Recounting His Adventures at the Feast
Oil and gold leaf on canvas, 500 (196⅞) × 462 (181⅞)

First Voyage: Sinbad and the Whale
Oil and gold leaf on canvas, 500 (196⅞) × 350 (137¹³⁄₁₆)

Second Voyage: Sinbad Rescued by the Eagle
Oil and gold leaf on canvas, 500 (196⅞) × 350 (137¹³⁄₁₆)

Third Voyage: Sinbad and the Wicked Giant
Oil and gold leaf on canvas, 500 (196⅞) × 290 (114⁷⁄₁₆)

Fourth Voyage: Sinbad Betrothed to the Young Maiden
Oil and gold leaf on canvas, 500 (196⅞) × 445 (175³⁄₁₆)

Fifth Voyage: Sinbad Slaying the Young Roc
Oil and gold leaf on canvas, 500 (196⅞) × 293 (115³⁄₈)

Seventh Voyage: Sinbad Captured by the Pirates
Oil and gold leaf on canvas, 500 (196⅞) × 408 (160⅝)

Seventh Voyage: The Elephants Capturing Sinbad
Oil and gold leaf on canvas, 500 (196⅞) × 346 (136¼)

Seventh Voyage: The Elephants' Burial Ground
Oil and gold leaf on canvas, 500 (196⅞) × 290 (114⁷⁄₁₆)

Gift of Anna Thomson Dodge (57.75.1–9)

PROVENANCE: J.M. Cosden, Palm Beach. Anna Thomson Dodge, Palm Beach and Grosse Pointe.

EXHIBITION: New York 1924 (unnumbered except for *The Elephants' Burial Ground*)

REFERENCES: Cortissoz 1924: n.p.; Flament 1924: 60; Castillo 1947: 114–17, pls. 40–48; *Detroit Free Press* 1957: 1; Curl 1984: 111, 215, n. 51, 110, fig. 82; Madrid 1987: 292.

Contrary to some information published at the time of their acquisition by the museum (*Detroit Free Press* 1957: 1), this series of large decorative canvases was not commissioned by King Alfonso of Spain, but instead by J.M. Cosden, perhaps advised by the famous Palm Beach architect Addison Mizner, for his Florida residence Playa Riente (Curl 1984: 111, 215, n. 51). All panels with the exception of the gigantic *Elephants' Burial Ground* were shown in the artist's first exhibition in New York, held in 1924 at the Wildenstein Gallery. This exhibition opened to Sert the doors of many important patrons and consecrated him in America as the great virtuoso muralist painter—a reputation that led to his eventual participation in the decoration of Rockefeller Center (1937), where his murals replaced those executed earlier by Diego Rivera,

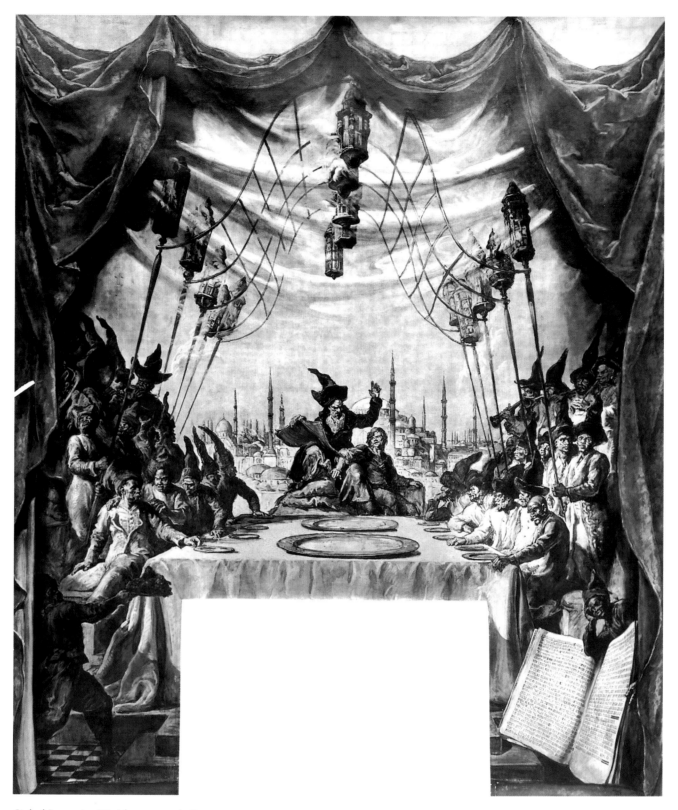

Sinbad Recounting His Adventures at the Feast

deemed too political. The Sinbad series was the first one commissioned to decorate an American private residence. When the Cosden residence was sold to Mrs. Dodge in 1938, the murals remained *in situ* until her own disposition of the house in 1957. At the auction sale of the house and its contents, the murals were bought by Ohan Berberyan, a New York dealer, for $100,000, but the sale was rescinded and the panels were offered to The Detroit Institute of Arts instead. Although shown in one of the Institute's galleries shortly after their acquisition, the paintings have unfortunately never been exhibited since because of their large dimensions.

Sinbad Slaying the Young Roc

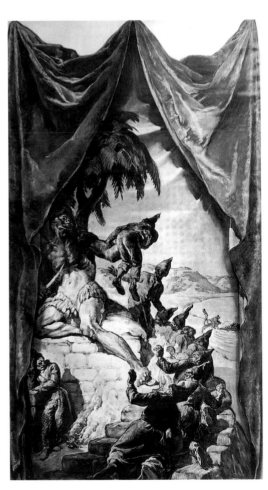

Sinbad and the Wicked Giant

It is only recently, and in particular since the Sert retrospective exhibition held in 1987 in Madrid, that the artist's own brand of *peinture mondaine,* for want of a better term, has been seriously reconsidered. Idolized during his lifetime by the most brilliant members of international café society, a regular fixture—along with his wife, Misia—of the most elegant salons, Sert was at the height of his career when he executed the Sinbad series. He had worked for such clients as the Rothschilds, the Sassoons, the princesse de Polignac (*née* Singer), and for Sergei Diaghilev's Ballets Russes, among others. Yet his reputation fell into rapid decline after World War II and his own death in 1945. In the aftermath of the war, his elegant and spirited compositions, with their bravura technique and references to Giulio Romano, the Baroque, and Tiepolo, seemed strangely at odds with the new society that was emerging from the ashes of Europe. Likewise in America, where modernism was about to become the new academicism, his traditional style found a decreasing audience. Furthermore, the era of palatial private residences, such as the ones built by Mizner in Palm Beach or David Adler in Illinois, had come to an end. Not only the need but the taste for the kind of decorative compositions Sert had brilliantly executed throughout his life were over.

In typical fashion, the Sinbad series does not follow a carefully established iconographic program: scenes are picked almost at random within the narrative and exploited to the full for their visual potential. Each subject is represented as a fake tapestry, whose borders are rolled to reveal the scene (a system already used in the decorations Sert had executed in 1920 at the palace of the Marques de Salamanca (Castillo 1947: pl. 24).

Sert's traditional art does not make abundant use of quotations, even though here and there in the Sinbad series a figure of a young black page seems borrowed—quite literally—from Albrecht Dürer. Rather, Sert's originality is to give the impression that he is quoting Old Masters. In fact, his working technique was fully modern and relied essentially upon drawings done after photographs he took himself of nude models. Several photographs are known that relate to the series of Sinbad (Paolo Vampa collection, Rome; see Madrid 1987: 263). A brilliant colorist, Sert was also able to limit his palette to monochrome tones. By reintroducing gold or silver backgrounds in mural compositions, Sert revived the great tradition of Venetian decorative painting exemplified by Giovanni Battista and Giovanni Domenico Tiepolo. The restraint shown by the artist in the Sinbad series, painted in a combination of maroons and gold, finds a parallel in Sert's oeuvre in the splendid decor of the Music Room of the Hôtel de Wendel, Paris, also executed in 1923–24 (the room has now been reconstructed in the Musée Carnavalet, Paris).

J. Patrice Marandel

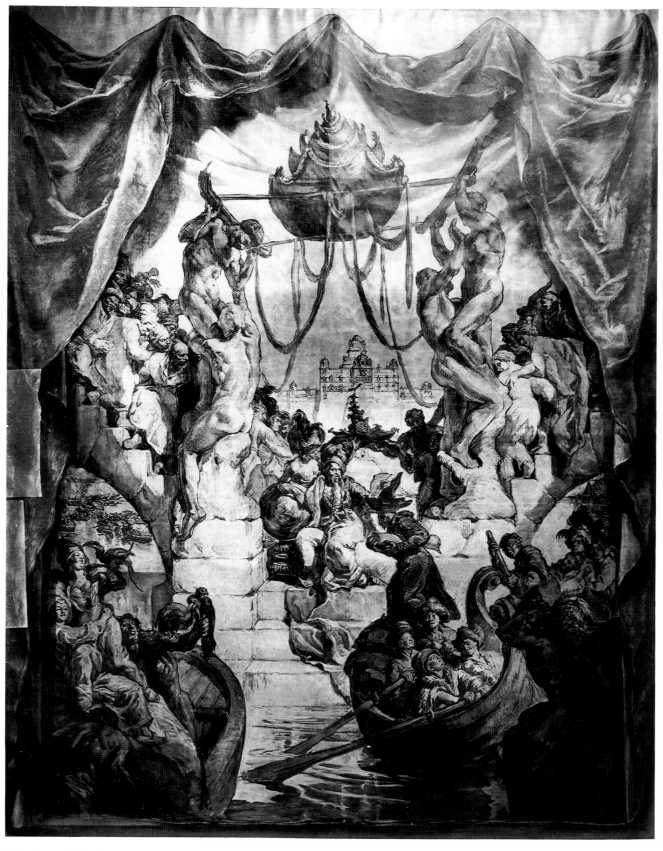

Sinbad Betrothed to the Young Maiden

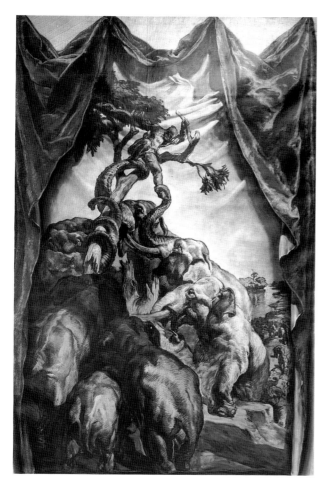

The Elephants Capturing Sinbad

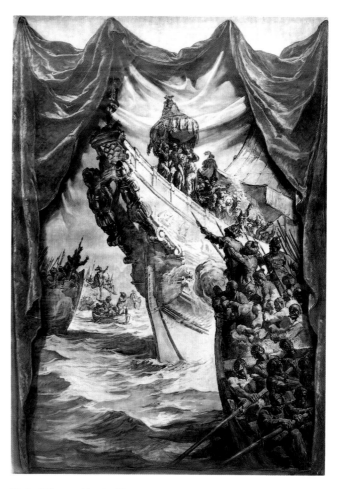

Sinbad Captured by the Pirates

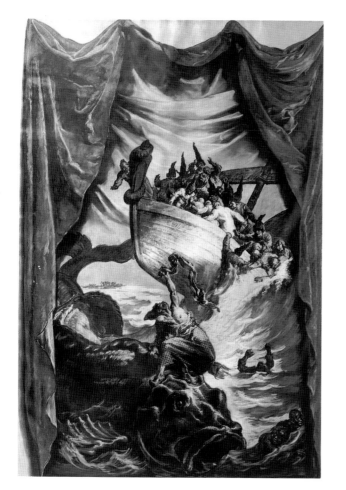

Sinbad and the Whale

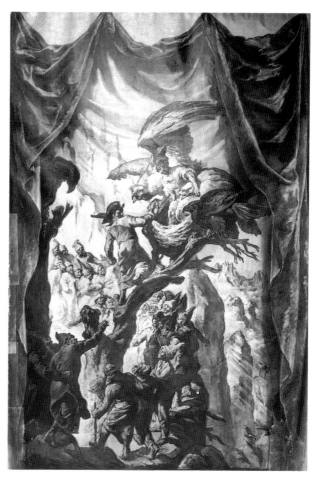

Sinbad Rescued by the Eagle

CLOCKS

Attributed to the workshop of André-Charles Boulle
(French, 1642–1732) and his sons
After a design by Gilles-Marie Oppenord

Pedestal Clock, c. 1720

Carcass of oak with a veneer of tortoiseshell, tortoiseshell
and brass marquetry and gilt-bronze mounts, 280 (110¼) ×
68.5 (27) × 33 (13)
Founders Society Purchase, Mr. and Mrs. Horace E. Dodge
Memorial Fund, Josephine and Ernest Kanzler Founders
Fund, and J. Lawrence Buell, Jr., Fund (1984.87)

INSCRIPTIONS: Painted on the enamel plaque below the dial:
JULIEN LE ROY, the name of the maker of the original
movement (see Condition).

CONDITION: The case is in extremely fine condition. The
mounts still retain their original mercury gilding, protected
as they were by a coat of lacquer, although there is the
expected wear along prominent edges and on highpoints.
When the case was restored by the English conservator David
Hawkins in the early 1980s prior to the clock's acquisition by
The Detroit Institute of Arts, it was found that the plain oak
top of the pedestal had once been veneered with tortoiseshell,
and this was replaced with new shell from the Cayman
Islands. Similarly, unused nail holes behind the gilt-bronze
molding framing the glass panel on the left side of the clock
indicated that this panel was not originally intended to be
hinged (as it then was to give easy access to the movement),
and it was returned to its original fixed position.

The unsigned movement is of early eighteenth-century
date, but not original to the clock. It was possibly substituted
in the late nineteenth century when the original had either
been lost or had presented too many problems for repair.
The present movement has undergone alteration during the
course of its life, principally the loss of its verge escapement
and silk suspension, both of which were reinstated by the
French master clock restorer Philippe Prutner at the time
the case was being restored. The arbor for the latter's adjust-
ment can be reached through a small hole in the dial plate
just below the numeral XII. Silk suspensions consist essen-
tially of a loop of thread wound at top around a horizontal
arbor and hung at bottom with the pendulum. When the
arbor is turned with a small key, the length of the silk is
changed as is that of the pendulum, thereby affecting the

duration of the pendulum's swing and the rate at which the
clock keeps time. Such suspensions, coupled first with verge
escapements and later with anchor ones, were standard on
French clocks from the time of the introduction of the pen-
dulum, c. 1660, until well into the eighteenth century, when
the more accurate and reliable anchor, dead beat, and pin-
wheel escapements gained favor. Indeed, coupled with anchor
escapements, silk suspensions survived on lesser movements
into the nineteenth century.

In 1985 the museum had the French restorer Jean Godeau
change the hands—which were not original and were frag-
ile after repeated repair—to ones closer in design to those on
the identical clock in the Bibliothèque de l'Arsenal, Paris
(reproduced in Tardy 1974: 144, fig. 1).

PROVENANCE: Anthony J. Drexel II (1864–1934), London,
c. 1895–1915. D.L. Isaacs (dealer), London, 1915. Mr. and Mrs.
Eric Langfeldt, Langenesbygd, Norway, by descent from
Mrs. Langfeldt's father (name unknown), who had bought it
c. 1915 from D.L. Isaacs. Alexander & Berendt Ltd. (dealer),
London, 1981.

REFERENCES: Vacquier 1914: pl. 37; Watson 1956: F42, pl. 48;
Bellaigue 1974, I: 51–55; Wilson 1976: 12–17; Wilson 1983:
18–19; Ottomeyer and Pröschel 1986, I: 41, fig. 1.2.7; Darr
1988: 497, figs. 106, 107; Bremer-David et al. 1993: 84–85;
Hughes 1994: 28–29; Hughes 1996: 365–75; Wilson et al.
1996: 164–73.

ADDITIONAL BIBLIOGRAPHY: Huard 1928: 311–29; *New York
Times* 1934: 15; Salverte 1962: 33–38; Boutemy 1973: 155–57;
Sheppard 1980: 141; Pradère 1989: 62–109

More an extraordinary work of art than a clock case, the
subject of the present entry embodies one of the most elegant
and satisfying designs produced in the eighteenth century.
Composed of three separate elements—the clock itself, the
pedestal on which it rests, and the plinth at bottom—the
clock and pedestal are conceived aesthetically as a single unit.

The carcass is constructed of oak, veneered with tortoise-
shell on the pedestal, tortoiseshell with brass banding on the
plinth, and tortoiseshell and brass Boulle marquetry on the
clock case. Much of the shell of the pedestal bears the curlicue
markings that appear naturally on the undersurface of some
shells, but that have more the appearance of calligraphy. The
bronze mounts are all very finely finished and have been
mercury gilded. The manner in which they encase all the

edges of the composition was a major advancement in furniture design, for they not only very strongly define the shape of the piece, but through the use of inner frames and foliated compositions refine it and give it a sense of lightness.

At the bottom of the pedestal, this sense is effected by the tall gilt-bronze paw feet that serve as piers for the high arches in between, the arch at front decorated above its apex with a fan-shaped palmette with a small vine ascending above, and those at the sides with intertwined strapwork tendrils. These very directional mounts drive the eye upward, along the sleek corner mounts, to the lesser of the clock's two focal points, the relief medallion at the top of the pedestal. From there, the eye rises up past the feet of the clock case to the primary focus, the dial of the clock itself. Here it rests again before beginning its final ascent up to the baldachin-like hood, its scrolled ribs reminiscent of those designed by Bernini (1624–35) for the baldachin above the high altar of Saint Peter's in Rome (reproduced in Wittkower 1981: 25, fig. IV, 83, pl. 45, 189–90), which may have been their source of inspiration. Then, following the line of the arch, the eye is brought down again, back down to the base of the clock, all the while taking in the rich decorative detail as it descends.

The dial of the clock is most unusual in being oval, a visual conceit found only on the Detroit clock and one of its allies (see below). In order that the blued-steel hour hand always points equidistantly to the enameled numeral plaques, it has been constructed in two sections joined by a spring device that allows it to expand and contract as it travels around a raised track cast into the inner edge of the chapter ring. This was almost certainly the invention of Julien Le Roy.

The principal sculptural elements refer almost certainly to the passage of time as marked by the course of the sun across the sky. At the corners of the clock case are terminal figures of the Four Continents, representing the earth over which the sun passes daily: Europe at front-left wearing a fur-trimmed hat and coat; Asia at front-right wearing a turban and a cloak over a tunic; Africa at rear-left wearing an elephant headdress; and the Americas at rear-right wearing a feathered headdress and skirt. At the top of the pedestal is a medallion incorporating the celestial globe, emblematic of the heavens across which the sun moves—the heavens here represented dramatically by the transfer of the celestial globe from the shoulders of Atlas to those of Hercules.

For his Eleventh Labor, Hercules was required to fetch the golden apples of the Hesperides, and to accomplish this he approached their father, Atlas, to perform the task for him. Largely out of self-interest, Atlas agreed to the mission provided that Hercules bear the heavens that he supported while he was gone. However, after returning with the apples and recognizing his advantage, Atlas tried to trick Hercules into bearing the weight forever. But Hercules proved too clever, and the heavens were soon back on Atlas's shoulders.

What is missing from the Detroit clock that would make the intent of these references clearer is an image of the sun itself. However, an identical clock in the Wallace Collection, London, has for its pendulum bob the rayed mask of Phoebus Apollo (Hughes 1994: 28–29), and this may have been part of the Detroit clock before its movement was changed. As the personification of the sun, Apollo rode his chariot across the sky daily. With the mask of Apollo as a pendulum bob, the interior of the clock case can then be viewed as a small shrine to the god and the smoke of the censer mounted on the wall behind perhaps as an interpretation of the vapors that arose from the Oracle at Apollo's temple at Delphi, or possibly the smoke from the temple's eternal flame. Flames arise from the censer of the Wallace Collection clock (see below). The wingless Cupid, aiming his bow on top of the clock, adds levity to the composition, reminding the viewer that love conquers all.

The eight-day movement of the clock is fitted with a verge escapement coupled with a silk suspension (see Condition) and has three spring-driven trains, the winding arbors for which can be seen in the center section of the dial: that of the going train is at bottom, that for the hourly striking train is at upper left; and that for the ting tang quarter-hour strike is at upper right. The bells for the strike are mounted on top of the movement, with one large bell for the hour and two smaller ones at its side for the quarter hours.

There are four identical clocks of this model dating from the period c. 1720–25: an example in the Bibliothèque de l'Arsenal, Paris (Vacquier 1914: pl. 37; Ottomeyer and Pröschel 1986, I: 41, fig. 1.2.7), mounted with an enamel plaque below its dial bearing the name of Julien Le Roy (master clockmaker in 1713) but apparently fitted soon after its completion with its present movement signed by Gilles Martinot (1658–1726); an example in The Wallace Collection, London, with a movement signed by Louis Mynuel (Watson 1956: no. F42, pl. 48; Hughes 1994: 28–29); an example in the James A. de Rothschild Collection at Waddesdon Manor, Buckinghamshire, with an English movement by George Graham (active 1695–1751) replacing an earlier French one (Bellaigue 1974, I: 51–55); and that in The Detroit Institute of Arts. Another clock of this model, with its movement engraved with the name of Julien Le Roy, is in The J. Paul Getty Museum, Malibu (Wilson 1976: 12–17; Wilson 1983: 18–19; Bremer-David et al. 1993: 84–85). Although the Getty clock has long been universally accepted as of eighteenth-century origin, Gillian Wilson, the museum's curator of decorative arts, now believes for technical reasons that that clock is a forgery (Wilson et al. 1996: 164–73). Principally, its mounts—and especially the flesh areas of the figures—are smoother than those on the other clocks; portions of the carcass are constructed with poplar disguised with a veneer of oak; machine-made screws are embedded in the carcass

beneath the veneer; and there is no indication that its nineteenth-century Brocot escapement is a replacement.

The Wallace and Waddesdon clocks differ from the Detroit and Arsenal ones in that they have additional mounts overlaying the upper portions of the glazed side panels: the mount at left with a crocodile, symbolizing the Americas, and that at right a rearing horse, symbolizing Europe. Although all four clocks have oval dial frames, only those in Detroit and at the Arsenal in Paris are actually fitted with dials of conforming shape.

Of these four eighteenth-century versions, three have provenances that can be traced back to that century. The Arsenal clock is described rather cursorily in the 1726 inventory made after the death of Gilles Martinot. In 1761 it passed into the Abbaye de Saint-Victor and then in 1791 into the Bibliothèque de l'Arsenal (see Wilson et al. 1996: 164–73). The Wallace Collection clock is recorded as having been presented by Monsieur Perrinet-de-Faugnes in 1770 to the Swiss town of Yverdon and remaining in the town hall there until 1866, when it was sold. It was acquired by the fourth Marquess of Hertford soon after. The Waddesdon Manor clock belonged in the eighteenth century to the fourth Earl of Chesterfield (1694–1773), who first visited Paris in 1714 (Bellaigue 1974, I: 54–55). The Detroit Institute of Arts clock is known back only to c. 1900, when it belonged to the American banker Anthony J. Drexel II (1864–1934), who acquired it for one of his residences in London, where he lived from c. 1895 until 1915.

Photographic comparison of the terminal figures of each of the four clocks shows that those of the Wallace, Waddesdon, and Arsenal clocks are virtually identical and seem, therefore, to have been cast from the same set of models, while the Detroit figures, which have subtle differences, seem to have been cast from another set. Besides the variations in the placement of the drapery folds and the modeling of the facial features, pronounced differences include: how the console support for the figure of the Americas turns sharply inward approximately one-quarter inch below the bottom of the feathered skirt on the Detroit clock and slightly above it on the other three; how the right ear of the same figure is placed totally outside the headband on the Detroit clock and tucked partially under it on the other three; and, most tellingly, how the elephant-mask headdress of Africa, which on the three identical clocks is surmounted by a looped-over elephant's trunk, is surmounted by a looped-over crimped ribbon on the Detroit clock.

As the Detroit mounts give every appearance of dating from the eighteenth century—and indeed this is the consensus of all who have seen them—one is left to hypothesize that, in making a final version of the clock, it became necessary to make new models for the casting of these mounts. Possibly the originals had been damaged or destroyed, as for

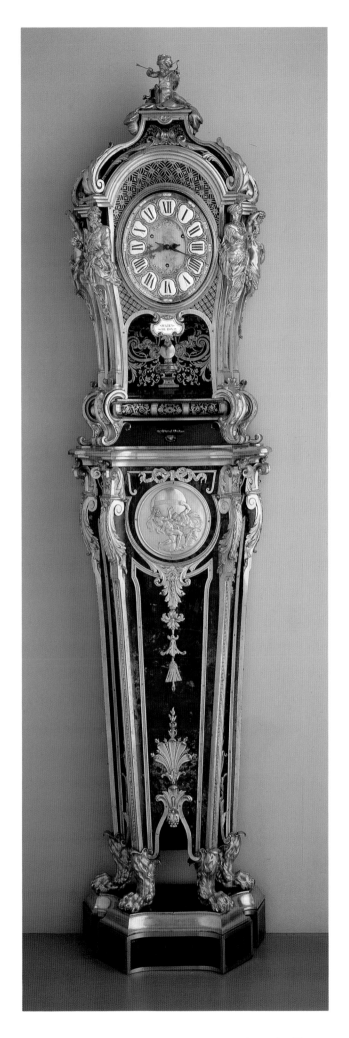

instance in the disastrous fire that swept a portion of the Boulle workshop in 1720, or perhaps they had become the subject of a personal or legal dispute. It would thus have become necessary to copy the mounts on a completed clock, one whose owner allowed access for detailed drawings to be made, but not disassembly. Under such circumstances, the artist involved may not have been able to see clearly the tops of the upper mounts, the clock being over ten feet tall, thus accounting for the misunderstanding of Africa's headdress and the fact that the Cupid at top has no wings.

As the pose of the Detroit Cupid replicates that surmounting the Arsenal clock, and not that of the other two versions, one must assume that it was this former clock that served as the model. One might speculate further that if the Getty clock is a forgery, it must have been copied from the Detroit example. Other than the fact that the Cupid of the Getty clock has wings, it replicates its peculiarities exactly.

Despite the importance of the model, virtually nothing is known about its origin. A work of such unified design would suggest that each of its elements had been designed especially for it. But, in fact, both the terminal figures of the clock case and the corner mounts of the pedestal had been created earlier for works of quite different character. The figures of the Four Continents were modeled perhaps eight to ten years earlier for a pedestal clock of very different shape, also now in The J. Paul Getty Museum, Malibu (reproduced in Wilson 1976: 26–33; Bremer-David et al. 1993: 84).

In the catalogue of the clocks in that museum, Gillian Wilson (Wilson et al. 1996: 164–73) shows that this earlier clock was almost certainly executed by the great Parisian cabinetmaker Alexandre-Jean Oppenordt (1639–1715) from a design produced by his son, the architect and designer Gilles-Marie Oppenord (1672–1742). To support her assertion she points to the fact that the corner mounts on the pedestal of the earlier Getty clock appear both in a drawing of a freestanding clock pedestal signed by G.-M. Oppenord in the Kunstbibliothek, Berlin (Berckenhagen 1970: 176), as well as on the actual pedestal itself, now in the Musée National des Techniques, Paris (Ronfort 1986: 486). This pedestal supports a globe clock, also designed by G.-M. Oppenord (Ronfort 1986: 486). The marquetry panel on the pedestal of this same Getty clock duplicates that on the pedestal of the Apollo clock at Fontainebleau (Guérinet 1908: title page; Tardy 1974: 110), now also considered like the Techniques clock to have been executed by the elder Oppenordt.

Jean Nérée Ronfort has pointed out to Gillian Wilson that the upper halves of the corner mounts on the pedestal of the Clocks of the Four Continents appear in inverted form—with goats' heads incorporated at the top—as the feet and corner mounts of a group of commodes stylistically dating c. 1700–20, and veneered variously with panels of quartered kingwood (London 1970: lot 129), fruitwood floral

marquetry (New York 1992b: lot 55), and brass and tortoiseshell scrolling marquetry (Geneva 1974: lot 57, and again London 1995b: lot 50; London 1979a: lot 138; London 1991: lot 88). Ronfort further pointed out that sections of the brass and tortoiseshell marquetry on the last-mentioned of these commodes (London 1991: lot 88) repeat exactly those on the top of the brass and tortoiseshell *bureau brisé* made by A.-J. Oppenordt in 1685 for Louis XIV at Versailles, and now in The Metropolitan Museum of Art, New York (Ronfort 1986: 44–51; Pradère 1989: 65, fig. 12). These works would therefore seem also to have been made in the A.-J. Oppenordt workshop. In regards to the marquetry on the Clocks of the Four Continents, it was also Ronfort's observation that the panel that is veneered to the inside back of each clock case repeats, in a somewhat simplified form, that veneered to the right door of the *armoire à régulateur* in The Wallace Collection, London (Watson 1956: F429, pl. 117; Hughes 1994: 24–25; Pradère 1989: 66–67, fig. 13), two examples of which are recorded among the works that Boulle made over to his sons in 1715 (Samoyault 1979: 65).

There had long been a close association between the Boulle and Oppenordt families. Both A.-J. Oppenordt and André-Charles Boulle, as *ébénistes du roi,* had been granted lodgings in the Louvre, Boulle in 1672 and Oppenordt in 1684. Thus Boulle would have been well aware of Gilles-Marie's precosity, at least from the age of twelve, and been able to follow his development at close hand. A.-J. Oppenordt, recognizing his son's great talent for architecture and design, arranged for him to study with Mansart and then helped send him off to Italy in 1692, where the young Oppenord stayed for seven years. G.-M. Oppenord returned to Paris in 1699 with a great feeling for the Italian Baroque and a wealth of ideas from which he drew for the rest of his life.

When Alexandre-Jean Oppenordt died in 1715, he left his entire estate to his son Gilles-Marie, including his Louvre workshop and whatever mount models it contained. A drawing signed by G.-M. Oppenord in the Cooper-Hewitt National Design Museum in New York (Dell 1992, V: 209, fig. 2), for one of A.-C. Boulle's most often produced *bureaux plats,* indicates that the younger Oppenord must have at least on occasion produced designs for this great maker.

With so little evidence it is difficult to assess just how the Clocks of the Four Continents came into being. What seems most likely is either that: G.-M. Oppenord designed a new clock case making use of already-existing mount models he owned from his father, commissioning the workshop of A.-C. Boulle and his sons to execute the *ébénisterie;* or conversely, that the Boulle establishment purchased from Oppenord the contents of Oppenord's father's workshop, commissioning him to produce a design that would incorporate some of these mounts. Very possibly a third party could have been involved, a *grand seigneur* who approached

either Boulle or Oppenord to provide the original version of this extraordinary clock, or possibly the clockmaker Julien Le Roy for one of his clients.

Terminal figures of this general form were used on a number of important pieces of late seventeenth-century French furniture, including works designed or executed by Jean Berain (Pradère 1989: 62, fig. 9), Sébastien Slodtz (Martin 1986: 103–11), Pierre Golle (Lunsingh Scheurleer 1980: 381–82), and Domenico Cucci (Verlet 1963: frontispiece and figs. 1a–1c; Pradère 1989: 54–55). Their inspiration seems principally derived from contemporary garden sculpture, which in turn had been inspired by terms from the Antique. Oppenord used them elsewhere in a design for the Salon d'Angle of the Palais Royal in 1719–20, where he coupled them with free-standing figures of the Continents (Kimball 1943: 121, fig. 133).

It is not known who modeled the present figures, although the sculptor involved would have followed closely the design that he had been given. It should be noted, however, that the head of Europe—with its downward tilt, brooding brow, and windblown beard—recalls the work of François Dumont (1688–1726), especially the head of his figure of Saint Paul, executed in 1713, and that of his figure of Saint Joseph, executed in 1725 (Souchal 1970: 237, fig. 11, 243, fig. 21; Souchal 1977: 273, fig. 136, 276, figs. 26C1 and C2). François Souchal compares these works with the even more closely related figure of Saint Matthew carved by Camillo Rusconi (1658–1728) for Saint John Lateran in Rome (Souchal 1970: 230, 237, fig. 12), which Dumont may very well have sketched on a brief trip to that city. François Dumont is believed to have worked with Gilles-Marie Oppenord in 1714 at the Hôtel de Toulouse in Paris. It is certain that he worked for him in 1725 at Saint Sulpice. Oppenord may also have sketched Rusconi's figure while he was in Rome.

The roundel of Hercules relieving Atlas of the Heavens is very close in conception to a design by G.-M. Oppenord for a free-standing globe clock incorporating such figures (Munich 1939: lot 348; Ronfort 1986: 486), an example of which, dated 1712 and probably executed by the elder Oppenordt, is in the Musée National des Techniques, Paris (Ronfort 1986: 486). The Atlas and Hercules compositions of both clocks stem almost certainly from Alessandro Algardi's mid-seventeenth-century relief of that subject in the Gallery of Hercules at the Villa Belrespiro (now Doria Pamphilj) in Rome (Montagu 1985, II: 454–55, fig. 90). This linkage is made more certain by the fact that Oppenord incorporated a trophy of Hercules from the same gallery into the base of this globe clock (Montagu 1985, II: fig. 94).

The Clock of the Four Continents was a major achievement in French clock design. Its sculptural shape, its baldachin-like hood, its elegantly posed figures of the Continents, and the roundel of Atlas and Hercules all seem to derive from

Oppenord's period in Rome. The young designer had been profoundly moved by the Italian Baroque, sketching all that interested him. His seven years in Italy were to affect him for the rest of his life.

Addendum

Besides the apparent Getty forgery, other nineteenth-century versions include two likely to have been executed from photographs of the Arsenal clock and bearing the signature of the Parisian cabinetmaker Emmanuel Zwiener (Amsterdam 1988: lot 237; Paris 1990a: lot 111), who is recorded as having worked in Paris between 1880 and 1895 (Ledoux-Lebard 1984: 645–46), and another executed from photographs, auctioned in London in 1995 (London 1995a: lot 190). A further example veneered with wood, its clock case lacking the figures of the Four Continents, was auctioned in Paris in 1993 (Paris 1993a: 18). As its movement was said to be signed by Mynnel [*sic*], it may possibly have been executed from a photograph of the Wallace example. A console table identified as dating from the Louis XIV period and having for its legs the same models of the Four Continents as those found on the Wallace, Waddesdon, and Arsenal clocks, was formerly in the collection of Baron Cassel (Paris 1954: lot 91).

THEODORE DELL

PAINTINGS

Maruyama Okyo
Japanese, 1733–1795

Pair of Two-Fold Screens: Tiger and Dragon, 1781

Ink, color, and gold on paper, 168 (66⅛) × 188 (74) overall
Founders Society Purchase, Mr. and Mrs. Horace E. Dodge Memorial Fund, Mr. and Mrs. Walter Buhl Ford II Fund, Josephine and Ernest Kanzler Founders Fund, Henry E. and Consuelo S. Wenger Foundation Fund, General Endowment Fund, Mary Martin Semmes Fund, and Abraham Borman Family Fund (81.693)

REFERENCES: Mitchell 1981: 60–61, 62, fig. 5; Cummings 1982: 8–9, fig. 5; Mitchell 1982: 28–29, 30–31, figs. 16a and b.

Alexandre Roslin
Swedish, 1718–1795

Louis Philippe, duc d'Orléans, Saluting His Army on the Battlefield, 1757

Oil on canvas, 300.4 (118¼) × 219.7 (86½)
Founders Society Purchase, Josephine and Ernest Kanzler Founders Fund, Mr. and Mrs. Horace E. Dodge Memorial Fund, and Robert H. Tannahill Foundation Fund (80.36)

EXHIBITIONS: Paris 1757: no. 69; Malmö 1937: no. 3.

REFERENCES: Lundberg 1957, I: 50–53, 304, II: pl. 27, III: 24; Sandström 1988: 47–54; Bjurström 1993: 23–25.

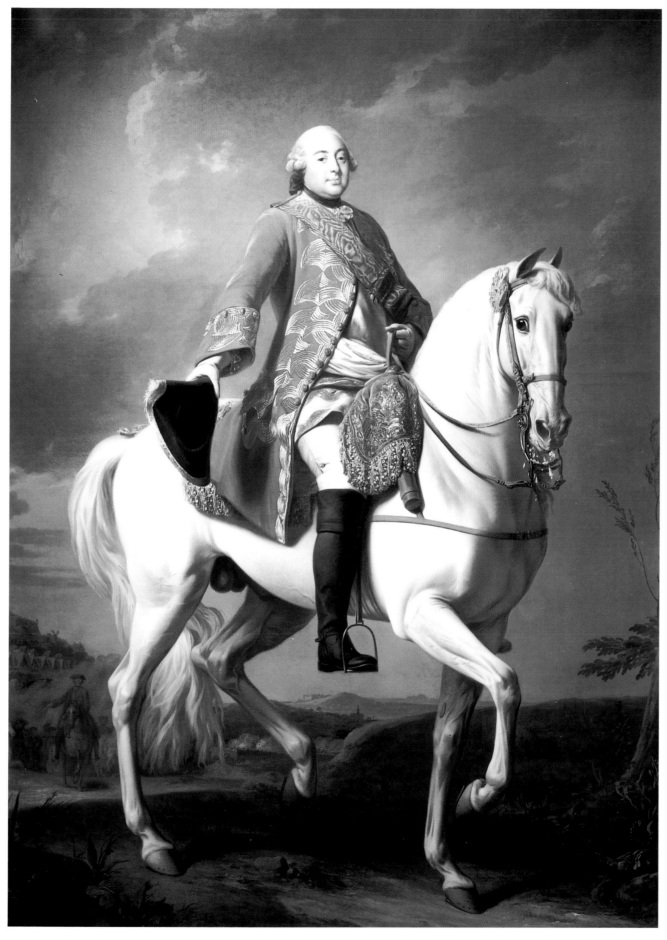

80.36

Antoine-Louis Barye
French, 1796–1875

Tiger Devouring a Gavial, 1831

Polychromed and patinated plaster, 43 (16¹⁵⁄₁₆) × 106 (41¾)
× 42 (16⁹⁄₁₆)
Founders Society Purchase, Mr. and Mrs. Horace E. Dodge
Memorial Fund, and Eleanor Clay Ford Fund (1983.11)

EXHIBITION: Paris 1831: no. 2177 (?).

REFERENCES: Los Angeles 1980: 126–28; Benge 1984: 31–34;
Darr 1988: 499, ill.

Attributed to Jean Thierry
French, 1669–1739

Bust of a Young Woman, c. 1715–20

Bronze, 66.4 (26⅛) × 41.3 (16¼)
Founders Society Purchase, Mr. and Mrs. Horace E. Dodge
Memorial Fund (71.397)

71.397

1983.11

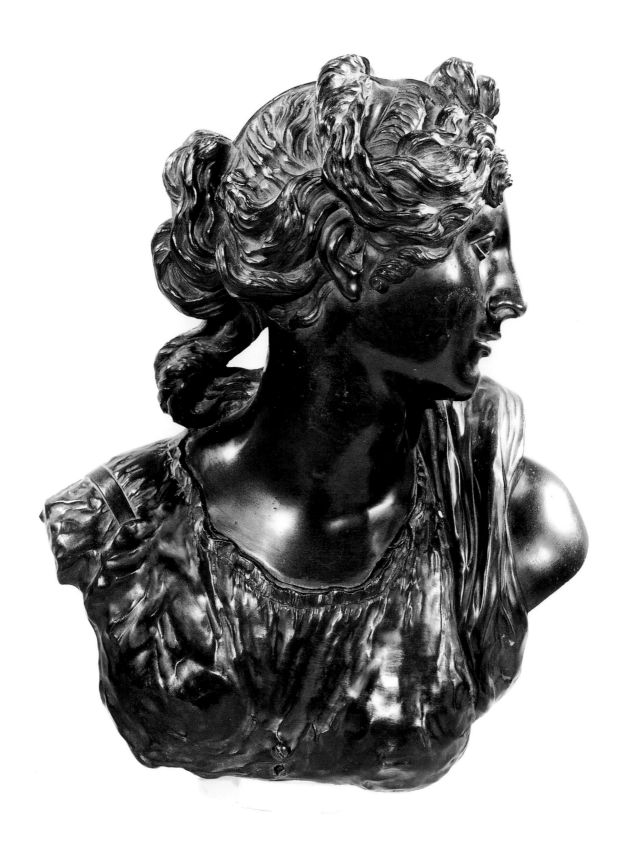

71.397

APPENDIX III
Concordance of Catalogue Entries and Accession Numbers

Accession no.	Catalogue no.	Accession no.	Catalogue no.
F71.47–F71.57	20	71.215	31
F71.58–F71.64	21	71.216, 71.217	32
F71.65	11	71.218, 71.219	59
F71.68	68	71.220a,b; 71.221a,b	55
71.169	66	71.222, 71.223	60
71.170	65	71.224, 71.225	57
71.171	67	71.226	58
71.172	12	71.227–71.230	56
71.173	22	71.231a,b; 71.232a,b	61
71.174, 71.175	25	71.233, 71.234	54
71.176	26	71.235–71.237	53
71.177	27	71.238, 71.239	62
71.178, 71.179	28	71.240a,b; 71.241a,b	47
71.180	37	71.242a,b; 71.243a,b	42
71.181	38	71.244a,b; 71.245a,b	43
71.182–71.187	19	71.246a,b; 71.247a,b	41
71.188–71.193	18	71.248a–c	51
71.194	15	71.249a,b–71.251a,b	40
71.195	14	71.252a,b	63
71.196	8	71.253a–c	50
71.197	13	71.254a,b	44
71.198	3	71.255	49
71.199	4	71.256	39
71.200	1	71.257	46
71.201, 71.202	17	71.258a,b; 71.259a,b	45
71.203, 71.204	16	71.260a,b; 71.261a,b	48
71.205	6	71.262a,b; 71.263a,b	52
71.206	7	71.294	23
71.207	10	71.295	24
71.208	2	71.296a–c; 71.297a–c	35
71.209	5	71.390–71.393	64
71.210	9	71.394, 71.395	34
71.211, 71.212	30	73.218a,b	33
71.213, 71.214	29	73.251a,b; 73.252a,b	36

ADAMS 1950. Adams, Philip R. "The Anson Room." *The Cincinnati Art Museum Bulletin* 1 (October 1950): 3–10.

ALCOUFFE, DION-TENENBAUM, and LEFÉBURE 1993. Alcouffe, Daniel, Anne Dion-Tenenbaum, and Amaury Lefébure. *Furniture Collections in the Louvre, I: Middle Ages, Renaissance, 17th–18th Centuries (Ébénisterie), 19th Century*. Dijon, 1993 (same pagination as the French edition, also 1993).

ALEXANDRE 1905. Alexandre, Arsène. "La collection E. Cronier." *Les Arts*, no. 47 (November 1905): 1–32.

ALEXEIEVA et al. 1993. Alexeieva, Alexandra Vassilievna, et al. *Pavlovsk: The Collections*. Paris, 1993.

AMSTERDAM 1988. Amsterdam, Sotheby's. *Decorative Arts, Including Parts of the Private Collection of Mr. D. Dooyes, Calgary, Canada, Formerly from Graveland, Holland*. Sale cat., May 31, 1988.

ANANOFF 1966. Ananoff, Alexandre. *L'oeuvre dessiné de François Boucher: Catalogue raisonné*. 2 vols. Paris, 1966.

ANANOFF and WILDENSTEIN 1976. Ananoff, Alexandre, and Daniel Wildenstein. *François Boucher*. 2 vols. Lausanne and Paris, 1976.

ANON. n.d. Anon., *Oeuvres de Fay et Prieur*. Paris, n.d.

APOLLINAIRE 1914. Apollinaire, Guillaume. *Fragonard and the United States*. Paris, 1914.

ARMSTRONG 1898. Armstrong, Walter. *Gainsborough and His Place in English Art*. New York, 1898.

ARMSTRONG 1900. ———. *Sir Joshua Reynolds: First President of the Royal Academy*. London and New York, 1900.

Art Quarterly 1971. "Recent Acquisitions of American and Canadian Museums." *The Art Quarterly* 34 (Winter 1971): 494–508.

ASSELBERGHS 1974. Asselberghs, Jean-Paul. *Les tapisseries flamandes aux États-Unis d'Amérique*. Brussels, 1974.

Athenaeum 1877. "The Royal Academy Winter Exhibition: Old Masters and Deceased British Painters (First Notice)." *The Athenaeum*, no. 2567 (January 6, 1877): 23–25.

Athenaeum 1877a. "The Royal Academy Winter Exhibition: Old Masters and Deceased British Painters (Third Notice)." *The Athenaeum*, no. 2569 (January 20, 1877): 86–87.

ATLANTA 1983. Atlanta, The High Museum of Art. *The Rococo Age: French Masterpieces of the Eighteenth Century*. Exh. cat. by Eric Zafran, 1983.

BADIN 1909. Badin, Jules. *La manufacture de tapisseries de Beauvais depuis ses origines jusqu'à nos jours*. Paris, 1909.

BAETJER et al. 1984. Baetjer, Katharine, et al. *The Jack and Belle Linsky Collection in The Metropolitan Museum of Art*. New York, 1984.

BAILLIE 1929. Baillie, G.H. *Watchmakers and Clockmakers of the World*. London, 1929.

BALDRY 1903. Baldry, Alfred Lys. *Sir Joshua Reynolds*. London and New York, 1903.

BAUDI DI VESME and CALABI 1928. Baudi di Vesme, A., and A. Calabi. *Francesco Bartolozzi: Catalogue des estampes et notice biographique d'après les manuscrits. . . .* Milan, 1928.

BAULEZ 1990. Baulez, Christian. "Meubles royaux récemment acquis à Versailles (1985–1989): Mobilier-Le bureau du Dauphin, fils de Louis XV." *La Revue du Louvre et des Musées de France*, no. 2 (1990): 98–99.

BELLAIGUE 1968. Bellaigue, Geoffrey de. *Buckingham Palace*. New York, 1968.

BELLAIGUE 1974. ———. *The James A. de Rothschild Collection at Waddesdon Manor: Furniture, Clocks and Gilt Bronzes*. 2 vols. Fribourg, 1974.

BELLAIGUE 1986. ———. "Jean-Frédéric Perregaux, the Englishman's Best Friend." *Antologia di Belle Arti*, nos. 29–30 (1986): 80–90.

BENGE 1984. Benge, Glenn. *Antoine-Louis Barye*. University Park and London, 1984.

BENOIS and PRAKHOF 1901–07. Benois, Aleksandr Nikolaevich, and Adrian Viktorovich Prakhof. *Les trésors d'art en Russie*. 7 vols. St. Petersburg, 1901–07 (vols. 3–7 Prakhof only).

BERCKENHAGEN 1970. Berckenhagen, Ekhart. *Die Französischen Zeichnungen der Kunstbibliothek Berlin*. Berlin, 1970.

BERENSON 1932. Berenson, Bernard. *Italian Pictures of the Renaissance*. Oxford, 1932.

BERLIN 1929. Berlin, Lepke's. *Kunstwerke aus den Beständen Leningrader Museen und Schlösser*. Sale cat., June 4–5, 1929.

BERLIN 1933. Berlin, Hermann Ball-Paul Graupe. *Kunstwerke aus dem Besitz Baron Albert von Goldschmidt-Rothschild*. Sale cat., March 14, 1933.

BIVER 1933. Biver, Paul. *Histoire du château de Bellevue*. Paris, 1933.

BJURSTRÖM 1959. Bjurström, Per. "Les illustrations de Boucher pour Molière." *Figura* 1 (1959): 138–52.

BJURSTRÖM 1993. ———. *Roslin*. Högans, 1993.

BLOCH 1930. Bloch, Stella Rubinstein. *Catalogue of the Collection of George and Florence Blumenthal*. 6 vols. Paris, 1930.

BLOCK 1933. Block, Maurice. *François Boucher and the Beauvais Tapestries*. Boston and New York, 1933.

BOTTINEAU and LEFUEL 1965. Bottineau, Yves, and Oliver Lefuel. *Les grands orfèvres de Louis XIII à Charles X*. Paris, 1965.

BOUILHET 1908–12. Bouilhet, Henri. *L'orfèvrerie française aux XVIIIe siècle.* 3 vols. Paris, 1908–12.

BOURNE 1984. Bourne, Jonathan. "Rothschild Furniture at Dalmeny." *Apollo* 119 (June 1984): 406–11.

BOUTEMY 1964. Boutemy, André. "Jean-François Oeben méconnu." *Gazette des Beaux-Arts* 43 (April 1964): 207–24.

BOUTEMY 1973. ———. *Meubles français anonymes du XVIIIe siècle.* Brussels, 1973.

BRACKETT 1922. Brackett, Oliver. *Catalogue of the Jones Collection.* Part 1, *Furniture.* Victoria and Albert Museum, London, 1922.

BRECKENRIDGE 1958. Breckenridge, James D. "Three Signed Pieces of Louis XVI Furniture." *The Baltimore Museum of Art News* 21 (April 1958): 1–16.

BREMER-DAVID et al. 1993. Bremer-David, Charissa, et al. *Decorative Arts: An Illustrated Summary Catalogue of the Collections of The J. Paul Getty Museum.* Malibu, 1993.

BRITTEN 1932. Britten, F.J. *Old Clocks and Watches and Their Makers.* London, 1932.

BRUGES 1987. Bruges, Gruuthusemuseum. *Bruges et la tapisserie.* Exh. cat. by Guy Delmarcel and Erik Duverger, 1987.

BRUNET and PRÉAUD 1978. Brunet, Marcelle, and Tamara Préaud. *Sèvres: Des origines à nos jours.* Fribourg, 1978.

BUCKINGHAMSHIRE 1977. Buckinghamshire, Sotheby Parke-Bernet and Co. *Mentmore II: Works of Art and Silver Sold on Behalf of the Estate of the Late 6th Earl of Rosebery and His Family.* Sale cat., May 18–23, 1977.

BUCKLAND 1972. Buckland, Frances. "A Group of Bureaux Plats and the Royal Inventories." *Furniture History: The Journal of the Furniture History Society* 8 (1972): 41–46.

BUCKLAND 1980. ———. "Die Karriere eines Kunstschreiners: Johann Heinrich Riesener—Ebenist am Hofe Ludwigs XVI." *Kunst & Antiquitäten* 6 (1980): 22–40.

Bulletin of The Detroit Institute of Arts 1942. "Accessions." *Bulletin of The Detroit Institute of Arts* 21 (February 1942): 42–46.

BURKARD 1970. Burkard, Suzanne. *Mémoires de la baronne d'Oberkirch sur la cour de Louis XVI et la société française avant 1789.* Paris, 1970.

BURKE 1967. *Burke's Genealogical and Heraldic History of the Peerage, Baronetage and Knightage.* 104th ed. London, 1967.

Burlington Magazine 1927. "Notable Works of Art Now on the Market." *The Burlington Magazine* 51 (December 1927): advertising supplement.

BURTON 1922. Burton, Clarence Monroe. *The City of Detroit, Michigan, 1701–1922.* 5 vols. Detroit, 1922.

CAREY and HOARE 1819. Carey, William, and Richard Colt Hoare. *A Descriptive Catalogue of a Collection of Paintings by British Artists in the Possession of Sir John Fleming Leicester, Bart. . . .* London, 1819.

CASTILLO 1947. Castillo, Alberto del. *Jose Maria Sert: Su obra y su vida.* Barcelona and Buenos Aires, 1947.

CAYEUX 1993. Cayeux, Jean de. "Le décor d'oiseaux colorés à Vincennes et à Sèvres." *Sèvres,* no. 2 (1993): 7–36.

CAYEUX DE SÉNARPORT 1968. Cayeux de Sénarport, Jean-Marc de. "Hubert Robert et sa collaboration." *Bulletin de la Société de l'Histoire de l'Art Français* (1968): 127–33.

CAYLUS 1752–67. Caylus, Anne-Claude-Philippe, comte de. *Recueil d'antiquités égyptiennes, étrusques, grecques et romaines.* 7 vols. Paris, 1752–67.

CHAMPEAUX 1896. Champeaux, Alfred de. *Dictionnaire des fondeurs, ciseleurs, modeleurs en bronze et doreurs depuis le moyen-age jusqu'à l'époque actuelle,* II. Manuscript notes on Duplessis, Musée des Arts Décoratifs, Paris, 1886.

CHARAGEAT 1953. Charageat, Marguerite. "Vénus donnant un message à Mercure par Pigalle." *La Revue des Arts* 3 (December 1953): 217–22.

CHARNOCK 1794–98. Charnock, John. *Biographia Navalis; or, Impartial Memoirs of the Lives and Characters of Officers of the Navy of Great Britain, from the Year 1660 to the Present Time, Drawn from the Most Authentic Sources and Disposed in Chronological Arrangement.* 6 vols. London, 1794–98.

CHENEVIÈRE 1988. Chenevière, Antoine. *Russian Furniture: The Golden Age 1780–1840.* New York, 1988.

CLARK 1985. Clark, Anthony M. *Pompeo Batoni: A Complete Catalogue of His Works with an Introductory Text.* New York, 1985.

CLÉMENT-GRANDCOURT 1994. Clément-Grandcourt, Brigitte. "Jean-Jacques Bachelier peintre de fleurs et d'animaux." *L'Estampille/L'Objet d'art,* no. 277 (February 1994): 31–43.

CLEVELAND 1964. Cleveland, The Cleveland Museum of Art. *Neo-Classicism: Style and Motif.* Exh. cat. by Henry Hawley, 1964.

CLOUZOT 1925. Clouzot, Henri. *Des Tuileries à Saint-Cloud: L'art décoratif du Second Empire.* Paris, 1925.

COHEN 1991. Cohen, David Harris. "The Chambre des Portraits Designed by Victor Louis for the King of Poland." *The J. Paul Getty Museum Journal* 19 (1991): 75–98.

COKAYNE 1910–59. Cokayne, George Edward. *The Complete Peerage of England, Scotland, Ireland, Great Britain, and the United Kingdom, Extant, Extinct, or Dormant.* Rev. ed. 13 vols. London, 1910–59.

COLE 1931. Cole, William, ed. *A Journal of My Journey to Paris in the Year 1765.* London, 1931.

COLES and MEAD 1973. Coles, William A., and Priscilla Mead. "Rose Terrace, Grosse Pointe, Michigan." *Classical America* 3 (1973): 37–47.

Connaissance des Arts 1953. "Charles Topino." *Connaissance des Arts,* no. 22 (December 1953): 53–57.

Connoisseur 1906. "The Chérémeteff Sèvres Porcelain." *The Connoisseur* 15 (1906): 243–48.

Connoisseur 1927. *The Connoisseur* 78 (July 1927): LI, advertisement.

Connoisseur 1971. "Works of Art with a Royal Provenance from the Collection of the Late Mrs. Anna Thompson Dodge of Detroit." *The Connoisseur* 177 (May 1971): 34–36.

Connoisseur 1972. *The Connoisseur* 181 (October 1972): 84, advertisement.

CONTET 1913. Contet, Frédéric. *Les sièges d'art: Époques Louis XIV, Louis XV, Louis XVI et Empire. Le mobilier d'art français au XVIIe et au XVIIIe siècles.* Paris, 1913.

CORTISSOZ 1924. Cortissoz, Royal. "An Original Master of Mural Decoration." *The New York Herald Tribune,* February 3, 1924. (Reprinted in the catalogue of the exhibition, New York 1924: n.p.)

COSTE-MESSELIÈRE 1969. Coste-Messelière, Marie-Geneviève de la. "La villa Demidoff." *L'Oeil,* no. 171 (March 1969): 40–47.

COTTON 1856. Cotton, William. *Sir Joshua Reynolds and His Works: Gleanings from His Diary, Unpublished Manuscripts, and from Other Sources.* London, 1856.

Country Life 1965. "Collectors' Questions." *Country Life* 138 (December 23, 1965): 1724–25.

COURAJOD 1965. Courajod, Louis, ed. *Livre-journal de Lazare Duvaux marchand-bijoutier ordinaire du roi 1748–1758* (1873). 2 vols. Paris, 1965.

CROFT-MURRAY 1963. Croft-Murray, Edward. "The Hôtel Grimod de la Reynière: The Salon Decorations." *Apollo* 78 (November 1963): 377–83.

CUMMINGS 1982. Cummings, Frederick J. "Director's Report." *Bulletin of The Detroit Institute of Arts* 60 (Summer 1982): 6–9.

CURL 1984. Curl, Donald W. *Mizner's Florida: American Resort Architecture.* Cambridge, Massachusetts, 1984.

CUZIN 1988. Cuzin, Jean-Pierre. *Jean-Honoré Fragonard: Vie et oeuvre.* Fribourg, 1988.

DAB 1974. *The Dictionary of American Biography,* Supplement 4, 1946–50. New York, 1974.

DACIER 1909–21. Dacier, Émile, ed. *Catalogues des ventes et livrets de Salons illustrés et annotés par Gabriel de Saint-Aubin.* 6 vols. Paris, 1909–21.

DACIER 1932. Dacier, Émile. "L'athénienne et son inventeur." *Gazette des Beaux-Arts* 8 (August–September 1932): 112–22.

D'AGLIANO 1986. D'Agliano, Andreina. "Alcune considerazioni sulle porcellane di Sèvres delle ex collezioni reali italiane." *Bollettino d'Arte,* nos. 35–36 (January–April 1986): 67–70.

DARCEL and GUICHARD 1878–81. Darcel, Alfred, and E. Guichard. *Les tapisseries décoratives du Garde-Meuble (Mobilier National): Choix des plus beaux motifs.* 3 vols. Paris, 1878–81.

DARR 1988. Darr, Alan Phipps. "European Sculpture and Decorative Arts Acquired by The Detroit Institute of Arts 1978–87." *The Burlington Magazine* 130 (June 1988): 495–500.

DAUTERMAN 1970. Dauterman, Carl C. *The Wrightsman Collection.* Vol. 4, *Porcelain.* New York, 1970.

DAUTERMAN 1976. ——. "Sèvres Figure Painting in the Anna Thomson Dodge Collection." *The Burlington Magazine* 118 (November 1976): 753–62.

DAUTERMAN 1986. ——. *Sèvres Porcelain: Makers and Marks of the Eighteenth Century.* New York, 1986.

DAUTERMAN, PARKER, and STANDEN 1964. Dauterman, Carl C., James Parker, and Edith Appleton Standen. *Decorative Art from the Samuel H. Kress Collection at The Metropolitan Museum of Art.* London, 1964.

DAVIDSON 1973. Davidson, Ruth. "Museum Accessions." *Antiques* 103 (March 1973): 440–54.

DAVILLIER 1876. Davillier, Baron Charles. "La vente du mobilier du château de Versailles pendant la terreur." *Gazette des Beaux-Arts* 14 (1876): 146–56.

DAVIS 1884. Davis, Charles. *A Description of the Works of Art Forming the Collection of Alfred de Rothschild.* Vol. 2, *Sèvres China, Furniture, Metal Work and Objects de Vitrine.* London, 1884.

DAWSON 1980. Dawson, Aileen. "The Eden Service, Another Diplomatic Gift." *Apollo* 111 (April 1980): 28–97.

DAYOT and VAILLAT 1907. Dayot, Armand, and Léandre Vaillat. *L'oeuvre de J.-B.-S. Chardin et de J.-H. Fragonard.* Paris, 1907.

DEL 1953. Del, Anden. *C.L. Davids Samling, Vol. 2.* Copenhagen, 1953.

DELL 1992. Dell, Theodore. *The Frick Collection: An Illustrated Catalogue.* Vol. 6, *Furniture and Gilt Bronzes, French.* New York, 1992.

DENNIS 1960. Dennis, Faith. *Three Centuries of French Domestic Silver.* 2 vols. New York, 1960.

DESNOIRESTERRES 1877. Desnoiresterres, Gustave. *Grimod de la Reynière et son groupe.* Paris, 1877.

DETROIT 1926. The Detroit Institute of Arts. *The Second Loan Exhibition of Old Masters: British Paintings of the Late Eighteenth and Early Nineteenth Centuries.* Exh. cat. by William R. Valentiner, 1926.

DETROIT 1933. *A Catalogue of Works of Art in the Collection of Anna Thomson Dodge.* Detroit, 1933.

DETROIT 1939. *A Catalogue of Works of Art of the Eighteenth Century in the Collection of Anna Thomson Dodge.* 2 vols. Detroit, 1939.

DETROIT 1956. The Detroit Institute of Arts. *French Taste in the Eighteenth Century.* Exh. cat. by Paul L. Grigaut, 1956.

DETROIT 1958. ——. *Decorative Art of the Italian Renaissance.* Exh. cat., 1958.

DETROIT 1961. ——. *European Decorative Arts in the Eighteenth Century.* Exh. cat. by Paul L. Grigaut, 1961.

DETROIT 1972. ——. "Annual Report 1971." *Bulletin of The Detroit Institute of Arts* 51 (1972): 14, 25.

DETROIT 1972a. Detroit, DuMouchelle Art Galleries. *Fine Furniture and Other Objects of Vertu.* Sale cat., October 20–22, 1972.

DETROIT 1979. The Detroit Institute of Arts. *Selected Works from The Detroit Institute of Arts.* Detroit, 1979.

DETROIT 1986. The Detroit Institute of Arts, Galeries Nationales du Grand Palais, Paris, and The Metropolitan Museum of Art, New York. *François Boucher, 1703–1770.* Exh. cat. by Alastair Laing et al., 1986.

Detroit Free Press 1957. "Detroit Institute to Get Famed Dodge Paintings." *The Detroit Free Press,* April 14, 1957: 1.

DIDEROT 1761. Seznec, Jean, and Jean Adhémar, eds. *Diderot Salons. I: 1759, 1761, 1763.* Oxford, 1975.

DILKE 1901. Dilke, [Emilia F.S.]. *French Furniture and Decoration in the XVIIIth Century.* London, 1901.

DNB 1967–68. *The Dictionary of National Biography: From the Earliest Times to 1900.* 22 vols. London, 1967–68.

DRAGESCO 1994. Dragesco, Bernard. "Les décors d'oiseaux à la mode de Vincennes-Sèvres au XVIIIe siècle." In Tournai, Musée des Arts Décoratifs, Musée des Beaux-Arts, and Musée d'Histoire Naturelle. *Des porcelaines et des oiseaux.* Exh. cat., 1994: 39–54.

DRAPER 1991–92. Draper, James David. "French Terracottas." *The Metropolitan Museum of Art Bulletin* 49 (1991–92): 1–57.

DREYFUS 1922. Dreyfus, Carle. *Musée National du Louvre: Catalogue sommaire du mobilier du XVIIe et du XVIIIe siècle.* Paris, 1922.

DREYFUS 1923. ———. *Musée du Louvre: Les objets d'art du XVIIIe siècle, époque de Louis XVI.* Paris, 1923.

DUMOLIN 1926. Dumolin, Maurice. "Rapport . . . sur l'hôtel de la Reynière et les servitudes d'aspect de l'avenue Gabriel." *Ville de Paris, commission de vieux Paris, procès-verbal.* Paris (November 1926): 143–44.

DUMOLIN 1928. ———. "Signalment de la vente de l'hôtel de la Reynière, . . ." *Ville de Paris, commission de vieux Paris, procès . . . verbal.* Paris (June 30, 1928): 138–39.

DUMOLIN and ROCHEGUDE 1923. Dumolin, Maurice, and Marquis de Rochegude. *Guide pratique à travers le vieux Paris.* Paris, 1923.

DUMONTHIER n.d. Dumonthier, Ernest. *Les bronzes du Mobilier National: Pendules et cartels.* Paris, n.d.

DURET-ROBERT 1972. Duret-Robert, François. "Les tapisseries de Beauvais n'atteignent pas toujours des prix élevés." *Connaissance des Arts,* no. 243 (May 1972): 35–36.

EDWARDS 1743–51. Edwards, George. *A Natural History of Birds.* 2 vols. London, 1743–51.

EDWARDS 1758–63. ———. *Gleanings of Natural History.* 3 vols. London, 1758–63.

ENNÈS 1989. Ennès, Pierre. "The Visit of the Comte and Comtesse du Nord to the Sèvres Factory." *Apollo* 127 (March 1989): 150–56, 220–22.

ERIKSEN 1968. Eriksen, Svend. *The James A. de Rothschild Collection at Waddesdon Manor: Sèvres Porcelain.* Fribourg, 1968.

ERIKSEN 1974. ———. *Early Neo-Classicism in France.* London, 1974.

ERIKSEN and WATSON 1963. Eriksen, Svend, and F.J.B. Watson. "The 'Athénienne' and the Revival of the Classical Tripod." *The Burlington Magazine* 105 (March 1963): 108–12.

FABIAN 1982. Fabian, Dietrich. *Die Entwicklung der Roentgen-Schreibmöbel.* Bad Neustadt a.d. Saale, 1982.

FABIANSKI 1985. Fabianski, Marcin. "Studies in Duquesnoy: His Literary Sources and Imitators." *Antichità Viva* 24, nos. 5–6 (1985): 40–49.

FALDI 1959. Faldi, Italo. "Le 'virtuose operazioni' di Francesco Duquesnoy, scultore incomparabile." *Arte Antica e Moderna* 5 (January–March 1959): 52–62.

FANIEL 1957. Faniel, Stéphane. *French Art of the Eighteenth Century.* London, 1957.

FARAGGI 1995. Faraggi, Catherine. "Le goût de la duchesse de Mazarin: Décor et ameublement de son hôtel parisien." *L'Estampille/ L'Objet d'art,* no. 287 (January 1995): 72–98.

FENAILLE 1904–07. Fenaille, Maurice. *État général des tapisseries de la manufacture des Gobelins depuis l'origine jusqu'à nos jours 1600–1900.* 5 vols. Paris, 1904–07.

FERRY 1968. Ferry, W. Hawkins. *The Buildings of Detroit.* Detroit, 1968.

FERRY 1980. ———. *The Buildings of Detroit.* Rev. ed. Detroit, 1980.

FEULNER 1927. Feulner, Adolf. *Kunstgeschichte des Möbels seit dem Altertum.* Berlin, 1927.

FLAMENT 1924. Flament, Albert. "Sur les décorations nouvelles de José-Maria Sert." *La Renaissance de l'art français et des industries de luxe* 7 (1924): 60.

FLIT et al. 1993. Flit, Marina Alexandrovna, et al. *Pavlovsk: The Palace and the Park.* Paris, 1993.

FLORENCE 1880. Florence, Charles Pillet. *Palais de San Donato.* Sale cat., March 15, 1880.

FORTI GRAZZINI 1982. Forti Grazzini, Nello. *L'arazzo ferrarese.* Milan, 1982.

FORTI GRAZZINI 1993. ———. *Il patrimonio artistico del Quirinale: Gli arazzi.* 2 vols. Rome and Milan, 1993.

FOWLES 1976. Fowles, Edward. *Memories of Duveen Brothers.* London, 1976.

FREDERICKSEN and ZERI 1972. Fredericksen, Burton B., and Federico Zeri. *Census of Pre-Nineteenth-Century Italian Paintings in North American Public Collections.* Cambridge, Massachusetts, 1972.

FRÉGNAC 1966. Frégnac, Claude. *Merveilles des châteaux de Normandie.* Paris, 1966.

FRÉGNAC 1975. ———. *Les styles français.* Paris, 1975.

FRÉGNAC and MEUVRET 1965. Frégnac, Claude, and Jean Meuvret. *French Cabinetmakers of the Eighteenth Century.* New York, 1965.

GALLET 1972. Gallet, Michel. *Stately Mansions: Eighteenth-Century Paris Architecture.* New York and Washington, 1972.

GASC and MABILLE 1991. Gasc, Nadine, and Gérard Mabille. *The Nissim de Camondo Museum.* Paris, 1991.

Gazette de l'Hôtel Drouot 1993. *La Gazette de l'Hôtel Drouot,* no. 23 (June 4, 1993): 18, advertisement for sale at Drouot-Richelieu, salle 10, June 11, 1993.

Gazette des Beaux-Arts 1972. "La chronique des arts." Gazette des Beaux-Arts 79 (January 1972): supplement, 1–188.

GENEVA 1973. Geneva, Christie, Manson and Woods. Important French Furniture, Objects of Art, Clocks, Tapestries and Carpets, the Property of Various Private Collectors. Sale cat., May 8, 1973.

GENEVA 1974. ———. Important French Furniture and Objects of Art. Sale cat., November 18, 1974.

GENEVA 1990. ———. European Silver, Objects of Vertu, Miniatures, Russian Works of Art and Fabergé. Sale cat., November 13, 1990.

GENEVA 1994. Geneva, Sotheby's. European Silver. Sale cat., May 16, 1994.

Gentleman's Magazine 1819. "Review of New Publications: 36. A Description of Hadleigh in the County of Suffolk." Gentleman's Magazine 89 (September 1819): 247.

Gentleman's Magazine 1833. "Obituary: Sir William Rowley, Bart." Gentleman's Magazine 103 (January 1833): 83.

Gentleman's Magazine 1850. "Obituary: Susannah-Edith Rowley." Gentleman's Magazine 188 (January 1850): 686.

Gentleman's Magazine 1860. "Obituary: Lady Arethusa Harland." Gentleman's Magazine 208 (May 1860): 531.

GILL and ZERBE 1973. Gill, Brendan, and Jerome Zerbe. Happy Times. New York, 1973.

GÖBEL 1928. Göbel, Heinrich. Wandteppiche, Part II: Die romanischen Länder. 2 vols. Leipzig, 1928.

GOMES FERREIRA 1982. Gomes Ferreira, Maria Teresa. Calouste Gulbenkian Museum: Catalogue. Lisbon, 1982.

GONCOURTS n.d. Goncourt, Edmond Louis Antoine Huot de, and Jules Alfred Huot de Goncourt. Portraits intimes.... Paris, n.d.

GONSE 1904. Gonse, Louis. Les chefs-d'oeuvre des musées de France: Sculpture, dessins, objets d'art. Paris, 1904.

GORDON 1968. Gordon, Katherine K. "Madame de Pompadour, Pigalle, and the Iconography of Friendship." The Art Bulletin 50 (September 1968): 249–62.

GRAVES 1905–06. Graves, Algernon. The Royal Academy of Arts: A Complete Dictionary of Contributors and Their Works from Its Foundation in 1769 to 1904. 8 vols. London, 1905–06.

GRAVES 1913–15. ———. A Century of Loan Exhibitions, 1813–1912. 5 vols. London, 1913–15.

GRAVES 1918–21. ———. Art Sales from Early in the Eighteenth Century to Early in the Twentieth Century (Mostly Old Master and Early English Pictures). 3 vols. London, 1918–21.

GRAVES and CRONIN 1899–1901. Graves, Algernon, and William Vine Cronin. A History of the Works of Sir Joshua Reynolds. 4 vols. London, 1899–1901.

GREBER 1980. Greber, Josef Maria. Abraham und David Roentgen: Möbel für Europa. 2 vols. Starnberg, 1980.

GROSSE POINTE 1981. Grosse Pointe, Michigan, University Liggett School. European Decorative Arts from Royal Collections. Exh. cat. by Alan Phipps Darr, 1981.

GROSSE POINTE FARMS 1971. Grosse Pointe Farms, Michigan, Christie, Manson and Woods, and H.O. McNierney, Stalker and Boos, Inc. The Remaining Contents of Rose Terrace, the Property of the Late Mrs. Anna Thomson Dodge, Sold by Order of the Executors, Comprising Fine Old French and English Furniture and Works of Art, Aubusson and Eastern Carpets, Oriental Objects of Art, Decorative Porcelain and Glass, Jewellery, Silver and Objects of Vertu, Pictures, Books and Household Furnishings. Sale cat., September 27–29, 1971.

GROSSE POINTE FARMS 1976. Grosse Pointe Farms, Michigan, Stalker and Boos. Public Auction on the Premises, Rose Terrace. Sale cat., June 5–9, 1976. (Rose Terrace fittings June 8–9 only)

GUÉRINET 1908. Guérinet, Armand. Le Palais de Fontainebleau, décorations intérieures et extérieures. Vol. 4: Les bronzes, objets d'art, etc. Paris, 1908.

GUÉRINET n.d. ———. L'oeuvre de Lepautre. Paris, n.d.

GUIGARD 1890. Guigard, Joannis. Nouvel armorial du bibliophile. 2 vols. Paris, 1890.

HAARLEM 1989. Haarlem, Frans Halsmuseum. Meubelen en zilver up de tentoonstelling. Edele eenvoud: Neo-classicisme in Nederland, 1765–1800. Exh. cat. by Reinier J. Baarsen, 1989.

HALL 1962. Hall, Douglas. "The Tabley House Papers." Walpole Society 1960–1962 38 (1962): 59–122.

HALL 1986. Hall, Michael. "The Chartres Forth Service, Philippe Egalité's Lavish Gift." Apollo 123 (June 1986): 386–89.

HAMBURG 1950. Hamburg, Galerie Dr. Hans Rudolph. Das Grossherzoglich-Mecklenburgische Silber, Drei Miniaturen-Sammlungen, Der Kabinettschrank des Fürsten von und zu Putbus, Der Sog "Wrangelschrank," Porzellan der Sammlung S.- Berlin, verschiedener Kunstbesitz. Sale cat., September 28–29, 1950.

HAMILTON 1884. Hamilton, Edward. A Catalogue Raisonné of the Engraved Works of Sir Joshua Reynolds, P.R.A., from 1755 to 1822, with a Description of the Different States of Each Plate, a Biographical Sketch of Each Person, and a List of the Pictures from which the Engravings Were Taken with Dates of Paintings, Names of Possessors and Other Particulars. Rev. ed. London, 1884.

HAUG 1965. Haug, Hans. "Musée des Beaux-Arts de Strasbourg: Récentes acquisitions (1958–1964)." La Revue du Louvre et des Musées de France, no. 2 (1965): 85–98.

HAUTECOEUR 1952. Hautecoeur, Louis. Histoire de l'architecture classique en France. 7 vols. Paris, 1952.

HAUTECOEUR 1953. ———. L'art sous la révolution et l'empire en France 1789–1815. Nouvelle encyclopédie illustrée de l'art français. Paris, 1953.

HAWLEY 1970. Hawley, Henry H. "Jean-Pierre Latz, Cabinetmaker." The Bulletin of the Cleveland Museum of Art 57 (September–October 1970): 203–59.

HAWLEY 1994. ———. "Tassaert's Venus, Not Falconet's Flora." La scultura, studi in onore di Andrew S. Ciechanowiecki, in Antologia di belle arti (1994): 100–06.

H.H. 1955. H.H. "Jean-Baptiste-Claude Odiot." Connaissance des Arts, no. 45 (November 1955): 52–57.

HIESINGER 1976. Hiesinger, Kathryn B. "The Sources of François Boucher's *Psyche* Tapestries." *Bulletin of the Philadelphia Museum of Art* 72 (November 1976): 7–23.

HILDEBRANDT 1908. Hildebrandt, Edmund. *É.-M. Falconet.* Strasbourg, 1908.

HODGKINSON 1970. Hodgkinson, Terence. *The James A. de Rothschild Collection at Waddesdon Manor: Sculpture.* Fribourg, 1970.

HODGKINSON 1974. ———. "A Clodion Statuette in the National Gallery of Canada." *National Gallery of Canada Bulletin* 24 (1974): 13–21.

HODGKINSON and POPE-HENNESSY 1970. Hodgkinson, Terence W.I., and John Pope-Hennessy. *The Frick Collection: An Illustrated Catalogue.* Vol. 4, *Sculpture, German, Netherlandish, French and British.* New York, 1970.

HOVEY 1975. Hovey, Walter Read. *Treasures of the Frick Art Museum.* Pittsburgh, 1975.

HUARD 1928. Huard, Georges. "Oppenord." In Louis Dimier, ed., *Les peintres français du XVIIIe siècle: Histoire des vies et catalogue des oeuvres.* Vol 1. Paris and Brussels, 1928: 311–29.

HUDSON 1958. Hudson, Derek. *Sir Joshua Reynolds: A Personal Study.* London, 1958.

HUGHES 1994. Hughes, Peter. *French Eighteenth-Century Clocks and Barometers in the Wallace Collection.* London, 1994.

HUGHES 1996. ———. *The Wallace Collection Catalogue of Furniture.* Vol. 1. London, 1996.

HUNTER 1925. Hunter, George Leland. *The Practical Book of Tapestries.* Philadelphia and London, 1925.

HUSSMAN 1977. Hussman, Geraldine C. "Boucher's *Psyche at the Basketmakers:* A Closer Look." *The J. Paul Getty Museum Journal* 4 (1977): 45–50.

HUTH 1928. Huth, Hans. *Abraham und David Roentgen und ihre Neuwieder Möbelwerkstatt.* Berlin, 1928.

HUTH 1955. ———. *Möbel von David Roentgen.* Darmstadt, 1955.

HUTH 1974. ———. *Roentgen Furniture. Abraham and David Roentgen: European Cabinetmakers.* London, 1974.

ISKIERSKI 1929. Iskierski, Stanislas. *Les bronzes du château royal et du Palais de Lazienki.* Warsaw, 1929.

JACKSON-STOPS and RIEDER 1976. Jackson-Stops, Gervase, and William Rieder. "French Furniture." In Robin Fedden, ed., *Treasures of the National Trust.* London, 1976, chap. 6.

JACOBY and CRAWFORD 1970. Jacoby, Oswald, and John R. Crawford. *The Backgammon Book.* London, 1970.

JANNEAU 1970. Janneau, Guillaume. *Le meuble d'ébénisterie.* Paris, 1970.

JARRY 1969. Jarry, Madeleine. "Esquisses et maquettes de tapisseries du XVIIIe siècle pour les manufactures royales (Gobelins et Beauvais)." *Gazette des Beaux-Arts* 73 (February 1969): 111–18.

JOHNSON 1976. Johnson, Edward Mead. *Francis Cotes: Complete Edition with a Critical Essay and a Catalogue.* Oxford, 1976.

JOUIN 1888. Jouin, Henri. *Musée des portraits d'artistes, peintres, sculpteurs, architectes, graveurs, musiciens, artistes dramatiques, amateurs, etc., nés en France ou y ayant veçu. État de 3,000 portraits, peints, dessinés ou sculptés, avec l'indication des collections publiques ou privées qui les renferment.* Paris, 1888.

Jours de France 1970. *Jours de France,* June 30, 1970: 104.

KENNETT 1973. Kennett, Audrey, and Victor Kennett. *The Palaces of Leningrad.* London, 1973.

KIMBALL 1943. Kimball, Fiske. *The Creation of the Rococo.* Philadelphia, 1943.

KIMBALL 1944. ———. "French Soft Paste Porcelain of the Louis XV and Louis XVI Periods." *Bulletin of the Philadelphia Museum of Art* 39 (March 1944): 69–111.

KJELLBERG 1980. Kjellberg, Pierre. *Le mobilier français.* Vol. 2, *De la transition Louis XV–Louis XVI à 1925.* Paris, 1980.

KJELLBERG 1989. ———. *Le mobilier français du XVIIIe siècle: Dictionnaire des ébénistes et des menuisiers.* Paris, 1989.

KLINGE 1991. Klinge, Margret. *David Teniers the Younger.* Antwerp, 1991.

KOSAREVA 1975. Kosareva, Nina. "Masterpieces of Eighteenth-Century French Sculpture." *Apollo* 101 (June 1975): 443–51.

KREISEL and HIMMELHEBER 1973. Kreisel, Heinrich, and Georg Himmelheber. *Die Kunst des deutschen Möbels.* Vol. 3, *Klassizismus, Historismus, Jugendstil.* Munich, 1973.

KUCHUMOV 1975. Kuchumov, Anatoly Mikhailovich. *Pavlovsk: Palace and Park.* Leningrad, 1975.

LAHAUSSOIS 1992. Lahaussois, Christine. "Assiette en porcelaine dure de Sèvres, vers 1792." *L'Estampille/L'Objet d'art,* no. 259 (June 1992): fiche 259D.

LAKING 1907. Laking, Guy Francis. *Sèvres Porcelain of Buckingham Palace and Windsor Castle.* London, 1907.

LAMI 1910–11. Lami, Stanislas. *Dictionnaire des sculpteurs de l'école française au XVIIIe siècle.* 2 vols. Paris, 1910–11.

LATHAM and AGRESTA 1989. Latham, Caroline, and David Agresta. *Dodge Dynasty: The Car and the Family That Rocked Detroit.* New York, 1989.

LEBEN 1992. Leben, Ulrich. *Molitor: Ébéniste from the Ancien Régime to the Bourbon Restoration.* London, 1992.

LE BLANC 1856. Le Blanc, Charles. *Manuel de l'amateur d'estampes.* 4 vols. Paris, 1856–90.

LE BRUN 1776. Le Brun, Jean-Baptiste-Pierre. *Almanach des artistes.* Paris, 1776.

LE BRUN 1777. ———. *Almanach des artistes.* Paris, 1777.

LE CORBEILLER 1963. Le Corbeiller, Clare. "Mercury, Messenger of Taste." *The Metropolitan Museum of Art Bulletin* 22 (Summer 1963): 22–28.

LE CORBEILLER 1981. ———. "The Construction of Some Empire Silver." *The Metropolitan Museum Journal* 16 (1981): 195–98.

LEDOUX-LEBARD 1975. Ledoux-Lebard, Denise. *Inventaire général du Musée National de Versailles et des Trianons.* Vol. 1, *Le Grand Trianon: Meubles et objets d'art.* Paris, 1975.

LEDOUX-LEBARD 1984. ———. *Les ébénistes du XIXe siècle, 1795–1889: Leurs oeuvres et leurs marques.* Paris, 1984.

LEFUEL 1923. Lefuel, Hector. *Georges Jacob, ébéniste du XVIIIe siècle.* Paris, 1923.

LEJEAUX 1928. Lejeaux, Jeanne. "Charles-Louis Clérisseau: architecte et peintre de ruines (1721–1820)." Parts 1, 2. *Revue de l'Art* 53 (April 1928): 225–31; 54 (October 1928): 125–36.

LEMONNIER 1983. Lemonnier, Patricia. *Weisweiler.* Paris, 1983.

LESLIE and TAYLOR 1865. Leslie, Charles Robert, and Tom Taylor. *Life and Times of Sir Joshua Reynolds: With Notices of Some of His Contemporaries.* 2 vols. London, 1865.

LEVEY and KALNEIN 1972. Levey, Michael, and Wend Graf Kalnein. *Art and Architecture of the 18th Century in France.* Harmondsworth, 1972.

LEVITINE 1972. Levitine, George. *The Sculpture of Falconet.* New York, 1972.

LOCQUIN 1912. Locquin, Jean. *La peinture d'histoire en France de 1747 à 1785.* Paris, 1912.

LONDON 1788. London, The Royal Academy of Arts. *The Exhibition of the Royal Academy, the Twentieth.* Exh. cat., 1788.

LONDON 1807. London, Mr. Christie. *A Catalogue of All the Original Sketches and Unfinished Works, of That Eminent and Admired Artist, John Russell, Esq. R.A..* Sale cat., March 25, 1807.

LONDON 1813. London, British Institution. *Catalogue of Pictures by the Late Sir Joshua Reynolds, Exhibited by the Permission of the Proprietors in Memory of That Distinguished Artist, and for the Improvement of British Art.* Exh. cat., 1813.

LONDON 1821. London, Mr. Christie. *Catalogue of the Very Valuable and Highly Important Collection of Ancient and Modern Pictures, of the Dowager Marchioness of Thomond.* Sale cat., May 18–19, 1821.

LONDON 1824. London, British Institution. *Catalogue of Pictures of the Italian, Spanish, Flemish, Dutch and English Schools, with Which the Proprietors Have Favoured the Institution.* Exh. cat., 1824.

LONDON 1827. London, Mr. Christie. *A Catalogue of the Very Choice Collection of Modern Pictures, Which Have Constituted the Very Distinguished and Universally Admired Gallery of That Accomplished and Truly Spirited Patron of the Arts, the Rt. Hon. Lord de Tabley. . . .* Sale cat., July 7, 1827.

LONDON 1859. London, British Institution. *Catalogue of Pictures by Italian, Spanish, Flemish, Dutch, French, and English Masters, with Which the Proprietors Have Favoured the Institution.* Exh. cat., 1859.

LONDON 1861. London, Christie, Manson and Woods. *Catalogue of the Extensive and Valuable Stock of Ancient and Modern Pictures of the Italian, Spanish, Flemish, Dutch, French, and English Schools, of Mr. J. B. Behrens, A Bankrupt, Late of Coventry Street.* Sale cat., July 26–27, 1861.

LONDON 1875. ———. *Catalogue of a Collection of Pictures by Italian, Flemish, French, and English Masters, the Property of a Gentleman.* Sale cat., January 30, 1875.

LONDON 1876. ———. *Catalogue of the First Portion of the Highly Important Collection of Modern Pictures, Chiefly of the Early English School, Formed by That Well-known Amateur, Wynn Ellis, Esq..* Sale cat., May 6, 1876.

LONDON 1877. London, The Royal Academy of Arts. *Exhibition of Works by the Old Masters and by Deceased Masters of the British School, Winter Exhibition.* Exh. cat., 1877.

LONDON 1878. ———. *Exhibition of Works by the Old Masters, and by Deceased Masters of the British School, Including a Special Selection from the Works of the Principal Representatives of the Norwich School, and a Collection of Engravings after Sir J. Reynolds, P.R.A., T. Gainsborough, R.A. and G. Romney.* Exh. cat., 1878.

LONDON 1883. London, Grosvenor Gallery. *Catalogue of the Works of Sir Joshua Reynolds, P.R.A., Exhibited at the Grosvenor Gallery.* Exh. cat. by F.G. Stephens, 1883.

LONDON 1887. London, The Royal Academy of Arts. *Exhibition of Works by the Old Masters and by Deceased Masters of the British School, Including a Collection of Water-Colour Drawings by Joseph M.W. Turner, R.A., Winter Exhibition.* Exh. cat., 1887.

LONDON 1887a. London, Christie, Manson and Woods. *[Dashwood Family Collection].* Sale cats., April 23, 1887, and June 23, 1887.

LONDON 1892. ———. *Collection of José Guedes de Queiroz, Marquis da Foz.* Sale cat., June 10, 1892.

LONDON 1896. London, The Royal Academy of Arts. *Exhibition of Works of the Old Masters and Deceased Masters of the British School, with a Selection of Works by Deceased French Artists, and a Collection of Plate and Other Objects Illustrating the Sculptor's-Goldsmith's Art.* Exh. cat., 1896.

LONDON 1907. London, Christie, Manson and Woods. *Catalogue of Pictures by Old Masters, and Works of the Early English School, the Property of Sir George Dashwood.* Sale cat., December 14, 1907.

LONDON 1909. London, Knight, Frank & Rutley. *Catalogue of Pictures of Sir George Dashwood, Bart., the Right Hon. Lord Abercromby, and Other Owners.* Sale cat., October 22, 1909.

LONDON 1912. *Lord Michelham: Catalogue of Works of Art.* London, 1912.

LONDON 1913. London, Christie, Manson and Woods. *Catalogue of the Choice Collection of French Furniture, Chiefly of the 18th Century, Porcelain and Objects of Art Formed by H.M.W. Oppenheim, Esq.* Sale cat., June 10–12, 16–17, 1913.

LONDON 1914. ———. *Catalogue of Important Pictures by Old Masters and Works of the Early English School, the Property of Arthur M. Grenfell, Esq., Also Important Pictures Forming the Dashwood Heirlooms Removed from Wherstead Park, Ipswich, and Fine Portraits of the Early British School.* Sale cat., June 26, 1914.

LONDON 1920. ———. *Furniture, Porcelain and Objects of Art . . . [Edward Arnold Collection].* Sale cat., June 8, 1920.

LONDON 1924. London, Victoria and Albert Museum. *Catalogue of the Jones Collection*. 3 vols. London, 1922–24.

LONDON 1925. London, Christie, Manson and Woods. *Catalogue of Fine French Furniture . . . the Property of the Rt. Hon. Almina, Countess of Carnarvon*. Sale cat., May 19–21, 1925.

LONDON 1929. London, Sotheby & Co. *Catalogue of Valuable Pictures and Drawings by Old Masters of the Italian, Dutch, and Flemish Schools*. Sale cat., December 11, 1929.

LONDON 1930. London, Christie, Manson and Woods. *Fine Old English and French Furniture, Objects of Art and Porcelain, the Property of Sir John Ramsden, Bart., Guy Fairfax, Esq., the Rt. Hon. Almina, Countess of Carnarvon and Others*. Sale cat., July 8, 1930.

LONDON 1933. London, 25 Park Lane. *Three French Reigns*. Exh. cat., 1933.

LONDON 1934. London, Sotheby & Co. *Catalogue of Valuable Oil Paintings and Drawings Comprising the Important Collection of Naval Paintings and Historical Portraits Relating to Admiral Vernon and His Family . . . The Property of C.G. Dashwood, Esq*. Sale cat., April 25, 1934.

LONDON 1936. London, 45 Park Lane. *Gainsborough*. Exh. cat. by Philip Sassoon, 1936.

LONDON 1937. London, Sotheby & Co. *Catalogue of the Magnificent Contents of 148 Piccadilly, W.1., Sold by the Order of Victor Rothschild, Esq*. Sale cat., April 19–22, 1937.

LONDON 1938. London, Christie, Manson and Woods. *Porcelain and Objects of Art, English and French Furniture, Tapestry and Eastern Carpets*. Sale cat., May 19, 1938.

LONDON 1938a. ———. *Fine Decorative Furniture, Important Objects of Art, Tapestry, Sculpture and Rugs, Being a Part of the Collection Formed by the Late Mortimer L. Schiff, Esq*. Sale cat., June 22–23, 1938.

LONDON 1952. *European Art Price Annuary 1950–1951*. Vol. 6. London, 1952.

LONDON 1953. London, Sotheby & Co. *Catalogue of the Important Collection of English and Continental Furniture, Works of Art and Ceramics Removed from Glympton Park, Woodstock [Alan P. Good Collection]*. Sale cat., July 2–3, 1953.

LONDON 1954. ———. *Catalogue of Fine Continental Porcelain, Tapestries and Carpets and Important French and English Furniture*. Sale cat., October 29, 1954.

LONDON 1955. London, Christie, Manson and Woods. *Catalogue of the Vagliano Collection of Fine Continental Porcelain, Objects of Art, Important French Furniture, Textiles, Rugs and Carpets*. Sale cat., July 14, 1955.

LONDON 1955a. London, Sotheby & Co. *The Important Collection of Sèvres Porcelain. The Property of Sir Chester Beatty*. Sale cat., November 15, 1955.

LONDON 1962. ———. *Important Medieval and Renaissance Works of Art, Italian Maiolica, Tapestries, Needlework, Clocks and French Furniture*. Sale cat., May 10–11, 1962.

LONDON 1963. ———. *The René Fribourg Collection: II, Eighteenth and Nineteenth Century Paintings*. Sale cat., June 26, 1963.

LONDON 1963a. ———. *The René Fribourg Collection: VII, French 18th Century and Empire Furniture, Clocks, and Works of Art*. Sale cat., October 17–18, 1963.

LONDON 1964. London, Frank Partridge and Sons. *Catalogue of the Winter Exhibition*. Exh. cat., 1964.

LONDON 1964a. London, Sotheby & Co. *Highly Important French Furniture, Works of Art and Tapestries*. Sale cat., April 17, 1964.

LONDON 1965. London, Christie, Manson and Woods. *The Earl of Harewood Collection*. Sale cat., July 1, 1965.

LONDON 1966. ———. *Important French and Other Continental Furniture, Tapestries, Eastern Rugs and Carpets*. Sale cat., December 1, 1966.

LONDON 1966a. ———. *Catalogue of Fine French Furniture, Works of Art, Clocks, Carpets and Tapestries*. Sale cat., December 16, 1966.

LONDON 1968. London, The Royal Academy of Arts. *France in the 18th Century: Royal Academy Winter Exhibition*. Exh. cat. by Denys Sutton. 1968.

LONDON 1968a. London, Christie, Manson and Woods. *Objects of Art and Clocks, French and Other Continental Furniture, Textiles, Eastern Rugs and Carpets*. Sale cat., February 29, 1968.

LONDON 1970. ———. *Fine French Clocks and Objects of Art, Highly Important French Furniture, Tapestries and Carpets*. Sale cat., May 14, 1970.

LONDON 1971. ———. *The Highly Important Collection of French Furniture and Works of Art Formed by the Late Mrs. Anna Thomson Dodge*. Sale cat., June 24, 1971.

LONDON 1971a. ———. *Highly Important Pictures by Old Masters*. Sale cat., June 25, 1971.

LONDON 1972. London, The Royal Academy of Arts and the Victoria and Albert Museum. *The Age of Neo-Classicism*. Exh. cat., 1972.

LONDON 1972a. London, Christie, Manson and Woods. *Highly Important English Pictures, c. 1600–c. 1850*. Sale cat., June 23, 1972.

LONDON 1973. London, Victoria and Albert Museum. *An American Museum of Decorative Arts and Design: Designs from the Cooper-Hewitt Collection*. Exh. cat., 1973.

LONDON 1973a. London, Sotheby Parke-Bernet & Co. *A Collection of Important Meissen Porcelain*. Sale cat., July 10, 1973.

LONDON 1973b. London, Christie, Manson and Woods. *Highly Important Continental Porcelain, French Furniture and Objects of Art, the Property of the Late Sydney J. Lamon of New York City*. Sale cat., November 29, 1973.

LONDON 1974. London, Sotheby Parke-Bernet & Co. *Continental Pottery and Porcelain*. Sale cat., February 5, 1974.

LONDON 1975. ———. *Important Continental Porcelain*. Sale cat., June 17, 1975.

LONDON 1976. London, Christie, Manson and Woods. *Highly Important French Furniture.* Sale cat., July 1, 1976.

LONDON 1978. London, Sotheby Parke-Bernet & Co. *The Robert von Hirsch Collection: Vol. III, Furniture and Porcelain.* Sale cat., June 23 and 27, 1978.

LONDON 1979. ——. *Fine French Works of Art, Tapestries, Rugs and Carpets.* Sale cat., July 6, 1979.

LONDON 1979a. London, Christie, Manson and Woods. *Objects of Art, Fine French Furniture, Tapestries.* Sale cat., December 6, 1979.

LONDON 1979b. London, The Queen's Gallery. *Sèvres Porcelain from the Royal Collection.* Exh. cat. by Geoffrey de Bellaigue, 1979.

LONDON 1980. London, Heim Gallery. *100 of the Finest Drawings from Polish Collections.* Exh. cat., 1980.

LONDON 1980a. London, The Tate Gallery. *Thomas Gainsborough.* Exh. cat. by John Hayes, 1980.

LONDON 1980b. London, Christie, Manson and Woods. *European and Chinese Porcelain, Objects of Art, English and French Furniture, the Property of H.J. Joel, Esq..* Sale cat., April 17, 1980.

LONDON 1982. ——. *Fine French Furniture and Objects of Art.* Sale cat., April 22, 1982.

LONDON 1983. ——. *Important English Pictures.* Sale cat., April 22, 1983.

LONDON 1983a. ——. *A Distinguished Collection of French Furniture, the Property of a Lady.* Sale cat., May 19, 1983.

LONDON 1983b. ——. *Highly Important French Furniture from Various Sources.* Sale cat., December 1, 1983.

LONDON 1986. London, The Royal Academy of Arts. *Reynolds.* Exh. cat. by Nicholas Penny et al., 1986.

LONDON 1986a. London, P. & D. Colnaghi and Co. *The British Face: A View of Portraiture 1625–1850.* Exh. cat. by John Martin Robinson, 1986.

LONDON 1986b. London, Sotheby & Co. *Continental Pottery and Porcelain.* Sale cat., March 4, 1986.

LONDON 1988. ——. *Highly Important French Furniture Including Property from the British Rail Pension Fund.* Sale cat., November 24, 1988.

LONDON 1990. London, Christie's South Kensington. *Carpets and Fine European Works of Art.* Sale cat., March 28, 1990.

LONDON 1991. London, Christie's. *Important French and Continental Furniture, Objects of Art, and Tapestries.* Sale cat., June 13, 1991.

LONDON 1995. London, Sotheby's. *Nineteenth and Twentieth Century Furniture and Decorations: Belle Epoque Series.* Sale cat., May 26, 1995.

LONDON 1995a. London, Christie's. *The Nineteenth Century.* Sale cat., June 2, 1995.

LONDON 1995b. ——. *Important French Furniture and Carpets.* Sale cat., June 15, 1995.

LONDON n.d. London, Wertheimer Galleries. *Notes on the Historic Chérèmeteff Sèvres Porcelain on View at the Galleries of Mr. Asher Wertheimer.* Exh. cat., n.d.

LORENTZ 1958. Lorentz, Stanislaw. "Victor Louis et Varsovie." *Revue Historique de Bordeaux* 7 (1958; reprinted as a catalogue of an exhibition of the same title at the Musée Jacquemart-André, Paris, 1958).

LOS ANGELES 1980. Los Angeles, Los Angeles County Museum of Art, The Minneapolis Institute of Arts, and The Detroit Institute of Arts. *The Romantics to Rodin: French Nineteenth-Century Sculpture from North American Collections.* Exh. cat. ed. by Peter Fusco and H.W. Janson, 1980.

LUNDBERG 1957. Lundberg, Gunnar W. *Alexandre Roslin.* 3 vols. Malmö, 1957.

LUNSINGH SCHEURLEER 1952. Lunsingh Scheurleer, Th. H. *Catalogus van meubelen en betimmeringen, Rijksmuseum.* Amsterdam, 1952.

LUNSINGH SCHEURLEER 1980. ——. "Pierre Gole, ébéniste du roi Louis XIV." *The Burlington Magazine* 122 (June 1980): 380–94.

LYONS 1921. Lyons, Salle des Fêtes de la Maison Berrier et Milliet. *Catalogue des objets d'art . . . provenant de la collection de M. J. Payet, antiquaire à Lyon.* Sale cat., March 21–25, 1921.

MACFALL 1908. Macfall, Haldane. *Boucher: The Man, His Times, His Art, and His Significance.* London, 1908.

MADRID 1987. Madrid, Palacio de Velázquez, Parque del Retiro. *Jose Maria Sert 1874–1945.* Exh. cat., 1987.

MAHER 1975. Maher, James T. *The Twilight of Splendor: Chronicles of the Age of American Palaces.* Boston, 1975.

MALMBOURG 1971. Malmbourg, Boo van, ed. *Slotten.* Malmö, 1971.

MALMÖ 1937. Malmö Museum. *Roslin.* Exh. cat., 1937.

MANN 1931. Mann, J.G. *Wallace Collection Catalogues: Sculpture.* London, 1931.

MARANDEL 1986. Marandel, J. Patrice. "Boucher et les 'chinoiseries.'" *L'Oeil,* no. 374 (September 1986): 30–37.

MARLY-LE-ROI-LOUVECIENNES 1992. Marly-le-Roi-Louveciennes, Musée Promenande. *Madame du Barry, de Versailles à Louveciennes.* Exh. cat., 1992.

MARTIN 1986. Martin, Michel. *Les monuments équestres de Louis XIV.* Paris, 1986.

MASSAR 1905. Massar, Frédéric. "La porcelaine de Sèvres: Collection Chappey." *Les Arts,* no. 38 (February 1905): 1–32.

MASSAR 1971. Massar, Phyllis Dearborn. *Presenting Stefano della Bella.* New York, 1971.

MASSIE 1990. Massie, Suzanne. *Pavlovsk: The Life of a Russian Palace.* Boston, 1990.

MAZE-SENCIER 1885. Maze-Sencier, Alphonse. *Le livre des collectionneurs: Les ébénistes, les ciseleurs-bronziers, les tabatières.* 2nd ed. Paris, 1885.

MCCORMICK 1971. McCormick, Thomas Julian. *Charles-Louis Clérisseau and the Roman Revival.* Princeton, 1971.

MCKAY and ROBERTS 1909. McKay, William, and W. Roberts. *John Hoppner, R.A.* London, 1909.

MCPHERSON 1975. McPherson, Thomas A. *The Dodge Story.* Glen Ellyn, Illinois, 1975.

MENPES and GREIG 1909. Menpes, Mortimer, and James Greig. *Gainsborough.* London, 1909.

MEYER 1974. Meyer, Daniel. "Meubles et objets d'art des Collections Royales à Versailles. I: À propos du mobilier de Marie-Antoinette au Petit Trianon." *La Revue du Louvre et des Musées de France,* nos. 4–5 (1974): 279–83.

MICHEL 1906. Michel, André. *François Boucher.* Paris, 1906.

MILLER and BAPTIE 1969. Miller, Hope Ridings, and Charles Baptie. *Great Houses of Washington, D.C.* New York, 1969.

MITCHELL 1981. Mitchell, Suzanne. "An Introduction to Recent Asian Acquisitions." *Bulletin of The Detroit Institute of Arts* 59 (Winter 1981): 56–65.

MITCHELL 1982. ———. "The Asian Collection at The Detroit Institute of Arts." *Orientations* 13 (May 1982): 14–36.

MOLINIER 1902. Molinier, Émile. "Le mobilier français du XVIIIe siècle." *Les Arts,* no. 1 (January 1902): 19–23.

MOLINIER 1902a. ———. *Le mobilier royal.* 2 vols. Paris, 1902.

MOLINIER n.d. ———. *Le mobilier au XVIIe siècle.* Paris, n.d.

MONACO 1979. Monaco, Sotheby Parke-Bernet. *Magnifique ensemble de meubles et objets d'art français: Collection Monsieur Akram Ojjeh.* Sale cat., June 25–26, 1979.

MONACO 1979a. ———. *Dessins d'ornements et d'orfèvrerie . . . provenant de la maison Odiot.* Sale cat., November 26, 1979.

MONACO 1980. ———. *Important mobilier et objets d'art.* Sale cat., May 26–27, 1980.

MONACO 1982. ———. *Important mobilier.* Sale cat., June 14, 1982.

MONACO 1983. ———. *Important mobilier.* Sale cat., February 13, 1983.

MONACO 1984. ———. *Bel ameublement.* Sale cat., March 4–5, 1984.

MONACO 1990. Monaco, Christie's. *Porcelaine et faïence françaises, mobilier et objets d'art.* Sale cat., December 8, 1990.

MONACO 1992. ———. *Collection d'un amateur européen, mobilier et objets d'art.* Sale cat., June 20, 1992.

MONTAGU 1963. Montagu, Jennifer. *Bronzes.* New York, 1963.

MONTAGU 1985. ———. *Alessandro Algardi.* 2 vols. New Haven and London, 1985.

MONTE CARLO 1988. Monte Carlo, Ader Picard Tajan. *Objets d'art de très bel ameublement du XVIIIe siècle provenant principalement des collections de deux grands amateurs.* Sale cat., March 17, 1988.

MORRIS 1939. Morris, Gouverneur. *A Diary of the French Revolution.* Boston, 1939.

MOURER 1974. Mourer, A.M. "Étienne de Lavalée Poussin 1735–1802." Dissertation. Université de Paris, 1974.

MUNGER et al. 1992. Munger, Jeffrey H., et al. *The Forsythe Wickes Collection in the Museum of Fine Arts, Boston.* Boston, 1992.

MUNICH 1939. Munich, Helbing. Sale cat., March 9–10, 1939.

MURDOCH 1992. Murdoch, Tessa, ed. *Boughton House, the English Versailles.* London, 1992.

MYERS 1991. Myers, Mary L. *French Architectural and Ornamental Drawings of the Eighteenth Century.* New York, 1991.

NAMIER and BROOKE 1964. Namier, Lewis [Bernstein], and John Brooke. *The History of Parliament: The House of Commons 1754–1790.* 3 vols. London, 1964.

NEW YORK 1914. New York, The Metropolitan Museum of Art. *Guide to the Loan Exhibition of the J. Pierpont Morgan Collection.* Exh. cat., 1914.

NEW YORK 1914a. New York, E. Gimpel and Wildenstein and Co. *Fragonard.* Exh. cat., 1914.

NEW YORK 1924. New York, Wildenstein and Co. *J.M. Sert.* Exh. cat., 1924.

NEW YORK 1928. New York, American Art Association. *Works of Art . . . of the Late Judge Elbert H. Gary.* Sale cat., April 19–21, 1928.

NEW YORK 1928a. New York, Anderson Galleries. *Magnificent Creations in Gold Plate Made by Claude Odiot for Count Nikolai Demidoff with Other Objects of Art from the Same Source Sold by Order of the Present Owner, an Anonymous English Gentleman of Title.* Sale cat., December 15, 1928.

NEW YORK 1934. New York, American Art Association/Anderson Galleries. *French XVIII Century Furniture and Works of Art, Property of the Estate of the Late Mrs. Benjamin Stern.* Sale cat., April 4–7, 1934.

NEW YORK 1935. ———. *French Furniture of the Eighteenth Century, Queen Anne and Georgian Silver, Chinese Porcelain, Property of the Estate of the Late Mary Strong Shattuck.* Sale cat., October 17–19, 1935.

NEW YORK 1935a. New York, The Metropolitan Museum of Art. *French Painting and Sculpture of the XVIII Century.* Exh. cat. by Harry B. Wehle and Preston Remington, 1935.

NEW YORK 1941. New York, Parke-Bernet Galleries. *The Mrs. Henry Walters Art Collection.* Sale cat., April 23–26, 1941.

NEW YORK 1943. ———. *French and English Furniture, English and Continental Silver. . . .* Sale cat., February 19 and 20, 1943.

NEW YORK 1947. ———. *French and English Furniture and Decorations, Property of the Estates of the Late Henry Morgenthau, New York, Julius Loeb and Hilda N. Loeb, New York, and of Other Owners.* Sale cat., February 12–15, 1947.

NEW YORK 1949. ———. *Fine XVIII Century French Furniture, Paintings, Tapestries, Jades, Porcelain, Gold and Silver Ware, Rugs Collected by the Late Thyrza F. Kiser.* Sale cat., April 16, 1949.

NEW YORK 1949a. ———. *French Furniture, Decorative Objects . . . Property of Isabella Barclay, Ins., Mrs. Reginald C. Vanderbilt, a New York Estate and Other Owners.* Sale cat., December 15–17, 1949.

NEW YORK 1952. ———. *French and English Furniture, Chinese Porcelains and Paintings on Glass, Old English and Irish Glass and Other Decorations from the Collection of the Late Mrs. Theodore A. Havemeyer.* Sale cat., January 3–5, 1952.

NEW YORK 1954. ——. *Important XVIII Century French Furniture and Works of Art, Oriental, Aubusson and Savonnerie Rugs, K'ang Hsi Porcelains and Other Art Property Belonging to the Estate of the Late Millicent A. Rogers and to Mabel Gilman Corey and Other Owners.* Sale cat., December 2–4, 1954.

NEW YORK 1955. ——. *Property of the Estate of the Late Baron Cassel van Doorn, Notable French Eighteenth Century Furniture and Objects of Art.* Sale cat., December 9–10, 1955.

NEW YORK 1957. ——. *French XVIII Century Furniture and Decorations, Italian and Other Renaissance Furniture, Gothic and Renaissance Bronzes, Wood and Stone Sculptures from the Estates of the Late Charles and Annie Wimpfheimer and Property of Other Owners Including J. Robert Hewitt.* Sale cat., January 11–12, 1957.

NEW YORK 1957a. ——. *The Georges Lurcy Collection, Vol. II: French XVIII Century Furniture, Objets d'art, French Modern Paintings and Drawings.* Sale cat., November 8–9, 1957.

NEW YORK 1959. ——. *French Modern Paintings and Drawings, Eighteenth Century French Furniture, Marble and Terra Cotta Sculpture, Bronze Doré, Objects of Art Collected by the Late Thelma Chrysler Foy, Part 1.* Sale cat., May 13–16, 1959.

NEW YORK 1959a. ——. *French XVIII-Century Furniture, Paintings… Collected by the Late Thelma Chrysler Foy, Part 2.* Sale cat., May 22–23, 1959.

NEW YORK 1961. ——. *The Countess Sala Collection of French Furniture, Bronze Doré, Paintings, Sculptures, Porcelains, Silver, Tapestries, Rugs.* Sale cat., November 17–18, 1961.

NEW YORK 1962. ——. *French Furniture, Meissen, Chelsea and Other Old Cabinet Porcelains, Paintings and Decorative Objects Belonging to Warren Clements, Estate of the Late Norman Lee Smith and Other Owners.* Sale cat., May 5, 1962.

NEW YORK 1966. ——. *French and Other Furniture, Russian Icons, Other Paintings Including Mexican School (Nineteenth Century), Primitive Portraits, the Collection of Helena Rubinstein (Princess Gourielli).* Sale cat., April 22–23, 1966.

NEW YORK 1966a. ——. *The Collection of the Late Robert Goelet, Fine French and English Furniture, Bronze Doré, Decorative Objects, Rare Rugs and Tapestries.* Sale cat., October 13–15, 1966.

NEW YORK 1968. ——. *Medieval, Renaissance and Eighteenth Century Works of Art Formerly in the Inventory of French and Company.* Sale cat., November 14, 1968.

NEW YORK 1968a. ——. *Eighteenth Century and Other French Furniture, Objets d'Art and Other Decorations Formerly in the Inventory of French & Company.* Sale cat., December 7, 1968.

NEW YORK 1972. ——. *Highly Important French Furniture, Decorations and Extremely Fine Continental Porcelain, Property of Mr. and Mrs. Deane Johnson, Bel Air, California.* Sale cat., December 9, 1972.

NEW YORK 1976. New York, The Metropolitan Museum of Art. *The Fire and the Talent: A Presentation of French Terracottas.* Exh. cat. by Olga Raggio, 1976.

NEW YORK 1977. New York, Christie, Manson and Woods. *Objects of Art, Fine French and Continental Furniture and Sculpture.* Sale cat., November 19, 1977.

NEW YORK 1977a. New York, Wildenstein and Co. *Paris–New York: A Continuing Romance.* Exh. cat., 1977.

NEW YORK 1978. New York, The Metropolitan Museum of Art. *The Arts under Napoleon.* Exh. cat. by James David Draper and Clare Le Corbeiller, 1978.

NEW YORK 1981. New York, Sotheby Parke-Bernet. *Property from the Collection of Mr. and Mrs. Leslie R. Samuels.* Sale cat., October 2, 3, 1981.

NEW YORK 1982. New York, Christie, Manson and Woods. *Fine English and Continental Silver, Magnificent Silver-Gilt, Watches and Objects of Vertu.* Sale cat., June 14, 1982.

NEW YORK 1982a. New York, Sotheby Parke-Bernet. *Important French Furniture, Decorations, and Clocks.* Sale cat., November 6, 1982.

NEW YORK 1984. New York, The Frick Collection. *Clodion Terracottas in North American Collections.* Exh. cat. by Anne L. Poulet, 1984.

NEW YORK 1984a. New York, The Metropolitan Museum of Art. *Notable Acquisitions 1983–1984.* New York, 1984.

NEW YORK 1985. New York, Sotheby's. *Property from the Jack and Belle Linsky Collection.* Sale cat., May 21, 1985.

NEW YORK 1987. ——. *Important Silver and Silver-Gilt.* Sale cat., October 28, 1987.

NEW YORK 1988. ——. *Important French Furniture, Decorations, Porcelain and Carpets.* Sale cat., May 21, 1988.

NEW YORK 1988a. New York, Christie's. *The Collection of Mr. and Mrs. Franklin N. Groves: Important French Furniture, Clocks, Objects of Art and Eastern Carpets.* Sale cat., October 15, 1988.

NEW YORK 1989. New York, Sotheby's. *Important Continental Porcelain, the Collection of Frederick J. and Antoinette H. Van Slyke.* Sale cat., September 26, 1989.

NEW YORK 1989a. ——. *The Collection of John T. Dorrance, Jr.* Sale cat., October 21, 1989.

NEW YORK 1991. New York, Christie's. *The Elizabeth Parke Firestone Collection, Part II: Important French Furniture, Works of Art, Old Master Paintings, Drawings and Chinese Porcelain and Jade.* Sale cat., March 22–23, 1991.

NEW YORK 1991a. New York, Sotheby's. *The Keck Collection from La Lanterne, Bel Air, California.* Sale cat., December 5–6, 1991.

NEW YORK 1992. ——. *English Furniture, Decorations, Ceramics and Carpets.* Sale cat., April 24–25, 1992.

NEW YORK 1992a. ——. *The Jaime Ortiz-Patiño Collection: French Furniture and Decorations.* Sale cat., May 20, 1992.

NEW YORK 1992b. ——. *Important French and Continental Furniture, Decorations, Ceramics and Carpets.* Sale cat., May 21, 1992.

NEW YORK 1993. New York, Christie's. *Important Silver, Objects of Vertu, Russian Works of Art and Judaica.* Sale cat., April 22, 1993.

NEW YORK 1993a. New York, Sotheby's. *Important French Furniture, Decorations and Carpets.* Sale cat., November 20, 1993.

New York Times 1934. "Anthony J. Drexel, Banker, Dies at 70." *The New York Times,* December 15, 1934: 15.

New York Times 1970. "Obituaries." *The New York Times,* June 4, 1970: 43.

New York Times 1971. "An Era Ends as a Great Estate's Trappings Go up for Auction." *The New York Times,* September 26, 1971: 80.

NICOLAY 1956–59. Nicolay, Jean. *L'art et la manière des maîtres ébénistes français au XVIIIe siècle.* 2 vols. Paris, 1956–59.

NORTHCOTE 1819. Northcote, James. *The Life of Sir Joshua Reynolds: Comprising Original Anecdotes of Many Distinguished Persons, His Contemporaries, and a Brief Analysis of His Discourses.* 2nd ed., rev. 2 vols. London, 1819.

NORTH MYMMS PARK 1979. North Mymms Park, Hatfield, Hertfordshire, Christie, Manson and Woods. *The Property of Major-General Sir George Burns, K.C.V.O.* Sale cat., September 24–26, 1979.

L'Oeil 1970. "C.I.N.O.A." *L'Oeil,* no. 184 (April 1970): 52–61.

OTTOMEYER and PRÖSCHEL 1987. Ottomeyer, Hans, and Peter Pröschel. *Vergoldete Bronzen.* 2 vols. Munich, 1987.

OWSLEY 1972. David T. Owsley. "A Rare French Transitional Fire Screen." *Carnegie Magazine* 46, 5 (May 1972): 194–95.

PACKER 1956. Packer, Charles. *Paris Furniture by the Master Ébénistes: A Chronologically Arranged Pictorial Review of Furniture by the Master Menuisiers-Ébénistes from Boulle to Jacob; together with a Commentary on the Styles and Techniques of the Art.* Newport, Monmouthshire, 1956.

PALLOT 1993. Pallot, Bill G.B. *Furniture Collections in the Louvre, II: Chairs and Consoles (Menuiserie), 17th and 18th Centuries.* Dijon, 1993 (same pagination as the French edition, also 1993).

PARIS 1750. *Livret.* Salon of 1750. Paris.

PARIS 1753. *Livret.* Salon of 1753. Paris.

PARIS 1757. *Livret.* Salon of 1757. Paris.

PARIS 1776. Paris, Pierre Rémy. *Cabinet de tableaux . . . Cabinet de feu M. Blondel de Gagny.* Sale cat., December 10–24, 1776.

PARIS 1776–82. *Almanach royal.* Paris, 1776–82.

PARIS 1781. Paris, Lebrun. *Duchesse de Mazarin Collection.* Sale cat., December 10–15, 1781.

PARIS 1795. *Livret.* Salon of 1795. Paris.

PARIS 1797. Paris, Paillet. *Grimod de la Reynière Collection.* Sale cat., August 21–September 7, 1797.

PARIS 1831. *Paris Salon de 1831.* New York and London, 1978.

PARIS 1869–72. Paris, Académie Royale de Peinture et de Sculpture. *Collection des livrets des anciennes expositions depuis 1673 jusqu'à 1800.* 42 vols. Paris, 1869–72.

PARIS 1886. Paris, Galerie Georges Petit. *Collection de M. Charles Stein.* Sale cat., May 10–14, 1886.

PARIS 1892. ———. *Catalogue des objets d'art . . . dépendant de la succession de Mme d'Yvon.* Sale cat., May 30–June 4, 1892.

PARIS 1898. ———. *Collection de M. Paul Eudel.* Sale cat., May 9–12, 1898.

PARIS 1903. ———. *Catalogue des objets d'art et d'ameublement des XVIIe et XVIIIe siècles . . . dépendant des collections de Mme C. Lelong, Vol. I.* Sale cat., April 27–May 1, 1903.

PARIS 1905. ———. *Collection Gutiérrez de Estrada: Catalogue des objets d'art et d'ameublement du XVIIIe siècle. . . .* Sale cat., April 28–29, 1905.

PARIS 1905a. ———. *Catalogue des tableaux . . . composant la collection de M. E. Cronier.* Sale cat., December 4–5, 1905.

PARIS 1907. ———. *Collection Édouard Chappey.* Vol. III. Sale cat., May 27–31, 1907.

PARIS 1907a. ———. *Chardin-Fragonard.* Exh. cat., 1907.

PARIS 1912. ———. *Collection Jacques Doucet, troisième partie: Meubles et objets d'art du XVIIIe siècle.* Sale cat., June 7–8, 1912.

PARIS 1914. ———. *Collection du Marquis de Biron, première vente.* Sale cat., June 9–11, 1914.

PARIS 1919. Paris, Galerie Manzi, Joyant & Cie. *Catalogue des objets d'art et d'ameublement anciens . . . appartenant à M. J. Jeuniette.* Sale cat., March 26–29, 1919.

PARIS 1921. Paris, Hôtel Drouot. *Catalogue des objets d'art et d'ameublement . . . appartenant à Monsieur Z. [Zambaux] . . .* Sale cat., March 14–15, 1921.

PARIS 1922. Paris, Musée du Louvre. *Catalogue de la collection Isaac de Camondo.* Paris, 1922.

PARIS 1922a. Paris, Galerie Georges Petit. *Catalogue des tableaux anciens et objets d'art et d'ameublement . . . composant la collection de Madame la Marquise de Ganay.* Sale cat., May 8–10, 1922.

PARIS 1923. ———. *Catalogue des objets d'art et d'ameublement du XVIIIe siècle . . . appartenant à Madame B.-D. [Billout-Desmarets].* Sale cat., June 1, 1923.

PARIS 1927. ———. *Catalogue des objets d'art et de magnifique ameublement du XVIIIe siècle . . . composant la très importante collection de Madame de Polès.* Sale cat., June 22–24, 1927.

PARIS 1927a. Paris, Hôtel Drouot. *Succession de Mademoiselle Marcelle Lender.* Sale cat., October 17–19, 1927.

PARIS 1928. Paris, Galerie Georges Petit. *Catalogue des tableaux anciens . . . sièges et meubles du XVIIIe siècle . . . appartenant à divers amateurs.* Sale cat., May 21–22, 1928.

PARIS 1929. Paris, Hôtel Drouot. *Succession de Mme la vicomtesse Louis d'Andigné: Objets d'art et d'ameublement, tapisseries anciennes.* Sale cat., November 27, 1929.

PARIS 1931. Paris, Galerie Georges Petit. *Catalogue des tableaux, anciens et modernes, aquarelles . . . de S.A.R. Mgr. le duc de Vendôme.* Sale cat., December 4, 1931.

PARIS 1932. ———. *Catalogue des objets d'art et d'ameublement du XVIIIe siècle . . .* [de] *M. George Blumenthal.* Sale cat., December 1–2, 1932.

PARIS 1933. Paris, Galerie Jean Charpentier. *Catalogue des tableaux anciens, aquarelles, pastels, objets d'art et d'ameublement, sièges et meubles, tapisseries anciens.* Sale cat., May 22, 1933.

PARIS 1934. ———. *Collection de Monsieur le comte de Gramont: Objets d'art et d'ameublement, tableaux anciens, objets de curiosité.* Sale cat., June 15, 1934.

PARIS 1934a. ———. *Objets d'art et d'ameublement anciens, tableaux anciens, gravures, objets d'art de la Chine.* Sale cat., November 27–28, 1934.

PARIS 1935. ———. *Collection de Monsieur W.B.* [Willy Blumenthal]. Sale cat., November 29, 1935.

PARIS 1936. Paris, Hôtel Drouot. *Collection de Monsieur A.G. . . .* Sale cat., April 3, 1936.

PARIS 1937. Paris, Galerie Jean Charpentier. *Objets d'art du XVIIIe siècle, bronzes, pendules, sièges et meubles composant la collection de Monsieur M.D..* Sale cat., March 12, 1937.

PARIS 1937a. ———. *Catalogue des objets d'art et de très bel ameublement du XVIIIe siècle . . . composant l'importante collection de feu Madame Louis Burat.* Sale cat., June 17–18, 1937.

PARIS 1938. Paris, Hôtel Drouot. *Collection de Madame Paul Gemeau.* Sale cat., February 24–25, 1938.

PARIS 1941. ———. *Collection de feu M. Dubois Chefdebien (3e vente).* Sale cat., February 13–14, 1941.

PARIS 1950. Paris, Galerie Jean Charpentier. *Tableaux anciens . . . objets d'art et de bel ameublement . . . sièges et meubles . . . appartenant à M.G. et à divers amateurs.* Sale cat., May 23, 1950.

PARIS 1954. ———. *Tableaux anciens, estampes, objets d'art et de bel ameublement . . . provenant des collections réunies pour le Baron Cassel et de la Baronne Cassel van Doorn.* Sale cat., March 9, 1954.

PARIS 1961. Paris, Palais Galliéra. *Succession Murat.* Sale cat., March 21, 1961.

PARIS 1961a. ———. *Tableaux modernes, tableaux et meubles anciens, bronzes [Farra Collection].* Sale cat., March 9, 1961.

PARIS 1963. ———. *Objets d'art et de bel ameublement du XVIIIe siècle.* Sale cat., December 4, 1963.

PARIS 1964. Paris, Galerie Cailleux. *François Boucher.* Exh. cat., 1964.

PARIS 1964a. Paris, Palais Galliéra. *Tableaux anciens, . . . dessins, bel ameublement du XVIIIe, . . . appartenant à divers amateurs. . . .* Sale cat., December 8, 1964.

PARIS 1965. ———. *Dessins et tableaux anciens, important ensemble de meubles et sièges du XVIIIe siècle, objets d'art . . . vente après départ de Mrs. Hamilton Rice.* Sale cat., June 24, 1965.

PARIS 1966. ———. *Collection du Baron James de Rothschild.* Sale cat., December 1, 1966.

PARIS 1968. Paris, Musée Carnavalet. *Collection Henriette Bouvier.* Paris, 1968.

PARIS 1968a. Paris, Palais Galliéra. *Collection de M. et Mme Henry Viguier.* Sale cat., March 21, 1968.

PARIS 1968b. ———. *Objets d'art et de bel ameublement . . . appartenant à divers amateurs.* Sale cat., April 3, 1968.

PARIS 1969. ———. *Objets d'art et de bel ameublement, appartenant à divers amateurs.* Sale cat., March 25, 1969.

PARIS 1971. Paris, Musée du Louvre. *François Boucher: Gravures et dessins.* Exh. cat. by Pierrette Jean-Richard. 1971.

PARIS 1971a. Paris, Palais Galliéra. *Collection Georges Heine.* Sale cat., March 23, 1971.

PARIS 1972. Paris, Hôtel Drouot. *Collection David David-Weill.* Sale cat., May 4–5, 1972.

PARIS 1972a. ———. *Objets d'art et de bel ameublement principalement du XVIIIe siècle.* Sale cat., November 15, 1972.

PARIS 1973. Paris, Union Centrale des Arts Décoratifs. *Musée Nissim de Camondo.* Paris, 1973.

PARIS 1974. Paris, Hôtel Drouot. *Objets d'art et d'ameublement, principalement du XVIIIe siècle.* Sale cat., October 28, 1974.

PARIS 1974a. Paris, Palais Galliéra. *Objets d'art et de bel ameublement . . . provenant des anciennes collections La Rochefoucauld et appartenant à divers amateurs.* Sale cat., November 26, 1974.

PARIS 1977. Paris, Pavillon Gabriel. *Objets d'art et de très bel ameublement.* Sale cat., June 14, 1977.

PARIS 1978. Paris, Musée du Louvre, Cabinet des Dessins, Collection Edmond de Rothschild. *L'oeuvre gravé de François Boucher.* Cat. by Pierrette Jean-Richard, 1978.

PARIS 1978a. Paris, Drouot Rive Gauche. *Objets d'art et de bel ameublement, principalement du XVIIIe siècle.* Sale cat., June 26, 1978.

PARIS 1979. Paris, Galeries Nationales du Grand Palais and The Cleveland Museum of Art. *Chardin.* Exh. cat. by Pierre Rosenberg, 1979.

PARIS 1979a. Paris, Palais d'Orsay. *Collection de Monsieur et Madame L.B..* Sale cat., June 13, 1979.

PARIS 1980. Paris, Musée d'Art et d'Essai, Palais de Tokyo. *Portrait et société en France, 1715–1789.* Exh. cat., 1980.

PARIS 1980a. Paris, Ader Picard Tajan, Hôtel George V. *Très bel ameublement des XVIIe et XVIIIe siècles.* Sale cat., June 17, 1980.

PARIS 1981. Paris, Ader Picard Tajan, Nouveau Drouot. *Objets d'art et de très bel ameublement principalement des XVIIe et XVIIIe siècles.* Sale cat., June 19, 1981.

PARIS 1982. Paris, Hôtel Drouot. *Collection d'un amateur.* Sale cat., June 22, 1982.

PARIS 1984. Paris, Musée Rodin. *Le Faubourg Saint-Germain, la rue Saint-Dominique.* Exh. cat., 1984.

PARIS 1985. Paris, Musée du Louvre. *Nouvelles acquisitions du département des objets d'art 1980–1984.* Cat. by Pierre Ennès et al., 1985.

PARIS 1986. Paris, Galeries Nationales du Grand Palais. *La sculpture française au XIXe siècle.* Exh. cat., 1986.

PARIS 1986a. Paris, Hôtel Drouot. *Collection de très belles montres . . . objets d'art et d'ameublement, très beau mobilier du XVIIIe siècle.* Sale cat., November 26, 1986.

PARIS 1987. Paris, Nouveau Drouot. *Succession de M. X . . . Tableaux anciens des écoles hollandaise et italienne, très bel ensemble de meubles et objets d'art des XVIIIe et XIXe siècles.* Sale cat., March 30–31, 1987.

PARIS 1987a. ———. *Collection de Gilbert Lévy.* Sale cat., May 6, 1987.

PARIS 1987b. Paris, Galeries Nationales du Grand Palais and The Metropolitan Museum of Art, New York. *Fragonard.* Exh. cat. by Pierre Rosenberg, 1987.

PARIS 1988. Paris, Ader Picard Tajan, Hôtel George V. *Objets d'art et de très bel ameublement.* Sale cat., December 11, 1988.

PARIS 1989. ———. *Objets d'art et de très bel ameublement, principalement des XVIIe et XVIIIe siècles.* Sale cat., December 5, 1989.

PARIS 1990. Paris, Musée du Louvre. *Nouvelles acquisitions du département des objets d'art 1985–1989.* Exh. cat., 1990.

PARIS 1990a. Paris, Drouot-Richelieu. *Tableaux anciens, meubles et objets d'art des XVIIe, XVIIIe et XIXe siècles.* Sale cat., December 6, 1990.

PARIS 1991. Paris, Ader Picard Tajan, Hôtel George V. *Collection Roberto Polo.* Sale cat., November 7, 1991.

PARIS 1991a. Paris, Galeries Nationales du Grand Palais. *Un âge d'or des arts décoratifs, 1814–1848.* Exh. cat. by Anne Dion-Tenenbaum et al., 1991.

PARIS 1992. Paris, Musée du Louvre. *Clodion 1738–1814.* Exh. cat. by Anne L. Poulet and Guilhem Scherf, 1992.

PARIS 1992a. Paris, Galerie Patrice Bellanger. *Joseph-Charles Marin, 1759–1834.* Exh. cat., 1992.

PARIS 1993. Paris, Drouot Montaigne. *Objets d'art et de très bel ameublement.* Sale cat., April 1, 1993.

PARIS 1995. Paris, Musée du Louvre. *Nouvelles acquisitions du département des objets d'art 1990–1994.* Exh. cat., 1995.

PARIS n.d. Paris, Musée de l'Union Centrale des Arts Décoratifs. *Les collections du Musée de l'Union Centrale des Arts Décoratifs.* Series 6. Paris, n.d.

PARISET 1956. Pariset, François-Georges. "Les découvertes du Professeur Stanislaw Lorentz sur Victor Louis à Varsovie." *Revue Historique de Bordeaux* 5 (1956): 281–97.

PARISET 1959. ———. "Notes sur Victor Louis." *Bulletin de la Société de l'Histoire de l'Art Français* (1959): 41–55.

PARISET 1962. ———. "Jeszcze o Pracach Wiktor Louisa dla zamku Warszawakiego." *Biuletyn Historii Sztuki* 24 (1962): 135–55.

PARISET 1963. ———. "Le roi Stanislas-Auguste Poniatowski et les arts: Son attitude artistique à propos des projets de Victor Louis en 1776." In *Utopie et institutions au XVIIIe siècle.* Paris, 1963.

PETERS 1985. Peters, David. *Identification of Plates and Services in the Sèvres Sales Registers.* French Porcelain Society, 1, 1985.

PHILLIPS 1894. Phillips, Claude. *Sir Joshua Reynolds.* London, 1894.

PHOMIN 1989. Phomin, J.B. *The Art of Marquetry in Eighteenth-Century Russia.* Moscow, 1989.

PINÇON and GAUBE DU GERS 1990. Pinçon, Jean-Marie, and Olivier Gaube du Gers. *Odiot l'orfèvre.* Paris, 1990.

PIRANESI 1769. Piranesi, Giovanni Battista. *Diverse maniere d'adornare i cammini. . . .* Rome, 1769.

PITRONE and ELWART 1981. Pitrone, Jean Madder, and Joan Potter Elwart. *The Dodges: The Auto Family Fortune and Misfortune.* South Bend, Ind., 1981.

PITTSBURGH 1925. Pittsburgh, Carnegie Institute. *An Exhibition of Paintings by Old Masters from Pittsburgh Collections.* Exh. cat., 1925.

PLAS 1975. Plas, Solange de. *Les meubles à transformation et à secret.* Paris, 1975.

PLATT 1976. Platt, Frederick. *America's Gilded Age: Its Architecture and Decoration.* New York, 1976.

POPE and BRUNET 1974. Pope, John A., and Marcelle Brunet. *The Frick Collection: An Illustrated Catalogue.* Vol. 7, *Porcelains.* New York, 1974.

POSNER 1990. Posner, Donald. "Mme. de Pompadour as a Patron of the Visual Arts." *The Art Bulletin* 72 (March 1990): 74–105.

POSTLE 1995. Postle, Martin. *Sir Joshua Reynolds: The Subject Pictures.* Cambridge, 1995.

PRADÈRE 1989. Pradère, Alexandre. *French Furniture Makers: The Art of the Ébéniste from Louis XIV to the Revolution.* Malibu, 1989.

PRÉAUD 1989. Préaud, Tamara. "Sèvres, la chine et les 'chinoiseries' au XVIIIe siècle." *The Journal of the Walters Art Gallery* 47 (1989): 39–52.

PRÉAUD and D'ALBIS 1991. Préaud, Tamara, and Antoine d'Albis. *La porcelaine de Vincennes.* Paris, 1991.

QUINQUENET 1948. Quinquenet, M. *Un élève de Clodion, Joseph-Charles Marin, 1759–1814.* Paris, 1948.

RAMOND 1989. Ramond, Pierre. *Marquetry* (1978). Newtown, Connecticut, 1989.

RATHBONE 1968. Rathbone, Perry T. *The Forsyth Wickes Collection, Museum of Fine Arts, Boston.* 1968.

RAYMOND 1770. Raymond, Jean, Abbé de Petity. *Le manuel des artistes et des amateurs. . . .* 2 vols. Paris, 1770.

RÉAU 1922. Réau, Louis. *Étienne-Maurice Falconet.* 2 vols. Paris, 1922.

RÉAU 1931–32. ———. "Correspondance artistique de Grimm avec Catherine II." In *L'art français dans les Pays du Nord et de l'Est de l'Europe (XVIIIe–XIXe siècles). Archives de l'Art Français* 17 (1931–32): 1–206.

RÉAU 1934. ———. "Un sculpteur flamand française du XVIIIe siècle: Tassaert (1727–1788)." *Revue Belge d'Archéologie et d'Histoire de l'Art* 4 (October–December 1934): 289–309.

RÉAU 1937. ———. "La décoration de l'hôtel Grimod de la Reynière d'après les dessins de l'architecte polonais Kamsetzer." *Bulletin de la Société de l'Histoire de l'Art Français* (1937): 7–16.

RÉAU 1950. ———. *Jean-Baptiste Pigalle.* Paris, 1950.

RÉAU 1956. ———. *Fragonard.* Brussels, 1956.

RÉAU, FÉRAL, and MANNHEIM 1929. Réau, Louis, Jules Féral, and M. Mannheim. *Catalogue de la collection Philippe Wiener.* Paris, 1929.

REDFORD 1888. Redford, George. *Art Sales: A History of Sales of Pictures and Other Works of Art, with Notices of Collections Sold, Names of Owners, Titles of Pictures, Prices and Purchasers, Arranged under the Artists of the Different Schools in Order of Date.* 2 vols. London, 1888.

REILLY and SAVAGE 1980. Reilly, Robin, and George Savage. *The Dictionary of Wedgwood.* Woodbridge, Suffolk, 1980.

REVEL 1959. Revel, Jean-François. "Les défaillances du Mobilier National." *Connaissance des Arts,* no. 84 (February 1959): 48–53.

REYNIÈS 1987. Reyniès, Nicole de. *Le mobilier domestique: Vocabulaire typologique.* 2 vols. Paris, 1987.

REYNOLDS n.d. Reynolds, S.W. *Engravings from the Works of Sir Joshua Reynolds, P.R.A.* 9 vols. London, n.d.

RICCI 1913. Ricci, Seymour de. *Louis XVI Furniture.* Stuttgart, 1913.

RICE 1939. "The Rice Bequest." *Bulletin of the Philadelphia Museum of Art* 35 (November 1939): n.p.

RIEDER 1984. Rieder, William. *Guide to European Decorative Arts, No. 3: France, 1700–1800.* Philadelphia Museum of Art, 1984.

ROBERTS 1959. Roberts, George, and Mary Roberts. *Triumph on Fairmont: Fiske Kimball and the Philadelphia Museum of Art.* Philadelphia, 1959.

ROBINSON 1913. Robinson, Edward. "The Morgan Collection." *Bulletin of The Metropolitan Museum of Art* 8 (June 1913): 117.

ROBIQUET 1920–21. Robiquet, Jacques. *Vie et oeuvre de Pierre Gouthière.* Paris, 1920–21.

ROCHE 1913. Roche, Denis. *Le mobilier français en Russie.* 2 vols. Paris, 1913.

ROCHEBLAVE 1919. Rocheblave, S. *Jean-Baptiste Pigalle.* Paris, 1919.

ROLDIT 1903. Roldit, Max. "The Collection of Pictures of the Earl of Normanton, at Somerley, Hampshire. I. Pictures by Sir Joshua Reynolds." *The Burlington Magazine* 2 (July 1903): 206–24.

RONFORT 1986. Ronfort, Jean Nérée. "Le mobilier royal à l'époque Louis XIV, 1685: Versailles et le bureau du Roi." *L'Estampille,* no. 191 (April 1986): 44–51.

RORSCHACH 1986. Rorschach, Kimerly. *Drawings by Jean-Baptiste Le Prince for the 'Voyage en Sibérie.'* Philadelphia, 1986.

ROSENBERG 1989. Rosenberg, Pierre. *Tout l'oeuvre peint de Fragonard.* Paris, 1989.

ROSS 1971. Ross, Nancy L. "Clearance Sale: Anna Dodge's Household Goods Go on the Block." *The Miami Herald,* September 29, 1971: 2-E.

ROTH 1987. Roth, Linda Horvitz, ed. *J. Pierpont Morgan, Collector: European Decorative Arts from the Wadsworth Atheneum.* Hartford, 1987.

ROUBO 1772. Roubo, André-Jacob. *L'art du menuisier.* Part 3, section 2, *L'art du menuisier en meubles.* Paris, 1772.

SAINSBURY 1956. Sainsbury, Wilfred J. "Soft-Paste Biscuit of Vincennes-Sèvres." *Antiques* 69 (January 1956): 46–51.

SAINT-OUEN 1993. Saint-Ouen, Espace Steinitz. *Vente Bernard Steinitz: Exceptionnel ensemble de meubles et objets d'art des XVIIe et XVIIIe siècles.* Sale cat., November 11, 1993.

ST. PETERSBURG 1907. St. Petersburg. *Khudozhestvennyya sokrovishcha Rossii (Les trésors d'art de Russie).* St. Petersburg, 1907.

SALET 1946. Salet, Francis. *La tapisserie française du moyen-âge à nos jours.* Paris, 1946.

SALVERTE 1962. Salverte, François de. *Les ébénistes du XVIIIe siécle: leurs oeuvres et leurs marques.* 5th ed. Paris, 1962. [Reprint (identical pagination), 8th ed. 1985]

SAMOYAULT 1979. Samoyault, Jean-Pierre. *André-Charles Boulle et sa famille.* Geneva, 1979.

SANDSTRÖM 1988. Sandström, Birgitta. "An Equestrian Portrait of the Duc d'Orléans by Alexander Roslin." *Bulletin of The Detroit Institute of Arts* 64, no. 1 (1988): 47–54.

SASSOON 1991. Sassoon, Adrian. *Vincennes and Sèvres Porcelain: Catalogue of the Collections, The J. Paul Getty Museum.* Malibu, 1991.

SAVAGE 1969. Savage, George. *French Decorative Art, 1638–1793.* New York, 1969.

SAVILL 1988. Savill, Rosalind. *The Wallace Collection: Catalogue of Sèvres Porcelain.* 3 vols. London, 1988.

SCHERF 1991. Scherf, Guilhem. "Autour de Clodion, variations, imitations, répétitions." *Revue de l'Art* 91 (1991): 47–59.

SCHLUMBERGER 1961. Schlumberger, Éveline. "La visite que la princesse Murat n'attendait pas." *Connaissance des arts,* no. 108 (February 1961): 38–47.

SCHMITZ 1926. Schmitz, Hermann. *Das Möbelwerk von Altertum bis zur Mitte des Neunzehnten Jahrhunderts.* Berlin, 1926.

SEIDEL 1900. Seidel, Paul. *Französische Kunstwerke des 18. Jahrhunderts.* Berlin and Leipzig, 1900.

SHAW 1798–1801. Shaw, Reverend Stebbing. *The History and Antiquities of Staffordshire: Compiled from the Manuscripts of Huntbach, Loxdale, Bishop Lyttelton, and Other Collections... Including Erdeswick's Survey of the County, and the Approved Parts of Dr. Plot's Natural History, the Whole Brought down to the Present Time, Interspersed with Pedigrees and Anecdotes of Families, Observations on Agriculture, Commerce, Mines and Manufactories.* 2 vols. London, 1798–1801.

SHEPPARD 1980. Sheppard, F.H.W., ed. *Survey of London.* Vol. 40, *The Grosvenor Estate in Mayfair, Part II, The Buildings.* London, 1980.

SHERIFF 1990. Sheriff, Mary D. *Fragonard: Art and Eroticism.* Chicago, 1990.

SIGURET 1965. Siguret, Philippe. *Le style Louis XV.* Paris, 1965.

SOKOLOVA 1967. Sokolova, Tatiana Mikhailovna. *Ocherki po istorii Khudozhestvennoi mebeli: XV–XIX vekov. (Studies in the History of Furniture, 15th–19th Centuries).* Leningrad, 1967.

SOUCHAL 1970. Souchal, François. "François Dumont, sculpteur de transition (1688–1726)." *Gazette des Beaux-Arts,* 75 (April 1970): 225–50.

SOUCHAL 1977. ———. *French Sculptors of the 17th and 18th Centuries: The Reign of Louis XIV.* Vol. 1: *A–F.* Oxford, 1977.

SOULANGE-BODIN 1925. Soulange-Bodin, Henry. *Les anciens châteaux de France: L'Ile-de-France.* Paris, 1925.

SOYER 1822. Soyer (first name unrecorded). *Modèles d'orfèvrerie choisis à l'Exposition des produits de l'industrie française, au Louvre, en 1819.* Paris, 1822.

SPILIOTI 1904. Spilioti, N. "La porcelaine à l'exposition historique des objets d'art à St. Petersburg en 1904." In *Khudozhestvennyya sokrovishcha Rossii (Les trésors d'art de Russie).* Vol. 4. St. Petersburg, 1904.

SPRETTI 1932. Spretti, Vittorio. *Enciclopedia storico-nalidiare italiana, V.* Milan, 1932.

STANDEN 1994. Standen, Edith A. "Country Children: Some *Enfants de Boucher* in Gobelins Tapestry." *The Metropolitan Museum of Art Journal* 29 (1994): 111–33.

STEPHENS 1884. Stephens, Frederic G. *English Children, as Painted by Sir Joshua Reynolds: An Essay on Some of the Characteristics of Reynolds as a Designer, with Especial Reference to His Portraiture of Children.* 2d ed. London, 1884.

STERN 1930. Stern, Jean. *A l'ombre de Sophie Arnould, François-Joseph Bélanger.* 2 vols. Paris, 1930.

STILLMAN 1966. Stillman, Damie. *The Decorative Work of Robert Adam.* London, 1966.

STILLMAN 1971. ———. "Works of Art with a Royal Provenance from the Collection of the Late Mrs. Anna Thomson Dodge of Detroit." *The Connoisseur* 177 (May 1971): 34–36.

STRATMANN 1971. Stratmann, Rosemarie. "Der Ebenist Jean-François Oeben." Dissertation. Ruprecht-Karl-Universität, Heidelberg, 1971.

STRONG, BINNEY, and HARRIS 1974. Strong, Roy, Marcus Binney, and John Harris. *The Destruction of the Country House: 1875–1975.* London, 1974.

TADGELL 1978. Tadgell, Christopher. *Ange-Jacques Gabriel.* London, 1978.

TARDY n.d. *La pendule française.* 2 vols. Paris, n.d.

THIÉRY 1787. Thiéry, Luc-Vincent. *Guide des amateurs et des étrangers voyageurs à Paris.* 2 vols. Paris, 1787.

THORNE 1986. Thorne, R.G. *The History of Parliament: The House of Commons 1790–1820.* 5 vols. London, 1986.

TOKYO 1989. Tokyo, The Bunkamura Museum of Art, The Kyoto Municipal Museum of Art, and The Museum of Modern Art, Ibaraki. *Masterpieces of The Detroit Institute of Arts.* Exh. cat., 1989.

TOKYO 1990. Tokyo, Odakyu Grand Gallery; Osaka, Daimaru Museum; Hokkaido Hakodate Museum of Art; and Yokohama, Sogo Museum of Art. *Three Masters of French Rococo: Boucher, Fragonard, Lancret.* Exh. cat. by J. Patrice Marandel, 1990.

TOWNSEND 1922. Townsend, James. *The Oxfordshire Dashwoods.* Oxford, 1922.

VACQUIER 1914. Vacquier, J. *Les vieux hôtels de Paris.* Vol. 10. Paris, 1914.

VALENTINER 1925. V[alentiner], W.R. "A Madonna by Matteo di Giovanni." *Bulletin of The Detroit Institute of Arts* 6 (April 1925): 74.

VAUCAIRE 1902. Vaucaire, Maurice. "Les tapisseries de Beauvais sur les cartons de F. Boucher." *Les arts,* no. 7 (August 1902): 10–17.

VEIS 1952. Veis, N.V. *Pavlovsk.* Moscow, 1952.

VERLET 1945. Verlet, Pierre. *Le mobilier royal français.* Vol. 1. Paris, 1945. [2nd ed., 1990]

VERLET 1950. ———. "The Wallace Collection and the Study of French 18th-Century Bronzes d'Ameublement." *The Burlington Magazine* 92 (June 1950): 154–57.

VERLET 1955. ———. *Le mobilier royal français.* Vol. 2. Paris, 1955. [2nd ed., 1990]

VERLET 1955a. ———. *Möbel von J.H. Riesener.* Darmstadt, 1955.

VERLET 1956. ———. *Les meubles français du XVIIIe siècle.* Vol. 2, *Ébénisterie.* Paris, 1956.

VERLET 1963. ———. *French Royal Furniture.* Vol. 3. London, 1963. [French ed., Paris, 1991]

VERLET 1967. ———. *The Eighteenth Century in France: Society, Decoration, Furniture.* Rutland, Vermont, and Tokyo, 1967. [First published as *La Maison du XVIIIe siècle en France: Société, décoration, mobilier.* Paris, 1966.]

VERLET 1982. ———. *Les meubles français du XVIIIe siècle.* Paris, 1982.

VERLET 1987. ———. *Les bronzes dorés français du XVIIIe siècle.* Paris, 1987.

VERLET 1990. ———. *Le mobilier royal français.* Vol. 4. Paris, 1990.

VERLET 1991. ———. *French Furniture of the Eighteenth Century.* Charlottesville and London, 1991.

VIAL, MARCEL, and GIRODIE 1912. Vial, Henri, Adrien Marcel, and André Girodie. *Les artistes décorateurs du bois, I: A à L.* Paris, 1912.

VIAL, MARCEL, and GIRODIE 1922. ———. *Les artistes décorateurs du bois, II: M à Z, supplément.* Paris, 1922.

VITRY 1912. Vitry, Paul. "Le legs de Mme Emile Masson aux Musées Nationaux." *Les Musées de France* 4 (1912): 62–63.

VORONIKHINA 1983. Voronikhina, A.N. *Vidy zalov Ermitazha i Zimnego dvortsa v akvareliakh i risunkakh khudozhnikov serediny XIX veda.* Moscow, 1983.

VOSS 1953. Voss, Hermann. "François Boucher's Early Development." *The Burlington Magazine* 95 (March 1953): 81–93.

WAAGEN 1857. Waagen, Gustav. *Galleries and Cabinets of Art in Great Britain: Being an Account of More than Forty Collections of Paintings, Drawings, Sculpture, Mss., &c &c Visited in 1854 and 1856, and Now for the First Time Described, Forming a Supplemental Volume to the Treasures of Art in Great Britain.* London, 1857.

WARDROPPER and ROBERTS 1991. Wardropper, Ian, and Lynn Springer Roberts. *European Decorative Arts in The Art Institute of Chicago.* Chicago, 1991.

WARK 1959. Wark, Robert R. *Sculpture in the Huntington Collection.* San Marino, 1959.

WARK 1961. ——. *French Decorative Art in the Huntington Collection.* San Marino, 1961. [1st ed.]

WARK 1968. ——. *French Decorative Art in the Huntington Collection.* San Marino, 1968. [2nd ed.]

WARK 1979. ——. *French Decorative Art in the Huntington Collection.* San Marino, 1979. [3rd ed.]

WASHINGTON 1948. Washington, D.C., National Gallery of Art. *Paintings and Sculpture from the Widener Collection.* Washington, 1948.

WASHINGTON 1951. ——. *Paintings and Sculpture from the Kress Collection.* Washington, 1951.

WASHINGTON and CHICAGO 1973. Washington, D.C., National Gallery of Art, and The Art Institute of Chicago. *François Boucher in North American Collections: 100 Drawings.* Exh. cat. by Regina Shoulman Slatkin, 1973.

WATERHOUSE 1941. Waterhouse, Ellis K. *Reynolds.* London, 1941.

WATERHOUSE 1953. ——. "Preliminary Check List of Portraits by Thomas Gainsborough." *The Walpole Society 1948–1950* 33 (1953): 1–130.

WATERHOUSE 1958. ——. *Gainsborough.* London, 1958.

WATERHOUSE 1969. ——. *Painting in Britain, 1530–1790.* 3rd ed. Harmondsworth, 1969.

WATERHOUSE 1973. ——. *Reynolds.* London, 1973.

WATSON 1956. Watson, F.J.B. *Wallace Collection Catalogues: Furniture.* London, 1956.

WATSON 1960. ——. *Louis XVI Furniture.* New York, 1960.

WATSON 1961. ——. "French Tapestry Chair Coverings: A Popular Fallacy Re-examined." *The Connoisseur* 148 (October 1961): 166–69.

WATSON 1964. ——. "The Paris Collections of Madame B., I: The Furniture." *The Connoisseur* 155 (February 1964): 2–11.

WATSON, DAUTERMAN, and FAHY 1966–73. Watson, F.J.B., Carl Christian Dauterman, and Everett Fahy. *The Wrightsman Collection.* 5 vols. Greenwich, Connecticut, 1966–73.

WEBSTER 1970. Webster, Mary. *Francis Wheatley.* London, 1970.

WEIGERT 1933. Weigert, Roger-Armand. "La manufacture royale de tapisseries de Beauvais en 1754." *Bulletin de la Société de l'Histoire de l'Art Français* (1933): 226–42.

WEIGERT 1962. ——. *French Tapestry.* London, 1962.

WHEATLEY 1825. Wheatley, Edmund. *A Descriptive Catalogue of Prints, with the Engravers' Names and Dates, Which Have Been Engraved from Original Portraits and Pictures by Sir Joshua Reynolds.* London, 1825.

WHITEHEAD 1992. Whitehead, John. *The French Interior in the Eighteenth Century.* London, 1992.

WILDENSTEIN 1960. Wildenstein, Georges. *The Paintings of Fragonard.* New York and Oxford, 1960.

WILDENSTEIN 1962. ——. "Simon-Philippe Poirier, fournisseur de Madame du Barry." *Gazette des Beaux-Arts* 40 (September 1962): 365–77.

WILSON 1976. Wilson, Gillian. *French Eighteenth-Century Clocks in The J. Paul Getty Museum.* Malibu, 1976.

WILSON 1977. ——. "Sèvres Porcelain at The J. Paul Getty Museum." *The J. Paul Getty Museum Journal* 4 (1977): 5–28.

WILSON 1983. ——. *Selections from the Decorative Arts in The J. Paul Getty Museum.* Malibu, 1983.

WILSON et al. 1996. —— et al. *European Clocks in The J. Paul Getty Museum.* Malibu, 1996.

WILSON, SASSOON, and BREMER-DAVID 1984. Wilson, Gillian, Adrian Sassoon, and Charissa Bremer-David. "Acquisitions Made by the Department of Decorative Arts in 1983." *The J.Paul Getty Museum Journal* 12 (1984): 173–224.

WINCKELMANN 1781. Winckelmann, Johann Joachim. *Lettres familières.* Amsterdam, 1781.

WIND 1931. Wind, Edgar. "Humanitätsidee und heroisiertes Porträt in der englischen Kultur des 18. Jahrhunderts." *Vorträge der Bibliothek Warburg* 9 (1930–31): 156–229.

WINOKUR 1971. Winokur, Ronald L. "The Mr. and Mrs. Horace E. Dodge Memorial Collection." *Bulletin of The Detroit Institute of Arts* 50 (1971): 43–51.

WITTKOWER 1981. Wittkower, Rudolf. *Gian Lorenzo Bernini: The Sculptor of the Roman Baroque.* 3rd edition. Ithaca, N.Y.: 1981.

WORTH PARK 1915. Knight, Frank & Rutley. *Worth Park, Sussex: Contents of the Mansion.* Sale cat., July 12–20, 1915.

YOUNG 1821. Young, John. *A Catalogue of Pictures by British Artists, in the Possession of Sir John Fleming Leicester, Bart., with Etchings from the Whole Collection, Including the Pictures in His Gallery at Tabley House, Cheshire, Executed by Permission of the Proprietor, and Accompanied with Historical and Biographical Notices.* London, 1821.

ZELLEKE 1991. Zelleke, Ghenete. "From Chantilly to Sèvres: French Porcelain and the Dukes of Richmond." *The French Porcelain Society* 7 (1991): 2–33.

ZURICH 1992. Zurich, Sotheby's. *Continental Ceramics, Furniture and Decorations.* Sale cat., June 4, 1992.

INDEX

Frick Collection, New York, 32n. 13, 78, 100, 104, 120, 159, 202; *Satyr with Two Bacchantes and an Infant Satyr*, 104

Friedenreich, Julius, 138

Friederike Sophie Dorothea, Duchess of Württemberg, 16, 58

Friedrich-Wilhelm, King of Prussia, 113

Frodrow (Prince) collection, St. Petersburg, 124

Fuller (George A.) Company, New York and Chicago, 21, 23

furniture, 28, 37–98; French eighteenth-century, 16, 17, 28, 29, 38–62, 64–98; French twentieth-century, 226; German eighteenth-century, 64, 66; Russian eighteenth-century, 62–63, 66

Gabriel, Ange-Jacques, 22, 136

Gainsborough, Thomas, 28, 208–15, 216, 219; *Anne, Countess of Donegall (Lady Anne Hamilton)*, 16, 17, 26, 208–10, 210, 211, 212, 214, 215, 219; *Ann Ford, Later Mrs. Philip Thicknesse*, 208; *The Blue Boy*, 208, 215; *John Joseph Merlin*, 215; *The Morning Walk*, 208; *Portrait of a Gentleman* (formerly *The Hon. Richard Savage Nassau de Zuylestein, M.P.*), 16, 17, 209, 210, 211, 213, 214, 215; *Reverend Sir Henry Bate-Dudley*, 215; *The Road from Market*, 208

Galerie Georges Petit, Paris, 128

Galleria Doria Pamphilj, Rome, 126, 239

Ganard, G., 214

Ganay, marquise de, 88

Garde-Meuble National, Paris, 81, 82, 90, 94, 130

Garnier, Pierre, 62

Gary (Judge Elbert H.) collection, New York, 120

Gatchina Palace, near St. Petersburg, 138

Genest, Jean-Baptiste-Étienne, 162, 170–72; *Pair of Covered Vases (vase carrache, second size)* [Decoration probably by Jean-Baptiste-Étienne Genest], 27, 170, 171, 172

Genty, Denis, 40, 46

Geoffrin, Madame, 123

George III, King of England, 25, 29, 208, 216, 219

George IV, King of England, 90, 216

Gérard, Marguerite, 202

Germain, François-Thomas, 123, 138

Germain, Pierre, 159; *Eléments d'orfèvrerie*, 159

German furniture, eighteenth-century, 64, 66

German porcelains, 159; late nineteenth–early twentieth-century, 226

Getty, J. Paul, 24, 31, 33n. 44

Getty (J. Paul) Museum, Malibu, Calif., 18, 24, 29, 31–32, 33nn. 44–45, 41, 59, 69, 76, 108, 130, 140, 181, 236, 237, 238, 240

Gilbert, André-Louis, 53

Girard, Étienne-Gabriel, 199–200; *Sugar Bowl and Stand (sucrier de Monsieur le Premier et plateau)* [Gilding by Étienne-Gabriel Girard], 199, 199, 200

Gobelins manufactory, France, 88, 94, 144, 147–50; *Four Tapestry Panels Mounted in a Screen* (Designed by François Boucher), 147, 148, 149, 149, 150

Goelet (Robert) collection, 62, 133

Goldsmith, Oliver, 219, 220

Golle, Pierre, 239

Good, Alan P., 94

Goodwood House, England, 182, 183, 186

Gould (George Jay) collection, 126, 146

Gouthière, Pierre, 69, 125–26, 130, 132, 134; other work by, 126; *Pair of Firedogs (Chenets)*, 125, 125, 126; *Pair of Sconces*, 132, 133, 133, 134

Gouthière, Pierre, formerly attributed to, *Pair of Sconces*, 132, 133, 133, 134

Graham, George, 236

Grand Style, 219

Gravelot (Hubert-François Bourguignon), 208

Graves, Frederick Percy, 211, 215

Greuze, Jean-Baptiste, *La marchande des marrons*, 166

Grimod de la Reynière, Alexandre, 135–36, 138

Grog-Carven Collection, Musée du Louvre, Paris, 86

Grosvenor Gallery, London, 223

Groves (Mr. and Mrs. Franklin N.) collection, 129

Grozer, Joseph, 223

Guay, Étienne Henry le, 162

Guillaume, Simon, 44

Gustavus III, King of Sweden, 90

Gwatkin, Theophila, 220

Hache, François, 48

Hamilton, Lady Anne, 209–12, 214, 215

Hamilton, Lord Spencer, 215

Hancock (C.F.) firm, London, 139

Haranc de Presle (François-Michel) collection, 17, 101

Harcourt (Viscount) collection, 77

hardstones, Chinese, 28, 31, 226–27

Harewood collection, 155

Harrison, William Welsh, 32n. 16

Havemeyer (Mrs. Theodore A.) collection, 90

Hawley, Henry, 110

Hayman, Francis, 208

Heine (Georges) collection, 128, 129

Hermitage, St. Petersburg, 94, 110, 114, 138, 140, 154, 155, 181, 219

Heurtaut, Nicolas, 94, 96

Hewitt, Mattie Edwards, 20

Hewitt (K.J.) collection, 88

Hillingdon collection, Messing Park, Essex, 58, 68, 220

Hitau, Édouard, 24, 27, 28

Hodgkinson, Terence, 102, 110

Hoppner, John, 28, 216–19; *Lady Almeria Carpenter*, 218; *Susannah-Edith Rowley (née Harland), later Lady Rowley*, 17, 216, 217, 217, 218, 219

Hôtel Grimod de la Reynière, Paris, 135, 136

Houdon, Jean-Antoine, 108, 110

Houston, Richard, 214

Hudson, Thomas, 219

Huet, Jean-Baptiste, 94, 147

Hunt, Richard Morris, 33n. 24

Huntington, Mrs. Henry E., 96

Huntington Library and Art Gallery, San Marino, Calif., 20, 32n. 13, 40, 96, 114, 132, 150, 208, 215, 219

Huquier, Gabriel, *père*, 156

Hutton (Barbara) collection, 46

Ice-Cream Coolers (seau à glace), 196, 196, 197

Ice-Cream Coolers (seau à glace, first size), 182, 186, 187, 196, 197

Igonet, Marie-Madeleine: *L'amusement de la bergère*, 147; *La petite beurière*, 147

Indianapolis Museum of Art, 203

Italian painting, fifteenth-century, 229

Iveagh Bequest, Kenwood House, London, 215, 219

Jacob, François-Honoré-Georges, 90

Jacob, Georges, 88, 89, 90–93, 94, 96; other work by, 92, 94, 96; *Set of Six Flat-Backed Fauteuils Upholstered with Beauvais Tapestry Covers*, 91, 91, 92–93, 96

Jacob, Georges, II, 90

Jacob, Henri, 90

Jacob-Desmalter, Georges-Alphonse, 90

Jacob-Desmalter et Cie, 90, 93

Jacob Frères, 90

Jacobs (Mary Frick) Collection, Baltimore Museum of Art, 76, 77

Jacques, Maurice, 94, 149

Japanese painting, eighteenth-century, 240

Jardinières (Athéniennes), 226, 227

Jeuniette, Fernand and Jules, 92

Johnson, Samuel, 219, 220

Johnson (Mr. and Mrs. Deane) collection, Bel Air, Calif., 76

Jones Collection, Victoria and Albert Museum, London, 40, 68, 82, 113

Joubert, Gilles, 40, 74

Jouin, Henry, *Musée des portraits d'artistes*, 110

Julliot, 68, 82

Kalinin Museum, Kalinin, 63

Kamsetzer, drawings of Hôtel Grimod de la Reynière salon, Paris, 135, 135, 136, 138

Kanzler Room, Detroit Institute of Arts, 18

Keck collection, Bel Air, Calif., 76, 133

Kelly, Gerald Festus, *Mrs. Horace Elgin Dodge*, 27, 34, 229

Kimball, Fiske, 33n. 32

Kimbell Art Museum, Fort Worth, Tex., 110

Knight, Edward C., Jr., 21

Kress, Samuel, 18

Kress Collection, Metropolitan Museum of Art, New York, 58, 68, 92, 133

Krieger, Paris, 149

Kunstbibliothek, Berlin, 238

Kunstgewerbemuseum, Berlin, 147

Kuskovo Estate Museum, Moscow, 63